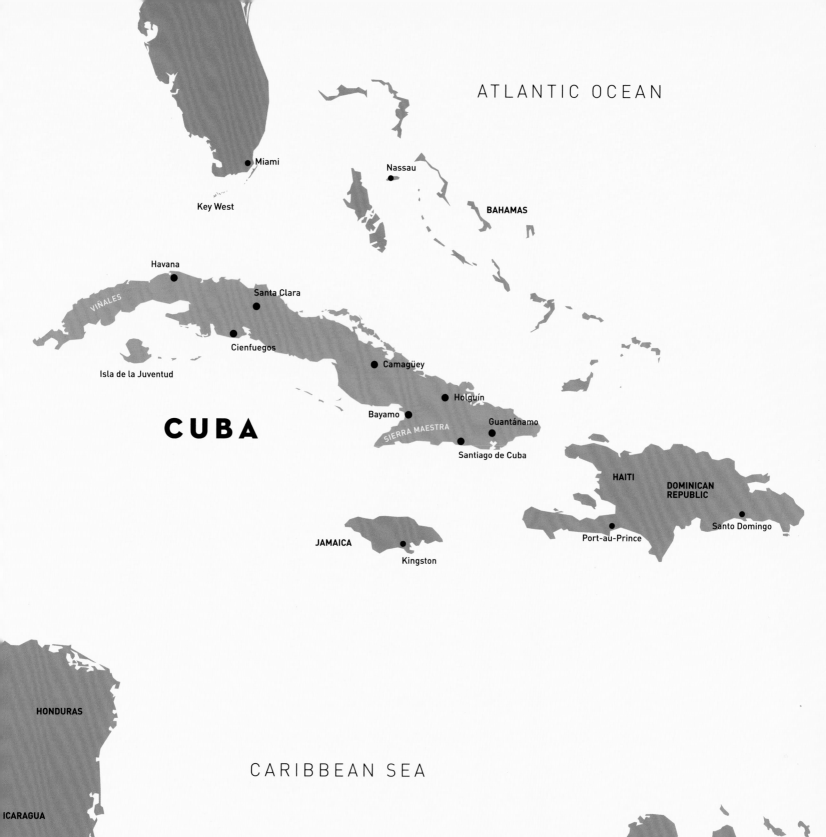
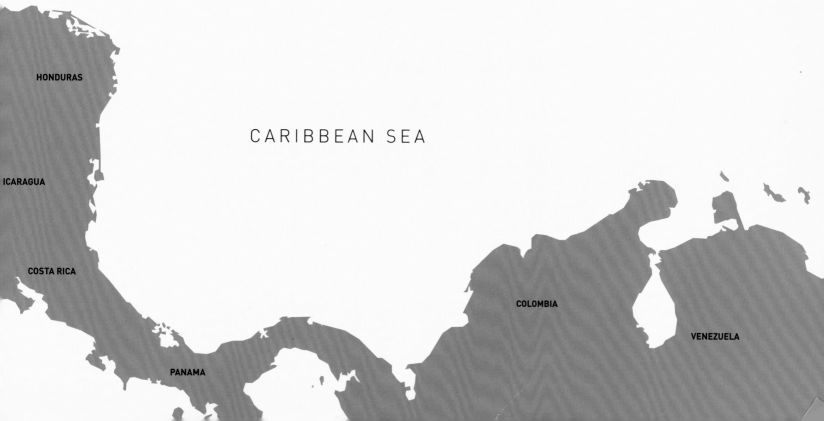

ATLANTIC OCEAN

Miami

Nassau

Key West

BAHAMAS

Havana

Santa Clara

VIÑALES

Cienfuegos

Camagüey

Isla de la Juventud

Holguín

Bayamo

CUBA

SIERRA MAESTRA

Guantánamo

Santiago de Cuba

HAITI

DOMINICAN REPUBLIC

Port-au-Prince

Santo Domingo

JAMAICA

Kingston

HONDURAS

CARIBBEAN SEA

ICARAGUA

COSTA RICA

COLOMBIA

VENEZUELA

PANAMA

CUBA

ART AND HISTORY FROM 1868 TO TODAY

M THE MONTREAL MUSEUM
OF FINE ARTS

CUBA. Art and History from 1868 to Today
An exhibition produced by the Montreal
Museum of Fine Arts in partnership
with the Museo Nacional de Bellas
Artes and the Fototeca de Cuba in
Havana.

The Montreal Museum of Fine Arts
Jean-Noël Desmarais Pavilion
From January 31 to June 8, 2008

Exhibition design
Daniel Castonguay
in association with David Gour

Catalogue
Edited by Nathalie Bondil, Director
The Montreal Museum of Fine Arts

English version: The Montreal Museum
of Fine Arts / Prestel Publishing
French version: The Montreal Museum
of Fine Arts / Éditions Hazan
Spanish version: The Montreal Museum
of Fine Arts / Lunwerg Editores

This exhibition is presented by Sun Life
Financial in co-operation with METRO.

The Montreal Museum of Fine Arts
wishes to thank Quebec's Ministère
de la Culture et des Communications,
the Canada Council for the Arts and the
Conseil des arts de Montréal for their
ongoing support.

The Museum's gratitude goes also
to the Volunteer Association of the
Montreal Museum of Fine Arts as
well as to all its Friends and the
many corporations, foundations and
individuals for their contribution.

The international exhibition program
of the Montreal Museum of Fine Arts
receives financial support from the
Exhibition Fund of the Montreal Museum
of Fine Arts Foundation and the Paul G.
Desmarais Fund

The Montreal Museum of Fine Arts

Bernard Lamarre
President

Nathalie Bondil
Director

Paul Lavallée
Director of Administration

Danielle Champagne
Director of Communications
Director of the Montreal Museum
of Fine Arts Foundation

CUBA

ART AND HISTORY FROM 1868 TO TODAY

THE MONTREAL MUSEUM OF FINE ARTS

General Curator
Nathalie Bondil
Director

Assisted by
Iliana Cepero Amador
Independant Curator

Stéphane Aquin
Curator of Contemporary Art

MUSEO NACIONAL DE BELLAS ARTES

Under the directorship of
Moraima Clavijo Colom
Director

Luz Merino Acosta
Deputy Director

Principal coordinator of the exhibition
Hortensia Montero Méndez
Curator of Cuban art of the 1970s

Curatorial committee
Department of Cuban Art
Ernesto Cardet Villegas
*Curator of the late 19th and
early 20th century*
Roberto Cobas Amate
Curator of Cuban "Vanguardia" art
Olga López Núñez
Curator of the 19th century
Aylet Ojeda Jequin
Curator of popular painting
Corina Matamoros Tuma
Curator of the 1980s and 1990s
Liana Ríos Fitzsimmons
Curator of the 1960s
Elsa Vega Dopico
Curator of the 1950s and posters

FOTOTECA DE CUBA

Under the directorship of
Lourdes Socarrás
Director

Rufino del Valle Valdés
Curator

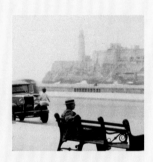

1 DEPICTING CUBA
finding ways to express a nation (1868–1927)

2 ARTE NUEVO
the avant-garde and the re-creation of identity (1927–1938)

Throughout its long history, it has been a practice of the Museo Nacional de Bellas Artes in Havana to present work in international venues out of our extensive collection. With a few exceptions, these exhibitions have generally been of limited scope, devoted to highlighting the importance of an artist or a period that is representative of Cuban or world art.

The vast exhibition *Cuba. Art and History from 1868 to Today*, which we are now presenting at the Montreal Museum of Fine Arts, is unprecedented in scope. It is the largest possible chronological survey of Cuban art, bringing together the work of well over a hundred artists in media ranging from the traditional to poster art, installation, video and an exceptional selection of photography, both documentary and artistic. The work of every major figure is present here. Special mention must also be made of the exhibition, for the first time, since 1968, outside of Cuba, of the enormous mural from the 1967 Salon de Mai, held in Havana. This mural is seen as emblematic of art in the latter half of the twentieth century.

While painting inevitably dominates the exhibition, there is also a broad panorama of other Cuban visual arts produced more than a century ago to the present day, including work from a great number of public and private collections. Within Cuba, crucial contributions came from the Fototeca de Cuba and institutions such as the Oficina del Historiador de la Ciudad, the Biblioteca Nacional José Martí, the Consejo Nacional de las Artes Plásticas, and the Centro de Desarrollo de las Artes Visuales.

This exhibition is the fruit of more than three years of collaboration between the Montreal Museum of Fine Arts and the Museo Nacional de Bellas Artes, which carefully selected the works borrowed from its collection and discussed every step of this wide-ranging and complex project involving more than a dozen experts and curators in Canada and Cuba. Here I can mention only the efforts of Nathalie Bondil, who worked tirelessly from the very beginning, to make this wonderful and inclusive exhibition a reality, an exhibition that will surely make its mark on the rich cultural life of Montreal.

We leave the exhibition to the broad public of this formidable institution in the hope that it will meet its discerning expectations through these images of Cuba's reality, and also of its story, which meet and mix in all true art. In Cuban art these have taken on unrepeatable value and meaning. This is the rich identity of our hybrid island nation, which has also been called upon to play a unique role in history.

Moraima Clavijo Colom
Director
Museo Nacional de Bellas Artes, Havana

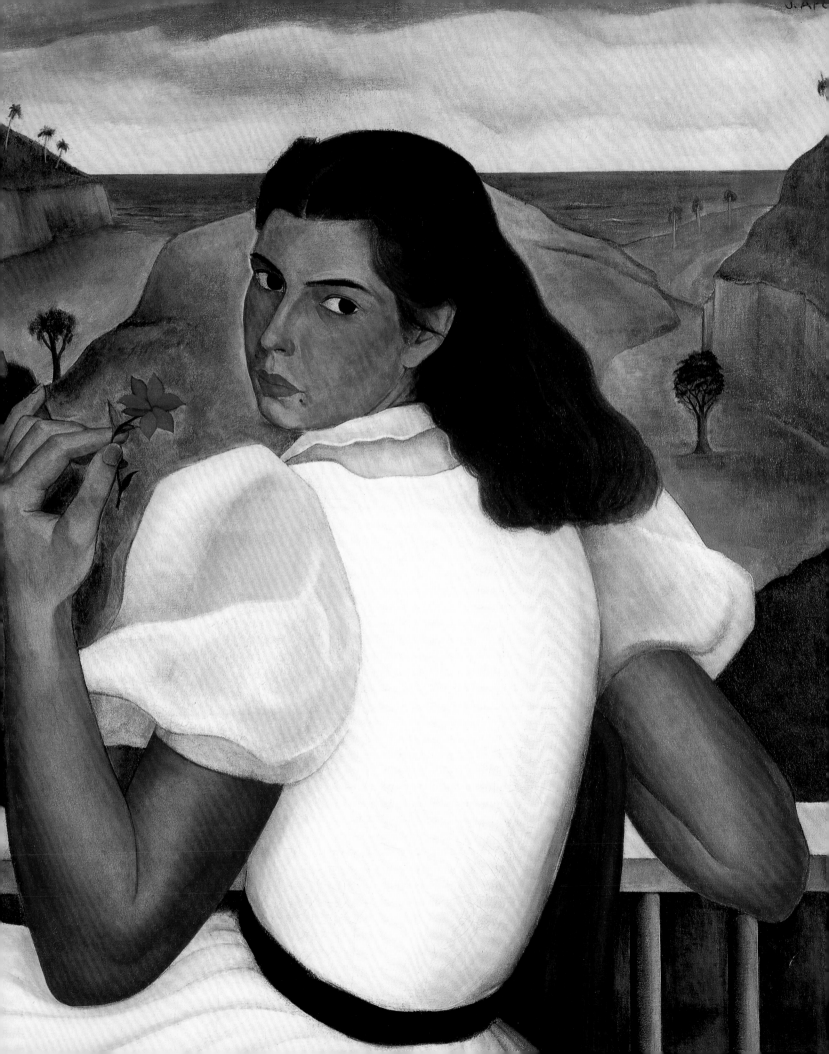

SUN LIFE Financial is proud to play a role in presenting
CUBA. Art and History from 1868 to Today, the first major
exhibition of its kind devoted to Cuban art.

This multidisciplinary exhibition takes us on a spellbinding
150-year journey through some 400 works, many never
before seen or being shown for the first time outside Cuba.

This is a perfect opportunity to trace the development of
Cubanidad and the rich artistic heritage of this Caribbean
island, described by Christopher Columbus as "the most
beautiful land human eyes have ever beheld."

Cultural life is brighter under the sun!

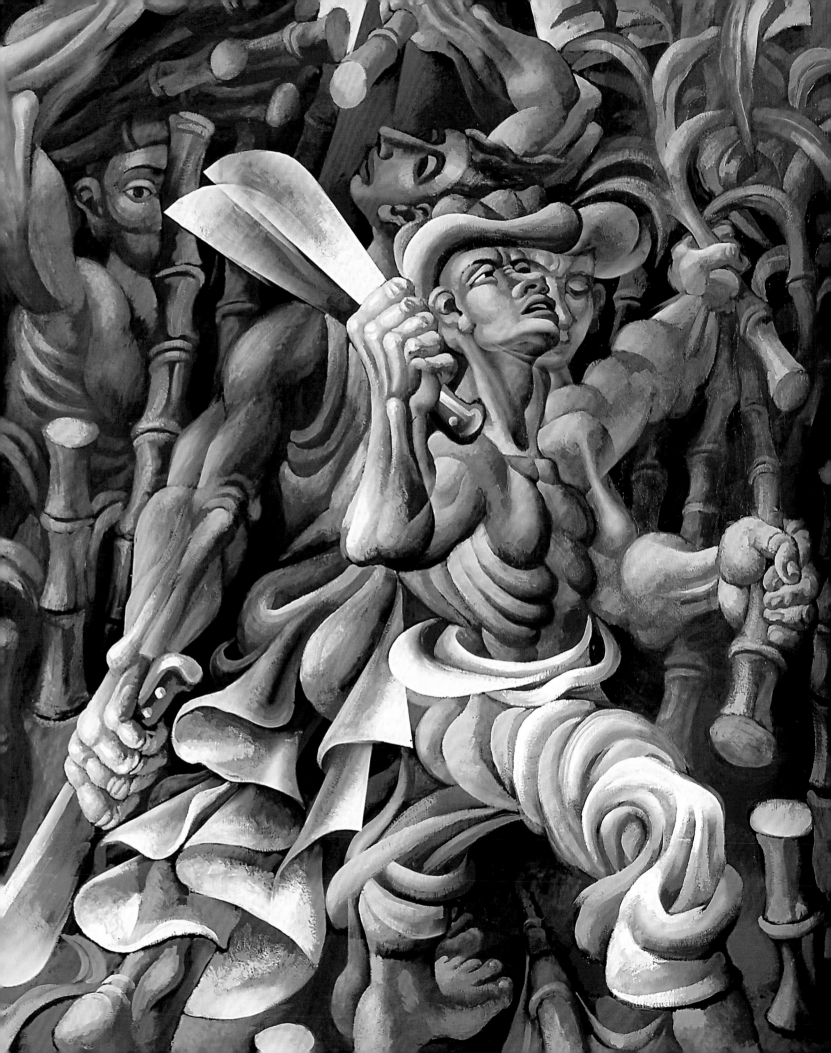

ACKNOWLEDGEMENTS

In a spirit of friendship

This major exhibition is the first of its kind to showcase 150 years of Cuban art. Many are the legacies that have left their mark on Cuba over its history. It is a land rich in culture, and although its music and literature are part of the world's heritage, its visual arts are little known among non-Cubans. A project such as this one can only have come to be through true friendship, such as the friendship forged between the Montreal Museum of Fine Arts and the Museo Nacional de Bellas Artes in Havana to bring together so many people for a common cause: to raise appreciation of Cuban art.

★

On behalf of the Montreal Museum of Fine Arts I would like to start by extending my heartfelt gratitude to Moraima Clavijo Colom, Director of the Museo Nacional de Bellas Artes, Havana. Thanks to her invitation, I discovered the Havana museum's Cuban art collections, a true revelation, and that's where it all began. Without her dynamic and intelligent resolve, such a collaboration would not have been imaginable. Her entire team deserves to be thanked: Regla García Henry, Deputy Director General; Heriberto Rodríguez Pérez,

Deputy Director of Management and Communications; Nadia Karandashov Robinson, International Relations Specialist; Esperanza Maynulet, Deputy Director, Cultural Services; Carlos Gálvez, Head of the Museography Department; Roberto Cuesta, Head of Conservation and Restoration; Aracelis Feria, Head of Registry and Inventory; Elba Gutiérrez, Head of the Educational Services Department; María de los Ángeles Hernández, Head of Communications; José Pérez Forcada, Head of the General Services Department; Antonio Hurtado, Head of the Programming Department; and Regla Portes, Head of the Antonio Rodríguez Morey Information Centre. I am of course also indebted to Luz Merino Acosta, Deputy Director, and Máximo Gómez, Head of the Collections and Curatorial Department, both of whom possess a deep culture and charm that are impossible to resist.

The curators of Cuban art at the Museo Nacional de Bellas Artes have shared their knowledge and professionalism, and become not only respected colleagues but also new friends. They deserve more praise than these words can offer. They are: Ernesto Cardet Villegas, Roberto Cobas Amate, Olga

López Núñez, Corina Matamoros Tuma, Aylet Ojeda Jequin, Liana Ríos Fitzsimmons, Elsa Vega Dopico and, of course, Hortensia Montero Méndez, who has effectively coordinated this project with the curators. My deepest thanks also go to Juan Francisco Olivera, Clara Díaz, Julio García, Raúl García, Anniubys García, Carlos Moré, Julio A. González, and Jorge E. Aguilar in the Curatorial Department; Julieta Santacana, Circe Ávila, Erich Gómez, Anabel Díaz, Boris L. Rodríguez, Reinier Díaz, Carlos Moré, Armando López, Héctor González, Daniel Sancho, Haydee Guasch, Roberto Díaz, Roberto Sabido, Héctor Sánchez in the Restoration Department; and to Delia M. López in the Registry and Inventory Department.

I would also like to express my appreciation to all those who welcomed us, always with a smile and warmth; I will remember them always.

In order to give structure to an exhibition covering so much history, the need to include photographs, both of an artistic or documentary nature, became clear following a visit to the archives of the Fototeca de Cuba. Its director, Lourdes Socarrás, has fortunately been an invaluable partner from the very

beginning. My warmest thanks go to Rufino del Valle Valdés, the collection's curator, whose involvement has greatly contributed to finding, documenting and obtaining photographs that have largely never been shown before.

I also wish to acknowledge the contributions of the following people in Havana: Ramón Cabrales, Archivo de FotoCreart, Ministry of Culture; Eduardo Torres Cueva, Fototeca de la Oficina del Historiador de la Ciudad; Raida Mara Suárez Portal, Heritage Director, Museo de la Ciudad; and Marta Haya, Head of the Department of Photographs, Biblioteca Nacional José Martí, for having given permission to reproduce the magazine cover of *Bohemia*.

★

Many private and public insitutions and private collectors from around the world have contributed to this project in a spirit of sharing and friendship. I wish to express my profound appreciation to all of them and to those who have chosen to remain anonymous.

Canada
Heidi Hollinger Collection, Montreal
McGill University Library, Rare Books
 and Special Collections Division:
 Richard Virr, Acting Head
Private collections, Montreal

Cuba
Biblioteca Nacional José Martí, Havana
Courtesy of the Fototeca de Cuba:
 Enrique de la Uz
 Ernesto Fernández Nogueras
 Liborio Noval
 Mario García Joya
 María J. González, Head of the
 Constantino Arias Collection

Private collection
 Roberto Salas, Head of the Osvaldo
 Salas Freire Collection
 René Peña
Courtesy of the Museo Nacional de
Bellas Artes:
 Aberlado Estorino
 Eladio Rivadulla
 Fondo Cubano de Bienes Culturales
 Fototeca de la Oficina del Historiador
 de la Ciudad, Havana
 José Gómez Fresquet (Frémez)
 Private collection, Havana

Dominican Republic
Isaac, Carmen Lif and family, Santo
 Domingo

France
Dr. Günter Schütz, Paris
Jean-Jacques Lebel, Paris
Musée national d'Art moderne / Centre
 de création industrielle, Centre
 Georges Pompidou, Paris:
 Alfred Pacquement, Director, and
 Isabelle Monod-Fontaine, Deputy
 Director (work on deposit at the
 Musée Cantini: Marie-Paule Vial,
 Director, Musées de Marseille)
Private collection, Paris

Germany
Sammlung Ludwig – Ludwig Forum
 für Internationale Kunst, Aachen:
 Harald Kunde, Director

Italy
Carlos Garaicoa. Courtesy of the
 Galleria Continua, San Gimignano /
 Beijing: Mario Cristiani, Director,
 Verusca Piazzesi

Switzerland
Collection Daros-Latinoamerica, Zurich:
 Hans-Michael Herzog, Director,
 Felicitas Rausch, Collection Director,
 and Laurence Nerlich

United States
Arizona State University Art Museum,
 Tempe: Marilyn A. Zeitlin, Director
 and Chief Curator
Couturier Gallery, Los Angeles: Darrel
 Couturier, Director
Cuban Foundation, Museum of Arts and
 Sciences, Daytona Beach: Wayne D.
 Atherholt, Executive Director
Darrel Couturier, Los Angeles
Diana Díaz, with Darrel Couturier,
 Korda Collection, Los Angeles
Ernesto Oroza, Aventura
Estate of Ana Mendieta Collection
 & Galerie Lelong , New York:
 Mark Hughes, Director
Jesús Fernández-Torna, Miami
Joe Abraham, Houston
Maria Bechily and Scott Hodes, Chicago
Museum of Art, Fort Lauderdale: Irvin
 Lippman, Executive Director
Museum of Contemporary Photography,
 Columbia College, Chicago:
 Rod Siemmons, Director
The Museum of Modern Art, New York:
 Glenn Lowry, Director, John
 Elderfield, Chief Curator, Department
 of Painting and Sculpture, Cora
 Rosevear, Associate Curator, and
 Thomas D. Grischkowsky, Archives
 Specialist
The Metropolitan Museum of Art,
New York: Philippe de Montebello,
 Director, and Jeff L. Rosenheim,
 Curator, Department of Photographs
Private collections, Miami
Private collection. Courtesy of the Sean
 Kelly Gallery, New York: Sean Kelly,
 Director

Vicki Gold Levi, New York
Wolfsonian-Florida International
 University, Miami Beach:
 Cathy Leff, Director, and Francis
 Xavier Luca, Director of the Library

I wish to credit the Museum of Modern
Art in New York in particular, for their
great generosity and vital contribution.
Meeting Vicki Gold Levi has been a true
pleasure. I greatly appreciate her allow-
ing us access to her rich collection of
photographs, and Cuban magazines
and other documents. I also wish to
thank Jesús Fernández-Torna for his
kind assistance. I also thank Dr. Günter
Schütz for helping to bring together
documents depicting the collective
mural project of 1967, which have never
been shown until now. Of course, the
works would not exist without the art-
ists, which is why I wish to express my
deepest gratitude to them and their rep-
resentatives for participating in different
ways. They are: Cundo Bermúdez and
Conrado Basulto, Tania Bruguera, Olivio
Martínez, Manuel Piña and, in particular,
Carlos Garaicoa, who has allowed an
adaptation of his work *Now Let's Play
Disappear, II*.

★

I also wish to express my gratitude for
the contributions made to this project
by Jennifer Alleyn, Emmanuel Cazeault,
Isbel Alba Duarte, Caridad Amador
Guzmán, Pavel Dueñas, Howard and
Patricia Farber, Sonia Maldonado,
in addition to Yolande Racine, Nicole
Laurin and Carole Line Robert of the
Cinémathèque québécoise, as well as
Nada Ghandour and Sylvain Chauvineau,
who worked under Colette Dufresne
Tassé, Director of Research, Université
de Montréal.

This catalogue was made possible
only through the work of many people.
Their knowledgeable contributions and
firsthand accounts have enriched the
panorama presented here. I thank all
the authors, starting with those at the
Museo Nacional de Bellas Artes and
the Fototeca de Cuba in Havana, as well
as Timothy Barnard, Ambrosio Fornet,
Rosa Lowinger, Gerardo Mosquera,
Graziella Pogolotti, Jeff L. Rosenheim,
Dr. Günter Schütz, Antonio Eligio
Fernández (Tonel), and Ramón
Vázquez Díaz.

★

From the Montreal Museum of Fine
Arts, I wish especially to acknowledge
the work of the team that helped pro-
duce this important publication. Led by
Francine Lavoie, Head of the Publishing
Department, it includes André Bernier,
Linda-Anne D'Anjou, Clara Gabriel,
Sébastien Hart and Micheline Poulin,
as well as graphic artists Guy Pilotte
and Susan Marsh. The photographs of
works in Cuba were provided by Rodolfo
Martínez. Published in two languages
by the Montreal Museum of Fine Arts,
the catalogue's international distri-
bution is handled by Prestel for the
English version, and by Hazan for the
French version. This publication will be
made available in Spanish by Lunwerg
Editores, S.A.: I am grateful to their
administration.

The exhibition itself is the result
of years of teamwork. I thank the
Montreal Museum of Fine Arts and its
always committed and professional
staff. I am grateful to my predeces-
sor, Guy Cogeval, for having allowed
me to initiate, conceive and oversee
a project with personal significance

for me. The following people and their
teams have given a lot to this project:
Danièle Archambault, Registrar and
Head of Archives; Joanne Déry, Head
of the Library; Sandra Gagné, Head of
Exhibitions Production; Richard Gagnier,
Head of Conservation; Hélène Nadeau,
Head of Education and Public Programs;
Pascal Normandin, Head of Exhibitions
Management; and Claude Paradis,
Head of Security; not to mention all the
other departments that contribute to
the Museum's operations. And last, but
certainly not least, I wish to thank Paul
Lavallée, Director of Administration,
and Danielle Champagne, Director of
Communications, as well as their staff.

I wish to commend the inspired exhibi-
tion design of Daniel Castonguay, who
was assisted by David Gour.

And right by my side, there was Jasmine
Landry, who tirelessly kept track of the
exhibition's evolution. I also wish to
express my warm thanks to my friend
Stéphane Aquin, curator of contem-
porary art, with whom this adventure
began, and to Iliana Cepero Amador,
with whom the adventure unfolded.
Absolutely everyone involved contributed
in a true spirit of friendship.

Nathalie Bondil
Director, The Montreal Museum of
Fine Arts

AUTHORS

Timothy Barnard
Cuban cinema specialist, Montreal

Nathalie Bondil
Director
The Montreal Museum of Fine Arts

Ernesto Cardet Villegas
Curator of Cuban art of the late 19th
and early 20th century
Museo Nacional de Bellas Artes

Iliana Cepero Amador
Art critic and independent curator

Roberto Cobas Amate
Curator of Cuban "Vanguardia" art
Museo Nacional de Bellas Artes

Rufino del Valle Valdés
Historian of photography
Curator, Fototeca de Cuba

Antonio Eligio Fernández (Tonel)
Artist, art critic and independent exhibition
curator, Vancouver

Ambrosio Fornet
Essayist, literary critic, publications editor
and screenwriter
Associate professor, Instituto Cubano de
Arte e Industria Cinematográficos, Havana

Olga López Núñez
Curator of Cuban art of the 19th century
Museo Nacional de Bellas Artes

Rosa Lowinger
Writer, journalist and art conservator,
Los Angeles

Corina Matamoros Tuma
Curator of Cuban art of the 1980s
and 1990s
Museo Nacional de Bellas Artes

Luz Merino Acosta
Deputy Director
Museo Nacional de Bellas Artes
Professor, Faculty of Arts and Literature,
University of Havana

Hortensia Montero Méndez
Curator of Cuban art of the 1970s
Museo Nacional de Bellas Artes

Gerardo Mosquera
Art critic, art historian and independent
exhibition curator
Associate curator, New Museum of
Contemporary Art, New York

Aylet Ojeda Jequin
Curator of popular painting
Museo Nacional de Bellas Artes

Graziella Pogolotti
Essayist and art critic
Professor, Faculty of Arts and Literature,
University of Havana

Liana Ríos Fitzsimmons
Curator of Cuban art of the 1960s
Museo Nacional de Bellas Artes

Jeff L. Rosenheim
Curator, Department of Photographs
The Metropolitan Museum of Art,
New York

Dr. Günter Schütz
Literary critic, Paris

Ramón Vázquez Díaz
Cuban art specialist, Havana
Former curator at the Museo Nacional de
Bellas Artes

Elsa Vega Dopico
Curator of Cuban art of the 1950s
and posters
Museo Nacional de Bellas Artes

The opinions expressed in the texts are
those of the authors.

REGARDING CUBAN ART

Nathalie Bondil

According to Christopher Columbus when he first set foot on Cuba in 1492, it was the most beautiful land human eyes have ever beheld. He also described the beauty of the landscape, with "graceful green trees different from our own and covered with flowers and fruit with wonderful flavour and many kinds of birds, some of which are quite charming." Once upon a time there was an island whose beauty inspired conquerors and creators, those visionaries of new worlds. A land of metaphors, it is the eldest daughter of the Greater Antilles, the key to the Caribbean Sea.

A snapshot, a postcard, a travel ad.

In the early twentieth century, when modern landscape painting required that painters work *en plein air*, a few Canadian artists set off for the West Indies in search of adventure. The myth of the *atelier des tropiques*, Gauguin's studio, like the hope of an endless summer, drew them to the earthly paradise. It was a quest for a lost paradise, a route to the south, a quest also taking place in Europe at the time. The "Mediterranean of the Americas" is true postcard material, there's no way around it. So true that James Wilson Morrice was directly inspired by it, as is now known, for the subject of several paintings: *The Pond, West Indies* (Ill. 3), the exact location of which was long unknown, turns out to have been a Cuban landscape—painted in Paris in about 1921.[1] This is one example among several. But is it that important? The luxuriance of this paradisiacal nature was the sole subject: "aquarium lighting in which everything floats between dream and reality, made iridescent by the strange mists of the Caribbean."[2] Morrice was the quintessential artist travelling about the Caribbean, in Matisse's words a "migrating bird . . . without any very fixed landing place"[3] who journeyed to Cuba in 1915 via Venice and Tunis on the invitation of a friend, the son of William Van Horne.

Cuba, in the early years of the twentieth century, was also a paradise for Canadian financiers and businesspeople.[4] Soon after the country was liberated from Spanish domination, they edged out their American competitors, who were then barred from operating there, and established insurance companies and banks. After completing the Canadian Pacific railroad, Sir William Van Horne, the "railroad man," set his mind to constructing a 630-kilometre railway line between Santa Clara and the port of Santiago, a major track completed in 1902 from which many branch lines sprung. This builder and collector built himself a sumptuous home in the Spanish style near Puerto Principe and established the head office of the Cuba Railroad Company in Camagüey, a prosperous province with a mostly white population. As was the case for many Americans, Cuba became a holiday destination for wealthy Canadians, along with the Bahamas, Barbados, Jamaica, and other vacations spots. The country's enchanting natural life also captivated scientists. Marie-Victorin, the renowned botanist and expert on Cuban flora, fled Quebec's winters for Cuba, which he commended with a dose of humour: "Cuba is a charming country . . . there are no venomous reptiles at all, you can roam about wherever you like in the countryside and even in the sea without danger, while in Mexico there are highly poisonous lizards, very dangerous scorpions, great numbers of revolutionaries, rattlesnakes, etc. etc. Cuba is the ideal place!"[5]

A picture-postcard beauty.

★

1 **James Wilson MORRICE**, *Café el Pasaje, Havana*, about 1915–19 2 **Anonymous**, *Café el Pasaje, Havana*, n.d.
3 **James Wilson MORRICE**, *The Pond, West Indies*, about 1921 4 *Cuba: Tropical Landscape*, postcard, before 1912
5 **James Wilson MORRICE**, *Village Street, West Indies*, about 1915–19 6 *Fishing Village*, postcard, before 1912

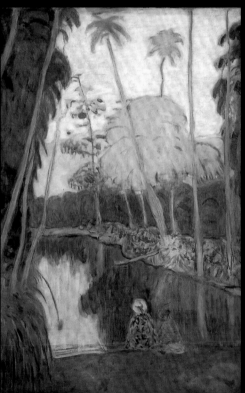

1

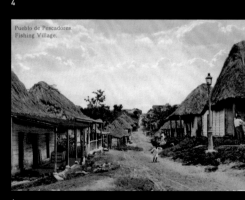

2

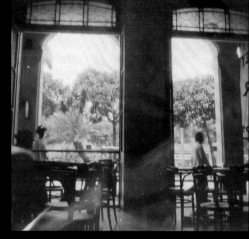

3

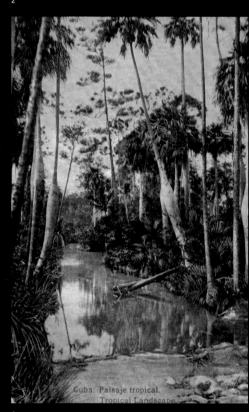

Cuba: Paisaje tropical.
Tropical Landscape.

4

5

Pueblo de Pescadores.
Fishing Village.

6

Beyond the stereotypes, which live on today,[6] the country's island status is a central theme in its art: the sea is both a boundless horizon and a boundary. While island dwellers are always aware of the vastness of the world, they also always have a sense of the physical limits of their own territory, surrounded on all sides by water:

This damned circumstance of water everywhere / compels me to sit down at a table in a café. / If I didn't think that water had me surrounded like a cancer I'd be able to sleep at night like a log.[7]

From one island to another, this exhibition traces a path; it tells a story of Cuba from the point of view of its visual arts, the story of a young country with an ancient culture. An island whose turbulent history is run through with the foremost issues of the twentieth century: decolonization, the search for national identity, wars of independence and revolution, new political utopias, the confrontation of East-West and North-South ideologies . . . issues that are a part of our shared history.

★

The art of this island has been greatly enriched as a result of its being at the meeting point of Europe and the Americas. And yet this Cuban school was able to construct and impose its own identity in a mere century. From the earliest wars of independence artists have contributed to defining a new national identity. They questioned *cubanidad*. Between a re-evaluation of the colonial past and openness to the avant-garde, they were able to invent a profoundly original synthetic art, taking inspiration from their "baroque" and

academic heritage, their Hispanic and African roots, and their various forms of spirituality, including Catholic and syncretic faiths. For this reason, the issues this exhibition addresses are not limited to questions of national identity, artistic expression or nationalist feeling. Cuban art, seen at times as a driving force behind collective political action and at others as an expression of individuality in the face of history, addresses essential questions about the place and role of the artist in society, questions a younger generation continues to pose in a relevant manner.

This is a summary, a survey of 150 years of artistic creation that involves presumptions that will give rise to no end of commentary: yes, other avenues could be explored. Although much excellent scholarly work by art historians and critics exists, Cuban art, with a few exceptions, has been too infrequently exhibited in its entirety.

Wifredo Lam, undoubtedly one of the great artists of the twentieth century, always enjoyed considerable notoriety beyond the country's borders. This Cuban artist, whose father was Chinese and mother was African-European, created a masterful synthesis of the European avant-gardes, from Picasso to Surrealism, which he enriched with a profound reflection on the myths and rituals of Afro-Caribbean religions. In art as in life, the work of this nomadic artist, who sought to create a "visual arts manifesto for the Third World," has always been seen in a more universal light and less as a strict expression of Cuban identity.

Images of the charismatic and media-friendly Revolution were the driving

force behind a visual explosion that was exported around the world; Cuba's school of photography, stimulated by current events, illustrated legend. Snapshots by Korda, Salas, Corrales, Noval and others have become world famous. And what can be said of the image of Che in *Guerrillero heroico*, the most widely seen photograph in history, an icon in constant exegesis? Exhibitions have been devoted to this "Mona Lisa of photography"[8]: *Che Guevara: Icon, Myth and Message* at the Fowler Museum of the University of California in Los Angeles in 1997, and *Che Guevara: Revolutionary and Icon* at the Victoria and Albert Museum in London in 2006. The Revolution also supported the creation of exceptional posters by establishing various information, culture and propaganda agencies. These posters, as avant-garde as the advertising posters whose place they took, were clearly intended for mass distribution. Ironically, their forcefully expressive style developed from scant means. Exhibited in numerous retrospectives, these posters are today sought after by collectors the world over.

Finally, the contemporary art scene in Cuba, one of the most interesting in the world, is relatively well represented and discussed in the international circuit of major museums, art fairs and galleries. Its incorporation into the art market, stimulated by greater support and flexibility within the country, exhibitions such as *Kuba o.k.* at the Städtische Kunsthalle in Düsseldorf in 1990, and the active patronage of the Ludwig Foundation have made the new generation a force to be reckoned with. Tonel remarks that the "almost nomadic" present-day circumstances of several artists "confirms that the

Cuban art scene has expanded beyond the country's geo-political borders, just as the influence of the market and international institutions has expanded within Cuba." These changes, he continues, "[open] the door to fundamental questions about what it means today to be a Cuban artist."[9]

★

And yet many other domains of its visual arts remain little known outside Cuba, even though its exceptional music and vast literary output have, justly so, become part of the world cultural heritage. Without listing every exhibition that has contributed to making Cuban art known beyond its borders, two such events bear mention here for their special impact.

Modern Cuban Painters was a milestone in the recognition of Cuban art. Organized in 1944 by Alfred H. Barr, advisory director of the Museum of Modern Art (MoMA) in New York, the exhibition travelled to several American cities. It presented some seventy works by thirteen artists of the then-flourishing "Havana school." The avant-garde Cuban journal *La Gaceta del Caribe* displayed the proud headline "Cuban Colours in New York,"[10] adding humorously "We've invaded the Yankees!" Without the enlightened support in Cuba of the artist and critic José Gómez Sicre and the patron of the arts Maria Luisa Gómez Mena, Barr would not have been able to mount such a project: "Cuba," he remarked, "because of its general lack of interest in its own painting, unfortunately has done little to deserve the real prestige that its painters have won for it. . . . The solution is clearly in the hands of Cubans: in those of intellectuals like

yourselves, in those of your rulers, in those of your collectors."[11] Thanks to the support of MoMA and the Inter-American Fund, numerous Cuban artists—Martínez, Portocarrero, Carreño, Peláez, Ramos Blanco and Lam—sold work during Barr's sojourn in Havana in 1942. Lam's painting *The Jungle* was purchased by MoMA in 1945.

The Salon de Mai, whose 1967[12] edition was held in the Americas for the first time, in Havana, was another essential step, a moment of contagious collective euphoria: "a cultural happening in the land of merry socialism" with worldwide repercussions. Wifredo Lam had the idea of transplanting this Parisian contemporary art show to Cuba. He invited the artists, who were joined by well-known journalists, critics and intellectuals. Among the many people invited to attend was the Quebec artist Edmund Alleyn (ill. 5), who tells the story of about a hundred participants in the Salon creating a monumental painting 55 metres square: "Last night, a collective painting was created out of doors in a large and very brightly lit square on La Rampa. On a canvas . . . was drawn a picture in charcoal and divided into a hundred numbered sections, for which the poets, sculptors and painters, both foreign and Cuban, drew lots. Neighbouring streets were closed and thousands of curious people crowded around enthusiastically. In front of the canvas and in the crowd, decked-out singers and dancers performed on stands. The party went on until morning. Some people worked until noon the next day. The painting has a bit of everything, but the theme of the Revolution dominates."[13] In keeping with José Martí's precept, "cultivate yourself to become free," the Revolution brought about changes in cultural life by sup-

porting the arts without preconceived ideas about style—unlike the Soviet Union, where only Socialist Realism was permitted—but with preconceived ideas about content: "our enemies are capitalism and imperialism," Fidel Castro said, "not abstract art."

★

Mounting an exhibition of the present scale would not have been possible without artworks from Cuban collections, which are obviously the most extensive, particularly that of the Museo Nacional de Bellas Artes in Havana. This museum has brought its collection of Cuban art to the forefront, revised its policy on acquiring contemporary art, put on shows in Havana and abroad, and published guides and catalogues. A travelling exhibition in Brazil in 2006–07, *Arte de Cuba*, was the first major tour of works from this collection, with more than a hundred pieces borrowed from it. For this exhibition, many more essential or hitherto unseen works have been loaned or published for the first time, including the collective mural of 1967. In addition to this imposing selection, other works have been borrowed from public and private collections in the Americas and Europe. We are thus able to move beyond borders and provide art lovers and the general public with an exceptional, one-time exhibition of Cuban art with its generous message of unity.

Marcelo Pogolotti, an illustrious and little-known painter, draftsman, essayist and critic at the time of Cuba's first *Vanguardia*, deserves special mention. Most of his work is held by the Museo in Havana and has been little seen outside the country. Paradoxically,

he spent much of his brief career in Europe. Concerned with more than Cuban identity and nationalism, his art, with its unique style—that of a remarkably effective synthesis of Futurist, machine art and Surrealist aesthetics—championed a broader ideology, that of a revolutionary activism in the interwar period. With his commitment to denouncing the social injustices of his time, Pogolotti put his cause ahead of his work. He is the embodiment of artistic conscience in the face of historical events that go beyond the issue of Cuban identity alone.

This narrative is supported by extensive photographic documentation, making it possible to connect the major stages of Cuba's history and to contextualize its fine arts by tracing a parallel history of Cuban photography. This history ranges from the objectivity sought by photojournalism in its early years to the appearance of highly talented photographers such as Blez and Arias, the advent of advertising stereotypes around an "island of fiesta and siesta," and the icons of the Revolution. Today this school of photography serves as material for the way a new generation thinks about and works in photography. The Fototeca de Cuba in Havana has exceptionally agreed to large-scale loans of its materials. Added to these are photographs from other public and private collections, many from the prerevolutionary period hitherto unseen. The American photographer Walker Evans is the exception: to illustrate the Carleton Beals book *The Crime of Cuba*, this famous photographer brought back from his 1933 sojourn in Havana a gripping account of the turmoil that preceded the fall of Machado. Today these photographs are preserved in the archives of his work at the Metropolitan Museum of Art in New York.

The ambition of this exhibition and publication is to foster a discovery, or rediscovery, of the story of Cuban art, to draw a portrait of an island described as "singing with bright tears . . . / sails Cuba on its map / a long green lizard / with eyes of stone and water."[14] It also carries a vital message: that of the power, the role and the beauty of art, which transcends borders and words. A message to be taken to heart, "since no one but me knows that these pieces of canvas, as wretched as they may be, are pieces of my entrails."[15]

1 My thanks to Lucie Dorais for kindly supplying me with this information.

2 John Lyman, quoted in Elizabeth Cadiz Topp, *Endless Summer: Canadian Artists in the Caribbean* (Kleinburg: McMichael Canadian Art Collection, 1988), p. 42.

3 Ibid., p. 16.

4 See Roger Paul Gilbert, *De l'arquebuse à la bure* (Montreal: Éditions du Méridien, 1999).

5 Marie-Victorin, letter dated April 20, 1913, *Marie-Victorin à Cuba. Correspondance avec le frère Léon*, edited by André Bouchard (Montreal: Les Presses de l'Université de Montréal, 2007), pp. 56–57.

6 More Canadians vacation in Cuba than any other nationality.

7 Virgilio Piñera, *La isla en peso* (1943). "La maldita circunstancia del agua por todas partes / me obliga a sentarme en la mesa del café. / Si no pensara que el agua me rodea como un cáncer / hubiera podido dormir a pierna suelta."

8 David Kunzle, "Che Guevara," *Print Quarterly*, 24 (2007), pp. 203–205.

9 Antonio Eligio Fernández (Tonel), "An Unpleasant Lucidity . . ." *Parachute*, 125 (January–March 2007), pp. 112–13.

10 "¡Estamos invadiendo a los yankis!" ("Colores cubanos en Nueva York," *La Gaceta del Caribe* [May 1944], p. 32).

11 "Desgraciadamente Cuba, por su colectivo desinterés hacia su propia pintura, no hace mucho por merecer el real prestigio que para ella han conquistado sus pintores. . . . Es evidente que la solución está en manos de los cubanos: en las de los intelectuales como ustedes, en las de los gobernantes, en las de los coleccionistas." (Letter from Alfred H. Barr, in Spanish, to the editorial board of *La Gaceta del Caribe*, June 23, 1944. The Museum of Modern Art Archives, New York).

12 That same year, the Cuban pavilion stood out at the Montreal International and Universal Exhibition.

13 Edmund Alleyn, "Un été à Cuba," *Le magazine Maclean* (February 1968), pp. 17–18.

14 Nicolás Guillén, "Un largo lagarto verde" (1958): "Cantando a lágrima viva . . . / navega Cuba en su mapa: / un largo lagarto verde / con ojos de piedra y agua."

15 José Martí, *Lucía Jerez* (1885): "Como nadie más que yo sabe, que esos pedazos de lienzo, por desdichados que me salgan, son pedazos de entrañas mías."

1–3 **Edmund ALLEYN**, *Edmund Alleyn's view on Cuba, 1967* (*Le magazine Maclean*, February 1968)
4 **Luc CHESSEX**, *Portrait of Bernard Rancillac wearing a hat, 1967* 5 **Luc CHESSEX**, *Edmund Alleyn at work, 1967*
6 *Cuban Pavilion, The Montreal Universal and International Exhibition of 1967*, photomontage, postcard, n.d.

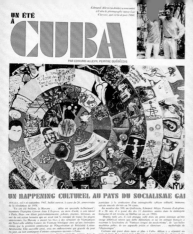

CUBA

UN ÉTÉ À

PAR EDMUND ALLEYN, PEINTRE QUÉBÉCOIS

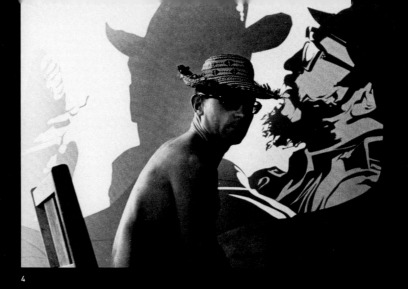

UN HAPPENING CULTUREL AU PAYS DU SOCIALISME GAI

CUBA

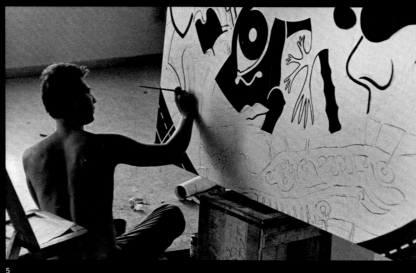

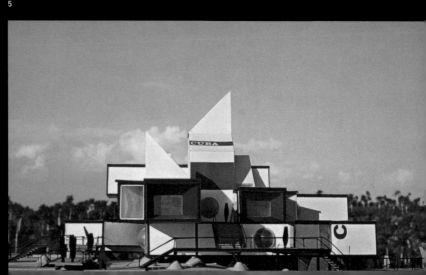

4

5

DEPICTING CUBA

finding ways to express a nation

TIMELINE
art and history

1868
The Ten Years' War begins when Carlos Manuel de Céspedes calls for Cuba's independence from Spain and an end to slavery.
Mambí troops capture Bayamo, and the first government of the Republic in Arms is established.

1869
The first Cuban constitution is adopted at the Convention of Guáimaro.
A clash between supporters of independence and Spanish government partisans leads to the Teatro Villanueva massacre in Havana.

1878
Miguel Melero becomes the first Cuban to be appointed director of the Academy of San Alejandro.
The Ten Years' War ends with the signing of the Pact of Zanjón.
General Antonio Maceo demands Cuba's independence from Spain and the abolition of slavery—the central issues in the recent Ten Years' War—at a meeting known as the Protest of Baraguá.

1879
Women are admitted for the first time to the Academy of San Alejandro.
The "Little War," an uprising of veterans of the Ten Years' War, begins.

1883
Telephone lines are installed in Havana.

1884
The Amateur Photographers Association is founded.

1885
Composer and musician Hubert de Blanck founds the National Conservatory.

1887
Slavery is abolished.

1889
José Martí founds the children's monthly *La Edad de Oro.*
Electric lighting is installed in Cárdenas, Havana and Camagüey.

1891
José Martí's *Versos Sencillos* is published.

1892
José Martí founds the Cuban Revolutionary Party and the newspaper *Patria* from New York.

1894
Armando García Menocal exhibits *Bobadilla Sending off Columbus* (ill. 68) at the World's Columbian Exposition in Chicago.

1895
The Cuban War of Independence begins. José Martí and Máximo Gómez sign the Montecristi Manifesto, which outlines the War's principles.
Martí dies in combat on the plains of Dos Ríos.
The Constituent Assembly meets in Jimaguayú and adopts the constitution of the Republic in Arms.

1896
Spanish Captain General Valeriano Weyler arrives in Cuba and implements his "re-concentration" policy, which aims to curb support to Mambí rebels by displacing the rural population to Spanish-controlled towns.

1897
A constitutional convention is held in La Yaya, during which it is decided to ratify the form of government established in Jimaguayú and to keep fighting until independence is attained.

1898
The *USS Maine* explodes in Havana's harbour, provoking the United States to intervene militarily.
Spain and the United States sign the Treaty of Paris, which ends Cuba's War of Independence; Spain relinquishes Cuba.

1899
The Cuban American Sugar Co. and Cuba Central Railways Ltd. are founded.

1900
In view of municipal elections, the Republican Party, the Cuban National Party and the Democratic Union Party are founded.
A constitutional convention is held.

1901
The poet Bonifacio Byrne publishes *Lira y espada.*
The newspaper *El Mundo* is published.
The U.S. government passes the Platt Amendment, containing eight provisions that must be incorporated into Cuba's constitution for it to form its own Republic and stipulating the right of the United States to intervene in the island's affairs.
Tomás Estrada Palma is elected president of the Republic.

1902
Havana's Ateneo is founded for the principal purpose of promoting culture.
Cuba signs the Reciprocity Treaty with the United States, which limits the island's economic autonomy.

Anonymous, *Coconut Trees on Avenida Del Puerto, Havana* (detail), late 1920s

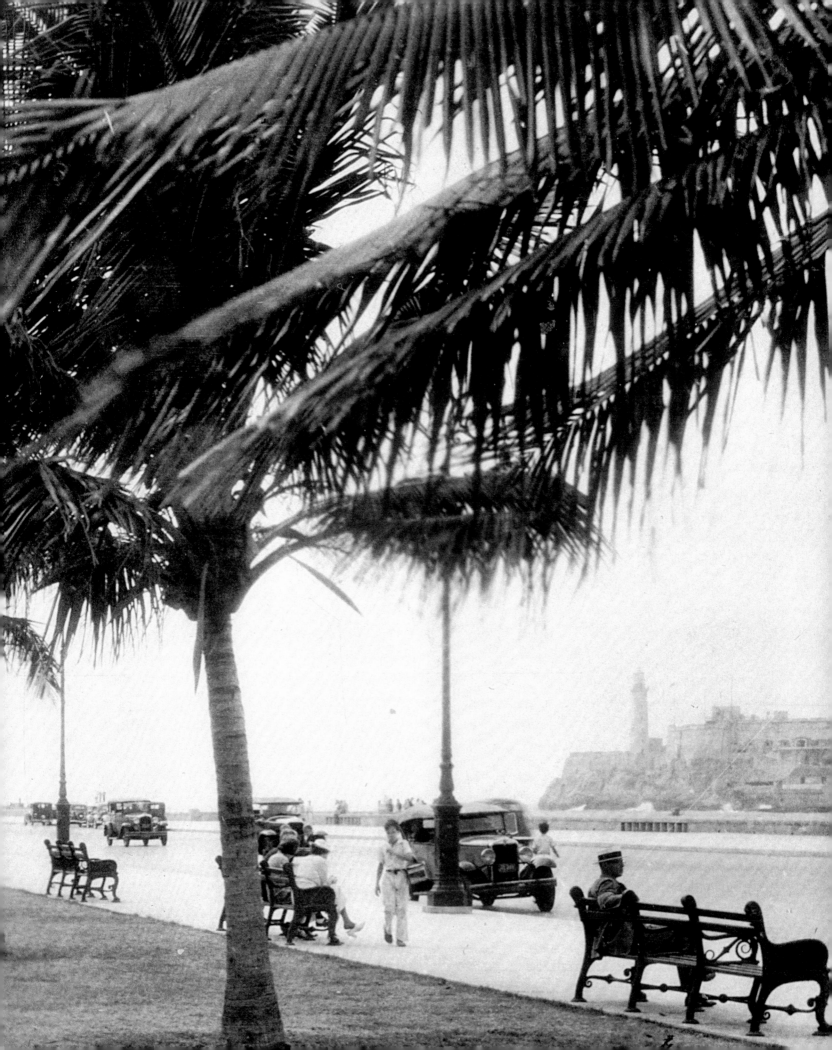

1903

The U.S. government occupies the base at Guantánamo.

1904

Carlos Baliño founds the Labour Party. Cuba and the United States sign the Permanent Treaty, which outlines future relations between the countries.

1905

Tomás Estrada Palma is re-elected president.

1906

Liberal rebellion breaks out against Estrada Palma, leading to the "Little War of August."
Estrada Palma is forced to resign and the United States intervenes a second time.
The Cuban Socialist Party is founded.

1907

Adriana Bellini becomes the first woman to teach at the Academy of San Alejandro.
The Conservative Party is founded by representatives of the national oligarchy and led by General Mario García Menocal.

1908

The Ateneo in Havana holds an exhibition of French art.
The Independent Party of Colour is founded to defend the rights of Cubans of African descent.

1909

José Miguel Gómez is elected president and U.S. military intervention ends.
The Cuban Telephone Company is founded.

1910

The Theatre Promotion Society, Havana Conference Society, Academy of History, and Cuban Academy of Arts and Letters are founded.
The art and literary review *Bohemia*, the first to reproduce colour prints by Cuban artists, is published.
The illustrated magazine *Minerva*, dedicated to disseminating the ideas of Afro-Cuban intellectuals, is published.
The College of Physicians is founded.

1911

A pavilion dedicated to the arts forms part of the National Exhibition at Quinta de los Molinos, Havana.

1912

The Independent Party of Colour protests against government repression.

1913

The Museo Nacional de Bellas Artes opens.
Mario García Menocal is elected president.

1914

The Centro Gallego is built.
The Labour Congress is organized.

1915

The Teatro Nacional opens.
The Cuban Theatre Society is founded.

1916

The magazine *Social*, which in addition to reviewing Cuban society also covers contemporary intellectual thought, is published.
The First Salon of Fine Arts is held.
The Painters and Sculptors Association is founded.
Mario García Menocal is re-elected president.

1917

Liberal uprising known as La Chambelona against the electoral fraud committed by the government in power.
Mario García Menocal declares war against Germany.

1918

The magazine *Bellas Artes* is published.

1919

The magazine *Carteles*, which covers Cuban and international political and social events as well as contemporary art and literature, is published.

1920

Wifredo Lam enrols in the Academy of San Alejandro.
Alfredo Zayas is elected president.

1921

The First Humour and Satire Salon is held.
Antonio Gattorno travels to Europe.
Marcelo Pogolotti returns to Havana.
José R. Capablanca wins the world's chess championship.
The Nationalist Party is founded.

1922

Students, including Julio Antonio Mella, demand university reforms.
The University Students Federation is founded.

1923

The Club Cubano de Bellas Artes is founded, an organization that brings together Cuban intellectuals and artists; its official organ is the magazine *Gaceta de Bellas Artes*.
Marcelo Pogolotti studies at the Art Students League, New York.
Wifredo Lam travels to Spain.
The Groupo Minorista is founded by young intellectuals with new ideas on art, politics and society.
Rubén Martínez Villena and other intellectuals take issue with the government of Alfredo Zayas, an attack known as the Protest of the Thirteen.
The First National Women's Congress is held.

1924

Havana's Philharmonic Orchestra is founded.
Víctor Manuel García has his first solo exhibition.
Amelia Peláez completes her studies at the Academy of San Alejandro and studies at the Art Students League in New York for six months.
Carlos Enríquez is enrolled for a short time at the Pennsylvania Academy of Fine Arts.
Gerardo Machado wins the presidential election.

1925

Carlos Enríquez returns to Cuba with the American artist Alice Neel; they marry that same year.
Víctor Manuel García travels to Paris.
Marcelo Pogolotti returns to Cuba.
The Cuban Communist Party is founded by Julio Antonio Mella and Carlos Baliño, and is quickly declared illegal and its members persecuted.

1926

Eduardo Abela exhibits at the Salon d'Automne, Paris.
Eduardo Abela's *El Bobo* [The Fool] appears in *La semana*.
Víctor Manuel García and Antonio Gattorno return to Cuba.
Julio Antonio Mella flees to Mexico to escape Machado's repression.

PHOTOGRAPHY AND REPORTAGE IN THE EARLY TWENTIETH CENTURY (1895-1930)

Rufino del Valle Valdés

Photographers will people the world!
— José Martí

The first mention in Cuba of the invention of photography was in an article published in *Diario de La Habana* on March 19, 1839, about the invention of the daguerreotype. The actual arrival of a camera—and the making of the first daguerreotype— were reported in an article published in *El Noticioso y Lucero* (April 5, 1840), which referred to the apparatus brought from Paris by Pedro Téllez-Girón y Fernández de Santillana, son of the island's Captain General, who took Cuba's first daguerreotype from the balcony of the Palacio de los Capitanes Generales.

However, the person really responsible for introducing and popularizing the new invention in Cuba was the American George Washington Halsey, who obtained the Captain General's permission to open a photographic studio. Cuba thus became the second country in the world—after the United States—and the first in Latin America to officially open a commercial photographic studio, on Sunday, January 3, 1841, on the terrace of the Royal College

at 26 Calle Obispo, between Cuba and Aguiar. It is worth noting that Halsey left Cuba in May or June of 1841, and that subsequently the Montreal directory for 1842 to 1843 places a certain G. W. Halsy [sic] in the east side of the Place d'Armes; other sources place him in Mexico.[1] Furthermore, Spanish historian Juan Miguel Sánchez points out that a Jorge W. Halsey introduced the daguerreotype to Cádiz, Spain, in December 1841.[2]

In this, Halsey forestalled the French draftsman and lithographer Frédéric (or Federico) Miahle, whose application to open a commercial photographic studio was turned down because the former already operated such an establishment. It is nevertheless to Miahle that the first use of photographs in print is owed: he reproduced as engravings two daguerreotypes by the Italian-born Canadian Antonio Rezzonico in the fourth instalment (July 1841) of his album *Isla de Cuba Pintoresca* [The Picturesque Isle of Cuba]. In the brief period between Halsey's introduction to Cuba of the daguerreotype portrait and the arrival in November 1843 of Esteban de Arteaga—the first Cuban photographer to have trained in Paris—at least half a dozen foreign daguerreotype

photographers passed through the island.

Oddly, a column in the *Diario de la Marina* in 1853 notes the presence of Cuba's first woman photographer, Encarnación Iróstegui (wife of the portraitist Pedro Arias).

Pioneers of Photojournalism
Some photographers elected to travel by wagon with all their gear to capture images of corners of cities, rural landscapes and major events such as fires, open-air masses and landslides, thus launching a new speciality, the documentary photograph. These prints were called "English cards" and in Cuba became commonly known as "tarjetones"; the print would be glued to a small card that bore on the back a brief account of the image. They were the forerunners of photojournalism, which along with text began to appear in newspapers and magazines thanks to the invention of photo-engraving.

The earliest examples of photojournalism in Cuba were produced at the start of the Ten Years' War in 1868. A group of Spanish photographers authorized by the colonial authorities had the sole rights to capture graphic evidence of

this conflict. Their work was published in two albums: the "Álbum Histórico Fotográfico de la Guerra ..." [Historic Photographic Album of the War . . .] with twenty-four plates by Leopoldo Varela y Solís and text by Gil Gelpe Ferro, and "El Álbum de la Paz, occurrencias de la campaña de Cuba durante el Tratado de Paz" [The Peace Album, events during the campaign in Cuba during the Peace Treaty], in 1878, with seventeen photographs by Elías Ibáñez, who travelled through the camps of the Mambí rebels.

In 1869, the events at the Teatro Villanueva on January 22, when over five hundred Spanish soldiers fired on the audience that had just seen the premiere of *El Negro Bueno*, and the death of American photographer Samuel A. Cohner two days later at the hands of Spanish forces firing on the cafés El Payret and Los Voluntarios, provoked consternation among the citizens of Havana and caused many photographic studios to close down.

However, by the start of Cuba's War of Independence in 1895, photography had already made great strides in the newspapers, thanks to the development of halftone prints and the introduction of the magnesium flash lamp (the forerunner of the electronic flash) to light up dark areas. Like the photos taken during the Ten Years' War, the pictures of the War of 1895 were posed and serene, consisting mainly of portraits of individuals and military groups (ill. 4, 5), occasionally presented in staged battles.

José Martí and Photography
The Apostle of Cuba, José Martí, a celebrated patriot, intellectual, writer,

teacher and diplomat killed early on in the Cuban War of Independence, was a prominent critic and prolific journalist who followed advances in the sciences, technology and art, and was therefore interested in the development of photography. His interest in the new visual art, which he fully understood, was demonstrated on many occasions, as in his statement of 1882, "Photographers will people the world!" which appeared in the newspaper *La Opinión Nacional* in Caracas, Venezuela, for which he often wrote.[3]

The scholar Jorge R. Bermúdez suggests that "Martí evolved a uniquely modern concept of the propagandistic ideas, which, looked at today in the light of the development of the mass media, shows him to have been a real precursor of social communication. The latter concept implicitly embraces his position as a visual communicator."[4] Not only did Martí express his thoughts on the new invention, but he had his portrait taken by leading photographers of the day, like the Cuban brothers José Manuel and José María Mora, whose Studio Mora in New York was considered one of the city's three best photographic studios. He also had his portrait taken by the Cuban photographer and patriot Juan Bautista Valdés in Kingston, Jamaica, in 1892 (ill. 1).

Eyewitness Photography, the Harbinger of Photojournalism
A key element in the development of eyewitness photography as the harbinger of Cuban photojournalism was the creation in 1881 of the first Studio of Photoengraving, Phototypography and Photolithography by the Portuguese photographer F. Alfredo Pereira y

Taveira. It was here that the first half-tone photographic reproduction was made, of a portrait of Don Nicolás Azcarate, and published in the magazine *El Museo* on March 25, 1883. Other activities demonstrate the meteoric rise and organization of photography in this decade. The year 1882 had seen the birth of the *Boletín Fotográfico*, the first periodical devoted to the art of photography, and the following year that of the Amateur Photography Association of Havana (the name was later changed to Photography Association of Havana).

Of the earliest Cuban periodicals with a photography department, the most notable was *El Fígaro* (published from 1885 to 1929), which used a wide range of pictures to report on the visit of the Princess Eulalia de Borbón to Havana in 1892, the War of Independence, the sinking of the *USS Maine* in 1898, the "re-concentration" camps of General Weyler (ill. 2), and the changes of national flag in 1899 and 1902, among other events. The press photographers were José Gómez de la Carrera until 1902 and thereafter Rafael Blanco. The former left behind images of the War of Independence, during which he photographed both the Mambí camps and the Spanish ones, since he held U.S. citizenship. Other outstanding photographers for *El Fígaro* were Joaquín López de Quintana, members of the Estudio Otero y Colominas, and Manuel Martínez Otero (the latter was succeeded by his sons Manuel and Arturo Juan Martínez Illa).

The event that changed the course of the War and became the pretext for U.S. intervention—the sinking of the battleship *USS Maine* in the bay of

Havana on February 15, 1898—did not escape the photojournalists. The explosion, the sinking and the funeral of the victims were captured on film by José Gómez de la Carrera, who was also the official photographer of the commission that investigated the disaster. Following the sinking of the *USS Maine*, William Randolph Hearst, the originator of "yellow journalism" (or tabloid journalism) and proprietor of the *New York Journal*, sent a team of photographers to Havana headed by Frederic Remington, who wired to Hearst, "everything quiet." Hearst's reply was terse: "Please remain. You furnish the pictures, and I'll furnish the war."[5] Days later, the *Journal* published a photograph that purported to show the breach in the *USS Maine's* armour caused by a torpedo. The picture enraged public opinion in the United States and led to the desired result. In 1916, in *America's Foreign Relations*, historian Willis Fletcher Johnson revealed that said photograph had been used earlier by the same newspaper to illustrate a total solar eclipse,[6] thus pointing out an early example of the manipulative power of the media.

On December 10, 1898, with the signing of the Treaty of Paris, Spain relinquished control of Cuba to the United States, and various reports appeared in the press. The lowering of the Spanish flag over the Castillo de los Tres Reyes del Morro (ill. 6), in the presence of the Spanish General Adolfo Jiménez Castellanos and Major General John R. Brooks representing the United States, was captured by photographer Luis Mestre from the Castillo de la Punta, and from the esplanade of the Castillo del Morro by José Gómez de la Carrera

and photographers from the Samuel A. Cohner studio.

A Historic Photograph, May 20, 1902
The moment on May 20, 1902, when the U.S. flag was lowered and the Cuban flag raised (ill. 7), which represented the birth of the Republic of Cuba, was immortalized by the cameras of Gómez de la Carrera at the Palacio de los Capitanes Generales and by Adolfo Roqueñí at the Castillo de los Tres Reyes del Morro. A new day had dawned in the history of Cuba, and by extension in that of its photography.

The official handover of power took place in the Palacio de los Capitanes Generales in the presence of the most senior members of government and the military, and was reported in the newspaper *El Mundo* of May 21 by staff writer Víctor Muñoz as follows: "The handover took place at the centre of the old Throne Room of the Palace. General Wood and his Chief of Staff Colonel Scott . . . General Máximo Gómez . . . and Estrada Palma to his right . . . The sound of cannon fire saluting the new nation punctuated the reading of the document signed by Mr. Roosevelt with remarkable precision. The U.S. flag was lowered. The two sergeants of Company 'E' of the Seventh Regiment of Cavalry, E. J. Kelly and Frank Vondrak, standing on the Palace balcony, and General Wood's second-in-command, Lieutenant MacKoy, on the terrace at the foot of the flagpole, waited for the ceremony indoors to end, and when the signal was given, began to lower the flag . . . while the troops around the Palace presented arms and the military bands played the American national anthem." Although the new nation's flag

was raised by American hands, there exists a photograph of General Wood and General Máximo Gómez raising the Cuban flag. The explanation for this is found in the newspaper *La Discusión* of the same day, May 21: "Historic flag. Within fifteen minutes of the raising of the Cuban flag, it was struck and a smaller one raised in its place, hoisted by General Wood and General Gómez." The second photograph of this historic moment was taken by Dr. George N. McDonell, senior representative of the Methodist Church in Havana, and the staff photographer of the magazine *El Fígaro*, José Gómez de la Carrera.

Photography and the Republic
Few societies have undergone such abrupt changes in the course of half a century as did Cuba. The war-hardened republic that was born out of the disaster of 1898 began to transform itself into a prosperous nation, with great mansions and a cemetery worthy of the magnates in the new sugar-producing oligarchy. The intellectual classes, who believed in progress and renewal, stood opposed to this powerful ruling class.

In the first half of the twentieth century the studio portrait, so popular in the nineteenth century, came into its own again. Leading artists in the genre were Néstor Maceo, E. Mañan, Otero y Colominas and Joaquín Blez. Other much-sought-after photographers were the Spaniard Gonzalo Lobo Suárez and the Hungarian Aladar Hajda, whose studios were respectively named the Van Dyck and the Rembrandt. In the same period José Manuel Acosta Bello stands out as an isolated figure among the photographers of the island; his work

echoed the European avant-garde trends of the 1930s, especially his abstract, geometric compositions in the Bauhaus style.

In this period, the launching of a number of newspapers and periodicals of a cultural, scientific and social nature encouraged the development of photojournalism documenting the life of the new republic. Among the most important of the new publications were the illustrated magazines *Bohemia* (1908), *Social* (1916) and *Carteles* (1919).

An indication of the surge in journalism was the founding of the Union of Press Photographers in 1927—an offshoot of the Press Association of Havana—which was disbanded during the Machado dictatorship.

Thanks to this proliferation of magazines, in the early decades of the century all major public events were presented through images: the funeral of General Máximo Gómez in 1905; the "Little War of August" in 1906; the salvaging of the wreckage of the battleship *USS Maine* in 1912; the Chambelona uprising in 1917; the economic boom resulting from the island's sugar industry, known as the "years of the fat cows," in 1920; the burial of student leader Julio Antonio Mella in 1929; the death of Rafael Trejo in 1930 and other revolutionaries in the conflicts of the Revolution of 1933, up to the crushing defeat of President Machado following a general strike. The pages of these periodicals also featured photos of grand banquets, tributes, openings, high-society weddings and debutantes' birthdays, which together with pictures of official receptions for notables pro-

vided a fairly comprehensive picture of how the life of the nation carried on after the shortages and adversity of the recent war.

1 Miguel Muñiz Castro, "Micronotas Fotográficas," in *Cuba. 100 años de fotografía* (Murcia, Spain: Ediciones Mestizo A.C.; in collaboration with the Fototeca de Cuba, 1998), p. 11.

2 Juan Miguel Sánchez Vigil, *El Universo de la Fotografía. Prensa, Edición y Documentación* (Madrid: Editorial Espasa Calpe S.A., 1999), p. 61.

3 José Martí, "Carta de Nueva York," *La Opinión Nacional* (Caracas, Venezuela: January 21, 1882).

4 Jorge R. Bermúdez, "Martí comunicador visual," unpublished paper, 2004.

5 Vladia Rubio Jiménez, "Cazadores de la Memoria," *Patria*, the historical-cultural magazine of the newspaper *Granma* (June 1995), p. 15.

6 Willis Fletcher Johnson, *America's Foreign Relations* (London: Eveleigh Nash Company, 1916), vol. 2, p. 250.

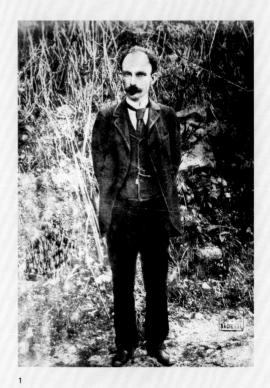

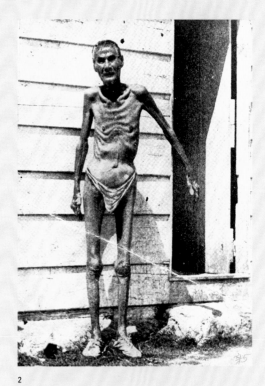

1
Juan Bautista VALDÉS
José Martí in Kingston, Jamaica
1892

José Martí is the national hero of Cuba. Born in Havana on January 28, 1853, he was a thinker, orator and writer who fought to free the island from Spanish rule. He died in combat against Spanish troops in the Battle of Dos Ríos, on May 19, 1895.

2
Anonymous
Male victim of the Re-concentration
1897

The "re-concentration" policy of Spanish military officer Valeriano Weyler confined hundreds of thousands of peasants (mostly children, women and the elderly) to camps set up in cities occupied by Spanish troops in order to prevent the rural population from helping the insurgents. The policy had a devastating effect on agricultural production, which led to widespread starvation, a situation that grew worse with the illnesses that arose from the deplorably unsanitary living conditions in the camps; the population was decimated. The re-concentration policy was implemented from 1896 to 1898.

3
Joaquín BLEZ
Peasants with General Molinet,
Chaparra Sugar Mill
About 1910

4

José GÓMEZ DE LA CARRERA

Riflemen of the Mambí Army

1898

5

José GÓMEZ DE LA CARRERA

Mambí fighter put in primitive stocks by his fellow men

1898

The Mambí militiamen were the Cuban combatants who fought in the 19th-century wars of independence against Spain. They are famous for their use of machetes as battle weapons.

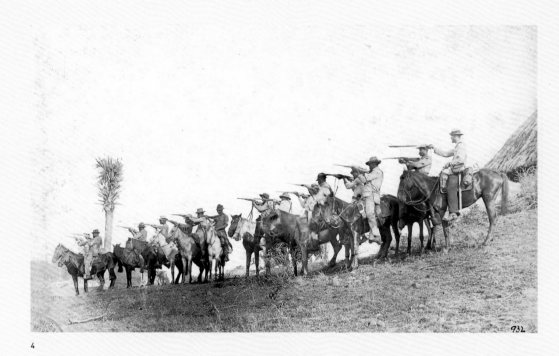

4

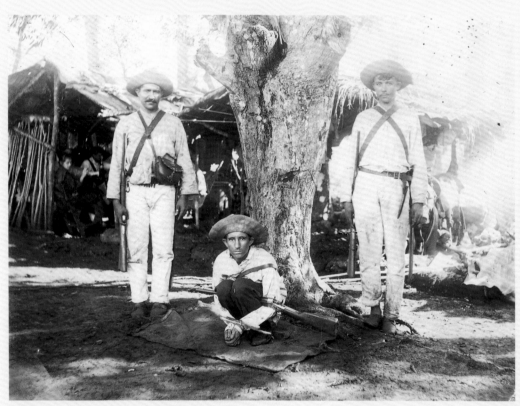

5

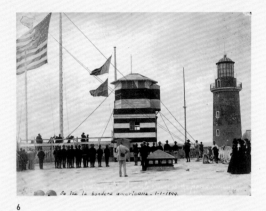

Se iza la bandera americana - 1-1-1899.

6

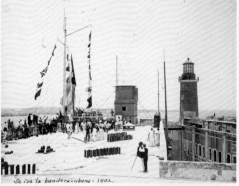

Se iza la bandera cubana - 1902.

7

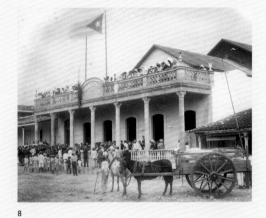

8

9

10
Joaquín BLEZ
President Mario García Menocal
About 1913

11
Joaquín BLEZ
President Alfredo Zayas
About 1921

12
Anonymous
*Young Woman Wearing a Cuban Flag
for a School Function*
1930s

6
Anonymous
*The Lowering of the Spanish Flag and
Raising of the American Flag at the
Castillo de los Tres Reyes del Morro,
January 1, 1899, Havana*
1899

On December 10, 1898, the
signing of the Treaty of Paris
brought an end to the Spanish-
American War. The United
States paid Spain a consider-
able amount of money for
possession of Guam, Puerto
Rico, the Philippines and Cuba.
Cubans were not present at the
treaty's signing. The raising of
the U.S. flag at the Castillo de
los Tres Reyes del Morro, in the
port of Havana, marked the
beginning of U.S. neo-colonial
control of the island.

7
Anonymous
*The Lowering of the American Flag
and Raising of the Cuban Flag at the
Castillo de los Tres Reyes del Morro,
May 20, 1902, Havana*
1902

On May 20, 1902, the United
States granted Cuba indepen-
dence with the Platt Amend-
ment, a rider added to the
Cuban constitution in 1901 by
Orville H. Platt that defined the
terms of relations between
the two countries. Conditions
included the sale or leasing
of naval bases to the United
States and the right of the
U.S. government to intervene
politically or militarily in Cuba.
Once again, at the Castillo de
los Tres Reyes del Morro, a
change-of-flag ceremony was
held; this time the U.S. flag was
lowered and the Cuban flag
raised.

8
Estudio MARTÍNEZ OTERO
*Official Raising of the Cuban and
Spanish Flags by the President of the
Spanish Community and the Mayor of
the Town, Havana*
1908

Many Spanish cultural and
social associations were
established throughout the
country, even after Cuba was
no longer a colony of Spain.
This photograph was taken
at the opening of such an
association in the centre of
the country.

9
Anonymous
*The "Texas" Entering the Bay of
Havana*
1925

Following pages:
13
Federico GIBERT GARCÍA
*Panorama of the Castillo de la Punta
and the Havana Prison*
1916

14
American Photo Studios, Havana
*Panorama with the Glorieta de
La Punta*
Early 20th century

0

1

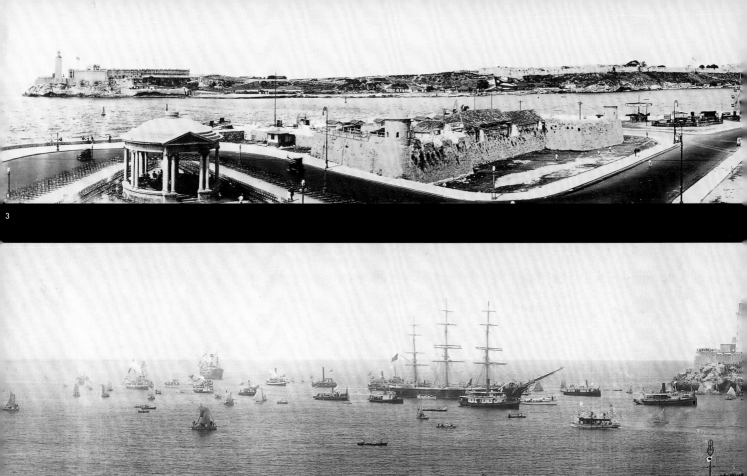

3

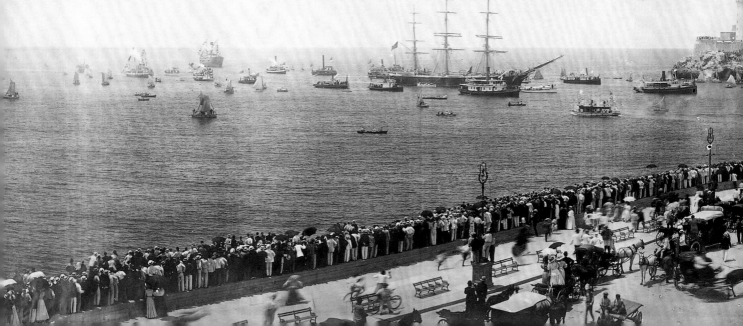

15

16

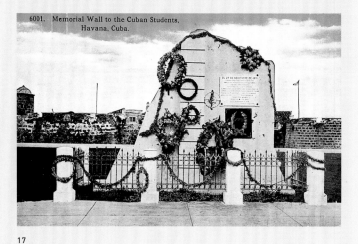

17

18

15
Postcard:
Havana: Carnival Float on the Malecón
About 1928

16
Postcard:
Havana: Carnival Season
About 1922

17
Postcard:
Memorial Wall to the Cuban Students, Havana, Cuba
1907–15

The memorial to medical students at La Punta commemorates the execution of 8 medical students falsely accused of having desecrated the tomb of a Spanish journalist named Gonzalo Castañón. The execution by members of the Spanish military under the governorship of General Blas Villate (Count of Valmaseda), occurred on November 27, 1871. This date is remembered in Cuba through patriotic acts carried out by students.

18
Postcard:
Shooting of Cuban Prisoners at Castillo de los Tres Reyes del Morro [*sic*], *Havana, Cuba*
About 1908

19–26
Postcard views of Havana:
Mid 1920s–early 1940s
19. *Palacio Presidencial, Avenida de las Misiones*
20. *Marianao Bathing Beach*
21. *The Prado*
22. *National Casino at Marianao*
23. *Parque Central, Capitolio, Teatro Nacional*
24. *Miramar Yacht Club*
25. *Parque Central, Hotel Inglaterra, Teatro Nacional*
26. *A Bit of Old Havana*

Habana: Palacio Presidencial, Avenida de las Misiones 25

President's House, Missions Avenue, Havana, Cuba

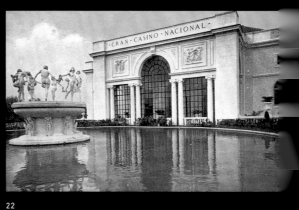

THE PRADO, HAVANA, CUBA

GRAN · CASINO · NACIONAL

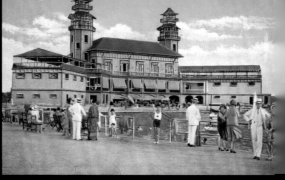

18 Habana: Parque Central, Capitolio, Teatro Nacional

Havana: Central Park, Capitol, Opera House

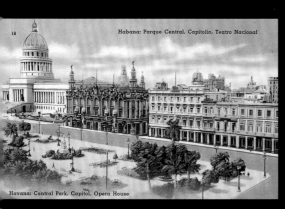

Habana: Parque Central, Hotel Inglaterre, Teatro Nacional.
Central Park-Opera House, Inglaterra Hotel.

A Bit of Old Havana, Cuba.

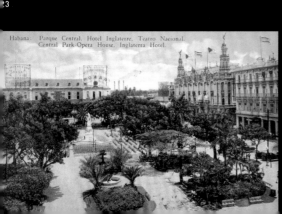

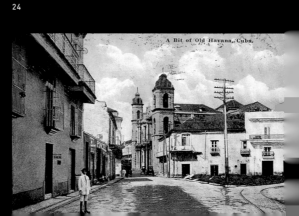

19

20

21

22

23

24

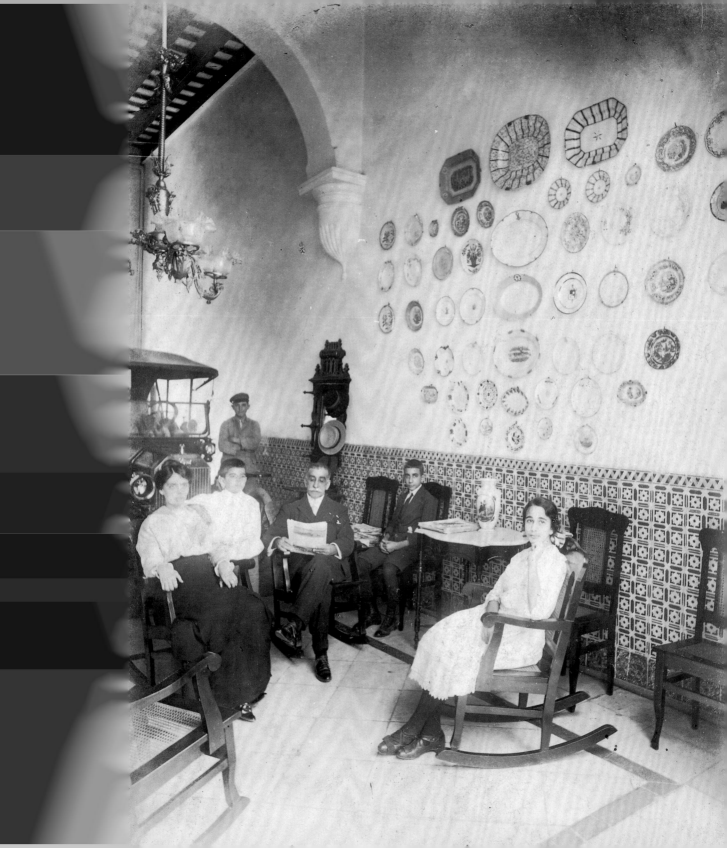

28

29

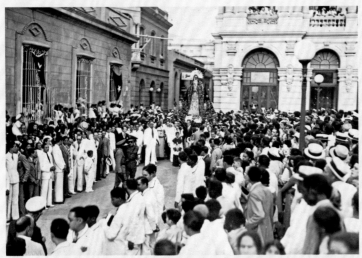

30

31

27
Anonymous
The Pérez Beato-Arango Family,
Calle Industria
1920s

28
Anonymous
Untitled, Santiago de Cuba
About 1910

29
Estudio MARTÍNEZ OTERO
Untitled
About 1908

30
Anonymous
Statue of a Virgin in a Catholic
Procession, Santiago de Cuba
About 1930

The Virgin of Charity of El
Cobre is the patron saint of
Cuba and its most venerated
religious figure. Legend has
it that an image of the Virgin
Mary appeared floating in the
Bahía de Nipe in the early
17th century. Two natives (the
Hoyos brothers) and a slaveboy
were gathering salt when they
saw Her on a plank with the
inscription: "I am the Virgin

of Charity." They carried Her
to Barajaguas. Years later
She was taken to the El Cobre
Parish, where a hermitage was
built for Her: it later became
the National Church and
Sanctuary in today's province of
Santiago de Cuba. The statue
of the Virgin is rather small,
and She carries the Baby
Jesus in Her left arm, and He
holds a globe in His left hand
and a cross in His right. Pope
Benedict XV declared Her the
patron saint of Cuba on May
10, 1916. She is celebrated on
September 8, on which day a
procession is held.

31
Estudio MARTÍNEZ OTERO
Untitled
About 1910

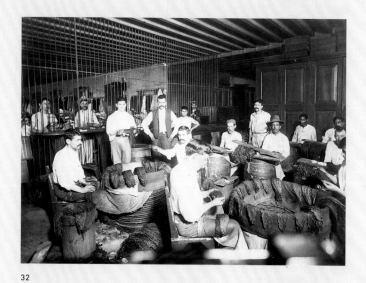

32

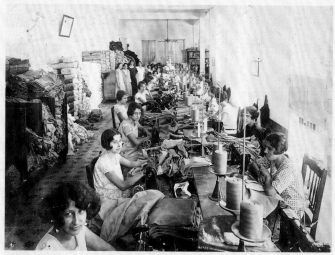

33

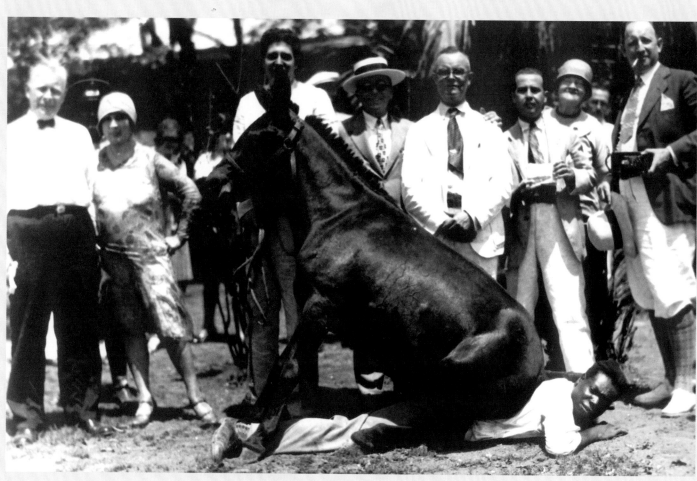

34

32
Estudio COHNER
Tobacco Sorting
About 1895

33
Estudio MARTÍNEZ OTERO
Untitled
About 1920

34
Moisés HERNÁNDEZ FERNÁNDEZ
Untitled, Santiago de Cuba
1927

35–39
Postcard views of Cuba: early 20th c.
35. *Source of the Almendares River*
 Cuban Landscape
36. *Tobacco Field*
37. *Cutting Sugar Cane* (19th c.)
38. *Cockfight*
39. *Wharf Scene, Havana*

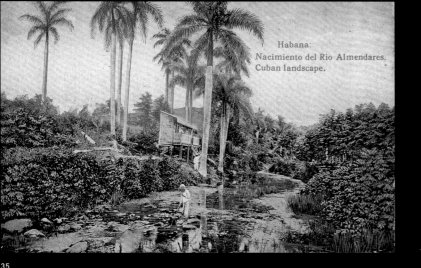

Habana:
Nacimiento del Rio Almendares.
Cuban landscape.

35

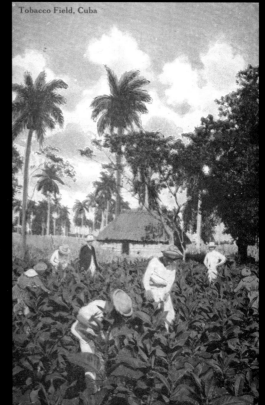

Tobacco Field, Cuba

36

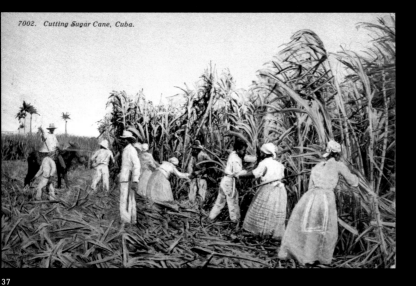

7002. Cutting Sugar Cane, Cuba.

37

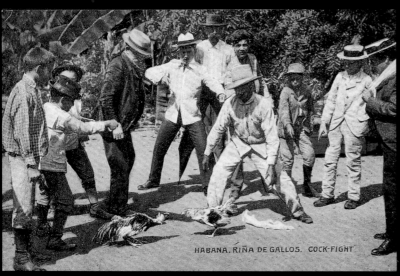

HABANA. RIÑA DE GALLOS. COCK-FIGHT

38

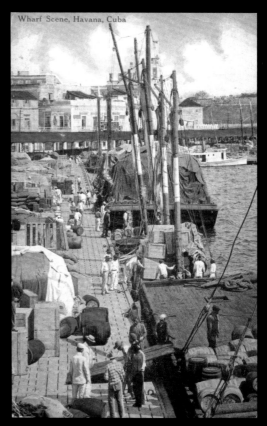

Wharf Scene, Havana, Cuba

39

NINETEENTH-CENTURY CUBAN SOCIETY

Olga López Núñez

Historians and literati often refer to the nineteenth century as the island of Cuba's "golden age." It was an era of opulence, characterized by rapid technological development. The steam engine, the driving force of this development, was introduced in the sugar-cane industry in the first few decades. Intense trade activity provided Spain with plentiful revenue generated from sugar, coffee and tobacco exports. In the late eighteenth century, the former service colony had changed into a plantation colony. Advancements were made in science, politics and, most particularly, literature. Remarkable writers proliferated, their names contributing to the enrichment of a Latin American heritage. Havana was considered one of the most important cultural centres of the Americas, and its visual arts employed a language of expression commensurate with the times.

Nevertheless, these developments were founded on the reprehensible slave trade and the institution of slavery, which had coexisted since colonization. The nineteenth century was also a tumultuous and chaotic time. Society was segmented, in conflict and split into social divisions. There were uprisings, clashes and the first political conspiracies against the colonial regime, which culminated in armed conflicts in the second half of the century, beginning in 1868 with the Ten Years' War and concluding in 1898 with the end of the Spanish-American War, known as the War of Independence in Cuba.

Various ideological currents marked the political scene shaped by the socio-economic contradictions tearing at colonial society. The reformers wanted economic-political solutions, without breaking ties with the mother country. Opposing them were the annexationists, who argued for joining the United States. Still more vehement were the proponents of independence, who advocated Cuba's total separation from the Spanish Crown to become a nation. Pro-independence ideas grew out of a concept of Cubanness, of an island homeland, held by a Cuban-born people. Patriotism and love for the native land swelled in the younger generations, shaped by teachers, most notably Father Félix Varela.

Society

On the social scene, the dominant class consisted of the rich Cuban-born and Spaniards. The former were landowners and the latter held high-ranking administrative and trade positions. In the eighteenth century they had become a powerful oligarchy—the most powerful in the Americas. They possessed titles of nobility and were highly cultured. They also had a group consciousness and decision-making power over their rights within the colony. With their entrepreneurial spirit, they introduced the steam engine and carried out research into tobacco, sugar and coffee, among other fields. They were noted for their loyalty to the Spanish King and their fondness for the *Patria Chica*, or little homeland. Despite a brief period of decline, this oligarchic group lasted until the time of General Miguel Tacón, who became governor of the island in 1834. He set out to destroy the nobility, thereby marking the end of one phase in Cuba's cultural life and the rise of a new local bourgeoisie of slave owners and sugar producers.

The first few decades of the century saw the emergence of a bourgeoisie made up of people of African descent who came from the battalions of free men of colour. Beginning in the sixteenth century, the colonial army had used Africans to defend the island from corsair and pirate attacks. Later

on, Spain organized its battalions along colour lines. Enlisted men of colour enjoyed certain advantages over their non-enlisted counterparts in terms of military privilege, pensions and priority for some jobs. In many cases, they achieved a comfortable economic position and a higher social standing than other men of colour.

The Visual Arts

At Intendant Alejandro Ramírez's initiative, the Economic Society of Friends of the Country founded the first art school in Cuba, in January 1818, in the cloisters of the San Agustín convent. It was called the Free Drawing and Painting School, and later was renamed the Academy of San Alejandro, in honour of Ramírez. Its first director, Juan Bautista Vermay, instructed the new generations of artists in Neoclassicism, and under successive French directors, the school later moved toward Romanticism.

While the subject matter of easel painting at the time was the ruling class, it was printmaking that captured the settings, types and mores of the popular classes. Lithographs became part of the country's cultural heritage, for, in addition to their artistic merit, they depicted social life in the nineteenth century. The anecdotal, the picturesque, popular characters and scenes of daily life were topics of interest to lithographers, who found their mode of expression in a new aesthetic.

The Legacy of Slavery

Spain introduced slavery in the sixteenth century. Santiago de Cuba was the first port to receive a shipment of human cargo, somewhere between 1503 and 1528. The slave trade continued until 1873, when the last shipment of slaves disembarked in Cuba's western provinces. Africans were confronted with a new culture and social structure very different from their own. Living in subhuman conditions, they were forced to adapt to their new environment through coercive means, and they lost the social framework, institutions and ways of living of their homelands. The crews, made up of men from different ethnic groups, could not communicate with one another nor did they share the same religious practices. They lived in overcrowded, filthy quarters and were subjected to an arduous work regimen by overseers who meted out the customary punishments of lashings and the stocks.

The lives of domestic slaves differed from those of plantation slaves. The former usually lived in urban areas and worked as house servants or had a trade. They too were subjected to physical punishment as a form of repression. Noticeable among urban slaves were mixed-race carriage drivers; they were often depicted in paintings and prints of the time as picturesque figures (ill. 59). There

were many runaway slaves (ill. 53): both urban and rural slaves became *cimarrones* in search of freedom. In the mountains of western and eastern Cuba, fugitive slaves gathered, living in *palenques*, or former slave communities, hidden in the forests, where they organized their resistance against the *rancheadores*, cunning slave hunters whose job it was to find and capture runaways.

Cabildos were religious mutual-aid associations of slaves or free men of the same African ethnic group or nation. The colonial government endorsed them since its policy was to encourage the division of the black population. The *cabildos* served a number of functions, including the provision of typical cultural activities: African-style music and dance, for example, and the worship of African gods in Christian forms. These associations brought together men of the same ethnic group and did important work to help turn slaves into men with a trade. They also played a notable recreational role in colonial Havana by holding Sunday festivities and a traditional parade on January 6, the Day of the Magi (ill. 59, 62, 64), when all the African nations, bearing their standards, gathered at the Palacio de los Capitanes Generales and then marched through the streets of the city.

The Sugar Industry and Its Depiction

Cuban plantation owners grew richer as the sugar industry developed and was mechanized, beginning in 1840. A sugar plantation covered a huge tract of land, requiring the felling of entire forests. It comprised the planted area of cane fields and the refinery area (ill. 43–50), with its various buildings, each with its own purpose in the process of sugar production. The mill also contained the boiler house (ill. 50, 52), the slaves' quarters, the overseer's house, the infirmary and other service buildings. And of course the grand house of the plantation owner and his family stood in a prominent location.

Mechanization caused upheaval in the slave system. Plantation owners wanted a workforce of low-paid day labourers for the new industry. Chinese immigration was engineered to cover the industry's needs. Starting in 1847, successive waves of Chinese migrants were brought to Cuba under contract. It is estimated that, in the 1860s, over 100,000 Chinese labourers arrived, making up the largest wave of immigration after the African slave trade.

In 1857, a book called *Los Ingenios* [The Sugar Mills] was published in Havana. Dedicated to the office of development, the texts of this beautiful tome were written by Trinidad landowner Justo Germán Cantero, who commissioned French painter and lithographer Eduardo Laplante to do the illustrations. Laplante travelled the length and breadth of the island, making sketches of the main sugar mills, after which he transferred the drawings onto lithographic stones. Apart from the beauty of the prints of exteriors and boiler houses, the book contains information about the technical advances made at the mills.

Costumbrismo

The portrayal of local customs as a subject was adopted later in painting than in lithography; nevertheless it reached artistic excellence. Like prints, the genre provided information on customs and settings of Cuban society of the time. Among the painters of local customs, Víctor Patricio de Landaluze was quite prolific. In his small oils appear the images of men from the popular classes. With a touch of humour he painted slaves from the plantation (ill. 54) and urban setting (ill. 60, 61), along with free men of colour and peasants (ill. 63) decked out at their country fetes.

In addition to Afro-Cubans as a subject in Cuban folklore, in both art and literature, peasants figured prominently. Given their festivities and closeness to nature, they were often portrayed in idyllic surroundings, with legend and poetry as part of their identity. Good horsemen, feisty, with a penchant for dancing and cockfights (ill. 38, 59), they would serenade their beloved with *décimas*, or ten-line verses, guitar in hand. A combination of poet and hero, Cuban peasants filled the ranks of the Mambí army and fought fiercely for their country's independence.

The Second Half of the Nineteenth Century

War broke out on October 10, 1868, with the uprising that took place on the grounds of the La Demajagua sugar mill, where the mill owner, Carlos Manuel de Céspedes, and other patriots proclaimed the abolition of slavery. In 1878, after ten exhausting years of fighting, the Ten Years' War came to an end with the signing of the Pact of Zanjón. A new period began in which several armed conflicts occurred because the idea of separation remained alive. After the War of Independence ended in 1898, the island underwent a social transformation. The abolition of slavery meant that Afro-Cubans could now live as free men. Moreover, the impoverishment of many wealthy Cuban families contributed to a considerable levelling between social groups. Former plantation owners dropped into the middle class, where they had to directly invest themselves in the support of their families. At this time, shared hardships and mutual assistance brought the racial groups closer together now that a tradition had been established of heroic actions taken by Cubans of all racial backgrounds and social classes.

There were many artists in the second half of the nineteenth century. On completing their studies in Havana, they travelled to Europe for further training. Outstanding among these artists was Esteban Chartrand, who developed landscape painting; he saw the Cuban countryside through the eyes of a Romantic painter (ill. 41). Another notable of this period was Guillermo Collazo, "the painter of great ladies," as poet Julián del Casal described him, because his art was always refined. He was careful to capture the sumptuous surroundings of his sitters. In addition to his elegant, well-proportioned lines, his technical skill is best exemplified in his use of colour (ill. 56).

In the last two decades of the century, talented young artists emerged, among them José Arburu Morell (ill. 57); however, his premature death cut short his work, destined to be an invaluable contribution to the national heritage. Others of the same generation represented the transition to the twentieth century, for example, Armando García Menocal (ill. 68, 70, 71) and Leopoldo Romañach (ill. 65–67). Not only were they excellent artists, but they also taught new generations of painters at the Academy of San Alejandro.

When armed battles for independence broke out in 1895, Menocal left his teaching position at San Alejandro and joined the struggle under the direct orders of Commander-in-chief Máximo Gómez. In the years leading up to the War, political and economic unrest had grown throughout the island. The failure of reformist programs had led the people to take up arms in search of a solution. In 1892, José Martí founded the Cuban Revolutionary Party, the organization that was needed to lend strength and cohesiveness to the war for freedom. Menocal, named commander of the Liberation Army, as witness and participant produced pictorial accounts of events in the form of small sketches he executed throughout the campaign. In his *Charge of the Machetes* (ill. 71), he recorded, quickly and accurately, a column of Mambí independence fighters going into battle.

At the end of the War, freed from Spanish domination but subjected to U.S. government intervention, Cuba became a republic in 1902. A new stage in the country's history began, but the War continued to preoccupy artists as a theme. Many of their works in the first few decades of the twentieth century portrayed heroic episodes of the War for Independence, giving the new generation something to think about.

See also:

López Núñez, Olga. "Notas sobre la pintura colonial en Cuba," in *Pintura europea y cubana en las colecciones del Museo Nacional de La Habana*. Madrid: Fundación Cultural Mapfrevida, 1997, pp. 49–73.

Víctor Patricio de Landaluze: sus años en Cuba. Bilbao: Museo de Bellas Artes de Bilbao, 1998.

El arte del tabaco: exposición de marquillas. Havana: Museo Nacional de Bellas Artes, 2005.

41 Esteban CHARTRAND, *Seascape*, 1877

DISCOVERING THE CUBAN LANDSCAPE

Ernesto Cardet Villegas

Historians relate that Christopher Columbus, when he arrived at the island of Cuba, declared it the most beautiful land human eyes had ever beheld. Columbus's comments became the first by a European on Cuba's environment, rendering full justice to the beauty of the land with its astounding topography, lush vegetation and clear blue sea and sky. It was through this prism that the Cuban landscape was captured in later years by Cuban and foreign artists, and adopted as one of the preferred genres of Cuban painting. With the passage of time a strong national tradition took shape and demand for landscape paintings constituted an incentive for artists.

The first Cuban landscape paintings date back to the beginnings of colonization and depict various historical events, rendered by foreign artists to satisfy Western Europe's enormous interest in the New World. In the nineteenth century, rural landscapes served to illustrate the progress of the nascent sugar industry (ill. 51); given the need to increase sales in the world market, no efforts were spared to demonstrate how the most advanced technology was being used. Paintings of the day depicted the principal Cuban cities with their native vegetation and local forms of urbanization. They were true documents of their time that also served as a backdrop to scenes of local customs.

As a subject proper, landscape paintings began to appear in Cuba in the mid-nineteenth century. The genre's birth coincided with the growth in interest in Cuban life and its depiction of Cuban sites and views of the country's shores became a part of national identity, which had long since been expressed by other art forms. These early images captured the topography of various regions, but they did so using light that was foreign to the country's tropical reality. Preferred subjects were daybreaks, twilight and moments before and after storms, when the sun's light is filtered.

Among the first artists to paint landscapes were the Chartrand brothers, of French descent—Felipe, Esteban and Augusto—who had settled in Limonar, where their family owned a sugar mill. In their work, the Chartrands highlighted locations (ill. 53) close to the city of Matanzas, especially the famous Yumurí Valley with its graceful palm trees, calm rivers and numerous sugar mills surrounded by sugar cane plantations.

Of the three brothers, Esteban created the most important work. When he was very young, he travelled to France, where he came into contact with Romanticism. Upon his return to Cuba he participated in various exhibitions, earning considerable renown. The poetry with which he depicted the landscape was evident in the work of other artists until well into the twentieth century (ill. 41).

In the second half of the nineteenth century, the Romantic manner of illustrating the landscape entered into dialogue with another, realist approach, creating an endless range of panoramas of the Cuban environment, in which colour and light were used as expressions of each artist's personality, with the subject itself varying little in the work of most painters.

Valentín Sanz Carta was a representative of the realist current in Cuban landscape painting. He was born in Santa Cruz de Tenerife in the Canary Islands and in 1882 moved to Cuba, where his most important work was carried out. Beginning in 1886, he

42

taught landscape painting to numerous artists at the Academy of San Alejandro, introducing new teaching methods that surpassed those of the classroom. Sanz Carta's Cuban work is the best late nineteenth-century depiction of rural (ill. 42) and coastal areas, incorporating the island's real light and colour. Occasionally in his work there appear animal and human figures, reduced in scale in order to convey the magnificence of the landscape.

Two San Alejandro pupils deserve to be singled out for creating the most important twentieth-century landscapes: Eduardo Morales and Antonio Rodríguez Morey. Morales employed a style that fluctuated between romanticism and realism, creating an intimate body of small- and medium-format works depicting valleys of palm trees, main roads and property boundaries, as well as panoramas of sugar mills and small settlements, in addition to compositions of rural scenes featuring every possible means of transport, from elegant carriages to the carts used to transport sugar cane.

Rodríguez Morey, essentially a landscape artist, occupies one of the principal positions in this area in the twentieth century. He was born in Cádiz, Spain, and moved to Cuba as a child; it was there that he learned how to paint. He later travelled to Europe and settled in Italy, where he completed his studies and adopted the styles in fashion at the time. His Cuban work, which was praised by critics and coveted by collectors, ranges from symbolist to highly realist paintings of greatly dissimilar vistas and a variety of topographies and coastlines.

Morales's and Rodríguez Morey's landscapes were the first work of their kind in the Cuban *Cambio de Siglo* or turn-of-the-century period, which lasted from approximately 1894 until 1927, when the *Exhibition of New Art* inaugurated modern art in Cuba. This period joined heterogeneous forms of expression and, with respect to landscape painting, demonstrated an overriding concern with tropical light and splendour.

Armando García Menocal was the indisputable pioneer during this period, although most of his landscapes were created in the twentieth century. A view of the Cuban coastline, enlivened by boats and small human figures, radiant with light and dated 1880, demonstrates how the young painter, recently graduated from the Academy of San Alejandro and before completing his studies in Europe, was interested in the brilliance of the environment. The painting is an important work in the development of Cuban painting and is one of the few works in which Menocal was inspired by the sea (see ill. 70). He generally preferred pleasant rural landscapes in addition to other settings that served as backgrounds in paintings of a historical (ill. 68, 71) or mythical nature.

Leopoldo Romañach was the other great turn-of-the-century figure. His work was noteworthy in various domains, including the portrait and compositions with human figures (ill. 66, 67), but it was his landscapes, especially paintings of the northern coastline in the province of Villa Clara, that achieved the most renown because of their modern approach (ill. 65). His paintings employ the lighting characteristic of Spanish Impressionism and demonstrate his great talent as a colourist and his ability, using ingenious techniques, to recreate the transparency of the sea.

Both of these masters, Menocal and Romañach, bequeathed an extensive and valuable body of work that greatly contributed to Cuba's cultural heritage. They also made a notable contribution in their respective areas of teaching at San Alejandro, where they taught several generations of artists, some of who would later join or introduce to Cuba European avant-garde idioms.

In the early twentieth century, depiction of the sea in Cuban landscape paintings was limited. Few artists worked with such views. In this sense, Romañach was the only painter of the day to distinguish himself in the field, with other artists such as Aurelio Melero, Juan Gil García, José Joaquín Tejada and Gonzalo Escalante, among others, working in it only sporadically, preferring rural views.

One name that stands out as an innovator in the history of Cuban landscape painting is that of Domingo Ramos, whose talent elevated the genre to new heights and made his work very well received by critics and the public alike (ill. 73, 76, 77). Ramos cannot be made to fit in a specific school because, after graduating from San Alejandro, he completed his studies in Spain, where various styles co-existed: Impressionism, Symbolism and Realism. He took from them what he needed and created his own style, which, through his work as a teacher at San Alejandro, became a school of landscape painting for younger generations of artists.

Following the rise of modern art in Cuba, the work of these turn-of-the century painters, which today is undergoing a thorough re-evaluation, was harshly dismissed by critics and certain figures within the country's intellectual and artistic milieu, who saw it as passé. With this new form of expression, landscape as a subject proper practically disappeared and, generally speaking, became subordinated to other types of paintings.

Since the late 1970s, landscape painting has seen a resurgence in Cuba as an independent subject. Its frequent presence in exhibitions and salons reserves it an important place in contemporary painting.

See also:

Cardet Villegas, Ernesto. "Aproximación a cien años de pintura en Cuba, siglos XIX– XX," in *Pintura española y cubana del siglo XIX*. Salamanca, Spain: Caja Duero, 1999.

Cardet Villegas, Ernesto. "Menocal y Romañach. Notas para una cronología," in *Menocal Romañach*. Salamanca, Spain: Caja Duero, 2003.

Domingo Ramos: paisajes. Havana: Museo Nacional de Bellas Artes, 2006.

43

44

45

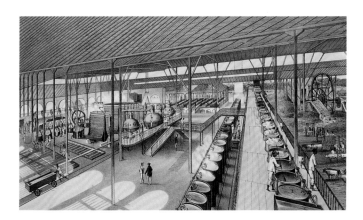

46

43–50

Eduardo LAPLANTE

After Justo Germán Cantero's
"Los Ingenios"
1855–57
Published by Luis Marquier,
Havana, 1857

43. *The Acana Sugar Mill*
44. *The Santa Teresa Sugar Mill in Agüica*
45. *The Ponina Sugar Mill*
46. *The Flor de Cuba Sugar Mill*
47. *The Buena-Vista Sugar Mill*
48. *The Narciso Sugar Mill*
49. *The Progreso Sugar Mill*
50. *The Boiler House at the Asunción Sugar Mill*

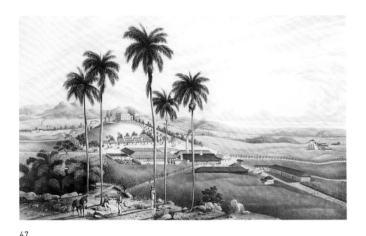

47

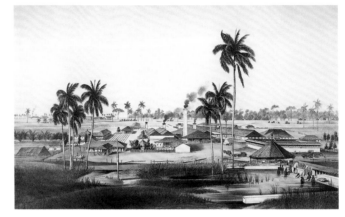

48

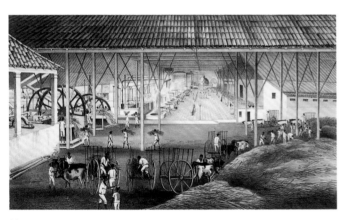

49

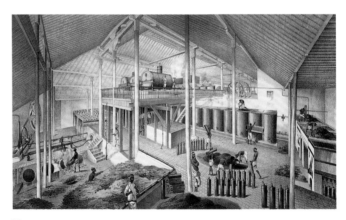

50

In 1857, *Los Ingenios* (Sugar Mills), a book dedicated to the office of development, was published in Havana. The texts of this beautiful tome were written by landowner Justo Germán Cantero from the province of Trinidad, and he commissioned French painter and printmaker Eduardo Laplante to do the illustrations. Laplante travelled widely throughout the island, making sketches of the main plantations, which he later transferred onto lithographic stones. The book's pages document the technological advancements employed at the sugar mills. Of the 28 illustrations, 19 are of exterior views and 9 are of the interiors of boiler houses.

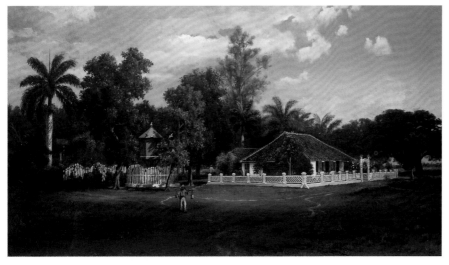

51

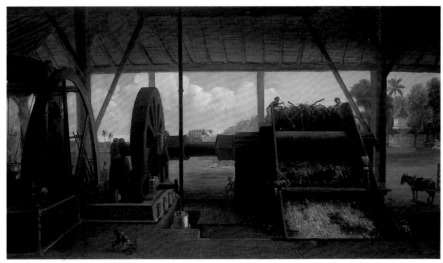

52

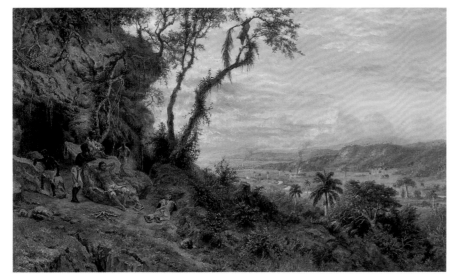

53

51
Esteban CHARTRAND
View of the Tinguaro Sugar Mill, No. 2
1874

52
Esteban CHARTRAND
*View of the Tinguaro Sugar Mill, No. 1
—Boiler House*
1874

53
Esteban CHARTRAND
The Runaways
1880

The *cimarrones* were the run-away slaves who had escaped Spanish slave owners. They lived like fugitives in remote mountain communities known as *palenques*.

54
Víctor Patricio de LANDALUZE
The Cane Harvest
1874

Following pages:
55
Federico AMÉRIGO
Landscape
n.d.

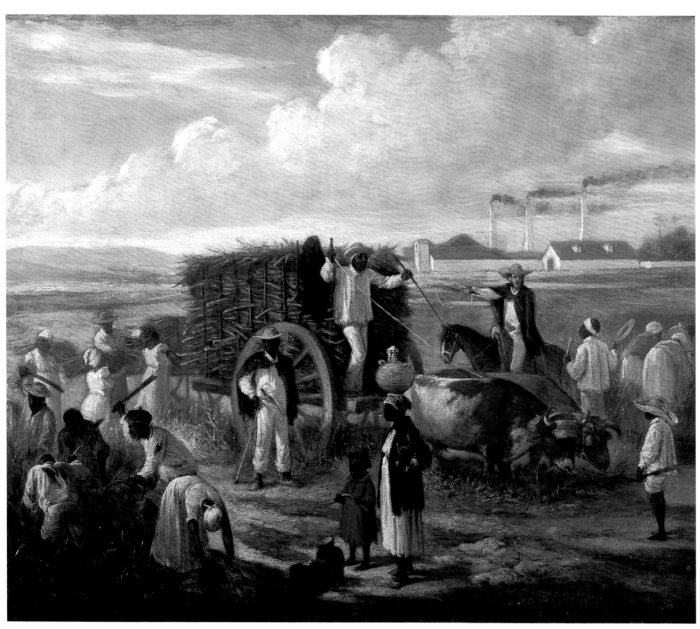

54

55

56

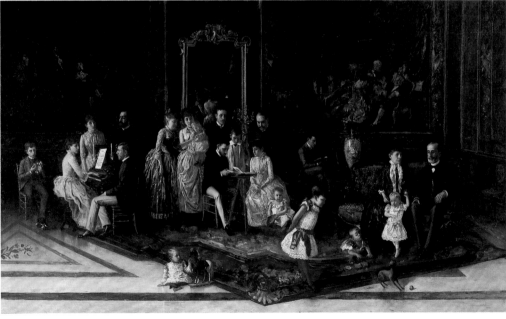

57

56
Guillermo COLLAZO
The Siesta
1886

57
José ARBURU MORELL
Portrait of the González de Mendoza Family
1886

José Arburu Morell painted this portrait of his patron, the lawyer Dr. Antonio González de Mendoza, and his family in Havana, shortly before he went to Spain to study. The composition is set in one of the drawing rooms of the González de Mendoza mansion. In addition to executing an interesting group portrait of a family, the artist unintentionally bequeathed to posterity a picture of the luxurious lifestyle of the fortunate wealthy of the day, who were known for their elegant taste.

58
Anonymous
Cigar box labels and cigar rings
19th century

The tobacco industry promptly adopted lithography for reproducing the elegant labels on their packaging as a way of preventing fraud. These lithographs, on a wide range of subjects, included the name of the brand, the manufacturer and the area of the plantation. In the second half of the 19th century, chromolithography arrived in Havana, and towards century's end labels were enhanced with embossing and gilding.

a

b

c

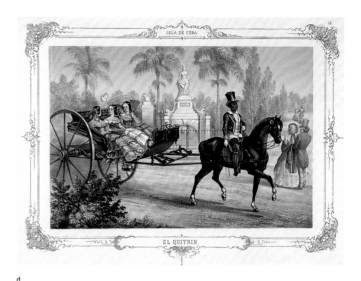

d

59 a–j
After Frédéric (or Federico)
MIALHE
Album pintoresco de la isla de Cuba
(Picturesque album of the island
of Cuba)
Published by Bernardo May & Cie.,
1853

Based on paintings produced by
the French painter and print-
maker Frédéric (or Federico)
Mialhe, *Album pintoresco de la
isla de Cuba* is a typical 19th-
century travel book. It contains
27 colour lithographs of views

and 2 maps in black ink—one of
Cuba and the other of Havana.
The prints are of a variety of
subjects, from views of Havana
and rural areas, to scenes
of daily life, landscapes of a
regional nature and festivities
celebrated by the people. The
book was originally published
in Havana in 1847–48 with the
title *Viaje Pintoresco Alrededor
de la Isla de Cuba*. In 1850, it
was reprinted in two other
versions.

a. Title page
b. Pl. 4: *Havana. View from
 Casa-Blanca*
c. Pl. 10: *Fuente de la India and Paseo
 de Isabel II*
d. Pl. 12: *The Two-wheeled Carriage*
e. Pl. 15: *Cockpit*
f. Pl. 16: *Day of the Magi*
g. Pl. 21: *The Outskirts of Baracoa
 and the Inhabitants' Mode of
 Transportation*
h. Pl. 23: *Living Quarters of the
 Sponge Fishermen of Bahía de
 Nuevitas*
i. Pl. 24: *Trinidad*
j. Pl. 26: *View of a Boiler House*

Following pages:

60
Víctor Patricio de LANDALUZE
When Nobody Is Around
About 1880

61
Víctor Patricio de LANDALUZE
José Francisco
About 1880

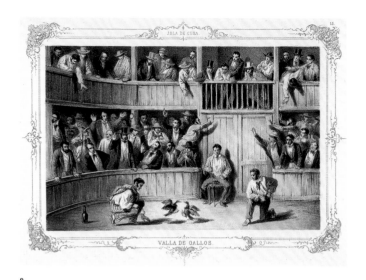

VALLA DE GALLOS.

e

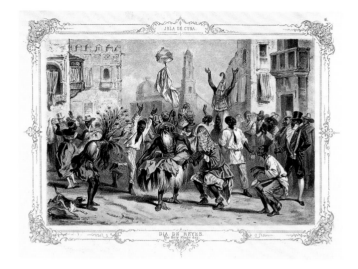

DIA DE REYES.
The Holy Kings day.

f

CERCANIAS DE BARACOA
y modo de viajar de sus naturales.

g

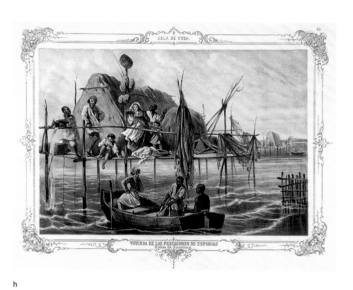

VIVIENDA DE LOS PESCADORES DE ESPONJAS
Bahia de Nuevitas.

h

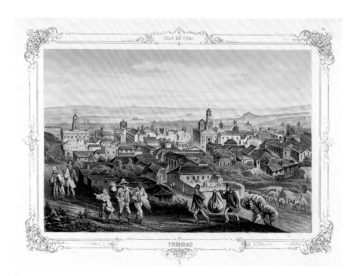

TRINIDAD

i

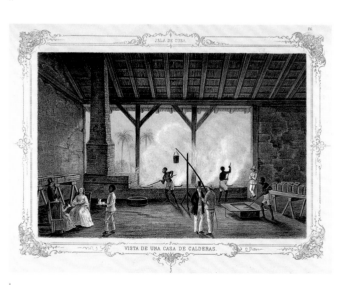

VISTA DE UNA CASA DE CALDERAS.

j

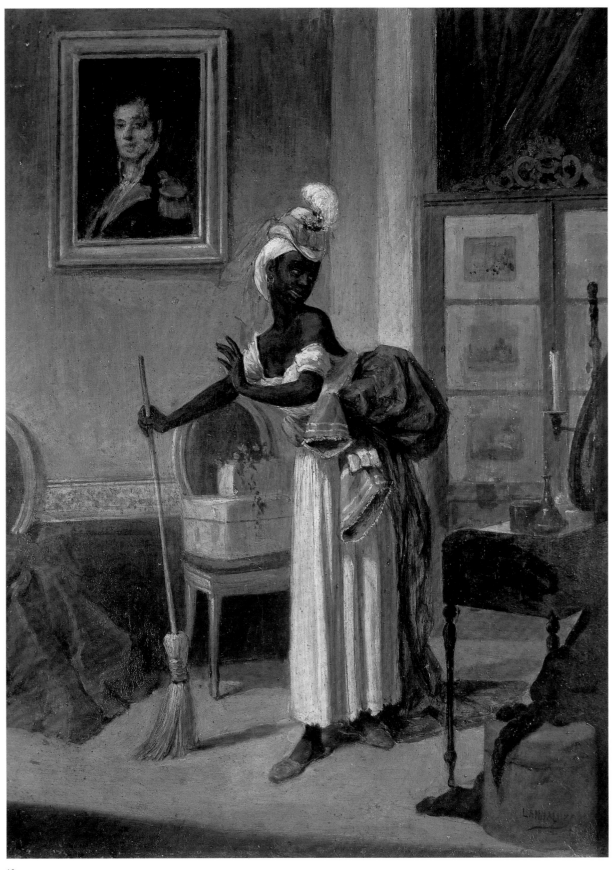

60

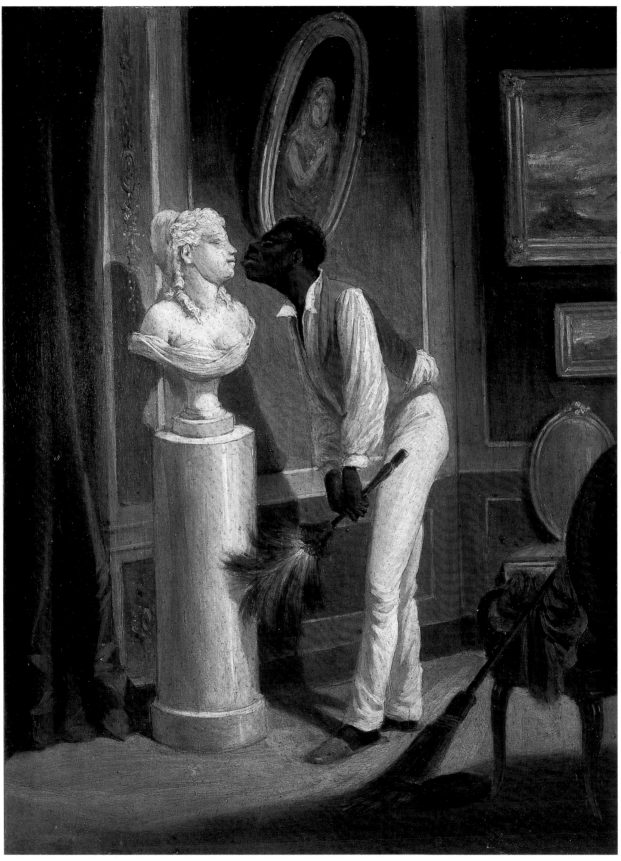

62

62

Víctor Patricio de LANDALUZE
Day of the Magi, Havana
n.d.

In colonial-era Havana, Sunday celebrations and the traditional procession on the Day of the Magi (January 6) were times when all people of African descent belonging to *cabildos* would gather at the Palacio de los Capitanes Generales with their banners, then walk through the city's streets. *Cabildos* were organizations of a religious nature created by the colonial government. They provided a support system for blacks and freed slaves of the same ethnic background or African country of origin, and served a number of functions, including the provision of traditional cultural activities, such as African-inspired music and dance, and the worship of African gods in Christian forms, thereby carrying on traditions.

63

63

Víctor Patricio de LANDALUZE
The Zapateo
About 1875

The *zapateo* is a traditional Cuban dance derived from Andalusian and Extremaduran ballads. In Cuba it is considered a dance of the countryside. Its beats are punctuated by constant foot tapping, and a variety of musical instruments are used, including maracas and claves, the scrapers güiro and guayo, and the stringed instruments tres, guitar, tiple and laud.

64

Víctor Patricio de LANDALUZE
Little Devil
n.d.

The so-called *diablito* or *ireme*
is a masked or custumed
dancer of the Abakuá society,
a male mutual-aid society
formed on the island by slaves
from Calabar, in the Cross
River region of what is today
southeastern Nigeria and
southwestern Cameroon.
The colonizers named these
slaves *ñáñigos*—meaning the
dragged—a term still used
today. The costume is worn
in Abakuá ceremonies, during
carnival and on the Day of
the Magi (January 6). The
brightly coloured suit consists
of a pair of embroidered eyes
and a conical-shaped hood
culminating in a pompom.
Around the neck, knees, cuffs
and ankles are scalloping of
frayed rope, and cowbells hang
from the belt. The dancers
carry in their hands pieces of
sugar cane and a branch of
bitter broom. The *diablitos* are
a highly symbolic part of a
ritual representing nature,
and they stand in for the spirit
of their forebears. Though
they see and hear, they do
not speak, but rather express
their emotions through
choreographed gestures.

65

66

67

65
Leopoldo ROMAÑACH
Seascape
n.d.

66
Leopoldo ROMAÑACH
*Portrait of a Young Girl with
Sugar Cane*
1926

67
Leopoldo ROMAÑACH
Girl of the Sugar Cane
n.d.

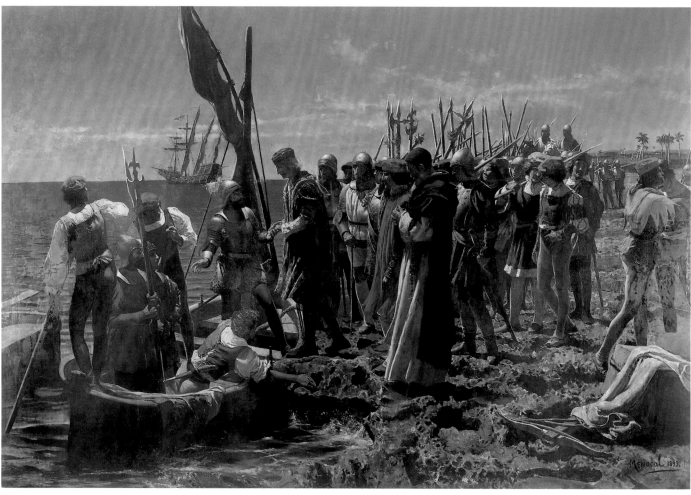

68

68

Armando GARCÍA MENOCAL

Bobadilla Sending Off Columbus
1893

Upon his return from an
expedition to the coast of what
is today Venezuela, Christopher
Columbus was confronted with
a revolt organized by the mayor
of Santo Domingo, Francisco
Roldán, which was fuelled
by the dissatisfaction of the
colonists with the admiral.

Columbus solicited help from
the Spanish monarchs, and
they responded by sending
a replacement, Commander
Francisco de Bobadilla, who
was appointed Governor
General of the West Indies. He
arrived in Santo Domingo in
August 1500. After a month of
resistance by Columbus, who
refused to give up command,
Bobadilla had him jailed and
sent back to Spain in chains
on board the caravel *La Gorda*.

69

Augusto GARCÍA MENOCAL

I Don't Want to Go to Heaven
1930

Hatuey was a Taíno leader
and is considered the first
hero of Cuba. Originally from
Hispaniola (today Haiti and
the Dominican Republic), he
went to Cuba in about 1511 to
warn the various indigenous
peoples of the arrival of Diego
Velázquez and his men.

Hatuey used guerrilla tactics
against the Spanish until he
was captured. On February 2,
1512, he was tied to a stake,
and moments before being
burned alive a Catholic priest
asked him if he wished to go
to Heaven. Hatuey replied with
a question: "Will those white
men also go to Heaven?" To
the affirmative response he
was given, he replied: "Well, if
they'll be there, then no, I don't
want to go to Heaven."

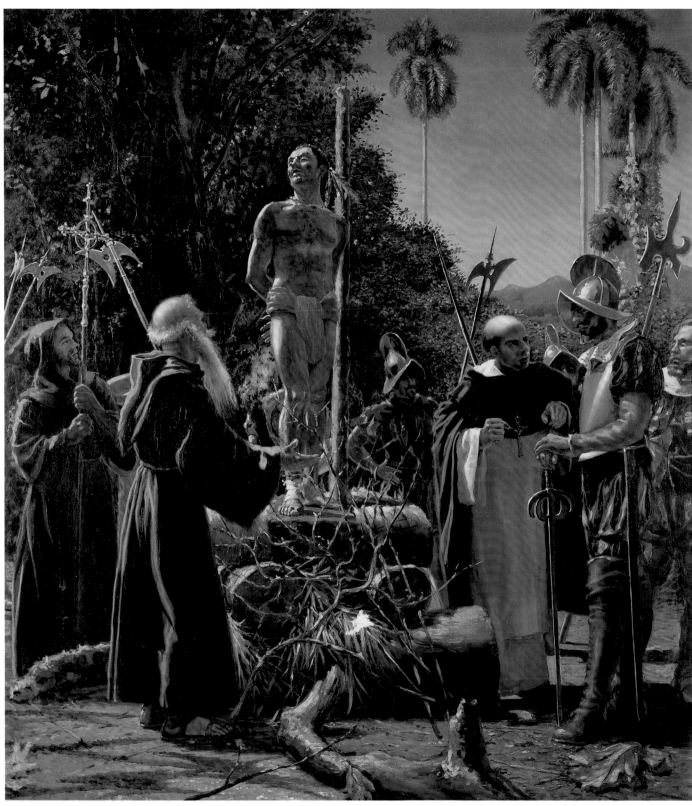

70

70
Armando GARCÍA MENOCAL
Nighttime at the Bay
About 1930

71
Armando GARCÍA MENOCAL
Oil sketch for "Charge of the Machetes"
About 1896

The first charge of the machete occurred at the beginning of the Ten Years' War, on November 4, 1868, at Pino de Baire, in the former province of Oriente. Máximo Gómez, Sergeant of the Liberation Army, decided to resist the advance of a Spanish troop of 700 men with nothing but machetes, battle weapons he had already used in his native Santo Domingo, which were most useful in hand-to-hand combat. The Spanish lost many men and it was then that the machete—a common tool to cut down sugar cane—was adopted as a cheap and highly effective weapon against the colonizer.

71

72

73

74

75

72
Domingo RAMOS
Landscape II
About 1940

73
Domingo RAMOS
Landscape of Matanzas
1930

74
Domingo RAMOS
Landscape with River
1942

75
Domingo RAMOS
Landscape I
Late 1940s

76
Domingo RAMOS
The Flamboyant Tree
1949

Following pages:
77
Domingo RAMOS
Landscape of Viñales
1940

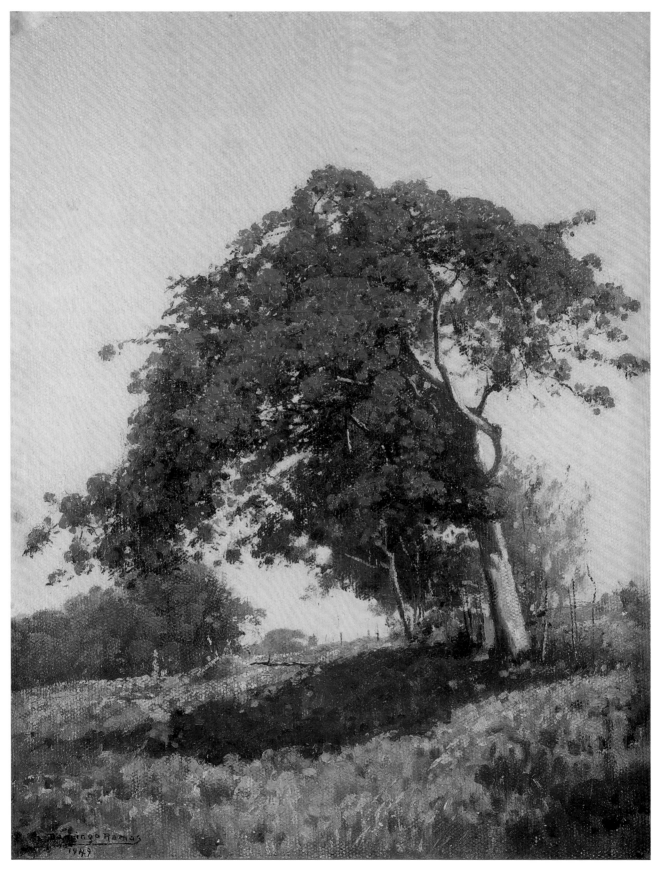

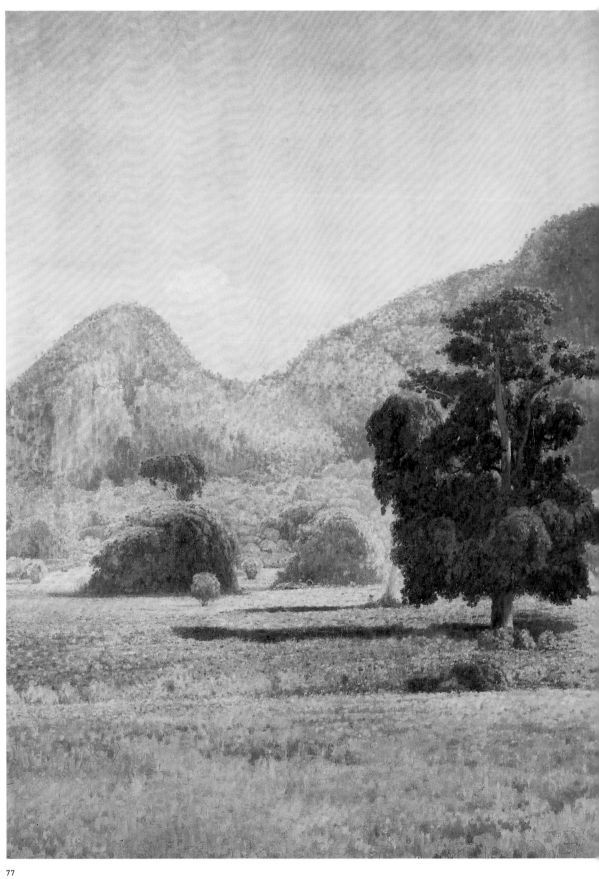

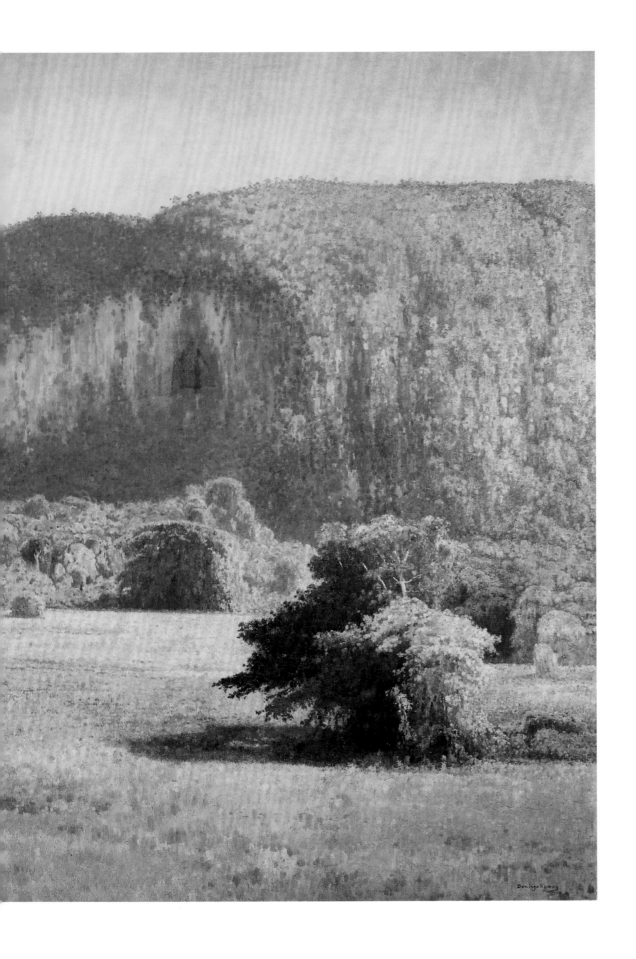

ARTE NUEVO

*the avant-garde
and the re-creation of identity*

TIMELINE
art and history

1927

The *Revista de Avance*, an important magazine covering the literature, art and styles of the day, is published.

Artist Armando García Menocal becomes director of the Academy of San Alejandro (until 1934).

The *Exposición de Arte Nuevo* [Exhibition of New Art], a major event that marks the rise of the Cuban avant-garde, is held at the Painters and Sculptors Association under the auspices of *Revista de Avance*.

Amelia Peláez, Domingo Ravenet, Eduardo Abela and Jaime Valls travel to Europe.

Carlos Enríquez travels to the United States.

University students rise up against Gerardo Machado's extended presidential term; the military intervenes.

1928

Joseíto Fernández composes the world-famous song *Guantanamera.*

The Lyceum y Lawn Tennis Club, an important cultural association for women that promoted the Cuban artistic avant-garde, is founded.

Marcelo Pogolotti settles in Europe.

Eduardo Abela exhibits his work at Zak gallery in Paris.

Wifredo Lam exhibits his work for the first time in Madrid.

The first National Photography Salon, the National Fine Arts Salon and the thirteenth Fine Arts Salon are held.

The Pan-American Conference is held in Havana.

Gerardo Machado is re-elected president.

1929

The Lyceum holds an exhibition of new art.

Eduardo Abela exhibits his work with European artists in Paris.

Marcelo Pogolotti is invited to exhibit his work with the Italian Futurists.

Eduardo Abela returns to Cuba.

Julio Antonio Mella is assassinated in Mexico by order of President Gerardo Machado, who begins a new term in office.

1930

The Círculo de Bellas Artes is founded through the merger of the Painters and Sculptors Association and the Cuban Fine Arts Club; its mandate is to bring together artists and promote cultural development through creative activities.

Spanish poet Federico García Lorca visits Cuba.

Eduardo Abela exhibits his work at the Lyceum.

Marcelo Pogolotti begins work on his series *Nuestro Tiempo* [Our Times].

A new University Student Directorate is founded.

1931

Marcelo Pogolotti exhibits his work with the Italian Futurists and signs the Futurist Manifesto.

Carlos Enríquez exhibits his work at the Ateneo Popular in Oviedo, Spain.

The secret organization ABC and the Student Left Wing group are founded; they wage a violent struggle against Machado's regime.

1932

Gonzalo Roig composes the zarzuela *Cecilia Valdés.*

Marcelo Pogolotti exhibits his work in Paris with the Futurists.

The Lyceum holds solo exhibitions of Eduardo Abela and Rafael Blanco's work as well as the *Unique Exhibition of Cuban Painters and Sculptors.*

The National Sugar Workers' Union is established.

1933

Amelia Peláez exhibits her work at Zak gallery in Paris in a show presented by Francis de Miomandre.

Carlos Enríquez exhibits his work at the Patronato Nacional de Turismo in Madrid and does the illustrations for the book *El terror en Cuba.*

Rubén Martínez Villena leads a general strike against President Machado, resulting in the fall of the regime.

Carlos Manuel de Céspedes Quesada becomes president for a short time.

Ramón Grau San Martín becomes provisional president of the "Hundred-day Government."

Emilio MOLINA, *Fall of Machado, August 12, 1933* (detail), 1933

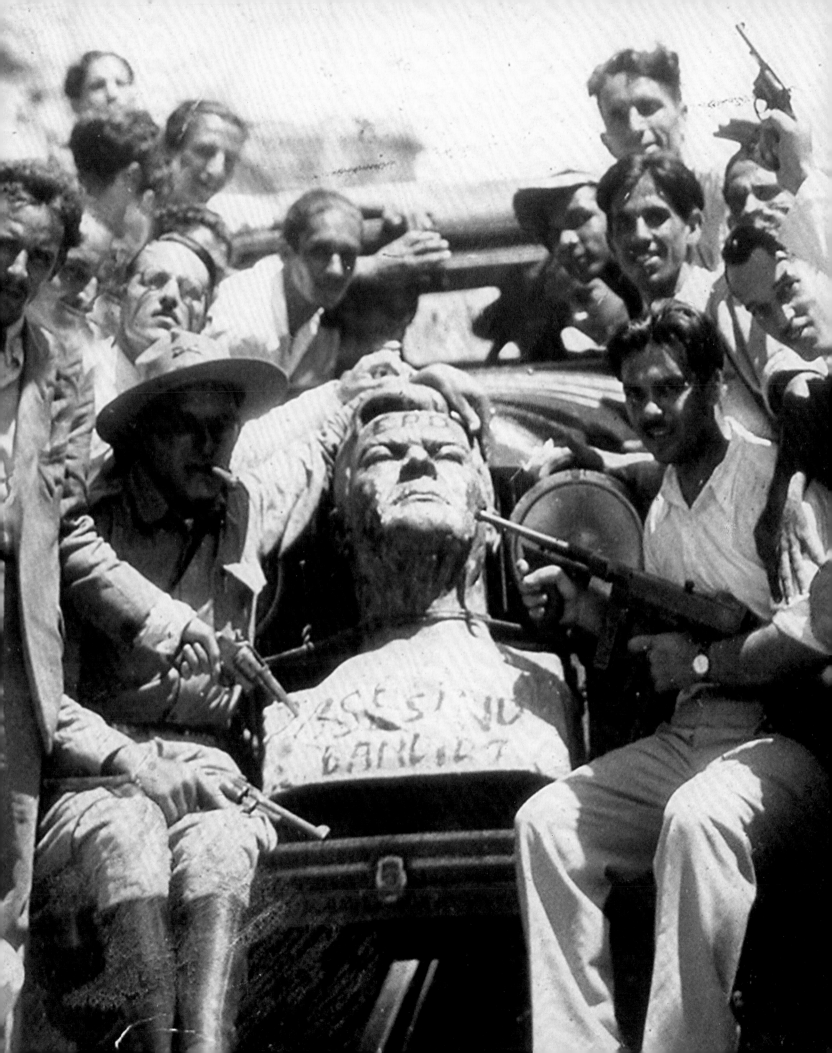

1934

The Department of Culture is established. Artist Leopoldo Romañach becomes director of the Academy of San Alejandro (until 1936).

Marcelo Pogolotti takes part in the *Exhibition of Revolutionary Artists* in Paris. Carlos Enríquez (his work is censored), Fidelio Ponce, Víctor Manuel García, Arístides Fernández (posthumously) and René Portocarrero exhibit their work at the Lyceum.

Amelia Peláez does the illustrations for Léon-Paul Fargue's *Sept poèmes* in France and returns to Cuba.

Rubén Martínez Villena dies.

A military coup establishes the government of Batista-Caffery-Mendieta.

A new Reciprocity Treaty is signed by Cuba and the United States.

Ramón Grau San Martín and Carlos Prío Socarrás found the Cuban Revolutionary Party (Auténtico Party).

1935

The National Salon of Painting and Sculpture is held; awards are given to Víctor Manuel García, Antonio Gattorno, Jorge Arche, Carlos Enríquez, Fidelio Ponce and Eduardo Abela.

Marcelo Pogolotti takes part in the second exhibition organized by the Association of Revolutionary Writers and Artists in Paris.

Revolutionary groups join forces in a general strike to topple the government of Batista-Caffery-Mendieta.

Antonio Guiteras is assassinated.

1936

Fernando Ortiz establishes the Society of Afro-Cuban Studies.

The third Exhibition of Modern Painting is held at the Friends of French Culture Circle.

Carlos Enríquez does the illustrations for Alberto Riera's book *Canto del Caribe.*

The exhibition *4 Painters* is held at the Lyceum and includes the work of Carlos Enríquez, Amelia Peláez, Domingo Ravenet and Víctor Manuel García.

Mariano Rodríguez and Mario Carreño travel to Mexico, where they meet the Mexican muralists.

Miguel Mariano Gómez is elected president.

Fulgencio Batista unseats the president and replaces him with Federico Laredo Bru

1937

The *Exhibition of Modern Art: Painting and Sculpture* is held in Havana; this important exhibition reveals the stylistic renovation underway amongst the second generation of the Cuban avant-garde.

The Free Studio for Painters and Sculptors is founded.

The mural project for the José Miguel Gómez School is carried out by Amelia Peláez, Fidelio Ponce, Carlos Enríquez and others.

The *Exhibition of Modern Cuban Painting* is held at the Lyceum.

The exhibition *8 Painters* is held at the University of Havana.

A mural project organized by Domingo Ravenet is carried out at the Santa Clara Teachers College; contributors include Amelia Peláez, Eduardo Abela, Jorge Arche, Mariano Rodríguez and René Portocarrero.

The Communist Party adopts a popular front and founds the Revolutionary Union Party, led by the intellectual Juan Marinello.

The National Congress of Writers and Artists is held.

78
Walker EVANS
Press clipping from the archives of a Havana newspaper photographed by Evans
Headline: *The Young González Rubiera Shot Dead as Flight Law Enforced*
1933

79
Walker EVANS
Photograph by Fernando Lezcano Miranda from the archives of a Havana newspaper reproduced as anonymous in Carleton Beals's *The Crime of Cuba* (1933)
Men Fighting on Street, Havana
1933

Muerto a Tiros El Joven González Rubiera, Al Sufrir La Aplicación De La Ley De Fuga

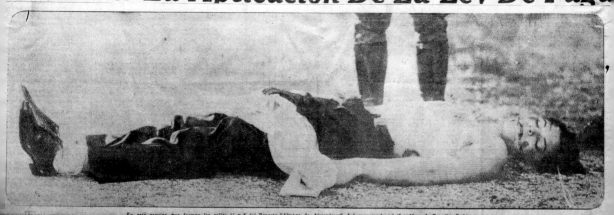

En esta esquina, que forman las calles 15 y 6 del Reparto "Alturas de Almendares" fué encontrado, así el cadáver de González Rubiera.

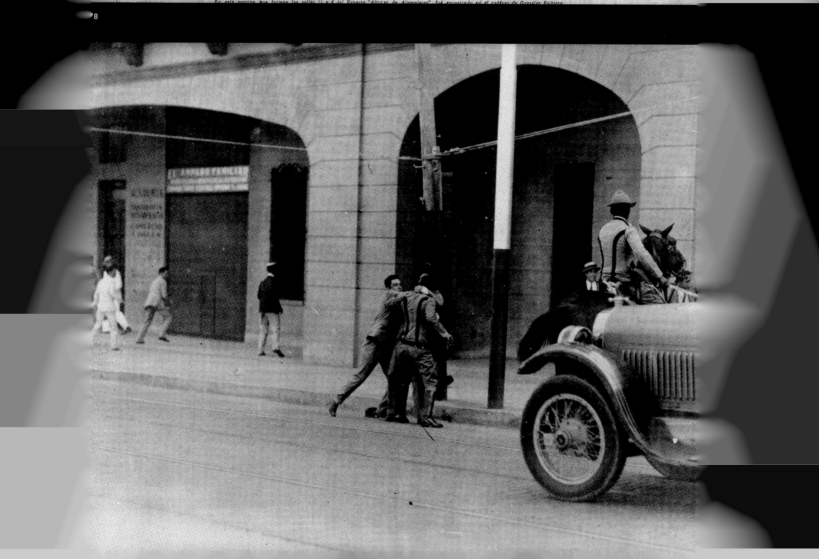

JOAQUÍN BLEZ, PHOTOGRAPHER TO HIGH-SOCIETY

Iliana Cepero Amador

The photographic studio constitutes one of the most fascinating markers of a country's psychological and cultural memory. It is a completely artificial setting, which at the start had to borrow its decorative elements from the theatre—traces of these can still be seen in the props. They were used to convey the aura of success that the middle class insisted on, in their desire to supplant the aristocracy. Over the course of the history of the studio portrait, there arose a set of conventions constituting a complex process of affirmation of social class, individualism and reputation. It reached its apogee following the publication of portraits of celebrities in the realms of politics and the arts in the nineteenth century. A new appetite for fame sparked a demand for such portraits all over the world, driven by a common desire to manufacture one's own particular and unique history. Photography, moreover, had something extraordinary to offer: the appearance of being true. Consequently, no medium could be better suited to constructing a self-portrait that, even though based on a predetermined ideal image, was nevertheless "credible" in the consumer's eyes. The studio portrait offered the emerging middle class access to the conventions that paintings provided for the aristocracy. For this reason, from the start it was evident that the standards of these images—despite being of a very different kind to those of painting—must guarantee the implications of standing, prosperity, prestige and strength characteristic of portraits in oils. On the other hand, the rituals marked by the studio photograph, such as confirmations, weddings and children's birthdays, not only constituted a reflection of the actual event but came to be regarded as a substitute for it. In this way the genre gradually became an irreplaceable adjunct of family feeling and an example of the symbolic function of the studio photograph, to emphasize individuality rather than collective identities.

★

One of the most esteemed photographic studios of Cuba's republican era was to be found at Number 210, Calle Neptuno. The sign proclaimed "Studio Blez, Photographer to High-society." The high prices of his photographs (5 pesos for small identity format, 10 pesos for larger prints) achieved the objective of keeping away the poor and people of colour. Thus Blez ensured for himself a clientele restricted to the closed circle of Havana's celebrities and the middle and upper classes.

Blez was born and brought up in Santiago de Cuba. As a very young man he opened his own business in Chaparra in 1906. There he first met Mario García Menocal (then administrator of the Chaparra sugar mill), who became president of Cuba in 1913 and two years later called on Blez to serve as presidential photographer. Blez thus became the official photographer to the republican cabinet for some decades, and established his studio on Calle Neptuno, initially at Number 65.

The portraits of the Menocal family still adhered closely to the nineteenth-century tradition (ill. 10). The composition based on that of oil paintings; the sitters rather stiffly posed against painted canvas backdrops, their sharply focused images in contrast to the soft misty backgrounds; the usual inventory of props such as massive chairs, truncated pillars, balustrades and garlands; all these are familiar elements from the earliest days of portrait photography. The props in particular serve to underscore the sitter's power and status. In the case of Menocal and his family, and later with Alfredo Zayas (ill. 11) and

Gerardo Machado (ill. 89), for example, the intention to highlight the subject's place in society, elegance or intellect is conveyed by the serious expression and dignified pose, the emblems of rank, or the books placed in close proximity. These conventions were inherited from Victorian paintings and the notion that an individual's face and posture constituted keys to "reading" his or her character and contribution to society.

★

In the early 1920s Blez decided to go to Europe to pursue training in his chosen profession. He studied photography in Berlin, which was at the time a world-class centre in the development of the medium. He continued to travel across the continent, spending time in Spain, France and Italy.

After his return to Cuba, Blez's work took a different turn. In addition to making a series of portrait studies of the president and other notables, he began to work regularly for magazines like *Social* and *Carteles*. In the late 1920s, *Carteles* decided to replace the imported photos of nudes (which occupied a whole page in each issue) with images of local women (ill. 82, 85). Blez began to photograph young French prostitutes, and according to research carried out by Lisset Ríos, archivist with the Fototeca de Cuba, he also portrayed famous performers on the Cuban musical theatre scene as well as those of foreign companies touring the island. This was the genesis of the famous nude studies known to all Cubans, the great photographer's "creative oasis" in the midst of his innumerable commissions for photos. These ingenuous images were part of

his tireless quest as a freelancer for interesting contrasts, and at the same time brought him good money and a particularly personal kind of delight. The series shows unmistakably the results of the techniques he had learned in Europe. These elegant nudes are side-lit to suggest the sculptural volume of the body (his use of lighting was to be one of Blez's most notable skills). The employment of chiaroscuro effects, the allusions to masterpieces such as Ingres's *The Source* and Goya's *Naked Maja* (see ill. 86), poses taken from ancient sculpture (see ill. 84) and the smooth curved lines of Art Nouveau, which researcher Maria Eugenia Haya has identified in this series, all indicate the conscious artistry that was henceforth to stamp Blez's work. To the end of his life he demonstrated a constant drive to improve his work and a fierce determination to achieve "beautiful" and technically immaculate images.

★

In the 1930s, he travelled to Hollywood to learn the latest techniques in makeup and studio lighting. These trips abroad were of inestimable value to him. On the one hand, the skills he learned in Europe enabled him to assimilate and later to refine the techniques of colouring, that is, "painting" on the print with crayon, and of retouching, by working on the negative or the glass plate with a pencil, a technique (ill. 81) that became his speciality. Indeed, the Blez hallmark, and the reputation he earned as a result, was precisely this skill in correcting the physical shortcomings of his subjects together with the high quality of his coloured photographs. His time in Hollywood, on the other hand, taught

him to perfect his use of lighting and to develop his "glamorous" style, which had and continues to have an immense influence on studio photography in Cuba.

In his relentless pursuit of perfection, Blez continued on a regular basis to travel to major centres of photography in order to keep abreast of new developments. Hollywood was an essential stop on his itinerary.

However, his experiments were not confined to adding colour to prints and retouching negatives; he also explored the possibilities of chemistry, using gold and selenium to obtain different tonal ranges, and ventured into resin printing, a technique of applying finely powdered resin to the final print to achieve a perfect finish.

★

The 1930s marked a new stage in Blez's oeuvre. During this decade he shot his sitters in soft focus, which he obtained by using special lenses or by covering the lens with silk gauze. The look of mystic femininity thus achieved was invented by the fashion photographer Baron de Meyer early in the twentieth century. This American's propensity for employing body language and gesture, such as the placing of the hands at waist level, to give the model a more elegant look, and the shading or sfumato technique to give the face greater allure, established a blueprint for representing female beauty that spread throughout the Americas and Europe. The use of artificial back-lighting also gave the model's face a special luminosity. Blez's fascination with depicting women in this way was immediately apparent in his studio work. Lidia Dotres (ill. 80), initially

one of his models and later his third wife, was the sitter most often portrayed with this aura of sublime aloofness.

Another mainstay of his portraits of women was the holding of a bouquet of flowers; this became an accessory connoting social privilege and established a subtle connection between nature and inner life. The poses in front of a mirror (a symbol of vanity associated with a supposedly inherent characteristic of the female sex), which were very popular between the wars, were another recourse much used by Blez.

During this period, in order to follow the European trend of using natural light, he had an enormous glass roof built over his studio, which filled the room with bright daylight (ill. 88).

Although he did not claim to be an innovator, Blez was always obsessed with learning new approaches, and he adapted to the new styles that appeared in European and, to a lesser extent, U.S. photography in the years between the wars, which were influenced by the avant-garde schools of painting. His ability to adapt to "modern" styles may have been somewhat superficial, but it brought about some fundamental changes of a practical nature. He had his studio remodelled again in the early 1940s, incorporating mercury lighting and rejecting the natural light characteristic of his earlier work. He changed the furnishings, the props and the backgrounds. Faithful to his lucrative portrait practice, he moved from out-of-focus backgrounds to clarity, introducing new visual arrangements derived from Cubism in the backdrops and the composition of the photos. In place

of canvases painted with idyllic misty landscapes or ancient monuments, he turned to semi-abstract backdrops with elements of Art Deco. The family groups or models played an active part in the composition, posed in juxtaposition to the geometric backgrounds. A new dynamic was apparent in the image, with the human figures standing out against elements that at times seem to herald Op art or Futurism.

★

From the 1940s and 1950s on, Blez's style became identified with the "glamour" photography he had assimilated in the course of his trips to Hollywood. This highly polished and flattering style, first developed by the American Alfred Cheney Johnston, was to be found everywhere in film magazines and publicity shots. Its basic characteristics included certain poses with the eyes cast down or romantically looking upward, bouquets of flowers hiding a plunging neckline, and dresses with long fringes.

First designed for film stars, the stylistic norms of "glamour" photography were soon adapted to the demand by the wealthy classes for validation and fame. Makeup was an important factor in this image making. By the 1940s false eyelashes, perfectly plucked eyebrows, face powder and heavy dark-coloured lipstick could transform almost any face into an image of desirability. The sensuality evoked by this new sophistication reached a high point in Blez's photography in the 1950s.

Happy as always to respond to the tastes of his clients, Blez carried on with his perennial speciality of idealizing his models—which he practised from the

start of his career—but now armed with the new and effective tools provided by the film industry for the purpose of manufacturing celebrities.

★

Blez went on working in this vein until the late 1950s. Within his strict adherence to existing canons, the style he developed in his portraits of women—a blend of Cuban taste and the more conventional manufactured beauty he learned in Hollywood—established a definitive model that many studio photographers were to follow, to please a clientele always hungry for validation, although with results very different from those of their inventor. In fact, not only the studio photographs of the post-1959 decades but even today's pictures of middle-class birthdays and weddings still manifest traces of the glamorous style of the 1940s and especially of the 1950s popularized in Cuba by Joaquín Blez. The style has persisted like a paradigm of creation frozen in time, simply because of the inability of the new studio photographers and freelance photographers to travel as Blez did to learn about the latest trends. So there is an enduring charm about these contemporary photographs, unique of their kind; they feature new props, modern surroundings and strange narratives, but the poses, the expressions, the clothes and the style of makeup still recall the 1950s.

★

Blez died in 1974, two years after the death of his beloved Lidia, for so many years his inspiration. Throughout the 1960s and until he died, he lived on a small pension from the Ministry of

Agriculture, since he also worked for the Ministry sporadically, despite being considered a full-time employee after the republican period.

It is said that after his wife's death he lost all interest in life, his only companions being Lidia's sister and the many cats who lived in his house.

His last years were not as happy as he might have wished. The most telling metaphor for his destiny may be found at Number 210, Calle Neptuno, where outside the ground floor of his studio, instead of the famous sign "Blez, Photographer to High-society," today we find a ragged sign with just his name to identify a very ordinary owner-operated café-kiosk.[1]

Most of the information on the life of Blez appears here courtesy of his assistant and close friend for many years, the photographer Nicolás Delgado.

See also:

Iliana Cepero Amador, "Joaquín Blez, el fotógrafo dandy," *Revista Revolución y Cultura* (January 2006).

82

83

84

85

86

Joaquín BLEZ
Odalisque
1926

87

Joaquín BLEZ
Facundo Bacardí, Jr.
About 1920

Facundo Bacardí was one of
the three sons of Facundo
Bacardí Massó, a wine
merchant who emigrated from
Spain to Cuba early in the 19th
century. Don Facundo settled in
Santiago de Cuba, and in 1852
began to filter rum or sugar-
cane brandy through charcoal
to eliminate impurities and
produce a more refined liquor,
which was then aged in large
oak barrels to "mellow" it. This
was the birth of white rum.
After 1872, the founder's son
Facundo Bacardí and his elder
brother Emilio ran the company
in Santiago de Cuba. As part of
a process of expansion, new
bottling plants were opened in
Barcelona and New York in
1912. The 1920s saw the
construction of the handsome
Art Deco Bacardi Building in
Havana, with the company's bat
logo; in the 1930s, another
bottling plant was set up in
Mexico City and a new distillery
in Puerto Rico. The firm of
Bacardi, which has continued
to expand and has acquired
other brands of liquors, is
now based in Bermuda.

82

Joaquín BLEZ
Nude
About 1920

84

Joaquín BLEZ
Nude, Havana
1920

83

E. MAÑAN
*Portrait of Tina de Jarquer, Spanish
music star with the band Velazco*
1923

85

Joaquín BLEZ
Nude
About 1920

88

Joaquín BLEZ
Blez's photo studio
About 1950

89

Joaquín BLEZ
President Gerardo Machado
About 1925

86

87

88

89

WALKER EVANS AND *THE CRIME OF CUBA*

Jeff L. Rosenheim

[Eugène Atget's] general note is lyrical understanding of the street, trained observation of it, special feeling for patina, eye for revealing detail, over all of which is thrown a poetry which is not "the poetry of the street" or "the poetry of Paris," but the projection of Atget's person. [1]

—Walker Evans
from his 1931 review of *Atget, photographe de Paris* (Paris: Henry Jonquières; New York: E. Weyhe, 1930)

The American photographer Walker Evans (1903–1975) was one of the most influential artists of the twentieth century. His elegant, crystal-clear photographs and articulate publications inspired several generations of artists, from Helen Levitt and Robert Frank to Diane Arbus, Lee Friedlander, Stephen Shore and Bernd and Hilla Becher. The progenitor of the documentary tradition in American photography, Evans had the extraordinary ability to see the present as if it were already the past, and to translate that knowledge and historically inflected vision into an enduring art. His principal subject was the vernacular—the indigenous expressions of a people found in roadside stands, cheap cafés, advertisements, simple bedrooms and small-town main streets.

Rare among visual artists, Evans was also an *homme de lettres*, a serious reader, a book collector and a fine literary critic. Soon after the 1929 publication of his first essay, a translation of a chapter of Blaise Cendrars's surrealist tale *Moravagine*,[2] he wrote for *Hound and Horn* magazine an incisive review of six current photography books, including monographs by August Sander, Albert Renger-Patzsch, Edward Steichen and Eugène Atget. Now a classic in the literature of twentieth-century photography, Evans's essay, "The Reappearance of Photography," excerpted above, provides a virtual outline of his own aesthetic program at a decisive moment in his still embryonic career in photography. A manifesto of the poetics of the documentary mode, Evans's analysis of the camera work of Eugène Atget (1857–1927) should be read as an indirect statement of artistic intent awaiting opportunity. Evans found that opportunity in Havana in May 1933.

A modest job from a Philadelphia publisher, J. B. Lippincott, sent Evans to Cuba to witness and photograph what turned out to be the final weeks of the brutal presidency of Gerardo Machado y Morales. Long before Evans departed for Havana, the mounting political unrest in Cuba seemed certain to lead to a full-fledged revolution. In fact, it did. On August 12, just eight weeks after Evans returned to the United States with hundreds of roll and sheet film negatives, Machado and his cronies left Havana by amphibian aircraft en route to asylum in the Bahamas.

In the United States, the first few months of 1933 had proved to be among the worst of the Great Depression and the assignment presented Evans with much-needed funds and an escape from the harshness of life in New York, where, he wrote to a friend, "no artists even the best are working with any spirit at all."[3] Lippincott commissioned Evans to produce a suite of photographs to be included in their new book, *The Crime of Cuba*. The muckraking exposé by Carleton Beals describes in excessive detail the cruel conditions under which Cubans lived during Machado's oppressive regime, a dictatorship overtly supported by the U.S. State Department. Evans was far less interested in the publication's politics than the opportunity to have a look at

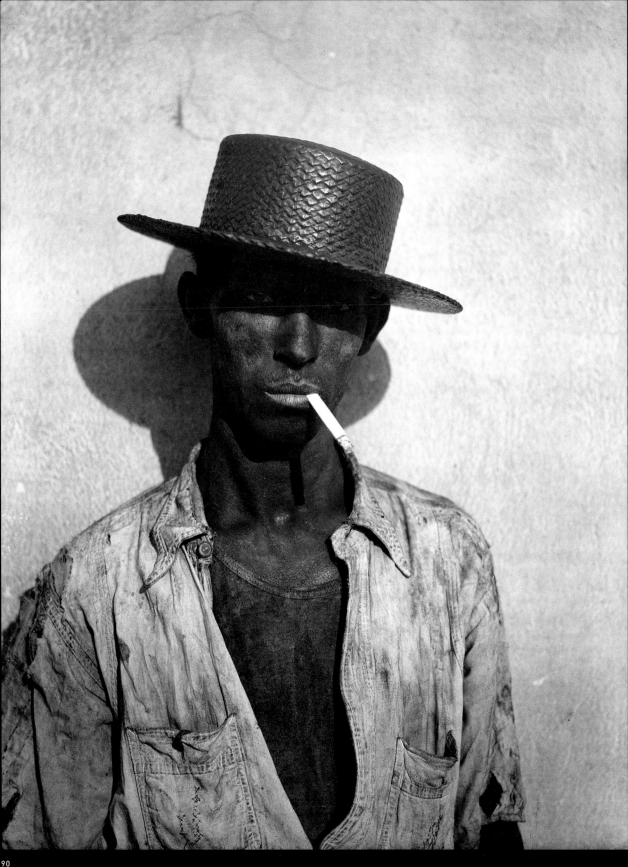

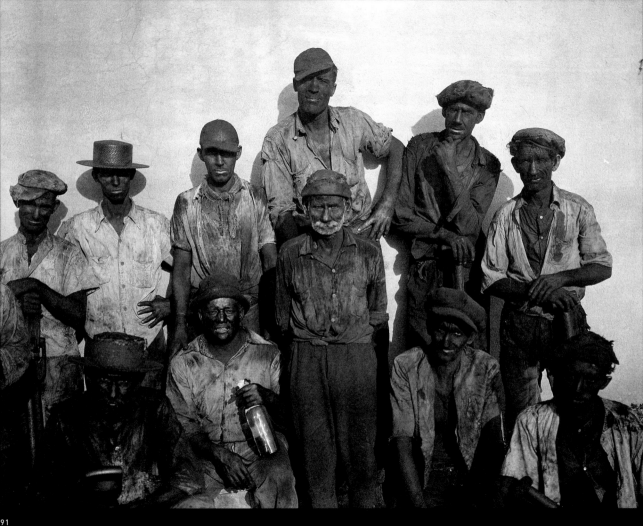

everyday life in Havana. *The Crime of Cuba* features thirty-one photographs by Evans in a discrete portfolio following the final chapter.

Beals drew his title from his extensive interview with Miguel de Araunaz, a professor of mathematics in Havana. Turned part-time baker after Machado seized power and began his tyrannical persecutions of university faculty, De Araunaz served as an erudite guide to the complex patterns that governed Cuba's bloody present. Beals quotes the professor in the book's second chapter "Panorama," which serves as a compressed history of modern Cuba:

In the United States crime is committed by gangsters. In Cuba, it is committed by the tyranny of Machado. He runs a sawed-off shotgun government. But do you know the real crime of Cuba? For nearly four centuries we were bowed under the iron rule of Spain. For nearly a century we fought to throw off that yoke. Not a spot of soil in Cuba is not drenched with the blood of patriots and martyrs. Then came America . . . You said, to free us . . . All you did was snatch victory from our grasp . . . Free Cuba? . . . Ha! . . . Our government, our President, is but a puppet of your dirty dollars . . . And that is the crime of Cuba, my friend. For all the blood and sacrifice of our people, of your people, we merely changed masters . . . We are exiles in our own land . . . That is the crime of Cuba.[4]

★

Upon arriving in Havana, Evans set to work with two cameras: one for more formal studies, one for quick snapshots of street life. It was an inspired, double-edged artistic method he had honed in New York to record the effects of

the Great Depression on the American condition. With a wooden view camera that necessitated a heavy tripod, large sheets of film and slow exposures—a technique borrowed from his artistic mentor Atget—Evans made precisely composed views of the city's impressive colonial architecture (building facades and courtyards), detailed studies of decaying painted advertisements, and formal portraits of a wide range of Havana citizens including coal dockworkers [ill. 91], newspaper editors, artists and prostitutes. For more informal studies of student protesters, newsboys [ill. 109], vagrants and the unemployed, Evans used a more up-to-date, small, hand-held, roll-film camera. Where the view camera pictures [ill. 101] reveal Evans as a sophisticated cultural analyst and impart the illusion of comprehensiveness, classicism and repose, the snapshots suggest nearly the opposite. Inherent fragmentation, confusion and discomfort—in essence, the often intense conflict of modern existence. Together, the two types of photographs (the backdrop and the stage itself, the actors and the drama) document Havana and its people with a shocking clarity of purpose and eloquence rarely found in contemporary photography of the period.

To accomplish his objective, Evans had to avoid the scrutiny of beat cops, Machado's many informers and his hired henchmen. He relied for protection on a list of trusted individuals provided by Beals who had spent much of 1932 in Cuba interviewing radical oppositionists. It seems certain that Evans's most important allies were two journalists, José Antonio Fernández de Castro and his brother Jorge Fernández de Castro. At the time, the former was

professor of history at the University of Havana, a proponent of vanguard literature and chief editor of the *Suplemento Literario Dominical* and the weekly magazine *Orbe*, both published by the newspaper *Diario de la Marina*. As an active member of the opposition movement, he had been frequently jailed by Machado and had, along with his brother, real-life stories to share with his colleague from New York.

Evans's diary provides an excellent, if at times paranoid, measurement of the artist's emotional temperature in Havana. An accomplished literary stylist, Evans borrows the phrasing of a detective novel to chronicle his early impressions of the city as well as his first (delayed) meeting with José Antonio Fernández de Castro:

I will be unable to finish this story. At least though I arrived in Havana in the middle of the month with a stimulating area of the unknown ahead of me. Ready for anything, too ready as it turned out. That is I took precautions. It is fatal for me to take precautions. The money belt for example. There I hid lots of cash (for me) and a collection of compromising (I hope) letters to well known oppositionists. The cool first evening in Havana I set out from my hotel having to undress in the bus to pay; a bus full of spys [sic], counter spys, plain clothes men, secret agents, and ordinary thieves. So I took more and more precautions; but, half my money was gone when I got off. I went to see Fernández de Castro at the other end of that bus ride. He wasn't there. No American takes the bus in Havana. "They" would suspect something and follow me. And of course everyone who is seen near Fernández de Castro's person is immediately filed in some official card

index somewhere; then shadowed . . . Havana was full of uniforms, Black armed men from recent [illegible], and men in tan with heavy, shouldered guns. It was all to keep their master gangster in power—the only way."[5]

The two Fernández de Castro brothers and their associates seem to have offered Evans and his cameras relatively safe passage along the city's often dangerous streets and, just as important, special access to the newspaper morgue, which Evans mined for more explicit evidence of Machado's cruelty. With his view camera, Evans made copy negatives of dramatic murder-scene photographs [ill. 112] believed to have been hidden in secret files at *Diario de la Marina*. These negatives show policemen grabbing pedestrians, revolutionary slogans and violent deaths that Evans could never have photographed even if he had, by day or night, come across such scenes on his own. Carefully guided by his advisers, however, Evans was able to safely document Machado's tyranny in a most profound way. Then, operating with full awareness of the consequences, Evans embedded three of the most incendiary of these contraband images in his portfolio of photographs in *The Crime of Cuba*. In each case, Evans captioned the photograph with a sly, yet simple citation: "Anonymous Photograph." By copying these politically explosive visual documents—bona fide signs of organized protest and concomitant bloodshed—Evans resurrected the lost lives of the subjects, and in one simple gesture breathed new existence into the wasted corpses and weary revolutionary cause. The artistic and conceptual sleight of hand is nearly imperceptible. Evans referred to these photographs as "Documents of the Terror."

<p style="text-align:center">★</p>

After a productive month with his cameras in Havana, Evans departed for New York on the *S.S. Virginia*. He immediately wrote to Jorge Fernández de Castro that his negatives of Havana were safe in his luggage, and so, too, his farewell gift, a bottle of fine rum. Evans's thoughts, however, had already drifted north; within a week he had printed, titled and sequenced the best of the photographs and submitted them to his publisher. He wrote to Fernández de Castro that he had "prayed to . . . [his editor] to leave the pictures in my order and to print the simple titles I gave."[6] Lippincott granted Evans's request and released *The Crime of Cuba* on August 17, 1933, five days after Machado left office and Carlos Manuel de Céspedes took over the presidency. The book instantly found its audience and went through four printings in six months. On August 20, 1933, the *New York Times* featured *The Crime of Cuba* on the front page of its book review section under the banner headline: "Cuba, The Crucified Republic, Carleton Beals Indicts the Machado Regime and American Penetration." Harold N. Denny began his extensive commentary: "Seldom has such a tale of greed, misery, bloodshed and futility been placed between the covers of a book as is told in this new volume by Mr. Beals." Denny also found Evans's contribution to *The Crime of Cuba* noteworthy. The review's final paragraph is Evans's alone: "Especial mention should be made of Mr. Evans's photographs. They form an appendix of thirty [sic] views of Cuban life, including two or three dreadful mementos of the horror."

1 Walker Evans, "The Reappearance of Photography," book review in *Hound and Horn*, no. 5 (October–December 1931). This essay is reprinted in Jeff L. Rosenheim and Douglas Eklund, *Unclassified, A Walker Evans Anthology* (Zurich, Berlin, New York: Scalo, 2000), pp. 80–84.

2 Blaise Cendrars, "Mad," translation from the French by Walker Evans in *Alhambra: A Literary Monthly*, vol. 1, no. 3 (August 1929), p. 34.

3 Walker Evans to Hanns Skolle, letter, April 20, 1933. Walker Evans Archive, The Metropolitan Museum of Art, New York, 1994.260.25 (36).

4 Carleton Beals, *The Crime of Cuba* (Philadelphia: J. B. Lippincott, 1933), p. 34.

5 Walker Evans, diary entry, May 19–20, 1933. Walker Evans Archive, The Metropolitan Museum of Art, New York, 1994.250.95.

6 Walker Evans to Jorge Fernández de Castro, letter, June 26, 1933, private collection.

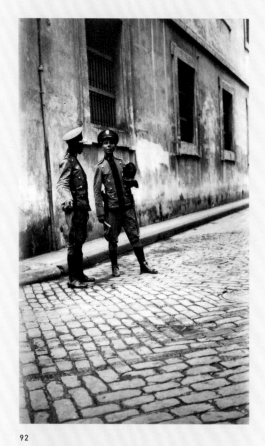

92

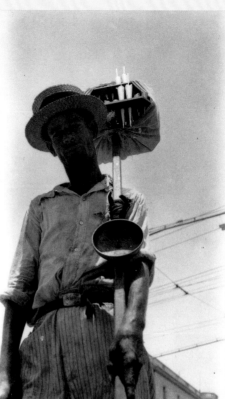

93

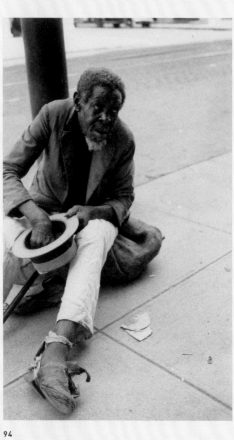

94

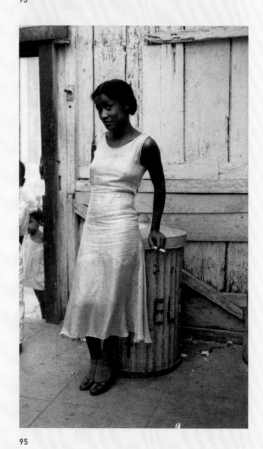

95

Walker EVANS
1933

92
Havana policemen

93
Candy vendor, selling caramels ("piruli"), Havana

94
Beggar seated on street, Havana

95
Woman in a courtyard, Havana

96
Señorita at a café, Havana

97
Citizen in downtown Havana

98
Cobbler posing, Havana

99
Woman standing on street

96

97

98

99

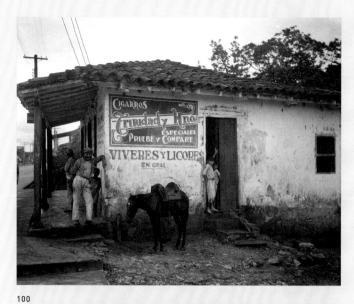

100

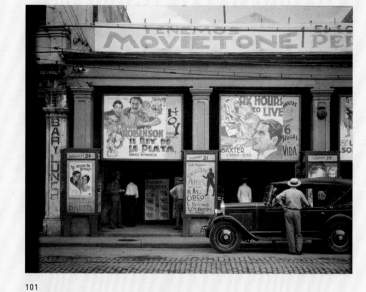

101

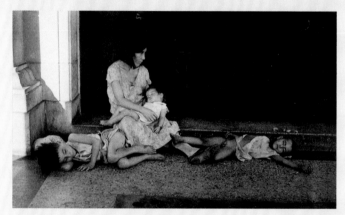

102

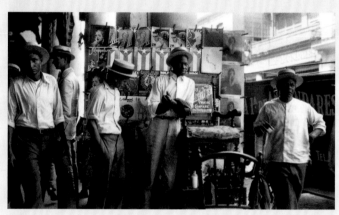

103

Walker EVANS

1933

100

Village general store

102

*Mother and children in doorway,
Havana*

101

*Cinema showing "Six Hours to Live,"
Havana*

103

*People in downtown Havana.
Shoeshine newsstand*

104

*Shanties with church in distance,
outskirts of Havana*

105

*Shanties in village, outskirts of
Havana*

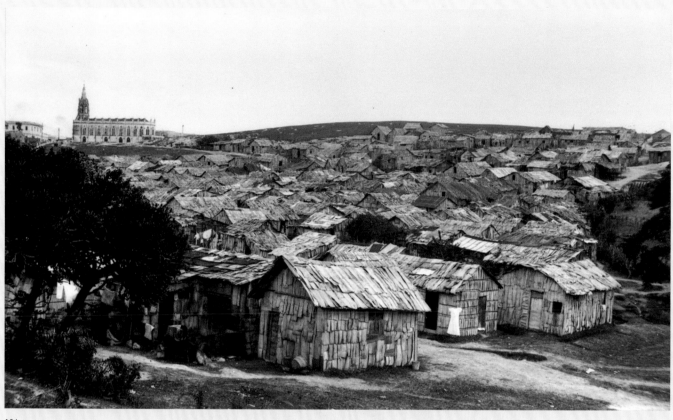

104

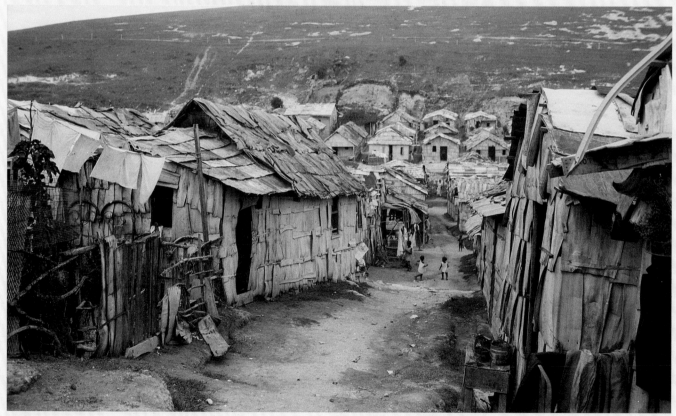

105

106

107

108

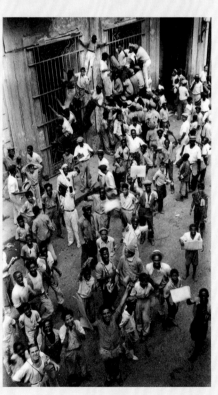

109

110

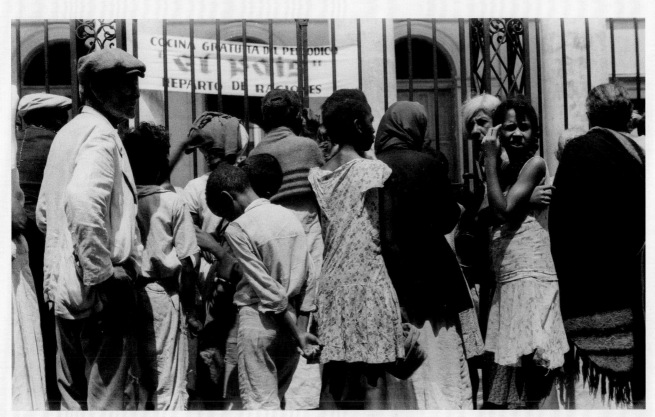

111

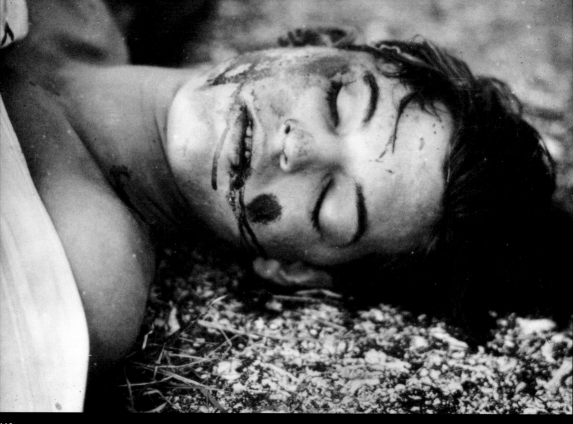

113

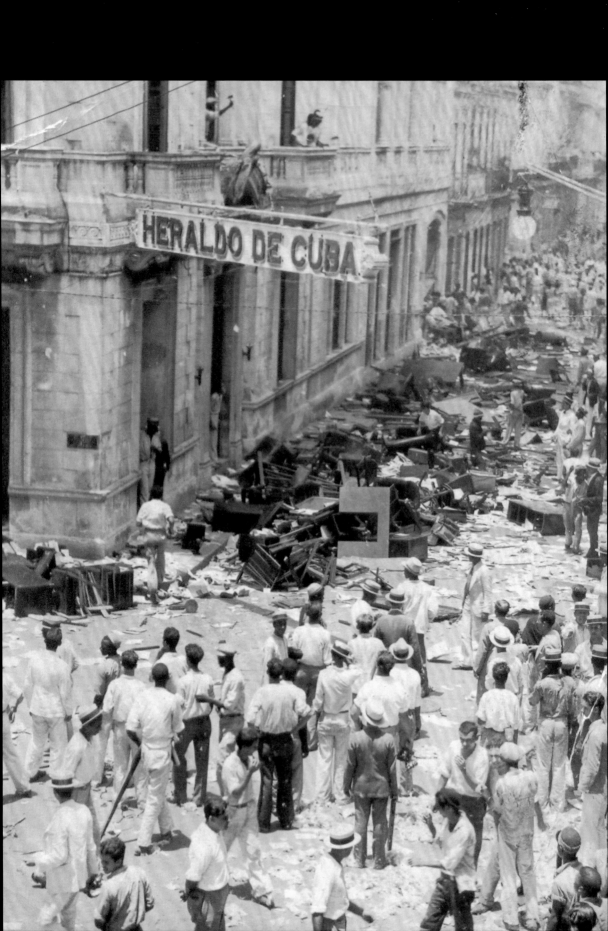

114
Emilio MOLINA
*The "Heraldo de Cuba" after riots
following the fall of Machado, Havana*
1933

115
Emilio MOLINA
Fall of Machado, August 12, 1933
1933

116
Anonymous
*The people kill Machado's assassin,
Gustavo Sánchez, in Santiago de
Cuba*
1933

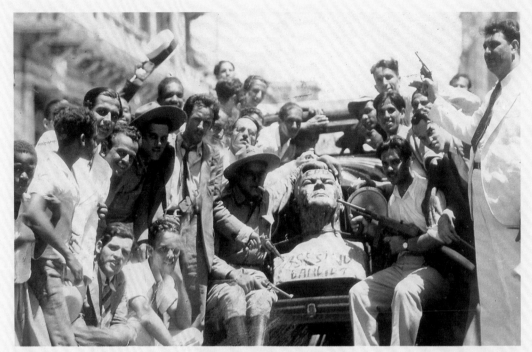

115

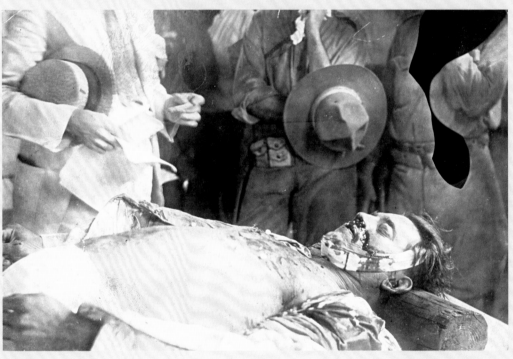

116

GRAPHICS AND VISUAL CULTURE

Luz Merino Acosta

In early twentieth-century Havana, illustrated periodicals began to appear. This new publishing phenomenon, which won over advertisers, featured layouts based largely on photographs but to an even greater extent on drawings; these guaranteed a devoted readership and high sales figures. The advent of new technologies—such as photogravure and two-colour printing—was a critical factor in this new visually driven press. *El Fígaro* (1885–1933) was one of the first publications to adopt these inventions, which produced much improved, clearer pictures.

From then on, illustration and illustrators flourished; this new source of patronage widened the field of art, as scholars have noted, and the hierarchies of the art world adjusted accordingly, or at least broadened their conceptions of what constituted art.

The magazine cover became the showcase for the image and reflected the various concerns and issues of the day that had visual appeal and established the initial contact with the consumer. The illustrators who familiarized readers with accepted notions of art in their drawings, caricatures (ill. 117) and advertisements became purveyors of a wide range of images. In this novel visual world, advertising was considered part and parcel of the periodical, since it shared space with editorial material and constituted a trial balloon for consumer reaction. From then on, illustrated periodicals would not only sell space but also make suggestions to the advertiser.

Jaime Valls, the man who transformed commercial illustration in Cuba, was one of the first artists to work in advertising and to open an agency, La Casa Valls. His aim was to find aspects of the product with which readers could identify, and he cared more about artistry than the message of the product. He had trained as a painter and could reconcile various requirements: the need to conform to the taste of the moment, to respect the preferences of the advertiser, and to find a balance between the art and the message. His use of recognizable types helped to establish a sense of identification with the public.

In a way, Valls represented the coming together of art, illustration and advertising at a time when these relationships were being reconfigured.

He was not only a painter but an illustrator trained as a painter whose work became known in the commercial field through his designs. For this reason, in the contemporary debate on painting, designs and commercial art, he was considered to be not a painter but an illustrator. For some twenty-one years (1906–1927), the indications of a fresh form of art, different from painting, found a home in illustration in its broadest sense, and hence in periodicals as channels of diffusion.

The 1920s brought a breath of fresh air. This was the era of so-called modernism, and the magazines reflected the shifts and transformations in the field of culture, in the visuality and sensibility that drove the new idea of culture. The magazine *Social* (ill. 118), edited by the talented caricaturist Conrado W. Massaguer, was a prime example of this trend. In its combination of illustrations, caricatures and advertisements, it provided the first indications that the old visual codes were being subverted. Thanks to Massaguer's unmistakable style, caricature became more relevant. With an approach characterized by synthesis and exaggeration that has been described as "simplification through exaggeration," without attempting to

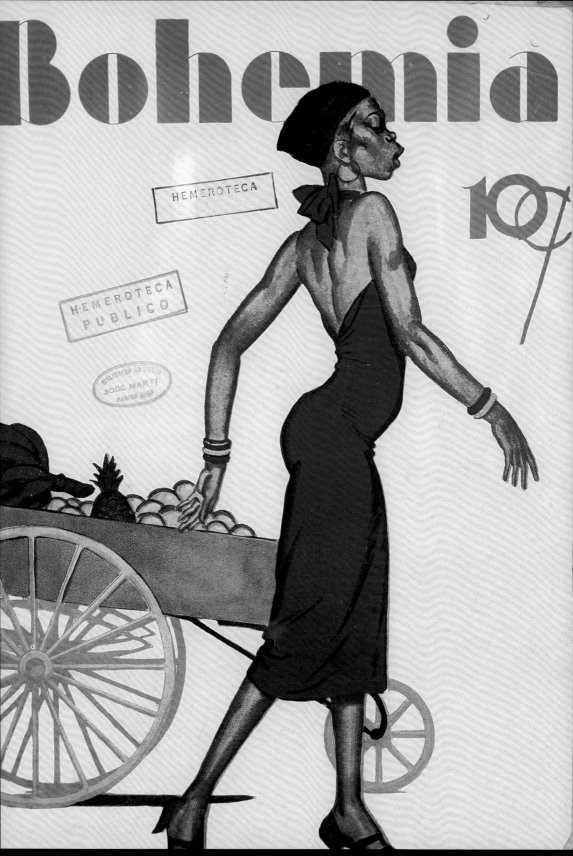

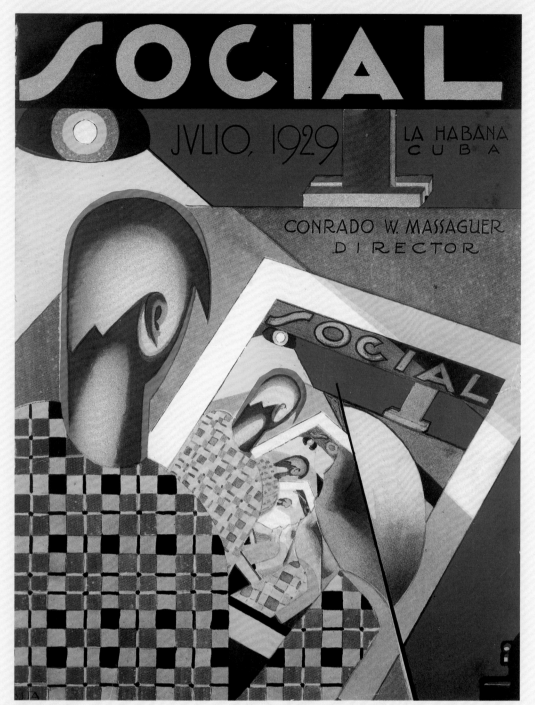

118

119

120

121

122

123

include everything or distorting bodies, he conveyed movement through undulating lines. The critical or ironic note in his work is not cutting but affable, the censure not obvious but oblique. These qualities combined to produce a remarkable body of work infused with gaiety, light-heartedness and energy; the publications in which it appeared were consequently credited with these same attributes.

In their layouts, publishers were starting to experiment with new approaches inspired by the innovations of European avant-garde movements and U.S. advertising styles. This new look was manifest on magazine covers and advertisements. Today, many of these images are labelled "Art Deco" since they feature design based on diagonals and asymmetry to create the visual dynamic. Without abandoning tried-and-true formulas that the public could easily recognize, they were composed and structured in a new way: disconnected images, fragmented shapes and a kind of expressive distortion proliferated in every kind of publishing (ill. 119).

Innovations like these, to be found in periodicals such as *Social*, *Bohemia*, *Carteles* (ill. 120–123) and *Perfiles*, were part of the revolution in the graphic arts, in which typography also played a part. The new styles came to predominate in advertisements as part of the structuring of text and image and the flat colours, the unifying signifiers of the messages. The intention was to raise the standard of the advertising message and to show that art could also be a marketing tool, blurring the distinctions between illustration

and commercial art. The possibility of one influencing the other did not eliminate disputes between them; on the one hand, the advertisers wanted to increase their sales, while on the other, artists wanted to create, innovate and incorporate new artistic approaches into their advertising work. Experts agree that an arbitrator on the matter was the art director, the conductor of this new arrangement, who organized the advertising process and acted as moderator in the tensions between art, advertising, presentation and the public.

The versatile Conrado Massaguer and Alfredo Quilez—director and art director respectively of *Social*—believed that art and commerce could work hand in hand, and fostered the attribution of a symbolic value to a practice that considered artistic excellence irrelevant while recognizing commercial artists as professionals. In *Social*, Massaguer demonstrated that art could co-exist with advertising, as could illustration, caricature and commercial photography. As an illustrator and caricaturist himself, he synthesized the new styles derived from avant-garde iconography and brought them into the world of commerce. In this way he made a notable contribution to the process of modernizing commercial art and to the recognition of illustrators as artists.

Variety magazines were foremost in presenting an expanded concept of art by including images that the public perceived as art in their graphics and by bringing the avant-garde repertoire to a wider audience. In addition, new paradigms were offered to readers who,

as it has been noted, had never been inside a museum, nor—given the Latin American and Cuban mindset—had any contact with contemporary art.

This period of tangents, blurring of categories and interchange between illustration, caricature and commercial art was cut short in the mid-1930s as a result of the Great Depression, which changed the whole context of advertising. Advertisers wanted no experimental artwork; what they sought for their products was a clear, direct, simple and if possible realistic image that would be grasped easily. As a result, illustration was replaced by commercial photography influenced by comics-style drawings. Art and advertising were once again separate, and other mediums were employed in advertising.

In general, the role played in the history of art by illustrators, caricaturists and commercial photographers has been dismissed as marginal. The object of these artists was to create works with instant impact, and their creativity was harnessed to predetermined objectives. Illustrators, most of whom were draftsmen, often working anonymously (they were rarely allowed to sign the advertisements they created) and linked directly or indirectly to journalism, were the originators of this broadening of visual culture.

It is understandable that scholars have underestimated this field of creativity, as even at the time it was not regarded as art. For this reason, Massaguer's efforts in *Social* were significant. By treating the whole graphic aspect of the

magazine—illustrations, caricatures, advertisements, photographs—as artistic products, he developed a broader concept of art, and based on this concept he opened the way to new definitions of what art is and is not, an undeniably innovative attitude in cultural terms.

Despite the efforts of Massaguer and others like him, one of the limitations, artistically speaking, of commercial art was, and for some critics still is, the fact that it can be mass-produced, which compromises its claim to be unique and original. Thus illustrators were not comparable to painters as artists, because their output was based on reproduction and multiplication by mechanical means and aimed at a broader public.

A re-evaluation of the part played by illustrators in magazines, in the promotion of tourism (the creation of the image of Cuba), in billboards and posters as heralds of a new visual phenomenon of everyday life acknowledges the historical importance of these protagonists—who were not bit players but leading figures—and of their contribution to the evolution of modern art and visual culture.

See also:

Merino Acosta, Luz. *La pintura y la ilustración: dos vías del arte moderno en Cuba*. Havana: Ministerio de Educación Superior, 1990.

Merino Acosta, Luz. "Nueva imagen desde la cotidianeidad," *Artecubano*, no. 1 (1996), pp. 37–45.

Levi, Vicki Gold and Steven Heller. *Cuba Style: Graphics from the Golden Age of Design*. New York: Princeton Architectural Press, 2002.

THE SCHOOL OF HAVANA: BETWEEN TRADITION AND MODERNITY

Ramón Vázquez Díaz

The selection of work discussed here illuminates some of the landmarks in the rise and consolidation of modern art in Cuba from the mid-1920s to the early 1950s. This essay presents the artists who created Cuban modernism, from its antecedents and early hesitant attempts to its magnificent flowering in the 1940s, when the quantity and consistent quality of modern painting and sculpture in the island were such that it was possible to identify what began to be called "the School of Havana." In only twenty-five years, Cuban artists had created from nothing one of the continent's most brilliant and integral artistic communities, with a variety of individual personalities, which was undeniably comparable to the Mexican, Brazilian and Argentinian movements that were developing their own aims and tenets in the same period.

To stress their intention of breaking with the past, the pioneers of the revitalization of the arts in Cuba first used the terms "new art," "*vanguardia*" or "*vanguardismo*," and then, shortly after the movement was launched, "modern art." However, it was the expression *vanguardia*, or *vanguardismo*—with all the contradictory implications—that paradoxically became the accepted title for this very specific phenomenon in Cuba's cultural development. Both the start and the establishment of modernism in Cuban art were in reality subject to a variety of pressures. As part of the general desire for transformation in Cuban society, and in the agenda that the young, more enlightened artists set themselves, the European avant-garde was only one of the many components—a significant one in the opinion of some Cubans, but always viewed with critical reserve—of the overall phenomenon. On the same side of the Atlantic, the Mexican example of modernism allied with aspirations to Pan-Americanism, one of the motives for renewal, was another point of attraction, although it was not necessarily cast in adversarial terms in statements of the day.

In reality, these *isms* came to Cuba piecemeal, without the strict definitions that applied in Europe. Furthermore, by the time Cuba's young artists were starting to worry about them, the European avant-garde had gone beyond its initial orthodoxies, which in hindsight were becoming "contaminated." Moreover, modernism was no longer just a matter of the avant-garde. The so-called "return to order," the revival of classicism, the recovery of realism in new guises, offered other possibilities, some of them more in tune with Cuba's needs. The experiments of the European avant-garde were already being dismissed by Marcelo Pogolotti, one of the island's pioneers, as just "a brilliant set of tricks," in need of other qualities. From the start, Cuba's innovators succeeded in keeping their distance from all external stimuli—avant-garde *isms*, the new realism, the extravagance of mural painting—and in establishing their own parameters for the creation of a Cuban modernism. The history of this initial process of rupture, which lasted a little over a decade, can be summed up as follows:

• *Ruptures and Experimentation: 1925–1927.* This period came to an end with the *Exhibition of New Art* in 1927, a roster of aspirations, discoveries and shortcomings in which the only mature "progressive" artists were Víctor Manuel García, Antonio Gattorno and Juan José Sicre, who had already spent time in Europe.

• *Withdrawal and Diaspora: 1927–1933.* The artists who were to become leaders in the new movement had gone to

Europe: Amelia Peláez and Eduardo Abela in 1927; Marcelo Pogolotti in 1928; Carlos Enríquez in 1930, and so the first direct contacts were made not only with the latest trends but with the whole tradition of Western painting. Thus began the dialectic of appropriation–transformation–integration–synthesis that led to the creation of the first classic works of Cuban modernism, which oddly enough were executed in Europe.

• *Reintegration in Cuba. Consolidation: 1934–1939.* With the return to Cuba of a large group of artists, the movement that had emerged in fits and starts over the previous decade acquired coherence and maturity for a number of reasons (one of the most important being the historic new beginning after the fall of the dictator Gerardo Machado). Those who had spent greater or lesser periods of time in Europe began to interact, to pass on what they had learned to younger artists about to launch themselves, to exert their influence on the cultural milieu and, above all, to be themselves, reacting to the Cuban environment, which they were rediscovering with trained eyes. This was the period in which Amelia Peláez (ill. 232, 233) created a purely Cuban style of painting and Carlos Enríquez (ill. 141) began to work on his *romancero guajiro*, or collection of peasant ballads. When Marcelo Pogolotti returned home in 1939, the scene was set, and he contributed an interesting counterpoint with his severe style and unflinching philosophy. Wifredo Lam was an unusual case.

His adoption of modernism during his years in Spain, and his links to the Surrealist movement and Picasso, meant that he moved in different circles from the Cuban *vanguardia* artists, and he deliberately kept his distance from them. Lam's contribution to the development of Cuban painting began in 1941 when the war cut short his stay in Europe: he returned to the Caribbean and settled in Havana (ill. 246), where his work underwent a radical transformation. His influence, which was often dismissed by his Cuban colleagues, began to make itself felt in the mid-1940s, outside the circles of the initial *Vanguardia* movement.

Without relying on manifestos or doctrinal pronouncements, the "new art" consisted of three main trends: *Criollismo*, Afro-Cubanism and painting of social commitment.

What was called, in a vague and imprecise manner, *Criollismo* or Cuban-inspired painting, sprang from vernacular subjects, mainly from peasant life, known as "themes of the soil," also found in some literature of the time. This trend, the equivalent of the Indigenismo movement in other Latin American countries, which could at times verge on a trivial folklorism, was exemplified at its best by the work of painters such as Carlos Enríquez and Arístides Fernández (ill. 139), whose approach achieved unparalleled expressive intensity.

So-called "Afro-Cubanism," a term applied to painting, poetry and music, was another of the great trends of Cuban "new art." For obvious reasons, the "discovery" of "African art" by the European avant-garde, which in their context appeared as an exotic novelty, had particular connotations in Cuba. The research of Fernando Ortiz, and later of Lydia Cabrera, into Afro-Cuban culture sparked the interest of a significant number of the intellectuals at the centre of the renovation movement, headed by Alejo Carpentier. In 1927, dazzled by the richness of this unmined lode, Carpentier began to write his Afro-Cuban novel *Écue-Yamba-O*. In Paris, encouraged by Carpentier, Eduardo Abela (ill. 129) began to paint his series of carnival actors, rumba dancers and musicians, exhibited in Galerie Zak, Paris, in 1929.

The final trend—painting of social commitment—was born of a particular moment in Cuban history and affected, if only tangentially, almost all the *vanguardia* artists. The stamp of the Mexican school is unmistakable. However, the most important proponent of this trend, Marcelo Pogolotti, forged his approach out of intensive and thoughtful experience in Europe of the French, Italian and German avant-gardes: Expressionism, Surrealism, "Machinism," Futurism and Abstract art (ill. 163).

These definitions did not, of course, appear so clear-cut in reality. "Native" Cuban art often blurred the distinction

between *Criollismo* and Afro-Cubanism, in the same way that the poetic intuition of some painters—Víctor Manuel Garcia, for example—transcended and absorbed the guidelines that seemed to be their starting point. On the other hand, the extreme politicization of the period, caused by the so-called Revolution of 1930, led to a blending of the trends noted above and to a certain confusion: both Afro-Cubanism and *Criollismo* took on at times very specific social connotations.

Other very important isolated figures, including Amelia Peláez and Fidelio Ponce, nonetheless avoided these categorizations, and their work heralded new concerns.

By the late 1930s, the modernist movement had defined its own lines of development in relation to European and Pan-American art, had created definite poetic trends, produced its first classic works and achieved its first triumphs. But alongside the figures already thought of as seminal—Víctor Manuel García, Abela, Peláez, Enríquez, Pogolotti—a new generation of artists, born between 1910 and 1915, were starting to exhibit: Mariano Rodríguez, René Portocarrero, Cundo Bermúdez, Mario Carreño, Martínez Pedro. These young men benefited from more than a decade of struggle to validate the modernist approach in the face of academic resistance. Unlike their elders, whom they considered masters, they did not start from scratch, since they

had found a body of work and theory to serve as their starting point, even when they criticized it or dismissed it outright. They were the children of another historic moment, the years of frustration and setbacks that followed the collapse of the Revolution of 1930, and they had different concerns. Their relationship with their predecessors took on the dialectic of approval and rejection characteristic of every intergenerational shift, resulting in more than one skirmish. However, what linked the generations, beyond occasional confrontations, was the fact that they formed part of the same process of evolution, characterized by the quest for a truly Cuban form of expression within Western artistic modernism.

The second National Salon of Painting and Sculpture, held in 1938, which brought together an array of modern Cuban art (including Víctor Manuel García's *Gitana tropical* [Tropical Gypsy], Carlos Enríque's *The Abduction of the Mulatto Women* (ill. 124), Fidelio Ponce de León's *Children* (ill. 265), Abela's *Peasants* (ill. 125), Jorge Arche's *Mi mujer y yo* [My Wife and I], Antonio Gattorno's *¿Quiere más café, Don Ignacio?* [Do You Want More Coffee, Don Ignacio?], Ramos Blanco's *Lo eterno* [The Eternal], Lozano's *Nosotros* [We], Mariano's *Unidad* [Unity] and Carreño's *Desnudo* [Nude]), presents several features of interest: the appearance of new protagonists, the influence of Mexican painting and the predominance of the "moderns" over the "academics."

At that moment, the interests of the two generations coincided briefly and then diverged. The imposing frescoes of Mexico had marked much of Cuban art, a mere ten years after Alejo Carpentier had first expressed his enthusiasm for Diego Rivera's colossal achievement. Mural painting was a fleeting though important influence that brought Cuban artists together for a while. Many young painters chose to travel to Mexico to study rather than to Europe. They started by looking for modernism—which for them already meant something different—in Mexico. However, mural painting was to serve only as a springboard for Cuban artists to move on to easel painting, without fully adopting its epic thrust, its grandiloquent style or politicized content.

Starting with this initial convergence, the art of the 1940s branched out in various directions, distancing itself emphatically from the movements that characterized the 1930s. "Born of the urge to create" is how Cintio Vitier describes the development of the new poetry that emerged out of the movement represented by the magazine *Orígenes*. The same definition could be applied to the impressive progress made in Cuban painting and sculpture in the same period.

Of the trends apparent in the 1930s, some disappeared, lacking any historical foundation, while others were replaced, at times through extreme reactionary attitudes, or

so changed from their original idea that they became something quite different. Painting on a political or social theme lost its initial vigour and practically disappeared; *Criollismo*, once concerned with rural or peasant subjects, turned to more obscure and mysterious evocations, while avant-garde Afro-Cubanism—genre scenes, social awareness, music and dance—was swept away with the advent of Wifredo Lam and Roberto Diago. The younger painters and sculptors began to offer new interpretations of lesser known or more hidden aspects of Cuban life, and thus brought about the real consolidation of modern art in Cuba. Cityscapes, now more common than rural landscapes, were often depictions of Havana seen as a mythical space. There was a rejection of the over-decorated domestic scenes of white Cuban society in favour of a new iconography, far removed from any hint of the picturesque, focused on Afro-Cuban culture. This expansive and sensual new use of colour was derived from the Mexican example, the Fauvism of Europe and the Cuban environment itself. Ornament seems to be the unifying element of the period and defines much of the oeuvre of the majority of these artists, in keeping with a penchant for an accumulation of elements called "baroque." Portocarrero, Carreño, Peláez, Bermúdez and Mariano, to name just a few, adopted this approach within their own poetic vision, using an array of references (iron lattices, screens, stained-glass windows (ill. 236, 237), architectural elements, interiors) that expressed, without prettifying, the atmosphere of a baroque environment reinterpreted in the light of European avant-garde movements. In the excitement of a new day, many of the original pathfinders experimented with changes or significant shifts in their work. The coming together of the two generations in a single endeavour produced a true golden age of Cuban art.

This dialectic between, on the one hand, a desire for contemporaneity and an openness to the outside world and, on the other, the passionate inward-looking exploration of what was essentially Cuban, formed the basis for the oeuvre of most of the island's first classic modern artists until the end of their careers; some of them followed this path without wavering, rising above the later development of Cuban painting until the latter part of the century. By the late 1940s and early 1950s this thrust began to be replaced as a dominant force by other trends adopted by a new generation: nationalist motivation gave way to an international language, with abstraction in the ascendant. Cuban art had entered a new era.

See also:

Vázquez Díaz, Ramón. "Encuentro con Amelia Peláez," in *Amelia Peláez: óleos, temperas y dibujos (1929-1964)*. Salamanca, Spain: Gráficas Varona, 1998.

Guía de Arte Cubano. Havana: Museo Nacional de Bellas Artes, 2003.

125 Eduardo ABELA, *Peasants*, 1938

THE SMELL OF ROASTED CHESTNUTS

Graziella Pogolotti

Under the winter drizzle, scarves and shoes, worse for wear by so much walking, afforded little protection from the bone-chilling cold, especially for pilgrims from the tropics, drawn to Paris by the dazzling splendour of modernity. Like echoes from the past, chestnuts were roasted on small charcoal braziers alongside the Luxembourg Gardens. But the distance covered by Cubans rarely took them to the limits of the Latin Quarter, where some of their compatriots were students at the Faculty of Medicine. The milieu of artists was more restricted. They lived in shabby hotels on Avenue du Maine, frequented cafés surrounding the Vavin metro station and sometimes passed by the Grande Chaumière studios.

Haven of Artists

Like the last flare of a dying fire, Paris as a cultural focal point shone across the Western world, and beyond, in the twentieth century's interwar period. French publishing houses established writers' reputations. In the visual arts, the avant-garde's thirst for renewal spread. The cosmopolitan aura was brightest in Montparnasse, a tiny area on the Left Bank of the Seine. One heard every language there, and all races and forms of attire intermingled. The merry night owls haunting the cafés wore the kind face of bohemia, with its hunger and poverty, and its tenacious fight for survival through unorthodox trades and imaginative schemes. A few found their way into the mainstream, as did Cuba's Francis Picabia, but for the great majority Paris was a must in the learning process before returning home. The city offered them the opportunity of catching up on the latest and learning the permanent open lesson of its great museums. Separated by the vast distances of Latin American geography, writers and artists from there were able to trade experiences and establish a framework for their experience of the grand city. For these and other reasons, a small Cuban colony was formed in the Paris of the 1920s and 1930s. *Vanguardia* artists Víctor Manuel García, Antonio Gattorno, Amelia Peláez, Carlos Enríquez, Marcelo Pogolotti and Domingo Ravenet frequented academic painters Enrique Caravia and Ramón Loy, musicians Diego Bonilla and Ángel Reyes, writers Alejo Carpentier and Félix Pita Rodríguez—not to mention designer Fico Franco and sculptor Juan José Sicre. At the same time, on the other bank, Cuban rhythms were winning over Montmartre's nightclubs to the tune of *El Manisero* [The Peanut Vendor] and *Mamá Inés*. Added to the multicoloured grouping were the students who continued their studies in France when the Machado dictatorship closed the University of Havana. The small, heterogeneous community was a refuge in which to share homesickness, bits of news from home, a plate of thickened black beans, popular beats and the solidarity so indispensable in difficult times.

Valuable Lessons

For almost all of these artists, the sojourn in Paris was a transitory period of learning. According to one scholar, Amelia Peláez dreamt of palm trees floating in the Seine, an image that summed up the profound nature of the latent designs of the *Vanguardia's* young founders, who were anxious to resolve modernization and modernity. With the establishment of the Republic, once the wounds of war had healed, the growth of cities, trade and means of communication had fostered pragmatic thinking, which tempered the drive for cultural renewal. Where art and literature were concerned, the nineteenth century extended into the first two decades of the twentieth. High culture

126

was breaking away from the world of entertainment, marked by the sudden appearance of cinema and the growing presence of U.S. models, even though more elaborate expressions continued to originate in Europe.

In Paris between the wars, Cubist codes had radically transformed pictorial language, beyond the prescriptions of Braque and Picasso. The representation of reality and the concepts of composition, light and colour were changing. Paintings were solidly set within an independent framework; nonetheless, Surrealism broke through the limits of doctrines with its emancipating thrust.

"Here and There"

For most Cuban artists, the Paris period was a transitory time of learning and experimentation. There, they established meaningful referents that, back at home, helped them circumscribe their own modernity. Only Marcelo Pogolotti completed in Europe a body of work that was soon cut short. He moved through Futurism and came to experimenting with a form of pictorial expression that would situate humankind's great conflicts in a convulsed time—a time that did not leave the distant and peripheral island untouched. What mattered most to his fellow adventurers was how to portray the nation, rendered overstated through focus on one of its facets. From Post-Impressionism, Cubism and Surrealism, they had learned to transcend illusory reality by ridding themselves of binding codes. Time stood still in this rescue operation. By striving for the eternal, chance

disappeared. That's what happened with Víctor Manuel García's little heads and silent parks. From crumbling houses in Old Havana, Amelia Peláez salvaged the solid architectural structure of their stained glass. Carlos Enríquez extolled the eroticism of women and landscapes. Before moving into his late period of personal minimalism, Eduardo Abela conferred monumental status on his *Peasants*. Arriving from Spain wracked by the Civil War, Wifredo Lam landed in Paris when nearly all of his colleagues had gone back to Cuba. His encounter with Picasso and Surrealism helped propel his work to maturity, which took its final form upon his return home. The greenery in the backyards of houses was transformed into jungle, animated by the merging of religious and racial dynamics.

The rather lengthy time in Paris spent by *Vanguardia* painters was beneficial most of all as a liberating experience. It redefined the basic parameters of a world view, thereby helping to reshape a broader perspective free from the prejudice and lethargic provincialism that persisted in Cuba. Strong individual personalities emerged therein. They avoided the temptation of jumping on the bandwagon in order to be up-to-date. As a result, they were far from being mere imitators of Cubism, Expressionism or Surrealism. They appropriated what they needed to become founders of Cuban modernity, starting from a fruitful dialogue between what Carpentier later called *el aca y el allá*, the here and the there.

Convergence

A cosmopolitan port of arrival for people from all over, Paris was also a place of confluence for Latin Americans who, without knowing each other, shared similar preoccupations. When looking back with the distance of time at the avant-garde process in Latin America, a basic commonality in purpose and attitude is evident over and above the particular characteristics of local history. Inherited codes needed to be swept away to arrive at an effective solution for a national agenda using symbolic images that were both diverse and convergent. Diego Rivera, Emilio Pettorutti, Pedro Fígari and writers César Vallejo and Miguel Ángel Asturias all passed through Paris. Under the shadow of neo-colonialism, Cuba was late in reaching independence. Despite the heavy burden of an outdated academicism, Cuban *Vanguardia* artists suddenly became the axis of the Americas.

The *Vanguardia* generation were founders because they introduced another modernity in the visual arts, one capable of appropriating and overhauling the codes of contemporaneity, one anchored at the central meridian of the Americas, at the—albeit peripheral—crossroads between two worlds. They assimilated the achievements of European art, from the Renaissance to the twentieth century, without becoming simple imitators. Having discarded the decorative aspect of art, they found themselves at the centre of the principal trend in Cuban culture of

the period; they engaged in an open dialogue with the explorations of Fernando Ortiz, the anthropologist and essayist, and in the experiments carried out in literature and music. In one fell swoop, they regained lost time with respect to poetry, which, step by step, had followed a similar path since José María Heredia's[1] awakening in the first half of the nineteenth century.

Despite the lyrics of that popular Cuban song "Ausencia," "to be absent does not mean to forget." The cosmopolitanism of Paris and its primacy in Europe, where the great conflicts of the era were being decided, precipitated the mature work of a group of artists; they threw off localism to build the utopia of nation in dialogue with the universal. Pogolotti plotted the larger world, inevitably marking Cuba's transformation. His contemporaries focused on the peripheral and arrived at an unexpected centrality. They did not form a school. Their successors went in new directions, no longer having to take the road to war-torn Europe. Without a market, they did not fall prey to fashion. Going beyond the situation of the day, they came up with a symbolic picture of the possible nation.

1 Not to be mistaken with the poet José María de Heredia (1897–1905), who lived in France.

See also:

Pogolotti, Graziella. *Examen de conciencia*. Havana: Ediciones UNION, 1965.

Pogolotti, Graziella. *Experiencia de la crítica*. Havana: Letras Cubanas, 2003.

Pogolotti, Marcelo. *Del barro y las voces*. Havana: Letras Cubanas, 2004.

FROM SOCIAL COMMENTARY TO MILITANT ART

Roberto Cobas Amate

A generation of restless artists burst on the scene in Cuba in the 1920s whose artistic ideas took over from the conventional academic art that had hitherto dominated Cuban art. At the same time, Cuban society saw a rise in civic engagement, bringing new life to the hopes for a democratization of people's lives. The trade union movement became organized, women began demanding their rights, students banded together and young people took on a leading role in the push for change. The generation of artists and intellectuals that emerged as a group in 1927, and whose aspirations were taken up in the magazine *Revista de Avance* and more precisely in the Declaration of the Grupo Minorista on May 7, 1927,[1] redeemed social action through the genuine expression of popular culture, sweeping away the stereotypical cultural models inherited from the colonial era.

The desire common to the time was to claim a national identity. In this way society, in its broadest sense, was reflected by modernist Cuban artists within the general lines stemming from the reform movement. Afro-Cuban culture, which had generally been relegated in earlier Cuban painting to picturesque scenes or a superficial folklore, was now interpreted by leading avant-garde artists through scenes of music and dance, and the exploration of the ethnic features of Afro-Cuban culture, in tandem with the casting of a critical eye to concerns such as unemployment and racial discrimination. Their temperament and degree of social engagement marked how noted artists of the period imparted their vision of things. Varying social hues were thereby revealed, ranging from Jaime Valls's sensual and elegant vision of the rumba to Alberto Peña's radical defence of the rights of the Afro-Cuban proletariat (ill. 137); from the rigorous construction and extraordinary synthesis achieved by Ramos Blanco (ill. 131, 132) to the visual metaphors of vernacular motifs created by Eduardo Abela. These artists became members of a broad movement to recover and legitimize Afro-Cuban cultural values as an integral part of the nation, a movement in which writers, poets and musicians also played a part, culminating with the publication in 1930 of Nicolás Guillén's book of poetry *Motivos de son*.

Another important aspect of visual art at this time was its return to popular culture, basically in the form of a visual expression of rural Cuban legends and traditions, taking shape in painting's *Criollismo*, which, in the work of some of its most important figures, transcended a folkloric, mannerist vision to vehemently denounce the impoverished and hopeless conditions of the Cuban peasant. This style of painting, in the variety of its approaches to Cuban culture, was a sweeping expression of very diverse sensibilities. So broad was its range of response that it included everything from the guileless gaze of Lorenzo Romero Arciaga (ill. 225), who avoided social commentary through the insubstantial quality of his characters, to Antonio Gattorno's impassive and tragic peasants, and all the way to Arístides Fernández's intensely dramatic quality. Every approach of Cuban painting is found in the work of Carlos Enríquez, who was inspired by what he described as *romancero guajiro*, or peasant ballads. With his singular vision he explored the mysticism of popular heroes (*Rey de los campos de Cuba* [King of the Cuban Fields, 1934]) and the sensuality of nature, whether expressed in landscapes (ill. 141), depictions of women (ill. 145) or a fusion of both (*Las bañistas de la laguna* [Women Bathing in the Pond, 1936]). The themes of popular heroes and

sensual nature came together in his most direct and expressionist works, such as *Horno de carbón* [Coal Oven, 1937] and *Happy Peasants*, 1938 (ill. 142), in which he managed to fuse an intense social critique with the purest artistry, confirming a definitively mature poetic vision.

After his brief and intense Afro-Cuban period in Paris, Eduardo Abela returned to Cuba in 1929 and abandoned painting, taking up the cartoon with unmitigated fervour. He resumed work on *El Bobo* [The Fool], created years earlier, transforming him into one of the most charismatic characters in Cuban political caricature. With his seeming naïveté, the Fool's scathing commentary created a real line of communication with a mass audience and established a coded language for thwarting the censor. With his caricatures, Abela not only consolidated a spirited political discourse, which had a significant role to play in the overthrow of the Machado dictatorship, but he also brought new ideas to the contemporary aesthetic of the caricature, his first significant contribution to Cuban modernity.

Arístides Fernández formulated one of the most intense and dramatic visual languages in all of Cuban painting. His work explored the essence of Cubanness, keeping its distance from the *Criollismo* without substance that some of his contemporaries practised. He was interested in the Cuban heartland, the Cuba of poor people who were masters of nothing, except perhaps their own wretched lives. The fundamental quality of his art was its ability to express the daily reality of hopelessness without robbing his characters of their dignity. His paintings

were sober and severe; their limited range of colour and rigorous sense of restraint prevented the tragedy from overflowing. This was the effect of his most striking work: *El batey* [The Sugar Mill] [about 1933, (ill. 139)] *La familia se retrata* [Family Portrait] and *Idilio* [Idyll], which reveal a critical mind capable of penetrating to the very root of what it is to be Cuban and of bringing new ideas to the formation of a national identity.

Alberto Peña was by far the Cuban artist who best achieved a systematically and deeply social approach to painting. His work does not tarry in a critique of racial discrimination but engages instead the most wide-ranging revolutionary ideas, such as the unity of all workers in the struggle against capitalist exploitation. Out of such ideas Peña forged visual allegories in which he joined the combative tradition of the nineteenth-century wars of independence with the aspirations of the working class. A good example of this is the painting *The Call of the Ideal*, 1936, (ill. 146), or *Martí*, in which the apostle of Cuban independence shines his light on difficult social conflicts of the day. In his work, however, the epic quality becomes nearly grandiloquent at times and lacks the vital engagement of the genuine work of art.

Paradoxically, the work of Marcelo Pogolotti, the most avant-garde painter of his generation, had the most lucid social quality. After exploring such paths as Abstract art, Futurism and Surrealism, Pogolotti took up social themes, which were to be his decisive contribution to Cuban art. First, he created *Our Times*, 1930–31 (ill. 152–159), an impressive series of drawings

in which he addressed the fundamental contradictions of his day, contradictions centred on the conflict between the working class and capital. He then created paintings with such pure technique and conceptual force that he quickly found himself at the vanguard of Cuban painting. *Cuban Landscape*, 1933 (ill. 162), one of his best-known works, placed Cuba—the violent Cuba of the Machado dictatorship—at the centre of contemporary capitalism's ravenous appetite. Five years of constant advancements in his work stand between *Paisaje cubano* and *Encuentro de dos épocas* [Meeting of Two Eras, 1938], a time when Pogolotti consolidated his formal language, joining the achievements of an advanced aesthetic discourse, in keeping with the spirit of the avant-gardes of the day, with a ringing revolutionary indictment in defence of humanity.

Paintings with social concerns were the expression of a singular historical moment. To greater or lesser degrees, these concerns remained present throughout the work of this first generation of avant-garde Cuban artists. Once the fundamental initial questions had been exhausted, these concerns became concealed in more metaphorical interpretations of society, setting in motion another era in Cuban art.

1 "Declaración del Grupo Minorista," (1927) *Claves del arte de Nuestra América* (Havana: Galería Latinoamericana, Casa de las Américas), vol. 1 (November 1986), document 11.

129

129
Eduardo ABELA
The Triumph of the Rumba
About 1928

The distinguished Cuban writer Alejo Carpentier said of the works *The Triumph of the Rumba* and *The Sparrow Hawk*: "From the American point of view, it is the picturesque element in Abela's painting that is the most important. The artist is less concerned with reproducing the physical details of Cuban life than portraying its soul. He does not attempt an exact rendering of the rumba dancer's rainbow-coloured shirt, but when he places his figures in rumba time, he makes us feel the very core of the rumba. His paintings are of synthesized characters rather than portraits. He is not interested in emulating *American Photo* but in capturing the spirit of things, hence his affection for a somewhat mythical Cuba and for the heroes of popular songs—Papá Montero and María la O. Abela evokes old-time carnival figures—*The Scorpion*, *The Sparrow Hawk*—with no concern for historical truth; what he wants to convey is the rhythm, the intensity, the rough poetry of those fiestas. . . . His figures move in an intensely modern, dream-like atmosphere, in which they seem at times to be mere symbols."

Alejo Carpentier. "Abela en la Galería Zak," *Social* vol. 14, no. 1 (January 1929).

130
Eduardo ABELA
The Sparrow Hawk
About 1928

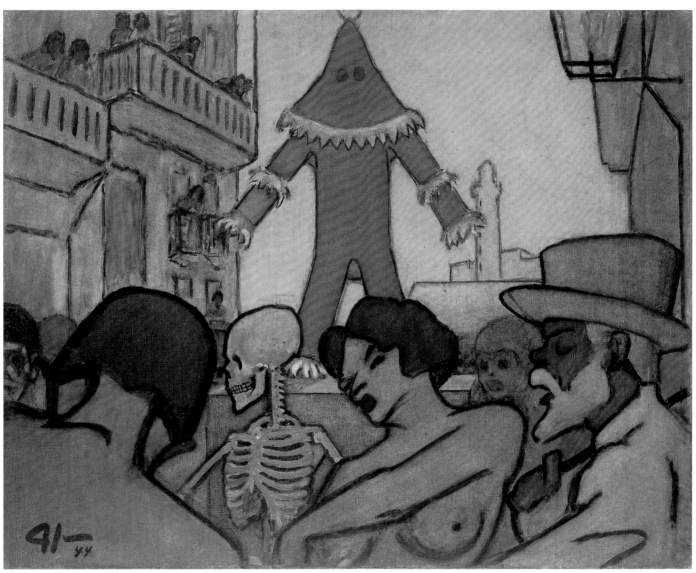

133

Previous pages:
131
Teodoro RAMOS BLANCO
Inner Life
1934

132
Teodoro RAMOS BLANCO
Old Black Woman
1939

133
Rafael BLANCO
The Virile Toga
1944

134
Fidelio PONCE DE LEÓN
The Faces of Christ
1936

135
Fidelio PONCE DE LEÓN
Tuberculosis
1934

134

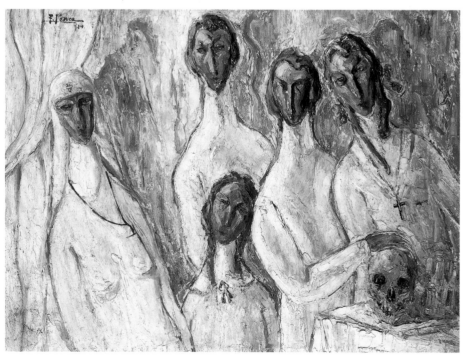

135

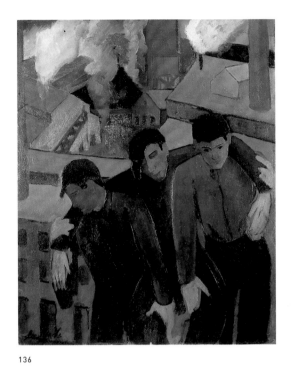

136

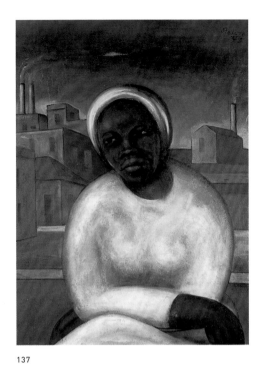

137

138

139

136
Jorge ARCHE
Workers
1936

137
Alberto PEÑA (PEÑITA)
Without Work
1931

138
Carlos ENRÍQUEZ
Woman on the Balcony
n.d.

139
Arístides FERNÁNDEZ
The Sugar Mill
About 1933

140
Víctor Manuel GARCÍA
Eviction
n.d.

141

141
Carlos **ENRÍQUEZ**
Oxen
1935

142
Carlos **ENRÍQUEZ**
Happy Peasants
1938

"The message is clear. The starving woman, who seems to have spent her life giving birth, is carrying one of her children, while another is clinging to the faded skirt that covers her distended belly, the sign of an imminent birth. . . . The man sitting in a hammock, a bag of bones, is a harrowing image of rural unemployment and isolation. On the dirt floor . . . a small pig and the obligatory family dog rub shoulders companionably. This living in cramped quarters is part and parcel of poverty. In the midst of this gloomy shack, the artist takes direct aim with bitter mockery at two clearly marked targets: blurry political posters of two candidates for Parliament or perhaps the Presidency—a pig and a donkey. The trace of 'humour' here is comparable to the black satires of Goya."

Juan Sánchez. *Vida de Carlos Enríquez* (Havana: Editorial Letras Cubanas, 2005), pp. 93–94.

143

144

145

143
Mario CARREÑO
Cyclone or *Tornado*
1941

144
Carlos ENRÍQUEZ
Virgin of El Cobre
About 1933

145
Carlos ENRÍQUEZ
Untitled
1937

146
Alberto PEÑA (PEÑITA)
The Call of the Ideal or *Martí*
1936

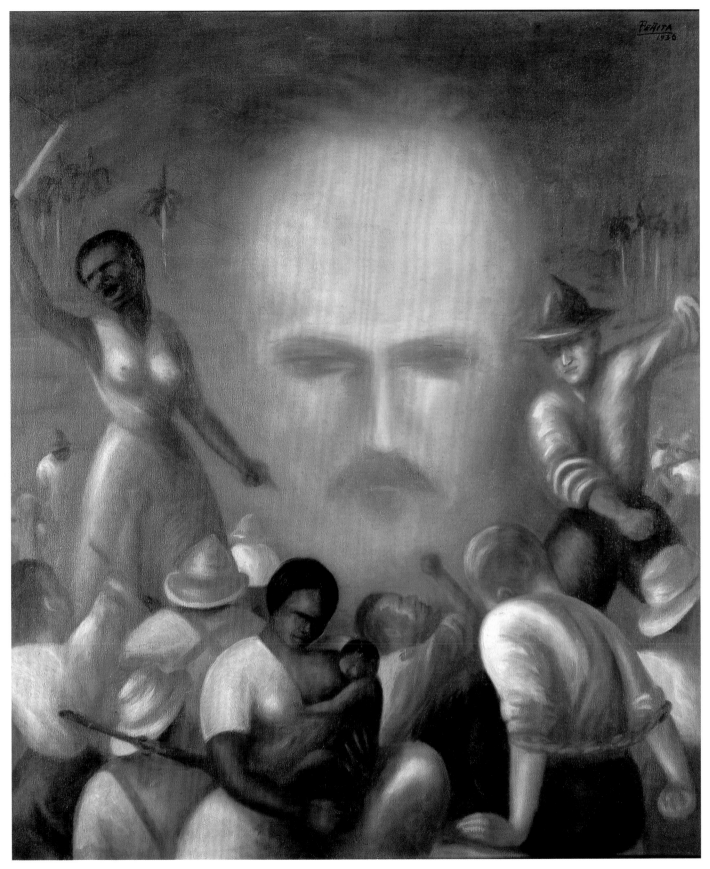

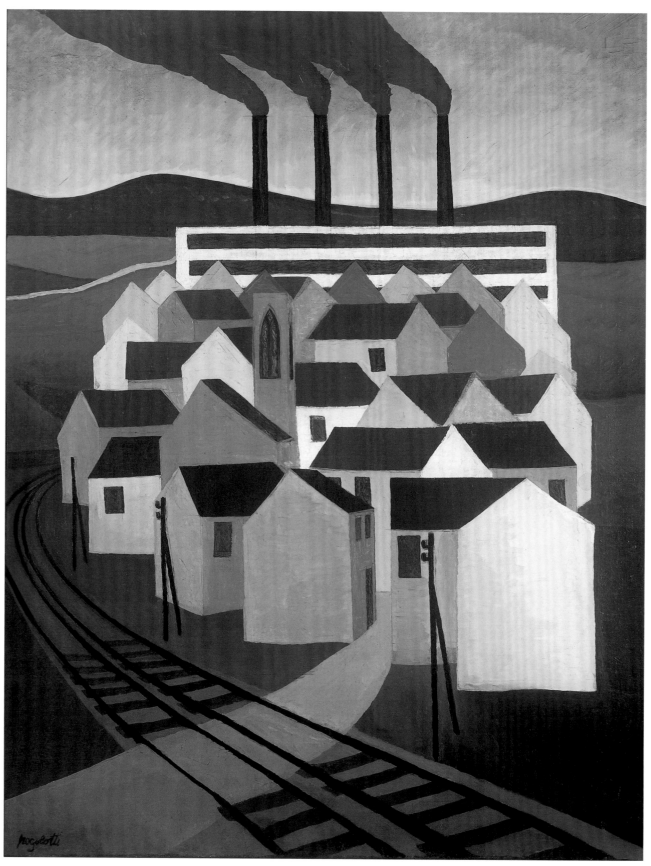

147

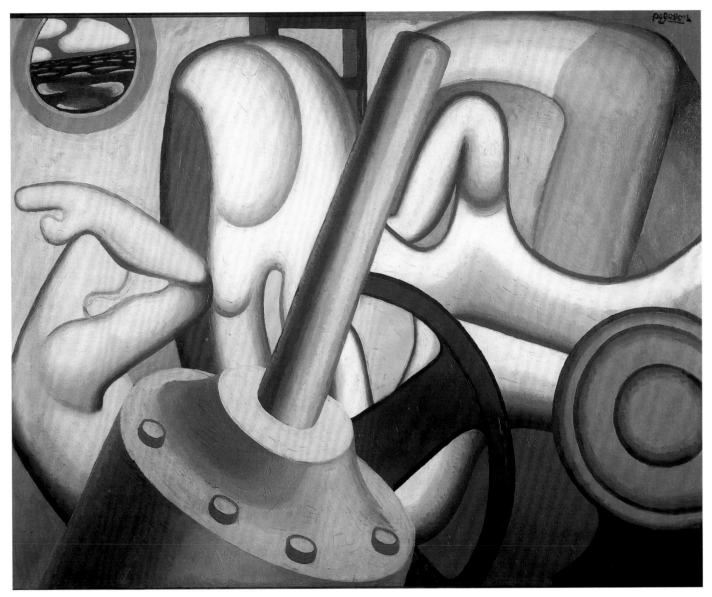

148

147
Marcelo POGOLOTTI
Industrial District
About 1938

148
Marcelo POGOLOTTI
Ship Interior (Marine, or Ship)
About 1934

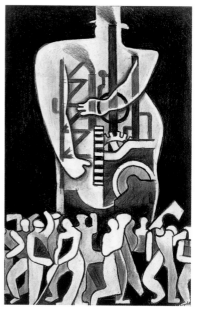

149

150

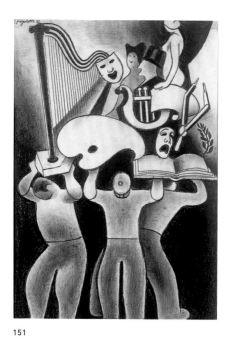

151

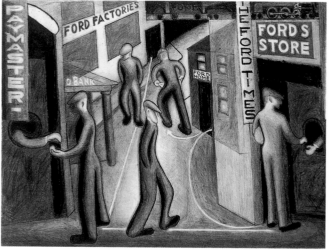

152

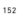
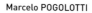

153

Marcelo POGOLOTTI
149. *Goliath*, n.d.
150. *Hitler*, 1935
151. *Untitled*, 1935

152–159
From the series "Nuestro Tiempo"
[Our Times], 1930-31
152. *Fordism (The Monopoly)*
153. *Charity (Charity of Metal Sickness)*
154. *Work here Is Done for Nothing (Colony)*
155. *To El Dorado (Emigration)*

156. *We Want Work! (The Line or Aid to the Unemployed)*
157. *Bloodbath*
158. *The Master and His Bulldogs (Nazi System)*
159. *Business is Good . . . (Hand-to-hand)*

Our Times, the series of drawings executed by Pogolotti between 1930 and 1931, proclaims the fundamental shift in his art from Futurism to social commentary. The artist said: "I started on a series of

works entitled *Our Times*, in which I looked at the present day with an eye honed by every aspect of our modern lives. I think I succeeded, to the extent that I had to immerse myself in the material that would dictate the form of my new art. . . . That the drawings had a propagandist slant is undeniable, but my intention was not to stop there, far from it, although the great art of the Middle Ages is clearly propagandist. Art can express

the thoughts and feelings of its day without needing to be crudely didactic or overtly propagandist; at its best it remains unspoiled by the communication of a message. Nevertheless, in an era as turbulent and painful as the one we are living through, art is bound to show its rough, bitter and violent side."

Marcelo Pogolotti, *Del barro y las voces* (Havana: Editorial Letras Cubanas, 2004), p. 261.

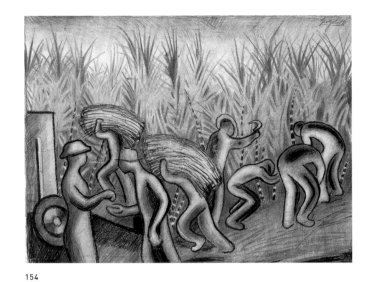

154

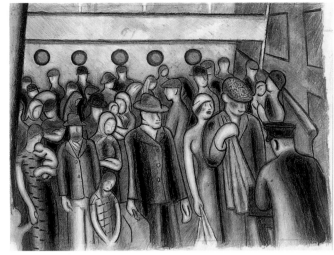

155

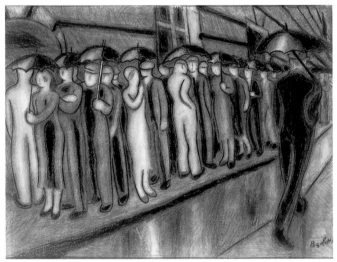

156

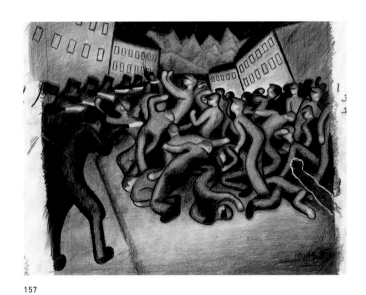

157

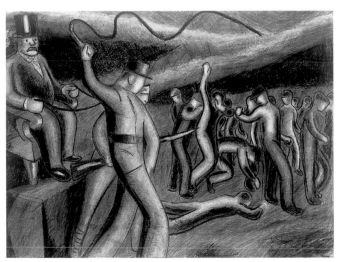

158

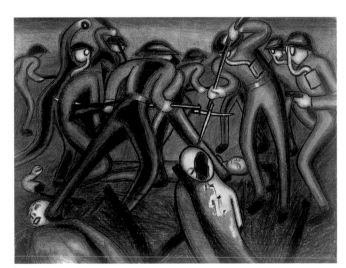

159

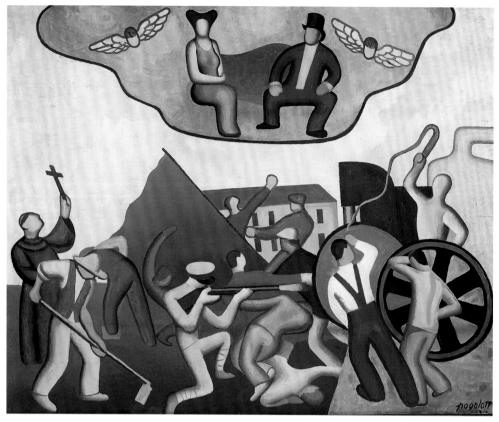

160

161

160
Marcelo POGOLOTTI
Heaven and Earth
1934

161
Marcelo POGOLOTTI
Untitled
About 1935

162
Marcelo POGOLOTTI
Cuban Landscape
1933

"I refused to present a picture of my country that would satisfy the appetite of the French, the English-speaking nations and other foreigners for exoticism, that is, as an uncivilized Caribbean island given to wild, unbridled merrymaking, the way Abela painted it three years earlier, or as a remote ideal dreamland as it was depicted by Víctor Manuel in his *Tropical Gypsy*, painted during his months in Paris in 1929. My goal was to paint the human reality in a social landscape. My picture included soldiers of Machado's repressive army supervising the cane cutters; the unemployed, waiting with arms crossed for a chance to work; the sugar mill; the trains taking the sugar cane to the mill and the sugar to a steamer, on which it would be loaded and transported to the North, where the speculators played the sugar market, while on the horizon the huge mouths of the Navy's cannons pointed at Cuba."

Marcelo Pogolotti, *Del barro y las voces* (Havana : Editorial Letras Cubanas, 2004), p. 280.

163
Marcelo POGOLOTTI
Workers and Peasants
About 1933

162

163

164

164
Marcelo POGOLOTTI
Group
About 1937

165
Marcelo POGOLOTTI
The Column or *The Recovery*
n.d.

166
Marcelo POGOLOTTI
The Intellectual or *Young Intellectual*
1937

"The thinking man was increasingly trapped by circumstances, denied all freedom of expression even in France, having already been silenced throughout most of the rest of Europe. The newspapers and periodicals in which he could express his opinions were becoming fewer and fewer . . . That was when I decided to tackle this distressing situation in a painting entitled *The Intellectual*. A man with his gaze turned in on himself, bent over a table with an open book and a typewriter on it, alone and cut off from the world for a moment, tries to come to terms with his conscience, with its impressions, in order to find an adequate interpretation without any external influence. But outside there lies in wait for him the shadow of a huge bird with a scythe, representing hunger, persecution and death. The man's body, dramatically placed on the diagonal, is strong, to give the lie to the common misconception that intellectuals are weaklings."

Marcelo Pogolotti, *Del barro y las voces* (Havana: Editorial Letras Cubanas, 2004), pp. 323–324.

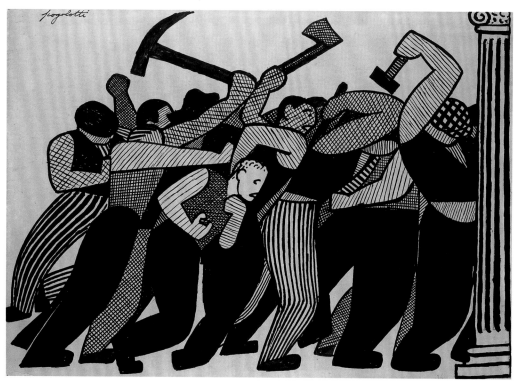

165

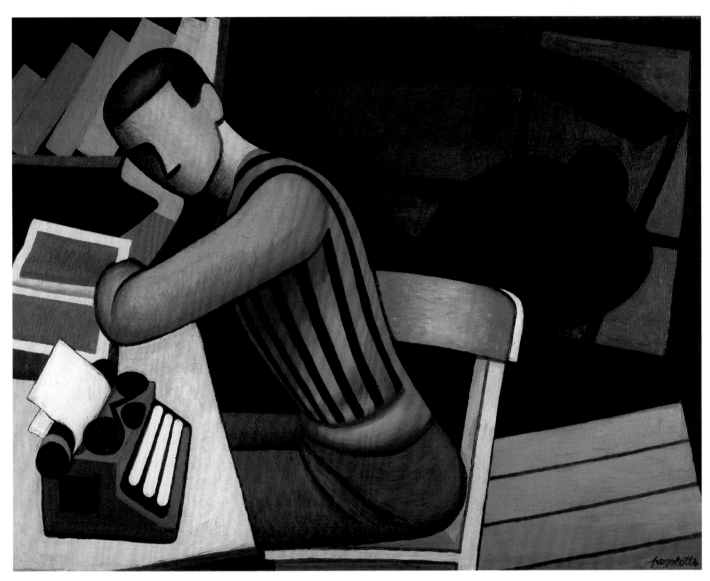

166

CUBANNESS

affirming a cuban style

TIMELINE
art and history

1938

The second National Salon of Painting and Sculpture is held; awards are given to Eduardo Abela, Jorge Arche, Carlos Enríquez, Víctor Manuel García, Antonio Gattorno, Amelia Peláez and Fidelio Ponce León.
Marcelo Pogolotti's work is exhibited at the Carrefour gallery in Paris; Jean Cassou presents the show.
The Communist Party is legalized and founds the newspaper *Hoy* as its official organ.

1939

The magazine *Espuela de Plata*, devoted entirely to culture and whose subtitle is "Bimonthly Journal of Art and Poetry," is published. Edited by José Lezama Lima, Guy Pérez Cisneros and Mariano Rodríguez, it plays an important role in bringing together intellectuals who would form a unified group years later around the magazine *Orígenes*. Among *Espuela de Plata*'s contributors are various members of the *Vanguardia* Cuban art movement.
The Cuban Photography Club is founded.
Marcelo Pogolotti returns to Havana.
Wifredo Lam's work is exhibited at the Pierre gallery in Paris.
The exhibition *Drawings by Picasso and Gouaches by Wifredo Lam* is held at Perls Galleries in New York.
René Portocarrero writes and does the illustrations for the poem *El sueño*.
The Cuban Federation of Workers is founded to unify the workers' movement.

1940

Fernando Ortiz's book *Contrapunteo cubano del tobaco y el azúra* [Cuban Counterpoint: Tobacco and Sugar] is published.
Two important exhibitions of Cuban art are held at the University of Havana: *300 Years of Cuban Art* and *Cuban Art: Its Evolution in the Work of Several Artists*.

René Portocarrero contributes drawings to the exhibition catalogues.
Wifredo Lam participates in the exhibition *Art of Our Times* at the Mai gallery in Paris and enters into contact with the Surrealists.
Fulgencio Batista is elected president. A new constitution is approved. It is essentially progressive, guaranteeing individual and social rights and containing important welfare provisions for workers.

1941

The exhibition *Contemporary Cuban Art* is held at the Capitolio Nacional.
Mariano Rodríguez does the illustrations for José Lezama Lima's *Enemigo rumor* and Wifredo Lam the same for André Breton's *Fata Morgana*.
Lam returns to Cuba.

1942

Mariano Rodríguez does the illustrations for Luis Amado Blanco's *Claustro*.
Wifredo Lam's work is exhibited at the Pierre Matisse gallery in New York. He does the illustrations for the Spanish edition of Aimé Césaire's book *Cahier d'un retour au pays natal* [Notebook of a return to the native land].

1943

Virgilio Piñera writes the famous poem *La Isla en peso*.
Mariano Rodríguez paints murals for the church in Bauta.
Mario Carreño and Wifredo Lam participate in the exhibition *Two Cubans: Carreño and Lam* at the Institute of Modern Art in Boston.
The *International Watercolour and Gouache Exhibition* is held in Havana.
René Portocarrero gives free drawing classes in Havana's jail, where he also paints the mural *San Francisco de Paúl*.

1944

The art and literature magazine *Orígenes* is published. Lezama Lima heads its editorial board of prominent Cuban thinkers.
The cultural magazine *Gaceta del Caribe* is published; it also features the work of leading Cuban intellectuals.
José Gómez Sicre writes the critical essay *Pintura cubana de hoy*.
The exhibition *Pogolotti: Our Times* is organized by the National Antifascist Front.
The exhibition *Modern Cuban Painters* is held at the Museum of Modern Art in New York.
The first Vicente Escobar Salon is held.
Wifredo Lam's work is exhibited at the Pierre Matisse gallery in New York.
Mariano Rodríguez travels to the United States.
Carlos Enríquez's work is exhibited at the Palacio de Bellas Artes in Mexico City.
The article *Pintura y escultura en 1943* by the art critic Guy Pérez Cisneros is published.
Ramón Grau San Martín wins the presidential elections for the Auténtico Party.

1945

Luis de Soto writes the essay *Esquema para la indagación estilística de la pintura moderna cubana*.
The exhibition *Modern Cuban Painters* is held at the Centre d'art in Port-au-Prince, Haiti.
Mariano Rodríguez exhibits his work in New York and does the illustrations for José Lezama Lima's *Aventuras sigilosas*.
René Portocarrero travels to the United States.
Carlos Enríquez and Wifredo Lam travel to Haiti, a trip that changes the work of each.
Wifredo Lam does the illustrations for Pierre Loeb's memoirs, *Voyage à travers la peinture*.
Gangsterism increases under Ramón Grau's government.

Estudio ARMAND, *Olga Chaviano, nightclub star and lover of the mafioso Norman Rothman*, 1950s

1946

The painter Domingo Ramos becomes director of the Academy of San Alejandro until 1947.

The exhibition *Modern Cuban Painting* is held at the Palacio de Bellas Artes in Mexico City.

The exhibition *11 Cuban Painters* is held at the Museo de Bellas Artes in La Plata, Argentina.

Marcelo Pogolotti publishes the novel *Estrella Molina*, illustrated by Mariano Rodríguez and René Portocarrero.

The third National Salon of Painting and Sculpture is held.

Wifredo Lam exhibits his work influenced by Haitian voodoo at the Centre d'art in Port-au-Prince, Haiti; André Breton presents the show.

Lam returns to France .

1947

Carlos Enríquez does the illustrations for Nicolás Guillén's *El son entero.*

Eduardo Chibás founds the Ortodoxo Cuban People's Party and publicly accuses Ramón Grau's government of corruption.

1948

The polemical art and literary review *Inventario* is published. In its pages Cuban culture is discussed in a markedly critical way. Its covers are created by Cuban painters.

Mariano Rodríguez exhibits his work in New York and does the illustrations for Lorenzo García Vega's book of poetry *Poesías I: Elegías.*

Carlos Prío Socarrás wins the presidential elections.

The leader of the sugar workers, Jesús Menéndez, is assassinated.

1949

The Cuban Printmakers' Association is founded.

Mariano Rodríguez designs the cover of Eliseo Diego's *En la Calzada de Jesús del Monte* and creates stained-glass windows for the church in Bauta.

René Portocarrero does the illustrations for José Lezama Lima's *La fijeza* and Enrique Labrador Ruiz's *Trailer de sueños.*

The exhibition *Cuban Woodcuts* is held at the Parque Central in Havana.

Sandu Darie begins working with the Argentine Concrete art group Madí, with which he exhibits his work thereafter.

1950

The fourth National Salon of Painting, Sculpture and Prints is held; awards are given to José Mijares, René Portocarrero, Mariano Rodríguez, Roberto Diago and Mario Carreño.

René Portocarrero creates a mural in the Esso building in Havana.

René Portocarrero, Mariano Rodríguez, Amelia Peláez and Wifredo Lam work in ceramics at the Santiago de las Vegas studio.

1951

The cultural association Nuestro Tiempo [Our Times] is founded, bringing together left-wing revolutionary artists and intellectuals.

Wifredo Lam's work is exhibited at the Nuestro Tiempo gallery.

Lam contributes to the magazine *Cobra.*

The fifth National Salon of Painting, Sculpture and Prints is held; awards are given to Wifredo Lam, Mario Carreño, René Portocarrero, José Mijares and Mirta Cerra.

The exhibition *Contemporary Cuban Art* is held at the Musée national d'art moderne in Paris.

Cuban artists participate in the first São Paulo Biennial at the Museum of Modern Art in São Paulo, Brazil.

Carlos Enríquez does the illustrations for *Elegía a Jesús Menéndez* and paints a mural in the Esso building.

Eduardo Chibás, leader of the Ortodoxo Party, commits suicide when he is unable to substantiate his accusation that the Minister of Education has been stealing public funds.

1952

Cuban artists participate in the twenty-sixth Venice Biennale.

Wifredo Lam illustrates a cover of the magazine *Orígenes* and returns to Europe.

Mariano Rodríguez begins a mural in the Retiro Odontológico building.

Fulgencio Batista seizes power in a military coup on March 10.

1953

The sixth National Salon of Painting and Sculpture is held; awards are given to Mario Carreño, Jorge Arche, Carmelo González and René Portocarrero.

The exhibition *Eleven Painters and Sculptors* is held.

The group Los Once, eleven young abstract painters and sculptors, is founded.

Wifredo Lam does the illustrations for René Char's *Le rempart des brindilles* and François Valorbe's *Carte Noire.*

Servando Cabrera Moreno exhibits his work alongside that of Antonio Saura in the Libros gallery in Zaragoza, Spain.

Luis Martínez Pedro receives an award from UNESCO.

The Moncada barracks are attacked on July 26 under the leadership of Fidel Castro, who is imprisoned, along with other members of the group. During his trial, Castro reads a statement in his defence entitled "History Will Absolve Me," which announces a program of radical social change.

1954

Inauguration of the Palacio de Bellas Artes, new site of the Museo Nacional de Bellas Artes.

The National Culture Institute (INC) is established under the Ministry of Education and continues to acquire Cuban art, for the most part contemporary.

The magazine *Nuestro Tiempo* is published, operating as the organ of the society it is named after, reporting on Cuba's cultural life.

Lydia Cabrera publishes her book on Afro-Cuban culture, *El monte.*

Loló de la Torriente's essay *Estudio de las artes plásticas en Cuba* is published.

The second Hispano-American Biennial is held, co-sponsored by the Batista and Franco governments.

The first *University Art Festival* is organized at the University of Havana to repudiate the Biennial.

The exhibition *Tribute to José Martí: Contemporary Cuban Art* is held at the Lyceum and is known as the anti-Biennial.

The cultural association Nuestro Tiempo establishes the Permanente gallery.

Wifredo Lam exhibits his work in the Salon de Mai in Paris, which he will do every year until 1982.

A campaign to grant amnesty to political prisoners obtains the release of those who attacked the Moncada barracks.

1955

The literary magazine *Ciclón* is founded by José Rodríguez Feo after he falls out with the magazine *Orígenes.*

Marcelo Pogolotti publishes the book *Puntos en el espacio: Ensayos de arte y estética.*

René Portocarrero writes and illustrates the book *Máscaras: 12 dibujos.* He also does the illustrations for Ángel Gaztelu's *Gradual de laúdes.*

Wifredo Lam's work is exhibited at the Museo de Bellas Artes in Caracas, Venezuela.

The Permanent Exhibition Hall is inaugurated in the Palacio de Bellas Artes.

The group Los Once disbands.

The first *Concrete Art* exhibition is held at the University of Havana.

The 26th of July movement is founded. After being released from prison, Fidel Castro leaves for Mexico, where he meets Ernesto (Che) Guevara.

José A. Echeverría, president of the University Students Federation, founds the Revolutionary Directorate, which will unite with the 26th of July movement to launch armed resistance against the government.

1956

Mariano Rodríguez illustrates the cover of Nicolás Guillén's *Elegía cubana.*

Wifredo Lam returns to Havana and exhibits his work at the University of Santa Clara.

The eighth National Salon of Painting and Sculpture is held at the Palacio de Bellas Artes; awards are given to René Portocarrero, Amelia Peláez, Mariano Rodríguez, Servando Cabrera Moreno and Sandu Darie.

The exhibition *Contemporary Painting and Sculpture*, known as the "Counter Salon," is held at the Cuban Association for Freedom and Culture.

Loló Soldevilla returns from Europe and organizes the exhibition *Painting Today: The Avant-garde School of Paris* at the Palacio de Bellas Artes.

Frank País leads an uprising in Santiago de Cuba as a cover for the return of Fidel Castro and his comrades aboard the yacht *Granma.*

Armed struggle in the Sierra Maestra begins. The Rebel Army is established under the command of Fidel Castro.

1957

René Portocarrero creates a ceramic tile mural in the Hilton Hotel (today the Habana Libre) and another mural and a Way of the Cross in the church in Baracoa.

Mariano Rodríguez paints a mural in the building located at 461 Calle E in the El Vedado district of Havana.

Wifredo Lam exhibits his work alongside that of Yves Klein at the Iris Clert gallery in Paris and travels to Mexico.

Loló Soldevilla and Pedro de Oraá found the Color-Luz gallery.

The La Plata barracks are attacked; first victory for the Rebel Army.

Herbert Matthews does a story on the guerrillas fighting in the Sierra Maestra for the *New York Times*, bringing them international recognition.

The Revolutionary Directorate attacks the Palacio Presidential and seizes Radio Reloj; José A. Echevarría dies in the fighting.

1958

René Portocarrero travels to Europe.

Mariano Rodríguez visits Venezuela and exhibits his work in the Museo de Bellas Artes in Caracas and the Centro de Bellas Artes in Maracaibo, Venezuela.

Wifredo Lam returns to Havana.

The exhibition *Cuban Abstract Painting* is held at the Centro de Bellas Artes in Maracaibo.

Servando Cabrera Moreno's work is exhibited at the Palacio de Bellas Artes in Havana.

Radio Rebelde begins transmitting from the Sierra Maestra.

A general strike is held on April 9, mobilizing the country against the Batista government.

Two rebel columns, led by Camilo Cienfuegos and Che Guevara, bring the rebel invasion to the country's western provinces; Che wins the battle of Santa Clara.

The rebel forces advance toward Santiago de Cuba under Fidel Castro.

THE ALL-NIGHT CITY

Rosa Lowinger

In 1928, noted bon vivant and travel writer Basil Woon published a book titled *When It's Cocktail Time in Cuba*. Written during Prohibition, when the Eighteenth Amendment to the U.S. Constitution and the Volstead Act prohibited the manufacture, sale and transportation of alcoholic beverages in the country, Woon's lively travelogue extols Cuba's virtues as a place where "personal liberty is carried to the nth degree" and "everyone is drinking and not a soul is drunk."[1] Woon rapturously describes Havana's bars and bodegas, the upscale restaurants and hotel lobbies where his characters—mostly well-heeled American travellers and expatriates—knock back whiskeys and assorted rum cocktails, such as daiquiris, *presidentes* (Bacardi and vermouth with a dash of either curaçao or grenadine) and Mary Pickfords (an icy rum and pineapple concoction created by British island-hopper Fred Kaufman to coincide with the film star's brief tenure in Cuba).[2]

The Club Scene

At the time, Havana's most famous watering hole was a no-frills, dimly lit place with a long mahogany bar called Sloppy Joe's (ill. 176, 177). Located near the city's Parque Central, the bar got its curious name when proprietor José (Joe) García Rio quarrelled with a local newsman over advertising, and the newsman ran an editorial in which he urged the city's sanitation commission to look into "a place on Calle Zulueta which should be called 'Sloppy Joe's.'" The name was a marketing success. Garcia Rio's business grew so rapidly that he had to expand twice and eventually employed eleven bartenders.[3] Over the following decades—the 1930s, 1940s and 1950s—those bartenders came into contact with the majority of Cuba's visitors, for the bar was written up in every guidebook to Havana, and having your picture taken there while on vacation was the sure sign that you'd partied heartily in Cuba. Cubans, on the other hand, didn't go there much because, as Graham Greene wrote in *Our Man in Havana*, "it was the rendezvous of tourists."[4] Another possible reason why Cubans didn't go to Sloppy Joe's was because the bar didn't feature music and dance, and for Habaneros, the city's residents, music and dance have always been central to a good night out.

In the 1920s, the good times often began at the outdoor tables of the Acera del Louvre, a covered walkway along Calle Prado, facing the Parque Central. Named after a café that was the nineteenth-century gathering place for intellectuals and anti-Spanish revolutionaries, the 1920s Acera was a popular spot for drinking and listening to live music while contemplating whether to catch a nearby vaudeville show, or the symphony across the street at the Teatro Nacional, or head a few blocks over to the Teatro Payret to listen to heralded pianist and composer Ernesto Lecuona perform George Gershwin's *Rhapsody in Blue*.[5] The spot was central and noisy—the septets and sextets that played the sweet boleros and guarachas of the day competed with the cacophony of honking cars, street vendors and incessant construction. Composer Moisés Simons is purported to have penned the megahit *El Manisero* [The Peanut Vendor] at a café table in the area while listening to the call of vendors hawking peanuts.

By 1930, when *El Manisero* hit the airwaves in New York and Paris, Havana had a bustling music scene featuring groups that blended percussive Afro-Cuban rhythms with traditional European instruments. The music gave rise to local singing stars like Rita Montaner (ill. 193) (the first to record

168

169

170

171

168
Magea RODRÍGUEZ
The band Hermanas Benítez
1950s

169
Anonymous
Hot tamales street vendor, Havana
1950s

170
Anonymous
Still from a Cuban television advertisement for Firestone tires
About 1950

171
Panchito CANO
Marines having a good time, Santiago de Cuba
1945

172
Anonymous
The famous Cuban boxer Kid Chocolate praying to Santa Barbara after serving seven months in prison for possession of marijuana
1950s

The famous boxer Eligio Sardiñas, better known as Kid Chocolate, learned to fight by watching old fight films in Cuba. In the course of his boxing career, he won about 136 bouts. His name is in the International Boxing Hall of Fame alongside those of fighters like Bass, Berg and Canzoneri, and he is considered one of the best featherweight boxers of all time.

173
Luis ARGÜELLES
Alicia Alonso choosing a dancing outfit
1950s

The celebrated prima ballerina assoluta Alicia Alonso began to study ballet at the Sociedad Pro-Arte Musical in Havana with Sophia Fedorova in 1931. She was one of the founding members of the American Ballet Theatre in 1940, and by 1943 had become one of its leading dancers. Here she worked with the great choreographers, including Michel Fokine, George Balanchine and Léonide Massine. In 1948, with Fernando Alonso, she founded the Alicia Alonso Ballet Company, now the National Ballet of Cuba, which she still directs.

172

173

174

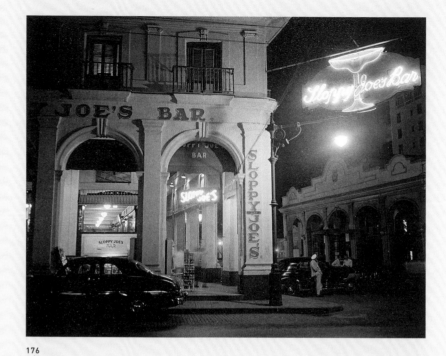

176

175

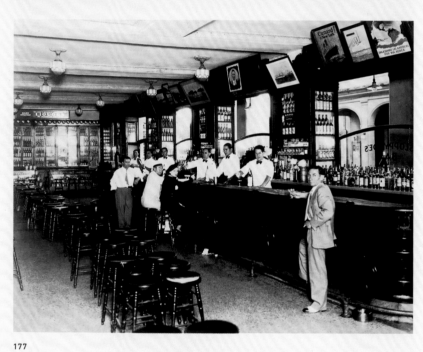

177

174
Anonymous
Meyer Lansky (right), the famous American gangster who financed the construction of the Hotel Riviera in Havana
1950s

Meyer Lansky began to develop gambling operations in Cuba about 1936. At the end of World War II, he joined another mafioso, Charles "Lucky" Luciano, who operated casinos under the protection of president Batista. Lansky invested in casinos and hotels most notably the Hotel Riviera.

175
Constantino ARIAS
Ernest Hemingway (right), with Reinaldo-Ramirez-Rosell, producer in the Travel and Tourism Department of the Tourism Institute, Havana
1952

176
José ABRAHAM
Sloppy Joe's Bar from the outside
1954

177
Anonymous
Sloppy Joe's Bar
1940s

178

179

180

181

178
Anonymous
Josephine Baker (centre) next to the pianist Felo Bergaza and other friends in the dressing room of the Tropicana cabaret
About 1950

179
Anonymous
Rodney, the country's most famous choreographer and artistic director of the Tropicana cabaret, with Carmen Miranda
1955

180
Anonymous
The actor Robert Taylor and his wife, the actress Barbara Stanwyck, at Sloppy Joe's Bar
1940s

181
Anonymous
Marlon Brando playing the conga, Havana. With him, the Cuban author Guillermo Cabrera Infante
1956

182

183

184

185

186

187

182

Anonymous

Postcard: "Smoke Havana Cigars: a sign of good taste!"

About 1939

183

Anonymous

Postcard: "This is for Ma . . . and this is for ME!: Greetings from Cuba—Isle of Bacardi"

About 1940

184

Anonymous

Postcard: La Florida, Bar Restaurant, The Cradle of the Daiquiri Cocktail

About 1925

185

Anonymous

Postcard: Sloppy Joe's Bar. Havana, Cuba

About 1925

186

Conrado W. MASSAGUER

Postcard: "Visit Cuba: So Near and Yet So Foreign"

About 1950

187

Anonymous

Guidebook cover: "Cuba, Ideal Vacation Land"

About 1951

188

Anonymous

Brochure cover: "Tropicana: A Paradise under the Stars"

1955

189

190

191

192

193
Anonymous
The singer Rita Montaner
1948

Rita Montaner was one of Cuba's greatest performing artists. She was famous for her lyrical ballads, but also traditional Cuban songs. In 1928, she performed at the Olympia in Paris; a year later she was part of Josephine Baker's revues. In the United States, she performed with Al Jolson. In Cuba, she performed at the Mulgoba Cabaret with her friend Bola de Nieve, and also at the Tropicana, where she sang for 9 years.

194
Anonymous
Showtime at the Sans Souci cabaret
1950s

195
Osvaldo Pedro Pascual
ALBURQUERQUE
Benny Moré (centre). To his left, the Cuban singer Gloria, with members of the group Los del Conjunto performing for a Radio Progreso broadcast
1950s

Benny Moré (*El Bárbaro del Ritmo*, or "the Wild Man of Rhythm") is considered by experts and fans alike the all-time greatest Cuban singer of popular music. Although he never studied music, he was a master of all genres of Cuban rhythms: *son montuno*, the mambo, the *guaracha*, the *guajira*, the cha-cha-cha, the *guaguancó*, the rumba, Afro-Cuban songs and the bolero. His famous Banda Gigante revolutionized the jazz-band style by giving the trombone a role it had never before played in Cuban and Afro-Cuban music. He was the indisputable star of the Havana nightclub the Ali Bar in the 1950s.

189
Vicente MUÑIZ
Archway at the entrance to the Tropicana cabaret
1958

191
Anonymous
The dancer Esperanza Muñoz, believed to be the inspiration for Rita Longa's sculpture and the Tropicana's logo
1950

190
Vicente MUÑIZ
Chorus of Paquito Godines at the Tropicana cabaret
1957

192
GUILLÉN
Dámaso Pérez Prado, popularizer of the mambo, with his orchestra
1950s

Dámaso Pérez Prado became world famous for his interpretation of the mambo, an upbeat adaptation of the rumba that would culminate in the rise of salsa. "The King of Mambo's" most famous compositions include *Qué rico mambo* (later known as *Mambo Jambo*) and *Mambo No. 5*.

193

194

195

196

196

Estudio NARCY

The singer Celia Cruz

1950s

Celia Cruz ("the *Guaracha* Queen of Cuba"), one of the 20th century's most successful singers in Cuba and Latin America, became the lead singer of Sonora Matancera in 1950, and stayed with them for 15 years. In 1961, she moved to New York and began to perform with La Sonora in the Palladium Ballroom. In the course of her career, she won 3 Grammies, 4 Latin Grammies, 23 Gold Albums and numerous important international awards. Her trademark shout of *¡Azúcar!* (Sugar!) was an assertion of her pride in being Cuban.

El Manisero); the pianist and singer Ignacio Villa, known as Bola de Nieve [Snowball]; and the vivacious showman Miguelito Valdés, who frequently headlined with Xavier Cugat's orchestra at New York's Waldorf Astoria, and was the first to introduce the conga rhythm to American stages when he sang Margarita Lecuona's hit song *Babalú*. These artists were the darlings of Havana's cabarets and lyric theatres as well as the new Cuban radio stations, which began broadcasting in 1922, only two years after Pittsburgh's KDKA became the first commercial radio station in the United States.

Though his act was considered overly commercial by mainstream Cuban musicians, the Spanish-born, Cuban-raised Cugat was the greatest ambassador of the island's music throughout the 1930s. Nearly two decades before mambo and cha-cha-cha were invented, Cugat was teaching Americans to dance Cuban *son*, calling it *rhumba*, with an "h" in the middle to distinguish it from traditional rumba, which is a distinctive series of Afro-Cuban dance styles that at the time were strictly the purview of the street. In the 1940s and 1950s, *rumberas* of the more traditional type became a mainstay of cabaret stages, with stars like Celeste Mendoza (ill. 198), belting out a type of rumba song called *guaguanco*, and Estela la Rumbera, known for "her tempting body . . . which is like a living sculpture," as much as for her dancing ability.[6]

Dazzling Women

Always perceived as preternaturally sensual, the Cuban woman's allure was often part of the nightlife experience. Whether on full view at the all-nude Shanghai pornographic theatre and burlesque house in Chinatown or more discreetly revealed on the city's numerous cabaret stages, womankind was the muse of music, with its sweet, plaintive and bawdy lyrics that dealt almost exclusively with love and the assorted betrayals and delights of courtship. *La engañadora* [The Deceiver], considered the first cha-cha-cha ever written, fits directly into this theme with its story of a girl who walks near a busy corner in central Havana (practically next door to the Acera del Louvre). The girl is so well-formed and full-bodied, the song says, that all men have to stare at her. However, when they learn that her shapeliness is achieved with padding, and that she is deceiving them about her buxomness, they stop staring.

And in Havana, the idea has always been to keep them staring. In the 1940s and 1950s, the top nightclub shows included *modelos*—statuesque beauties whose only job was to sashay seductively on stage during performances. These showgirls were the epitome of female beauty; but all the cabaret women—singers, dancers, ballerinas and singer-dancers known as *vedettes*—were celebrated in television advertisements, magazines and on carnival floats for their bodies, which were ideally, in the words of Eddy Serra, a former dancer at the Tropicana, "shaped like *una guitarra*," which essentially meant having small waists, wide hips and fleshy thighs.[7] The sublime drawings of the nation's leading caricaturists often represented them—*rumberas* and other dancers—in contraposto, sinuous reminders that Cuba is about music and women, and that the two are as inseparable as the star and stripes of the Cuban flag.

Behind the Scenes

Sizzling sensuality was also a selling point for the all-female bands that played the *plein-air* cafés of the mid-1930s near the newly erected Capitolio building. The most famous was called Anacaona, after the queen of the native Taínos. Queen Anacaona was murdered by the Spanish during the conquest, and when her namesake band performed its foot-tapping melodies opposite the new, imposing seat of government, there was indeed renewed political mayhem on the island. "There we would be, with Rita [Montaner] onstage, singing *Mejor que me calle, que no diga nada, que tu sabes lo que yo sé* [It's better that I shut up, that I say nothing, because you know what I know], while outside the cabaret walls you could hear the shooting in the streets," recalled Tropicana bandleader Armando Romeu of his stint at the Eden Concert cabaret opposite Sloppy Joe's.[8]

Ruby Hart Phillips, the wife of *New York Times* Cuba correspondent James Doyle Phillips (whose post was filled by his wife after his death in 1937), describes these times as so chaotic—the government of president Gerardo Machado armed a group of civilian vigilantes called the *porristas*, who openly murdered students, labour unionists, journalists and anyone else who challenged the regime—that people began to telephone her Havana home to ask when the U.S. Marines planned to land.[9] But the Marines didn't have to land. They were already there (ill. 171). They too could be seen parading on the streets and drinking up a storm at carnival time, or crowding the entrance to Havana's Two Brothers Bar—a favourite with American sailors—or taking in the revue at Montmartre, the largest cabaret in the city.

197

Anonymous

Famous Cuban caricaturist Conrado W. Massaguer (third from the left) at a birthday party organized by friends
1943

Massaguer was a distinguished self-taught Cuban caricaturist. In 1916, he founded the magazine *Social* and later in the same year established the Instituto de Artes Gráficas. In 1921, together with other cartoonists, he organized the First Humour Salon.

198

Anonymous

Left to right:
The singer in Orquesta Sensación; a friend; the singer Pacho Alonso; and Celeste Mendoza (The Queen of "Guaguancó") at La Bodeguita del Medio
About 1950

The repertoire of singer Celeste Mendoza from Santiago de Cuba embraced the *son*, the *guaracha* and the bolero, but it was in the *guaguancó* that she excelled, earning for herself the title of "the Queen of *guaguancó*." Pacho Alonso sang in a variety of genres, including the bolero, the *guaracha* and the *son*. He popularized the musical form *pilón*, in the mid-1960s, which originated with the barrel organ and took its name from the old-fashioned coffee grinder used by country people.

197

198

After World War II, Havana's nightclub scene grew exponentially. Fuelled in part by increased American tourism and laws that relaxed restrictions on gambling, new cabarets popped up all over the city. These places could be found in basements in the posh El Vedado neighbourhood, on the road to the airport, or along the coast in the nearby suburb of Marianao. Most stayed open until three or four in the morning, while some barely got going at that hour. But they all featured live music and dancers to showcase the new rhythms of the day—the lightning-speed mambo and the tamer, more easily danceable cha-cha-cha.

The top-tier clubs—Sans Souci (ill. 194), Montmartre, Tropicana (ill. 190), the Hotel Nacional's Parisien and Meyer Lansky's Copa Room at the Hotel Riviera—had extravagant revues with star headliners like Tony Bennett, Josephine Baker (ill. 178), and Nat King Cole. These were places where diamonds and tuxedos were part of the dress code and where forty-piece swing bands alternated nightly with Cuban *conjuntos*. These were also places where gambling made money and, as such, most gaming establishments were in some way either owned or operated by American mobsters. The scene from *Godfather II* shows a group of mafiosi, led by a fictional Meyer Lansky (ill. 174), in the character of Hyman Roth, dividing Havana between them. Whether the meeting ever took place remains a mystery, but what is clear is that Lansky (who at various times ran the casinos at Montmartre,

the Parisien and his own Hotel Riviera) and his rival Santo Trafficante (who controlled the Capri, where cinema tough-guy George Raft was the host, the Comodoro and the Sans Souci) were fixtures on the gambling scene of 1950s Havana.

Paradise under the Stars
The only one of the top casino cabarets that was both Cuban-owned and operated was the Tropicana. Founded in the patio of an early-twentieth century mansion with six acres of tropical gardens, the Tropicana (ill. 189) eventually came under the control of a visionary impresario named Martín Fox, who set out to turn it into Havana's premier nightlife attraction. By all accounts, he was successful. Everyone who went to Cuba in the 1950s visited the "Paradise under the Stars," as the Tropicana was known. Celebrities who played the cabaret, like Nat King Cole, rumbaed in the dressing room with the performers. Marlon Brando (ill. 181) tried to buy the congas off the Tropicana orchestra, and Ava Gardner and her entourage occupied the best seats in the house. For Cubans and Americans alike, the main attractions were the beguiling garden setting and the shows, staged by Roderico Neyra, or Rodney (ill. 179), as Tropicana's choreographer came to be known. "Nothing was the *sueño* [dream] that Tropicana was," said Eddy Serra. "Tropicana was the maximum. Whether you were a principal dancer or in the chorus, working with Rodney you felt like royalty."[10]

A cantankerous, sharp-witted former song-and-dance man who had had to abandon the stage when he contracted leprosy, Rodney was his generation's undisputed genius of choreography. At Sans Souci, where he worked until being lured to the Tropicana by a then astronomical weekly salary of $300, Rodney staged numerous blockbusters, including *Sun Sun Babae*, a musical based on Afro-Cuban ritual that would become the trademark of nightclub entertainment in Cuba. Featuring singing star Celia Cruz (ill. 196) and a troupe of bona fide Afro-Cuban religious drummers, *Sun Sun Babae* was an onstage re-enactment of a *toque de santo*, a ceremony in which initiates dance and are possessed by the spirit of the Orishas who select them. At the Tropicana, Rodney mounted an annual Afro-Cuban production featuring the same traditional *batá* drummers and added a heart-stopping acrobatic leap by the lead dancer from the high-modernist steel sculpture of the 1920s that graced Tropicana's outdoor stage. Every three months he staged two or three new productions, with themes as far-flung as Italian light opera, Mexican folklore, Brazilian samba and the Japanese tea ceremony. Martín Fox eagerly funded these productions, which allowed costumes to be brought in from Europe and dancers from as far as Singapore. And of course there were the stars, like Carmen Miranda (ill. 179), Nat King Cole, Josephine Baker, and the greats of Cuban music, including Olga Guillot, Rita Montaner, Bola de Nieve, Celeste Mendoza, Miguelito Valdés, and the great *conguero* and Dizzy Gillespie collaborator, Chano Pozo.

One Cuban musical giant who was conspicuously absent from the Tropicana roster of stars was Benny Moré (ill. 195). The Wild Man of Rhythm, as he was called, was considered one of the country's most talented and versatile singers in the 1950s, quite possibly the best musician Cuba has ever produced, according to listeners as well as critics. Moré was an expert musical improviser and adept singer and dancer of rumba, *son*, *guaracha* and all manner of Afro-Cuban music. He was also famous for heavy drinking and not showing up to gigs—something Rodney would not put up with. Indeed, it took Moré two years of cajoling until Tropicana management finally gave him a two-week gig in 1957. "He didn't miss a performance," said Martín Fox's widow, Ofelia. But those who wanted to catch "El Benny" on a regular basis could see him at the Ali Bar—a small cabaret with a palm-thatched roof and plank tables on Avenida de Dolores, off the highway to the airport.

The best music and most raucous fun was to be had at the second- and third-tier cabarets like the Pennsylvania, the Panchín and the Rumba Palace (ill. 206–209) along the beach in Marianao. "That's where performers from the better-known clubs would go after the shows, to have some laughs and recharge our batteries," said Eddy Serra, doubled over with laughter as he told tales of aspiring artists who played these places, like the singer with a gold tooth who mimicked bolero diva Olga Guillot, or the transvestite who performed the "Dance of the Seven Veils" from *Salome*, copying Rita Hayworth's

coquettishness and ultimately feigning suicide with a kitchen knife. Unlike Sloppy Joe's, where tourists ruled and English was the language of the day, these places offered a party that was decidedly local, full of uproarious laughter, gossip, in-jokes, lots of rum (sometimes drugs) and, above all, dance and music.

"Havana was the all-night city," said Eddy Serra. "Our lives were like a show choreographed by Rodney."

1 Basil Woon, *When It's Cocktail Time in Cuba* (New York: Horace Liveright, 1928), pp. 4, 33.

2 In 1914, Mary Pickford signed a contract with Independent Motion Pictures, a company that moved its headquarters to Cuba shortly thereafter. Pickford is rumoured to have been "extremely unhappy in Havana" and cancelled her year-long contract three months short. Eyman, Scott. *Mary Pickford: From Here to Hollywood* (Toronto: Harper Collins, 1990). Also, Woon 1928, p. 40.

3 Woon 1928, pp. 43–44.

4 Graham Greene, *Our Man in Havana* (New York: Penguin Books, 1958), p. 25.

5 Leonardo Acosta, *Cubano Be Cubano Bop: One Hundred Years of Jazz in Cuba* (Washington, D.C.: Smithsonian Books, 2003), p. 31.

6 *Show Magazine* (October 1956), p. 23.

7 Among the most celebrated of the era's cabaret women was Olga Chaviano, the purported lover of mobster Norman Rothman, who managed the Sans Souci nightclub.

8 Personal communication between Armando Romeu and Marisel Caraballo, 2000.

9 Ruby Hart Phillips, *Cuba: Island of Paradox* (New York: McDowell, Obolensky, 1959).

10 Personal communications between Eddy Serra and the author, April 2007.

See also:

Lowinger, Rosa and Ofelia Fox. *Tropicana Nights: The Life and Times of the Legendary Cuban Nightclub*. Orlando, Florida: Harcourt, 2005.

CONSTANTINO ARIAS: THE INDEFATIGABLE FREELANCE PHOTOGRAPHER

Iliana Cepero Amador

Cuba entered the 1940s in a reformist mood. In 1938, the Communist Party had been made legal, and in 1939 President Laredo Bru had convened the Constituent Assembly, representing all of the island's political parties, whose task was to write a Magna Carta.[1] The Constitution of 1940—a kind of democratic socialist parliament considered one of the world's most progressive at the time—introduced a series of measures designed to implement a system of representative democracy: public education programs, reform of the labour laws and family protection programs were among its provisions. That same year Fulgencio Batista was elected president. Four years later the Auténtico Party came to power, and the governments led by Ramón Grau San Martín and Carlos Prío Socarrás became riddled with corruption; gangsterism was rife. In 1952, Batista's military coup ushered in an era in which growing economic prosperity went hand in hand with political instability. The Congress was dissolved, the constitutional guarantees of 1940 were suspended and all left-wing organizations declared illegal.

★

This was the complex historical context in which the oeuvre of Constantino Arias evolved. He was entirely self-taught, picking up the tricks of the trade in the darkroom he shared with some members of the Cooperativa Fotográfica.[2] Arias did not have a steady job with any publication, nor even a studio; he was essentially an itinerant freelance photographer, or *lambiero* as the Cubans say, a photographer working for himself, taking pictures of birthdays, weddings and baptisms. During these years he also sold photos to magazines and newspapers, shots of political and social events that might be of interest to their readers.

He had learned from the co-operative's photographers how to organize his working day. He started the morning checking the social columns of the newspaper for the announcements of the day's most prominent social events, whether it was the coming out of a debutante, a wedding between wealthy families, an important reception or a celebrity-filled party. Then he would rush off to the venue, laden with his heavy equipment, in the hope of getting there before his competitors, who were also on their way; it was a constant struggle for very little money. With

the single-mindedness characteristic of him, Arias would quickly develop his shots, either to sell to the guests at the event or to be the first to get pictures to the offices of the magazine or newspaper. This did not, of course, mean that they would always buy them.

In other words, in the context of Havana at that time he was the equivalent of the contemporary "paparazzo," although his targets were not just the celebrities of the day but rich unknowns. He spent his time attending events, banquets and birthdays: for a photographer "who had to eat," any of these occasions could provide him with a living for a day or so.

The Hotel Nacional was, however, his headquarters and his most stable source of income. He worked there as official photographer from 1941 to 1959, and set up a small darkroom in one of the bedrooms, for which he paid a hundred pesos a month. His exclusive contract with the hotel imposed a very busy schedule, taking photos constantly of whoever and whatever he came across and of people who asked for their picture to be taken. He wandered around every part of the building, from the swimming pool (ill. 202) and the restaurant to the casino (ill. 201) and

the gardens, taking souvenir photos for the swarms of tourists, mostly from the United States, enjoying the amenities of this luxurious establishment. Another of his duties was to photograph for free all the celebrities who frequented the Nacional, images that were used in the hotel's advertising material.

Arias's other priority was his political activism. He was a member of the Ortodoxo Party and of the 26th of July Movement, and a personal friend of Eduardo Chibás, a politician who actively denounced corruption, and the student leaders.[3] Thus, in addition to the social calendar and the hectic life of the Nacional, he found time to work for publications with a decidedly political orientation such as the newspaper *La Calle*[4] and the university magazine *Alma Mater* (charging the latter not a cent for the photos). From early 1940, he also published in *Bohemia*, a periodical of reformist and progressive views. It was in this publication that in 1943, in alliance with journalists Carlos Lechuga and Enrique de la Osa, he began to work on the section "In Cuba," devoted to examining the most controversial topics of the day.

★

During these years, Havana was famous for its glamorous nightlife. Hollywood film stars, celebrities of show business and the worlds of culture and international politics rubbed shoulders with the city's notables, most of them sugar barons. This hectic social scene was reported in great detail in the newspapers *Diario de la Marina*, *El Mundo* and *El País*. Not only the media but also the leading photographic studios through-

out the city displayed portraits of the wealthy classes and local or foreign celebrities, providing them with other sources of fame and validation.

But there was another Havana, the one composed of people without the means to have themselves portrayed: the beggars, the poor living in the slums, the unemployed. This part of Havana was frequently rocked by unrest involving the unions and students, by bombs going off and by political clashes in which people died. Images like these appeared in the more radical publications such as *Hoy*—the organ of the People's Socialist Party—and *La Calle*, before they were closed down by Batista's government. *Bohemia*, on the other hand, remained in print as an organ of social criticism; the content varied depending on the whims of government censorship, but it never abandoned its combative approach. Nevertheless, it must be pointed out that these disparate worlds within the same city rarely figured together in the same periodical.

Arias's insatiable quest for subjects, driven by economic necessity, political conviction and professional pride, led him to produce one of the most interesting, and certainly the most comprehensive, collections of photos of Cuba's last republican era. His work as a freelancer enabled him to cover all the diverse and dissimilar sectors of Cuban society, images of which were usually generated in isolation from each other and consequently published in media with diametrically opposed viewpoints.

The universality of Arias's oeuvre may be divided into five basic themes that

symbolize the power struggles and the marked social and racial divisions in the island. These subjects are: family and commemorative functions of the well-off classes; the poor; the marginal nightlife in and around the Rumba Palace cabaret; the comfortable ambience of the Hotel Nacional; and the mood of political uncertainty demonstrated by electoral lampoons and police on the street (ill. 210). He also photographed demonstrations by workers and university students.

His method was the so-called "flash and run" approach, for which he used a Speed Graphic camera and 4 x 5 negatives. Later on he resorted to a Rolleiflex and 6 x 6 negatives. The continual use of the flash (resulting from the lack of high-speed film) and the rapidity with which he worked produced highly realistic photographs with a great degree of immediacy and harshness. This style is also known as that of the "visual predator," since the photographers act like detectives, pouncing unexpectedly on their subjects and thus obtaining truly spontaneous images. Arthur Fellig (Weegee) was the leading exponent of this practice in U.S. press photography of the 1930s and 1940s. It might be said that Arias was Cuba's Weegee.

The strong contrasts, the use of close-ups and the feeling of improvisation are what give this rough quality to Arias's photos. Looking at his gallery of "fallen angels," there is no doubt that the most disturbing image is the one of the troubled homeless woman sleeping on the ground at the foot of a wall (ill. 199). The rough grey stone on which she is lying is an apt symbol for the

harsh life she must lead, exacerbated by the tragedy of her insanity and hopelessness. In this corner of Havana the photographer found the right person and situation to connote the sense of an acid eating away at the social fabric of the captivating city. The image also demonstrates his infallible eye for capturing the relationship between the setting and the people in it.

In the same vein, the *Parisian Gentleman* (ill. 205) sits raving on the grass like a vanquished Don Quixote. In another photo a housewife (ill. 204) in her cramped kitchen with its battered pots and pans stares at us with a look of resignation, while the gravedigger (ill. 203) hollows out a trench as if he needed it to achieve his own final destiny. All these scenes testify to the photographer's gift for revealing a direct and convincing message in almost any scene of everyday life.

The "Rumba Palace Bar" series, which Arias created for his own interest, also demonstrates his characteristic expressionist style. The rumba dancer performing her number on the ground (ill. 208), the musicians of El Chori's band (ill. 209) and the nightclub's customers (ill. 207), almost all of them Afro-Cubans, and above all, the atmosphere of the club with its ramshackle construction and makeshift decor, are the visible signs of a popular culture created by and for society's losers, rooted in eroticism, improvisation and a lack of moderation but ferociously authentic.

The photos of the Hotel Nacional show the other side of the coin. It is a luxurious setting, and some of the subjects are captured in an unexpected way as they pursue their pleasurable activities. But these images also have the pitiless quality we so often find in Arias's work. The photos of the destitute reveal the brutality of poverty, and those of the Rumba Palace show a questionable morality that is nonetheless unapologetic; the portraits of the Hotel Nacional's habitués focus on the absurd, vulgar and artificial traits that wealth fosters in those who possess it.

Finally, his snapshots of strikes by workers and students are taken in the daytime and from a distance in order to present a picture of group solidarity and unity to communicate the idea that one sector of the island's population is not complacent. In general, these subjects exude an attitude of determination, in line with the encouraging message the photographer wished to convey in this group of works. His political leanings motivated the creation of these images (ill. 211), which were intended to point to a symbolic solution of the social inequalities that his camera recorded day after day.

In the period examined here, Arias, the most famous of the freelancers, won greater regard for this craft, which had often been undervalued in the field of photography. His vast body of work explored the many layers of a flawed and turbulent society, a society in which luxurious sensuality coexisted with mental illness, pitiful destitution with mesmerizing glamour, where the sacrosanct ceremonies of families and the state took place at the same time as street riots. It was only a matter of time before there was upheaval.[5]

Most of the information about the life of Constantino Arias was provided thanks to the generosity of his widow, María Josefa González. The article "Constantino, testimonio de sus fotos" by Mayra A. Martínez in *Revolución y Cultura*, July 1986, was also consulted. The comments on publications of the period were graciously contributed by Cuban historian Carlos Bartolomé Barguez.

1 The Constituent Assembly was made up of seventy-six delegates representing nine political parties. Six of the delegates were members of the Communist Party.

2 The Cooperativa Fotográfica was founded by freelancers to protect their interests in the face of competition with the union.

3 The Ortodoxo Party was founded on May 15, 1947, by Eduardo Chibás. His main slogans were: "*Morals versus money*" and "*We promise not to steal.*" His ideology was based on anti-imperialism and the war against corruption.

4 The newspaper *La Calle*, edited by Luis Orlando Rodríguez, was dedicated to publishing articles of strong social criticism that were rejected by other periodicals because of official censorship. It was first shut down on the night of August 14, 1952. However, some time later it reopened and published numerous articles by Fidel Castro. On June 16, 1955, it was closed down for good.

200

Constantino ARIAS

200
José the lottery ticket seller. Plaza del Vapor, Havana
1948

201
Placing bets. Parisien Casino, Havana
1953

202
Guest at the Hotel Nacional, Havana
About 1950

203
Gravedigger. Colón Cemetery, Havana
1958

204
Housekeeper. Marianao, Havana
1952

205
The Parisian Gentleman. Havana
1950

The Spaniard José María López Lledín—known as "the Parisian Gentleman"—was for many years a legendary figure in Cuba. He arrived in Havana in 1913, and according to numerous reports, he lost his mind when in 1920 he was arrested for a crime he had not committed and sent to prison in the Castillo del Príncipe in Havana. He wandered the streets of Havana, always wearing a black cloak. He was never violent or foul-mouthed, and never begged, accepting money only from people he knew. The sculptor José Villa made a bronze statue of him, which now stands in a square in Old Havana.

201

202

203

204

205

206

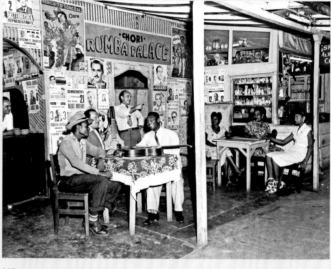
207

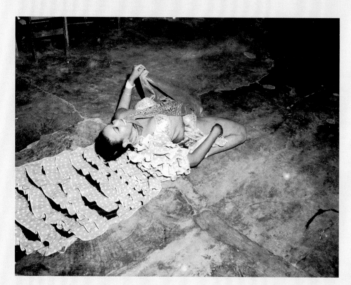
208

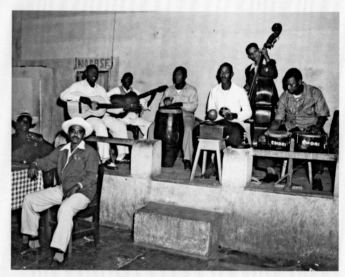
209

Constantino ARIAS
The series "Rumba Palace Bar"
(Marianao Beach, Havana)
1950

206
Prostitutes

207
Untitled

208
Dancer

209
El Chori and His Orchestra

The Rumba Palace Bar, established in 1929, was one of the second-tier nightclubs clustered around Marianao Beach in Havana. The star of the club was the drummer Chori, who played there from the 1930s until the early 1960s. The club was considered a place where "respectable people" did not go: its clients were Afro-Cubans, heavy drinkers, street peddlers, marginal members of society and petty criminals. Nevertheless, such nightspots were also a sure source of first-class music, mainly *son* and rumba. The musicians of Marianao Beach were known to be the hardest workers (on the job from 9 o'clock at night until 5 in the morning) and also the worst paid. Many rumba dancers learned their trade there, and artists of the calibre of Benny Moré, Manuel Corona, Chano Pozo and Miguelito Valdés would drop by and play.

Constantino ARIAS

210
Voting Day, Calle Virtudes, Havana
1950

211
Burying the Constitution. Martí Forge, Havana
1952

Just days after Batista's coup of March 10, 1952, Fidel Castro appeared before the Emergency Tribunal and read out a document in which he formally accused Batista of having violated all the statutes of the Constitution of 1940. In a symbolic act, students with the University Student Federation placed the document in a coffin in the main lecture hall of the University of Havana and stood vigil over it for some days. On April 6, a crowd of them carried the coffin down the steps of the university to Rincón Martiano Corner (now Martí Forge) in the old quarries where José Martí once did hard labour.

210

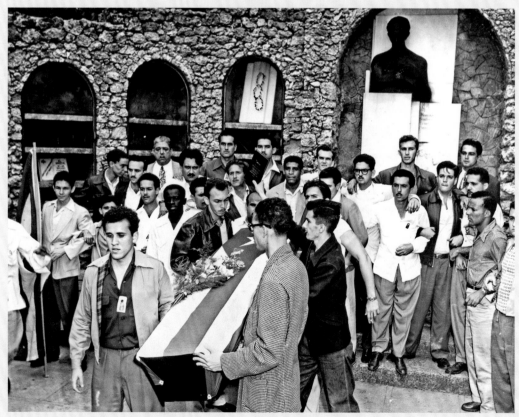

211

IN SEARCH OF AN IDENTITY (1938-1958)

Rufino del Valle Valdés

Following the fall of the Machado dictatorship, an economic crisis raised the cost of living and increased unemployment. Although there is no evidence of heightened social or political awareness, there was a renewed sense of national identity that persisted throughout the 1940s under the rule of the so-called "authentic governments," made up principally by members of the Auténtico Party. This period was captured in many documentary photographs, some of them taken at unexpected moments. For example, on March 11, 1949, Fernando Chaviano recorded some "Yankee Marines" defacing the statue of José Martí in Havana's Parque Central (ill. 213), an image that provoked outrage across Cuba. The first half of the 1950s saw a new phase in the Cuban people's long struggle. On March 10, 1952, came Fulgencio Batista's military coup. From then on, the University of Havana, its celebrated stairs and the adjacent streets were the stage for confrontations between the students and the forces of a repressive regime.

Historic images of these upheavals were produced by a number of press photographers, and the substantial portfolio of Constantino Arias demonstrates a gift for synthesis well in advance of the much praised neo-realism of 1950s cinema. With a clear and objective gaze he documented a wide range of problems, juxtaposing the vacuous dishonesty of the bourgeoisie and the dignity of the student protests, moving from working-class demonstrations and slum neighbourhoods to the glamorous lives of pre-Revolutionary Cuba's fashion models. His images are not slanted or manipulated but authentic, and provide strong contrasts between subjects he liked to photograph. His oeuvre, which constitutes crucial graphic evidence of Cuba's history, also confirms his artistic status as a major photographer.

Another important photographer of the 1950s was Vicente Muñiz, who captured the ebullient atmosphere of the Tropicana in spectacular images (ill. 189, 190). The celebrated nightlife of Havana was a recurrent subject of the period and much photographed; anonymous pictures of the time include those of Sloppy Joe's Bar, a rendezvous for Hollywood stars (ill. 180) and international celebrities.

The Sierra Maestra and its Rebel Army were also recorded for posterity by the fighters themselves, who photographed each other. But according to a letter written by Fidel Castro on March 12, 1958, the first Cuban photographer in the Sierra Maestra was Eduardo Hernández Toledo, better known as Guayo. *De la tiranía a la liberación*, a documentary he made to demonstrate why force of arms was necessary, was released early in 1959.

An image that encapsulates the history of this period was taken by Ernesto Fernández Nogueras in 1957 during the building of the Plaza Cívica (today the Plaza de la Revolución). It is a photograph of the head of the statue of José Martí in which two wooden stakes seem to blindfold the liberator's eyes (ill. 212), as if to ensure that he could not see what was happening. This untitled image is easy to read, and conveys its message eloquently without the need for words: it sums up the whole of the history of that period.

See also:

Díaz Burgos, Juan Manuel, and Mario Díaz Leyva and Paco Salinas, eds. *Cuba, 100 años de fotografía: antología de la fotografía cubana, 1898–1998*. Murcia, Spain and Havana: Mestizo and Fototeca de Cuba, 2000.

212 Ernesto FERNÁNDEZ NOGUERAS, *Statue of Martí during construction at the Plaza Cívica, Havana* (detail), 1957

213

213
Fernando CHAVIANO
Untitled
From the series "Insult to the Statue
of Martí" (Chaviano. Parque Central
Havana)
1949

On the night of March 11, 1949, drunk U.S. Marines urinated on the statue of José Martí in Havana's Parque Central. The following morning, after a photo of the incident had appeared in the newspapers, students and workers gathered in the park to denounce the profanation of the monument.

214
Anonymous
Anselmo Aliegro and Fulgencio Batista. Santiago de Cuba
About 1950

215
Ernesto OCAÑA ODIO
Homeless, Santiago de Cuba
1945

216
Raúl CORRALES
Indigents
1954

214

215

216

THE SEARCH FOR CUBAN UNIVERSALITY

Roberto Cobas Amate

The 1940s were marked by the most terrible of wars. Cultured Europe was torn apart by a conflict dominated by irrationality and greed. Artists and intellectuals were compelled to leave the theatre of war and look for new horizons. Hitherto pre-eminent cultural centres were eclipsed and attention shifted to vigorous artistic movements generated in far-off cities in the south. This was the case with Havana, which in those years became one of the most attractive cultural spaces in the world.

Against this backdrop, one of the most vibrant visual arts movements in the Americas developed. Its immediate forerunners were the *Exhibition of Modern Art* of 1937, where for the first time there was talk of the emergence of a new school of Cuban painting, and the second National Salon of Painting and Sculpture, in June 1938, the show in which modern painting was definitively entrenched, overshadowing the work of academic painters. The fundamental influence on Cuban visual art prior to the 1940s was that of Mexican paint-ing, particularly the work of the great muralists Diego Rivera, José Clemente Orozco and David Alfaro Siqueiros. This deeply Latin American sensibility

caught the attention of a new crop of artists who appreciated this Mexican art as a way of being both modern and indigenous, as well as different from the School of Paris. From this brief but intense period came some emblematic works of Cuban art: *Peasants* (ill. 125), 1938, by Eduardo Abela; *Unidad* [Unity], 1938, by Mariano Rodríguez; and *Casablanca*, 1939, by René Portocarrero. The figures in these paintings have in common a profoundly Latin American sense of an intrinsic creative principle, beyond fortuity.

Alongside the Mexican influence, some artists adapted their approach to incor-porate a reinterpretation of classical tradition, understood as a contribution to Cuban modernism. The result was the emergence of works of great impor-tance that left their mark on Cuban art of the period. Among the pioneers were Antonio Gattorno, whose oil *The Siesta*, 1939–40; (ill. 224) represents the apogee of his Cuban-inspired painting and the starting point of his surrealist cycle, and Mario Carreño with two of the masterpieces of his career, *The Birth of the American Nations* (ill. 217), 1940, and *Discovery of the Caribbean* (ill. 218), 1940. These ambitious allegories, inspired by the Americas and strongly influenced

by the Italian Renaissance, are consum-mate examples of Carreño's classical leanings, adapted with great sensitiv-ity to Cuban themes on his return to Havana. Similar in spirit is the work of Jorge Arche (ill. 219–223), the leading portraitist of Cuba's *Vanguardia* genera-tion. One of his most important paint-ings is *Springtime* or *Repose* (ill. 219), 1940. At a time of worldwide disquiet, Arche set his pair of lovers in an ideal landscape, resting happily in a state of physical and emotional fulfilment. Escaping from cruel reality, he sought in the spiritual a measure of comfort impossible to attain by other means.

Indeed, it was this quest for a spiritu-ality that would rescue and exalt the essence of Cuba that constituted the main thrust of the modernist movement on the island. In the 1940s, a mastery of contemporary visual language together with a renewal of Cuban cultural traditions brought about a productive maturity of Cuban art. The avant-garde legacy of the School of Paris was taken up, though filtered through a sensibility geared toward the search for a genuine expression of Cubanness.

In this historical context, José Lezama Lima's poetry and essays had a decisive

217

influence on some of the best painters of the period, leading a group of them to attempt to revive the historical memory of Cuban culture's Hispanic roots. This creative, dynamic rediscovery of the past became the cornerstone of a modern vision, supporting a reconfirmed identity projected as a paradigm of what is Cuban. The work of Mariano Rodríguez and René Portocarrero falls into this category. Both were close to Lezama's aesthetic concerns and involved with publishing projects for his magazines *Espuela de Plata* (1939–41) and *Orígenes* (1944–56). Other artists at that time, like Amelia Peláez, Cundo Bermúdez, Mario Carreño and Felipe Orlando, shared the sensibility of their era, which was part of the whole movement of renewal.

In 1941, Mariano Rodríguez and Cundo Bermúdez revealed the potential of their approach to art by focusing on the life around them. The rooster (ill. 228) became the basic symbol of Mariano's poetics and a quintessential expression of national identity. An icon of Cuban painting, *El gallo pintado* [The Painted Rooster], made its appearance, marking a crucial moment for Cuban art in its quest to attain a universal dimension. The same can be said of his cityscapes of Havana—a city rediscovered as a space to affirm Cuban self-awareness, given legendary status—and also of his domestic interiors, in which the sensuality of his female figures is tempered by his self-contained hedonism.

Cundo Bermúdez's painting alternates between Renaissance classicism and a fascination with popular art. Two remarkable portraits, the *Retrato de Luisita Caballero* [Portrait of Luisita Caballero, 1938] and *Retrato de Fina y Bella García Marruz* [Portrait of Fina and Bella García Marruz, 1940], bear witness to his love for the classical. However, his definitive works were rooted in his love of everyday city life and the traditional customs of ordinary people. The first painting to demonstrate his mature style was *The Balcony*, 1941 (ill. 230). It is an affectionate glorification of his beloved Havana and its inhabitants. Cundo Bermúdez discovered the essence of his art in the splendour of the banal. His contemporary re-creation of ordinary scenes such as *Barber Shop* (ill. 231), *El billar* [Billiards], *El limpiabotas* [The Shoeshiner] and *Pareja en el parque* [Couple in the Park] show the key themes of his painting elevated to the status of Cuban archetypes.

Amelia Peláez translated into painting the formal values inherited from Cuba's magnificent colonial architecture, threatened with disappearance. The "Cubanization" process she began in the mid-1930s achieved extraordinary density and opulence in the 1940s. More particularly, she recaptured the beauty of interior spaces, revealing an exuberant variety of shapes based on the infinite possibilities offered by stained-glass windows, ironwork, columns and furniture, arranged around a

central motif: the still life (ill. 232, 233). Women are included in the scene as just another decorative element in profoundly private paintings. Nonetheless, the new atmospheres Peláez created, imbued with a particular baroque grace, convey a feeling of endlessness and sublimation that make her painting a conclusive synthesis of what is Cuban.

René Portocarrero's work is among the most representative of that defining time for Cuban art. A vigorous colourist with a forceful expressionistic style, Portocarrero structured his paintings with a profuse ornamentation that evolved into the baroque style of his private scenes in enclosed spaces (ill. 236, 237), so oppressive as to be stifling. His celebrated *Interiores del Cerro* [El Cerro Interiors] epitomizes what is most valued in his oeuvre: childhood memories re-created in his fertile imagination. Portocarrero looked back at the past but was not content with the nostalgic vision of a bygone age; he singled out the meaningful elements of that environment, reworking the notion that "what is Cuban," as José Lezama Lima said, "achieves universality naturally."[1]

When Wifredo Lam returned to Cuba in 1941, he brought a different viewpoint to Cuban art, one dedicated to restoring the rich heritage of the island's Afro-Cuban cultures. His attitude was far removed from that of the artists and intellectuals connected with the magazine *Orígenes*, who were reviving

the Hispanic values of Cuban culture. Over and above this difference in focus, however, the two lines of thought converged in the search for new definitions of Cubanness.

"Find the universal in the depths of what is local, and in what is circumscribed, the eternal" was the Miguel de Unamuno dictum that Alejo Carpentier used to describe Wifredo Lam's work.[2] It applies equally well to all the other Cuban artists of the 1940s, whose determination, talent and intelligence created one of the most powerful art movements in the Americas, the legendary School of Havana.

1 José Lezama Lima, *La visualidad infinita* (Havana: Editorial Letras Cubanas, 1994), p. 238.

2 Alejo Carpentier, "Wifredo Lam en New York," *Información* (June 21, 1944), p. 14. Also appears in *Wifredo Lam. La cosecha de un brujo*, an anthology edited by José Manuel Noceda (Havana: Editorial Letras Cubanas, 2002), pp. 185–186.

218

218
Mario CARREÑO
Discovery of the Caribbean
1940

219
Jorge ARCHE
Springtime or *Repose*
1940

219

220

Jorge ARCHE

220
Bathers
1938

221
Domino Players
1941

222
Portrait of Mary
1938

223
José Martí
1943

221

222

223

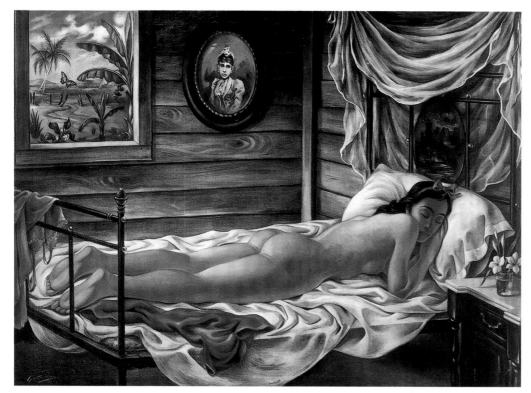

224

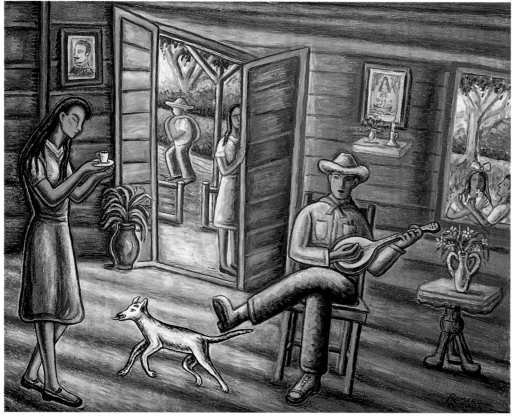

225

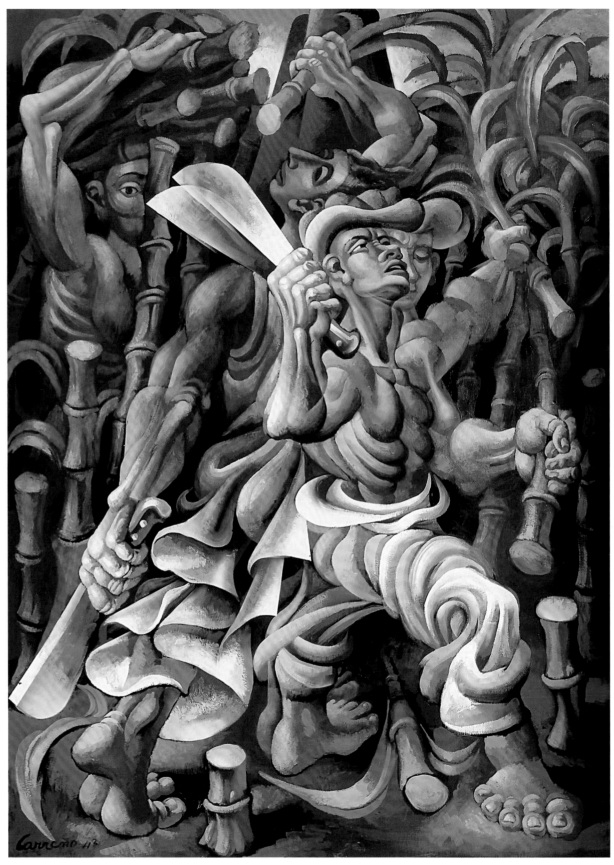

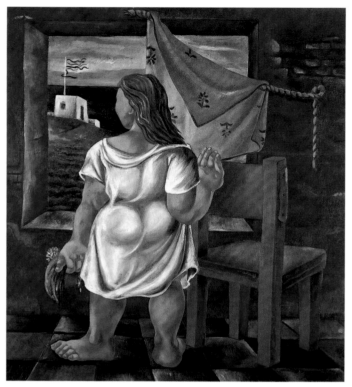

227

228

229

230

190

227
René PORTOCARRERO
Woman at the Window
About 1940

228
Mariano RODRÍGUEZ
Rooster
1941

The rooster has become a
symbol of Cuban identity and
cockfighting has always been
an abiding passion on the
island, and so the fighting
cock is a metaphor for virility
in popular culture. The artist
Mariano Rodríguez used
this symbol in many of his
paintings.

229
Mario CARREÑO
Interior
1943

230
Cundo BERMÚDEZ
The Balcony
1941

231
Cundo BERMÚDEZ
Barber Shop
1942

231

232

Amelia PELÁEZ

232
Pitcher of Flowers
About 1945

233
Fish
1943

233

234

235

234
René PORTOCARRERO
Mythological Figure
1945

235
José MIJARES
Life in an Interior
1950

236
René PORTOCARRERO
Tribute to Trinidad
1951

237
René PORTOCARRERO
Landscape of Havana in Red
1972

236

237

LAM, A VISUAL ARTS MANIFESTO FOR THE THIRD WORLD

Roberto Cobas Amate

Wifredo Lam returned to Cuba in August 1941 following a long, dangerous trip. He arrived in the Americas, like so many other intellectuals and artists, leaving behind the horrible drama of the war in Europe. After seventeen long years, his emotions upon returning were mixed: on the one hand, there was the joy of seeing his loved ones again, on the other, the bitter realization of having to start over in a world where he was an unknown.[1]

His reintegration into the Cuban cultural setting in the 1940s was doubtless complex and difficult. For an artist who had worked at the very centre of modernity, as an active member of the School of Paris, praised by Picasso and admired by Breton, it was hard to be in tune with an environment where visual arts had developed within a different dynamic. At that time, Cuban modernism had already consolidated a strong, original expression, rooted in the rediscovery of traditions contained in the idealized memory of a colonial past—a past whose opulent features were still apparent in the legacy of architecture and furniture belonging to the white-Cuban culture with Spanish roots. This

recuperated memory corresponded closely to the poetry and essays of José Lezama Lima and the generation of intellectuals and artists who would be brought together by the magazine *Orígenes*—far removed from Lam's cultural interests. In Paris, he had been closely connected with the appreciation and enjoyment of African art, and his first works of importance stemmed from studying this art, in terms of its form and spirituality; for example, *Mother and Child, II* [ill. 240], 1939.

In Lam's eyes, if anything deserved to be rescued and saved in Cuba, it was the dignity of Afro-Cubans and their ancestral culture. He declared: "I wanted, with all my might, to paint the drama of my country, but expressing in depth the spirit of blacks, the beauty of the art of blacks. This way I would be like a Trojan horse from which would emerge fantastic figures capable of surprising, of troubling the exploiters' dreams."[2] This is the essence of his thinking. His progress in this direction, however, was modest and the initial results can be considered somewhat frustrating, despite André Breton's enthusiasm over the gouaches Lam sent for his show at the Pierre Matisse Gallery in New York, in November 1942.

The work he did in Havana in 1941 and 1942 shows how his artistic expression was still dominated by stages left unfinished due to the vicissitudes of war. The powerful personalities of Picasso and Breton cohabited in his mind. Thus *Mujer e niño* [Woman and Child], 1941, evokes other portraits of mothers he did in Paris; this is a composition with a Cubist structure but marked by the rising influence of African sculpture. In it, he timidly introduces the presence of colonial ironwork that moves the scene closer to a new cultural geographic location: Havana. For their part, *Estudio para un retrato de Helena* [Study for a Portrait of Helena], 1941, and *El rey del juguete* [The King of Toys], 1942, paintings on paper, take up images executed in ordinary notebooks in Marseille, which Lam brought with him on his return to Cuba.

While Lam was busy struggling to find himself in his country of birth, other Cuban visual artists had asserted their discourse in the search for an indigenous expression of identity. This was true for Amelia Peláez, with her exquisite native still lifes; René Portocarrero and his nostalgic interiors in the old Havana neighbourhood of El Cerro;

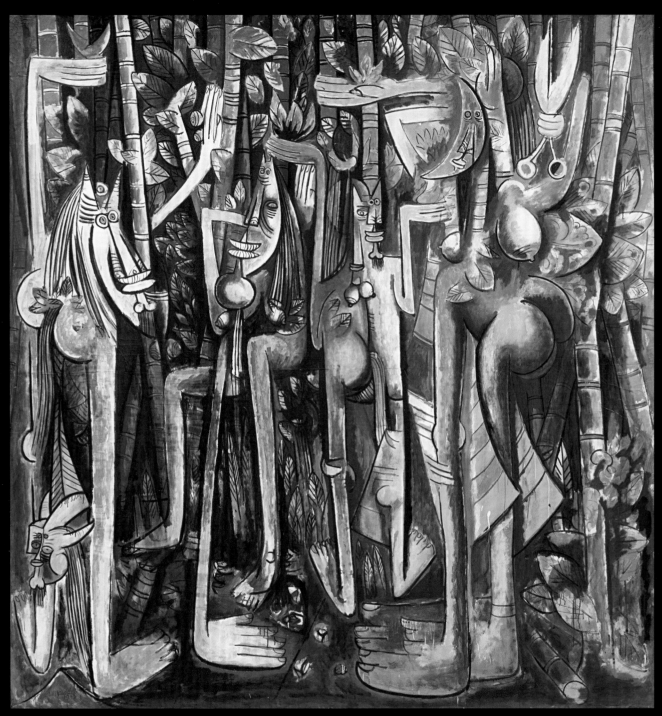

Víctor Manuel García and the idyllic landscapes of Matanzas; Mariano Rodríguez, with his splendid roosters, bursting with colour and movement. Together with other equally notable personalities, they created images that quickly became icons of Cuban painting at the time.

Lam did not despair, however. He worked methodically but intensely to find original solutions to this first cycle of Cuban works so close to his French experience. His friendship with Cuban writer and ethnologist Lydia Cabrera, a scholar of Afro-Cuban folklore and customs, turned out to be decisive in his development. Thanks to her, Lam was introduced to the poetry embedded in Afro-Cuban beliefs. This was unexplored territory and triggered painting that would serve as an isolated but powerful pole in the visual arts of the period. Because of this revelation, Lam went beyond the boundaries of established practice within analytical Cubism and imbued it with new life, with an unprecedented lyricism.

From then on, Lam worked hard on adapting Cubism and Surrealism to the magical "virgin" world he had just discovered: "Here in Cuba were things that were pure Surrealism, for example, Afro-Cuban beliefs; in them one could see poetry preserved in its magical primitive state."[3] He worked tirelessly, painting on kraft paper. The experiment was successful and thus *Mother and Child in Green* (ill. 242), *Woman on Green Background* (ill. 243) and *Figure with Rooster* (ill. 244) made their appearance, along with other oils and temperas, which were important precursors to outstanding paintings in his later work. This path led him to *The Jungle*

(ill. 238), *The Chair* (ill. 247), *La mañana verde* [The Green Morning], *Mofumba* (ill. 248) and other works in which he achieved a novel aesthetic interpretation of the turbulent, complex reality of the Americas. The vitality of this painting and the regenerating power it radiates catapulted Lam into the avant-garde of Cuban art of the time.

Lam's work in his first Cuban cycle sparked writer Alejo Carpentier's enthusiasm. The two had met in Spain in 1933. When they met again in Havana, they formed a close friendship. Carpentier was a passionate defender of Cuban culture of African origin. His first novel, *Ecué-Yamba-Ó* [Praise Be the Lord], published in Madrid in 1933, was a sensitive introduction to the subject. It is not surprising then that Lam's painting aroused Carpentier's interest and earned his unconditional support, expressed in favourable critiques and commentaries that appeared in various Cuban and foreign cultural publications. In these writings, imbued with his astute observations, he endorsed with keen appreciation the importance of Lam's work in the context of Latin American art in the 1940s. It was Carpentier who, early on in 1944, pointed to its unprecedented significance: "The monumental painting *The Jungle*, and all those that heralded it and derived from it are a momentous contribution to the new world of Latin American painting."[4] In *The Jungle*, Lam synthesizes the main contributions of the avant-garde artists (mainly Picasso, Cézanne and Matisse) and, in disturbing images of disconcerting visual and conceptual density, puts them to use in expressing an original poetic sensibility that could not have occurred anywhere

else than in what José Martí described as "Our America."[5]

Lam went on to paint large-scale works in which he gave full rein to the expressive richness of a luxuriant vegetation and exuberant tropical fruits, like bananas and papayas, which he skilfully incorporated in his painting, drawing on their sexual connotations. At the same time, he worked on a group of compositions in which he pursued the study of the optical effects of light and colour and their use in a Cubist framework. The dazzling result is seen in a series of oils on paper, mostly painted in 1943 and 1944, and characterized by an impressionist, almost pointillist brushstroke that gives shape to the loosely defined outlines of the figures through contrast of colour, light and the ochre background of the paper. This is apparent in *Mujer con las manos en alto* [Woman with Hands Raised] and *Pájaro-flor* [Flower-Bird]. Lam's fascination with "Cuban light" is revealed when he says admiringly how "the transparency of the light produces a magical effect on colours. Our light is so transparent that the leaves on some trees give the impression of being lighted from within. For here, even with your eyes closed, the Sun gets inside you, through your mouth, your ears. In Cuba the light causes me to live in a permanent state of drunkenness. Actually, I can't talk about how I see colours, only about their transparency, which suggests a new relation between their values."[6]

Having consolidated what would be the core of his artistic vision—around which his subsequent periods revolved in a spiral—Lam explored traditional subjects in painting, to which he brought a different visuality as a result of the

synthesis of Cubism and Surrealism. He attained a new pictorial dimension based on a poetic interpretation of the singular Latin American reality. It is the visual realization of the "marvellous reality," the revolutionary thesis that Alejo Carpentier formulated in the prologue to his novel *El reino de ese mundo* [The Kingdom of This World].[7] The Cuban writer became aware of the magical essence of the American continent's reality on a trip he made to Haiti in 1943: "I find myself . . . in the presence of the wonders of a magical world, a syncretic world . . . in me arises . . . the perception of what I call 'the marvellous reality,' which is different from magic realism and Surrealism per se."[8] It was precisely in Wifredo Lam's painting that Carpentier found confirmation of his marvellous reality thesis, describing it as a paradigm. He stated categorically, "And it had to be a painter from the Americas, the Cuban Wifredo Lam, to show us the magic of tropical vegetation, the unbridled Creation of Forms of our natural world, with all its metamorphoses and symbioses, in monumental canvases of expressiveness unique in contemporary painting."[9]

Thus landscapes, still lifes and portraits are transmuted and impregnated with a vibrant magic present in everyday life. From this cycle come the so-called altars, a series of works executed in about 1944, in which Lam incorporated elements from Santeria and spiritualism. In them, he reshaped the traditional subject of still lifes, giving them a magic-symbolic content. The altars are made up of offerings to the Afro-Cuban deities and spiritual entities who eat and drink just like human beings. One of the more suggestive ones is *The Dinner* (ill. 249), where three Eleguas

appear in a bowl on a table surrounded by vegetation. The representation of Elegua—one of the most important Orishas in the Yoruba pantheon, the keeper of "the keys of destiny, [who] opens and closes the door to misfortune or happiness"[10]—points to Lam's immersion in the Afro-Cuban religions, in which he moved with complete freedom and lofty poetic flight.

Of great interest too is how he approached portraits and how they evolved, from those done in Spain in the second half of the 1920s in a realist style to those created now in Havana, with his inspiring muse, his inseparable partner and wife Helena Holzer. Already in his Marseille drawings, Helena's face appears as an essential source of inspiration. Her lovely profile and delicate beauty are recognizable in some of Lam's ink drawings for André Breton's book *Fata Morgana*. The Surrealist influence was to dominate the first works Lam executed with Helena as subject after he arrived in Havana: for example, the very interesting study for a *Portrait of Helena*, 1941, points to some of the directions his painting would take in the years to come, and the innocent charm of *Retrato de Helena* [Portrait of Helena], about 1942, in which she appears as a graceful mermaid. In 1944, however, when they married, Lam threw himself fully into what was to be a masterful study in synthesis, which led him, work by work, from an almost realistic conception to a totally transfigured interpretation of the human subject. In these portraits, Helena appears mostly seated and in repose. In some of them, her introspective, thoughtful nature is apparent, but it is not physical or psychological resemblance that really interests Lam, rather it is the

transformation of the subject into a new spiritual entity: Helena's Caucasian profile disappears and her form reappears, emerging triumphantly from vegetation suggested by sugar cane, her face transformed into an African mask.

In other works Lam addressed the apparently antagonistic diversity of the universe, a conflict he resolved through an osmosis in which all creatures, material or immaterial, take part, in an action that reaffirms the unity of existence. The figures arising from this imagery are integrated into nature as a universal expression of life. In *Flower-Bird*, 1944, or *Winged Figure* (ill. 251), 1945, we observe the consolidation of a poetics of transmutation and a symbiosis of different worlds, apparently opposite and irreconcilable, reconciled in an act of perpetual fusion.

The Influence of Haiti
In the 1940s, a powerful cultural movement emerged in the Caribbean islands. The European intellectuals who had recently arrived there fleeing the war marvelled at the calibre of literature and art in those countries. In this regard, Haiti was remarkable for the potential of its culture and its ability to disseminate it in the area. This was the period of splendour in Haitian poetry, expressed with remarkable originality and quality in the work of René Bélance, Magloire Sainte-Aude and René Depestre, among others. Popular painting also was discovered, its most outstanding artist being Hector Hyppolite, praised by Breton.

Cuban writers and artists were captivated by the inspirational power of Haiti's art and set out to discover its fascinating culture. Poet Nicolás

Guillén, novelist Alejo Carpentier and painter Carlos Enríquez all went there. Particularly noteworthy was the exhibition *Les Peintres Modernes Cubains*, held at the Centre d'Art Port-au-Prince from January 18 to February 4, 1945. At the end of that year, René Depestre and other Haitian intellectuals founded an avant-garde art magazine called *Ruche*, which devoted a special issue to André Breton. All this interest in art developed during writer Pierre Mabille's stay in the country. He had been named Free France's cultural attaché in Haiti, and he invited Wifredo Lam to mount a show there.

Just as Lam's sojourn in Marseille had a decisive influence on his subsequent work in Havana, the trip to Haiti in late 1945 with his wife Helena, the exhibition he put together at the Centre d'Art in Port-au-Prince, and the months he spent in the country brought about an unexpected change in his work. It was the result of his contact with the Haitian intellectual movement, the exchanges he had with Mabille and Breton (who was also visiting the country and delivered a historic lecture there) and, especially, his discovery of voodoo. The syncretic sense of his work was enriched by his admiration for the literature and the arts of Haiti. He was surprised by the widespread respect for culture of African origin, as expressed in fiction writing. Haitian artists and writers manifested their interest in European avant-garde trends through poetry that reconciled voodoo and Surrealism. What most impressed Lam, however, were the voodoo ceremonies he witnessed in the company of Mabille and Breton. He expressed his excitement when describing one night in particular: "What savage beauty! A

non-intellectual beauty welling up to the surface, human emotion in all its nakedness. But André [Breton] couldn't stand the spectacle. It made him nauseous. I mocked him affectionately, reminding him that he had written: 'Beauty will be convulsive or will not be at all.'"[11]

Lam had his show at the Centre d'Art in Port-au-Prince from January 24 to February 3, 1946. André Breton gave the opening address and the exhibition was a major cultural event. Breton also gave a lecture in Port-au-Prince in which he made statements of great importance about Lam's work, raising it to the status of a paradigm in Surrealist thinking of the day. Breton affirmed categorically: "Never, except for Lam, has the union of the objective world and the magical world come about, without a hitch. Never, except through him, has the secret been found of unifying physical perception and mental representation—a secret we are still seeking in Surrealism."[12]

The close relationship Lam maintained with Breton and Mabille in Haiti confirmed his renewed interest in alchemy and hermetic philosophy. In Haiti he discovered, much to his surprise, that the local religion, voodoo, had incorporated practices from European witchcraft. The assimilation of these bases into the Afro-Caribbean cultural components already found in his painting led him to project a new discourse of open exchange between cultures. It was in this forging of integration that his work took on a new dialectical and intercultural dimension.

Expressing Continental Americanism

On his return from Haiti, Lam did not

rest. In an exhibition he held at the Havana Lyceum from April 11 to 19, 1946, he showed some twenty canvases painted between 1943 and 1946, some of them outstanding such as *Presente eterno* [Eternal Present] and *Bodas químicas* [Chemical Weddings]. This show marked an especially significant moment since it was a compendium of the extremely high level the artist had achieved in his first Cuban cycle—what Alejo Carpentier called "the period of classical Wifredo Lam."[13] At the same time, it was the beginning of a second period stamped with the imprint of Haitian culture on his soul, with major changes in form, iconography and colour.

In this respect, *Hurricane* (ill. 239), an oil on jute executed in 1946, is the pinnacle of the new expression of continental Americanism as Lam conceived it. It is an impressive work in that it concentrates all the mystery of creation in a moment of apparent calm; when animist forces are in a state of utmost tension, gods and plants, animals and fruit, day and night, converge, becoming part of a unifying whole. With *Hurricane* Lam puts the chaos of creation in order.

In the work he did in 1947, a group of totemic figures stand out; they are driven by a disconcerting aggressiveness, reflecting intense spiritual turmoil and an inner need for expression. These images emerged from a renewed desire to confront viewer apathy with a fresh and vital message. A radical overhaul of his visual language occurred at this time. The sun-infused painting of his first Cuban cycle (1942–45) was replaced by an esoteric style in which the shadows of night prevail. He obtained this effect

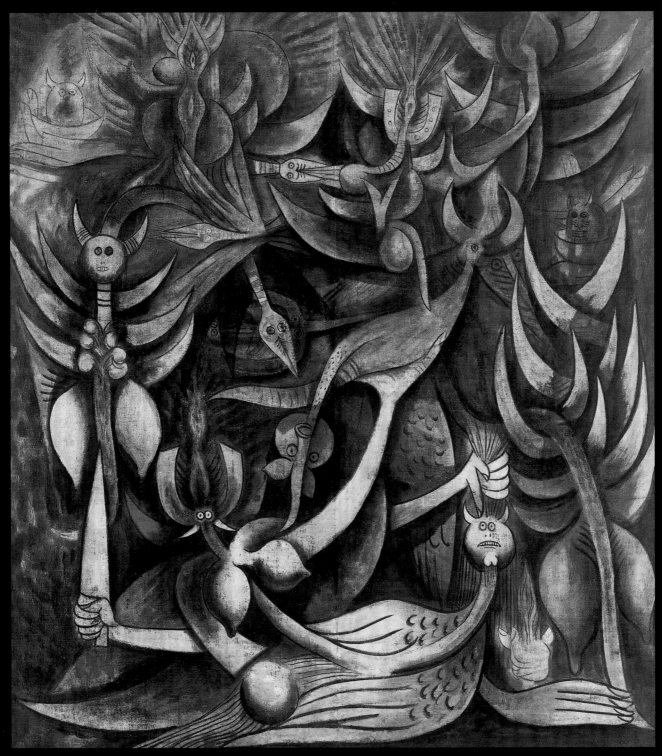

239

with a limited palette: black, ochre and sienna. Thus emerged one of his most impressive creative cycles, in which the series known as "Canaima" (ill. 253) is particularly noteworthy, along with other works characterized by their vibrant energy and the erection of powerful, sharp, menacing forms. Among them are *Figura sobre fondo ocre* [Figure on Ochre Background], *Female Torso* (ill. 254), *Cuatro figuras sobre fondo ocre* [Four Figures on Ochre Background], *Figuras zoomorfas* [Zoomorphic Figures], *Personaje con dos elegguás* [Figure with Two Eleguas] and other compositions painted in oil or tempera on kraft paper, dominated by a sombre atmosphere. Although the paintings in this series have enough character to stand on their own, they are studies for four major compositions summarizing the conceptual and visual experiments of the period: *Tres dimensiones* [Three Dimensions], *Nacimiento* [Birth], *La boda* [The Wedding] and *Belial, emperador de las moscas* [Belial, Emperor of the Flies].

The monumental nature of the striking works on canvas and kraft paper created in 1947 and 1948 gave way in 1949 to a different kind of composition— equally impressive but presenting in addition an elegant, integrated design. Here the figures, drawn in charcoal, look like cut-outs on a neutral background. There is an evident return to earlier themes, such as seated women and motherhood, to which he added the woman-horse, an emblematic figure of powerful sensuality, and the roosters of the Caribbean.

Crucial to the new direction his paintings took were an exhibition at the Pierre Matisse Gallery in New York in May 1950 and another in Havana's Parque Central in October of that same year. In a group of imaginary portraits of slender women, Lam started from a classical representational schema only to subvert it by including plant and animal elements, as in *La novia de Kiriwina* [The Bride from Kiriwina], 1949, and *La sirena del Níger* [The Mermaid of the Niger], 1950. At the same time he painted other works using geometric motifs whose symbolism was left open to the viewer's interpretation. Distinguished by rigorous design and the austere application of colour, these works verge on abstraction without yielding to its demands. *Punto de partida* [Starting Point] and *Umbral* [Threshold], both dated 1950, and *Contrapunto* [Counterpoint], 1951, established a new development in his paintings, which achieved a conceptual breakthrough based on their multiple meanings.

Beyond the simultaneity of his creations, whether closer to figuration or abstraction, and the approach to his themes, whether new or recurrent, Lam elaborated an original visual discourse through an alignment of elements from different cultures—Afro-Caribbean, European, Asian and the Pacific islands—which should be viewed as "elements introducing an open discourse."[14]

In the 1950s, Lam was deeply moved by the art of the "primitive" cultures of New Guinea, adding a group of pieces from the region to his collection. His interest in these disturbing totemic sculptures would be reflected in new variations in form in his painting. In a work like *Cuando no duermo, sueño* [When I Don't Sleep I Dream], 1955, he combines the permanent presence of African masks, on the one hand, and, on the other, the inclusion of elongated figures that stretch from one end of the composition to the other, stemming from a reinvention of New Guinean sculpture.

In the 1960s, he worked on a set of large compositions in which he summarized the conceptual and stylistic achievement of his painting in the 1940s and 1950s. The cycle began with some works from the late 1950s, for example, *Amanecer* [Dawn], *Cerca de las Islas Vírgenes* [Close to the Virgin Islands] and *The Sierra Maestra* (ill. 257), each created in 1959, heralding the changes to come in his painting. Lam's art was revitalized and took on new vigour, flooding museums and galleries with a social spirit. His canvases resonated with the mood of rebellion of the world's dispossessed, and were consonant with African countries' decolonization movements and the struggles of guerrilla fighters demanding dignity for the peoples of the Americas.

The Third World (ill. 258) was conceived in the stunning intensity of New Year's Havana, 1965–66, and marks a climactic moment in this series. This canvas is, in the words of the artist himself, "my tribute in painting to the Cuban Revolution."[15] Alejo Carpentier described it as "a monumental paint-

ing, an extraordinary painting in its size and content."[16] In *The Third World* the canvas is invaded by figures contorted by an intense dynamism in a synthesis of Lam's iconographic universe. The work's expansive energy is balanced by the horizontality of the main figure, whose extremities span the entire composition. With its dramatic force and powerful poetic imagery—comparable to Picasso's *Guernica*—this painting is capable of rattling consciences, and quickly became an essential emblem of an era.

Wifredo Lam, poet of the mythical, was able to find, in the wealth of cultures overlooked by the powerful, the fuel that fed his own fire. Through his art, he created a bridge that united, that broadened understanding among people. The syncretic, integrating nature of his work fostered the development of a multicultural discourse with which he reached every latitude. His is Esperanto painting, because his art was nourished by the very essence of human knowledge. That is why his legacy continues to be absolutely relevant, and today he is proudly acknowledged to be one of the truly universal artists of the twentieth century.

1 Lydia Cabrera recognized the situation when she pointed out: "We didn't know that this 'authentic painter' (the phrase is Picasso's) . . . whose name we often saw in catalogues of modern painting exhibitions alongside those of Braque, Léger, Klee, Ernst, Miró, Gris, Chagall, Picasso . . . was Cuban!" Lydia Cabrera, "Un gran pintor: Wifredo Lam," *Diario de la Marina*, Literary Supplement (May 17, 1942), p. 2.

2 Max-Pol Fouchet, *Wifredo Lam* (Barcelona: Ediciones Polígrafa, S.A., 1989), p. 188.

3 Gerardo Mosquera, "Mi pintura es un acto de descolonización." Interview with Wifredo Lam, in *Exploraciones en la plástica cubana* (Havana: Editorial Letras Cubanas, 1983), p. 189.

4 Alejo Carpentier, "Reflexiones acerca de la pintura de Wifredo Lam," *Gaceta del Caribe* (July 1944). Also appears in Alejo Carpentier, *Conferencias* (Havana: Editorial Letras Cubanas, 1987), p. 226.

5 *Nuestra América* [*Our America*] is the title of one of the most clear-sighted political essays about the Americas, written by Cuban independence hero José Martí in the nineteenth century.

6 Antonio Núñez Jiménez, *Wifredo Lam* (Havana: Editorial Letras Cubanas, 1982), p. 232.

7 On his return to Cuba from a trip to Haiti that deeply impressed him, Carpentier began to write *El reino de este mundo* [*The Kingdom of This World*], which he finished in Caracas in 1948. The prologue of this novel, titled "Lo real maravilloso de América," was published for the first time on April 8, 1948, in the Caracas paper *El Nacional*. It is an essential text for understanding the literature and art of the Americas. *El reino de este mundo* was first published in Mexico in 1949.

8 Quoted by Araceli García-Carranza, in *Biobibliografía de Alejo Carpentier* (Havana: Editorial Letras Cubanas, 1984), timeline, p. 20.

9 Alejo Carpentier, *El reino de este mundo* (Havana: Editorial Letras Cubanas, 1987), p. 3.

10 See Natalia Bolívar Aróstegui, *Los orishas en Cuba* (Havana: Ediciones Unión, 1990).

11 Fouchet 1989, p. 206.

12 *André Breton y el surrealismo*, exhib. cat. (Madrid: Museo Nacional Centro de Arte Reina Sofía, 1991), p. 359.

13 Alejo Carpentier, "La pintura de Wifredo Lam," *La cultura en Cuba y en el mundo* (Havana: Editorial Letras Cubanas, 2003), p. 120.

14 Recommended reading is the essay "Un Eleguá para acercarse al cíclope," by professor and art critic Lázara Menéndez, who makes an important appraisal of the polysemic character of Lam's work, in *Artecubano*, vol. 1 (2000), pp. 72–79.

15 Núñez Jiménez 1982, p. 217.

16 Carpentier 2003, pp. 115–116.

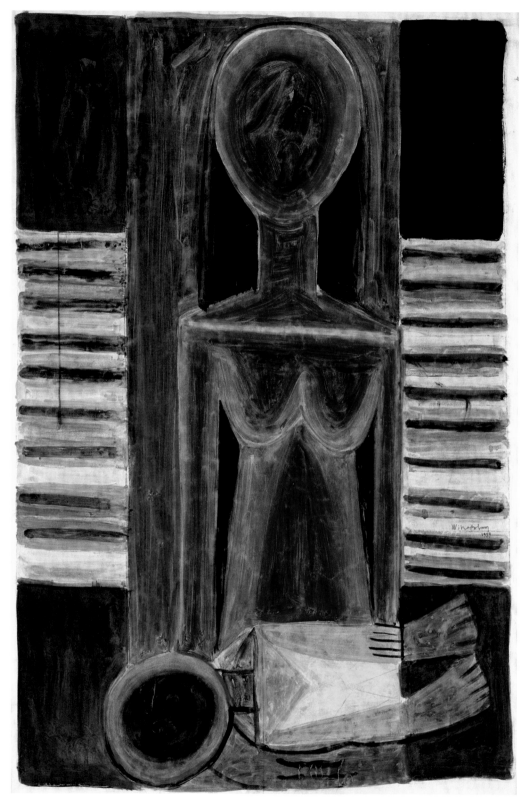

240

Wifredo LAM

240
Mother and Child, II
1939

241
The King of the Cup and Ball Game
or *Zoomorphic Figure*
1942

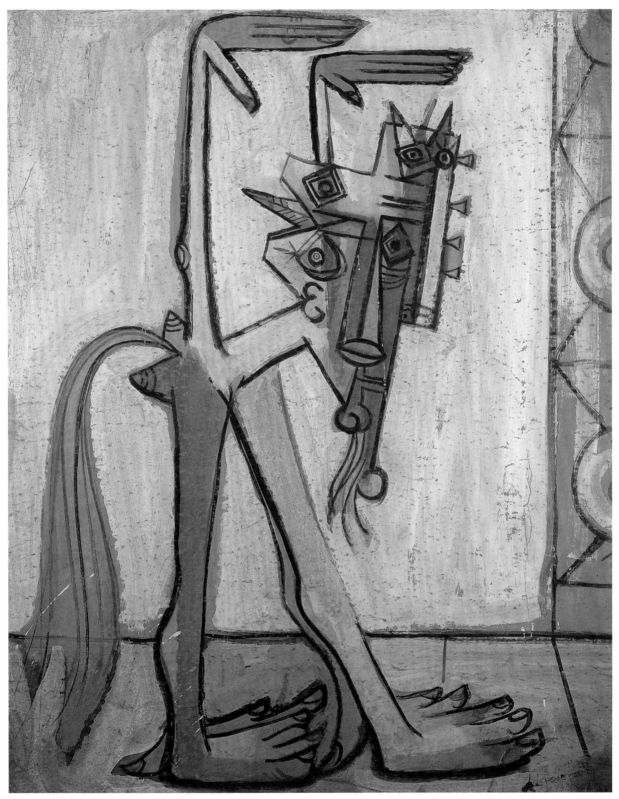

241

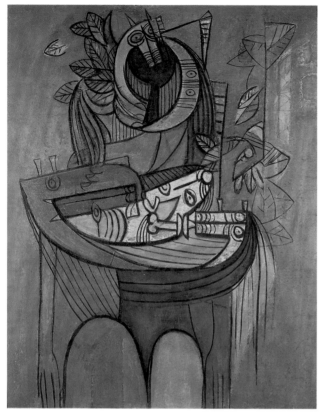

242

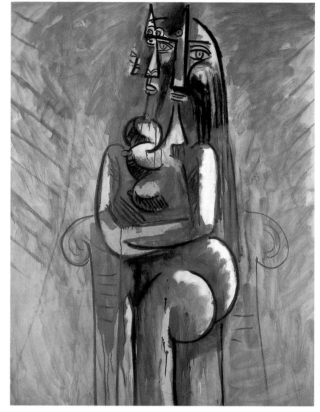

243

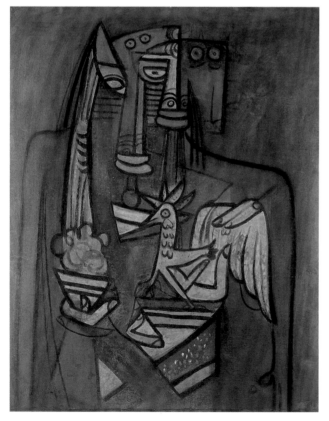

244

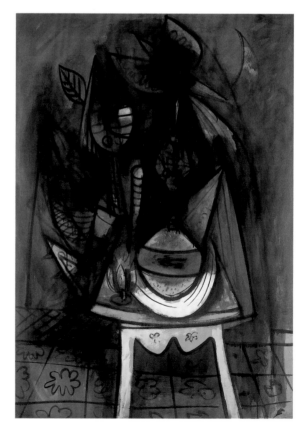

245

Wifredo LAM

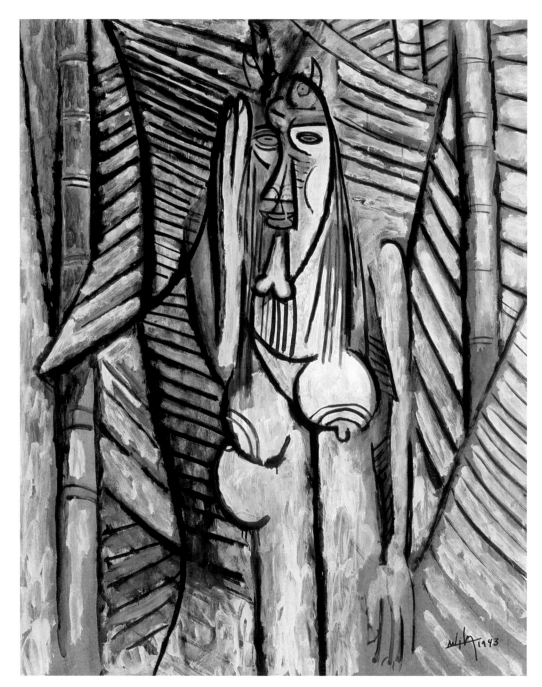

246

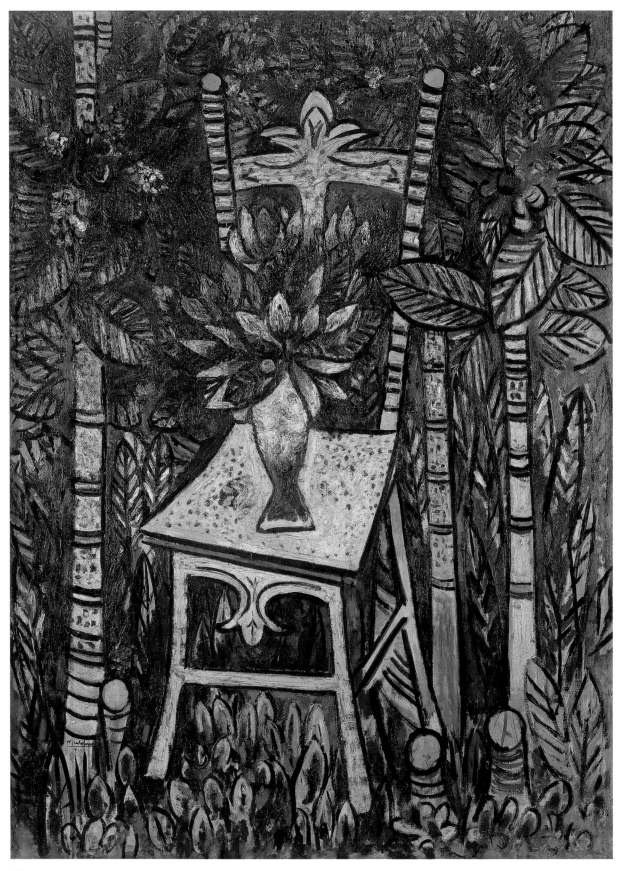

247

Wifredo LAM

247
Chair
1943

248
Mofumba
1943

248

249

250

Wifredo LAM

249
The Dinner
About 1944

250
Buen Retiro
1944

251
Winged Figure or *Composition*
1945

252
Portrait of H. H., VI
About 1944

251

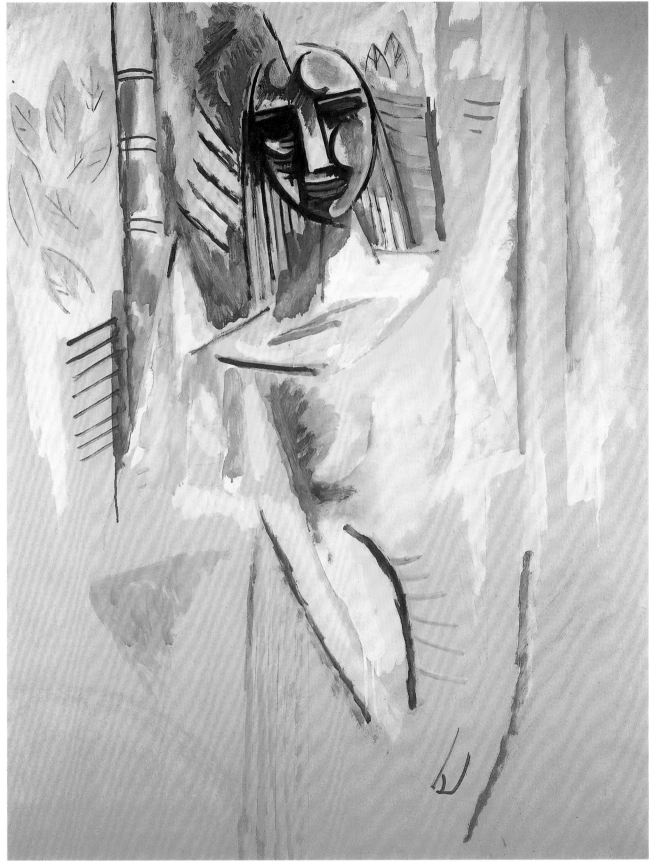

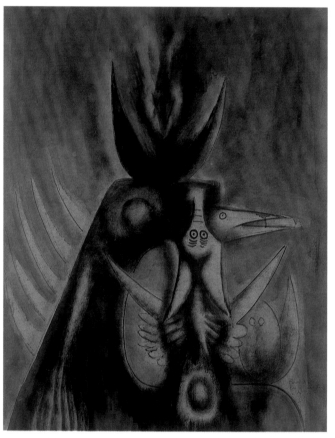

253

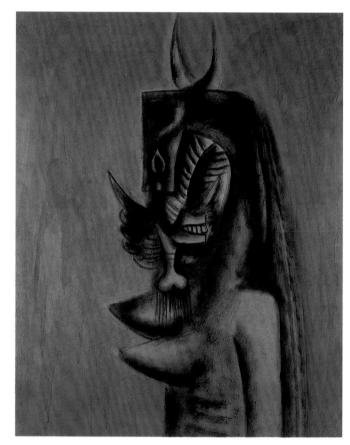

254

Wifredo LAM

253
Untitled
From the series "Canaima"
1947

254
Female Torso
About 1947

255
Nude on a Black Blackground
About 1950

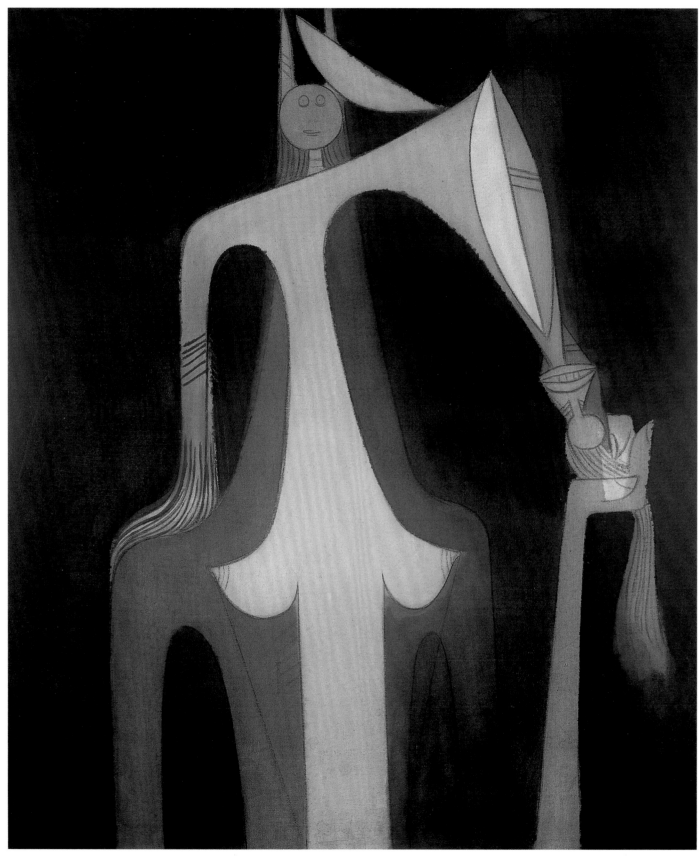

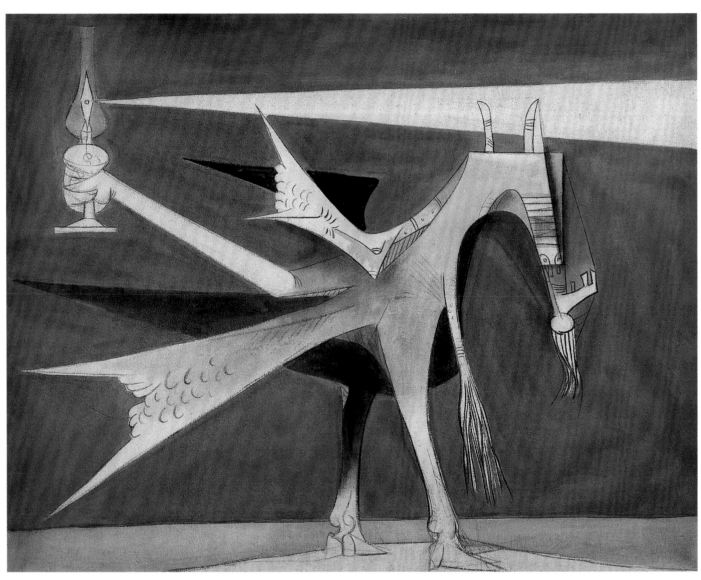

256

Wifredo LAM

256
Figure with Oil Lamp or *Winged
Figure with Lantern*
1955

257
The Sierra Maestra
1959

258
The Third World
1965–66

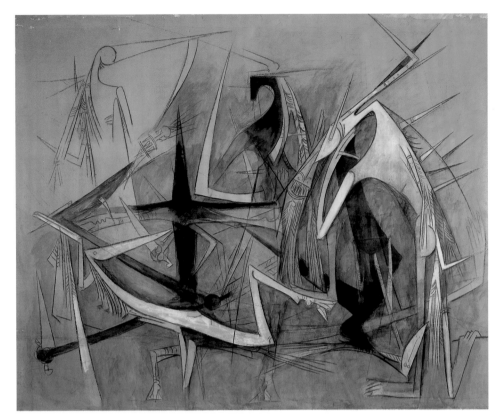

257

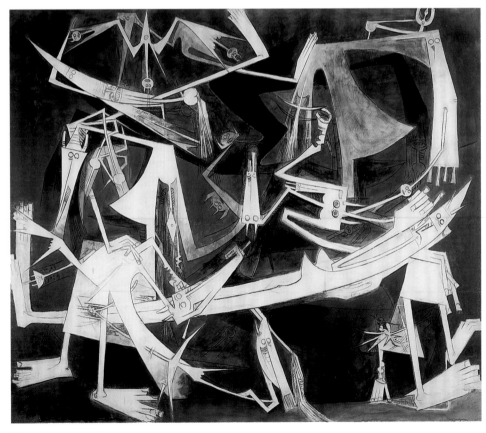

258

FROM HAVANA TO THE MoMA

Luz Merino Acosta

Sixty-five years have elapsed since Cuban painting was first shown in New York's Museum of Modern Art (MoMA). Most fortunately, the Montreal Museum of Fine Arts' exhibition of Cuban art from the holdings of the Museo Nacional de Bellas Artes de Havana provides an opportunity for part of the MoMA's fine collection of Cuban painting and works from the Havana collection of modern painting to be presented together for the first time. The process of mounting the MoMA exhibition of 1944 was triggered by a visit paid by MoMA director Alfred H. Barr (ill. 259) to Havana in 1942. He had travelled to the Caribbean in search of the new art movements burgeoning in Latin America, where primitivism was at its height, in keeping with activities of the time. Strategically speaking, Barr had more specific goals, such as offering grants through the Inter-American Fund.

Barr's visit to Havana surely electrified Cuba's artistic community: for the director of a major museum to be showing an interest not only in seeing their work but also in acquiring it implied a measure of support and legitimized their achievements as a group and as individuals. In a sense, Barr was obliged to visit the artists in their studios, since there was at the time no exhibition space to give him even a partial idea of modern Cuban art, nor was there a single gallery owner or art dealer to represent these artists or to guide Barr. It may well have been as a consequence of his trip that a commercial art gallery, the Galería del Prado, was opened. This seemingly impossible venture came to fruition thanks to funding from its patron María Luisa Gómez Mena. The gallery served both as a showcase for Cuba's modern art and promoting the artists, and as a working space for Barr and the MoMA staff to organize and make the technical arrangements for the New York exhibition.

When Barr asked for a bibliography of modern painting in Cuba, he discovered that no such work of reference existed, only articles in newspapers or magazines. This was the genesis of *Pintura cubana de hoy*, edited by José Gómez Sicre, to fill the need for a text describing and legitimizing contemporary art that would also serve as a catalogue for the Cuban exhibition at the MoMA. This text, published in 1944, undoubtedly represents the first publication to deal with modern painting in Cuba.

The *Modern Cuban Painters* Exhibition (March 17–May 7, 1944)

Barr's visit in 1942 opened up a range of possibilities, not only in terms of his acquisitions of art but also of new contacts for the artists themselves, who, trapped in the bleak cultural prospects of a country battered by war, were eagerly seeking channels to express their concerns and to enrich their work. This new atmosphere was reinforced when an exhibition of Cuban art at the MoMA was proposed and planning began in August of 1943.

It should, however, be noted that even in September the Exhibition Committee was not particularly interested in such an exhibition. As Barr himself said, he was no longer director; he was trying to drum up support for the show but had received no confirmation. For unknown reasons, he was unable to be present at the Committee's discussion, but he wrote the museum's first president, A. Conger Goodyear, a very interesting letter. In the first place, he confesses that before embarking for Cuba he had no great expectation of finding artworks of any interest, but that during the week he spent there he had been tremendously impressed by the quality of the work produced by the island's young

artists. Furthermore, Havana had no museum prepared to exhibit contemporary art, although a few collectors chose to invest in modern art rather than in works by recognized European artists. He admits that Cuba's artists cannot be ranked with Mexico's muralists, but insists that many of them are really first-rate. He emphasizes that the exhibition would be an unofficial affair, exempt from government control, and that most importantly, the United States should continue working with Latin America towards a policy of friendship, mutual interests and exchanges, and that the Cuban show would be an extension of that policy.

Another argument for holding the show was the fact that during the recent MoMA exhibition of new acquisitions, the Cuban works had received the most acclaim from the critics, and the New York press had published more reproductions of the art from Cuba than of any of the other participating countries. An added argument was that Havana would defray the cost of transportation and would produce a book on the exhibition. Finally, consent was given to the project in the fall of 1943.

As with any such show, various adjustments and rewordings were necessary, but the agreement was eventually signed for the show to be mounted in the spring of 1944. Barr's initial plan had been for fifty works, but a larger number had to be sent in order for a stricter selection to be made in New York. Oil paintings and drawings, not prints, were preferred, and the artists had to be residents of Cuba. Even before the Committee's official sanction, the exact number of artists and works began to be set. After much dis-

cussion, the show was to be titled *Modern Cuban Painters* and would consist of seventy-seven works by thirteen artists, including the primitivists Felicindo I. Acevedo and Rafael Moreno. As there was no exhibition catalogue, the relevant information was published in the Museum bulletin (vol. 11, no. 5, April 1944) with an introduction by Barr, which was reproduced in *Ultra*, the magazine of the Institución Hispanocubana de Cultura in May 1944. However, José Gómez's publication *Pintura cubana de hoy*, though not a catalogue since it did not correlate exactly with the exhibition, was an informative text that complemented the show and presented a range of modern Cuban artists in addition to those included in the show.

Press reaction to the exhibition was positive, especially in the United States. Some reviews appeared in Cuba, in *El Mundo*, *Carteles* and *Gaceta del Caribe*, the latter regretting the absence of Lam from the show. Barr was somewhat annoyed by this review and wrote a letter to the editors, in which he explained, among other things, why Lam was not represented in the show:

I was personally responsible for the selection of artists who appeared in the exhibition, and naturally I would have liked to include Lam, whose work the Museum had already appreciated and acquired long before it was recognized in Cuba. However, Mr. Lam, after agreeing in principle to take part in the exhibition, changed his mind and refused to appear in our show, preferring to exhibit his works in one of New York's commercial galleries . . . I deeply regret Mr. Lam's decision, as his collaboration would have

increased not only his own reputation but also the importance of our exhibition.

The show at the MoMA undoubtedly offered the possibility of further exhibitions abroad, of promoting Cuban art and creating a market for it, given the right circumstances. But it must be viewed in the context of a specific time in history, of U.S. policy in regard to Latin America, Pan-Americanism and the ongoing World War. And above all, the roles of the protagonists, especially that of Alfred Barr, must be examined. His judgement was occasionally at fault, but as an art historian he was fully aware of his mission to promote and collect the contemporary art of his day, and he was able to recognize the creative potential of Cuba's artists.

See also:

"Carta de José Gómez Sicre a Barr," in *Alfred H. Barr, Jr. Papers in the Museum of Modern Art Archives. Series 1: correspondence*, folder 1.81.

"Colores cubanos en Nueva York," *La Gaceta del Caribe*, May 1944, p. 5.

259

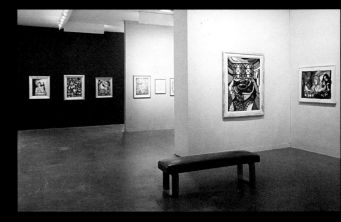

260

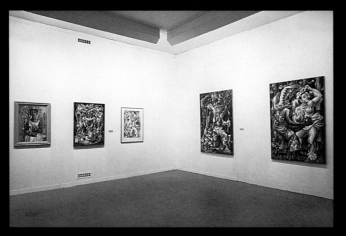

261

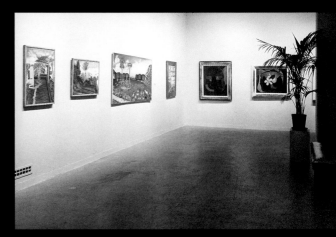

262

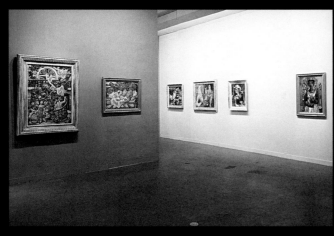

263

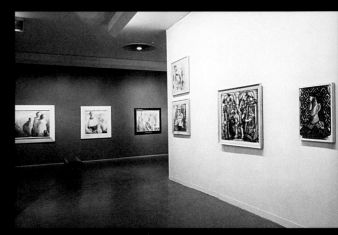

264

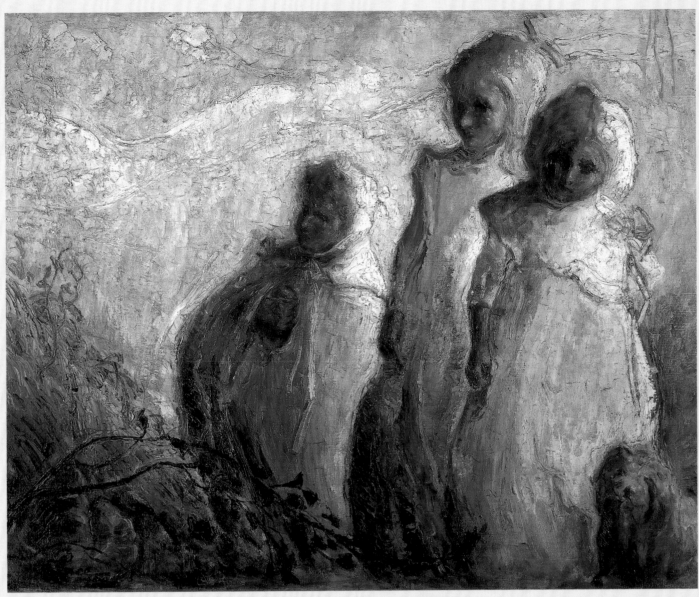

265

Anonymous
Left to right:
Alfred H. Barr Jr.,
José Gómez Sicre, María Luisa
Gómez Mena and Albert Kaufman
1943

260–264
Anonymous
The exhibition "Modern Cuban
Painters," organized by Alfred H. Barr
for the MoMA,
March 17 to May 7, 1944

265
Fidelio PONCE DE LEÓN
Children
1938

"Modern Cuban painting, for
instance—though we need not
feel so embarrassed by our
ignorance in this field since the
modern movement in Havana
is very young, in fact has taken
on a consistent and recogniz-
able character only within the
past four or five years. It has

something of the brashness,
but even more the virtues of
youth—courage, freshness,
vitality, and a healthy disrespect
for its elders in a country which
is very old in tradition and
very new in independence. . . .
Ponce is famous for his bohe-
mian eccentricities, his elabo-
rate irresponsibility toward his
friends and himself, his mys-
terious disappearances from
Havana for years at a time, no
one knows where. At his best

he is Cuba's foremost painter,
cloaking his disquieting figures
in veils of pallid tan, white and
green."

Alfred H. Barr, "Modern Cuban
Painters," *Museum of Modern Art
Bulletin,* (New York), vol. 11, no. 5
(April 1944)

THE 1950s: CONCEALED IDENTITY

Elsa Vega Dopico

A revolution in form is a revolution in essences.
— José Martí

Art, as a record of its time, does not rely on the degree of figuration found in it but on the cognitive and intellectual content it implicitly bears. Art cannot detach itself from history, and history, in turn, is reflected in art like the story of lived experience.

"The first task of artists is to open themselves up to the culture of their time, to accept various influences and then to sift them and speak with their own voice," the Cuban author Edmundo Desnoes remarks.[1] Perhaps here, precisely, lies the heart of the creation-reality / creation-identity question raised in so much of the discussion of Cuban art in the 1950s. The question arises: is abstraction a way of avoiding reality or is it in fact another way of interpreting it?

The 1950s was a stormy decade, full of political, social and cultural events. In the context of the Cold War between the former Allies and of the constant threat of nuclear war, Cuban society was marked by an atmosphere of angst and despair. It should come as no surprise, therefore, that the human figure lost its clearly defined outline and gave way to abstraction as the period's dominant form of artistic expression.

The 1950s generation of artists was attempting to get in synch with the movements in fashion at the time, striking off in different directions from previous generations of avant-garde Cuban artists. In this they succeeded. The influence of Paris and New York was deeply felt in Cuban culture, giving rise to a decidedly cosmopolitan art. Both Abstract Expressionism from the United States and the latest forms of Concrete art from the so-called avant-garde in Paris arrived exceptionally quickly in Cuba.

In this noble mission of rendering Cuban art universal, two groups of artists took the lead. Both Los Once[2] [The Eleven] and Los Diez Pintores Concretos[3] [The Ten Concrete Painters] set themselves up as the bearers not only of new aesthetic paradigms but also of social responsibility and a professional ethic. They viewed everything that had gone before as completely exhausted, taking as their starting point a total negation of all referents and imposing a different reality. Without the full support of the critics, they directed their attention to what was happening outside Cuba and insisted on seeking out new horizons. Although the perspective of Cuban artists transcended the country's borders, they were not engaged in merely imitating the original. They were able to adapt intelligently to new forms of expression and to create a Cuban version out of them. On this point, the critic Joaquín Texidor wrote in 1953: "As to whether abstract painting in Cuba is a 'slavish copy' of the same style of painting being done in Europe, those who believe this would be well advised to open their eyes and minds, because they have not understood the quite substantial differences between what is going on in the Old World and what is being done here. The difference between them is so obvious that their rhythm, colour, form and sense are diametrically opposed."[4]

If identity is defined as a permanent or invariable feature—or simply as what makes us the same and at the same time different—we may be able to understand that behind these gestural brushstrokes or rational geometries full of nuance and vitality are hidden authentic expressions of nationality.

266 Hugo CONSUEGRA, *Cannibalism* or *Opposite Babylon*, 1960

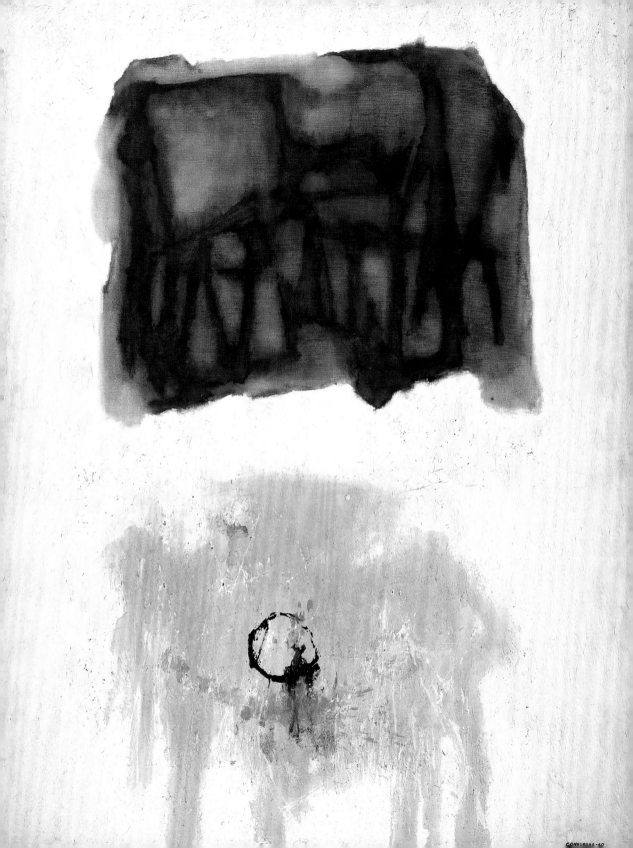

In this way, Luis Martínez Pedro (ill. 267) depicted the country's waters in their simplest essence, without detail, and Loló Soldevilla reduced the capital city to its visual essence or feted the country's leader in a peculiar tribute (ill. 269). Hugo Consuegra, for his part, approached history not as a mere recounting of events but as a serious effort to understand humanity and its condition. It is also how Raúl Martínez, with the spontaneity of his lines, captured the provocative power of a setting such as the Sierra Maestra mountains, the symbol of the island's revolutionary struggles. Many other artists too echoed the various events stored in the memories of Cubans, expressed not in their most precise literalness but as something submerged in their range of meanings.

For abstract art was not a mimetic and obedient copy of nature; it stripped it of all its anecdotal quality in order to reveal unobserved realities. It is an aesthetic formula that opts for the essence of things over giving objects physical meaning.

Perhaps those who thought that abstract art was a way of avoiding reality could never understand that artists may not be trying to escape it but rather that its absence reveals the impossibility of living in a world that is not transformed. As Joaquín Texidor remarked: "Denying abstract painting the very right to existence, as was the case, the way that was done, for no more reason than that it 'wasn't art' and that it was so little reminiscent of human qualities it was incomprehensible, was to negate outright all the richness it had created for world painting. With abstract painting, painting has once again become painting. It has achieved an architecture that not only pleases the eye and gives a feeling of the magic of colour, but also goes one step further and touches our mind with its intellectual essence . . ."[5]

1 Edmundo Desnoes, "1952–62 en la pintura cubana," *Pintores cubanos* (Havana: Ediciones R, 1962), p. 48.

2 This group was active between 1953 and 1955 and basically represented the abstract expressionist current of Cuban art. Its members were Antonio Vidal, Guido Llinás, Fayad Jamis, Hugo Consuegra, René Ávila, Agustín Cárdenas, José Antonio Díaz Peláez, Francisco Antigua, Tomás Oliva, Viredo Espinosa and José Ignacio Bermúdez. Raúl Martínez was introduced to the group a little later by Bermúdez.

3 This group was founded in November 1959 and represented the geometric abstraction wing of Cuban art. Its members included Loló Soldevilla, Pedro de Oraá, Salvador Corratgé, Luis Martínez Pedro, Sandu Darie, José Mijares, José Rosabal, Wilfredo Arcay, Rafael Soriano, Alberto Menocal and Pedro Álvarez.

4 Joaquín Texidor, "El arte contemporáneo y el VI Salón Nacional," *Noticias de Arte*, vol. 1, no. 8 (April 1953), p. 3.

5 Ibid.

267 Luis MARTÍNEZ PEDRO, *Territorial Waters No. 5*, 1962

268
Sandu DARIE
Spatial Dynamism (Vertical Triptych)
Second half of the 1950s

269
Loló SOLDEVILLA
Tribute to Fidel
1957

269

WITHIN THE REVOLUTION, EVERYTHING

against the revolution, nothing

TIMELINE
art and history

1959

Casa de las Américas is established with the goal of creating cultural exchange with the rest of Latin America.

The weekly *Lunes de Revolución* appears as a cultural supplement to the daily newspaper *Revolución*, covering new Cuban writing and the new art being produced in the early days of the Revolution.

The state film institute, the Instituto Cubano de Arte e Industria Cinematográficos (ICAIC), is established.

The exhibition *Contemporary Cuban Painting* is held at the University of Santo Tomás de Villanueva in Havana.

The exhibition *Ten Concrete Painters Exhibit Paintings and Drawings* is held at the Color-Luz gallery.

The group Diez Pintores Concretos is formed.

The National Salon of Painting, Sculpture and Prints is held at the Palacio de Bellas Artes.

Raúl Martínez paints a mural at the Teatro Nacional.

Ángel Acosta León participates in the fifth São Paulo Biennial in Brazil.

Wifredo Lam participates in documenta 2 in Kassel, Germany.

The Cuban Revolution triumphs.

The government passes social welfare legislation.

The first Agrarian Reform law is passed, nationalizing large landholdings and conferring ownership of the land on tens of thousands of peasants.

Fidel Castro visits the United States.

1960

ICAIC establishes the Cinemateca de Cuba and the magazine *Cine Cubano*.

The newsreel service *Noticiero ICAIC Latinoamericano* is established, led by the famous filmmaker Santiago Álvarez.

The Agrarian Reform Institute publishes the magazine *INRA*, covering a variety of topics.

Jean-Paul Sartre and Simone de Beauvoir visit Cuba.

Tomás Gutiérrez Alea makes the film *Historias de la Revolución*.

The short film *P.M.* by Sabá Cabrera Infante and Orlando Jiménez Leal is censored.

The exhibition *Contemporary Cuban Painting* is held at Casa de las Américas.

Ángel Acosta's work is exhibited at the Palacio de Bellas Artes.

Umberto Peña's first solo exhibition is held at the Centro de Arte Mexicano Contemporáneo in Mexico City.

The exhibition *Free Siqueiros* is held in the Seguro Médico building.

The National Print Salon, on revolutionary themes, is held at the Palacio de Bellas Artes.

The ship *La Coubre* explodes in the port of Havana.

Fidel Castro makes the First Havana Declaration, condemning the injustices of imperialism and all forms of human exploitation, promoting pan-Latin Americanism and confirming Cuba's friendship and solidarity with the world's peoples.

A law is passed nationalizing all U.S. businesses in Cuba.

The United States begins an economic embargo of Cuba.

1961

The literacy campaign succeeds in eradicating illiteracy in Cuba.

Debates around the censorship of the documentary film *P.M.* culminate in an encounter at the Biblioteca Nacional during which Fidel Castro delivers his famous "Words to the Intellectuals" speech.

The writers' and artists' association Unión de Escritores y Artistas de Cuba (UNEAC) is established.

The magazine *Casa de las Américas* is published.

The National Cultural Council is established.

The exhibition *Painting, Prints and Ceramics* is held at the Palacio de Bellas Artes.

The Color-Luz gallery closes.

Ángel Acosta León's work is exhibited at Casa de las Américas.

Antonia Eiriz receives an Honourable Mention at the sixth São Paulo Biennial in Brazil.

Mariano Rodríguez creates the stage design for the ballet *Estudio rítmico*.

The exhibition *The Declaration of Havana: 40 Cuban Woodcuts* is held at the Palacio de Bellas Artes.

Mercenaries trained by the U.S. government invade Cuba at the Bay of Pigs, culminating in Cuban victory.

The socialist nature of the Revolution is declared.

The United States breaks all diplomatic relations with Cuba.

Cuba changes its currency.

A law making all education public is passed.

1962

The Cuban Radio and Television Institute, the National Art School (ENA), the National Folklore Ensemble, the Academy of Science, the History Institute, the Nacional publishing house, the Experimental Graphics Studio and the record label EGREM are established.

UNEAC publishes the art and literature journal *La Gaceta de Cuba* and the magazine *Unión*.

René Portocarrero illustrates Onelio Jorge Cardoso's *Cuentos completos*.

The exhibition *Cuban Painting* tours socialist countries.

The National Painting and Sculpture Salon is held at the Palacio de Bellas Artes.

The first Cuban Poster Salon is held at the Palacio de Bellas Artes.

The Exhibition of Havana is held at Casa de las Américas.

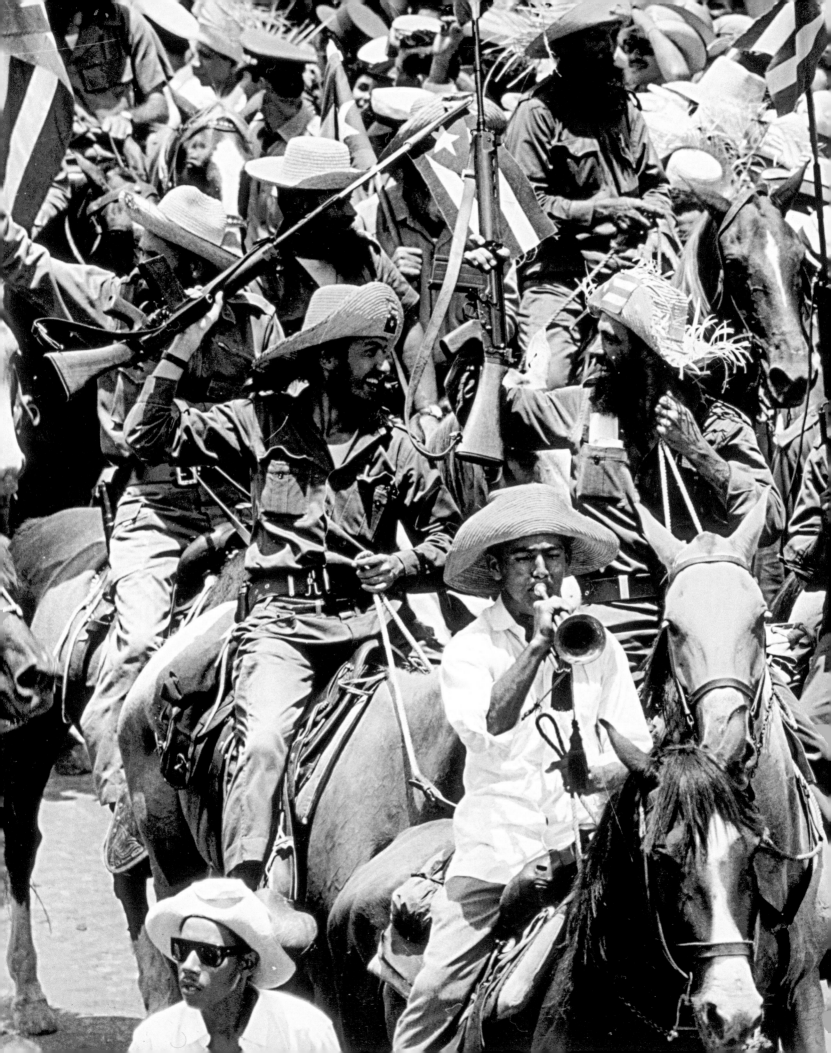

Cuba is expelled from the Organization of American States (OAS).
The Cuban Missile Crisis, a conflict between the United States and the U.S.S.R. over the presence of Soviet nuclear missile bases in Cuba, erupts in October.
Fidel Castro makes the Second Havana Declaration, denouncing Cuba's expulsion from the OAS and the U.S. government's influence in Latin America.

1963

The Rene Portocarrero exhibition *Colour of Cuba* is held at the Palacio de Bellas Artes.
Portocarrero wins an award at the seventh São Paulo Biennial in Brazil.
The exhibition *The Museo Nacional at Fifty: 1913–1963* is held at the Museo Nacional de Bellas Artes (MNBA).
The National Print Salon is held at the Palacio de Bellas Artes.
Antonia Eiriz creates a mural for the Ministry of Public Health.
The exhibition *Abstract Expressionism* is held at Habana gallery.
Cuba signs trade agreements with the U.S.S.R.
Fidel Castro travels to the Soviet Union.
Social security legislation is passed.
The second Agrarian Reform law is passed, carrying out measures that had been left unfinished in the first law.

1964

The Soviet filmmaker Mikhail Kalatozov makes *Soy Cuba* [I Am Cuba].
The National Salon of Painting and Sculpture is held at the Palacio de Bellas Artes; awards are given to Servando Cabrera Moreno, Antonia Eiriz, Hugo Consuegra, Amelia Peláez and Mariano Rodríguez.
Antonia Eiriz's work is exhibited at Habana gallery and at the MNBA.
A retrospective of the work of Mariano Rodríguez is held at the MNBA.
An exhibition of the work of Raúl Martínez, entitled *Tributes*, is held at Habana gallery.
The Exhibition of Havana is held at Casa de las Américas. Umberto Peña is awarded a Special Prize.

1965

Edmundo Desnoes's novel *Memorias del subdesarrollo* is published.
Graziella Pogolotti publishes the anthology of essays *Examen de conciencia.*
The Literature and Linguistics Institute is established.
The Havana Cordon is established to grow coffee on the outskirts of the city.

1966

René Portocarrero participates in the Venice Biennale.
Loló Soldevilla's work is exhibited at Habana gallery.
The exhibition *Photo-Lies!?* of the work of Raúl Martínez, Mario García Joya and Luc Chessex is held at Habana gallery.
The Organization for Solidarity with the People of Africa, Asia and Latin America (OSPAAAL) is established.

1967

The Cuban Book Institute (ICL) and the Arte y Literatura publishing house are established.
The International Protest Song Festival is held.
The OSPAAAL magazine *Tricontinental* is published.
René Portocarrero paints a mural in the Palacio de la Revolución and a retrospective exhibition of his work is held at the MNBA.
The twenty-third Salon de Mai is held in Havana.
Raúl Martínez and Ángel Acosta León exhibit their work at the MNBA.
Umberto Peña wins an award at the fifth Biennial of Young Painters in Paris.
Ernesto "Che" Guevara dies in Bolivia.

1968

Marcelo Pogolotti's book *Del barro y las voces* is published.
The Havana Cultural Congress is held with delegations from various countries attending.

A retrospective of the work of Amelia Peláez is held at the MNBA.
The exhibition *Cuban Masters* is held at the Instituto Nacional de Bellas Artes in Mexico City.
The exhibition *Panorama of Cuban Art* is held at the MNBA.
Cuba receives the Adam Montparnasse award for young painting at the twenty-fourth Salon de Mai in Paris.
Rafael Zarza receives the Portinari award at the Exhibition of Havana at Casa de las Américas.
The remaining private businesses and services in Cuba are nationalized under the "Revolutionary Offensive."

1969

The Experimental Sound Group is created at ICAIC.
The magazine *Signos*, dedicated to popular culture, is published under the editorship of Samuel Feijóo.
Servando Cabrera Moreno receives a mention in the eighth International Joan Miró Drawing Prize in Barcelona.
The Cuban Poster Salon, entitled *26th of July*, is held at the Cuban Pavilion.
Resources are mobilized for the campaign to harvest ten million tons of sugar.

1970

Salon 70 is held at the MNBA.
Demythologizing Art, an exhibition of the work of Julio Le Parc, is held at Casa de las Américas.
Manuel Mendive receives an award at the second Cagnes-sur-Mer International Painting Festival in France.

1971

The First National Education and Culture Congress is held, where Fidel Castro utters the famous phrase "Art is a weapon of the Revolution."
The first National Salon for Young Artists is held at the MNBA; awards are given to Tomás Sánchez, Nelson Domínguez, Juan Moreira and Mario Gallardo.

1972

The magazine *Revolución y Cultura*, the official organ of the National Cultural Council, is published.

1973

The exhibition *Images of Cuba 1953–1973* is held at Casa de las Américas.
The *26th of July* competition is held as part of the Salon of the 20th Anniversary of the Attack on the Moncada barracks at the MNBA; awards are given to César Leal and Frémez, with a mention to Flavio Garciandía.
The justice system is reorganized and the criminal code reformed.

1974

The exhibition *Women: Time and Images* is held at the MNBA.

1975

The exhibition *Panorama of Cuban Art from the Colonial Era to the Present Day* is held at the Instituto Nacional de Bellas Artes in Mexico City.
The exhibition *Political Drawing in Cuba 1868–1959* is held at the MNBA.
The *Small Salon* is held at the MNBA (annually until 1984).
Cuban troops are sent to Angola.
The First Congress of the Communist Party of Cuba is held.
A new family law is introduced.

1976

The Ministry of Culture is established.
The Art Institute of Graduate Studies (ISA) is established.
The first Youth Salon opens at the MNBA.
A referendum is held to approve the Socialist Constitution.
New political and administrative directives divide the country into fourteen provinces.
A terrorist attack against a Cubana airplane in Barbados results in 73 deaths.

1977

The exhibition *50 Years of the "Revista de Avance"* is held at the MNBA.
Cuba and the United States agree to open "interest sections" in their respective capitals.

1978

The National Monuments Commission and the Cuban Cultural Foundation are established.
The exhibition *160th Anniversary of the Academy of San Alejandro* is held at the MNBA.
The exhibition *Cuban Painting and Prints* is held at the Museo de Arte Contemporáneo in Madrid.
The XI World Youth and Student Festival is held in Havana.

1979

The first New Latin American Film Festival, organized by ICAIC, is held (and has been held annually since).
The exhibition *The History of Cuban Photography* is held at Casa de las Américas.
The exhibition *Interpressfoto '79* is held at the Cuban Pavilion.
The exhibition *1,000 Cuban Film Posters* is held at the MNBA.
The sixth Summit of Non-aligned Countries is held in Havana.
A dialogue between the Cuban exile community and the government begins. Cuban émigrés are allowed to visit the country and Cubans are allowed to leave the island for family reunification reasons, as are political prisoners and former political prisoners.

MYTHS AND REALITIES: CUBAN PHOTOGRAPHY OF THE 1960s AND 1970s

Iliana Cepero Amador

In 1964, the travelling exhibition of photography entitled *Cuba, 10 Years of Revolution*, part of the Days of Solidarity with the Caribbean island, was held in London. It showcased the period of fighting in the mountains and in the city leading up to the Revolution in 1959. Kevin McDonnell, head of production at the English periodical *Photographic Magazine*, wrote that the photographs on display were like the Cuban people: full of vitality, exciting, fierce and imbued with an unimaginable physical bravura. Of course, they were propaganda in the sense that they brought to the fore the official point of view on recent Cuban history, but an intelligent and well-thought-out propaganda.[1]

For the photographers in the exhibition who recorded post-1959 events, there was nothing "propagandistic" about their pictures; they were simply impromptu depictions of the euphoria and sense of triumph felt by them and their compatriots. Yet McDonnell saw them as clear and blunt examples of imagery with ideological ends. Other foreign critics agreed with him, although some held more extreme and critical positions; for example, there were those who believed that the figure of Fidel Castro appeared excessively in the media. Alberto Korda was accused of being one of the main culprits behind this; his position as the official photographer to the then prime minister resulted in an abundant supply of portraits of the leader. And so, months after the exhibition that saw the word "propaganda" applied to these images, Korda felt compelled to write, with the help of journalist Euclides Vázquez Candela, an open letter to clear up "misunderstandings" regarding the seemingly obsessive interest of photographers in Castro and the Revolution. The letter was given the title "From Journalists to Journalists. A Message to Three American Colleagues." In it, Korda declared: "With them (the Americans) we shared the Commander-in-chief's eastern travels and his return to Havana. We, Cuban journalists, revolutionaries and patriots, are devoted to our prime minister. We know how pleased and enthused the people are that we report on his deeds, and so we do. We are motivated by militant and professional considerations. For us, Fidel Castro is always news, moreover, revolutionary news. . . And you cannot deny, like it or not, that a revolution is always newsworthy; that Fidel Castro is always newsworthy. In all languages, in all countries, whatever their social structure and makeup, Fidel Castro and the Cuban Revolution are newsworthy, to the pleasure of some and the displeasure of others."[2]

There were reasons for Korda's defensive stance. His veneration for revolutionary accomplishments and for the revolutionary leader had not been something imposed on him. Korda and his associate Luis Korda owned one of the country's most prosperous advertising and fashion studios of the 1950s. Most of the photographers of this generation, who actively participated in the revolutionary process, were, like Korda, from the world of business and publicity, and so enjoyed an undeniably comfortable bourgeois lifestyle. Nevertheless, with the victory of the Revolution, they wholeheartedly joined in the general elation and considered themselves spontaneous protagonists in all events and, as a result, simple reporters of "reality." Yet regardless of the euphoria, these photographers (unconsciously, or perhaps knowingly) participated in one of the most effective propagandistic programs of the postwar period.

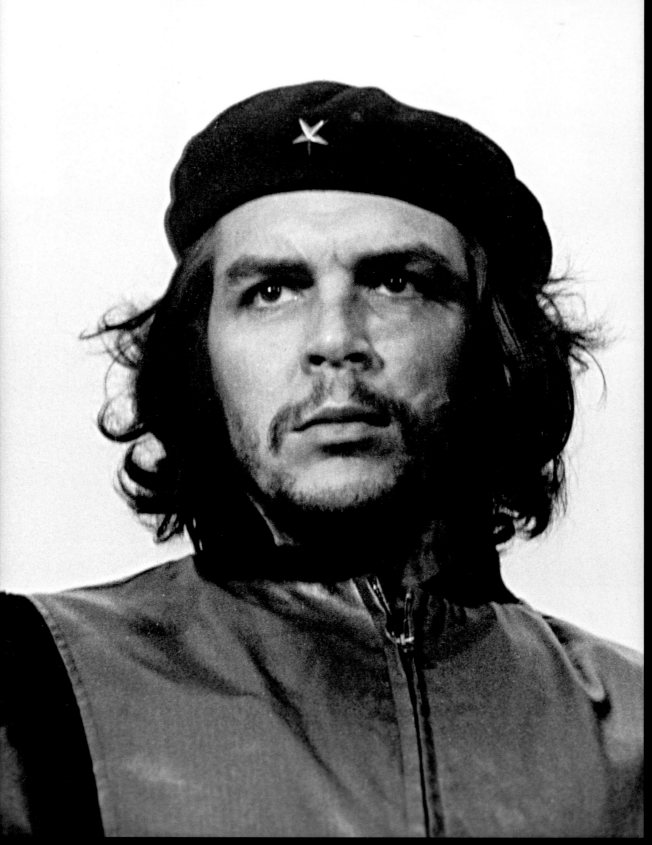

270
Alberto KORDA
Heroic Guerrilla
1960

On March 5, 1960, the funeral of the victims of the sabotage of the munitions freighter *La Coubre* was taking place. Korda was covering the event as staff photographer for *Revolución*. His description of how he came to take the famous photo was as follows: "I was about 8 or 10 metres from the podium where Fidel was speaking, and I had a camera with a semi-telephoto lens. Suddenly I noticed Che approaching the railing beside Jean-Paul Sartre and Simone de Beauvoir. He had been standing at the back and came forward to look at the crowd. I had him in focus, I took one shot and then another, and at that moment he turned away. It all happened in half a minute." On returning to the office, Korda developed the film, but the editors chose to publish a shot of Fidel addressing the crowd on the front page and pictures of the two French writers on other pages. The *Heroic Guerrilla* was not published in *Revolución* until April 15, 1961. After Che's death in 1967, the Italian publisher Giangiacomo Feltrinelli reproduced and printed the image on millions of posters that sold across the globe. For many years, Korda never received a cent in royalties for this photo, considered the most frequently reproduced image in the history of photography.

271
Alberto KORDA
*Contact sheet: Shots of
Fidel Castro, Jean-Paul Sartre,
Simone de Beauvoir and Che Guevara
(including the "Heroic Guerilla")*
1960

The 1960s: *INRA, Revolución* and the Look of Victory

The first step in this program was taken one evening when Fidel Castro summoned to his office Raúl Corrales, head of the photography department of the National Institute for Agrarian Reform (INRA). He proposed creating a publication that, resembling *Life* in format and design, would offer in-depth coverage of the reform program and carry reports turned down by bourgeois media outlets because of their radical political implications. Taking into account the country's high rate of illiteracy—especialy in rural areas—Castro insisted on the need for an image-filled magazine, so that it might be accessible to all. And so *INRA* (1959–62) was born—later *Cuba* (1962–69)—consisting of large black-and-white and colour photographs accompanied by brief descriptive texts.

The newspaper *Revolución*—founded by Carlos Franqui as the daily of the 26th of July Movement during the dictatorship of Batista—became the official organ of the 1959 revolutionary government and served as the true chronicle of the Revolution. Its twenty-eight-page large format reported daily on the events taking place throughout the country. The paper frequently carried full-page photographs illustrating all manner of decisions and measures taken. The news was presented in a highly straightforward manner, drawing on the principles of billboard advertising. Spaces hitherto devoted to advertisements began carrying political slogans or phrases. The most significant photograph of the day would be printed on the cover, and the biggest news item would be covered in a one- or two-page photo spread. Corrales himself, as

INRA's head of photography, applied a similar format to the magazine, which inspired healthy competition among the reporters. Photographers were not paid a fixed salary; their remuneration depended on whether their work was selected for publication and the importance it was given. The best picture went on the cover and the best news item appeared in the middle pages. Corrales made these decisions, and according to an interview he gave, Che Guevara, who was minister of industry at the time, helped him select the images that had to do with economic activity. The magazine covered the photographers' travelling expenses when they had to go to the country's interior for their reports. In this way, they could devote themselves entirely to their work, without financial or time constraints, creating conditions that produced high-quality results and, consequently, greater receptivity. This clever strategy nevertheless soon turned into an unfortunate restriction due to bureaucracy and politics: from then until the 1980s, the only way to attain photographic material was to work for a press organization or government agency. This partly explains the long-lasting scarcity, even near absence, of other photographic viewpoints and genres—aside from the documentary or press related.

The periodicals *Revolución* and *INRA*, designed to be the two official publications of the revolutionary government, were the period's most visually appealing vehicles for radical ideology. Considering the scarcity of televisions in the country in the early 1960s, it is only natural that the press alone could ensure the public consumption of practical and immediate

information. Images were made to stand out from text in order to inform a largely illiterate population, mostly rural, of the changes the country was undergoing. Photography had to secure the Revolution's credibility with the people, and so a team of photographers (Korda, Osvaldo Salas, José Tabío, Liborio Noval, Pepe Agraz, Ernesto Fernández, Mario García Joya and, of course, Corrales himself) committed themselves to the cause and were contracted. With their proven track record and professional competence they could provide the necessary means to "sell" to the entire island what the government so strongly desired—the idea of a Cuba in transformation under the leadership of committed militants.

Up until then, the image of the country that had been exported was that of a Caribbean tourist destination, where the picturesque and sentimental—the "island of fiesta and siesta" and the "island of romance"—was mixed with a measured dose of licentiousness in the form of unbridled gambling, sex, alcohol and nighttime entertainment. This romantic and dissolute vision was sold with a fresh design, evocative settings showcasing tourist centres and luxurious nightclubs, mythical beaches and local types, which included the sensual *mulata* and the smiling black man ready to serve.

Alongside the new reforms that were sweeping away the old order, there was an urgent need to do away with the clichés of a "loose-living" Cuba lacking dignity. The first photographic representations that were introduced at this time focused on the creation of new types. As photographer and scholar Maria Eugenia Haya (Marucha)

expressed so well in her research: "As the Revolution moved forward, it increasingly identified with its own image. It would no longer be the Cuba of the 'very nice typical *mulata*' or the 'servile black man.' Now, the bearded man, the militia woman, the peasant and the labourer would give shape to a rich and telling popular iconography."[3]

Figural types did in fact change. The militiaman, the labourer, the peasant were quickly embodied in a new iconographic repertory. The former voluptuous woman now grasped a gun or donned the Cuban flag (ill. 274) and the *criollo* with the beaming smile was now stern and in uniform. Although the representation of the masses was overwhelming, some faces continued being standards of individuality. And so Korda's *Lamppost Quixote* (ill. 280) and beautiful *Militia woman* (ill. 282), Corrales's severe peasant militiamen, the Malagones, and bearded guards asleep in a hotel in Caracas, and Mario Garcia Jóya's cheery young literacy teachers and militia woman-mother stoically carrying her baby in the middle of a procession all became some of the most heroic and captivating celebrities from this historic period.

Images of tourist sites were replaced by rural scenes, and by streets and plazas filled with excited people. Scenes of elegant nightlife gave way to a daytime world full of work to be done, political gatherings and calls to defend the country against any threat of attack. This change of protagonists and settings reflected the abolition of class divisions in Cuban society. The people in uniform were a single people: social divisions disappeared, women were no longer available to pleasure tourists,

and blacks were no longer satisfying the least bourgeois caprice. Everyone seemed to be marching together, swept up in a common goal. This unity of ideals and sense of a collective nation became two of the most important myths of the day. It is why the theme of popular rallies (ill. 272), typical of the Russian model of the 1920s, and the visual depiction of the October Revolution started to appear daily in the pages of *INRA* and *Revolución*. The riveted masses listening to their leader or parading in small groups (ill. 275) were an indispensable form of visual indoctrination for those who still questioned the authenticity of this nationalism—looking at these images the doubtful could not help but feel a certain guilt or alienation. For those completely immersed in the nascent Revolution, these images also constituted a personal and political reaffirmation for those completely immersed in the nascent Revolution.

The triumphal tone they depicted created a sense of headlong movement. Fidel's momentous entry into Havana, recorded by Corrales and by Luis and Alberto Korda; Corrales's emblematic *Cavalry* (ill. 276), depicting the arrival of guerrillas on the former lands of the United Fruit Company; the Bay of Pigs victory photographed by Ernesto Fernández, Osvaldo Salas and Corrales; the pictures taken by Liborio Noval and Mario García Joya documenting the effectiveness following the emphatic victory of the literacy campaign: these established the ideas of victory and invincibility as the immanent principles of the new revolutionary ideology.

Charismatic Leaders
The triumphant combination of epic

gesture–the masses–historical protagonists would not be complete at the time without the presence of the leader. Beginning in early 1959, three great leaders promptly distinguished themselves on the national stage (ill. 287, 288): Fidel Castro, Camilo Cienfuegos and Che Guevara. The physical appeal of these very young Commanders of the Revolution is a factor that cannot be overlooked. At the same time, each had his own specific qualities: Fidel was the charismatic intellectual and guerrilla fighter; Camilo the popular hero who disappeared tragically in 1959; and Che the untiring nomadic revolutionary. Their individual qualities complemented each other in this troika. It was natural that their photogenic faces would become the most common subject of photojournalists with the most access to them in those days.

In addition to capturing their seductive personalities, portraits of Fidel, and Che, in particular, throughout this period invariably exuded a high level of masculinity. The virility of these two leaders, accentuated by their sensual bearing, their taste for cigars and the decision to wear only battle fatigues (ill. 283)—thereby perpetuating the stereotypes associated with such clothing—was another of the myths forged by these images. Their power was a natural corollary in a country such as Cuba, where machismo and sexual boasting are a regular part of everyday life.

Beginning with the fighting at Sierra Maestra, Fidel stood out as the incontestable chief. Later on, after the triumph of the Revolution, a dove landed on his shoulder while he was

giving one of his first speeches in 1959 (ill. 290, 291), and the aura that had taken shape around him grew even larger in the collective imagination. This incident contributed another of the myths about the messianic nature of Fidel's labour. For the devout Cuban mentality of the day, this event conferred an the almost religious transcendence that the Revolution had for many at the time. It was the so-called "miracle" that everyone had been waiting for after severe dictatorship. It also confirmed the supreme leader as the fundamental agent of this miracle.

Fidel, for his part, made another smart move: he designated Korda and Corrales as his personal photographers. Each was to accompany him on his numerous travels and functions as prime minister, ensuring the meticulous deployment of the information he wished to show the people with respect to his work as ruler. Here, the past experience of these two photographers in selling images came into play. Corrales came out of the world of radical journalism and advertising agencies of the 1940s and 1950s. His work, marked by the photojournalism of American magazines such as *Life* and *Time*, and by the early influence of Dorothea Lange and Walker Evans, gave greater priority to the common people than to the leader. Nevertheless, the series of photos taken of Fidel back in the Sierra Maestra with brigades of university students, or a snapshot such as that of the First Declaration of Havana (ill. 289) surely provide ample evidence that a few images could iconically express Fidel's dedication to the people, his untiring will and his indisputable leadership.

Korda, on the other hand, was a true star-making photographer. His trajectory in the advertising and fashion industries and his veneration of Richard Avedon had shaped a career in which the celebration of beauty joined with psychological insight. His snapshots of Fidel and Che playing golf on the grounds of what is now the Art Institute of Graduate Studies (ISA) and the entire series of Fidel's return to the Sierra Maestra in 1962 employed commercial and relaxed attitudes along with traditional and grandiloquent poses according to the demands of a particular situation. In each case, significant details show through. The informal settings and animated gestures suggestive of the world of advertising narrowed distances: the leaders were shown playing baseball, fishing and reading: activities with which all Cubans could easily identify. They were trustworthy men. Nevertheless, Fidel's stern bearing in Korda's *Commandante en Jefe* ["Commander-in-Chief"] or Che's similar pose in the world-famous *Heroic Guerrilla* (ill. 270) spoke of persistent qualities in the potent placement of these figures in a frozen world, a timeless world of political commitment and eternal ideals, paradoxically well-grounded at the same time in a firm belief in the future.

This photographic framing was derived from the Soviet model of the 1930s. As critics have remarked about this style, in ideologies turned toward the future any sign of conflict must be smoothed out in the interest of a convincing message of confidence and optimism. Gazing off into the distance, for example—like Che in *Heroic Guerrilla*—had been, in the

Soviet style, firmly established as a codification of faith in the future. The heroic and military postures taken up by many personalities in the 1960s were a sign of the solidity of principle and hardened spirit dear to this ideology. The photographs of this initial phase of the Revolution, which live on to this day, rarely embodied either the symptoms of the internal dilemmas that any political change will generate or the problematic nature of the obstacles that the country constantly had to overcome or avoid in the face of external pressure. Rather, photographers of the time chose to record solution and success, therefore, the triumphant spirit that accompanied it. Cuba was a forward-looking country of archetypal and glorious images in which the stiffness of Soviet icons— brought to life by the new American photojournalism of the 1930s—was skilfully softened and reinvested with the publicity angle employed by this generation of photographers. The freshness and radiance brought to the studied preparation of a product that would appeal to consumers, combined with the famous Caribbean sensuality of the people depicted, were mixed into and superimposed onto the severe Soviet iconographic sensibility, to fascinating results.

Sugar, Sweat and the Snapshot: Photography in the 1970s

After the first four years of the Revolution, it was undeniable that its propagandistic goals had been fully met. The overthrow of the Batista dictatorship was not all; the new government, once in power, had to demonstrate that it would not let its many followers down. The principal new legislation and most important changes had already been introduced and

carried out, and everything had been recorded in the pages of *INRA* and *Revolución* according to Fidel's wishes. The supreme leader's credibility had already been established by the wide media coverage at his disposal at all times. The press had demonstrated that his was a government of the people and for the people, that it always faced up to any eventuality. Now the country needed to devote itself to higher-priority projects such as the economy, which was another key theme used by the Soviet model to herald the construction of a utopian world. Sugar production and manufacturing became the recurring theme in the photography of Cuba in the 1970s.

The year 1968 marked a turning point in Cuban history. The so-called "Revolutionary Offensive," which nationalized the remaining redoubts of private capital in the country, even the small-scale businesses, was followed by the idea of carrying out a harvest of ten million tons of sugar. Accomplishing this colossal target would bring about the country's economic independence, one of Fidel's long-cherished dreams.

The magazine *Cuba*—renamed *Cuba Internacional* in 1969—was the venue for the new subjects photography was about to address. The publication worked with the second generation of photographers, who did not receive their training in the world of business and advertising, to take up the challenge of creating a look

for the new decade. Self-taught, these photographers had varying backgrounds, but all had been influenced by cinema and took as their guide the Swiss-born photographer Luc Chessex. One of the first photo-essays published by *Cuba* on the sugar campaign consisted of a selection of photographs taken by Cuban photographer Chinolope. It was entitled *Una temporada en el ingenio* [4] [A Season at the Sugar Mill], and was conceived of as a cinematic sequence. In printing his images, Chinolope left in the edges of the negative, making it seem like they were part of the picture. Some of the shots were taken several times, with only imperceptible differences between them, imitating cinema's moving photographic images. Italian neo-realism and German expressionism are evident in the photo-essay's peculiar style in the form of high contrasts, the use of backlighting, the way the space was framed, in the high-angle shots and expressionistic flourishes and in oppressive and shadowy settings. These sequential images decidedly transmitted a different narrative. The message, so clearly articulated in the iconography of the early 1960s, here became dense and allegorical. Chinolope did not proclaim a doctrine; rather, he described the reality of the sugar workers' tribulations as they toiled. For this reason alone, the aesthetic he developed in this series broke with the previous paradigm. In this new way of looking at industrialization as a topic,

the clean and abstract compositions of the earlier period were replaced, as was the hierarchical arrangement of compositional elements seen in pictures of the same subject in the 1960s. The scene depicted was now somewhat chaotic and disjointed. Above all, man did not dominate the machine; rather, the machine imposed its presence in brutal fashion. The picture's subjects had become anti-heroes.

This element of conflict became the dominant aesthetic of *Cuba Internacional*. According to statements by members of the magazine, its way of approaching photojournalism was transgressive for its day. This is largely due to the style introduced by the Swiss-born photographer Chessex, a self-confessed fervent admirer of Robert Frank. His snapshot aesthetic, with its use of wide-angle lenses, tilted horizon and grainy, out-of-focus images, gave rise to a subjective handling of the camera and an approximation of reality. At the same time, Chessex stressed that a sole symbolic image was not sufficient; it was necessary to work with sequences in order to reflect the inherent subtleties and allegories in the complex unfolding of reality. Another precept Chessex put forward was that of the confrontational portrait, in which the individual looked directly at the camera in order to create a more direct means of communication between the photographer and the model, something rarely seen in 1960s photography.

Ten Million Tons of Sugar

A large part of the photojournalism in *Cuba Internacional* in the 1970s was explicitly drawn from Chessex's model. One of the photo-essays that began the decade and has become proverbial was entitled *There Is No Other Way to Harvest the Cane* (ill. 294, 295), by Enrique de la Uz, Iván Cañas and Chessex. These three photographers shot the harvest like a scene from a film. There are no formal poses, no prepared space for the action, just a man chosen at random to cut cane. Nothing could have been more lyrical and at the same time heroic. Nevertheless, the basis of the struggle remains human strength. Some of the pictures show only the sugar cane, invoking an abstract or minimal task. Others alternate images of the harvest with billboards and political slogans, bringing the leader to mind and transmitting in unison the ideological message raised by the harvest, without ever becoming demagogic.

For the series *With the Sweat of the Workers for the "Million"* (ill. 296, 297) of 1974, Rigoberto Romero and Leovigildo González chose a town on the outskirts of Havana that practised what is known as the Australian way of cutting cane. While the images seem to continue the tradition of gallantry and exhibitionism established in the 1960s, they are also an attempt to transmit a hard reality without softening the picture. This was typical of the new photographic language of the 1970s. The photographs' subjects appear in dirty and threadbare clothes, their faces sweaty and greasy, looking directly at the camera. These techniques were not in favour in those days. The norm had been to photograph workers in the midst of their labours and, above all, clean and prepared in the chosen location. But here was the dirty and painful reality of work in the cane fields, and here lay the moral of *With the Sweat of the Workers for the "Million"*: despite the seeming disfigurement and dirtiness that the tiring work gave rise to, figures were capable of radiating their individual excellence. Romero and González had created a new aesthetic that overthrew the 1960s symbolic glamour, clearly achieving beauty out of the spontaneous and the difficult and hazardous work of cutting cane.

The iconography of the 1970s led to the natural undoing of the mythological constructions of photography in the 1960s, but it also offered its own version of events. While photography continued to document the demands the Revolution placed on its citizens, in the hands of this new wave of photographers the iconic and frozen codes of the 1960s became a world of movement and constant tension. This period's image of utopia, through the subject of work, did not produce such perfect pictures as before. By resorting to the style of the snapshot, with the sense of disquiet and anxiety it gave rise to, Cuban photography in the 1970s revealed that the ideal world being sought by the official policies of the day was often the site of a precarious balance.

1 Kevin McDonnell, *Photographic Magazine, Cuba* (January 1964).

2 Alberto Korda and Euclides Vázquez Candela, "De periodistas a periodistas," *Revolución* (August 10, 1964).

3 María Eugenia Haya, "Sobre la fotografía cubana," *Revolución y Cultura* (May 1980).

4 The book *Una temporado en el ingenio* contains more photographs of this series and a foreword by renowned writer José Lezama Lima. It was published for the first time in 1987 by the publishing house Letras Cubanas.

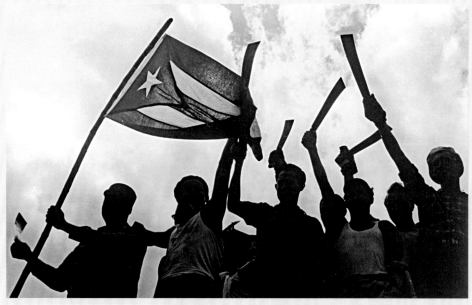

272

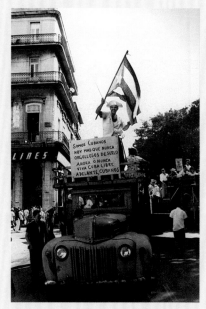

273

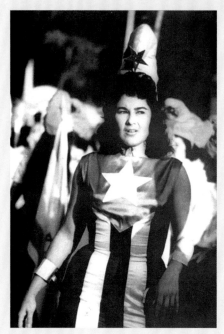

274

275

272	**273**	**274**	**275**	**276**
Liborio NOVAL	Mario GARCÍA JOYA	Mario GARCÍA JOYA	Raúl CORRALES	Raúl CORRALES
We Won	*We are Cuban, Havana*	*Untitled, Havana*	*Militia on the Malecón*	*Cavalry*
1960	1959	About 1960	1960	1960

277

277
Liborio NOVAL
I like mine better (Peasant looking at hats, Havana)
1960

278
Raúl CORRALES
Hats, Havana
1960

279
Alberto KORDA
Camilo parading with the Cavalry, Havana, July 26, 1959

280
Alberto KORDA
The Lamppost Quixote, Havana, July 26, 1959

281
Raúl CORRALES
Conga, Santo Domingo, Las Villas
From the series "The New Rhythm Band"
1962

282
Alberto KORDA
Militia woman, Havana
About 1962

278

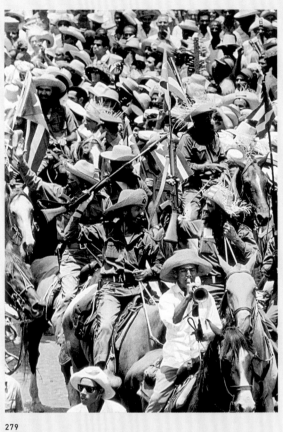

279

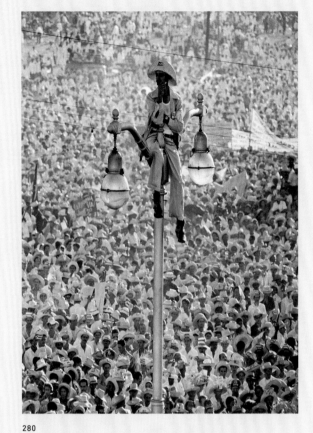

280

281

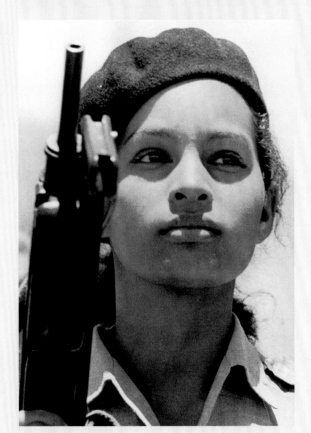

282

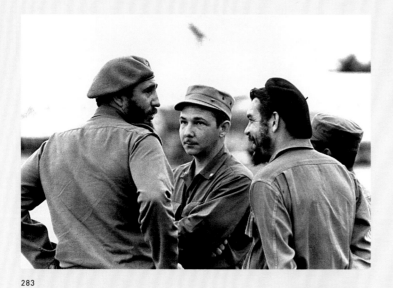

283

284

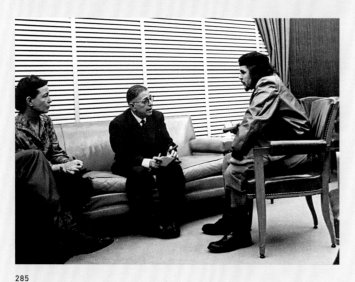

285

286

283
Osvaldo SALAS
Three brothers
1963

284
Liborio NOVAL
Untitled
1961

285
Alberto KORDA
Che, President of the National Bank of Cuba, speaking with Jean-Paul Sartre and Simone de Beauvoir
1960

286
Alberto KORDA
Fidel visiting the Bronx Zoo
1959

287
José (Pepe) AGRAZ
Che and Camilo, Havana
1959

288
José (Pepe) AGRAZ
Fidel and Camilo, Havana
1959

"'Come early; at midnight,' the director of the State Bank tells me. Other visitors are seen at 2:00 in the morning. Working non-stop, the leaders of the new regime cut back as much as possible on their sleep."

Jean-Paul Sartre, "Ouragan sur le sucre" (twelfth article), *France-Soir* (July 10–11, 1960).

289
Raúl CORRALES
First Havana Declaration, Plaza de la Revolución, Havana, September 1960

Before launching into his speech proclaiming the First Declaration of Havana on September 2, 1960, Fidel Castro called Raúl Corrales, who was taking photographs down in the crowd, to the podium. The leader asked Corrales to take a photo that would include him and a view of the crowd. The photographer had to ask two ministers to vacate their seats so he could get the right angle for the shot. Later, Corrales would joke about how many of his colleagues would have liked to have taken the same shot, but that only he had permission to "get two ministers out of their seats." The picture became so popular that it appeared for years on the Cuban ten-peso banknote.

290, 291
José (Pepe) AGRAZ
From the series "Havana"
January 8, 1959

Following pages:
292
Alberto KORDA
David and Goliath
1959

293
Osvaldo SALAS
Cigar
1967

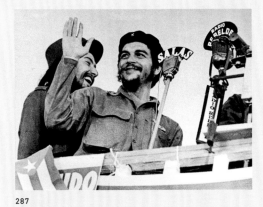

287

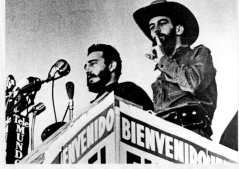

288

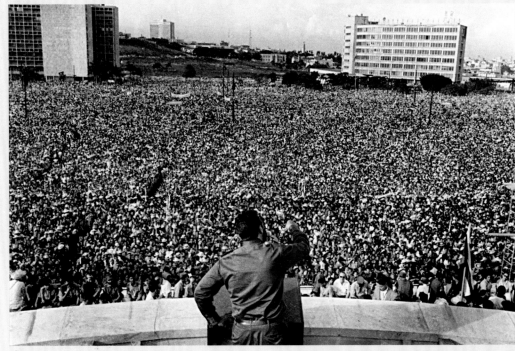

289

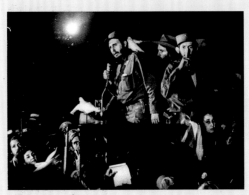

290

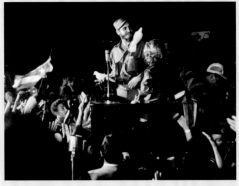

291

293

294

295

296

297

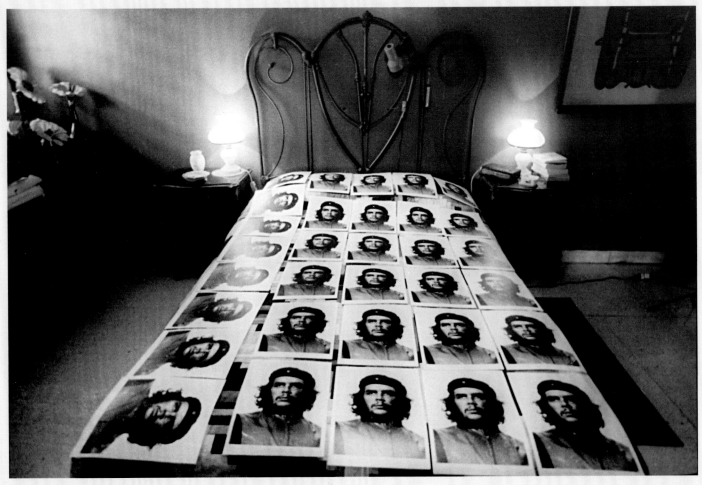

298

294, 295
Enrique de la UZ
*From the series "There is No Other
Way to Harvest the Cane"*
1970

296, 297
Rigoberto ROMERO
and
Leovigildo GONZÁLEZ
*From the series "With the Sweat of
the Workers for the '10 Million'"*
1974

298
José Alberto FIGUEROA
El Vedado
1991

THE 1960s: REDISCOVERING IDENTITY

Liana Ríos Fitzsimmons

Any action produces a reaction, which is why the abrupt, significant change brought about by the triumphant Revolution in 1959 was reflected obliquely, but earnestly, in artistic output. It would have been impossible for artists to ignore the implementation of José Martí's objectives and Che Guevara's ideals, or fail to be concerned over the instances of sabotage by the United States, the Bay of Pigs invasion and the imminent danger during the Cuban Missile Crisis. The clear, incredible force of that event was manifested in a sense of justice and freedom that, in due course, broke with the motivations behind and norms of the abstract art that went before. The heartfelt reaction of artists—at last without reservation—burst forth in a mixture of jubilation and drama, heartbreak and defiance, hope and expectation.

As in the preceding decade, art contributed topicality in the styles of the day. It was characterized by a vibrantly explicit expressionism in the New Figuration and also in Pop art, which was consolidated in the second half of the 1960s. Photography was included in painting and played a prominent role by the end of the decade. Collages and assemblages also appeared as effective resources in the appropriation of reality, which most artists approached from an autobiographical rather than a documentary viewpoint.

Ángel Acosta León, one of the decade's most solitary beings for personal and artistic reasons, stamped the whole drama of his life on everyday objects that fascinated him and, with the same feeling, expressed in images the tragic events of the early years of the Revolution. *Palma bélica* [Warlike Palm] is a cannon that he placed on wheels, which he worked on every day. There is evidence of the same vital spark and the reflection of his inner conflicts in the cots, toys and other objects; in those feverish, agitated transcriptions of coffee pots—so Cuban and so venerated by him—and in the powerful impression made on him by the explosion of the ship *La Coubre* and the attack on the Bay of Pigs.

Servando Cabrera Moreno also presented a heartfelt version of the Bay of Pigs, not a mere description. Although he had ventured sporadically into abstraction in the 1950s, he now showed his vocation for figuration, portraying events in the revolutionary saga with great feeling. Notable among his works at this time are his *Peasant Militia* (ill. 312) and *Bombardeo del 15 de abril* [Bombing on April 15]. Servando identified with the new reality and interpreted it as true freedom, a feeling that also appeared in his expressive-grotesque works and especially in the later pieces of his erotic period. Examples are *Homenaje a la soledad* [Tribute to Solitude] and *El pan nuestro de cada noche* [Our Nightly Bread], in which sexuality is boldly affirmed with the Cuban's characteristic relish, his irrepressible ego displayed on the canvas with the same brio found in his epic painting. However, *El sacrificio* [The Sacrifice], as Gerardo Mosquera has rightly noted, has other implications, since the male member stands defiantly erect in the midst of the reference to the destructive Vietnam War.

Antonia Eiriz, who had been spiritually involved with abstraction, found her own style within New Figuration. Her portrayal of her personal and family situation, and the circumstances of her immediate environment, was rather caustic, but she showed genuine solidarity with people beaten down by life and with her own kind.

She also proclaimed a scathing and explicit condemnation of dictatorship as a deadly form of government in *A Tribune for Democratic Peace* (ill. 315), *Naturaleza muerta* [Still Life] and *Los caídos* [The Fallen]. And in *Réquiem por Salomón* [Requiem for Solomon] she expressed her admiration for the humorist Chago and denounced the ostracism from which he suffered.

Umberto Peña was another creative artist who revealed personal, intimate matters in which are seen contradictions with immediate reality. He produced Pop art with grotesque elements, strong colours and onomatopoeic sounds: an aggressive form and content in a compact expressionist style intended to disturb the viewer (ill. 308). Many of the titles of his 1967 pieces are in the first person; most often they allude to heartrending situations or have a sarcastic function, so that the context of reference arises through sentiment.

Alfredo Sosabravo was a completely different artist in terms of content, approach and intent. He created an uncontaminated space independent of contingencies and full of delightful characters, and presented the most controversial events with seeming complacency. His addition of monochrome fabrics sewn onto the canvas to produce dense textures was an almost artisanal process, and a singular way of approaching collage (ill. 306, 307).

Raúl Martínez, an abstract artist par excellence, began to include elements of reality in his collages in 1964. He thus transformed Informalism into Pop art, blending this technique with repetition of the same photo on the canvas. This led him to discover the communicative possibilities of this resource as an ideal way of reflecting the reality of Cuba and the new social image of the Revolution. He began in 1966 with portraits of Martí (ill. 317), where the brushstroke is still evident, and then added Che Guevara, Camilo Cienfuegos, Fidel Castro and anonymous heroes of the nation (ill. 316). Later, in about 1970, he presented reality from a very different viewpoint from the one that prevailed in the 1960s.

The work of Frémez is situated at this crossroads. Using codes borrowed from German Dada photomontage and from Pop art, his approach is faithful to the postulates of the 1968 Havana Cultural Congress, which was to determine the ideological and aesthetic parameters of the ensuing decade. He took photographs of different subjects and sizes to produce areas of specific visual weight in which to display his open denunciation of social and political ills. He also experimented with fusing traditional and innovative printmaking techniques. In the pieces of the series "Songs of the Americas" (ill. 309–311), he used photography to create new realities and colour to emphasize the idea expressed.

Other codes and other needs came to the fore, putting an end to that period of definitions, paradoxes and splendour in which hope and the intensity of feelings and contradictions produced the art described here.

See also

Alonso, Alejandro Alonso. "Raúl Martínez: el tiempo que vive," *Revolución y Cultura*, no. 10 (October 1986), pp. 40–51.

Alonso, Alejandro G. *Sosabravo. Alea jacta est.* Catalogue raisonné. Havana: 2005.

Fernández, Antonio Eligio. "Umberto Peña expone," *Revolución y Cultura*, no. 9 (September 1988), pp. 26–31.

Pogolotti, Graziella. "Antonia Eiriz: arte entre dos mundos," *UNION*, vol. 3, no.1 (1964), pp. 157–58.

Pogolotti, Graziella. "Revelación de la máquina en Acosta León," *Casa de Las Américas*, no. 9 (November–December 1961), pp. 129–30.

THE INCREDIBLE DECADE: A PERSONAL REMINISCENCE

Ambrosio Fornet

The impossible is possible. We are crazy, but have good sense.
— Jose Marti

Cuba's first contribution to 1960s culture was our belief that that decade began in 1959. The difference is not one of years but of eras. In 1959, our entire history began to be defined by the dramatic extremes *before* and *after*. The intensity with which that dizzying *now* was lived was a result of the fact that as a nation we had suddenly become sane: the world *could* be changed and each of us, in the process, could also change. Although others claimed differently, Cuba was more than just sugar.

The most visible sign of frustration and impotence—shrugging one's shoulders—disappeared from Cuban body language. The impossible was now possible; the unheard of, as a character from an Alejo Carpentier novel might remark, became a part of everyday life. Along with the vocabulary of historic fatalism—plantation, submission, eviction—the technical terms of shameful behaviour quickly disappeared from the language: embezzlement, malfeasance, bribery, in addition to the anachronistic words

gambler and hustlers (male or female). An egalitarian gale, like the one that had swept away the straw hat twenty-six years earlier, now confined the suit and tie to the closet where old *Bohemia* magazines were piled up and replaced these civilities and their whiff of snobbery with others, making it possible to coin such democratic expressions as "Comrade President," for example. Havana was filled with *yarey* hats (a coarse hat made of palm leaf with a decorative ribbon), worn by thousands of amazed peasants discovering light bulbs and telephones; the countryside was filled with berets and primers with the arrival of *brigades* of bold literacy teachers who taught the ABCs under the glow of an oil lamp while learning what wood coffee-grinding mortars, footpaths and teams of oxen were, and how much injustice can fit inside a small dirt-floored thatched hut. In remote mountain villages both children and grown-ups doubled up in laughter watching Charlie Chaplin on a makeshift movie screen "for the first time."[1]

In that fascinating and subversive maelstrom there was a liberating drive we could call *affirmative* carnivalesque: it wasn't about turning the world on its

head, but about putting an upside-down world aright. When the first stage of this process was over with the redress of the *great* centuries-old injustices—illiteracy, institutional racism, prostitution, unemployment, the abandonment of rural areas and the lack of free medical care—it was obvious that the period of the magic wand was over and that it had to give way to individual and collective effort. Only by encouraging *awareness* and the ability to make sacrifices for the common good would it be possible to leave underdevelopment behind and lay the foundations of the *new* society. Voluntary labour, focused on agricultural production and especially the sugar harvest, was a practical way of expressing this commitment to the future. Now redefined as *socialist*, the revolutionary project was consolidated by military victory over the old dominant classes and its servants, organized as shock troops by the CIA in an attempt to make a triumphant return to the past. The victory at the Bay of Pigs has come to be seen as imperialism's first military defeat in the Americas.

★

All these projects and events—even those that seemed by nature remote

from the field of culture—had cultural implications because they had direct or indirect implications for the thorny realm of ideology. Hundreds of thousands of people could read a book for the first time: what ideas and values would they absorb from that reading? Hundreds of thousands of teenagers visited a painting exhibition for the first time, heard recorded classical music or attended a ballet or performance of folkloric dance. What good would the experience *do* them? All these questions touch on two major issues: freedom of expression and the function of art and literature in a socialist society. But these activities were carried out from a corrupted perspective, one as utilitarian as the bourgeois who asks what poetry is *for*: it was assumed that art's purpose is mainly didactic. It frightens me to think that over forty years ago, during a Critics Forum at the National Library, I thought it wise to clear up the confusion by appealing to the authority of Antonio Gramsci, when he described how "art is educative in so far as it is art, but not in so far as it is 'educative art' because in the latter case it is nothing and nothing cannot educate."[2]

I should make clear that it was quite easy to defend this position back then because we had, so to speak, "official support": in that same library, one year earlier, Fidel Castro had set the terms of the debate with his now famous maxim: "Within the Revolution, everything; against the Revolution, nothing." It was clear that this *everything* opened up endless possibilities for the creative work of the vast majority of our artists and writers, who from the start saw in the Revolution—and this

was now confirmed by these *Words to the Intellectuals*—the possibility of an authentic cultural renaissance. In this way, an alliance between the artistic and political vanguards, perhaps the most fruitful in our history, was organically sealed. The impact of this alliance on the culture of the 1960s was so great that it extended beyond our borders. But one problem remained. Since artistic language is not monolithic—it has, as is well known, various interpretations—what was now at stake was a question of power: if there was ever any doubt, who would draw the line between *within* and *against*?

The meeting between Fidel and the intellectuals had itself been motivated by the polemic that arose when documentary film about nightlife in small-time Havana nightclubs was refused screenings in movie theatres when it had already been aired on television. This could be taken as a threat to freedom of expression, which was how the members of the *Orígenes* group saw the stream of abuse from *Lunes de Revolución* against José Lezama Lima a short time before, and there was no lack of people to insinuate that the ghost of Stalin had begun to cast its ominous shadow over the land. It was an unfounded fear, or at least an exaggerated one, as was demonstrated afterwards; but the truth is that not far from us, in secret gatherings of mediocre writers, opportunists without a political track record and cultural bureaucrats turned into fervent self-proclaimed custodians of doctrine, the idea of "educative art" was taking shape under the equally ominous shadow of "Socialist Realism." Mimesis may be a good defensive tactic for small forest-

dwelling animals, but it is unfortunate that it was adopted as a password in Cuba at a time when the Revolution was embarking on the greatest project of cultural decolonization ever in Cuban history.

In fact, the *dogmatics*, the name we gave the ideologists whose only merit had been to introduce academic Marxism in Cuba through their famous *manuals*, were rowing against the stream, although they did have a compass. They must have felt chills go up and down their spine when Che Guevara ridiculed Socialist Realism, calling it an art of "frozen forms" good only for expressing "what everybody knows, that is what government bureaucrats know." By then, polemics were part of our intellectual routine; anyone who still hadn't taken part in one was, like a sniper, taking careful aim. Culture had finally become a battlefield, a symbolic space where all kinds of arguments took place and various power groups battled for hegemony. Throughout the decade, the most active gave their opinions in magazines and literary supplements such as *Lunes de Revolución*, *Cine Cubano*, *Casa de las Américas*, *La Gaceta de Cuba*, *Unión*, *El Caimán Barbudo*, *R y C* and *Pensamiento Crítico*. But there was also the "foreign front," and since we thought we were the bold musketeers of continental revolution, we fought left and right with equal vigour, battling enemies we hated (the magazine *Mundo Nuevo*, a cultural front for the CIA) and friends we admired (such as Pablo Neruda) whenever disagreements arose.

★

The defenders of unlimited freedom of expression found themselves in a tight spot: all of the country's cultural activity—and this is something the literacy teachers knew well, because they already had their own martyrs—took place in an atmosphere of violent confrontation; that is, from entrenched positions in which it was impossible to embrace the noble ideal of ideological co-existence. Indeed, we lived under the constant threat of terrorism. Sabotage was frequent, as were threats of invasion (like the one that finally took place at the Bay of Pigs), armed banditry carried out with CIA support in the Escambray mountains, the hijacking of planes and ships and manoeuvres to destabilize the government (one of which—the deceitful campaign around the suppression of parental guardianship—was the reason thousands of children were forced by their own parents to emigrate *alone*). Back then, no one had any idea that these conflicts, of varying intensity, would continue for almost half a century, after reaching a climax with the Missile Crisis. In other words, alongside the euphoria of construction we were experiencing that terrible thing that Jean-Paul Sartre, who witnessed the funeral procession for the victims of the *La Coubre* bombing, called "foreign threat felt as anguish."[3] And, we might add, as indignation.

Perhaps the reason the ideological struggle in this early stage was so complex was the constant pressure of this political atmosphere, which brought out the best and the worst of each of us. Generosity and meanness could alter-

nate, and even be one and the same thing. Anyone who had played a role in the success of the literacy campaign as a teenager could, as a university student a few years later, accuse fellow students who let their hair grow or secretly listened to the Beatles of being "extravagant" or "apathetic." Those who wholeheartedly and with daily sacrifices supported the project of a different society could, in the name of that same project, be intolerant toward those who claimed their right to be *different*, whether in their sexual orientation, religious beliefs or taste for hippie fashion. Homophobia found a breeding ground in the constant exultation of Spartan morals and the ancient prejudices of a traditionally sexist culture. And in the same way as the thick-headed bourgeois sent his irresponsible or spineless son to a military academy in order to "make a man out of him," thick-headed socialist officials, with identical aims, also decided one day that youth who had "gone astray" should carry out compulsory military service in the so-called Military Units of Assistance to Production (UMAP). In the troubled waters of the new scale of values, everything seemed to be justified by the supreme objective: a freer and fairer society liberated from past injustices. However, this inescapable goal gave rise to a reversal of theological schema, whose secular expression was the harebrained idea of paradise on earth—another sad legacy of Socialist Realism that has been the excuse for the enemy's countless and cynical jibes. "How can we take you seriously?" they ask. "You believe in fairy tales!" More than half a century ago, a left-wing Mexican activist, José Alvarado, trying to defend his ideas in the face of his

adversaries' mockery, commented that he and his comrades weren't so foolish as to be aiming for a world in which all human beings were happy. What we want, he said, is "a world where pain doesn't arrive infected with the rise of food prices, where remorse isn't tinged by unemployment, where worries have nothing to do with imperialist invasions." We could call that stance *Socialist* and *Realist* if these terms weren't already so discredited.

★

Speaking about the 1960s is difficult for my generation without yielding to nostalgia. Back then we were part of a great collective project and we had all the time in the world to carry it out. Those of us who had, until shortly before then, been living in the age of contempt, in which writing, painting or reading poetry had to be done in absolute secrecy, suddenly saw ourselves summoned to take part in a heroic civic endeavour, the new owners of the means of production and distribution necessary to putting our cultural heritage within the reach of all. We saw this heritage as encompassing the whole world, from Altamira to Picasso, Homer to Kafka. In a country where poets and authors had to defray the costs of publising their very few books, the newly created publishing houses not only published the books of the masters but also those of their disciples—and *paid them* too. The impossible really was possible; we had regained our senses. I was once able to say, about the hundred thousand copies of the book that launched the Imprenta Nacional [National Printing House], that *Don Quixote* was the first novel of

the Cuban Revolution. Latecomers to the classics no longer had to go to the library to find "archeological" works such as *Espejo de paciencia* by Silvestro Balboa or José Antonio Saco's *Papeles sobre Cuba*; they had only to go to the corner bookstore.

What gave intellectual legitimacy to our project was that rupture was always accompanied by rediscovery. Twentieth-century Cuban artists had been formed in this fruitful contradiction, clearly aware that the avant-garde was our tradition. Thus, while economists spoke of the need to leave underdevelopment behind once and for all, we spoke about the need to establish ourselves once and for all in modernity. We rejected plantation agriculture, racism and Socialist Realism, to give three very different examples, for one and the same reason: they were all signs of *backwardness*. The Revolution seemed to us the quickest and surest way to reach our goal, not only in the cultural field but in every facet of society. They were not separate: it would have been a crime of lèse-Cubanité to have illiterates in a country of so many and such great men of letters. To sum up, and to paraphrase Marx for the nth time, the principle of constant creativity involves a process of mutual feedback in which the artist, in creating a *new* work of art for the spectator, also creates a *new* spectator for the work of art. Here again we see the error in believing in the didactic function of art, but at another level. What art *teaches* us is to sharpen our senses; what art *educates* is our sensitivity.

The radical transformation of social life—and with it the appearance of a mass audience, seeking out literature and art previously reserved for an urban minority—was something that couldn't help but influence the work of cultural *workers*. In the first place, because of their working conditions themselves: through the support of autonomous institutions and a kind of sponsorship (state subsidy), they were freed from both bureaucratic and market exigencies and could work with complete autonomy. Second, because every new era brings its own aesthetic, every new world view brings its own language. If these transformations take place organically—I return here to the idea of continuity in rupture—sedimentary identities always survive in them. In painting exhibitions we suddenly discovered, against a background of brushstrokes whose lineage was that of the purest abstraction, a collage of graphic symbols that brought us back to the most imperative present, thereby inaugurating revolutionary Pop art through a clever synthesis of formal codes. Singers no longer sang about the solitary pain of lost love, but about an era that was giving difficult birth to a heart and a Vietnamese child abandoned to its fate in the midst of a napalm hell. Similar encounters and shifts could be seen in film, graphic design and literature; in all of them, their most innovative elements carried out a two-fold search for authenticity and modernity. Like in the 1920s, but with a social reach that would have been unimaginable at the time, our *ajiaco*, or stew, was really coming to

the boil. Not only within Cuba but also abroad. Its reach was so great that a critic asserted that we were on the verge of "the most important political revolution in the cultural history of the Americas," while another said, in a mixture of amazement and irony, that Cuba had become the "Rome of the Caribbean." [note] Both views were Latin American reflections of what had been accomplished, especially by two organizations: Casa de las Américas and the Cuban film institute (ICAIC).

★

In the final three years of the decade, celebration and grief, apotheosis and catastrophe came together at home and abroad. From Paris came the Salon de Mai, the largest exhibition of modern painting Havana had ever seen. The Protest Song Festival and the Havana Cultural Congress, huge gatherings of intellectuals and artists from around the world, eager to show their support for the Revolution, took place. But Che Guevara had been murdered in Bolivia three months earlier, putting an end to an entire stage in the continental revolutionary project. Soviet intervention in Czechoslovakia soon followed, deepening the crisis in European socialism and in leftist movements on both sides of the Atlantic. At home, the Revolutionary Offensive liquidated all remaining private property in the commercial sector and preparations began for the 1970 sugar harvest and the introduction of universal education and the Schools

in the Countryside program. There was a return of dogmatism in the critical analysis of two books that won awards for the Union of Cuban Writers and Artists (UNEAC) literary competition, as well as in the overall climate of Cuban intellectual life. In the United States, the feminist and counter-culture movements, the Black Panthers, the student left and opposition to the war in Vietnam on the part of large sectors of the population were making news. In fact, something was happening everywhere: in Vietnam came the Tet Offensive, which offered the first glimpse of American defeat; in Paris, the festive student insurrection in May 1968; in Mexico, there were the Tlatelolco killings; in Uruguay, the spectacular efforts of the Tupamaros guerrillas; in Argentina, the "Cordobazo" uprising; in Peru, the expropriations and nationalizations by Velazco Alvarado's government; in China, the end of the so-called Cultural Revolution; and on the moon, the arrival of the first man. Latin American culture saw the rise of the New Latin American Cinema movement and witnessed the coming of age of the new novel. It truly was an "incredible decade" that seemingly exhausted the range of options in many fields of human activity.

To me and other members of my generation, the era left us a store of renewable energy that we call *good sense*, following José Martí's paradox. It is a paradox that now enables us, with the authority of someone who speaks from experience, to assert that a better world is possible.

1 Octavio Cortázar's 1967 documentary film *Por primera vez* (*For the First Time*) followed a government mobile cinema unit—a pick-up truck, projector, generator and cloth screen—into remote mountain villages to record the reactions of their inhabitants to seeing their first movie—here, Charlie Chaplin's *Modern Times*. (Trans.)

2 David Forgacs, Geoffrey Nowell-Smith, eds., *Antonio Gramsci: Selections from Cultural Writings* (Cambridge, Mass.: Harvard University Press, 1985), p. 107.

3 Jean-Paul Sartre, "Ouragan sur le sucre" (last article), *France-Soir* (July 15, 1960).

THE 1970S: RECOVERY AND CONTEMPORANEITY

Hortensia Montero Méndez

The 1970s were a complex and contradictory period[1] in which the educational nature of art as an ideological paradigm was emphasized and young artists adopted a prescribed, legitimized aesthetics in keeping with the prevailing socio-cultural guidelines. It called into question Cuban identity, the continuity of the avant-garde movements, indigenous and Afro-Cuban myths, rural traditions and the trend toward popular art, creating diverse visual imagery. Preference was given to historical-social themes; portraiture and landscape, approached from different perspectives; and the reaffirmation of patriotic values. Pop art, Neo-Expressionism, photorealism and abstraction fuelled experimentation, playfulness, introspection and formal exploration.

Rafael Zarza was a superb graphic artist with a critical, mordant sense of humour that was Goyaesque and satirical. He used Pop art aesthetics in figurative works alluding to the culture of bullfighting. Bulls, cows, oxen and skeletons appear in visual polemics about the artist himself, his social environment, art and politics. In *In the Field* (ill. 300) the bull is employed as a symbol of power, and through allegory,

mockery, irony and double meanings Zarza created a symbolic strategy with creatures that gaze at us with the intensity of human beings in misery.

The ancestral cultural heritage of Manuel Mendive, a devotee of the Regla de Ocha or Santeria, is manifested in an iconography of environment, tradition, religious feeling and syncretism. He championed mixed blood by finding art within himself, co-existing with the mythological beliefs that were part of his thinking and of his life, and brought new styles from the rest of Latin America into Cuban and international settings. His cosmopolitan approach went beyond the traditional framework of the gallery through popular participation in his performances. In *Che* (ill. 319) he showed the individual's link to his natural environment, and how his philosophical world is inherent in the legitimacy of the physical and thinking self of human nature.

Gilberto Frómeta employed both realism and abstraction as means of expression. His use of photorealism, experiments with symbols, textural effects and visual contrasts of different surfaces reveal an ability to synthesize, a gift for design and for conveying

a concise message. His mastery of technique, expressive touch and vigorous line produced carefully balanced compositions in which the idea takes precedence over formal effects.

Tomás Sánchez began practising yoga in 1964 and meditation in 1970, intensifying his emotional bond with nature. His philosophy led him to revere emblematic phenomena such as humans and their habitat, even if human beings are absent. Landscape, always an essential factor in his art, became pre-eminent in 1973. In *In the Morning* (ill. 318) we see figures perfectly integrated in rural surroundings, rendered with contrasting colours in a free, spontaneous manner; these are appealingly comic beings, some grotesque, others inspired by Chagall, enchanting creatures whose expressive ugliness is presented in a critical and satirical manner yet with a certain tenderness.

Although Sánchez did not adopt photorealism, it changed his attitude to realism in landscape. After 1975, his growing spiritual connection with nature gave him a new concept of landscape, as he imbued it with a

meditative quality reflecting his inner feelings. Affected by the aerial photos of flooding along the beaches east of Havana in 1982, he painted a series of works conceived in a cinematic style, enhanced by three-dimensional effects and perspective, as seen in *The Flood* (ill. 361). Achieving his full creative potential, he became an internationally recognized exponent of this kind of ecological art with its opposing forces, the spiritual and the real.

Photorealism, which originated in the international art circles, was an avant-garde movement of renewal in the visual arts. It became a part of the societal blueprint for Cuba when the country's artists took a bold step: they turned back to the ethical function of art as an assertion of universal values, reaffirming identity from a humanist, lyrical and intimate standpoint. *All You Need Is Love* (ill. 321), an essential work in this movement in Cuba, expresses the ideal of the social message, the power of which lies in its human value. This is projected in the meaning, spirit and intention of the artwork itself, which reveals a love of humanity and the reflexive nature of descriptive personal accounts. The focus on the human figure led to an increase in portraiture and a revolutionary iconography with a new concept. This allowed artists to be critical of the source (U.S. photorealism), to remain committed to history and to work out a fresh new approach within the tradition of contemporaneity in twentieth-century Cuban art.

Manuel Castellanos, a meticulous draftsman, created a world of imaginative and symbolic richness in an original style, tackling Cuban reality with mordant wit. A master of the pencil drawing, he employs an intellectualized popular theme in *A Combatant People on the March* (ill. 303). A landmark in Cuban drawing, it was a pioneering use of a map of the country's outline to refer to Cuban society as a whole. This contemporary motif was subsequently adopted for other purposes by Antonio E. Fernández (Tonel), Ibrahim Miranda, Sandra Ramos and Abel Barroso.

The artists of the 1970s adopted the new concepts and visuality of the Cuban renaissance that would mark the 1980s. They subscribed to the practical sense of associations of meanings, taking advantage of the potential of symbols and parody and borrowing codes from popular culture, the civilization of the Americas, Afro-Cuban religions, the Caribbean's transcultural heritage and European cultures. Manuel Mendive, Rafael Zarza, Ever Fonseca, Pedro Pablo Oliva, Flavio Garciandía,[2] Tomás Sánchez, Rogelio López Marín (Gory), Nelson Domínguez, Roberto Fabelo, Manuel Castellanos, Zaida del Río, Eduardo Roca (Choco) and Ángel Ramírez, together with Cosme Proenza, Rocío García, Arturo Montoto and Manuel Alcaide (who perfected their individual means of expression in the 1990s after graduating from several universities in the defunct Soviet Union), constituted an important nucleus within a broad movement of creative artists. They all enriched their work by conceptualizing their modes of expression,[3] broadening the variety of media and formats they used, and demonstrating the interrelation of the arts as a key factor in contemporary practice.

1 Its historical antecedents were the twenty-third Salon de Mayo (Havana, 1967), the twenty-fourth Salon de Mai (Paris, 1968) and the Salón 70 (Havana, 1970), the latter a group exhibition of the most prominent artists of the previous ten years and a significant number of young artists.

2 Garciandía fostered a revolution in teaching starting in 1984, when he was elected head of the department of painting at the Art Institute of Graduate Studies (ISA). He brought his convictions as an artist— embracing cosmopolitanism, a thirst for information and a discriminating view of local and universal culture—to establishing very relevant educational practices. He influenced José Ángel Toirac, Lázaro Saavedra, Adriano Buergo, Ana Albertina Delgado, Ciro Quintana, Ermy Taño, Glexis Novoa, Carlos Rodríguez Cárdenas, Tomás Esson Reid and others.

3 The National School of Art (ENA) was founded in 1962, followed by ISA in 1976. The historical and artistic importance of ISA lies in the fact that it is a university-level centre. ENA graduates were ISA professors and/or graduates. Designed for the academic teaching of art, it is the workshop where the change in Cuban visual arts was forged, starting from the renewal of the 1980s, characterized by a multifaceted, pragmatic approach—a place where intellectual and aesthetic curiosity combined with the interaction of other facets of spiritual and social life such as science, religion, politics and philosophy.

300

300
Rafael ZARZA
In the Field
1971

301
Ángel ACOSTA LEÓN
Coffee Maker
1959

301

302

302
Santiago ARMADA (Chago)
The Gulf Key
1967

303
Manuel CASTELLANOS
A Combatant People on the March
1980

304, 305
Gilberto FRÓMETA
Diptych: *When it Comes to Governments, This Slogan Will Always Hold True, Even if Only One of Us Is Left Standing*
1975

303

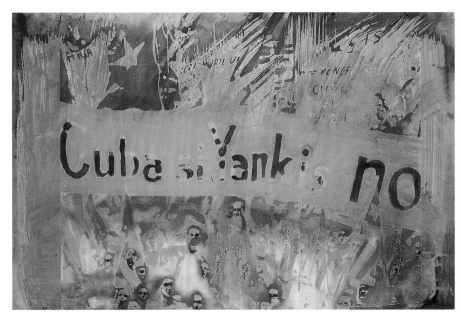

304

305

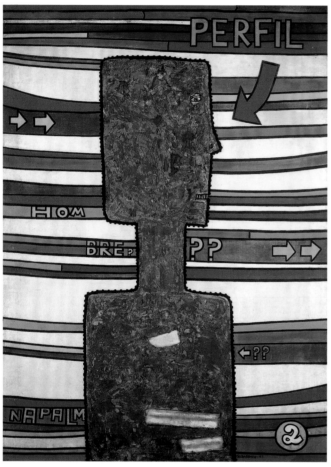

306

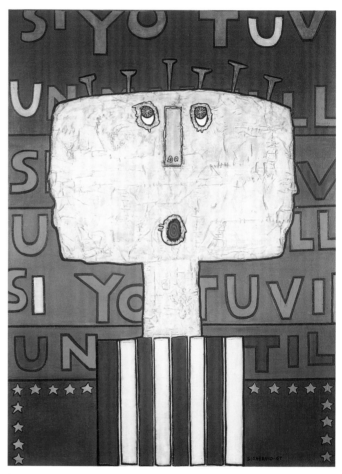

307

306
Alfredo SOSABRAVO

Napalm Man

1967

307
Alfredo SOSABRAVO

If I Had a Hammer

1967

308
Umberto PEÑA

*Aayyyy, Shass, I Can't Stand it
Anymore*

1967

309

309–311
José GÓMEZ FRESQUET (Frémez)
From the series "Songs of the
Americas"
1969

Untitled
Untitled
Children and Machine Gun

310

311

312

313

Servando CABRERA MORENO

312
Peasant Militia
1961

313
Youthful Days
1973

314
Pure
1979

314

315

315
Antonia EIRIZ
A Tribune for Democratic Peace
1968

316
Raúl MARTÍNEZ
We Are All Children of the Homeland
1965

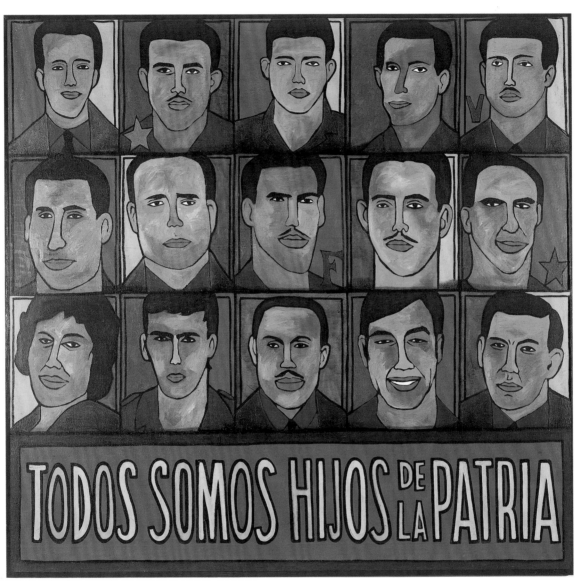

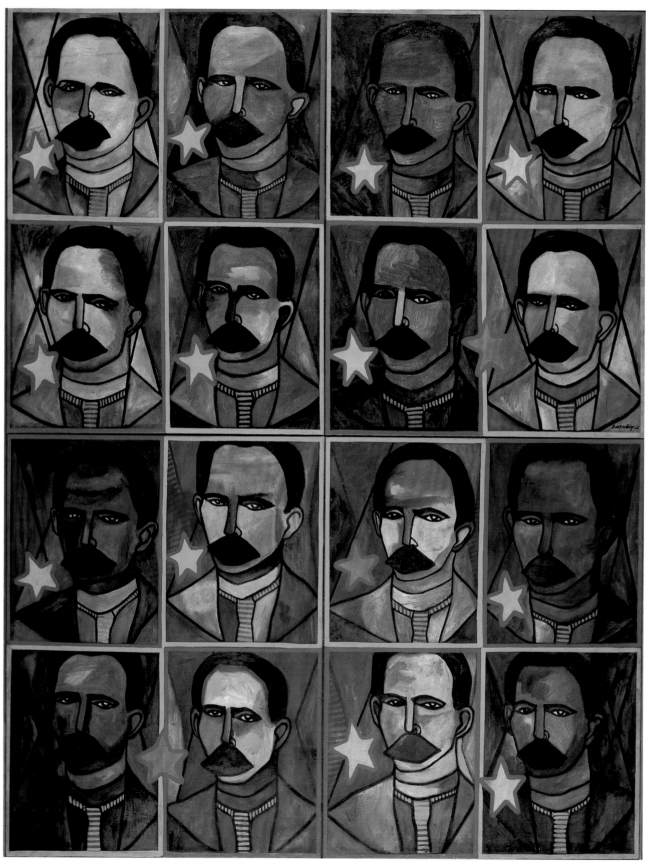

317
Raúl MARTÍNEZ
Martí and the Star
1966

318
Tomás SÁNCHEZ
In the Morning
1973

319
Manuel MENDIVE
Che
About 1975

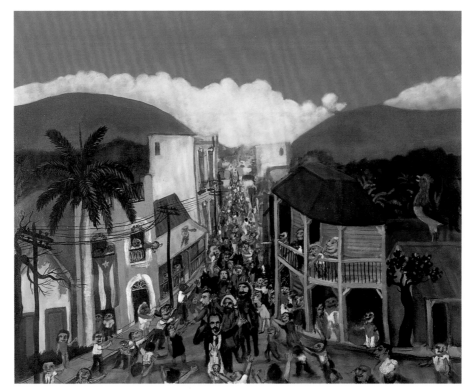

318

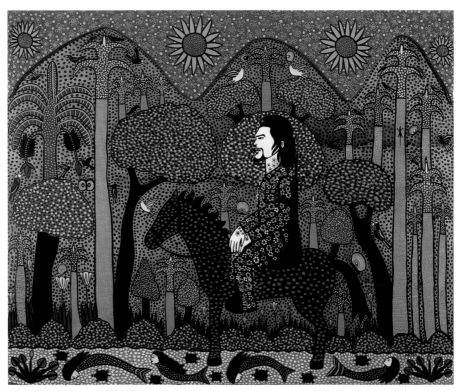

319

320

320
Rogelio LÓPEZ MARÍN (Gory)
The Bermuda Triangle
1978

321
Flavio GARCIANDÍA
All You Need Is Love
1975

PARIS IN CUBA 1967: THE SALÓN DE MAYO AND THE *CUBA COLECTIVA MURAL*

Günter Schütz

In 1967, the Salon de Mai, an annual exhibition of modern and contemporary art held in Paris since 1944, was also held in Cuba in August. The importance of the Cuban-hosted event is clear not only from the names of artists represented but also from the fact that before Cuba, the Salon de Mai had been hosted in previous years in Sweden, Switzerland, Yugoslavia and Japan. One can justifiably speak of it as "one of the most important events in international visual arts"[1] and emphasize that Cuba was the first country in the Americas to be given the privilege of hosting it. Wifredo Lam observes that the Salon's arrival was especially important "because it helped counter the cultural blockade levelled against Cuba."[2]

Lam's works had repeatedly been exhibited at the Salon de Mai since 1954 and he was close to both the executive and its president Gaston Diehl. Lam returned for a lengthy stay in post-revolutionary Cuba for the first time in 1963. He went back in 1966, when he painted the canvas *The Third World* (ill. 258) and donated it to the people of Cuba; it was placed in the Palacio de Bellas Artes (the Museo Nacional de Bellas Artes). It was a subject that brought home the fact that he "alone

contained this great expanse, the Third World, within himself, because he was Cuban-born, but from a mother of African descent and a Chinese father," as Michel Leiris observed.[3] It was during this visit that Lam and the Cuban authorities had the idea of hosting the following year's Salon de Mai in Havana (which afterwards went to the Museo Bacardí in Santiago de Cuba). The idea was taken up with enthusiasm in Paris, because Parisian intellectuals and artists were very interested in the Cuban Revolution.[4] There was on the one hand virulent anti-Stalinism in such circles, the French Communist Party's popularity then being in sharp decline, which gave a sense of urgency to the search for an alternative to the Soviet model. On the other hand the enthusiastic reports of their 1960 visit to Cuba by intellectual opinion-makers Jean-Paul Sartre[5] and Simone de Beauvoir[6] also led to widespread admiration for the Cuban Revolution.

Wifredo Lam and the Cuban director Carlos Franqui, jointly arranged not only to host the Salon in Cuba, but to invite many artists—as guests of the revolutionary government—who were then working in Europe to Cuba. The guest list drawn up by Lam was

accepted without exception, although the proposed artists and intellectuals represented various artistic tendencies and were politically no less diverse a group. As a result, some one hundred people of varied provenance were guests of the Revolution: painters, sculptors, writers, journalists, publishers, photographers, museum personnel and their significant others. Almost all those invited took up the offer, but among the celebrities who could not make it, Pablo Picasso and Max Ernst had to decline the invitation because they had other engagements, while Man Ray was too ill to attend.

The first group of visitors, which in addition to the Lam family included exhibition organizers Jacqueline Selz, Yvon Taillandier and many artists (including Adami, Camacho, Cárdenas, César, Corneille, Couteau, Couturier, Delfino, Erró, Labisse, Monory, Peverelli, Rancillac, Rebeyrolle, Recalcati, Télémaque), flew from Madrid to Havana on June 25, 1967. On July 16, those who followed included Michel Leiris and his wife, Marguerite Duras and Dionys Mascolo, Peter Weiss and Gunilla Palmstierna-Weiss, *L'Express* editor-in-chief Françoise Giroud, publisher Max Grall, art critic

Giroud, publisher Max Grall, art critic Alain Jouffroy, journalists K. S. Karol and Rossana Rossanda, authors Juan Goytisolo, Jorge Semprún and Maurice Nadeau, Surrealists José Pierre and Jean Schuster, in addition to Sir Roland Penrose, museum director Werner Schmalenbach, exhibition organizer Harald Szeeman, poet Lasse Söderberg and photographer Lütfi Özkök. There was also the poet Ghérasim Luca, painter Micheline Catty and their retinue: Anne Zamire, Piotr Kowalski, Gilles Ehrmann and Nat Liljensten. Most visitors stayed until the joint return on August 21. The first group therefore spent nine weeks, and the second, five, in Cuba. During their stay almost all of them participated in the creation of the group mural, attended the opening ceremony of the Salón de Mayo, and travelled across the island to Santiago de Cuba for a visit lasting several days. Artists had studios placed at their disposal, and as a thank you the painters and sculptors donated the works created there to the Cuban people, which were to form the basis of an anticipated museum collection of modern art.

The group painting (*Cuba colectiva, El mural;* ill. 334) came into being on the night beginning July 17 and ending in the early morning of the 18th, immediately after the arrival of the second group of visitors. It was Wifredo Lam's idea. Canvases were mounted by the Cubans on six wood panels, creating a surface of fifty-five square metres; scaffolding was set up in front of this painting surface placed in the Cuban Pavilion, located on Calle La Rampa, close to the Habana Libre Hotel. Eduardo Arroyo and Gilles Aillaud had drawn a large spiral with fields of exactly the same size, only two of which were allocated, one in the centre, which was painted by Wifredo Lam, and field number 26—a nod to July 26, the day of the attack on the Moncada barracks in Santiago—reserved for Fidel Castro, who had also been invited to the Salón (field 31 calls for him with its *VEN PRONTO FIDEL* [Come Quickly Fidel]). He failed to appear, however, and field 26 remained empty. All the other fields of the canvas were drawn by lot, with author and painter Peter Weiss for instance painting a grenade-like object exploding into countless black and blue pieces on a red background over which is written *VIVA LA REVOLUCIÓN* [Long Live the Revolution] (field 13).[7] He was not the only one using this statement: Ghérasim Luca and Carlos Franqui also wrote *VIVA LA REVOLUCIÓN* [Long Live the Revolution] on a Cuban flag, adding three French inscriptions: *LA POÉSIE SANS LANGUE / LA RÉVOLUTION SANS PERSONNE / L'AMOUR SANS FIN* [Poetry without Language / Revolution without People / Love without End] (field 8). Alain Jouffroy wrote *REVOLUCIÓN EN LA REVOLUCIÓN* [Revolution within the Revolution] (field 83); the same comment as Juan Goytisolo, to which he added *Revolución Permanente / Insumisión al Orden* [Permanent Revolution / Insubordinate to Order] (field 60), while Piotr Kowalski kept it short, simply writing *REVOLUCIÓN* [Revolution] (field 9), and Michel Leiris expressed *AMITIÉ à CUBA, la ROSE des Tropiques et de la Révolution* [FRIENDSHIP toward CUBA, the ROSE of the Tropics and of the Revolution] (field 28). Two Cubans, Oscar Hortado and Carruana, were very farsighted: *CON LA REVOLUCIÓN HASTA MARTE* [With the Revolution to Mars] (field 21). Maurice Nadeau thanked Cuba: *Merci à Cuba qui a rendu son sens au mot Révolution* [Thanks to Cuba for Giving Meaning to the Word Revolution] (field 90). Lisandro Otero, vice-president of the Cuban National Council for Culture, expressed himself more cautiously: *LA REVOLUCIÓN ES LA CREATIVIDAD DE TODOS LA RESPONSABILIDAD DE TODOS* [The Revolution is the Creativity of All, the Responsibility of All] (field 54). Gunilla Palmstierna-Weiss painted three breasts with aureoles in yellow, ochre and red, around which is written: *LA REVOLUTION / EST AUSSI / POUR LA FEMME* [Revolution / is Also / for Women] (field 55). Others celebrated the new Cuba: Penrose with *VIVA LA CUBA NUEVA* [Long Live the New Cuba] (field 56), and Georges Limbour rediscovered the New World for himself writing *ICI après l'aventure assoiffée se découvre une seconde fois Le NOUVEAU MONDE* [Here the Long Awaited Adventure, THE NEW WORLD, is Discovered a Second Time] (field 89). Heberto Padilla and Lou Laurin-Lam wrote *Vivan las guerillas / mira la vida al aire libre / los hombres remontan los / caminos recuperados y can / ta el que sangraba* [Long Live the Guerrillas / Look at Life Outdoors / the Men Retrace their Steps / along Roads Regained and / Those Who Once Bled Now Sing] (field 68), and Edward Lucie-Smith, the art critic of the *Times* of London, somewhere between an observation and an exhortation, remarked that LA POESIA SANGRA [Poetry Bleeds], accompanied by a blood-red handprint (field 70). I must however limit ourselves to these cursory indications and pass over the solely pictorial representations as well as the many participating Cuban artists, of whom I will only name Portocarrero, Pablo Armando Fernández, Roberto

Retamar, Mariano Rodríguez, Fayad Jamís, Raúl Martínez and Matamoros. *El mural* is a group effort that bears the mark of individual capabilities and wishes. Images and texts, painting and poetry, art and politics mingle and unite, creating a cheerful celebration of the Cuban Revolution. The group painting was transported to Paris for the 1968 Salon de Mai, but could only be seen by very few visitors because the events of May 1968 led to the exhibition's closure within a few hours of its opening.

The production of the group painting was a big celebration that went on through the night and well into early morning. There was rum and Cuban music, and the dancers of the famed Tropicana cabaret were largely responsible for the high spirits of the Cubans who thronged in the streets in their thousands to watch the show. Anticipating the Salón de Mayo opening, Michel Leiris observed, "Art and culture, rural production and urban entertainment were blended in a unique conglomerate, which showed that in these difficult times *we need arms to safeguard all of this* and, thanks to a canvas that is the work of some one hundred artists in public and not in their ivory towers, speaks to the necessity of a huge alliance between those who commonly hold at least a vague will to see the world change."[8] The truth of Leiris's interpretation of events has been borne out by statements made by a number of participants.[9] Piotr Kowalski said, "For one night art became a collective freedom where the revolution was fulfilled in poetry." Corneille for his part remarked, "In the wild, crazy atmosphere of that beautiful tropical night, my heart beat at the

same rhythm as the hearts of all those Cuban women, men and children who watched us paint. It was a unique joy." César was no less exuberant: "There is no phrase in the French language that can express the human worth, the beauty of this event, which was a deep shock for me, nor the force of expression in that complete performance, which I will always cherish." For Eduardo Arroyo, the experience was about "a truly whole spectacle where, for once, those little individualistic irritations did not creep in and where, for the first time, sacrosanct gestures of the Western artist did not manifest themselves." The Italian journalist and exhibition organizer Rossana Rossanda expressed herself more thoughtfully, and, referring to Brecht and Gramsci, observed that "a revolutionary society . . . must not only know about but must choose" ("between different forms of art and different languages"). According to her, this society would only choose revolution, once it knew it in all its richness and complexity. The French painter Robert C. Gillet revealed something akin to skeptical melancholy by remarking that such an event, as with all great adventures, is probably irreproducible. Edward Lucie-Smith spoke of this night as "total art" that would be unthinkable elsewhere, and Sir Roland Penrose from the Institute of Contemporary Arts in London remarked that he noticed a deep wish "to nurture and extend the basic qualities of the human spirit: friendship, generosity and love of the arts. We look to Cuba for a vision of a new world." The mural poem by Peter Weiss described a similar vision of a new world: *La noche de la pintura colectiva / Una visión de un mundo / Donde el hombre es libre / Una totalidad de acción / abrimiento para*

todas las posibilidades / y alegría de vivir [The Night of Collective Painting / A Vision of a World / Where Man is Free / Totality of Action / An Opening for Every Possibility / And the Joy of Living].

On July 20, all the guests left for a bus tour across the island with stops in Varadero, Guamá, La Boca, Cienfuegos, Camagüey, Holguín and finally Santiago, where they arrived on the evening of July 23. After visiting the Moncada barracks and the Revolutionary Museum, they travelled to Guantánamo, where they were able to see the U.S. naval base from an observatory on July 25. The next day they all participated in celebrations of the Revolution in Santiago, the highlight of which was a speech by Fidel Castro.

Everyone was back in Havana for the opening of the Salón de Mayo, on the evening of July 30. To their surprise, the two hundred pieces brought from Paris were accompanied by a Canadian breeding bull and anti-aircraft artillery. The Cuban foreign minister Raúl Roa gave a remarkable speech (the *Granma*[10] headline read "The Revolution Ensures and Exalts the Right of Artists and Writers to Express our Reality Freely") at a reception. The list of artists represented reads like a who's who of the contemporary art scene. In addition to other painters and sculptors, there were Pierre Alechinsky, Karel Appel, Arman, Arp, Enrico Baj, Miguel Berrocal, Pol Bury, Alexander Calder, Willem de Kooning, Jean Dewasne, Hans Hartung, Jacques Hérold, Hundertwasser, Jean-Robert Ipoustéguy, Isidore Isou, Asger Jorn, Félix Labisse, Richard Lindner, René Magritte, Man Ray, Mathieu, Matta, Joan Miró, Picasso, Édouard Pignon, K.H.R.

Sonderborg, Soto, Pierre Soulages, Saul Steinberg, Dorothea Tanning, Antoni Tàpies, Raoul Ubac, Bram van Velde, Vasarely, Maria Elena Vieira da Silva, Jan Voss, Hugh Weiss, Zao Wou-Ki, not to mention the artists who came to Havana, some of whom were named above. It is important to note that in addition to classic modernism, all the significant currents of contemporary art were represented, Surrealism as much as New Figuration, Lettrism, Situationists such as the COBRA group, Neo-Realists and Pop art, Op art and Action Painting—only Socialist Realism was not represented. More than 200,000 Cubans visited the exhibition.

Regardless of the course taken by Cuban history afterwards, and although some participants have been critical of it since, I know for certain from conversations with them how deep and lasting an impression their 1967 visit to Cuba and "the Cuban party" made on them, as confirmed by a number of autobiographical works by the artists themselves, in addition to exhibition catalogues and catalogues raisonnés.[11]

1 Raúl Palazuelos, "Crónica comprimida de un evento demasiado amplio para reportar," *La Gaceta de Cuba*, year 6, no. 60 (July–August, 1967), p. 2.

2 Quoted by L. Lopez Nussa, "Vísperas del Salón de Mayo," *La Gaceta de Cuba*, year 6, no. 60 (July–August, 1967), p. 5.

3 Michel Leiris, *La règle du jeu*, IV: "Frêle bruit" (Paris: Gallimard 1976), p. 138.

4 For example, see the magazines *Europe*, no. 409–410 (May–June 1963) and *L'Arc*, no. 23 (Autumn 1963).

5 Jean-Paul Sartre, *Huracán sobre el azúcar* (Havana: Ministerio del Estado, 1960). See *Sartre on Cuba* (New York: Ballantine Books [1961]). See also *Sartre visita a Cuba. Ideologia y revolución. Una entrevista con los escritores cubanas* (Havana 1960). Sartre's text "Ouragan sur le sucre" was widely read in France, because his feature articles promptly appeared in *France-Soir* (between June 29 and July 15, 1960).

6 Simone de Beauvoir, *La force des choses II* (Paris: Gallimard 1963). Trans. *Force of Circumstance* (London: André Deutsch / Weidenfels and Nicolson 1963).

7 A picture of the group painting appeared on the cover of the catalogue for the twenty-fourth Salon de Mai (Musée d'art moderne de la Ville de Paris, 1968), and two years later in Ezio Gribaudo [one of those invited]: *Mural. Cuba Colectiva 1967* (Turin: Edizioni d'Arte Fratelli Pozzo, [1970]), preface by Alain Jouffroy, n.p., on the cover and inlay poster; the fields are reproduced separately inside. There was also a series of twenty-five postage stamps issued to commemorate the Salón de Mayo in Havana and Santiago in 1967 along with a large stamp of the group painting.

8 Leiris 1976, p. 138 (author's emphasis).

9 All quotations are from "MURAL Cuba colectiva 1967" in the special issue of *Granma* entitled "Salón de Mayo. Pabellón Cuba," (July 30, 1967), p. 6.

10 "Raúl Roa hizo la apertura de la exposición del Salón de Mayo," *Granma* (July 31, 1967), p. 2. Raúl Roa also quotes the well-known Fidel Castro dictum: "Within the Revolution, everything; against the Revolution, nothing." See also the French edition of *Granma*, "Discours de Raúl Roa à l'inauguration de l'exposition du Salón de Mayo," (August 6, 1967), p. 1.

11 Space does not allow for a more detailed description, especially after forty years and all manner of political and ideological upheavals, and disappointed hopes and illusions on the international scene. It would be all too easy to give a negative appraisal. There have already been a number of denunciations of "Revolution tourists."

* A word of heartfelt thanks to Lou Laurin-Lam and Eskil Lam, who have generously permitted me access to their private archives. I would also like to thank participants of the trip to Cuba, who readily shared information with me: Lou Laurin-Lam, Micheline Catti-Ghérasim Luca, Gunilla Palmstierna-Weiss, Alain Jouffroy, Yvon Taillandier, Erró, Pierre Gaudibert (†), Albert Bitran, José Pierre (†), Gilles Aillaud, Leonardo Delfino, Ansgar Elde (†) and Irène Dominguez.

322

323

324

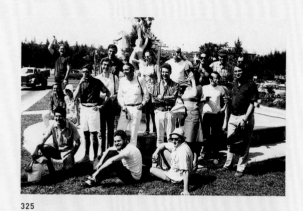

325

326

327

Salón de Mayo, Havana, 1967

322
Estudio KORDA
*Construction of the temporary gallery
at the Cuban Pavilion*

323
Osvaldo SALAS
*Wifredo Lam in the 1967 Salón de
Mayo gallery ("Composition" (1957) on
the left and "Mother and Child, III
(about 1952) on the right)*

324
Estudio KORDA
Wifredo Lam in Pinar del Río

325
Luis CASTAÑEDA
Group photo, Havana

326
Guillaume CORNEILLE
Street mural by children

327
Anonymous
*Wifredo Lam and schoolchildren
in front of a memorial to Che*

328
Anonymous
*Special issue of "Granma" covering
the 1967 Salón de Mayo*

SALON DE MAYO
PABELLON CUBA, LA HABANA, 30 DE JULIO DE 1967

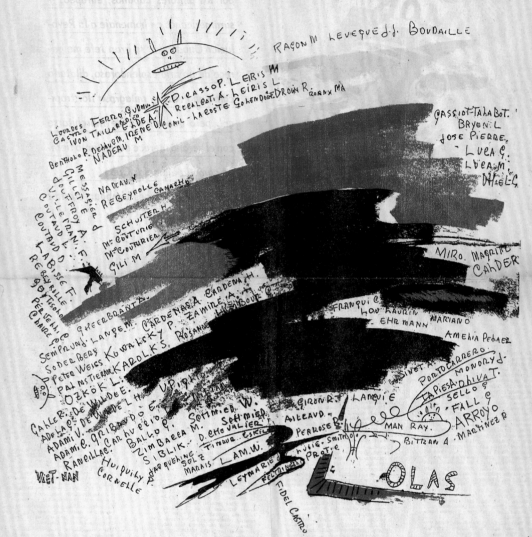

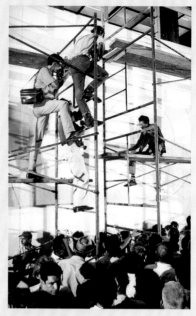

329

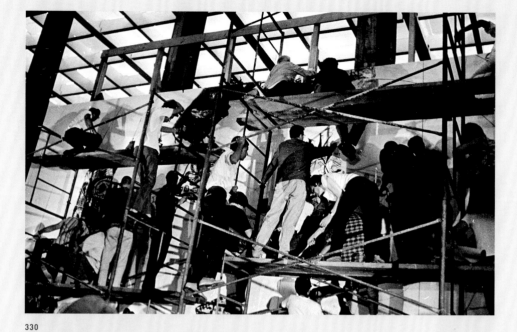

330

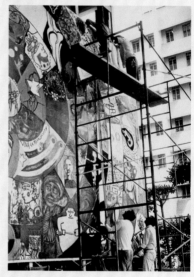

331

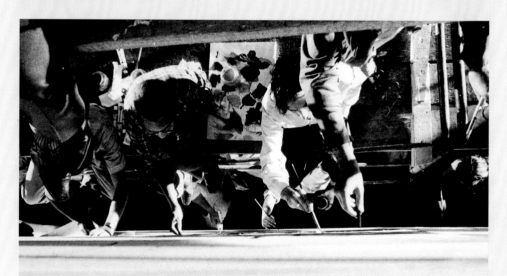

332

**Creating the Salón de Mayo Mural
at the Cuban Painting, 1967**

329
Gilles EHRMANN
*Wifredo Lam begins work on the
spiral*

331
Lou LAURIN LAM
*Painters Eduardo Arroyo and Gilles
Aillaud standing by the mural*

330
Osvaldo SALAS
Artists painting

332
Luis CASTAÑEDA
*View from above of artists working on
the mural*

333
L. Adele GALLO
*The finished Salón de Mayo Mural on
site at the Cuban pavilion*
1967

Following pages:
334
Collective, Salón de Mayo
"Cuba colectiva" Mural
1967

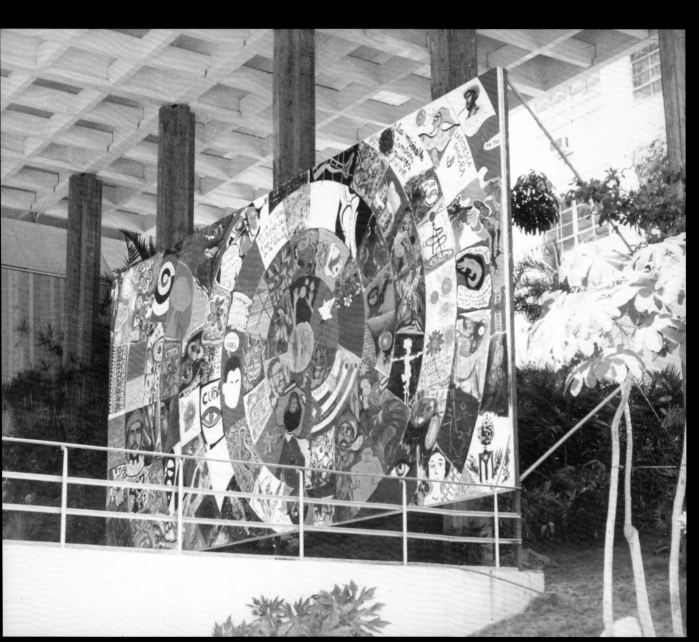

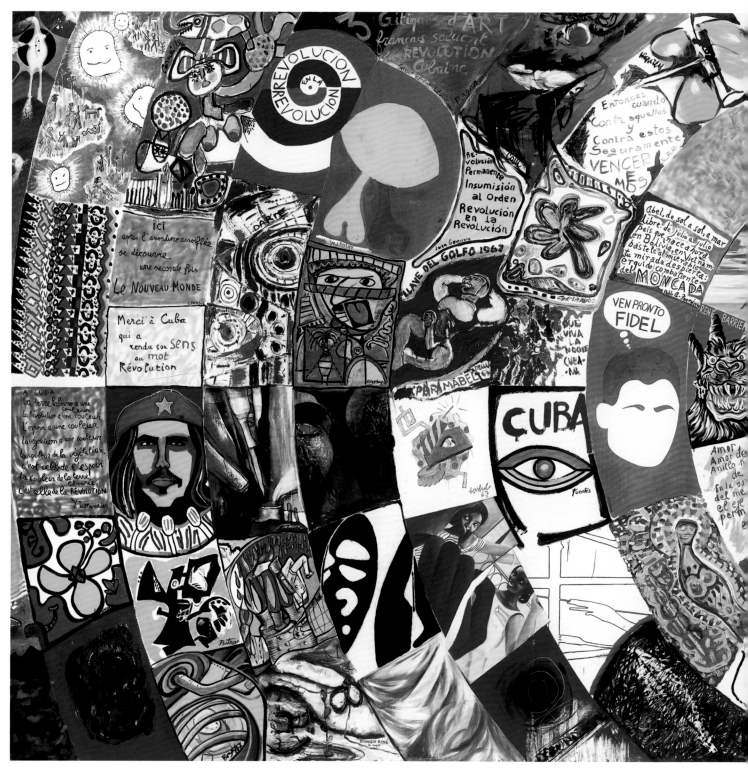

334

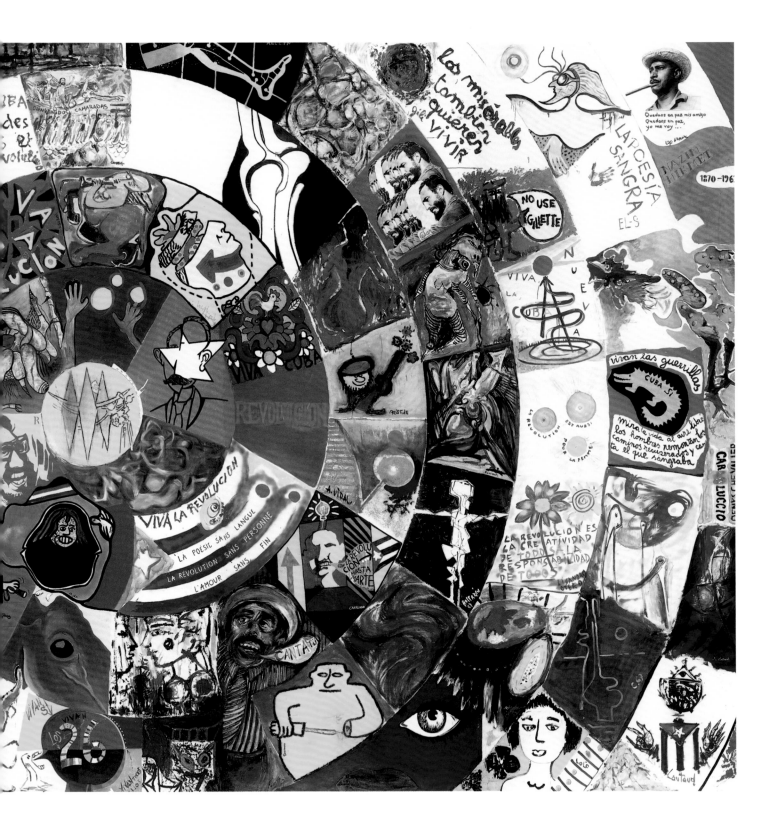

THE CUBAN POSTER: BETWEEN THE ROSE AND THE THORN

Elsa Vega Dopico

As British historian Hugh Thomas wrote, "To many people January 1, 1959, in Havana was a unique moment in history, golden in promise, the dawn of a new age."[1] In the early morning of that day, on learning that the dictator Fulgencio Batista had fled, the distinguished graphic designer Eladio Rivadulla Martínez printed in red and black what is considered to be the first political poster of the Cuban Revolution (ill. 340). The artist's referent was a photograph taken while *New York Times* journalist Herbert Matthews was interviewing the Cuban guerrilla leader in the Sierra Maestra mountains in early 1957. A single caption accompanied the image: "Fidel Castro. 26th of July."

From then on, history began to be told in a different way, for everything had changed. Martinez's poster marked the start of the development of a genre that consciously adjusted to the changing times. There was an urgent need for advertising to make known the social, economic, ideological and cultural program being put together in these new circumstances, and posters were the answer, to illustrate the fact that the country was reorganizing.

The triumph of the Cuban Revolution signalled an important change for the nation's life and gave rise to profound changes in all classes of society and its institutions. Its repercussions in Cuban life of the early 1960s can be compared only to those of a nuclear reaction whose outcomes are varied and simultaneous. Caught up in a social phenomenon of such intensity—a victorious revolution—people found themselves undergoing a process of change, and thus developing increasingly keen perceptions.

Discussing Cuban poster art yet again may seem a redundant exercise. Much has been written on the topic, but considering that a major exhibition of Cuban art is being presented for the first time in Canada, then the discussion is justified. And perhaps the occasional repetition may be forgiven.

Scholars mainly agree that the decade from 1965 to 1975 was the golden age of Cuban poster art, given the astonishingly high quality of most posters. This period (give or take a few years) has been studied by countless art specialists, critics and art historians. The widely held view of the 1960s as the beginning of a uniquely Cuban graphic

style can be justified on many counts. As Jorge R. Bermúdez remarks: "It can never be overstated that what was new in Cuban poster art—what made it a real movement—stemmed from the originality of the Cuban Revolution itself. This art form was part of the Revolution's dynamics and drama, conveying its messages and hopes. Posters forged its visual code, while interpreting foreign styles and appropriating them just as decisively as the appropriation carried out socially by the Revolution, which also entailed adjustment, transformation and change."[2]

Bearing witness to the events of the day, posters accompanied every announcement of big marches and mass rallies, and since they had both an illustrative and an educational function, they also marked each new anniversary of major historical events. And they publicized films, plays, new books, concerts and other artistic activities, thereby contributing to the cultural education of a country that proudly declared itself fully literate in 1961.

Among the salient features of Cuban poster art in the 1960s and 1970s was that it blended a variety of styles into a national perspective. This meant that

286

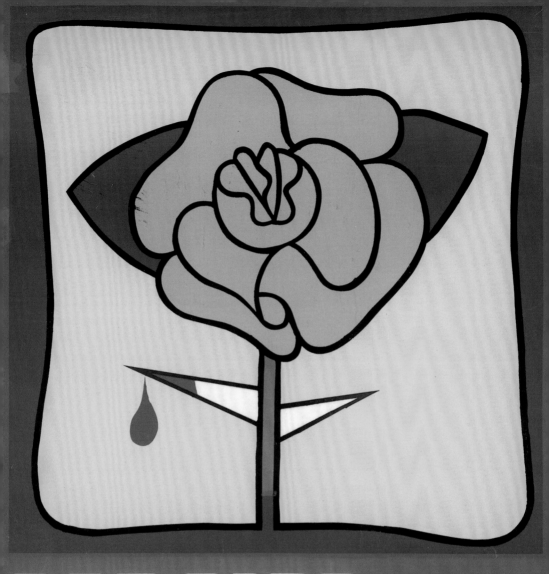

CANCION
PROTESTA

encuentro agosto 1967 casa de las américas / cuba

the artists could take avant-garde codes of expression and reinterpret them in the light of a declared interest. Thus, along with photography, we find substantial pop culture referents (*Festival de la Canción Popular* [Festival of Popular Song], 1967; Cuba en Grenoble, 1969), Art Nouveau, informal abstractionism and the vibratory illusions of Op art (*Day of the Heroic Guerrilla*, ill. 342), 1968; *XVII Aniversario del 26 de julio* [Seventeenth Anniversary of the 26th of July], 1970. The broad range of graphic techniques and resources they employed included elements borrowed from comics, Surrealism, collage and photomontage.

In terms of aesthetics and the ability to communicate with the public, the first successes were achieved with posters promoting culture. One of the leading institutions where this qualitative leap in graphic design was made was the Cuban Film Institute (ICAIC), founded in March 1959. Pursuing a film policy in keeping with the broadening process of educating and bringing culture to the people, ICAIC film posters went beyond the pre-Revolutionary stage, when all the components of design achieved the highest degree of direct visual communication. The previous policy of using the original advertising accompanying foreign films, which basically promoted the values of the Hollywood star system, was discarded. Gradually ICAIC posters found their own style, emphasizing artistry and originality as cultural values in addition to satisfying their mandate to inform.

Among the designers associated with ICAIC were René Azcuy, Alfredo Rostgaard, Rafael Morante, Raúl Oliva, Aldo Amador, Julio Eloy Mesa (Julioeloy), Antonio Fernández Reboiro and Eduardo Muño Bachs. In 1960 Bachs designed the poster for *Historias de la Revolución* [Stories of the Revolution], the first fiction film produced entirely by this brand-new cultural institution. From then on, revolutionary film posters were primarily designed to be more analytical as a way of providing the public with an increasingly reflexive understanding of the message they contained.

Cuban poster art first achieved international recognition in 1965, when *Harakiri* (ill. 337), by Antonio Fernández Reboiro, won a prize at the International Contest of Film Posters in Colombo, Sri Lanka. It is generally acknowledged that this emblematic poster closed one stage of ICAIC's production and heralded another, one largely characterized by the use of symbols. The limited palette and the use of blank space were not, in this case, due to the familiar scarcity of resources—which at other times limited graphic art—but to an essentially artistic interest in making the most of synthesis and in the intrinsic value of the images themselves.

Two other institutions, apart from ICAIC, played a prominent role in this noble endeavour to promote a cultural revolution in the broadest sense of the term. The National Council of Culture (CNC) promoted everything to do with theatre, dance, ballet, music and the

visual arts. Casa de las Américas, with its strongly Latin American orientation and unusual approach, sponsored exhibitions, literary contests, cultural symposia and conventions far and wide. Its emblematic poster *Protest Song* (ill. 335), became an archetype in the history of Cuban revolutionary poster art. Its two elements, the thorn and the rose, became paradigmatic symbols of this kind of poster; the thorn hurts us because it pierces our senses with the visual sharpness of its messages, while the image, a legitimate work of art, has the beauty of a flower.

Political posters, most of which were published by the Commission of Revolutionary Orientation (COR), clearly lagged behind their cultural counterparts: it was not until the latter half of the 1960s that they began to show real signs of quality. Before then are found only a few outstanding posters amidst an unimaginative body of work adhering closely to the codes of Socialist Realism. However, the posters reflecting the Missile Crisis of October 1962, in which photography was used to convey a wide range of ideas, stood out for the excellence of their design. *At Your Orders, Commander in Chief* (ill. 341), by Ayús and Korda, and *A las armas* [To Arms], by Roberto Quintana, are two of the most celebrated of these.

Because of its function, political poster art evolved as a mainstay in the process of consciousness raising and the forging of new values in society. *Muerte al invasor* [Death to the Invader], *Todos a la*

336

Alfredo GÓNZALEZ ROSTGAARD

Black Power. Retaliation to Crime: Revolutionary Violence

1969

337

Antonio FERNÁNDEZ REBOIRO

Film poster for Masaki Kobayashi's "Harakiri"

1964

338

Olivio MARTÍNEZ

July 26/53. 14th Anniversary of the assault on the Moncada Barracks

1967

339

René AZCUY

Film poster for François Truffaut's "Stolen Kisses"

1970

336

337

338

339

Plaza [Everyone Off to the Square], *En pie de guerra, Comandante en jefe* [We're Ready for War, Commander-in-chief], *A otra invasión, otro Girón* [Another Invasion, Another Bay of Pigs] were some of the watchwords that mobilized an entire population ready to defend what they had won. These titles were not perceived as mere slogans but as authentic ways of reaffirming Cuba's national identity.

The COR went on to produce truly allegorical visual messages, such as those celebrating the fourteenth and seventeenth anniversaries of the 26th of July, designed by Olivio Martínez and Félix Beltrán respectively. Beltrán joined the collective made up of Martínez, René Mederos, José Papiol, Faustino Pérez, Asela Pérez and Gladys Acosta after his remarkable success in the Cuban pavilion at Expo'67 in Montreal. Often described as the most intellectual of Cuban designers because of his frequent use of symbols and extraordinarily synthetic images, Beltrán produced astonishingly elegant and informative posters, including *Click. Saving Electricity Saves Oil* (ill. 354), a typical example.

True to its name, the Year of the Revolutionary Offensive, 1968, was aimed at consolidating the achievements of Cuban poster art, which was steadily earning increased national and international renown. In that year, a vast campaign was launched for the centennial of the wars of independence, which gave rise to an interesting series called *X Aniversario del triunfo de la Rebelión* [Tenth Anniversary of the Triumph of the Rebellion], by the designers José Papiol, Faustino Pérez

and Ernesto Padrón. The following year saw the convening of the first National Poster Salon, which promoted Cuban graphic art and publicized the best works in the genre.

Another important subject for this art form was the targeted harvest of ten million tons of sugar cane in 1970. With a view to illustrating one of the main economic challenges launched by the Cuban government, COR asked all its designers to reflect this goal. One of the results was a series of billboards designed by Olivio Martínez (ill. 353) in which he portrayed each million as it was harvested. Given the eventual result (it turned out to be an impossible target), Martínez's last two sketches were never printed in billboard format. Turning the setback into victory was the lesson at the time to the whole population, not to give up when faced with similar failures.

The founding of the Organization for Solidarity with the People of Africa, Asia and Latin America (OSPAAAL) in 1966 was certainly a major factor in the new look of COR's political poster art. OSPAAAL's graphic art and communications style first appeared in the *Tricontinental* newsletter in April 1966 and then in the magazine of the same name in August of the following year. The launch of this periodical had been announced in a special supplement given over to Che Guevara's "Message to the Peoples of the World through the *Tricontinental*." The supplement included the only poster depicting the charismatic revolutionary published during his lifetime, *Crear dos, tres... muchos Viet Nam* [Create Two, Three . . . Many Vietnams].

Mostly printed in offset, OSPAAAL posters initially tended to be small-format so that they could be inserted folded in the *Tricontinental*. As a result, political themes made an international impact, with solidarity being the primary message. The originality and quality of OSPAAAL's posters were apparent from the start. Artists used a wide variety of graphic techniques and paid particular attention to typography. They combined dissimilar elements from Third World cultures, particularly those with the most authentic indigenous traditions. Symbolic objects were recontextualized in an interplay of images melding past and present: *Guatemala* (ill. 348) *Day of Solidarity with Zimbabwe* (ill. 349); and *Day of Solidarity with the People of Laos* (ill. 346). Subsequently, OSPAAAL used larger formats as it tried to maintain, with some ups and downs, the effectiveness of its initial poster work.

As the 1960s wore on, the excellence attained in Cuban poster art was beyond question. (In those years, the leading Polish designers Wiktor Gorka, Waldemar Swierzy and Bronislaw Zelek visited Cuba and, after seeing what was happening in the graphic arts, supported this view.) In the first half of the 1970s, poster artists fought hard to maintain the earlier high standards, but thereafter inertia set in, bringing a degree of complacency and a noticeable deterioration.

Nevertheless, the achievements of the first fifteen years of the Revolution make this period one of the most important in the history of Cuban art and graphic design in particular. In addition to its documentary value and direct language, the poster was an

aesthetic and cultural artifact that attracted the attention of graphic arts circles worldwide. As a visual chronicle of the Revolution, Cuban poster art of the 1960s and 1970s was an important element in creating "the beauty of the everyday"[3]; and its superb quality earned it a place of honour in the history of art.

1 Hugh Thomas, *Cuba or the Pursuit of Freedom* (London: Eyre & Spottiswoode Ltd, 1971), p. 1090.

2 Jorge R. Bermúdez, *La imagen constante: El cartel cubano del siglo XX* (Havana: Editorial Letras Cubanas, 2000), p. 203.

3 In the words of professor and art critic Adelaida de Juan.

26 de JULIO

FIDEL CASTRO

340

CON MAS CORAJE Y VALOR QUE NUNCA

COMANDANTE EN JEFE:
ORDENE!

341

340
Eladio RIVADULLA
Fidel Castro, 26th of July
1959

341
Juan AYÚS
and
Alberto KORDA
Commander-in-chief: At Your Orders!
1962

342
Helena SERRANO
Day of the Heroic Guerrilla. October 8
1968

344
Félix BELTRÁN
Other Hands Will Take Up Arms
1969

343
Antonio PÉREZ GÓNZALEZ (Ñiko)
Until the Victory Always
1968

345
Alfredo GÓNZALEZ ROSTGAARD
Radiant Che
1969

342

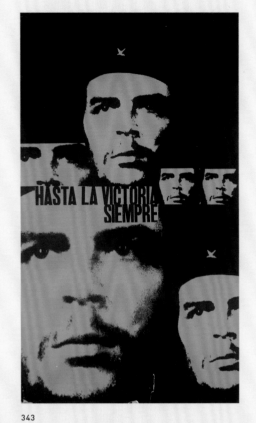

343

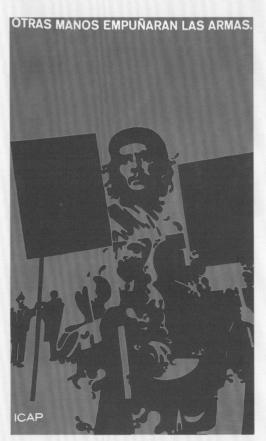

344

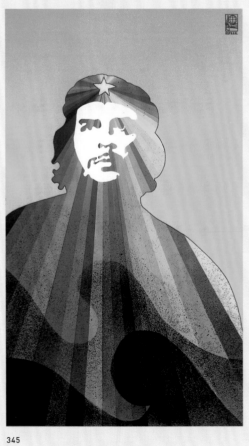

345

346

347

348

349

350

351

346
Rafael ZARZA
Day of Solidarity with the People of Laos. October 12
1969

347
Ernesto PADRÓN
Together with Viet Nam. March 13–19
1971

348
Olivio MARTÍNEZ
Guatemala. Day of Solidarity with Guatemala. February 6
1969

349
Jesús FORJANS
Day of Solidarity with Zimbabwe. March 17
1969

350
Faustino PÉREZ ORGANERO
Day of Solidarity with Zimbabwe. March 17
1970

351
Faustino PÉREZ ORGANERO
Day of Solidarity with the People of Palestine. May 15
1968

352
Eladio RIVADULLA
Emulating We Will Win
1960s

EMULANDO
VENCEREMOS

a

b

c

d

e

f

g

h

i

j

353 a–j
Olivio MARTÍNEZ
Ten designs for panels
From the series "Campaign of
the 10-million-ton Cane Harvest"
1969–70

a. One Million
b. Two Down
c. Third
d. Four Already
e. Half Way
f. Six
g. Seventh
h. Eight Down
i. One to go
j. Ten

354
Félix BELTRÁN
Click. Saving Electricity Saves Oil
1968

CLIK

AHORRO DE ELECTRICIDAD ES AHORRO DE PETROLEO

354

CUBAN CINEMA

Timothy Barnard

From the vantage point of middle-aged exile, the renowned Cuban author and erstwhile film critic Guillermo Cabrera Infante recalled his boyhood migration with his family in the early 1940s from the countryside to Havana—with its legendary picture palaces and nightlife—where he was taken to the cinema by a family friend: "[It was] the first time I went to the movies during the day. . . . We saw a double feature, that other novelty: in our town they always showed only one movie. At one point the movie repeated itself, obsessively, and Eloy Santos murmured: 'This is where we came in.' Neither my brother nor I understood. 'It's a continuous show,' explained Eloy Santos. 'We've got to go.' 'Why?' my brother asked. . . . 'Because the movie repeats itself.' 'And what's so bad about that?' my brother wanted to know. 'It's the rules of the game . . . we've got to go.'"[1]

That day, the twelve-year-old Cabrera Infante discovered not only the double bill and the unique thrill of watching a movie while the tropical sun burned outside; he encountered a curious practice, still seen today in Cuba and other parts of the developing world and once, long ago, a part of the film-going experience in the West: entering the cinema at any moment and then dutifully exiting hours later when the moment one entered recurs. He doesn't mention it, but Cuban audiences are also famous for the vocal dialogue they enter into with the film, cajoling the characters and letting their views be known.

How, one might ask, could the production model that came to be known as the "classical Hollywood cinema" of the 1930s, 1940s and 1950s achieve its narrative (and ideological) aims under the viewing conditions Cabrera Infante describes? The short answer is that it could not, at least not entirely. Cuban viewers chopped up the film's storyline, the bricks and mortar of the classical model, viewing it out of order and vocally appropriating it. By reconstructing the film's narrative in this way, Cuban audiences became to a degree the improbable subjects of a cinema that was not theirs. Their viewing habits broke, or at least weakened, the crucial unity and identification mechanism of classical narrative, substituting for them a kind of observation similar to Brecht's famous "alienation" or estrangement effect.

Cuba, back then, had practically no indigenous film industry. The vast majority of the films on view there were from Hollywood, or were Argentine or Mexican comedies, melodramas and musicals. And yet Cuba had the highest per capita rate of film-going in the hemisphere; in Havana in particular people were simply crazy about movies. This peculiar situation—high levels of film consumption, little in the way of film production—has been railed against by many as a deformation of underdevelopment, but it also proved to be fundamental to the distinct film aesthetic and social role for Cuban cinema fashioned by the young revolutionary filmmakers of the 1960s.

With the establishment of the Cuban film institute (ICAIC) in 1959, these young filmmakers, in the absence of an indigenous film industry and production model, turned to their audiences' long-standing viewing habits to arrive at an aesthetic strategy whose ambition, both artistic and social, was—like Brecht's—that of creating a true revolutionary subject. Not the subject of the film, in the sense of its protagonists and milieu, although this was certainly also the case, but an agent on a par with the filmmaker him or herself. This agency

rostgaard/69

icaic decimo aniversario

was created by refusing the narrative identification of Hollywood films and encouraging the audience's informed and critical awareness of the mechanisms of cinema itself and its participation in the process of constructing the film's meaning.

Tomás Gutiérrez Alea, Cuba's most talented and renowned director, got the ball rolling in 1966 with his fourth feature and second comedy, *La muerte de un burócrata* [*Death of a Bureaucrat*]. *Death of a Bureaucrat* did more than consolidate comedy as one of the most important genres in Cuban cinema. A pastiche composed in large part of quotations of other films, it was the first Cuban film to rely on the viewer's knowledge of the medium, its history and workings to create its significance. A list of filmmakers in the opening credits, to whom the film is dedicated, tips viewers to the fact that they will find in it traces of everyone from Laurel and Hardy to Luis Buñuel, Buster Keaton to Jean Vigo, Orson Welles to Akira Kurosawa. Alea then proceeds to create scenes that, in many cases, are direct reconstructions of famous or less-famous scenes from these filmmakers' films, but in the entirely different context of revolutionary Cuba; it is up to the viewer to identify the reference and realize the full import of the scene. Even a refrain from *Tosca* sung by an elevator operator has "hidden" significance. But the film is more than a mere parody or, even worse, an academic exercise in postmodern quotation. As if to highlight the lack of an indigenous tradition, it is made, in effect, out of bits and pieces of other films (re-shot in contemporary Cuba with a thoroughly Cuban storyline), like the spare parts that make up the

machine turning out busts of José Martí in the film's opening sequence. It was constructed, in other words, out of viewers' *knowledge of cinema*. Thirty years later, Alea returned to this film's style of black comedy, the safest and most effective vehicle for social criticism in Cuba, in his final and best-known films abroad, *Fresa y chocolate* [*Strawberry and Chocolate*, 1994] and *Guantanamera* (1995).

Soon after Alea's experiment, another major figure in Cuban cinema, Julio García Espinosa, went one step further in *Aventuras de Juan Quin Quin* [*The Adventures of Juan Quin Quin*, 1968; ill. 358], a picaresque tale set in rural Cuba on the verge of revolt in the late 1950s. *Juan Quin Quin* not only employs a number of explicit distancing devices—intertitles commenting on the action, narrative sequences placed out of order—it also goes beyond Alea's reconstructions of scenes from specific films in favour of shooting entire sequences according to various generic conventions. The result, as the historian of Cuban cinema Michael Chanan remarks, is a "series of escapades through different cinematic genres,"[2] a self-consciously reflexive patchwork of styles. To watch *Juan Quin Quin* is to see the inner workings of classical cinema laid bare. The viewer, in true Brechtian fashion, is not absorbed into the narrative but rather adopts a critical attitude toward it and the devices usually employed to deliver it. This experiment was an immense success, with 3.2 million admissions in a country whose population at the time was slightly less than 10 million.

Both Alea and García Espinosa—the latter in the thick of things, in 1969, the

former at a distance of twenty years, in 1988—set their film theories down on paper, an important part of the New Latin American Cinema of the period. García Espinosa, in his essay "For an Imperfect Cinema," prophesied that audiences' ever-greater level of participation in the creation of the film would lead to the disappearance of the viewer as such.[3] Alea, in a short monograph entitled, appropriately enough, *The Viewer's Dialectic*, remarked on the variety found in most Cuban film programs (generally made up of a newsreel, a documentary short and a fiction feature film) and commented that this format enables viewers to "experience *various levels of mediation* [emphasis in the original] . . . which can offer them a better understanding of reality . . . seeing various genres at one screening does not always have the greatest coherence. . . . Nevertheless, this possibility of connections throws light on what could be achieved here, *even if we are just considering the framework of a single film* [my emphasis]."[4] By watching a variety of films at one sitting in which the feature, out of order, straddled the shorts, Cuban audiences gained insight into reality and its cinematic mediation they might otherwise not have acquired.

From the late 1960s to the mid-1970s, other Cuban filmmakers took up the project of transforming the normally passive viewer into a social and historical subject through the use of reflexive techniques that called on them to become active participants in the film's construction—not just in the formal, modernist sense familiar to us, but in the precise context of the revolutionary social and political construction going on around them. Manuel Octavio Gómez's *La primera*

356
Antonio FERNÁNDEZ REBOIRO
*Film poster for Sergio Giral's
"The Other Francisco"*
1975

357
Antonio FERNÁNDEZ REBOIRO
*Film poster for Humberto Solás's
"Cecilia"*
1982

358
Eduardo MUÑOZ BACHS
*Film poster for Julio García
Espinosa's "The Adventures of Juan
Quin Quin"*
1967

359
Eduardo MUÑOZ BACHS
*Film poster for Juan Padrón's
"Elpidio Valdés and the Rifle"*
1980

356

357

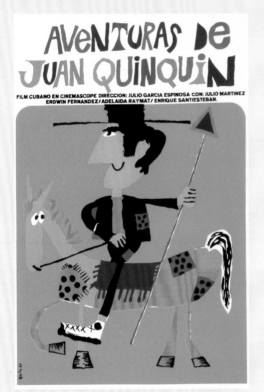

358

359

carga del machete [*The First Charge of the Machete*, 1969] filmed the 1868 uprising against Spanish colonialism as a *cinéma direct* documentary employing a frantic hand-held camera and such techniques as battlefield interviews, documentary interludes and a roving troubadour (the popular Cuban singer Pablo Milanés). Similarly, the film *Girón* (1972) by Manuel Herrera, about a much more recent conflict, the ill-fated Bay of Pigs invasion of 1961, uses a wide variety of generic modes and conventions—interviews, voice-over narration, archival footage, dramatic re-enactments, romantic interludes, among others. Of special interest to our discussion of the contemporary viewer being brought into the film as an active agent and historical subject is Herrera's willingness to transport back in time from the present day those who participated in the events in order for them to comment on the battles as they unfold around them in re-enactment.

Another Gómez film, *Ustedes tienen la palabra* [*Now It's Up to You*, 1974], adapts the classical cinema's "courtroom drama" genre to this new approach. In its customary form, this genre is among the most powerful examples of narrative absorption and identification. Gómez, however, employs a number of devices to distance the viewer from this rural trial of saboteurs of the revolution, culminating in the film's final direct address to the audience: "Now it's up to you" to determine the men's guilt or innocence, a process of critical analysis, not narrative identification. The following year Sergio Giral, one of a very few black filmmakers in a country with a large black population, took up the nineteenth-century anti-slavery novel *Francisco*, not to dramatize it

but to dissect it and to confer upon the fictional slave Francisco the status of historical subject he was denied in the novel. But the use of documentary and other techniques in *El otro Francisco* [*The Other Francisco*, 1975; ill. 356] had a mechanical, didactic quality that was not appreciated by the public and that suggested the project set in motion a decade earlier, joining modernist formal techniques with revolutionary politics, was beginning to run out of steam.

As decline set in, the Cuban film industry was struck by two major crises in its history, the first internal and the second external. In 1982, the veteran director Humberto Solás, famous for "revolutionary melodramas" such as *Lucía* (1968), released *Cecilia* (ill. 357), more of the same as its title suggests, but in a distinctly overripe state. Fully half of ICAIC's production budget had been poured into it in the hopes of securing lucrative foreign markets, so that when it flopped it provoked a crisis in the institution. Heads rolled and García Espinosa took over, determined to diversify production and allow younger filmmakers the opportunity to direct lower-cost, popular films. One of the results was Juan Padrón's refreshing animated feature *Vampiros en Habana* [*Vampires in Havana*, 1985], about a clan of Cuban vampires, able to withstand the tropical sun, being hunted down by the mafia. It unexpectedly earned widespread foreign release, demonstrating how modest local efforts sometimes fare better than mega-productions. And yet, once the pleasant shock and exoticism of discovering this irreverent spoof has faded somewhat, one realizes the difference between it and Alea's *Death of a Bureaucrat* twenty years earlier. Here, generic convention is

merely parodied, requiring no effort from the viewer other than simple recognition of the convention in question, with the humour deriving in part from the incongruity of the associations (mobster vampires, vampire revolutionaries, and so on).

A more serious blow was struck in the early 1990s, the time of the country's "special period" following the end of Soviet economic assistance. The film community was particularly shocked to learn not only that its budget was to be cut, as was to be expected, but that the highest levels of political power in the country were planning to dismantle ICAIC and farm out what little film production remained to the Armed Forces' film unit. It was a huge moral blow to an artistic community that had always considered itself essential to Cuban life. Even after protests succeeded in reversing the decision, the institution was gutted and directors were left to fend for themselves in the international co-production market. Adding to the crisis was the fact that, by the middle of the decade, almost all the major directors of the 1960s and 1970s were inactive, dead or abroad, at a time when it was not yet clear what to expect from the "young" generation, then in their forties (Cuban filmmakers must undergo a long apprenticeship before being allowed to direct feature films). It was truly a bleak moment: it seemed perhaps as if all might be lost.

It soon became apparent, however, that the new generation was up to the task. The country was immediately faced with the controversy over Daniel Díaz Torres's quickly banned *Alicia en el país de maravillas* [*Alice in Wonderland*, 1991], a bitter allegory about life in Cuba.

Other directors also produced comedy with a social edge, including Gerardo Chijona, whose *Adorables mentiras* [*Adorable Lies*, 1994] depicted lying as a pervasive fact of Cuban life. One of the greatest post-crisis revelations has been Fernando Pérez, whose personal and lyrical films, perhaps unimaginable before the special period, depict a fractured or at least multiple Cuban subject, in contrast to the unity of the revolutionary subject. In the unusual *Madagascar* (1994), a young woman dreams of escaping a Havana in ruins to live in . . . Madagascar.

Just before the crisis, Juan Carlos Tabío had demonstrated his extraordinary talent. His 1989 film *¡Plaff! o demasiado miedo a la vida* [*Plaff!*], a black comedy full of biting social critique and Brechtian tricks, is worthy of his mentor Alea, whose last two films he later co-directed. At one point the film's protagonist, a lonely middle-aged woman (veteran actress Daisy Granados), alone in her room, sobs that she feels so "alone, alone, alone." Thereupon, the door of her wardrobe creaks open, its full-length mirror revealing the film crew bent over the camera a few short feet away. *¡Plaff!* goes so far as to incorporate into its very structure the viewing practices described by Cabrera Infante at the outset of this article. Granados is plagued by someone throwing eggs at her house (making a plaff! sound as they hit), but which of her friends and family is the culprit is a mystery to us because we don't see the first reel of the film until the very end. The film begins in darkness, with a projectionist calling out to his audience that he didn't receive the first reel of the film and that he is going to start with the second reel while he locates the missing reel, which we, the real audience, eventually see last. Tabío created a whodunit—and in the process a brilliant, *sui generis* film—where none would have existed if the film had been projected normally, as if to emphasize the importance of the viewing experience and the role of the viewer—and of the "imperfect" conditions of Cuban cinema.

These and other directors have continued to work under difficult conditions into the twenty-first century, producing other important films, alongside new developments in Cuban cinema such as amateur film, underground film, video and the diaspora work of Cubans living abroad. As the country's revolutionary political project lost the unity of its early years, so too has the subject of Cuban cinema become multiple and displaced, within Cuba and without, like the Cuban people itself.

1 G. Cabrera Infante, *Infante's Inferno* (New York: Harper and Row, 1984 [1979]), p. 11. ". . . fui al cine de día. . . . Vimos un programa doble, esa otra novedad: en el pueblo siempre exhibían una sola película. Pero hubo una revelación que fue un misterio. En un momento la película se repetía, obsesiva, y Eloy Santos murmuró: "Aquí llegamos," y se levantó como si fuera el fin de la tanda. No entendíamos ni mi hermano ni yo. "Es una función continua," explicó Eloy Santos. "Hay que irse." "¿Por qué?", preguntó mi hermano . . . "Porque la película se repite." "¿Y eso qué tiene de malo?", quiso saber mi hermano. "Son las reglas del juego . . . hay que irse." G. Cabrera Infante, *La Habana para un Infante difunto* (Barcelona; Caracas; Mexico City: Editorial Seix Barral, 1979).

2 Michael Chanan, *The Cuban Image* (London: British Film Institute, 1985), p. 210.

3 Julio García Espinosa, "For an Imperfect Cinema," in Michael T. Martin, ed., *New Latin American Cinema*, vol. 1 (Detroit: Wayne State University Press, 1997 [1969]), p. 77. Julio García Espinosa, "Por un cine imperfecto," in *Hojas de cine. Testimonios y documentos del nuevo cine latinoamericano*, vol. 3 (Mexico City: Secretaria de Educación Pública/ Fundación Mexicana de Cineastas, 1988 [1979]), pp. 70–71.

4 Tomás Gutiérrez Alea, *Dialectica del espectador*, in Tomás Gutiérrez Alea et al., *Tomás Gutiérrez Alea: Poesía y revolución* (Canary Islands: Filmoteca Canaria, 1994), pp. 50–51. An alternative English translation can be found in Tomás Gutiérrez Alea, "The Viewer's Dialectic," in Michael T. Martin, ed., *New Latin American Cinema*, vol. 1 (Detroit: Wayne State University Press, 1997), p. 118.

THE REVOLUTION AND ME

the individual within history

TIMELINE
art and history

1980

The first Havana Theatre Festival is held.
In April, there is an exodus of thousands of Cubans to the United States via the port of Mariel.

1981

The exhibition *Volumen uno* is held at the Centro de Arte Internacional in Havana.
The exhibition *Cuban Pop Artists* is held at the Museo Nacional de Bellas Artes (MNBA).
The first National Small Format Salon is held at the Habana Libre hotel.
The exhibition *First Look: 10 Young Artists from Today's Cuba* is held at Westbeth gallery in New York.

1982

Old Havana is declared a World Heritage Site by UNESCO.
The Centro Cultural Juan Marinello and the Centro Cultural Alejo Carpentier are opened.
The Landscape Salon is held at the MNBA; awards are given to José Bedia (grand prize) and to Juan Francisco Elso.

1983

The Centro de Arte Contemporáneo Wifredo Lam, which organizes the Havana Biennial, is established.
The exhibition *Photography in Cuba: A Retrospective* is held at the MNBA.

1984

The first Havana Biennial is held; awards are given to various artists, including the Cubans Gustavo Acosta and Rogelio López Marín.
Cuba and the United States sign an agreement normalizing their immigration and emigration policies.

1985

The *Billboard Art* project is launched.
The exhibition *Contemporary Art* is held at the MNBA.
The exhibition *Cuba: A View from Inside. 40 Years of Cuban Life in the Work and Words of 20 Photographers* is held at the Ledel gallery in New York.
The exhibition *New Art from Cuba* is held at the Amelie A. Wallace gallery at SUNY in Westbury, New York.
The Department of Religious Affairs is established within the Central Committee of the Communist Party.

1986

The New Latin American Cinema Foundation and the International School of Film and Television are established.
The exhibition *Puré on View* is held at Galería L, the first show by the Grupo Puré, made up of Lázaro Saavedra, Ana Albertina Delgado, Adriano Buergo, Ermi Taño and Ciro Quintana.
The exhibition *10 Years of the ISA* is held at the MNBA.
The second Havana Biennial is held; this edition encompasses Asia, Africa and the Middle East, and José Bedia wins a prize.
Juan Francisco Elso participates in the Venice Biennale.
The Rectification of Errors and Negative Tendencies campaign is launched; its objective is to review the country's political economy and the ways in which labour is organized.

1987

The first *Gathering of Young Visual Artists* and the first Young Artists Salon are held at the Museo Provincial de Villa Clara. José Bedia, Carlos A. García and Ricardo Brey participate in the São Paulo Biennial in Brazil.
A new Civil Code and modifications to the Criminal Code are approved.
The "family doctor" program is established, a new public health-care program that brings medical care to residential neighbourhoods.

1988

The MNBA presents retrospective exhibitions of the work of Raúl Martínez and Umberto Peña.
An exhibition of the work of Tomás Esson Reid, *Broken Horn II* is held at the Centro de Arte 23 y 12.
A retrospective exhibition of the work of Robert Rauschenberg is held in Havana.
The exhibition *Made in Havana* is held at the Art Gallery of New South Wales in Sydney, Australia.

1989

The third Havana Biennial is held.
The exhibition *Kitsch* is held at the Centro de Arte Galiano y Concordia.
The Castillo de la Fuerza project is organized jointly by the Visual Arts Council and the MNBA. One of its exhibitions *The Melodramatic Artist*, is closed down because of censorship; the project is ended, and in reponse artists carry out that same year an action in Havana known as *Cuban Art Dedicated to Baseball*.
José Bedia participates in the exhibition *Magicians of the Earth* at the Georges Pompidou centre in Paris.
Mikhail Gorbachev, president of the Soviet Union, visits Cuba.

1990

Peter Ludwig, a German collector, buys large numbers of contemporary Cuban artworks.

The exhibition *The Sculptured Object* is held at the Centro de Desarrollo de las Artes Visuales in Havana (CDAV).

The first National Humour and Satire Salon is held at the Museo del Humor in Havana.

The exhibition *Kuba O.K.* is held at the Städtische Kunsthalle Düsseldorf, Germany.

The Special Period in Times of Peace begins as a result of the disappearance of the socialist camp, producing a period of great scarcity for the Cuban people.

1991

The fourth Havana Biennial is held.

The exhibition *A Few Funny Stories* is held at the CDAV.

The MNBA presents the exhibition *New Acquisitions of Contemporary Cuban Art*.

The exhibition *The Children of William Tell* is held at the Alejandro Otero Museo de Artes Visuales in Caracas, Venezuela.

Cuban soldiers return from Angola at the end of the war.

1992

The first solo exhibition of the work of Kcho is held at the MNBA.

A new constitution is approved by the National Assembly of People's Power. The United States approves the Cuban Democracy Act (known as the "Torricelli Law"), which intensifies the embargo against Cuba.

1993

Tomás Gutiérrez Alea and Juan Carlos Tabío make the film *Strawberry and Chocolate*, which goes on to great success in Cuba and abroad; it is the first Cuban film to deal openly with homosexuality and was nominated for an Academy Award.

The exhibition *Myths of Cuban Art* is held at the CDAV.

The exhibition *The Metaphors of the Temple* at the CDAV is curated by Carlos Garaicoa and Esterio Segura.

Belkis Ayón wins first prize at the first International Print Biennial in Maastricht, the Netherlands.

Legal restrictions on the possession of U.S. dollars are lifted.

1994

The Ludwig Foundation of Cuba is established to disseminate Cuban art.

The fifth Havana Biennial is held.

The National Visual Arts Award is inaugurated and is awarded to Raúl Martínez.

Sandra Ceballos and Ezequiel Suárez found Espacio Aglutinador, an independent, alternative site for curated exhibitions.

Antonio Eligio Fernández (Tonel) participates in the twenty-second São Paulo Biennial in Brazil.

The so-called balsero crisis, known as the Rafter Phenomenon, another exodus to the United States, occurs. To prevent similar events in the future, the governments of Cuba and the United States sign a new emigration and immigration agreement.

1995

The National Visual Arts Council establishes the editorial imprint ARTECUBANO and the magazine *Artecubano*, devoted to visual art in Cuba.

The theoretical journal *Temas* is published, devoted to the analysis of cultural, ideological and social problems.

The first Contemporary Cuban Art Salon is held at the CDAV; the grand prize is awarded to Carlos Estévez.

The National Visual Arts Award goes to Rita Longa and Agustín Cárdenas.

The exhibition *One of Each Kind* is held at the Ludwig Foundation of Cuba.

The exhibition *New Art from Cuba* is held at the Whitechapel Art Gallery in London.

The exhibition *Cuba: The Possible Island* is held at the Centre de Cultura Contemporània in Barcelona.

The National Assembly of People's Power adopts a new law concerning foreign investment in Cuba.

1996

The exhibition *Get Up, Chago, Stop Screwing around, Lázaro* is held at the Espacio Aglutinador.

The exhibition *And the Ship Sails on . . . ISA at Twenty* is held at the CDAV.

The National Visual Arts Award goes to Raúl Corrales.

The exhibition *The Multiple Trace* is held at the CDAV; this print exhibition is curated by Belkis Ayón, Sandra Ramos, Ibrahim Miranda and Abel Barroso.

The exhibition *Twentieth-century Cuba: Modernity and Syncretism* is held at the Centro Atlántico de Arte Moderno in Las Palmas, Canary Islands, Spain.

Tania Bruguera participates in the twenty-third São Paulo Biennial in Brazil.

The United States passes the Helms-Burton Act, tightening the economic embargo against Cuba.

1997

The sixth Havana Biennial is held.

The third edition of *From a Pragmatic Pedagogy*, a project of René Francisco Rodríguez, leads to the foundation of the DUPP gallery at the Art Institute of Graduate Studies (ISA).

The National Visual Arts Award goes to Alfredo Sosabravo.

The exhibition *1990s Art from Cuba* is held at Art in General in New York.

The exhibition *Utopian Territories: New Arts from Cuba* is held at the Morris & Helen Belkin Gallery in Vancouver.

Cuban, Bolivian and Argentine experts recover the remains of Che Guevara in Valle Grande, Bolivia.

1998

The second Contemporary Cuban Art Salon is held at the CDAV.

The first *Ana Mendieta Performance Festival* is held at UNEAC in Havana.

The National Visual Arts Award goes to Julio Girona.

The touring exhibition *Contemporary Cuban Art: Irony and Survival on the Utopian Island* opens at the Arizona State University Art Museum.

Pope John Paul II visits Cuba.

1999

The National Photography Salon is held at the Fototeca de Cuba.
The National Visual Arts Award goes to Antonio Vidal.
The exhibition *Trabajando pal'inglé* [Workin' for the Englisman] is held at the Barbican Centre in London.
The ninth Ibero-American Summit is held in Havana.

2000

The seventh Havana Biennial is held.
An exhibition of the work of Los Carpinteros, *Transportable City*, is held at the Fortaleza de la Cabaña as part of the Havana Biennial.
The exhibition *People at Home* is held at the MNBA.
The exhibition *The Conjunction of Nothing: Cuban Art in the New Millennium* is held at the CDAV.
The National Visual Arts Award goes to Ruperto Jay Matamoros.
The exhibition *From the Negative* is held at pArts Photographic Arts in Minneapolis.
The Group of 77 Summit is held in Havana.
The little boy Elían González is illegally taken from Cuba by his mother, who dies in the crossing to Florida. He is kept in the United States and after a trial known around the world, he is taken back to Cuba by his father.
A new program of social and political change entitled the Battle of Ideas is launched.
Fidel Castro visits Venezuela.
Cuba and Venezuela enter into a bilateral cooperation agreement.

2001

The MNBA re-opens its doors to the public after renovations that began in 1997 with an exhibition of Cuban art up to the late 1990s.
Tania Bruguera participates in the Venice Biennale.

A posthumous exhibition of the work of Belkis Ayón, *Images from Silence*, is held at the MNBA.
Kcho exhibits *The Jungle* at the MNBA.
The exhibition *Entrópicos* is held at the Centro Cultural de España in Havana.
The third Contemporary Cuban Art Salon is held at the CDAV in Havana.
The National Visual Arts Award goes to Manuel Mendive.

2002

José Manuel Noceda publishes an anthology under the title *Wifredo Lam: La cosecha de un brujo.*
Margarita González, Tania Parson and José Veigas publish the book *Déjame que te cuente: Antología de la crítica en los 80.*
The National Visual Arts Council creates the Havana Auction.
The centenary of Wifredo Lam's birth is celebrated in Havana.
The National Visual Arts Award goes to Adigio Benítez.
The exhibition *Copyright* is held at the Centro Cultural de España in Havana.
Tania Bruguera and Carlos Garaicoa participate in documenta 11 in Kassel, Germany.

2003

The anthology of critical essays *Experiencia de la crítica* by Graziella Pogolotti is published.
José Veigas, Cristina Vives, Adolfo Nodal, Valia Garzón and Dannys Montes de Oca publish the book *Memoria: Cuban Art of the 20th Century.*
The eighth Havana Biennial is held.
The exhibition *Domestic Labour: Towards a New History of the Image in Cuba. Gender, Race and Social Class* is held at the Centro Provincial de Artes Visuales in Pinar del Río.
Los tres mongos sabíos [The Three Wise Morons], an exhibition of the work of Flavio Garciandía, Lázaro Saavedra and José Toirac, is held at Habana gallery.
The National Visual Arts Award goes to Osneldo García.

2004

The National Visual Arts Award goes to Roberto Fabelo.

2005

The fourth Contemporary Cuban Art Salon is held at the CDAV in Havana.
The National Visual Arts Award goes to Frémez.
Carlos Garaicoa receives the International Contemporary Art Award from the Principality of Monaco.
Tania Bruguera participates in the Venice Biennale.

2006

The MNBA publishes the magazine *¿Qué pasó?* a summary of the five years that have passed since the institution re-opened.
The ninth Havana Biennial is held.
The National Visual Arts Award goes to Pedro Pablo Oliva.
Fidel Castro informs the people of Cuba that he is experiencing health problems and temporarily delegates power to Raúl Castro, Second Secretary of the Cuban Communist Party.
The fourteenth Summit of Non-aligned Countries is held; Cuba assumes the presidency of the movement.

THE EMERGENCE OF A NEW POETICS: VOLUMEN UNO

Corina Matamoros Tuma

The renewal of the arts that took place in Cuba beginning about 1979 can be termed the second avant-garde movement of the twentieth century. It was a renewal that swept through all the arts, from literature to theatre, and it brought with it a total change in the cultural landscape.

The island was awakening from a period of cultural and societal lethargy marked by heavy-handed officialdom and strict regulations under which individuals, their struggles and varying desires had been reduced to cogs in the system. It was, fortunately, shortlived, and the necessary changes can be attributed to a number of factors. The world's political blocs following the war in Vietnam and the signing of the SALT II Treaty seemed to settle differences for a while. On the island, the new Cuban Constitution (1976), the creation of the Ministry of Culture and the Art Institute of Graduate Studies (ISA; 1976), along with the signing of migration agreements with the United States (1978), among other factors, brought about a feeling of change in the air that would resonate most in the following years.

This was the context that produced a series of exhibitions organized by very young artists who opened the door to a decisive influx of new poetics. In a home in Havana, that of José Manuel Fors, they mounted the collective show *Pintura fresca* (Fresh Paint, 1979), and with this simple title a whole new generation side-stepped the prevailing aesthetic. The participants included Carlos José Alfonzo, José Bedia, Rubén Torres Llorca, Ricardo Brey, Juan Francisco Elso, Emilio Rodríguez, Tomás Sánchez, Gory, Leandro Soto, Flavio Garciandía, Gustavo Pérez Monzón, Israel León and José Manuel Fors himself. That same year, the exhibition travelled to Cienfuegos, a city in the centre of the island, thanks to Leandro Soto, who helped his colleagues by securing its art gallery as a venue. The first public show by the artists who were to be known, two years later, as Volumen uno, was accompanied by a rock concert by a local band and uninhibited dancing by those present.

The year 1981 produced two exhibitions heralding the new attitude, *Volumen uno* [Volume One] and *Sano y sabroso* [Healthy and Tasty], and these, along with others like *Trece artistas jóvenes* [Thirteen Young Artists] and *Retrospectiva de jóvenes artistas* [Retrospective of Young Artists], kicked off the campaign. *Volumen Uno* opened on January 14 to unusual public acclaim, and introduced a transitional approach that hinted at the transformations to come. Drawing from Pop (Llorca), Informalism (Rodríguez Brey; ill. 366), Abstract art (Fors; ill. 364), and Neo-Expressionism (Garciandía) these artists also evoked the photographs of Leandro Soto's *acciones plásticas* or performances,[1] individual styles already well defined, like Bedia's work in his series *Crónicas americanas* [American Chronicles], and the spatial experiments of Gustavo Pérez Monzón. The mixture was, as its title suggested, a real beginning.

Sano y sabroso constituted the most authentic inrush of popular influence on the realm of avant-garde art. All the participating artists worked on creating a domestic, kitsch (ill. 373), everyday atmosphere within the gallery. There were neither exemplary nor sugar-sweet renderings of daily life, but rather a direct analysis from a humorously anthropological and broad-scale viewpoint, a close and ironic look at today's Cuba kitsch.

Thus there began to appear a range of new approaches that included a different understanding of Cuban history as it relates to the individual; religious traditions that offered previously unexplored possible subjectivities for art; popular culture as a cultural fact and not as merely a source to be dipped into at random for creative purposes; and a questioning of the artistic tradition itself. And these new approaches required new languages for creation.

Conceptualism was one of the strongest influences on new Cuban art in the 1980s. Arturo Cuenca (ill. 392) was one of the pioneers of this trend. At ISA, which graduated its first class in 1981, there was a significant change in teaching methods and syllabus: these became anti-academic and focused on research as a factor inherent in the creative process. From these classrooms there emerged concepts of art nourished by aesthetic theory, philosophy and cultural reasoning in its widest sense, and all of this shaped the work of successive generations of young artists. The masterly output of creators such as Consuelo Castañeda and Flavio Garciandía provide ample evidence of this.

During this period of change, crammed with installations, "found" art, happenings and artists' collectives, painting also evolved and demonstrated new potential in the hands of artists like Carlos Alberto García, Moisés Finalé, Gustavo Acosta, José Franco, Sandra Ceballos, Humberto Castro and others. Drawing, too, came into its own, partly as a result of the common scarcity of painting materials that Cuban artists had to endure. Collections of works on paper as remarkable as those by Tonel, Humberto Castro, José Bedia, Rubén Torres Llorca, Gustavo Acosta, Santiago R. Olazábal and Alberto Morales (Ajubel) are prime examples from this period.

The initial moment of rupture was affected in about 1986 by new social pressures. Just as it seemed that the huge possibilities of the "new" art had been fully demonstrated, the new graduates of the revamped system of ISA astonished everyone by plunging into a kind of committed art involved with contingent reality—committed not to adulation or showing support, considered pointless, but to redressing the social body, in keeping with the so-called "rectification of errors" campaign.[2] Art engaged in a one-on-one battle against intolerance, double standards, conventionality, hypocrisy and a narrow outlook not seen since the painting of the 1960s. Ethics was at the centre of the storm that judged all aspects of society. Humour, vernacular art, social criticism and politics were their way of packing a punch. Many of their exhibitions began to be viewed as scandalous, aggressive and provocative. The fight was being waged in the streets. Tomás Esson Reid, Lázaro Saavedra, José Toirac, Juan Pablo Ballester, Glexis Novoa, Alejandro Aguilera, Ana Albertina Delgado, Eduardo Ponjuán, Sandra Ceballos, Adriano Buergo, Ciro Quintana and René Francisco Rodríguez were among the most noteworthy of the artists involved.

The most important event of this period was the Castillo de la Fuerza project,[3] a group of exhibitions mounted by the National Council for the Arts in close collaboration with the artists, to provide room for shows that had proved unwelcome in Cuba's official galleries. March 25, 1989, saw the opening of the first of these exhibitions, *Patria o Muerte* [Homeland or Death], by the artists Tomás Esson Reid, Glexis Novoa and Carlos Rodríguez Cárdenas. Many of the emerging young talents showed their work in the Castillo. The end of the project—with the closure of the presentation *El artista melodramático* [The Melodramatic Artist] by René Francisco Rodríguez and Eduardo Ponjuán, and the one-day only showing of *Homenaje a Hans Haacke* [Tribute to Hans Haacke] by José Toirac, Ballester, Villazón and Angulo—can be seen as the culmination of the first phase in a far-reaching renovation of Cuban art. The finishing touch to what at the time appeared to be the final act of this tumultuous period was a memorable baseball game organized by the artists left with nothing to do[4] —in a matter of weeks, the Berlin Wall fell.

1 The term with which Leandro Soto heralded, early on, the practice of performance art in Cuba.

2 In 1986, Fidel Castro launched a crusade for the "rectification of errors and negative tendencies" in Cuba, to counter corruption in vital sectors like the economy and, by extension, to counter all extravagance and abuse.

3 This project comprised a group of exhibitions funded by the National Council for the Arts together with the Museo Nacional de Bellas Artes. It was initiated in 1988 and opened its doors on March 25, 1989, in the Museum's main building, the fortress called the Castillo de la Fuerza. The goal was to provide exhibition space for a kind of art considered subversive or at least incompatible with what was usually shown in the country's art galleries. Under the direction of Marcia Leiseca, the curators of the project were Helmo Hernández, Antonio E. Fernández (Tonel) and Corina Matamoros, together with other advisers. The artists Félix Suazo, Alejandro Aguilera and Alexis Somoza were the main promoters of the project.

4 A large number of artists took part in this ball game, which came to be known as a happening called *La plástica cubana se dedica al béisbol* [Cuban Art Dedicated to Baseball]. It took place on September 24, 1989, in the Círculo Social José Antonio Echeverría, Havana.

NEW CUBAN ART BEGINS

Gerardo Mosquera

Since 1977 a group of young people had been trying, unsuccessfully, to exhibit something different from the derivative nationalist modernism, ideologized and agreeable to the Cuban authorities. They did not succeed until early in the following decade. In the 1980s their exhibitions *Pintura Fresca* [Fresh Paint] and *Volumen uno* [Volume One] unleashed a movement that renewed not just the visual arts but culture as a whole. This was the birth of New Cuban Art, a term that refers to the art that began then and to an open-minded approach that continues today. Above and beyond their work, the historic achievement of these artists was to shatter the conservative, repressive status quo and initiate a new era in Cuban culture. They broke away from submissiveness to official dictates and, moreover, brought back a spirit of creative freedom. This did not mean the end of repression, which continues to this day, but a mental liberation had taken place. Thus began a culture of criticism that, from art, spread far and wide; its latest and most extraordinary manifestation has been the recent "electronic outpouring," beyond state control, whereby intellectuals use e-mail for critical discussions about the situation in Cuba.

It must be stressed that this transformation was a collective phenomenon that brought together different approaches to art, not a program with a manifesto or led by an individual, nor was it the result of strong personalities sweeping others along. Its protagonists introduced a postmodern perspective; they opened up to the world and upheld the autonomy of artistic production. Rather than rebelling against the prevailing stereotypes and constraints, they loftily ignored them. Their determination enabled them to prevail despite official hostility. They were fortunate in that the atmosphere gradually became less stifling after the Ministry of Culture was founded in late 1976. But change came about only after a vehement cultural-ideological confrontation, which was even manifested in public meetings. The artists were accused of being everything from counterrevolutionary and deviationist to derivative. A few critics who backed them developed a very useful tool in their defence: they supported their positions using a left-wing theoretical discourse. By mid-decade these positions had been consolidated, ensuring a place for the new art—the starting point for the rest of the culture to take on a more active, critical and independent role. The artists, however, received no commissions for public works, a usual practice then, nor did the Museo Nacional de Bellas Artes purchase their work at this time.

The *Volumen uno* exhibition in 1981 is regarded as a milestone, marking the moment when the new art burst on to the scene, heralding the most dynamic period in the entire history of Cuban art—a period that produced the "liveliest art in Latin America," according to Jürgen Harten[1] and other observers. In a symbolic coincidence, that same year the celebrated Cuban American artist Ana Mendieta (ill. 368–372) worked for the first and only time in Cuba, in the Escaleras de Jaruco and Varadero. She was in close contact with young artists on her trips to the island, and developed a mutually beneficial relationship with them, providing them with information and putting them in touch with the New York scene. They discussed their work together, and the Cubans were very important in Mendieta's return to her native land. In fact, she based her work on the "return to one's roots," as Aimé Césaire put it.

The new artists came from various popular sectors of society, and they remained there because of the

realities of Cuban life: widespread poverty, a shortage of housing and other resources, social levelling, the creation of an undifferentiated mass, and pseudo-egalitarianism, to name a few. As exponents of folklore and as professionals trained in a free universal education system, many of them created "high" art shaped from within by the values, sensibilities and world views of these groups. This was not a matter of including "primitive" or vernacular elements in "high" art but of creating it out of them.

Another important shift was the rise of the sensibilities, tastes and values of popular urban culture and even of the marginalized sectors of the population, which have tended to become increasingly influential in Cuban lifestyles. With Flavio Garciandía (ill. 321, 373) came the legitimization of an entire aesthetics of "bad taste,"[2] evolving from the "garish" baroque style of popular home and festive decorations. This was a recovery—not devoid of humour—of some stereotypes, especially of the abstract ornamentation used in both spontaneous decorations and professional work for market stalls, fabrics, carnival floats and so on. These discredited motifs were used by artists in an ironic reworking that highlighted their aesthetic potential for the "cultured" sensibility. Garciandía later used these motifs in his ironic treatment of the symbols of communism.

While some artists focused on an aesthetic re-appreciation of "bad taste" or based their own style on it, Osvaldo Yero used the complex shapes and meaning of common plaster ornaments to design hybridizations and appropriations of this production

as the basis for his cultural, social and political criticism of the situation in Cuba. Others, like Tonel and Adriano Buergo, formed their own poetics in part by doing "high" art re-creations of elements taken from marginal culture. This kind of decentring has a real cultural basis, unlike many instances of postmodern pseudo-decentring, although the latter undeniably influenced the trend in Cuba to some extent.

A guiding principle of the new art was to deconstruct official mythologies by appropriating and carnivalizing their imagery, rhetoric and ceremonials in a critique of the mechanisms and representations of the state. Glexis Novoa, Carlos Rodríguez Cárdenas and José Ángel Toirac are perhaps the best examples of the systematic deconstruction of institutional imagery. Novoa appropriated forms of official propaganda to execute paintings and gigantic installations that also included formal references to Russian Constructivism and Futurism. At times these grandiose displays of visual effects were abstract, seemingly a tribute to emptiness. Novoa painted huge texts, like those on propaganda billboards, in fake Cyrillic characters that could not be read. In this way, he pointed out the devaluation of meaning in discourses, ideas and orientations coming from the Eastern bloc. He also painted enormous semi-abstract pieces of commemorative architecture, totalitarian in style, and combined them in large installations such as *Mausoleo* [Mausoleum], 1990, which included a direct reference to the logo of the Communist Party of Cuba.

Cárdenas mainly employed a carnivalized grotesque and scatological

approach to deconstruct the rhetoric proliferating in the media and in political ceremonies. He did so by playing with visuals and words that, although full of popular humour, would have appealed to Wittgenstein or Derrida. He parodied the possible meanings of words and phrases in Cuban newspaper headlines, propaganda billboards and slogans, exposing the empty semantics that belied reality. More than ridiculing these slogans and headlines—which in Cuba have reached heights of absurdity comparable to North Korean standards—he problematized them to analyze the contradictions of socialism. This was also a form of carnivalization confronting the immaculate, lofty language of government rhetoric, aseptically detached from real life.

Toirac (ill. 404–405) is the artist who has worked most systematically to examine the representations of power in Cuba from within, working mainly with photographs and texts from the press. He took images from the newspapers and painted them on canvas, altering their meaning by simply isolating and magnifying them. For example, a ridiculous photo of lowly potatoes appeared on the front page in a report about the usual great successes of the harvest; when reproduced as a painting, it became an abstraction. Among other things, the work referred to the abstract nature of the statistics and successes touted by the press, which had little to do with reality. Toirac has taken an obsessive interest in official representations of Fidel Castro, revealing their religious connotations, giving them a critical quality and deconstructing their propaganda-serving rhetoric.

In Cuba, humour, appropriation and deconstruction have often gone hand in hand. Lázaro Saavedra and other artists used brilliant humour with a social and political edge (ill. 394, 407), in the vein of political jokes heard in the street. In other circumstances Saavedra, a designer and installation artist, would undoubtedly have been a great newspaper humorist. With the recent electronic outpouring, he has taken on that role and circulates e-mails containing critical jokes every day. Before that, he had used the space of visual arts, which was less controlled and more permissive, being small and the domain of a minority, to pursue an ongoing humorous critique of life in Cuba. Among his most memorable works are his buffet table laden with paintings, drawings and objects, an X-ray of the situation in the late 1980s, and his *Altar a San Joseph Beuys* [Altar to Saint Joseph Beuys], which uses votive offerings and petitions to expose the aspirations and fears of Cuban intellectuals.

Another form of decentring was forged by artists who were either initiates of Afro-Cuban religions or brought up in communities with longstanding traditions in them. José Bedia (ill. 365, 367), Ricardo Brey (ill. 366), Juan Francisco Elso (ill. 360), Marta María Pérez (ill. 374) and others produced "international" art structured from within the African-based world views of those religious-cultural complexes. They did not approach them from the outside, as an anthropologist or Surrealist might do, for the simple reason that they were inside. By the same token, this was not the "illustrated primitivism"[3] of Joseph Beuys and other artists with an interest in ethnography. Nor was their art

pristine primitivism, for they were also part of avant-garde Western practice. They operated from the content of these beliefs, not by re-creating forms, rites or myths. One could say that they made Western culture from non-Western bases, transforming it and thereby diversifying contemporary global culture. The new artists disassociated themselves from the Latin American fixation on identity (still so strong that it has partly determined the structure and contents of this publication), and confronted nationalist dogmas instead.

Whereas in the first half of the 1980s conceptual and anthropological approaches predominated, in the latter half the focus shifted to appropriation, parody and the new allegorical expressionism with artists like Buergo, Ana Albertina Delgado and Tomás Esson (ill. 380) Reid. Although the new direction came to some extent from the influence of the neo-expressionism of the day, these artists assimilated it in order to develop radical expressions from Cuban reality and popular culture. Grotesquery, scatology and brazen sexuality were very much in evidence. This was, moreover, a backlash against the rhetorical image of an uncontaminated society promulgated by the Cuban media until this day. At times this movement made direct cultural allusions—Esson Reid's painting of a Cuban flag made out of sausages and cuts of meat, and his *Mi homenaje al Che* [My Tribute to Che], where two grotesque monsters copulate in front of the image of the hero depicted with African features. The exhibition of these pieces in the late 1980s provoked a famous instance of censorship. The casual use of national symbols in a critical spirit

was deeply displeasing to bureaucrats and the military.

Despite its variety, which makes it impossible to single out constants of style, there are certain characteristics common to all art of the 1980s. One major feature is the importance of a conceptual approach in this art of ideas, which tended to incorporate discursive analytical elements and a reflexive dimension even within the neo-expressionist tendency. Another common characteristic is humour: wit and gaiety are very apparent in works by Tonel and the Grupo Puré. The latter, in their first exhibition in 1985, broke away from the sort of "clean-cut" seriousness typical of the first half of the decade. Artists felt free to appropriate any object, image or idea and recontextualize it, often incorrectly, for their own purposes.

The new artists took appropriation to extremes of mockery and cynicism. Joseph Kosuth described the work of Consuelo Castañeda, based on reappropriations of appropriations of art history, as "post-Postmodernism." The group composed of Tanya Angulo, Juan Ballester, José Ángel Toirac and Ileana Villazón (ABTV) made crude photocopies of Sherrie Levine's *After Alexander Rodchenko*, taken from magazines, and exhibited them under the title *After Sherrie Levine*. This work had implications as much for postmodern discourse as for the use of cultural appropriation in the "peripheries," an avenue in which the group continued working.

The most important change brought about by the new art, however, was to

move culture toward social and political criticism. The process began before perestroika and glasnost in the Soviet Union as a result of the evolution of the new art within the ideological and social situation in Cuba at that time, although it was stimulated by the events in the Eastern bloc. From the mid-1980s on, something remarkable happened: art—without contradicting itself—substituted functions of the (controlled) public assemblies and mass media and became a space to express people's problems. Some street performances, such as those by the Grupo Arte Calle [Street Art Group], for example, were real street demonstrations. Aldito Menéndez, a member of the group, painted the phrase "Reviva la Revolu" (which could mean both "Long live anew" or "Revive" the Revolution) on canvas and put a bin beside it with a sign asking the public to help finish the work. In 1989 Tonel created a visual summary of the situation in Cuba: his installation *El bloqueo* [The Blockade; see ill. 386] (the name used on the island for the absurd U.S. trade embargo) spelled out its title in letters of poured concrete placed on the floor beside a map of Cuba composed of cement blocks. The work was a metaphor for the blockade and the self-blockade, defence and enclosure.

It is surprising that the visual arts, an activity with a rather elitist slant, took on such an important social role. Paradoxically, this is what made it possible: the authorities paid little attention to art because its scope was so limited, and artists took advantage of this fact. The slim little exhibition catalogues constituted a relatively free space for publication. It is equally surprising that art carried out this role without compromising its mission for artistic exploration and experimentation. On the contrary, the symbolic powers of art were put to use in a process of problematizing discourse that confronted the many complexities of art and Cuban life.

The harsh cultural, social and political criticism expressed in the visual arts escalated, and at the end of the 1980s went beyond the limits of what the authorities were prepared to tolerate. A 1989 exhibition by Eduardo Ponjuán and René Francisco was partially censored as soon as it opened, when two works were withdrawn. Another, by the ABTV group, was unable to open on its first night. Titled *Homenaje a Hans Haacke* [Tribute to Hans Haacke], the show consisted of works that deconstructed the mechanisms of power in Cuba's cultural milieu.

These events marked the start of a new cultural shutdown. Ángel Delgado, who defecated on a copy of the periodical *Granma* as part of a performance at an opening in 1990, spent six months in prison among common criminals. The young artist was made a scapegoat in a clear warning to intellectuals by the authorities. This whole situation, coupled with the economic, moral and social crisis precipitated by the end of the Soviet subsidy and the international interest in new Cuban art, led to a diaspora of intellectuals that peaked in the early 1990s. Unfortunately, exile thwarted the work of a good many of these artists.

1 Jürgen Harten, Foreword, *Kuba OK*, exhib. cat. (Dusseldorf: Stadtische Kunsthalle, 1990), p. 7.

2 Gerardo Mosquera, "Bad Taste in Good Form," *Social Text* (Fall 1986), pp. 54–64.

3 Luis Camnitzer, "Arte 'primitivo' en el MoMA," *Art Nexus*, 27, pp. 21–25.

361

Tomás SÁNCHEZ

361
The Flood
1984

362
Relation
1986

362

a

b

c

d

e

f

g

h

i

363 a–i

Rogelio LÓPEZ MARÍN (Gory)

It's Only Water in a Stranger's Tear—
1986

a. *Like a swimmer trapped
beneath a layer of ice, I keep
searching for a way out*

b. *. . . but there is no place. I've
swum for a lifetime holding my
breath. I can't imagine how the
rest of you do it*

c. *We are blind. Blinded by the
future. We never see what's com-
ing, never the next moment, only
what we have already seen. That
is, only the layer of ice above us,
looking for a way out*

d. *I can't be the only one to have
noticed, I'm not that smart.
They've merely agreed not to talk
about it*

e. *We all walk blindly throughout
our lives, never knowing what the
next moment will bring, or
whether with our next step we'll
touch solid ground or tumble into
the void*

f. *I thought I had ended up in the
wrong dream or the wrong world.
Or maybe I was wrong for this
world, or this dream*

g. *. . . but if it turns out that I'm
only your shared collective
dream, that you all dreamt me
from the start, that I was never
anything but other people's
dreams, then I beg of you dear
dreamers, from the bottom of my
heart, free me. Dream of
something other than me*

h. *I can't stand it any longer.
I don't expect you to wake up.
Sleep as long as you like, sleep
well, but dream of me no more*

i. *Tell me something, ladies and
gentlemen: What happens to a
dream when its dreamer
awakes? Nothing? Is nothing
happening any longer?*

364

365

366

367

364
José Manuel FORS
Tribute to a Silviculturist
1984

365
José BEDIA
The Blow of Time
1986

366
Ricardo BREY
The Structure of Myths
1984

367
José BEDIA
Affluent
1980

368

369

370

371

Ana MENDIETA

Photographs and still
from a video of the artist's
"earth-body sculptures"
1981

368
Untitled (Varadero)

369
Rupestrian Sculptures

372
First Woman (Rupestrian Sculpture)

370
Untitled (Guanabo)

371
Ochún, Key Biscayne, Florida (still 5)

373

373
Flavio GARCIANDÍA
Lead Feet
From the series "Proverbs"
1985

374
Marta María PÉREZ
"Memories of Our Baby"
1987–88

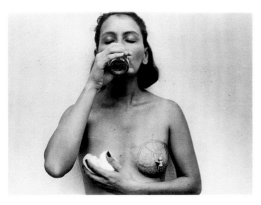

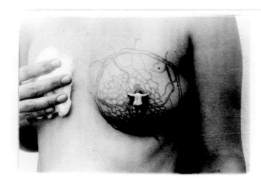

374

375

375
Juan Carlos ALOM
Transplanted Tree
1994

376, 377
Belkis AYÓN
The Sentence No. 1
The Sentence No. 2
1993

376

377

378

378, 379
René PEÑA
From the series
"Man-made Materials"
Keloid 2
Lips
1998–99

379

ART'S ROUND TRIP TO UTOPIA: THE VISUAL ARTS AND CULTURAL POLITICS IN LATE TWENTIETH-CENTURY CUBAN SOCIETY

Antonio Eligio Fernández (Tonel)

We will only stop when we get to Heaven.
—From Luis Rogelio Nogueras's poem
¡Adelante!

From the late 1970s onward, a movement of renewal in the visual arts in Cuba was clearly apparent, and after 1986 this process entered a second stage when a group of very young artists came on the scene.[1] Two successive exhibitions in Havana in that year heralded the arrival of these new and increasingly influential talents in the second wave of the 1980s: *Puré expone* opened in January in the centrally located Galería L, and *Relevo* ran through November and December in the faculty of visual arts at the Art Institute of Graduate Studies (ISA) as part of the opening of the second Biennial of Havana.

These "even younger youths" played leading roles in the artistic and ideological battles and skirmishes characteristic of the art world and cultural milieu at the time, especially in the years 1986 to 1990.[2] They had absorbed the conceptualist approach characteristic of the previous generation together with a postmodernist use of media, with incursions into parody, appropriation and the carnivalesque. It

is undeniable that in the mid-1980s the new arrivals were leading art into areas that previous artists had tried to avoid, with experiments like *Volumen uno*: into politics, pamphleteering, satirical and critical social commentary, visual power and use of words defined by the colours and sounds of popular culture and language.

At the same time, it is an accepted fact that in the mid-1980s "the symptoms of burnout in the development plan for Cuba became unmistakably apparent."[3] The response to these symptoms was a policy entitled the "process of rectification of errors and negative tendencies" launched by Fidel Castro in 1986. The goal of the rectification process was to turn the revolution back on to the "right track," a straight path that would take the Cuban people forward through the socialist present into the distant future of a communist society. The move toward the right track, as Haroldo Dilla Alfonso remarks, "was characterized by a strong antimarket rhetoric, the recovery of national autonomy (in contraposition to both the United States and Soviet perestroika), and a strong reliance on ethical and nationalist arguments that had as their emblematic figures José Martí and Che Guevara."[4]

These directives of the "rectification process" shaped the ideological space within which art would manoeuvre until about 1990. Occasions when the rectifying rhetoric seems to have infiltrated the visual arts of the day will be discussed later on. But first another factor must be raised, which is essential to an understanding of the Cuban artistic process in the period between the mid-1980s until well into the 1990s: the dramatic changes that took place in the nation in the early 1990s, changes accelerated by the disappearance of the Soviet Union and the return to capitalism in countries where European "real socialism" was tried. Immediately after this geopolitical turmoil, the Cuban government adopted a dual economic model in which the U.S. dollar circulated freely and market relationships had their place. Even after these changes the first half of the 1990s was a time of rapid decline in the Cuban economy. A decisive factor in the worsening state of things during this critical period was the abrupt withdrawal of Soviet subsidies and support, coming on top of the usual U.S. economic and trade embargo against the country, which the Cubans call "the blockade." These and other factors brought about a traumatic drop in the overall standard of living,

causing in turn a weakening of the social fabric and hence episodes such as the boat people of the Cuban Rafter Phenomenon of 1994. Thus in the first half of the 1990s Cuba underwent the most painful stage of what has officially been called the "Special Period."

To practise as an artist during the early years of the Special Period (1990–95) meant making one's way in a new reality in every respect, one marked by scarcity and a survival mentality both inside and outside cultural circles. Many of the artists most active during the previous decade had emigrated, mainly to Mexico or Miami. After 1991, art institutions (exhibition venues, salons, competitions, and even the famous Biennial of Havana) lost much of their scope and influence as a result of the precarious economy, while the role of the market as a dominant factor in establishing cultural values and hierarchies became indisputably greater.

In the course of the 1990s, the art produced in Cuba made a kind of stamp or trademark (especially for the export market) out of the irreverent and satirical Grupo Puré, Carlos Rodríguez Cárdenas, Glexis Novoa, Alejandro Aguilera, Tomás Esson Reid and others. This satire and irreverence revealed the country's social and political contradictions or played on patriotic symbols such as the flag, the national coat of arms, the portraits of heroes and the shape of the island on the map. A trademark, as is well known, is a vital component in consumption, in commercial transactions based on the fluctuations of supply and demand. Although the irreverence and irony of the 1980s gradually became, in the 1990s, a trademark—that ordinary but indispensable

component of consumption—it cannot be viewed as separate from demand (most often foreign, from without), that is, from the increasingly important influence of the international art market on the definition of artistic activity of Cuba.

The consolidation of a stratified market, in which the most powerful sectors rely to this day on hard currency, was a gradual process spread out over the years from the "rectification" to the "Special Period"—two almost antithetical phases that were nonetheless inseparable in what Dilla Alfonso calls their "structural continuity."[4] Although in the first of these phases direct resistance to market forces was proclaimed, in the second phase, without the support of various forms of Soviet aid, it was assumed that the market was a necessary, even desirable, option, in the realm of culture as well. The two stages came together in the heightened atmosphere of survivalism in the 1990s, which in practical terms meant postponing any return to the quest for a bright utopia. With the "rectification" version of the "right track" on hold, the nation was faced with a bewildering labyrinth of short and irregular pathways that at times seemed impassable. At the end of this impasse the Edenic image of communist society was fading and disappearing amid the spectacular collapse of Soviet and European socialism and the birth, as if it were a universal phenomenon whose varied effects must therefore also be felt in Cuba, of what the theorist Boris Groys calls the "post-communist condition."[6] Groys is referring here to a new stage in world history, defined as the moment when most attempts to bring about communist utopia belong to the past: they

"took place as a real event in the real history"[7] of the twentieth century.

This profound universal change, a true historical fracture, encountered in Cuba a situation that has been summarized by the Marxist intellectual Fernando Martínez Heredia as: "conditions . . . governed by economic crisis and in large part by institutional and ideological crisis, by a crisis in people's beliefs. This all took place as part of the iron-clad necessity of economic reinsertion into a world dominated by capitalism."[8] Cuban culture, from the late twentieth century until today, has had to operate and develop amid these internal events and in a world coloured by "post-communism."

Apart from the fact that Cuba, like China, North Korea and Vietnam in their respective ways, is officially a socialist country and has been since 1961, it is an undeniable fact that the immediate socio-political reality in which Cuban artists have been working since the latter half of the 1980s has been marked by ebbs and tides and at times irreversible dramatic changes. The general, "global" context in which the work of this period was created was joined, in large part, by what Aleš Erjavec describes as "post-socialism," or "something different from Western capitalism and from the various forms of socialism, such as 'real socialism,' 'self-management,' etc. found in Europe and elsewhere."[9]

In speaking of "post-socialism," Erjavec refers to the historic crisis taking place in the Soviet Union, the European socialist countries, including Yugoslavia, and China and Cuba.[10] The phenomenon was occurring in each of

these countries in its own particular way from the 1960s on, and in some of them from the 1980s. A common aspect of this crisis was economic and social stagnation. Looking at the evolution of Cuban society since the second half of the 1980s, it becomes clear that Cuba was not immune from the effects of this process, as dependent as it was on relations with the Soviet and European socialist camp.

Among the other aspects particular to Cuban reality in the mid-1980s, Rafael Hernández mentions the deterioration of the economy, with "falling growth rates, low productivity, mismanagement of resources . . . excessive centralization and bureaucratization of the mechanisms of government, over-dependence on imported goods and a growing national debt."[11] The author also points out that "along with these signs of stagnation was a social structure that had lost its former dynamism and upward mobility."[12] With the arrival of the 1990s and the "Special Period" these symptoms converged in a generalized situation that Martínez Heredia describes as "socialism greatly losing steam."[13]

In Cuba's case, the vicissitudes of the socialist model coincided with a cultural policy that since the late 1970s had decided to stress that the country formed part of Western culture; this same policy emphasized as never before Cuba's debt to and connections with Latin America, Africa and the Caribbean."[14] In the domain of the visual arts, the Havana Biennial, held for the first time in 1984, constituted a very clear statement of the new cultural strategy: Cuba's leadership in the Third World and an openness to the West. The

second Biennial was seen as the "magnet"[15] that Third World art required. Thus the policy of a cultural alignment centred on Havana reveals an aspiration toward an ideal state of things with somewhat utopian aspects, which would offer coherence and homogeneity to the artistic cultures of the countries involved.

In the 1980s, when Cuba was increasingly affected by the internal problems of its economy and by the changes being gradually unleashed in the world of "real socialism," initiatives like the Havana Biennial demonstrated an intent to strengthen the Latin American and Third World connection with the revolution. Cuban nationalism embraced a complexity that tried to reconcile the pan-Third World values with those of the West, while retaining an earlier factor, that of the country's traditional ties to Soviet and European socialism. This factor was what obliged the country's institutions to maintain the obligatory exchanges with the "sister" cultures of the U.S.S.R. and the socialist countries of Europe, even though it was obvious that these relationships were of dwindling importance and were gradually becoming less necessary.

Efforts to reorient Cuban art in the new international context were accompanied by another and very odd tactic. I am referring to the experiments aimed at creating an alliance between art, on the one hand, and industry, mass production and design, on the other. These experiments led to projects such as *Telarte* [Woven Art], *Arte en la fábrica* [Art in the Factory], and the *Simposio internacional de escultura* [International Sculpture Symposium], among others. Given their scale and widespread

visibility, heightened by the incorporation of elite aesthetic standards into everyday objects, these experiments can be considered a reappearance in the Caribbean of the utopian ideals embraced by the Russian avant-garde following the 1917 Revolution.

The energy invested in products destined for everyday use did not mean that artists stopped creating more traditional works conceived for Salons and galleries. In the mid-1980s conceptualism was still a considerable presence in Cuba's art world, and it has remained important, to varying degrees, up to the present day. It is apparent in works that feature a density of signifiers in their aesthetic discourse, works that incorporate dialogue with scientific or philosophical theories, with anthropology, history and religion, and also with formal solutions and beliefs and tastes associated with the syncretism of popular culture. Many of these characteristics can be found in the work of artists such as Leandro Soto, Juan Francisco Elso, Arturo Cuenca, Consuelo Castañeda, Alejandro Aguilera, Lázaro Saavedra, Tomás Esson Reid, Carlos Rodríguez Cárdenas, Eduardo Ponjuán, Pedro Álvarez, José Toirac, and later on in those of Kcho, Tania Bruguera, Los Carpinteros, Sandra Ramos, Manuel Piña and Fernando Rodríguez.

In the work of these artists is seen an amplification of—and sometimes even a break with—traditional notions of sculpture, painting and photography, along with a tendency to expand into three-dimensional space. These explorations bring flexibility to the conception of installations and temporary works. The use of written language in art also gains ground, as do the

possibilities for combining image and text. This work often bears out some of the general propositions Erjavec makes about the art of post-socialism in Europe, the former Soviet Union and China: "Its Conceptualism and its specific use of the secondary discourse, ironically distanced from the official ideology that it employed; its conscious or spontaneous use of what are today considered to be postmodernist techniques and procedures; its use of socialist and communist imagery, national symbols, and folk, traditional, and mass culture."[16]

During the 1980s and even into the 1990s, the nationalist ideology proper to Cuban socialism occasionally filtered into works of art, without leaving much space for distancing irony, as can be seen in Elso's *For the Americas* (ill. 360) and Aguilera's *Playitas and the Granma* (ill. 397). Elso's sculptures dramatize and sanctify José Martí, the towering symbol of Cuban aspirations for independence. The lone figure of Martí, the tattered hero of the struggle for the American continent, constitutes a striking parallel to the discourses that evoke Cuba as the embattled heart of the aspirations for Latin American sovereignty. But this parallel should not be pushed too far, since the rustic power of the sculpture and its romantic earnestness, springing from authentically popular roots, make it distinct from more simplistic ideological depictions. Aguilera takes up the image of Martí in *Playitas and the Granma*, a work that also brings in historical and religious elements. It reasserts, with a hint of irreverence, the historiography of Cuban socialism in a hagiographic sculpture that interprets the country's history as a series of successions. By

identifying the revolutionary leaders with popular Catholic traditions, it makes gentle fun of the enthusiastic populist nationalism of "rectification."

Soto's *The Revolutionary Family* (ill. 399) is a commentary on the impact of grand projects of renewal on the private space of the domestic hearth. The installation presents a nostalgic vision of the typical family, "integrated" into the confusion of the Cuba of the 1960s. The execution evokes the tone of urgency and improvisation that characterized that moment in history, although the stiff poses of the group portrait somehow contradicts these implications of spontaneity.

Other artists also ventured mordant and ironic interpretations of history and politics. In his *First Cuban Convention on the Purpose of History* (ill. 401), Pedro Álvarez, the Cuban painter who has best connected postmodernist sarcasm and appropriation with this rethinking of history, presents a satire on convention tourism, a national institution, especially after the 1980s. Saavedra's *Ideology Detector* (ill. 394), on the other hand, warns viewers of the perils of ideological dogmatism (which in the case of Cuba is inseparable from the demotic Marxism adapted from Soviet textbooks). Saavedra has constructed an instrument that seems to have come right out of the workshop of a worker who knows how to improvise, one of those technicians constantly confronted by the U.S. blockade and thus the ideal model of the socialist worker. Saavedra mocks the naïveté of thinking that ideology is something that can be measured, that its intensity and fluctuations can be detected with primitive devices. The subject of ideology and socialism is found again in Cuenca's *Science and*

Ideology (ill. 392), although Cuenca dispenses with humour, preferring to emphasize the differences between the various fields of human knowledge.

In the works of Kcho and Ponjuán are seen two different levels of a never-ending dialogue between Cuban art, on the one hand, and the Russian avant-garde and Soviet art in general, on the other. While Kcho identifies fully with Tatlin (ill. 391) and the potential of utopian thinking in both art and society, Ponjuán—who works in the same ironic vein as Álvarez and Saavedra—presents a sarcastic commentary on utopian ideology, which he reduces to the measurable and the manipulable. In Ponjuán's work (ill. 395), utopianism becomes a tool to measure everything, the instrument that defines the physical and aesthetic dimensions of art. Thus measured, art is reduced to the word, the very concept of utopia; and where the concept has been imposed there remains only a blank canvas, devoid of images.

Tomás Esson Reid and Carlos Rodríguez Cárdenas got together in 1989 somewhere in Havana and set out to create an enormous oil on canvas that they were going to call *Long Live Free Cuba!* (ill. 380). The painting was inspired by *Masha and the Bear*, a traditional Russian children's story that the two artists took and converted into a picture of Cuba's complex and dependent relations with the declining U.S.S.R. during the perestroika period. The U.S.S.R. is shown as a large bear with skinny legs, a grotesque animal bleeding yet still moving forward, carrying on its back clever little Masha. The child, thanks to her little flag, becomes an image of Cuba still being borne comfortably on

the back of her powerful carrier. The wiliness demonstrated by Masha in the original story becomes in the painting the new Cuban pragmatism, the nationalist ideology that hurriedly sought to distance itself from any identification with the Soviet bloc (or with the misfortunes of that bloc), while maintaining as much as possible every sort of trading relationship with the wounded bear. Meanwhile, the city in which these young artists shared their creative enthusiasm was seen with each passing day with greater clarity as the capital of a country shaken by a profound crisis and stagnating economically since 1986.[17]

Like so many works of art from that period of history, *Long Live Free Cuba!* succeeds in capturing with maximum effect the socio-economic context and political events from which it sprang. For this reason it is an unsurpassable example of an art that is particularly well equipped, following Erjavec, to reflect the historical process of which they are a part and which they also affect in their turn.[18] It is no exaggeration to say that much of the Cuban art produced during the years of the "rectification" and "Special Period" stands today as witty and eloquent testimony to those difficult times in the recent history of the Cuban nation.

1 Among the artists who took a leading role from then on were the members of the Grupo Puré —Ana Albertina Delgado, Adriano Buergo, Ciro Quintana, Lázaro Saavedra and Ermy Taño— and also Segundo Planes, Tomás Esson Reid, Alejandro Aguilera, Belkis Ayón, Carlos Rodríguez Cárdenas, Glexis Novoa, Abdel Hernández, Ernesto Leal, Luis Gómez, Sandra Ceballos, Pedro Vizcaíno and Pedro Álvarez, to name only a few of the most prominent.

2 In his survey of Cuba in the 1980s, Desiderio Navarro defines many of the things that led to increasingly frequent clashes between artists and intellectuals on the one side and political and cultural bureaucrats on the other. Navarro remarks, for example, on the "willingness to criticize and engage in public discussion" shared by artists and the "unprecedented proliferation of cultural spaces of every kind: exhibition, publication, reading and discussion spaces; institutional and non-institutional spaces; private and public spaces." He also describes how at the time there was an abundance of "spontaneous interventions that did not have prior approval, authorization or planning," and emphasizes that "this critical intellectual activity was oriented, in a way never seen before, toward the non-institutional and the anti-institutional." See Desiderio Navarro, "*In media res publicas*: Sobre los intelectuales y la crítica social en la esfera pública cubana," in *Las causas de las cosas* (Havana: Letras Cubanas, 2006), p. 15.

3 Rafael Hernández, *Mirar a Cuba. Ensayos sobre cultura y sociedad civil* (Havana: Letras Cubanas, 1999), p. 93.

4 Haroldo Dilla Alfonso, "Cuba: The Changing Scenarios of Governability," *Boundary 2. From Cuba: A Special Issue*, John Beverley, ed., vol. 29, no. 3 (Fall 2002), p. 60.

5 Ibid.

6 Boris Groys, "La condición postcomunista," p. 3. (http://www.criterios.es/pdf/mondediplogroyscondicion.pdf).

7 Ibid., p. 2.

8 Fernando Martínez Heredia, "En el horno de los noventa. Identidad y sociedad en la Cuba actual," in *Corrimiento hacia el rojo* (Havana: Letras Cubanas, 2001), p. 76.

9 Aleš Erjavec, "El Segundo Mundo: postmodernismo y socialismo," *Criterios*, no. 35 (2006), p. 213–248.

10 Aleš Erjavec, *Postmodernism and the Postsocialist Condition: Politicized Art under Late Socialism* (Berkeley and Los Angeles: University of California Press, 2003), pp. 2–4.

11 Hernández 1999, p. 94.

12 Ibid.

13 Martínez Heredia 2001, p. 69.

14 Armando Dávalos Hart, *Cambiar las reglas del juego. Entrevista de Luis Báez* (Havana: Letras Cubanas, 1983), pp. 61–73.

15 Luis Camnitzer, "La Habana: Un imán que nuestro arte necesita," *Granma Internacional* (February 15, 1987), p. 7.

16 Erjavec 2003, p. 31.

17 While Esson Reid and Cárdenas were combining their talents in painting a 2 x 2 metre canvas, Cuba's gross national product was dropping abruptly, so abruptly that in the space of only four years (1989–93) it fell by at least 35 per cent. See Julio Carranza Valdés, Luis Gutiérrez Urdaneta and Pedro Monreal González, Cuba: *Restructuring the Economy: A Contribution to the Debate* (London: Institute of Latin American Studies, University of London, 1996), p. 9; and Dilla Alfonso 2002, p. 59.

18 Erjavec 2003, p. 7.

THE ISLAND BURDEN: INSULARITY AND SINGULARITY

Corina Matamoros Tuma

The rereading carried out by young Cuban artists in the 1990s of the poem *La Isla en peso* [Island Burden], written by Virgilio Piñera in 1943, was a truly astounding example of the re-signification of tradition. Piñera, the exemplary poet of the "culture of no," who regarded the enigmas of nationality with sorrow and a keen and critical eye, was redeemed by Cuban art produced in a period of extreme economic and spiritual poverty. Like a giant amplifier, the poem appeared in Sandra Ramos's prints (ill. 381–383) with the famous line "la maldita circunstancia del agua por todas partes" [the damned circumstance of water everywhere]; in sculptures such as *Mi jaula* [My Cage] by Kcho, unthinkable five years earlier; and in Tania Bruguera's video installation, in which she acts out with dramatic gestures the line "país mío, tan joven, no sabes definir" [Country of mine, so young, you know not how to define]. The condition of being an island, the emigrant's trauma and the conflicts of nationality appear everywhere in art.

Scrutinizing the nation's most sacrosanct archetypes was, however, the healthiest thing that could have happened to Cuban art in the 1990s. That it was forced to do so in the midst of a struggle for survival is a sociology lesson in itself.

Contrary to the predictions made abroad, at the close of the century Cuba lives on; it emerged with a changed face. A wounded society and an economy recovering after a relentless decline are attempting to recover together. Innocence is not found in art anymore; artists are taking a step back, and other viewpoints are being defined instead. Cubans have hit bottom and see themselves differently. The ancestral human body, cross-dressed, homoerotic, ambiguous or regarded as a trophy, emerges in the innovative photography of René Peña (ill. 378, 379). The much-sought-after identity—a sort of perennial El Dorado—is gradually undone in work by artists like Luis Gómez, and becomes sarcasm with Ernesto Leal, who has purchased on Mars a *Nueva patria para descansar*

[A New Homeland to Rest In]. The stereotypes of nationality will be held up to scrutiny by a new poetics that will unceremoniously dispense with them, rejecting the well-trodden path.

Rewriting history is another road being travelled. Tania Bruguera explores the Cuban auditory memory by invoking forty years of revolutionary slogans in the remarkable sound installation *Autobiography* (ill. 408). José Toirac dissects a current political event, the kidnapping of the boy Elián González, in a simultaneous triple account of the incident, using his typical deconstructive, symbolic methodology to probe for the truth (ill. 405). And Garaicoa's work sets itself up as a paradigm of the new history, where memory and longing construct in a new fashion the enigma of the city (ill. 410, 411).

People search on for their own meaning. On the national arts scene, Francisco de la Cal ceased to be the strange blind character who for ten years painted by dictating his imaginary visions to the artist, and became

an element in a chain of continuous production. What happens to Francisco de la Cal in *Modern Times* (ill. 406) is a metonym for what is happening on the island, according to Fernando Rodríguez.

Religious introspection deepened, and the trail blazed by Belkis Ayón (ill. 376, 377) and Marta María Pérez (ill. 374) a few years before revealed more subjective and elaborate implications in Juan Carlos Alom's photographs and videos (ill. 375).

A world bristling with paradoxes and inverted meanings is highlighted in the extraordinary sculptures of Los Carpinteros (ill. 403), which have amazed the whole of Cuba since they appeared in the early 1990s. Their universal scope and resonance have grown ever since.

Lázaro Saavedra, meanwhile, persists in satirizing the prerogatives of power. Whereas *Ideology Detector* (ill. 394), roughly cobbled out of cardboard, was emotionally explicit and almost naive, his restrained humour now bursts forth in a video where self-suspicion is analyzed as a social disease (ill. 407).

In recent years, some exhibitions of Cuban art have chosen to emphasize the imprints of the end of the utopia, as if the erosion of chimeras was exclusive to it and not experienced anywhere else. I like to think that Cintio Vitier was wise on his part to say that Latin America, doomed always to search for itself, finds its true identity in utopia.[1]

It can be considered that the island fits into the structure this Cuban intellectual described, that of a continent that, unhappily, found cohesiveness first under colonial domination and later in its thirst for independence from the metropolitan powers,[2] and whose destiny seems to lie now—and perhaps forever—in a future constantly in sight that forcefully shapes its present. With all its bitter criticism and supposed remove, Cuban art still manifests a powerful emotional tie to the island's destiny. Not all symbolic representations are able to suggest this feeling.

While it has gradually developed greater universal scope, contemporary Cuban art, from Wifredo Lam to today, has also brought to light the features of a significant number of local cultural networks. Whether because of changes in global thinking or the vigour of artistic production, the fact is that the island's best art has been associated with a broader feeling that has made possible a shift in the balance of what is called "world art." As in a magnetic field, there has been a revolution against the styles and one-sided viewpoint of the dominant cultures, while knowledge of other cultural settings is no longer confined to the realm of ethnology. The objects produced by cultures that were subject peoples for centuries have finally begun to "write back,"[3] as Michel Leiris predicted. Art has been largely responsible for this upheaval. I like to believe that Cuban art has signed on (also and with zeal) to this great and necessary revolution. If, at the dawn

of the conquest, the Americas were everything the world needed in order to know itself, as Carpentier noted,[4] today we could not be ourselves without the creations of all those displaced cultures, all those "Americas," which like our own, taught us how to value, in their day, every aspect of the whole wide world.

1 Cintio Vitier, *Resistencia y libertad* (Havana: Ediciones Unión, 1999), p. 8.

2 Ibid., p. 27.

3 Quoted by James Clifford in *The Predicament of Culture: Twentieth-century Ethnography, Literature and Art*, (Cambrige, Massachusetts: Harvard University Press, 1988), p. 256.

4 Alejo Carpentier, *Visión de América* (Havana: Editorial Letras Cubanas, 2004), p. 127.

381

382

383

384

385

381–383
Sandra RAMOS
The Raft
The Boat
The Bathyscaphe
1995

Antonio Eligio FERNÁNDEZ (Tonel)

384
Dos Cubas [Two ¨Cubas¨]
1990

385
Cuba [Bucket]
1991

386
El bloqueo (The Blockade)
1989
Photo and plan of the installation
(1992)

"EL BLOQUEO" (instalación), 1989.
MATERIALES: Bloques de construcción, cemento, arena, recebo, alambrón.
PRIMERA VERSIÓN, PRESENTADA EN LA 3ERA BIENAL DE LA HABANA (NOV. 1989) EN EL MUSEO NACIONAL, PALACIO DE BELLAS ARTES Y QUE INCLUYE LAS OBRAS "CUBA" Y "DOS CUBAS". (FOTO: EDUARDO RUBÉN (1989) IMPRESA POR ADALBERTO ROGUE (1991)).

usar bloques con estas medidas

15 o 20 cm

40 cm 20 cm

EL BLOQUEO

pared

0,60 m

2,80 m

8,40 m

99 BLOQUES

VISTA EN PLANTA DE "EL BLOQUEO"
1 cm = 40 cm (ESCALA).

pared letra piso

·GERigioTONEL, La Habana, 1991.

387

388

387
José Alberto FIGUEROA
Rafter, Havana
1994

388
José Alberto FIGUEROA
Tribute
From the series "Havana Project"
1993

389
Manuel PIÑA
Untitled
From the series "Water Wastelands"
1992–94

389

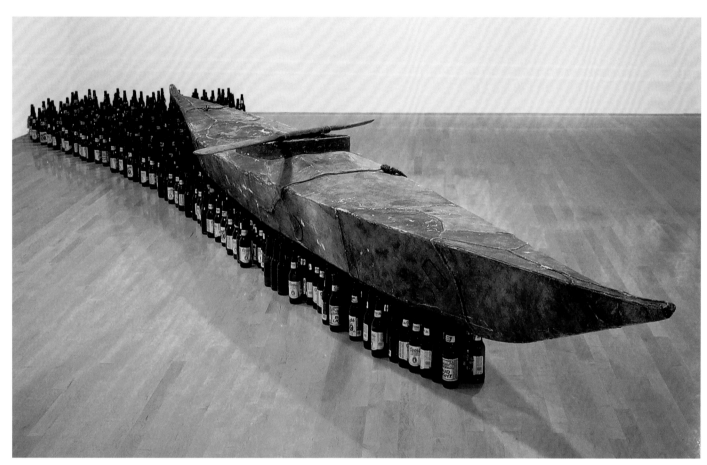

390

Alexis LEYVA (Kcho)

390
In Order to Forget
1996

391
In the Eyes of History
1992–95

colador

café

alambre Ramm

Colador de
café

Ramas
de árbol
y alambre.

"A los ojos de la Historia"

(altura de 265 cm)

392

393

394

392
Arturo CUENCA
Science and Ideology
1988

393
Lázaro SAAVEDRA
Art: A Weapon in the Struggle
1988

394
Lázaro SAAVEDRA
Ideology Detector
1989

395
Eduardo PONJUÁN
Utopia
1991

396
Eduardo PONJUÁN
To Die for Your Country Is to Live
1989

395

396

397

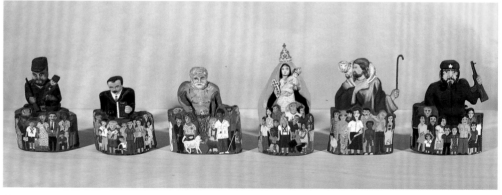

398

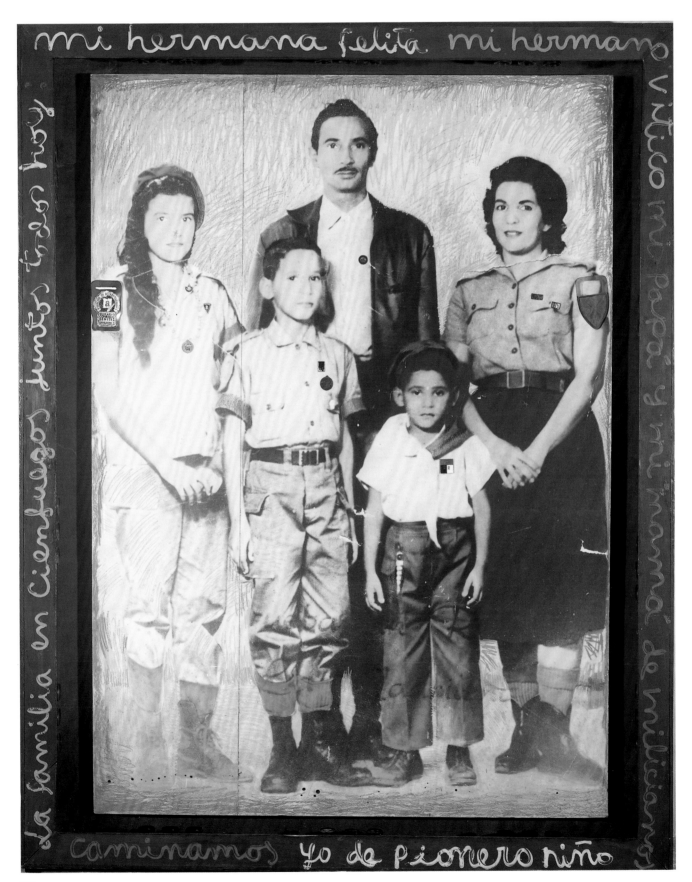

399

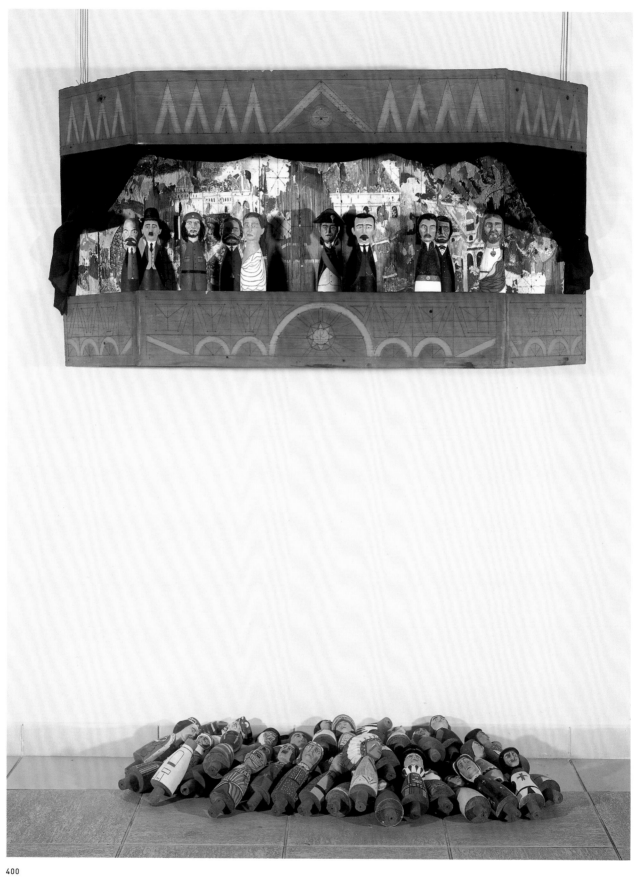

400

401

400
Carlos Alberto ESTÉVEZ
The True History of the World
1995

401
Pedro ÁLVAREZ
First Cuban Convention on the Purpose of History
1993

Pedro Alvarez's work satirizes a so-called "congress tourism" that became institutionalized in Cuba, especially since the 1980s. The painting includes very specific figures who allegorize historic moments in the country's history, including the Spanish colonizer, the aboriginal American, the Mambí rebel, the Spanish soldier, the U.S. Marine and a current leader. Their co-existence in the canvas is an ironical comment on the political game always involved in history.

LOS CARPINTEROS

402
Coal Oven
1998

403
Jewellery Case
1999

404

404
José TOIRAC
Self-portrait. Tribute to Dürer
1995

405
José TOIRAC,
Meira MARRERO
Patricia CLARK
Video *"The Golden Age"*
2000

¿De dónde venimos?

Where do we come from?

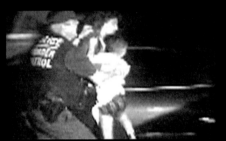

¿A dónde vamos?

Where are we going?

406

406
Fernando RODRÍGUEZ
Animated film "Modern Times"
2006

407
Lázaro SAAVEDRA
Stills from the video installation
"Suspicion Syndrome"
2004

407

408

408
Tania BRUGUERA
Autobiography
Sound installation
(revolutionary slogans)
2003

409
Ernesto OROZA
Video "Aachen to Zurich"
2005

Revolución

Westwood LET

REVOLUCIÓN

CosmicTwo

Revolución

DeadGrit

Revolución

EckmannD

REVOLUCIÓN

Eklektic

REVOLUCIÓN

Zinjaro LET

Revolución

EnviroD

revolucion

Freeble

REVOLUCIÓN

GoldMine

REVOLUCIÓN

Griffon

REVOLUCIÓN

Hazel LET

Revolución

Hollyweird LET

REVOLUCION

Keystroke

Revolución

Kids

Revolución

Milano LET

Revolución

Pablo LET

Revolución

Prick

Revolucion

Tooth Achel

410

Carlos GARAICOA

410
How the Earth Wants to Be Like the Sky (II)
2005

411
Now Let's Play Disappear (II)
2002

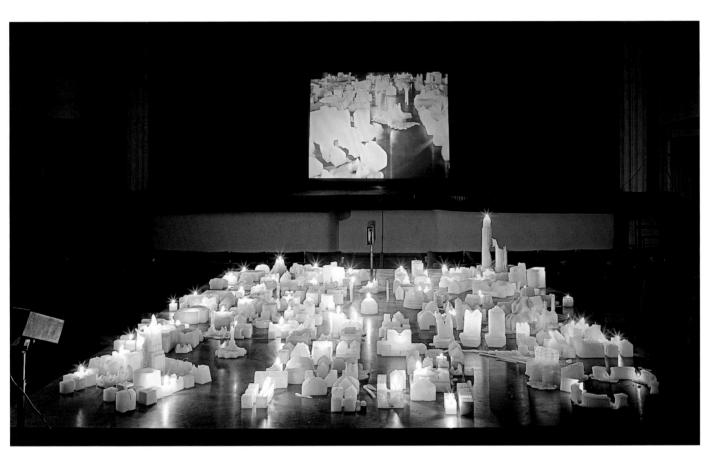

411

BIOGRAPHICAL NOTES

JA : Joe Abraham
SA : Stéphane Aquin
EC : Ernesto Cardet Villegas
IC : Iliana Cepero Amador
RC : Roberto Cobas Amate
OLN : Olga López Núñez
CM : Corina Matamoros Tuma
LM : Luz Merino Acosta
HM : Hortensia Montero Méndez
EO : Ernesto Oroza
LR : Liana Ríos Fitzsimmons
JR : Jeff L. Rosenheim
RDV : Rufino del Valle Valdés
EV : Elsa Vega Dopico

CDR—Comités de Defensa de la Revolución
[Committees for the Defence of the Revolution]

COR—Comisión de Orientación Revolucionaria
[Commission of Revolutionary Orientation]

DOR—Departamento de Orientación
Revolucionaria [Department of Revolutionary
Orientation]

ENA—Escuela National de Arte
[National Art School]

ICAIC—Instituto Cubano del Arte e Industria
Cinematográficos [Cuban Film Institute]

ICL—Instituto Cubano del Libro [Cuban Book
Institute]

ISA—Instituto Superior de Arte [Art Institute
of Graduate Studies]

OSPAAAL—Organización para la Solidaridad
con los Pueblos de Africa, Asia y América Latina
[Organization for Solidarity with the People of
Africa, Asia and Latin America]

UNEAC—Unión Nacional de Escritores y Artistas
de Cuba [National Union of Cuban Writers and
Artists]

Eduardo ABELA
San Antonio de los Baños, 1889 – Havana,
1965

EDUARDO ABELA, *In Glory* (José Martí and the
character *El Bobo*), 1932

Eduardo Abela began studying painting at
the Academy of San Alejandro in Havana in
1911. At the same time, he began contributing
drawings full of local flavour to Havana
newspapers and magazines. He lived in Spain
from 1921 to 1924, where several exhibitions
of his work were held. Back in Cuba, he
returned to drawing caricatures and in 1925
created the memorable character *El Bobo*
[The Fool], which he deployed against the
Machado dictatorship. In 1927 he joined the
magazine *Revista de Avance* and participated
in the *Exhibition of New Art*. His first major
contribution to modern Cuban art, however,
was the "Afro-Cuban" series he painted in
Paris in 1928. He returned to Cuba in 1929,
ceased painting and devoted himself to
El Bobo. With the fall of the Machado

dictatorship he stopped drawing caricatures
for good. He travelled to Milan as a diplomat
and saw first-hand the work of the early Italian
masters. This discovery, alongside a strong
Mexican influence, shaped his "classical" or
"Creole" period, during which he produced
Guajiros [Peasants], in 1938, one of the iconic
works of modern Cuban painting. Following
his wife's death in 1950, he painted *El caos*
[Chaos] and exhibited a number of barely
representational works in Guatemala, a
prelude to the last and longest phase of his
work. He returned to Paris for two years
and there experienced the true revelation of
modern art. He imitated the work of some of
the masters of modern painting, among whom
Paul Klee was a decisive influence in his return
to representational art, undertaken in a very
personal style. This, after his return to Cuba
in 1954, was the high point of his career. There
he began his final and perhaps most important
series, small-format works depicting birds,
children, imaginary characters, animals and
flowers in dream-like fantasy settings. — RC

José ABRAHAM
Havana, 1912 – Houston, 1997

José Abraham was born in Cuba in 1912. He
lived and worked in Havana most of his adult
life until emigrating to the United States in
the 1960s with his wife and son. He was an
amateur photographer and loved to direct
his large-format view camera at the diverse
architecture and lifestyle of his beloved city.
He passed on his collection of 4 x 5 negatives
to his son Joe after they lay dormant for nearly
twenty years in an old, flimsy Kodak box in
a dresser drawer. His collection consists of
hundreds of beautiful scenes of Havana from
the 1950s. He passed away in 1997. — JA

Julio LOPEZ BERESTEIN, *Galeria del Prado.* (reading from the right:
*José Gomez Sicre, Mario Carreño, Cundo Bermúdez, Alfredo Lozano, Amelia Peláez, Mestre, María Luisa
Gómez Mena, Roberto Diago, Eugenio Rodriguez, Acevedo, a sculptor, a gallery employee* (detail), 1944

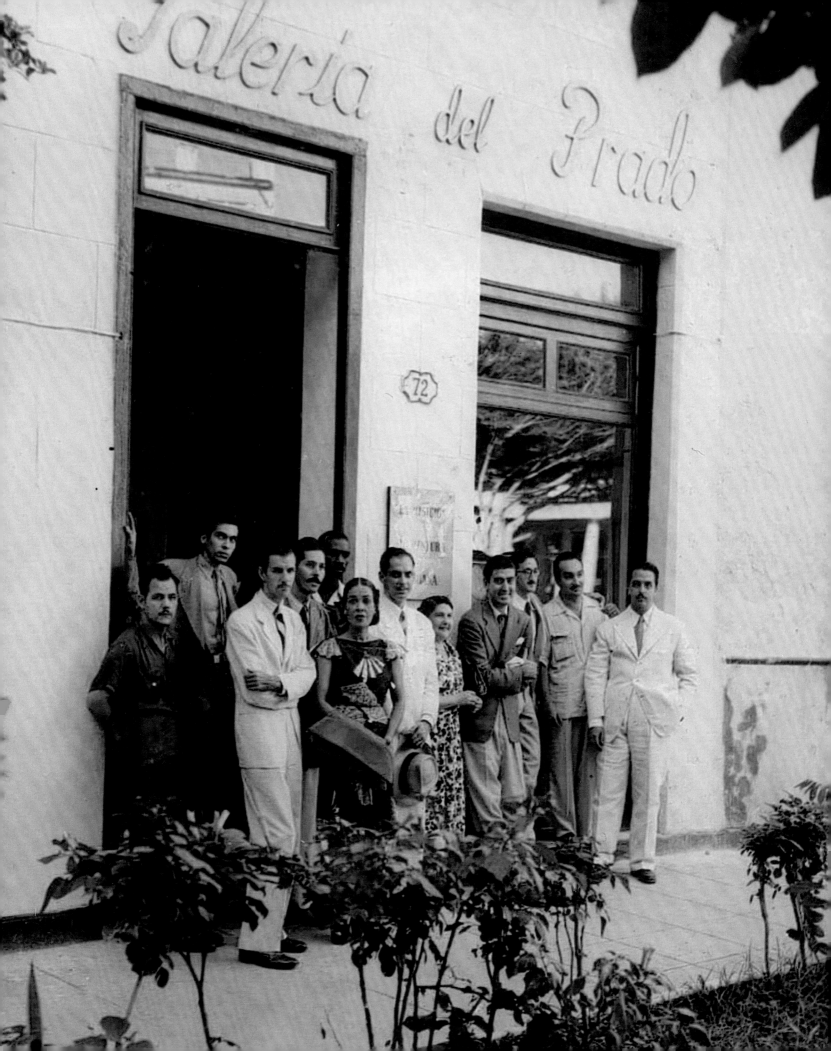

Ángel ACOSTA LEÓN
Havana, 1930 – Havana, 1964

Ángel Acosta León graduated from the Academy of San Alejandro in 1957. Two years later he arrived on the scene with the painting *Familia en la ventana* [Family in the Window], which marked his break with the academy and won a prize at the Salon of Painting and Sculpture. In 1960 he introduced the themes that would characterize his work—coffee makers, cane-liquor bars, wire-frame beds, toys, anvils—and in 1961 he began to work with events around the Cuban Revolution. In 1963 he travelled throughout Europe, exhibiting his work in major galleries in Paris, Amsterdam, Rotterdam and Brussels. He drowned at sea returning to Cuba. — LR

José (Pepe) AGRAZ
Havana, 1909 – Havana, 1982

José Agraz was a photojournalist specializing in sports reporting. He built a sequential camera, synchronizing the magnesium flash up to 1/500th of a second. He worked for the most important Cuban newspapers and magazines, and won more than twenty awards for his work, including the Juan Gualberto Gómez award, the Víctor Muñoz award, the Miami Press Photographer Association, the Inter American Press Association's Mergenthaler award and the second Fernando Chenard Piña National Photography Salon. His best-known pictures include the bombing of the freighter *La Coubre*, a race-car accident in 1958 (published in *Life* and *Paris Match*) and Fidel Castro's entry into Havana in 1959. — RDV

Alejandro AGUILERA
Born in Holguín in 1964

Alejandro Aguilera graduated from ISA in 1989 and is one of the sculptors who most contributed to the artistic changes that took place in Cuba in the 1980s. He began stud-ies in 1990 at the Massachusetts College of Art in Boston on a fellowship. Some of the solo exhibitions of his work include *A Brief History of Usage*, Bernice Steinbaum gallery, Miami, 2007; *Forty Yards of Lines,* Milledgeville College and State University, 2006; and *Objetos de uso* [Everyday Objects], Ramis Barquet gallery, Monterrey, Mexico, 2002. He also participated in the Castillo de la Fuerza

project in Havana in 1989. His work has been included in group exhibitions such as *Redefining Georgia: Perspectivas en arte con-temporáneo*, Columbus Museum, Columbus, Georgia, 2004; *Cuba Siglo XX. Modernidad y Sincretismo*, Centro Atlántico de Arte Moderno, Las Palmas, Canary Islands, 1996; *Kuba o.k.*, Kunsthalle Düsseldorf, 1990; and *Tradición y contemporaneidad* [Tradition and Contemporaneity], third Havana Biennial, 1989. Antonio Aguilera lives in Atlanta, Georgia. — IC

Osvaldo Pedro Pascual ALBURQUERQUE
Born in Havana in 1926

Osvaldo Pedro Pascual Alburquerque is a photographer and composer. He was known for his use of slow camera lenses. In the 1950s, he devoted himself to taking portraits of Cuban entertainment personalities. As a composer, his songs were popularized by major figures in popular music. He relocated to the United States in 1967. — RDV

Juan Carlos ALOM
Born in Havana in 1964

Juan Carlos Alom graduated from the International Press Institute in Havana, where he studied semiotics. In the early 1990s he emerged as one of the most important conceptual photographers in Cuba. Solo exhibitions of his work include *Juan Carlos Alom*, Metrònom – Fundació Rafael Tous d'Art Contemporani, Barcelona, 2006; *Evidencia*, Iturralde gallery, Los Angeles, 2001; and *El libro Oscuro, Imaginario de Juan Carlos Alom* [The Dark Book: Juan Carlos Alom's Imaginary World] as part of the event *El voluble rostro de la realidad* [The Fickle Face of Reality], Ludwig Foundation of Cuba / Fototeca de Cuba / Centro de Desarrollo de las Artes Visuales, Havana, 1996. His work has been shown in group exhibitions such as *Open Maps: Latin American Photography 1991–2002*, Amos Anderson Art Museum, Helsinki, 2005; *The Daros-Latinamerica Tapes*, Huis Marseille Museum for Photography, Amsterdam, 2004; and *Shifting Tides: Cuban Photography after the Revolution*, Los Angeles County Museum of Art, 2001. He has made videos and 16mm documentary films. — IC

Eufemia ÁLVAREZ
Born in Havana in 1943

Eufemia Álvarez is a painter, sculptor, draftsman and graphic and interior designer. She studied commercial drawing at Havana's School of Design and is known to have completed her studies in the United States. She has worked as a designer in the graphic propaganda section of DOR since 1979. Her drawings have also been included in numerous group exhibitions. In 1970 she won first prize in the second National Poster Salon with her emblematic poster *Revés* [Reversal] During her long career she has received many other important awards, including first prize in the fourteenth anniversary of the CDR Competition, 1974; third prize in the poster category of the twelfth 26th of July National Salon of Graphic Propaganda; and first prize in the National Transportation Salon in 1982. — EV

Pedro ÁLVAREZ
Havana, 1967 – Tempe, Arizona, 2004

A painter and draftsman, Pedro Álvarez studied at the Academy of San Alejandro and the Graduate Studies Teaching Institute in Havana. The first solo exhibition of his work was held at the Trinidad art gallery. Later important exhibitions of his work include *Desde el paisaje* [From Landscape], Havana, 1991; *La canción del amor* [The Love Song], Centro de Desarrollo de las Artes Visuales, Havana, 1995; *Pedro Álvarez. Pinturas* [Pedro Álvarez: Paintings], Universidad de Alicante, Spain, 1996; *Rojo y verde* [Red and Green], Madrid, 1998; and *African Abstract y otras pinturas románticas* [African Abstract and Other Romantic Paintings], Galería Habana, 2003.

His work was included in a number of group exhibitions, including *Kuba o.k.* at the Kunsthalle Düsseldorf, 1990; *New Art from Cuba*, Whitechapel Art Gallery, London, 1995; *Una de cada clase* [One of Each Kind], Havana, 1995; *Cuba: La Isla posible* [Cuba: The Possible Island], Centre de Cultura Contemporània, Barcelona, 1995; *Mundo Soñado. Joven Plástica Cubana* [A Dreamt World: Young Cuban Visual Artists], Madrid, 1996; and *Caribe insular. Exlusión, fragmentación y paraíso* [The Insular Caribbean: Exclusion, Fragmentation and Paradise], Museo Extremeño e Iberoamericano de Arte Contemporáneo (MEIAC), Badajoz, Spain, 1998. He died in an accident while visiting Tempe, Arizona, during an exhibition of his work there in 2004. — CM

Federico AMÉRIGO
Matanzas, 1840 – Valencia, Spain, 1912

Federico Amérigo travelled to Spain at a very young age to study painting. His work was shown in the 1867 Valencia exhibition and later, in 1873, he settled in Alicante, working as a portrait painter and stage designer. He returned to Cuba, where he designed the front curtain of the Teatro Tacón. He also drew for the magazine *El Fígaro* for several years. In 1900 he moved to Mexico, where he managed a ceramics manufacturer and decorated major theatres in Guanajuato and Chihuahua. — OLN

Jorge ARCHE
Santo Domingo, 1905 – Cádiz, Spain, 1956

Jorge Arche's formal training took place at two Havana academies: the Fundación Villate and the Academy of San Alejandro. In truth, he was practically self-taught, through his friendship and dealings with other artists. He was an informal pupil of Víctor Manuel García, whose influence can be seen in his early work. He was a close friend of Arístides Fernández, whose home served as a meeting place for artists to work, discuss their work and serve as each other's models. He became known in 1935, when he won a prize at the first Salon of Painting and Sculpture for *La carta* [The Letter]. In the second edition of the event, in 1938, his portrait *Mi mujer y yo* [My Wife and I] also won a prize. In 1937 he created a mural at the Santa Clara teachers college and had his first solo exhibition at the Havana Lyceum. That same year, he participated in the Free Studio for Painters and Sculptors. When Arche came on the scene, Cuban painting was already in a state of maturity. He became known for a body of work, made up almost exclusively of portraits in the early years, which was the product of a re-reading of the great classical tradition in a modern key, using simplified and elegant lines, discreet and synthetic compositions and deep, muted colours. Among his most evocative and poetic work of this period are *Retrato de Arístides Fernández* [Portrait of Arístides Fernández], 1933; *Autorretrato* [Self-portrait], about 1935; *Retrato de Mary* [Portrait of Mary], 1936; *Retrato de José Lezama Lima* [Portrait of José Lezama Lima], 1938; and another *Retrato de Mary* [Portrait of Mary] in 1938. Later, in the 1940s, his interest in classical painting led to a passion for the early Italian and Flemish masters. During this second period he painted *Primavera o Descanso* [Springtime or Rest], 1940; *Retrato de Don Fernando Ortiz* [Portrait of Fernando Ortiz], 1941; *Retrato de Jorge Mañach* [Portrait of Jorge Mañach], 1941; *Jugadores de dominó* [Domino Players], 1941; and *José Martí*, 1943. — RC

Lorenzo Romero ARCIAGA
Havana, 1905 – (?)

Lorenzo Romero Arciaga studied at the Academy of San Alejandro in Havana. He participated in the first *Exhibition of New Art* in 1927. With Rafael Suárez Solís, he organized the first National Salon of Painting and Sculpture in 1935. Three years later he coordinated the second National Salon of Painting and Sculpture at the Castillo de la Fuerza in Havana. He was one of the founders of the Free Studio for Painters and Sculptors in 1937. That same year he created a mural at the José Miguel Gómez municipal school in Havana. In the early 1950s he began teaching at the Visual Arts School in Camagüey, and in 1956 he organized the eighth National Salon of Painting and Sculpture at the Museo Nacional de Bellas Artes in Havana. — RC

Constantino ARIAS
Havana, 1920 – Havana, 1991

Constantino Arias was a self-taught photo-journalist. His work anticipated what became known in the 1950s as cinematic neo-realism. He created testimonial parallels between the Havana bourgeoisie and the dignity of university protests, and worked with a direct vision in both poor neighbourhoods and the sophisticated pre-revolutionary Cuban milieu of modelling and nightclubs. He began his career as a photographer with the Gráfica agency (1939–40) and later worked at the Hotel Nacional (1941–59); at different periods for the magazine *Bohemia* (1941, 1943, 1959–81); at the newspaper *La Calle* (1956); and at the University of Havana magazine *Alma Mater* (1952–59). He never knew that he was creating photographic history; he created realistic images without distorting or manipulating his subject. The flash was his faithful companion, as it was for the U.S. photographer Weegee. After his death his work was re-appraised and seen as the most complete body of photography in the history of Cuban photography, to the point that he is considered the Walker Evans of Cuba. Beginning in 1972, he won various awards in competitions sponsored by the Cuban Press Union (UPEC). His work has appeared in the most important Cuban and Latin American magazines, anthologies and catalogues. He took portraits of political, intellectual and artistic figures such as Fidel Castro, Ernest Hemingway, Winston Churchill, Chano Pozo, Wifredo Lam, Josephine Baker, Gary Cooper, Pedro Vargas, Pedro Almendaris, Alexander Fleming, Pedro Infante, Tennessee Williams, Alicia Alonso, Maurice Chevalier, Jorge Mistral, Bob Hope, Ava Gardner, Martine Carol, Debbie Reynolds, Édith Piaf, Christian Dior, María Félix, Ima Sumac, Cantinflas and Lola Flores. He also documented historical events such as Fidel Castro's entry into Havana in 1959 and student and worker demonstrations in the 1950s, among many others. — RDV

Estudio ARMAND
Armando HERNÁNDEZ LÓPEZ
Santa Clara, 1906 – Miami, 1992

Armand was the professional name of Armando Hernández López, who was known as the "photographer to the stars." He was popular from 1940 to 1960, taking glamorous portraits of Cuban entertainment personalities. In 1951 he was awarded the title "World's No. 1 Photographer" by the Saxony Hotel in Miami Beach. After the Cuban Revolution he relocated to the United States. — RDV

Belkis AYÓN
Havana, 1967 – Havana, 1999

Belkis Ayón graduated from ISA in 1991 and was one of the key figures in the resurgence of printmaking in Cuba in the 1990s. Her work centred on Abakuá mythology, a religion of African origin with deep historical roots in Cuba. Among the awards she received were two major prizes, at the Printmaking Conference at Casa de las Américas in Havana in 1993 and at the first International Printmaking Biennial in Maastricht, the Netherlands, that same year.

Among her principal solo exhibitions were *Siempre vuelvo* [I Always Return], Havana, 1993; *Belkis Ayón and Santiago Rodríguez Olazábal*, Italy, 1994; *Ángel Ramírez and Belkis Ayón: The New Wave of Cuban Art*, Tokyo, 1997; and *Disquiet*, Los Angeles,

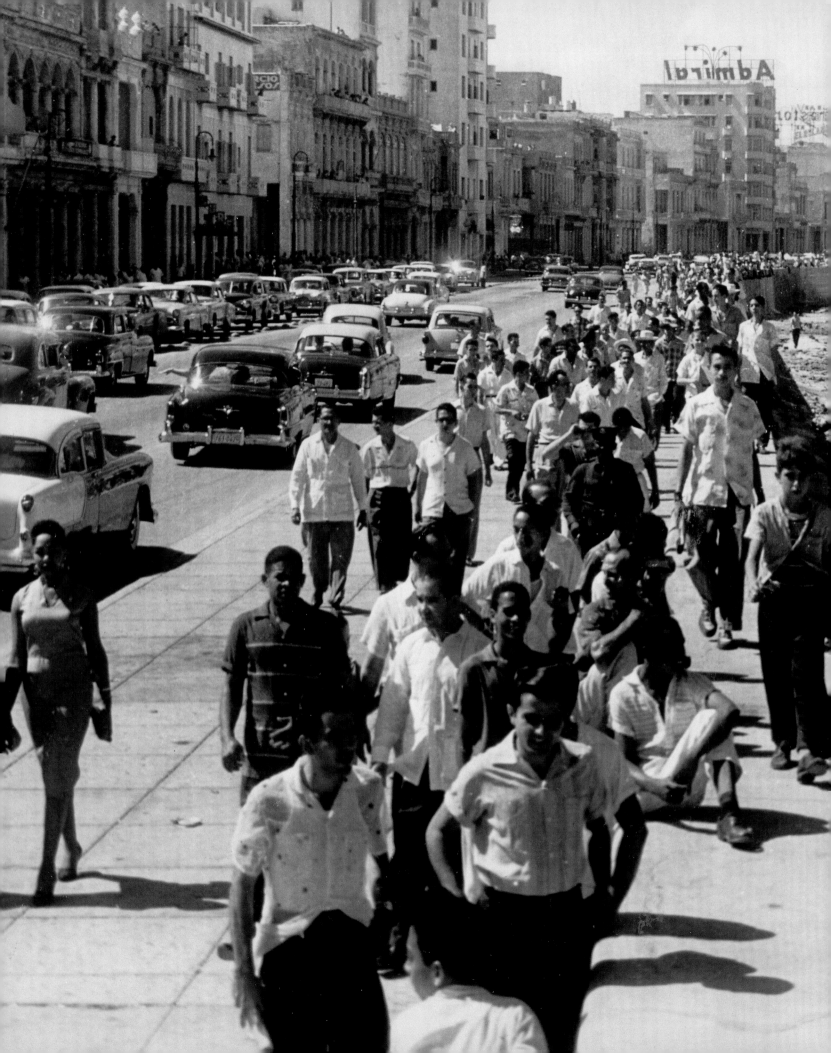

1998. In 2001 the Museo Nacional de Bellas Artes in Havana re-opened its facilities with a posthumous exhibition entitled *Imágenes desde el silencio. Colografías y matrices de Belkis Ayón* [Images from Silence: Collographs and Stencils by Belkis Ayón].

Belkis Ayón participated in numerous group exhibitions, including the fourth Havana Biennial in 1991; *The Cuban Round* at the Van Reekum Museum in Apeldoorn, the Netherlands, in 1992; the Instituto Italo-Latinoamericano at the 45th Venice Biennale in 1993; the Kwangju Biennial in South Korea in 1997; the Museo Nacional de Bellas Artes' travelling exhibition *Three Centuries of Cuban Prints*; and *Contemporary Cuban Artists* at the Museu de Arte Moderna in Rio de Janeiro in 1998. Belkis Ayón took her own life at her home in Havana in 1999. — CM

Juan AYÚS
Born in Havana in 1937

Juan Ayús obtained a degree in journalism from the University of Havana. In 1961–62 he was artistic director of the magazine *Mella*, a position he has also held at publications such as *Juventud Rebelde*, *El Caimán Barbudo*, *Moncada* and *Avanzada*. In the late 1980s he became artistic director of the newspaper *Granma*, where he was also responsible for implementing new printing technologies. He has taught in the social communications department of the University of Havana. Among his noteworthy achievements is his work as head of the Cuban Association of Propagandists and Advertisers. He has won numerous honours throughout his career. — EV

René AZCUY
Born in Havana in 1939

René Azcuy completed his studies at the Academy of San Alejandro in 1955, the same year that he graduated from the Graduate School of Arts and Trades in Havana. In the years leading up to the Revolution he worked in advertising. In 1964 he joined the team of artists at ICAIC, where he remained until 1983. He studied psychology at the University of Havana in 1971–72. His first solo exhibition, *Las manos de Azcuy* [Azcuy's Hands], was held in the Rubén Martínez Villena hall of UNEAC in 1977. Throughout his long career his work has been shown in more than fifty group

exhibitions. Numerous awards testify to the excellent quality of his graphic designs. Some of the most noteworthy of these include an award in the poster and print logo category at the Havana Cultural Congress, 1968; first prize (awarded collectively) at the second Festival du Film de Paris, 1976; first prize for best international poster in the *Hollywood Reporter* Annual Key Art Awards, 1982; and third prize in the second International Poster Biennial in Mexico in 1992. Azcuy has also devoted considerable time to teaching. He has served on the juries of various graphic design events. Major institutions in Cuba and abroad collect his work. In 1983 he was awarded the National Order of Culture by Cuba's Council of State. He has resided in Mexico City since 1992. — EV

B

José BEDIA
Born in Havana in 1959

José Bedia graduated from ISA in Havana in 1981. He was one of the most important figures in the resurgence of Cuban art in the early 1980s. He participated in *Volumen uno*, one of the high points of the period that became the name of a group of breakaway artists.

The first of Bedia's numerous solo exhibitions was held in 1980, with the series *Crónicas americanas* [Chronicles of the Americas] in Havana. More solo shows were held at the Museo Nacional de Bellas Artes between 1984 and 1989 with *Persistencia del uso* [Persistence of Use], *Tres visiones del héroe* [Three Visions of the Hero], *Viviendo al borde del río* [Living on the River's Edge] and *Final del Centauro* [The End of the Centaur]. He also participated in the first four editions of the Havana Biennial, where he won the award for installation in 1986 for *El golpe del tiempo* [The Blow of Time]. Major solo exhibitions of his work have been held in Mexico, including *Sueño circular* [Circular Dream], 1990; *Brevísima relación de la destrucción de las Indias* [A Brief Account of the Destruction of the Indies], 1992; *La Isla en peso* [Island Burden], 1993; and *Crónicas americanas* [Chronicles of the Americas], 1997. In the United States, where he has lived since 1993, solo exhibitions of his work have been held over the years at the Frumkin/Adams gallery in New York, inSITE 94 in

San Diego and the Fredric Snitzer gallery in Florida. His work has also shown at the San Diego Museum of Contemporary Art in 1994; at the Museum of Art, Fort Lauderdale, in 1995; at the Edwin Ulrich Museum of Art in Kansas in 1998; at the Joslyn Art Museum in Nebraska in 1998; and at the Samuel P. Harn Museum of Art at the University of Florida in 1999. International shows include the Pori Art Museum in Finland in 1996; more recently, the solo exhibition *Estremecimientos* [Tremors] travelled to Spain and went to the Museo Extremeño e Iberoamericano de Arte Contemporáneo (MEIAC), Badajoz, and to Domus Artium 2002 in Salamanca, and to the American Institute for Foreign Study in Granada in 2004.

Bedia has participated in some of the most important group exhibitions of contemporary art around the world in the past fifteen years and his work has had considerable influence in Cuba and throughout Latin America. — CM

Félix BELTRÁN
Born in Havana in 1938

Félix Beltrán is a painter, draftsman, printmaker and graphic designer. In the early 1950s he worked in advertising. He lived in New York from 1956 to 1962, where he studied at various institutions: the School of Visual Arts (graphic design); the New School for Social Research (drawing); the Pratt Graphic Art Center (lithography); the Art Students League (drawing); and the American Art School (painting). Upon his return to Cuba he taught graphic design at the Industrial Design School in Havana and worked for COR and DOR, where most of his activity as a graphic designer has been carried out. He is essentially interested in social interest posters and some noteworthy examples of his skilful use of both visual and typographical elements include *Clik. Ahorro de electricidad es ahorro de petróleo* [Click. Saving Electricity Saves Oil] and *Viva el XVII Aniversario del 26 de julio* [Long Live the Seventeenth Anniversary of the 26th of July]. In 1967 his first solo exhibition, *Símbolos* [Symbols], was held in the Rubén Martínez Villena hall of UNEAC. That same year he collaborated in the design of the Cuban pavilion at Expo '67 in Montreal. He relocated to Mexico City in 1982 and teaches at the Iberoamericana and Autónoma Metropolitana universities. He is also curator of the latter institution's inter-

José A. ENGUITA, *The Malecón in the summer, Havana* (detail), 1956

national print archive. In 1996 he worked as an adviser to the National Design School at Mexico's National Fine Arts Institute and to the Advanced Communications Centre, also in Mexico City. That same year he began working for the magazines *De diseño* (Mexico City) and *Step-by-Step Graphics* (Milwaukee). His work has been shown in a great many group exhibitions and has won many awards. He is the author of many articles and books on graphic design. — EV

Cundo BERMÚDEZ
Born in Havana in 1914

Cundo Bermúdez enrolled in the Academy of San Alejandro, but quit before completing his studies. He first exhibited his work in 1937 in various exhibitions in Havana at the Lyceum, the Emplyment Centre and Parque Albear. The following year his painting *Maternidad antillana* [West Indian Motherhood] was shown in the second National Salon of Painting and Sculpture at the Castillo de la Fuerza in Havana. That same year he travelled to Mexico, where he studied with Rodríguez Lozano. His contact with modern and popular Mexican art was a decisive factor in his artistic maturation. On his return to Cuba, steeped in modernity, he saw his surroundings in a new light and created daring work in which he combined the folklore of popular paintings of cheap restaurants and bars with the universal tradition of the early masters. His use of colour became increasingly intense and personal, with audacious combinations of opposites taken to the highest level of intensity. The first solo exhibition of his watercolours and gouaches was held at the Havana Lyceum in 1942. Two years later, his participation in the exhibition *Modern Cuban Painters* at the Museum of Modern Art in New York confirmed his position in the eyes of New York critics. Among the memorable works of this period are the paintings *El balcón* [The Balcony] (1941), *La barbería* [Barber Shop] (1942) and *Romeo y Julieta* [Romeo and Juliet] (1943). Cundo had attained his definitive style, to which would be added, beginning in the 1950s especially, variations of accent and form, mid-way between flatness and volume and representation and abstraction. An occasional landscape artist, a painter of still lifes and portraits of musicians and circus performers, his best work depicted scenes of typical Cuban life and domestic interiors, which he refined to the point of becoming mythical spaces. — RC

Rafael BLANCO
Havana, 1885 – Havana, 1955

Rafael Blanco studied at the Academy of San Alejandro in Havana. His first solo exhibition was held at the Ateneo in Havana in 1912. He created an interesting body of paintings, but is best known for his illustrations and caricatures and, above all, for his incisive satirical cartoons with their local flavour. He called these forerunners to the Cuban avant-garde "whimsies." He exhibited his work regularly in the Fine Arts Salon from its first edition in 1916. In 1917 he was awarded the first, second and third prizes for illustration by the Havana magazine *La Ilustración*. In 1921, alongside another outstanding caricaturist, Conrado Massaguer, he founded the Humour and Satire Salon in Havana. Along with other young artists, he participated in the 1927 *Exhibition of New Art*. In its first and second issues in March 1927, the magazine *Revista de Avance* published a long essay by Martí Casanovas, one of its editors, on the importance of Blanco's work and its relation to the new sensibility taking hold among Cuban artists. In 1930 Blanco received the gold medal award at the Exposición Iberoamericana in Seville. His *Colección Satírica* [Satirical Collection] was exhibited at the Havana Lyceum. After not exhibiting his work for several years, a solo show was held at the Círculo de Bellas Artes in Havana in 1941. In 1950 he was named honorary president of the Cuban Caricaturist Association. Blanco's caricatures, illustrations and drawings are found in the most important Cuban periodicals of his time, including *Bohemia*, *Carteles*, *Diario de la Marina*, *El Fígaro*, *Revista de Avance*, *Social* and the U.S. magazine *Life*. — RC

Joaquín BLEZ
Santiago de Cuba, 1886 – Havana, 1974

Joaquín Blez was a photographer specializing in studio portraits. In 1900 he began working as an apprentice to Antonio Desquirón. In 1901 he documented the earthquake in Montego Bay, Jamaica, and upon his return to Cuba published his only news photographs. He set up a photographic studio at the Chaparra sugar mill in 1906 and in 1915 moved to Havana, where he opened a photographic studio considered the best equipped in the city. He broadened his knowledge of photography and its techniques at Rodolfo Namias's school in Milan, where he graduated in 1922, and later in Berlin. He published numerous studio portraits in the Cuban periodicals *El Hogar*, *Carteles*, *Capitolio*, *Social*, *Graphos* and *Diario de la Marina*. In 1925 he patented an invention to obtain positive images on glass plates or celluloid film using metallic reflections. He created artistic novelties on oven-fired porcelain and in ivory miniatures. He became well known and called himself "photographer to high-society" and "the magician of sodium thiosulphate." He took nude portraits, which he printed in gold, platinum and other monochromes. In 1927 he was invited to participate in the London Photographic Exhibition with his photo-essay "Cuban Society Beauties." He studied makeup and lighting techniques in Hollywood. In 1939 he joined the Cuban Photography Club. He won several prizes in competitions and was a jury member for numerous events. He worked on more complex compositions, reminiscent of an art nouveau style, and created "glamour" portraits influenced by Hollywood, introducing a psychological aspect to his work with great success at the International Exposition in New York in 1948. His late-1940s portraits were a part of the "New Glamour" movement, in which more attention was paid to the body than to the face. His work reflects the evolution of the bourgeois portrait genre within Cuban high society. — RDV

Juana BORRERO
Havana, 1877 – Key West, Florida, 1896

Although she died as a teenager, Juana Borrero occupies a privileged position in Cuban art as a creative genius working in lyric poetry. Borrero was one of the most important figures in Cuban modernism and her surviving work inspires admiration even today. Her poems appeared in the newspaper *El Fígaro* and she published two volumes of poetry, *Grupo de Familia* and *Rimas*, both in 1895, the latter with a preface by Aniceto Valdivia. She lived her life in a family setting, and various members of her family were authors of poetry. At the age of nine she began attending the Academy of San Alejandro, where she studied with Herrera Montalbán. Later, she was a pupil of Armando Menocal. When the Cuban War of Independence broke out her family was forced

to move to Key West, Florida, for political reasons, where she died a few months later, barely nineteen years of age. Of her surviving canvases, *Los Pilluelos* [Urchins], painted in Key West shortly before her death, is an example of her remarkable execution and charm. — OLN

Ricardo BREY
Born in Havana in 1955

Ricardo Brey studied at the Academy of San Alejandro and ENA. He graced the Cuban art world of the 1980s with one of the most refined and intelligently poetic bodies of work dealing with the historical and cultural appreciation of science. Some of the solo exhibitions of his work include: *Universe*, S.M.A.K., Ghent, Belgium, 2006; *Ricardo Brey*, GEM, Museum of Contemporary Art, The Hague, 2005; *Ricardo Brey*, VanRam gallery, Ghent, 2003; *Ricardo Brey, New Links*, Tanit gallery, Munich, 2001; and *Ricardo Brey: Installation and Drawings*, Kunstverein Schwerte, Germany, 1998. His work has also been included in group exhibitions such as: *How Life Really Is*, Museum Dr. Guislain, Ghent, 2003; *Nature, Art and Wonder*, Museo Civico di Storia Naturale, Verona, 2001; and *Holding Back*, Venice Biennale, 1999. He has won the Cera award, Belgium, 2004, the Flemish Culture Award of the Belgian Ministry of Culture and a Guggenheim Fellowship, the latter two in 1997. He resides in Ghent, Belgium. — IC

Tania BRUGUERA
Born in Havana in 1968

Tania Bruguera works solely in performance art, video and process art. Her early work was inspired by the work of the Cuban-American artist Ana Mendieta. She studied at the Academy of San Alejandro in Havana, graduating in 1987, and later at ISA in Havana, graduating in 1992. In 2000 she obtained an M.F.A., specializing in performance, at the School of the Art Institute of Chicago.

Among her most important exhibitions and performances are *Dédalo o el imperio de la salvación* [Daedalus or the Empire of Salvation], Museo Nacional de Bellas Artes, Havana, 1993; *Lo que me corresponde* [What Goes with Me], twenty-third São Paulo Biennial, 1996; *El peso de la culpa* [The Burden of Guilt], artist's workshop, Havana, 1997;

and the untitled performance presented at Fortaleza de San Carlos de la Cabaña during the seventh Havana Biennial in 2000.

Bruguera was awarded a Guggenheim Fellowship in 1998. Her work was exhibited at the forty-ninth and fifty-first editions of the Venice Biennale in 2001 and 2005, at documenta 11 in Kassel in 2002 and at the eighth Istanbul Biennial in 2003. She teaches at the School of the Art Institute of Chicago and in the performance program she founded at ISA in Havana. — CM

C

Servando CABRERA MORENO
Havana, 1923 – Havana, 1981

Servando Cabrera Moreno graduated from the Academy of San Alejandro in 1942. His first solo exhibition was held at the Havana Lyceum in September 1943. Three years later he took a course at the Art Students League in New York and in 1949 studied at the Grande Chaumière in Paris. His first break with tradition occurred in his oil paintings of 1950–51, in which geometric shapes similar to Cubism led him to approach abstraction about 1954. His rejection of the mechanisms of the art market in his successful exhibition at the La Roue gallery in Paris that same year provoked a sudden change in his painting. In Spain he created a series of realistic charcoal sketches of ordinary people, work he continued in Cuba until 1955, culminating in the oil painting *Los carboneros del Mégano* [The Mégano Coal Workers]. In the wake of the Revolution Cabrera Moreno introduced themes from recent Cuban history into his paintings; by 1961 his style had fully adapted to the new reality. Late that year he presented his epic work at the Palacio de Bellas Artes in Havana, which was followed by an exhibition of the series "héroes, jinetes y parejas" [heroes, horsemen and couples] at the Galería Habana in 1964. He entered an expressionist period in 1965, which gave way about 1970 to a large series of erotic paintings. He received the silver medal at the International Joan Miró Drawing Contest in Barcelona in 1969. — LR

Panchito CANO

Panchito Cano was a photojournalist whose real name was Francisco Cano Cleto. He worked with the journalist Marta Rojas at the magazine *Bohemia*. His most famous images are those of the attack on the Moncada barracks in 1953, which traumatized him for years. He moved to the United States after 1959, where he died soon afterwards. — RDV

LOS CARPINTEROS
Active in Havana since 1991

Alexandre ARRECHEA
Born in Las Villas in 1970
and
Marco CASTILLO
Born in Camagüey in 1971
and
Dagoberto RODRÍGUEZ
Born in Villa Clara in 1969

For more than a decade, beginning in the early 1990s, Los Carpinteros was a trio of Cuban artists working in sculpture and drawing. Today the group has two members, Marco Castillo and Dagoberto Rodríguez, whose work is found in major collections and is shown in important exhibitions around the world. They graduated from ISA in Havana in 1994 and 1995 and, in addition to their large body of drawings, work with fine hardwoods. Their memorable arrival on the scene in Havana dates from the 1992 exhibition *Easel Paintings*.

Los Carpinteros has had numerous important exhibitions of its work, including *Ingeniería civil* [Civil Engineering] at Galería Habana, 1995; *Todo ha sido reducido a la mitad del original* [Everything Has Been Reduced to Half the Original], Havana, 1996; *Construimos el puente para que cruce la gente, contruimos para que el sol no llegue* [We're Building the Bridge so People Can Cross, We're Building so that the Sun Won't Come], Ángel Romero gallery, Madrid, 1997; and *Mecánica popular* [Popular Mechanics], Galería Habana, 1998.

In November 2000, for the seventh Havana Biennial, they created their famous *Ciudad transportable* [Transportable City], a work which has become an icon of contemporaneity. An exhibition of the same name was held at the Los Angeles County Museum of Art and at P.S.1 in New York in 2001. In 2003, the Museo Nacional de Bellas Artes orga-

nized the exhibition *Fluido* [Fluid]. In 2005, a major retrospective of their work was held at the Museum of Contemporary Art at the University of South Florida in Tampa, which later travelled to other cities in the United States and Canada. Among their most recent exhibitions is *Downtown* in New York in 2004. — CM

Mario CARREÑO
Havana, 1913 – Santiago, Chile, 1999

Mario Carreño began his artistic career as an illustrator for periodicals. His first solo exhibition was held at a business office in Havana in 1930. He lived in Madrid from 1932 to 1935, returning to Cuba in 1935 and exhibiting his work at the Havana Lyceum. A year later, he travelled to Mexico. Meeting the Dominican painter Jaime Colson was decisive for the new direction his painting was taking. In 1938 he travelled to Paris, where he studied the great classical paintings at the Louvre and once again explored new ideas with Colson. With the outbreak of war in 1939 he left Paris for Spain's Costa Azul and Florence and Naples in Italy. His neo-classicism was becoming richer, a process that was visible in his style. In 1940 he travelled to New York and the following year returned to Cuba, where he exhibited paintings done in Paris, New York and Havana at the Lyceum. This return to Cuba after a prolonged absence abroad was a chance to rediscover his native country. In 1943 he returned to painting with lacquer, leading him to contact the Mexican painter David Alfaro Siqueiros, whose influence is visible in some of Carreño's most monumental work. With his wife María Luisa Gómez Mena he founded the Galería del Prado, devoted to promoting modern art in Cuba. He returned to the United States in 1944 and participated in important collective exhibitions at the San Francisco Institute of Art and the Museum of Modern Art in New York; a solo show was held at Perls Galleries in New York. He travelled to Chile for the first time in 1949, exhibiting drawings, gouaches and works in ink in Santiago. He published the album *Antillanas* [West Indian Women] there late that same year. He was a member of the advisory body to the National Institute of Culture. In 1957 a solo exhibition of his work was held at the Palacio de Bellas Artes in Havana. That year he moved to Chile, where he lived until his death, continuing to add to his important body of work. — RC

Manuel CASTELLANOS
Born in Sancti Spíritus in 1949

Manuel Castellanos graduated from ENA in 1970 and taught there until 1979. He is a member of the Experimental Graphics Studio and of UNEAC. His work has been included in important group exhibitions. His first solo exhibition was held in 1976 and two more, of his drawings and prints, were held in the Pequeño Salón of the Museo Nacional de Bellas Artes in Havana in 1977 and 1979. He has won many Cuban drawing and printmaking awards and an honourable mention at the Biennial of Illustrations in Bratislava, Czechoslovakia, in 1977. He currently resides in Helsinki. — HM

Esteban CHARTRAND
Limonar, Matanzas, 1840 – New York, 1883

Esteban Chartrand's French parents owned the Ariadna sugar mill in Guamacaro in the Limonar region, where Esteban was born. In 1854 the family travelled to Europe, visiting England, Germany, Switzerland and France. During this trip Chartrand may have taken lessons with the landscape artist Théodore Rousseau. Back in Cuba he painted the places he fondly remembered from his early childhood.

In 1866 he exhibited his work in the Floral Competition in Havana, where he received first prize for his landscape *La soledad* [Solitude]. The following year, at the Juegos Florales in Matanzas's Lyceum, his painting *Las lomas de San Miguel* [The Hills of San Miguel] won the Golden Flower award. In 1877, along with Miguel Melero and his son Miguel Ángel, he painted murals in the chapel of Nuestra Señora de Lourdes in the church Nuestra Señora de la Merced. In 1881 he exhibited several works in the Matanzas exhibition, among them a view of a coffee plantation.

When painting a landscape Chartrand painted from nature, in keeping with practices of the Barbizon School. He lyrically depicted the landscape in a Romantic idiom, choosing extreme moments of the day and showing a taste for cloudy skies evocative of nature's state of mind or forebodings. His colour scale lacked stridency and created poetic warmth. His health broken by a respiratory ailment, he moved to the United States, but continued to make frequent visits to Cuba. In New York he was represented by the Goupil gallery. He died of his illness, far from his homeland, on January 26, 1883. — OLN

Patricia CLARK
Resides and works in Phoenix, Arizona

Patricia Clark is a media artist working with video, digital imagery and experimental installation forms that explore cultural, political and economic relationships of the United States, Latin America and the Caribbean with a current emphasis on the island of Cuba. Clark's recent works include *Cada día en mis sueños* [Every Day in My Dreams], *Trabajo Voluntario* [Volunteer Work], *Los Trabajadores* [Workers] and *La Edad de Oro* [The Golden Age]. She teaches digital media arts at Arizona State University. — IC

Estudio COHNER
Samuel Alejandro COHNER
Washington, D.C., 1833 – Havana, 1869

Samuel Alejandro Cohner was a daguerreotype photographer and painter. He was a member of the photographic societies of London, Paris and Vienna. He opened a gallery in Havana in 1856 and introduced the "carte de visite" there. He was murdered by Spanish partisans in the Louvre café for wearing a blue tie (the colour of the Cuban independence movement). His business remained in operation until the early twentieth century. — RDV

Cooperativa Fotográfica
1933 – late 1960s

The commercial photographic agency Cooperativa Fotográfica was founded in 1933. It offered custom services ranging from photographs for newspapers and magazines and work for government, religious and cultural bodies, to marriages and other celebrations. Located at 156 Calle Industria in Havana, its founder and first director was Luis Rives. It ceased operations in the 1960s because of the Revolutionary Offensive campaign, in which all private business disappeared. — RDV

Walker EVANS, *Cinema entrance with movie poster for "A Farewell to Arms," Havana* (detail, left), 1933

Raúl CORRALES (Corral Varela)
Ciego de Ávila, 1925 – Havana, 2006

Raúl Corrales was a photojournalist whose real name was Raúl Corral Fornos. He worked at the Cuba Sono-Film agency. In 1946 he began working at the newspaper *Hoy*, where he remained until it closed in 1953. In 1957 he was put on contract by the Siboney advertising agency, working at the same time for the magazine *Carteles*. In 1959 he moved to the newspaper *Revolución*, this time working also as head of the photography department at the National Agrarian Reform Institute (INRA). When the magazine *INRA* was founded in 1960 he was named photography editor, an activity he continued at the magazine *Cuba*. In 1962 he stopped working for the press and was named head of the photography department of the Cuban Academy of Science and in 1964 divided his time for a few years between this work and the job of head of the microfilm and photography department of the Office of Historical Matters of the Council of State. His camera caught Fidel Castro's entrance to Havana, the Bay of Pigs invasion, the Missile Crisis, Hemingway's stay in Cuba, street demonstrations and the rural school program, among other events of the day. His work has been exhibited in major world museums and galleries. Among the awards he has received are the Casa de las Américas Contemporary Latin American and Caribbean Photography award in 1981; the Ministry of Culture's Special Prize for Photography as part of the Cuban Photography Awards in 1982; the Ministry of Culture's National Visual Arts Award in 1996; and the OLORUM lifetime achievement award from the Fondo Cubano de la Imagen Fotográfica in 1997. In 2005 he received an honorary doctorate from ISA in Havana. His images are an essential part of any Cuban or Latin American history or anthology of photography. — RDV

Arturo CUENCA
Born in Holguín in 1955

Arturo Cuenca became known in the late 1960s for his hyper-realist paintings, which presaged the conceptual enquiries that came to characterize his work. He has worked with a markedly experimental approach in painting, drawing and, especially, photography. He graduated from ISA in Havana in 1988. Cuenca's first solo exhibition was *Imagen*

[Image] in Havana in 1983. That same year the Museo Nacional de Bellas Artes mounted the solo exhibition *Espectador* [Spectator]. In 1986 his show *Reclined Man Thinks* was put on by Art Space in Rotterdam and in 1989 his work was exhibited once again in the Museo Nacional de Bellas Artes under the title *Ciencia e ideología* [Science and Ideology]. More recent solo exhibitions have included *Sharing Roots: Cuenca and Gory*, Museum of Art, Fort Lauderdale, 1995; *Arturo Cuenca: A Decade of Photographs 1983–1993*, INTAR, New York, 2003; and *Photographs: Arturo Cuenca and Eduardo Muñoz*, Sicardi gallery, Houston, Texas, 2003. He lives in New York. — CM

D

Sandu DARIE
Romania, 1906 – Havana, 1991

Sandu Darie left his native Romania for France, where he obtained a degree in law in 1932. He published humorous drawings in progressive Romanian newspapers and magazines such as *Adam* and *Cuvantul Liber*. He arrived in Cuba in 1941 and began painting and drawing the following year, becoming a Cuban citizen in 1945. His first solo exhibition, *Composiciones* [Compositions], 1949, was held at the Havana Lyceum. He entered into contact with Gyula Kosice, founder of the Argentine concrete art group Madi. An exhibition of his work entitled *Estructuras pictóricas* [Pictoric Structures], a foray into abstraction, was held in 1950. He worked in kinetic art with the series *Estructuras transformables* [Transformable Structures] in 1955–56 and his *Cosmorama* in 1966. In 1960 he became a member of the group Diez Pintores Concretos [Ten Concrete Painters]. He also created work for architectural and urban environments. — EV

E

Antonia EIRIZ
Havana, 1929 – Miami, 1995

Antonia Eiriz graduated from the Academy of San Alejandro in 1957, and in the 1950s maintained close relations with artists fluent in abstraction. Following her first

solo exhibition in 1957 she was invited to participate in the second Inter-American Biennial in Mexico in 1960 and in the sixth São Paulo Biennial in 1961, where her work received an honourable mention. From 1962 to 1969 she taught at the School for Art Teachers and ENA in Havana. In 1963 she won first prize in the Exhibition of Havana, organized by Casa de las Américas. The following year Galería Habana mounted the important exhibition *Pintura/Ensamblajes* [Paintings/Assemblages], a body of work of great quality and force, as was her show in the space dedicated to the "Artist of the Month" in the Museo Nacional de Bellas Artes in Havana. In 1966 she exhibited her work alongside that of Raúl Martínez in Casa del Lago at Mexico's Autonomous National University and a year later in the twenty-third Salon de Mai in Paris. She received the National Order of Culture in 1981 and two years later the Alejo Carpentier Medal. In 1985 the exhibition *Antonia Eiriz* was held in the Espacio Cultural Latinoamericano gallery in Paris and in 1989 she was awarded the Félix Varela Order by Cuba's Council of State, the country's highest distinction in the cultural field. In 1991 an exhibition of her work entitled *Reencuentro* [Re-encounter] was held at the Galiano gallery in Havana and in 1994 she obtained a Guggenheim Fellowship. After her death the Museum of Art in Fort Lauderdale organized the exhibition *Antonia Eiriz: Tribute to a Legend* in 1995. — LR

Juan Francisco ELSO
Havana, 1956 – Havana, 1988

Juan Francisco Elso is one of Cuba's most important sculptors. He studied at the Academy of San Alejandro and ENA in Havana, graduating from the latter in 1978. In 1981 he participated in the important exhibition *Volumen uno* at a time of great innovation in the visual arts.

His first solo exhibition, *Tierra, maíz, vida* [Earth, Corn, Life], was held in Havana in 1982, revealing his interest in indigenous culture and working in sculpture with materials such as earth, jute, unbaked clay, seeds and other organic elements. That same year he won the National Landscape Salon award in Havana.

His work *El monte* [The Forest], with its spiritual and methodical ties to Afro-Cuban tradition, was shown at the first Havana Biennial in 1984. In 1986 he began work on a project dealing with Latin American spiritual-

ism. This was to become the true nucleus and ultimate meaning of his body of work. His impressive piece *Por América* [For the Americas], which was awarded an honourable mention in the Havana Biennial that year, is evidence of this.

Also in 1986, his second solo exhibition, *Essay on the Americas*, was presented at the Venice Biennale. It was later shown in Mexico City, where he began work on the major project *La transparencia de Dios* [The Transparency of God], which was never completed. Afflicted by a serious and recurring illness, he returned to Havana, where he died in November 1988. — CM

Carlos ENRÍQUEZ
Zulueta, 1900 – Havana, 1957

Carlos Enríquez grew up in his native village, where his father was a doctor. He attended secondary school in Havana and in 1920 was sent to Philadelphia to study business. In 1924, at the completion of his studies, he took intermittent summer courses in painting in Pennsylvania, where he met the painter Alice Neel. The two married and returned to Cuba in 1925. In Havana he joined other young artists in the incipient struggle for a modern Cuban art. He contributed to the magazine *Revista de Avance* and his work was noticed in the *Exhibition of New Art*. From 1927 to 1930 he lived in New York, although he continued to contribute regularly to *Revista de Avance*. After a brief passage through Havana, where he exhibited scandalous drawings in Emilio Roig de Leuchsenring's law office, he travelled to Europe, where he lived until 1933, residing in France and Spain and making brief journeys to Italy and England. Solo exhibitions of his work were held in Oviedo (1930) and Madrid (1933). He returned to Cuba in early 1934 and prepared an exhibition of his European work at the Havana Lyceum. The show was closed the night it opened and was re-opened to the public in Roig's office. In 1935 he published *El criollismo y su interpretación plástica*, a "romancero guajiro" [book of peasant ballads], a term he used to define his new style of painting the following year. He lived from 1939 until his death in a simple house on the outskirts of Havana that he called the "Hurón Azul" [Blue Ferret]. He painted murals, among them *La invasión* [The Invasion], 1937, at the José Miguel Gómez municipal school, and illustrated numerous books. He wrote three novels: *Tilin*

García, *La vuelta de Chencho* and *La Feria de Guaicanama*. — RC

Walker EVANS
Saint Louis, Missouri, 1903 – New Haven, Connecticut, 1975

Walker Evans is the progenitor of the documentary tradition in American photography. From the late 1920s to the 1970s he recorded the daily lives of ordinary citizens in photographs that focus on the indigenous expressions of people found on small-town main streets, in roadside architecture, along the avenues of Old Havana and on the faces of subway passengers in New York. *American Photographs*, his 1938 publication and exhibition at the Museum of Modern Art, secured Evans's position as one of his generation's most important critics of the American scene.

Like many others, Evans found employment during the Great Depression in Franklin Delano Roosevelt's New Deal. He photographed primarily in the American south for the government's Resettlement (later called the Farm Security) Administration. In 1936 Evans took an official leave of absence to work with his friend, the poet and essayist James Agee, on a written and photographic portrait of the lives and personal effects of three tenant farm families in Alabama; *Let Us Now Praise Famous Men* (1941) soon became a landmark in the history of American literature and photography. After World War II, Evans worked as an editor at *Fortune* magazine and taught at Yale University. He made his last photographs in 1973–74 with an SX-70 Polaroid camera. — JR

F

Antonio Eligio FERNÁNDEZ (Tonel)
Born in Havana in 1958

Antonio Eligio Fernández obtained a degree in art history from the University of Havana in 1982 and has since engaged in art criticism, curating exhibitions and teaching in addition to his work as an artist. He began exhibiting in group exhibitions in 1973 and in 1982 joined the group Hexágono, which was devoted to carrying out interventions and performances in public places. His first solo exhibition, alongside Osmani Simanca, was *Drawings* in Havana. Another important exhibition was *Yo*

lo que quiero es ser feliz [What I Want Is to Be Happy] at the Museo Nacional de Bellas Artes in Havana in 1989. That same year his installation *País deseado* [Desired Country] was shown at the twelfth São Paulo Biennial and *Aquí se escucha una música del cuerpo* [Here the Body's Music is Heard] was exhibited at the fifth Havana Biennial. Among his most important exhibitions are *Cuatro obras: las partes que más me sudan* [Four Works: The Parts that Make Me Sweat the Most], Havana, 1995, and *Lessons of Solitude*, Vancouver 2000 and New York 2001. Solo exhibitions of his work have also been held in Germany, Peru, England, Canada, the United States and the Netherlands. Tonel is currently an adjunct professor at the University of British Columbia in Vancouver. — CM

Arístides FERNÁNDEZ
Güines, 1904 – Havana, 1934

Evidence of Arístides Fernández's early calling for painting can be found in the archives of the Academy of San Alejandro. His time at the school, however, served only to lead him to reject its out-of-date practices and to join up with a group of young artists combating academicism, which included Víctor Manuel Garcia, Domingo Ravenet, Lorenzo Romero Arciaga, Jorge Arche and others. He met with them in salons or worked with them during informal sessions in his own home. This was his real education, anarchic and inadequate but carried out in an atmosphere of creative freedom, without preconceptions and fed by a passion for modern expression in Cuba. In this environment Arístides Fernández created his intimately connected paintings and writings, for which he is seen today as a true precursor. The basic concerns of his paintings—rural subjects, peasants, social topics—situate him within the "new art" movement. His *guajiro* peasants, intent in their dramatic struggles with a wretched and denuded nature, marked the inauguration of a new way of looking. His scenes of street protests, painted during the final days of the revolt against the Machado dictatorship, avoid demagogy. As important as his small number of oil paintings are his works on paper, where in latent form can be seen the mural, which also obsessed him but which he never had an opportunity to create. His sparse output was cut short by a premature death and was not sufficiently appreciated by his contemporaries. His work was

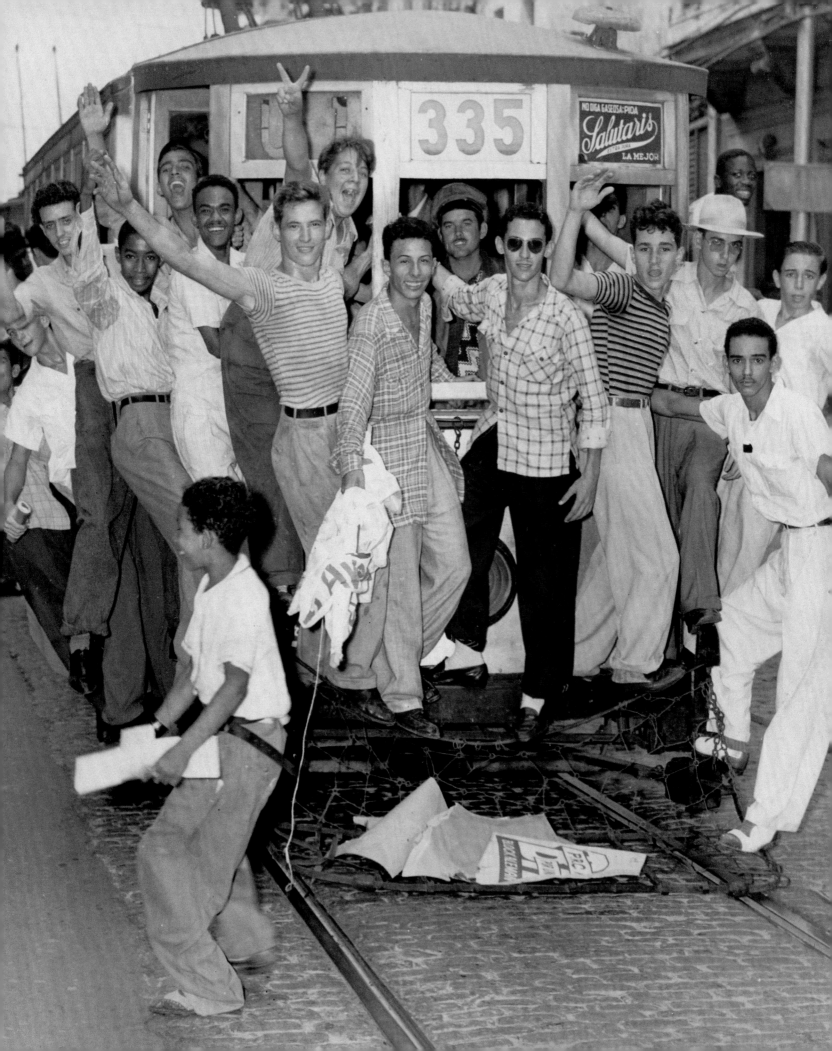

not included in the early individual or group exhibitions of Cuban "new art." His first solo exhibition was held at the Havana Lyceum soon after his death. The re-evaluation of his work began at the same time, finding its most enthusiastic exegete in José Lezama Lima, whose first published essay, in 1935, was on this singular personality. — RC

Ernesto FERNÁNDEZ NOGUERAS
Born in Havana in 1939

Ernesto Fernández Nogueras is a photojournalist, draftsman and publisher. He began working in photography in 1955 with the magazine *Carteles*. In 1958 he joined the newspaper *Revolución* while it was still being published clandestinely. He worked for the magazines *Mella* and, after 1960, *Cuba Internacional* and for the press agency Prensa Latina. He was a war correspondent during the country's first mobilization against foreign attack in 1960, the Bay of Pigs invasion a year later, the Missile Crisis and the campaign to wipe out banditry in the Escambray mountains, as well as in Angola and Nicaragua. Various solo exhibitions of his work have been held in Cuba and abroad. He published the book *Unos que otros*, a photo-essay on construction workers, in 1978. His work has also appeared in *Cuba: fotografía de los 60* in 1988; and *Cuba: 100 años de fotografía* in 1998. He has won numerous national and foreign awards, including third prize from the International Press Organization of the former Soviet bloc in 1961 and the OLORUM prize, awarded by the Fondo Iberoamericano de Fotografía during the third Conference for Culture and Development in Latin America and the Caribbean in Havana in 2005. He is currently preparing several books, including one on war photography, and works with his son in digital advertising photography. — RDV

José Alberto FIGUEROA
Born in Havana in 1946

José Alberto Figueroa began his career in 1964 as an assistant at the Korda studio. He has worked as a photojournalist with the magazine *Cuba Internacional* and as a camera operator for Cinematografía Educativa. He has won nine awards in national competitions. His photographs have been exhibited in more than eighteen countries and are part of the permanent collections of major institutions.

He is the author of the book *Señor retrátame*. — RDV

Jesús FORJANS
Born in Havana in 1928

Jesús Forjans is a self-taught graphic designer who began his career at the Siboney advertising agency. Between 1961 and 1973 he worked at COR, where he designed political posters on topics dealing with important events in Cuban history. Among his most noteworthy work are the posters he designed during the 1962 Missile Crisis. His posters are also among the most representative of the style practised at OSPAAAL. — EV

José Manuel FORS
Born in Havana in 1956

José Manuel Fors is a photographer and painter. He graduated from the Academy of San Alejandro in 1976 and has worked at the Museo Nacional de Bellas Artes in Havana. His work has been shown in various solo and group exhibitions in Cuba and abroad. He is a past recipient of a residency grant from the Banff Centre in Alberta and won the gold medal at the forty-ninth International Photographic Salon of Japan in 1989. Some of the other awards for his work include, in Cuba, an honourable mention at the first National Salon of Ecological Art in 1996, a National Culture Distinction award in 1999 and the Alejo Carpentier Medal in 2002. He has served on the jury of major Cuban art exhibitions. — RDV

Gilberto FRÓMETA
Born in Havana in 1946

Gilberto Frómeta studied commercial drawing at the Continental School in California. He graduated from ENA in 1967 and ISA in 1984. He worked as a graphic designer for the magazine *Cuba Internacional* and was director of the National Drawing School until 1989. He won an international award at the Espacio Latinoamericano in Paris and the Francisco Javier Báez award at the first Havana Biennial in 1984, in addition to a print award at the Venezuelan Small Format Print Biennial organized by the Associated Graphic Artists Studio (TAGA) in Caracas in 1990. Numerous solo exhibitions of his work have been held in

Cuba and abroad, including *Pinturas 1984–1986* [Paintings 1984–1986] at the Museo Nacional de Bellas Artes in Havana in 1986. He has served on the jury of various events and taught in Cuba and abroad. He is a member of UNEAC and UNESCO's International Association of Visual Artists. — HM

G

Carlos GARAICOA
Born in Havana in 1967

Carlos Garaicoa came on the Havana scene in the 1990s. He studied at ISA in Havana after attending a technical school. His first solo exhibition, *Childhood Days*, was held in 1989, but it was when he and the sculptor Esterio Segura curated the exhibition *metáforas del templo* [Metaphors of the Temple] in 1993 that he became a full-fledged member of the Cuban art world.

Garaicoa works in photography, drawing, the print, video and public interventions and performances. Some of his most significant solo exhibitions include *El sueño de la razón* [The Dream of Reason] at the Centro Wifredo Lam, Havana, 1994; *El voluble rostro de la realidad* [The Fickle Face of Reality] at the Centro de Desarrollo de las Artes Visuales and the Ludwig Foundation of Cuba in 1996; and *Carlos Garaicoa: The Ruins, the Utopia* in Bogotá, New York and Caracas in 2000. An important project was *The Intimate Mark of Memories*, carried out in Africa with the artists Fernando Alvin of Angola and Gavin Younge of South Africa. His work has been widely seen in group exhibitions, including the fourth and fifth editions of the Havana Biennial in 1994 and 1996; *Más allá del documento* [Beyond the Document] at the Museo Nacional Centro de Arte Reina Sofia, Madrid, 2000; and at documenta 11, Kassel, Germany in 2002. In 2003 he created the magnificent installation *Letter to the Censors* in Rome and Florida. In 2005 he won the Fondation Prince Pierre de Monaco award. His most recent solo exhibition was *Capablanca's Real Passion* at the Museum of Contemporary Art in Los Angeles. — CM

EDDO, *Students rioting over the killing of the student Carlos Martinez* (detail), 1947

Víctor Manuel GARCÍA
Havana, 1897 – Havana, 1969

Víctor Manuel García studied at the Academy of San Alejandro with Leopoldo Romañach. His first solo exhibition was held in 1924 at Las Galerías in Havana. He travelled to Europe for the first time in 1925 and in Paris began to sign his work Víctor Manuel. There he was introduced to and studied classical painting, especially the early Italian masters, and made contact with modern painting, beginning with the post-Impressionists. He began to transform his style, gradually abandoning his academic training. He returned to Cuba in 1927, the year of two major exhibitions: a solo show in February and the *Exhibition of New Art* in May, which marked the birth of modern painting in Cuba. From that point on he was seen as a major voice in Cuban art, not only because of his paintings but also for his work teaching younger artists. In 1929 he returned to Europe, travelling through Spain and Belgium before settling in France. In Paris he painted *Gitana tropical* [Tropical Gypsy], which has become emblematic of his work. By the time he returned to Cuba he possessed a personal and unmistakable style, expressed through two themes he would never abandon: women's heads and Cuban landscapes. He won awards in the 1935 and 1938 editions of the National Salon of Painting and Sculpture. In 1959 the annual Salon paid him homage with a retrospective of his work. In 1964 he began to exhibit work in a new medium, lithography, which he created at the Experimental Graphics Studio of the Plaza de la Cátedral in Havana. — RC

Andrés GARCÍA BENÍTEZ
Holguín, 1916 – Holguín, 1981

Andrés García Benítez was a draftsman, set painter for the theatre, graphic designer and cover artist for the magazine *Carteles*. He is better known for his fashion design work and theatre productions. Andrés, as he sometimes signed his work, filled an entire era of graphic and stage design with a singular style characterized by its force and dynamism. — LM

Mario GARCÍA JOYA
Born in Santa María del Rosario in 1938

Mario García Joya is a photographer and cinematographer. He studied philology at the University of Havana. He worked at *Revolución*, began working at ICAIC in 1961, and in 1963 worked as a photojournalist with the magazines *Bohemia* and *Cuba*. His work has been exhibited in various countries throughout Europe and the Americas. He was director of photography on more than sixty films, including several award-winning films such as *Los sobrevivientes* [The Survivors], 1978, and *Fresa y chocolate* [Strawberry and Chocolate], 1993. His work can be found in the collections of some of the most important galleries and museums in the world. He emigrated from the country in 1992. — RDV

Armando GARCÍA MENOCAL
Havana, 1863 – Havana, 1942

Armando García Menocal was a member of a prominent Cuban family. He enrolled in the Academy of San Alejandro in 1876 and went to complete his studies at the School of San Fernando in Madrid, where he became associated with such well-known painters of the day as Francisco Jover and Francisco Domingo Marquéz. He won awards in Madrid and became friends with noteworthy artists such as Joaquín Sorolla. Upon his return to Cuba he became the preferred painter of Havana society. His portraits were sought after by distinguished families and collectors. When the battle for independence broke out, he enrolled in the rebel forces, and with the conclusion of hostilities he joined the faculty of San Alejandro in 1891. There he distinguished himself teaching several generations of artists for more than fifty years. He has the distinction of being the first to engage in *Cambio de Siglo* or turn-of-the-century painting in Cuba and also one of the first in the Spanish colonies. His nineteenth-century portraits belong to both currents. His landscapes, the other genre in which he distinguished himself, have a luminosity and freshness little seen in Cuban painting. — EC

Augusto GARCÍA MENOCAL
Havana, 1899 – Havana, 1974

Augusto García Menocal studied at the University of Havana's school of architecture and at the Academy of San Alejandro. The latter institution awarded him a travel grant to complete his studies in Europe. He travelled throughout the continent, but spent most of his time in Italy and Spain, where he contacted well-known artists of the day and studied the great masters of world art. Upon his return to Cuba he taught at various institutions, including the Enrique José Varona School of Industrial Technology and the School of Arts and Trades, in addition to the University of Havana's school of architecture and San Alejandro. He was an adviser to the renovation of the Museo Nacional from 1933 to 1952. He received various awards and decorations for his work as a teacher and artist. His most noteworthy work took on historical themes, especially with respect to Cuba. — EC

Flavio GARCIANDÍA
Born in Caibarién in 1954

Flavio Garciandía graduated from ENA in 1973 and from ISA in 1981. He taught at the latter institution from 1980 until 1990. He was artist in residence at Old Westbury College in New York in 1985 and visiting professor at the Helsinki Academy of Fine Arts in 1988 and received fellowships from the Académie des Beaux-Arts, Paris, in 1989, from the Gesamthoschule in Kassel, Germany, in 1990 and 1993, and from the John Simon Guggenheim Memorial Foundation in the United States in 1993. His work has been shown in the Havana, Sydney, Paris, Venice and São Paulo biennials and in other major contemporary art exhibitions. Numerous solo exhibitions of his work have been held in Cuba and abroad, including on three occasions at Havana's Museo Nacional de Bellas Artes, in 1989, 1995 and 2006. In 2007 he received the National Curating Award from the National Visual Arts Council. He won the award for painting at the Košice Biennial in Czechoslovakia and the drawing award at the fourth Inter-American Graphic Arts Biennial in Cali, Colombia. He resides in Mexico. — HM

Antonio GATTORNO
Havana, 1904 – Acushnet, Massachusetts, 1980

Antonio Gattorno studied painting at the Academy of San Alejandro. In 1921 he won a competition held by the academy for a painting scholarship in Europe. In Italy, he copied the work of the early Italian masters, establishing his style, which began to break with the academy. In Spain he visited Madrid, Toledo and Ávila and stayed in Galicia for a time to paint. He finally arrived in Paris where, impressed by the work of modern painters such as Rivera, Gris, Modigliani and Picasso, and moved by Puvis de Chavannes, he burned all of his existing paintings. In France his peculiar modernity, rooted in the great tradition of classical painting, ceased to conform. He returned to Havana in 1926 and joined the movement to renew Cuban culture. He contributed to the magazine *Revista de Avance* and held a major solo exhibition at Havana's Association of Painters and Sculptors, presented by Alejo Carpentier. Here he introduced his studies of typical Cubans. A solo exhibition of his work was held at the Passedoit gallery in New York. In 1935 Ernest Hemingway's article about Gattorno was published in Havana. A painting depicting scenes of rural Cuban life decorated a room in Bacardí's offices in the Empire State Building in New York. At about this time, he moved to New York permanently. Sporadic exhibitions in Havana brought him to the city from time to time, while exhibiting his work in New York regularly throughout the 1940s at the Passedoit (1944, 1946) and Marquié (1945, 1946) galleries. According to Gattorno, the 1944 Passedoit exhibition marked his painting's return to his Italian years, with the influence of the fifteenth-century masters now marked by a surrealist presence and by themes from dramatic events of the day: the war in Europe. — RC

Federico GIBERT GARCÍA
Matanzas – Havana, 1953

Federico Gibert García studied at Frankfurt's Graphic Arts Institute and was an assistant photographer at the newspaper *Philadelphia Press*. In Cuba he was in charge of the photography and photogravure departments of the newspaper *La Discusión* for twenty-two years, where he also created photographic panoramas. Later he was in charge of the photography department of *El País* for fourteen years. He was the first president of the Cuban Association of Photojournalists. — RDV

José GÓMEZ DE LA CARRERA
Spain (?) – Havana, 1908

José Gómez de la Carrera was a photojournalist who settled in Havana in 1885. He worked for *La Caricatura*, *La Lucha*, *El Figaro*, *La Discusión* and various foreign publications. He introduced snapshot photography to Cuba and was the most active war correspondent during the Cuban War of Independence. Since he was a U.S. citizen, he could visit and document both the Cuban and Spanish camps. He was the official photographer of the U.S. commission investigating the sinking of the battleship *USS Maine*. In 1902 he left the magazine *El Figaro* and worked out of his home. His photographic archive was donated by his widow to the Biblioteca Nacional. — RDV

José GÓMEZ FRESQUET (Frémez)
Havana, 1939 – Havana, 2007

José Gómez Fresquet was a self-taught printmaker whose active career in national and foreign publications and for certain institutions began in 1959. He exhibited his first silkscreens, marked by a strong experimental quality, in 1968, for which he won an award at the Exhibition of Havana organized by Casa de las Américas in 1969. An exhibition of his work entitled *Impresos de Frémez* [Prints by Frémez] was held at Galería Habana in 1976. In 2005 he was awarded the National Visual Arts Award and the following year, prompted by this award, the exhibition *Frémez, alto contraste* [Frémez, High Contrast] was held. — LR

Alfredo GÓNZALEZ ROSTGAARD
Guantánamo, 1943 – Havana, 2004

Alfredo Gónzalez Rostgaard was a painter, draftsman and graphic designer. He studied at the José Joaquín Tejada Provincial Visual Arts School in Santiago. In 1963 he began work as a caricaturist for the magazine *Mella*, published by the Unión de Jóvenes Comunistas (UJC). Two years later, his first solo exhibition, alongside Armando Morales, was held at the Biblioteca Nacional José Martí. Between 1969 and 1977 he worked as artistic director and illustrator for the magazine *Tricontinental*, published by OSPAAAL. From about 1988 to 1993 he taught at the Industrial Design Institute in Havana. In 1993 he became a member of the Comité Pro-gráfica Cubana and taught design in Xalapa, Mexico, until 1995. His work has been included in more than fifty group exhibitions. His vast experience as a graphic designer led him to serve on juries at many design events. He won innumerable awards during his long and prolific career, including a prize at the National Poster Salon in 1969; a special group prize at the twenty-seventh Cannes film festival in 1974; and a gold medal at the third Inter-American Graphic Arts Biennial organized by the Museo de Arte Moderno La Tertulia in Cali, Colombia, in 1976. In 1981 he received the National Order of Culture from Cuba's Council of State. In 1997 the Galería Latinoamericana of Casa de las Américas organized a retrospective of his work. He created some of the most paradigmatic posters in Cuban history, including *Canción protesta* [Protest Song], *Hanoi martes 13* [Hanoi, Tuesday the 13th], *Now!* and *ICAIC. Décimo Aniversario* [ICAIC: Tenth Anniversary]. In 2004 he received the National Design Award from UNEAC. — EV

H

Moisés HERNÁNDEZ FERNÁNDEZ
Spain, 1877 – Santiago de Cuba, 1939

Moisés Hernández Fernández arrived in Cuba as a child. He was a schoolteacher, bookkeeper and photoengraver before deciding to devote himself entirely to photography. He began working with *El Diario de Cuba* and was the Santiago correspondent for *El País* and later for *Diario de la Marina*, *Social*, *Carteles* and *Bohemia*. — RDV

K

Alberto KORDA (Díaz Gutiérrez)
Havana, 1928 – Paris, 2001

Alberto Korda was an advertising reporter and photojournalist whose real name was Alberto Díaz Gutiérrez. He is the Cuban photographer best known in the rest of the

world. He introduced fashion photography to Cuba with the model Norka Méndez, who later became his wife. In the 1940s he studied business at Candler College and the Havana Business Academy, both in Havana. With Luis Pierce (Luis Korda) he founded the Estudios Korda (1953–68), where they carried out all kinds of commercial photography. Although self-taught, he learned his craft first from Newton Estapé and later with Luis Pierce. After the Revolution he worked for the newspaper *Revolución* and accompanied Fidel Castro on various journeys in Cuba and abroad. In 1960 he created the portrait *El Guerrillero Heroico*, of Che Guevara, which critics consider one of the ten best photographic portraits of all time and is the most reproduced photograph in the history of world photography. He pioneered underwater photography in Cuba in 1968 at the Oceanography Institute. His work has been exhibited in the leading galleries of Europe, Asia and the Americas. He has published various books of his photographs. His work can also be found in catalogues and books on the history of Latin American photography. He received many awards and honours, including the National Cultural Distinction award in 1982; the Félix Varela Order in 1994; the OLORUM award from the Fondo Cubano de la Imagen Fotográfica in 1998; third prize in the fifth international underwater photography competition of the Italian magazine *Mondo Sommerso* in 1979; first prize for historical photography from the magazine *Revolución y Cultura*; and an award at the tenth 26th of July National Photography Salon in 1980. — RDV

Luis KORDA (Pierce Byers)
Manzanillo, 1912 – Havana, 1985

Luis Korda was a photographer whose real name was Luis Antonio Pierce Byers. He was the son of an American miner and a Jamaican mother. With Alberto Díaz Gutiérrez, he founded the Estudios Korda in 1953, whose name they borrowed from the Hungarian filmmakers Alexander and Zoltan Korda, with which they made their name in Cuban photography. He began working as a photojournalist in 1959 with the founding of the newspaper *Revolución*. He later worked for the newspaper *Granma* from its inception, for the weekly *Palante* and eventually, until his retirement, for the magazine *Bohemia*. His photograph *Entrado de Fidel a La Habana* [Fidel's Entry into

Havana], taken on January 8, 1959, is one of the most emblematic images in Cuban history. Some of his other photographs include a panorama of the Plaza de la Revolución taken during a speech by Fidel Castro; the inauguration of the Hotel Capri, the Havana Tunnel and the Hotel Focsa; and the effects of Hurricane Flora. — RDV

L

Wifredo LAM
Sagua la Grande, 1902 – Paris, 1982

Wifredo Lam studied at Havana's Academy of San Alejandro. In 1923 he travelled to Spain and joined the painter Fernando Álvarez de Sotomayor's studio in Madrid. He painted portraits and landscapes and, by 1930, was practising a kind of painting close to Spanish Surrealism. He moved to Paris in 1938, where he met Picasso, who put him in touch with Pierre Loeb, his first dealer. Loeb organized Lam's first Paris exhibition in 1939 and offered him his first contract. Late that year Lam exhibited his work alongside Picasso at Perls Galleries in New York. In 1940 he moved to Marseille, where he met a group of surrealist painters and writers. He participated with them in *Tarot de Marseille* [Game of Marseille] and collaborated with them on collective drawings. He illustrated André Breton's poem *Fata Morgana* with six ink drawings. In 1941 Lam returned to Cuba and settled in Havana. He met the writer Lydia Cabrera, who introduced him to Afro-Cuban culture. His famous work *La jungla* [The Jungle] achieves a synthesis of European and Afro-Cuban cultural elements, which would henceforth become the basic nucleus of his visual world. In 1946 his work was exhibited at the Centre d'Art in Port-au-Prince, Haiti, where he witnessed voodoo ceremonies for the first time. His encounter with this culture led him to renew his formal vocabulary and the themes that inspired him. In 1951, his work *Contrapunto* [Counterpoint] won first prize at the National Salon of Painting, Sculpture and Prints. A year later he decided to move to Paris, although he continued to visit Cuba regularly. In 1953 he received the Italian Lissone award. In 1958 he enrolled in the Graham Foundation for Advanced Studies in Fine Arts. In 1964 and 1965 he divided his time between Albisora Mare in Italy and Paris; he also received a Guggenheim International Award and the

Italian Marzotto award. In 1966 he completed *El Tercer Mundo* [The Third World] a work he conceived as his artistic tribute to the Cuban Revolution. — RC

Víctor Patricio de LANDALUZE
Bilbao, Spain, 1830 – Havana, 1889

Víctor Patricio de Landaluze arrived in Cuba about 1850, initially settling in the city of Cárdenas and later in Havana, where he drew for the magazine *El Almendares*. In 1852 he worked on the album *Los cubanos pintados por sí mismos. Colección de tipos cubanos* [Cubans as They See Themselves: A Collection of Cuban Types], made up of a series of articles by various authors with drawings by Landaluze. He also worked on a second album, *Tipos y costumbres de la Isla de Cuba* [Cuban Types and Customs], published by Miguel Villa in Havana in 1881.

Politically, Landaluze was an anti-separatist, an attitude evident in his political drawings, in which he criticized the independence movement. His satires in the pages of *Moro Muza*, *Don Junipero* and *Juan Palomo*, among other publications, attacked and ridiculed prominent Cubans involved in the revolutionary movement. In addition to his humorous drawings, Landaluze painted themes of local culture. He created an interesting series of small-format works in this genre in which he put his finger on the surroundings and human types of the second half of the nineteenth century. His depictions of local culture were not a form of social condemnation; his was a picturesque vision, far from the realism of his day. — OLN

Eduardo LAPLANTE
France, 1818 – Cuba, after 1860

Eduardo Laplante arrived in Cuba about 1848 and settled in Havana, where he created an important body of drawings and lithographs. Along with Leonardo Barañano, he drew and printed the series *Isla de Cuba Pintoresca* [The Picturesque Island of Cuba] in 1856, depicting the country's major cities. Published in monochrome and coloured, the series was complemented by a handsome landscape of the Yumurí Valley. The following year he worked with the sugar baron Justo Germán Cantero on the publication of the book *Los Ingenios* [The Sugar Mills], for which he drew the country's major sugar

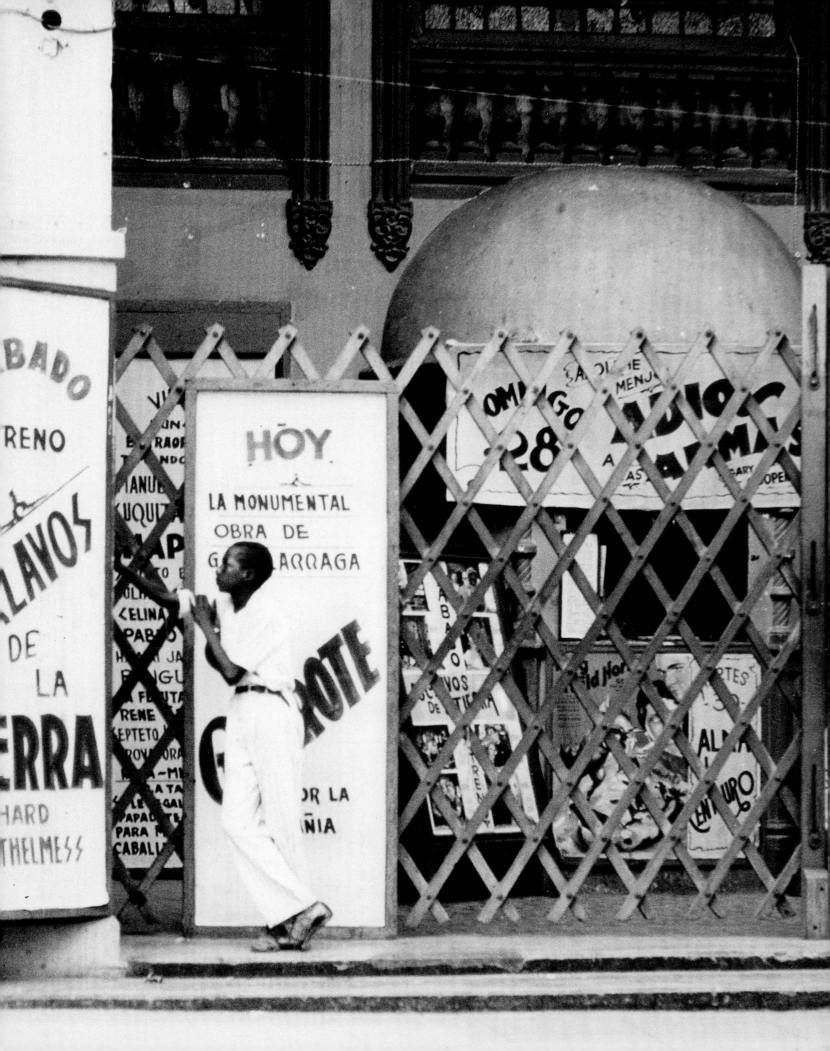

mills from nature. In addition to the mills' exteriors and diverse outbuildings, the book contained attractive lithographs of the boiler houses where sugar is made, along with new machinery recently introduced to the industry.

The number of oil paintings he made is quite small. The Museo Nacional de Bellas Artes in Havana has two such pieces in its collection: *Ingenio Güinía de Soto* [The Güinía de Soto Sugar Mill] and *Trinidad, vista general tomada desde la loma de la Vigía* [Trinidad, General View from the Lomas de la Vigía], both of which belonged to Cantero. Laplante composed the latter work the same way he composed his series of lithographs of Cuban cities. The oil painting meticulously depicts every detail of the city's buildings, as do the portraits of the Cantero family in the foreground, created with the skill of a miniaturist. — OLN

Alexis LEYVA (Kcho)
Born in Isla de la Juventud in 1970

Alexis Leyva graduated from ENA in Havana in 1990 and has had a brief but internationally-renowned career in sculpture, installation and drawing. He received two major awards in 1995, sharing the UNESCO Prize for the Promotion of the Arts and winning the grand prize at the Kwangju Biennial in South Korea.

Some of the important exhibitions in which his work has been shown include *Paisaje popular cubano* [Popular Cuban Landscape], Havana, 1990; *Desde el paisaje* [From Landscape], Museo Nacional de Bellas Artes, Havana, 1992; and *Cómprame y cuélgame* [Buy Me and Hang Me Up], Centro de Desarrollo de las Artes Visuales, Havana, 1993. In this latter exhibition he presented for the first time the original idea for *Regata* [Regatta], a work that became known internationally. Significant solo exhibitions in his career have included *El camino de la nostalgia* [The Path of Nostalgia], Centro Wifredo Lam, Havana, 1995; *Para olvidar* [In Order to Forget], Centre International d'Art Contemporain, Montreal, 1996; *Todo cambia* [Everything Changes], Museum of Contemporary Art, Los Angeles, 1997; *Saying the Obvious Was Never a Pleasure for Us*, Israel Museum, Jerusalem, 1997; *Encounter: Bruce Nauman and Kcho*, Museum of Contemporary Art, Chicago, 1999; and *La columna infinita* [The Infinite Column], Museo Nacional Centro de Arte Reina Sofía, Madrid, 2000. In 2002 a second solo exhibition of his work *The Jungle*,

a tribute to the Cuban painter Wifredo Lam, was held at the Museo Nacional de Bellas Artes in Havana; the exhibition travelled that same year to Turin. Some of the most recent exhibitions of his work include *Kcho, Every Man is an Island* at the New World Museum, Houston, Texas, 2005, and *The Winds' Passage* at the Joan Prats gallery in Barcelona in 2006.

Kcho has participated in numerous biennials, including the fourth, fifth and seventh Havana Biennials in 1994, 1997 and 2000, and the twenty-second São Paulo Biennial in 1994, in addition to other important exhibitions around the world. — CM

Rogelio LÓPEZ MARÍN (Gory)
Born in Havana in 1953

Rogelio López Marín studied painting at ENA, graduating in 1973, and art history at the University of Havana, graduating in 1978. He is a major artist in whose hands photography surpasses its documentary function to become an artistic medium in its own right. Some of his most important solo exhibitions include *Innerland*, Chelsea gallery, Miami, 2006; *The City*, Couturier gallery, Los Angeles, 2003; and *Beyond Cuba: Mirages of Absence*, Beadleston gallery, New York, 2001. His work has been included in group exhibitions such as *Latin American Photography II: Selections from the Lehigh University Art Gallery Collection*, Bethlehem, Pennsylvania, 2006; *Icons, Memories & Reminders*, Naomi Silva gallery, Atlanta, 2005; and *Shifting Tides: Cuban Photography after the Revolution*, Museum of Contemporary Photography, Chicago, 2002. His awards include a Peter S. Reed Foundation visual arts grant, 2001; Tina Modotti photography award, first Havana Biennial, 1984; and first prize at the Landscape Salon in 1982. He currently lives in Miami. — IC

M

E. MAÑAN

E. Mañan was a photographer who had a studio at 45 Calle O'Reilly in 1868 known as Dufart y Mañan. In the twentieth century, however, an E. Mañan had his own studio on Calle Neptuno; it is not known whether it was the same person. Photographs from both studios, with identifying tags, are held in various Cuban archives. — RDV

Olivio MARTÍNEZ
Born in Santa Clara in 1941

Olivio Martínez studied painting, sculpture and printmaking at the Leopoldo Romañach Visual Arts School in his native city. In 1962 he joined the design department of ICAIC and two years later moved to the Intercomunicaciones advertising agency. He began working for COR in 1966. He designed the emblematic poster *XIV Aniversario del 26 de julio* [Fourteenth Anniversary of the 26th of July] in 1967, in which the innovations of Cuban posters in the late 1960s were clearly visible. In 1970 he led a team of designers responsible for promoting the campaign to harvest ten million tons of sugar cane. That same year he joined OSPAAAL, where he created an excellent body of work. His work has been included in numerous group exhibitions and has received various prizes. — EV

Raúl MARTÍNEZ
Ciego de Avila, 1927 – Havana, 1995

Raúl Martínez studied at the Academy of San Alejandro and its annex. He was a founding member of the Nuestro Tiempo [Our Times] society and won a fellowship from the Chicago Institute of Design in 1952. In late 1953 he became a member of the group Los Once and participated in many of their exhibitions. In 1960, the year after the Cuban Revolution, he was named artistic director of the magazine *Lunes de Revolución*, photographed theatre and dance performances and created his first book designs for the publisher Ediciones R. He taught design in the school of architecture at the University of Havana. In 1964 he presented the exhibition *Homenajes* [Tributes], in which he began to depart from abstraction and to work in Pop art and collage. Two years later, along with Luc Chessex and Mario García Joya, he participated in the exhibition *¿Foto-Mentira!* [Photo-Lies?!] at Galería Habana, where he presented his multiple images of José Martí. He participated in the Havana edition of Paris's Salon de Mai in 1967 and in Salon 70 with his oil painting *Isla 70* [Island 70]. In his 1978 solo exhibition *La gran familia* [The Great Family] he offered a view of society as a whole from the perspective of the family and the everyday. Two later exhibitions of his work are worth singling out: his participation in the forty-first Venice Biennale in 1984 and

the first and largest retrospective of his work, entitled *We*, at the Museo Nacional de Bellas Artes in Havana in 1988. He was the recipient of the most important awards granted by the Ministry of Culture and the Council of State. He began writing his memoirs in 1990 and in 1995 won the first National Visual Arts Award, prompting the Museo Nacional de Bellas Artes to organize the exhibition *El desafío de los sesenta* [The Challenge of the 1960s] that same year. — LR

Estudio MARTÍNEZ OTERO
Manuel MARTÍNEZ OTERO
Valencia, Spain, 1862 – Caibarién, 1906

Manuel MARTÍNEZ ILLA
Puerto Padre, 1883 – (?)

Arturo Juan MARTÍNEZ ILLA
Puerto Padre, 1886 - Caibarién, 1965

Manuel Martínez Otero was a photographer who arrived in Cuba in 1877. He settled in Caibarién, where he established a photographic studio. He worked with glass plates and sunlight directed by cloth reflectors, and documented important events in the central region of the country. Striving not to repeat himself, he used every kind of stage prop. He was very imaginative and careful in his technique, making him one of the most important Cuban photographers of the late-nineteenth and early-twentieth centuries. His sons Arturo Juan and Manuel Martínez Illa took up photography and followed in their father's footsteps after his death. — RDV

Conrado W. MASSAGUER
Cárdenas, 1889 – Havana, 1965

Conrado Massaguer was a self-taught artist. While staying in Mérida, Mexico, he worked as a caricaturist for various publications. In early 1908 he returned to Cuba, settling in Havana and contributing to a variety of newspapers and magazines. In 1910 he was on the board of directors of the Ateneo in Havana and opened the Mercurio advertising agency. The first solo exhibition of his caricatures was held the following year at the Ateneo. In 1913 he published the first issue of *Gráfico*. Three years later he founded *Social*. In late 1916 he established the Institute of Graphic Arts. In 1918 he exhibited *Los 401* at the Association of Painters and Sculptors in Havana. In 1921,

along with other draftsmen, he founded the Humour and Satire Salon. He travelled to New York, contributing to numerous publications there, and later to France, where he exhibited his work in the Charpentier gallery in Paris. The King Features Syndicate appointed him artistic director and sent him to the League of Nations in Geneva. He was active in the anti-fascist movement: the foreign press thought his piece *Doble-Nueve* [Double Nine] the most popular of World War II. In 1944 he was decorated with the Carlos Manuel de Céspedes Order and the Order of the Cuban Red Cross. Later, he received the Finlay Order. — EC

Ana MENDIETA
Havana, 1948 – New York, 1985

Ana Mendieta was born into a prominent Havana family—her father, Ignacio Alberto Mendieta Lizaur, was active in the Auténtico Revolutionary Party of Cuba and served briefly in Fidel Castro's first government—but left Cuba in 1961 with her sister Raquelín in 1961 as part of Operation Peter Pan. Immediately upon her arrival in Miami, she was placed in the orphanage St. Mary's Home in Dubuque, Iowa. In 1966, in Sioux City, she was reunited with mother Raquel and brother Ignacio. She enrolled in the University of Iowa in Iowa City in 1967, where she obtained a Master of Fine Arts degree in painting in 1972, when her professional career began. Under the influence of her companion Hans Breder, professor and founder of the Intermedia Program, which made the University of Iowa one of the most avant-garde American art centres of the day, and of the people who spent time there, including the artists Vito Acconci and Willoughby Sharp and the critic Lucy Lippard, Mendieta became acquainted with the most innovative currents in contemporary art and developed an original aesthetic using body movements in natural settings. Following frequent visits to Europe and Mexico, where she explored pre-Columbian history, she moved to New York in 1978. In 1979 she exhibited her photographic series *Silhueta* (Silhouette) at the A.I.R. Gallery and became involved with the artist Carl Andre. She made the first of seven trips to Cuba in January 1980. During her second journey, in the winter of 1981, when she attended the opening of the exhibition *Volumen uno*, she became friends with several local artists and developed an interest in Afro-Cuban rituals, and created a series of spontaneous actions in Varadero.

Back in the country in July of that year, she produced her *Esculturas Rupestres* [Rupestrian Sculptures] in Jaruco park, sponsored by the Cuban Ministry of Culture. In November she exhibited films and photographs documenting the work at the A.I.R. Gallery. In 1985 she fell from the window of the apartment she shared with Andre, located on the thirty-fourth floor of a building in SoHo. In 2005 the Hirshhorn Museum and Sculpture Garden in Washington D.C. mounted a retrospective of her work that confirmed her unique place in art history. — SA

Manuel MENDIVE
Born in Havana in 1944

In 1955 Manuel Mendive won a prize in the International Contest on Children's Paintings awarded by UNESCO's Associated Federations and Japan's Society of Tribute to Mothers. He graduated from the Academy of San Alejandro in 1963 and is a member of UNEAC and UNESCO's International Association of Visual Artists. His work has been shown in the forty-third Venice Biennale in 1988; in the *Art in Latin America: The Modern Era 1820–1980* exhibition at London's Hayward gallery in 1989; at the Nationalmuseum in Stockholm in 1989; at the Palacio de Velázquez in Madrid in 1990; in the exhibition *Pintura cubana 1820 – 1991* [Cuban Painting 1820–1991] at the Poliforum Cultural Siquieros in Mexico City in 1991; and in the *Latin American Surrealists* exhibition at the Kunstmuseum Bochum in Germany in 1994. He was among the recipients of the Adam Montparnasse award for young painters at the twenty-fourth Salon de Mai in Paris in 1968, and was awarded the National Prize at the second International Painting Festival in Cagnes-sur-Mer, France, in 1970, in addition to the Espacio Latinoamericano award at the first Havana Biennial in 1984 and the International Award at the second Havana Biennial in 1986. Cuba's Council of State awarded him the Alejo Carpentier Medal in 1988 and the Félix Varela Order in 1994. He was named a Knight of Arts and Letters by the Republic of France in 1994 and in 2001 was awarded the National Visual Arts Award by the Cuban National Arts Council. — HM

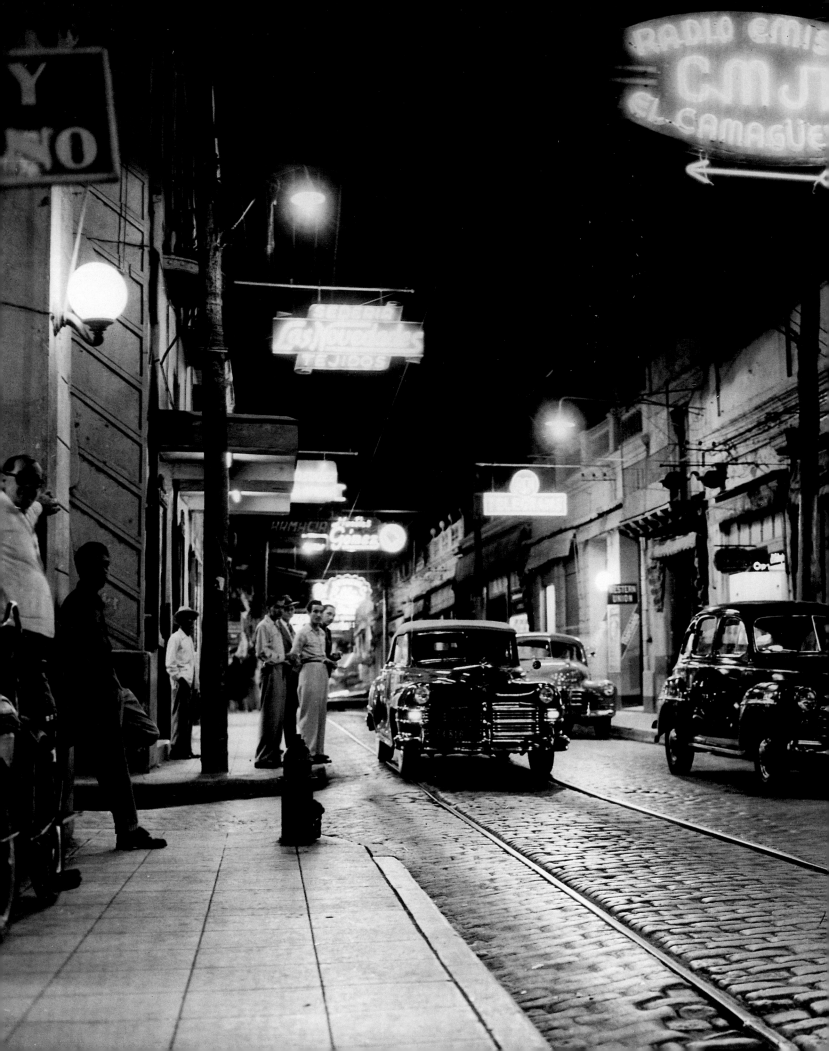

Frédéric (or Federico) MIALHE
Bordeaux, France, 1813 – Paris, 1881

Federico Mialhe was a painter and lithographer. He studied painting at the Fine Arts Academy in Paris and began studying lithography in 1832. He participated on several occasions in annual salons, in which he presented himself as a landscape artist. He arrived in Havana in December 1838, under contract with the company Imprenta Litográfica de la Real Sociedad Patriótica to take sketches of the city and the surrounding area. The following year, he began the series *Isla de Cuba Pintoresca* [The Picturesque Island of Cuba], totalling forty-eight lithographs over a three-year period. In 1848 he published another series, *Viaje Pintoresco alrededor de la Isla de Cuba* [A Picturesque Journey around the Island of Cuba], this time with the publisher Francisco Luis Marquier, made up of twenty-one lithographs for which he undertook journeys in the interior of the country. He returned to France in 1854, settling in Paris, where he resumed exhibiting his paintings in annual salons. — OLN

José MIJARES
Havana, 1921 – Miami, 2004

José Mijares studied painting at the Academy of San Alejandro in Havana in 1936. He was a friend of Fidelio Ponce and acknowledged his influence, stating that he was the artist who "most helped me break with the academic mould and to find my own manner of expression." In 1944 his first solo exhibition was held at the Hubert de Blanck National Conservatory in Havana. In 1950 his painting *Vida en un interior* [Life in an Interior] won first prize at the fourth National Salon of Painting, Sculpture and Prints, and the following year he won second prize in the fifth edition of the event. He began to work with geometric forms in 1953, which became one of his most interesting periods, lasting until 1968. He participated in the second and fourth São Paulo Biennial and in the major exhibition *Plástica cubana contemporánea: Homenaje a José Martí* [Contemporary Cuban Art: Tribute to José Martí] held at the Havana Lyceum in January 1954. Along with the Diez Pintores Concretos he made a series of silkscreens for the 1961 exhibition *"A"/Pintura Concreta* ["A"/Concrete Painting] at the Museo de Bellas Artes in Havana. He moved to Miami in 1968. — RC

Emilio MOLINA
1906 – (?)

Emilio Molina was a photographer who worked in the most important Cuban newspapers and magazines and was a correspondent for the *New York Times*, the International News Service, Associated Press and United Press. He documented the 1926 hurricane, the Gibara Rebellion and events leading up to the overthrow of the Machado dictatorship. In 1937 he attended the coronation of England's King George VI. — RDV

Vicente MUÑIZ
Havana, 1916 – Miami, 2007

Vicente Muñiz was the official photographer of the Tropicana nightclub. He began publishing his pictures in newspapers and magazines in the 1940s. He created portraits of famous singers and stage performers such as Celia Cruz and Olga Guillot. He left the country in the 1960s and settled in Miami about 1970, where he worked in the Howard Thomson Photographic Laboratory. — RDV

Eduardo MUÑOZ BACHS
Valencia, Spain, 1937 – Havana, 2001

Eduardo Muñoz Bachs was a self-taught painter, cartoonist and graphic designer who moved to Cuba in 1942. In the 1950s he worked as a draftsman, first for the television station CMQ and later in the animation department of the Artistic Advertising Organization (OAP) at the Siboney advertising agency. Beginning in 1960, he performed the same work in the animation department of ICAIC. That same year he created ICAIC's first film poster, for the film *Historias de la Revolución* [Stories of the Revolution]. He worked as a poster designer in ICAIC's marketing department from 1961 to 1993. His first solo exhibition, *Where Clowns and Others Are Painted*, was held in the Pequeño Salón of the Museo Nacional de Bellas Artes in Havana. Other solo exhibitions and many group exhibitions of his work were held throughout his career. He also won many awards in various salons and competitions in his field. Another important aspect of his work was the background illustrations he drew for short fiction and animated films produced by ICAIC: *El Maná* [Manna], 1960; *Carnaval*, 1960; and

El tiburón y las sardinas [The Shark and the Sardines], 1961. As an illustrator and poster designer he had a peculiar style, one that often employed humour. In 1983 he received the National Order of Culture from Cuba's Council of State and the Alejo Carpentier and Raúl Gómez García medals, the latter conferred by the National Union of Cultural Workers. In 1998 he was named honorary president of the Conrado Massaguer graphic design department of the University of Havana. — EV

N

Estudio NARCY
Ibrahim ARCE
Camagüey, 1908 – Havana, 1968

Narcy was a photographer whose real name was Ibrahim Arce. He began as an assistant to Armand and specialized in glamorous studio portraits of radio, television and theatre performers. His first business was located on Calle Monserrate at the corner of Empedrado in Havana and later on San Nicolás, between Concordia and Virtudes. He won various awards for his work. — RDV

Liborio NOVAL
Born in Havana in 1934

Liborio Noval is a photojournalist who began his career at the Siboney advertising agency in 1953, first as a market researcher and then as a photographer in 1957. He moved to the newspaper *Revolución* in 1959 and contributed to the magazines *INRA* and *Cuba*. He was a founding member of the newspaper *Granma* in 1965 and chair of the photojournalists section of the Cuban Press Union (UPEC) from 1994–98. For many years he was one of the journalists who accompanied Fidel Castro around Cuba and on his visits abroad. He has received more than thirty-two prizes and honourable mentions for his work in Cuba, and three abroad. He has served on juries and published several books of photographs. Some of the decorations and medals he has received for his work include the Juan Gualberto Gómez award in 1995; the National Cultural Distinction award in 1997; the OLORUM lifetime achievement award from the Fondo Cubano de la Imagen Fotográfica in 2000, awarded during the first Latin American

Fernando LEZCANO MIRANDA, Camagüey *street scene at night, 1949*

Community Photography Conference as part of the fourth Latin American and Caribbean Congress of Socio-Cultural and Community Development Agents "Community 2000"; and the Jose Martí National Journalism Award in 2002. In 2003 he was president of the organizing committee of the first Latin American Press Photography Conference. His work has been exhibited in Europe, Asia and throughout the Americas. — RDV

Ernesto OROZA
Born in Havana in 1968

Ernesto Oroza lives and works in Aventura, Florida. He graduated from Havana's Graduate Institute of Design in 1993 and the Polytechnic Institute of Design in 1988. He is the author of *Objets Réinventés. La création populaire à Cuba*, Paris, 2002. In 1998, he was visiting professor at Les Ateliers, École Nationale Supérieure de Création Industrielle (ENSCI), Paris, and professor at the Polytechnic Institute of Design in Havana between 1995 and 2000. He is a multidisciplinary artist working primarily in conceptual design and architecture.

Oroza's work has been exhibited in museums, galleries and cultural spaces in dozens of countries, including Haut Definition Gallery in Paris and the Museum of Modern Art and Exit Art Gallery in New York. He has received support from the Fonds d'incitation à la création (FIACRE), France, in 1999, the Danish Cultural Centre for Development in 2005, and Cuba's Ludwig Foundation, 2002–04.

He was artist in residence for the Fondation Christoph Merian's international exchange studio program in Basel, Switzerland, in 2006, and was made a Guggenheim fellow in 2007. — EO

Ernesto PADRÓN
Born in Cárdenas in 1948

Ernesto Padrón is a graphic designer, comic book artist, novelist and director of animated films. He obtained a journalism degree from the University of Havana and for a time was

head of the drawing and text workshop of DOR. He also led the propaganda group Dissemination Front at the José Martí Pioneer Organization and was director of the children's magazines *Zunzún* and *Bijirita*. He has taught various specialized courses and workshops on graphic design, creating scenarios for comic books and computer animation. He is currently a filmmaker in the animation department of ICAIC. Throughout his prolific career he has won countless awards and honours. — EV

Amelia PELÁEZ
Yaguajay, 1896 – Havana, 1968

Amelia Peláez studied painting at the Academy of San Alejandro. Her first solo exhibition was held in 1924, alongside María Pepa Lamarque; that year she also took a summer course at the Art Students League in New York. She travelled to Europe in 1927 and settled in Paris, studying at the École Nationale Supérieure des Beaux-Arts and the École du Louvre and taking free drawing courses at the Grande Chaumière. She exhibited her work at the Zak gallery in 1933. Portraits of women, landscapes and still lifes reveal the variety of her work during this European sojourn. She returned to Cuba in 1934 and set up a studio in her home in La Víbora, a suburb of Havana, where she worked until the end of her life. The following year she exhibited a selection of her Paris work at the Havana Lyceum. About 1936 she began to exhibit the first oil paintings completed since her return to Cuba, "*criollo* still lifes" with fruit and flowers that introduced aspects of Cuban life to her work. In 1937, she painted murals at the José Miguel Gómez municipal school in Havana and the Santa Clara teacher's college. She participated in the exhibition *El arte en Cuba* [Art in Cuba] at the University of Havana in 1940 and contributed drawings to the magazines *Espuela de Plata* (1939–41), *Nadie Parecía* (1942–44) and *Orígenes* (1944–56). A retrospective of her work was held at the Institución Hispano-Cubana de Cultura in 1943. She began to work in ceramics about 1950 in a modest experimental studio in Santiago de las Vegas near Havana. She created murals in various media in the 1950s. A major solo exhibition was held at the Galería Habana in 1964 and three years later she contributed to the collective mural created on the occasion of the presentation of the Salon de Mai in Havana. — RC

Alberto PEÑA (Peñita)
Havana, 1897 – Havana, 1938

Alberto Peña was an informal pupil of Víctor Manuel Garcia and studied civil engineering at the School of Arts and Trades in Havana. He was a member of the Society of Afro-Cuban Studies, led by Emilio Roig de Leuchsenring. His first solo exhibition was held in 1934 at the Havana Lyceum. Two years later, he exhibited his work alongside the sculpture of Ramos Blanco at the Club Atenas. In 1937 he created a mural at the José Miguel Gómez municipal school in Havana. — RC

René PEÑA
Born in Havana in 1957

René Peña is a photographer who obtained a degree in English from the higher languages institute at the University of Havana. During the 1990s, Peña's work focused on issues ranging from race to exile. Some of the solo exhibitions of his work include *Icon*, ninth Havana Biennial, Casa de Asia gallery, 2006; *Public Duty*, Centro de Arte Contemporáneo Wifredo Lam, Havana, 2004; and *René Peña: Photographs* at the Intemporel gallery in Paris in 2004, the Diana Lowenstein gallery in Miami in 2003, Joan Guaita-Art, Palma de Mallorca, 2002, and the Fototeca de Cuba, Havana, 2002. His work has been included in group exhibitions such as *Without Any Consideration: Contemporary Latin American Art* as part of a parallel exhibition at the ninth Havana Biennial, 2006; *Art Basel 2005*, Diana Lowenstein gallery, Chicago, 2005; ARCO Contemporary Art Fair, Madrid, 2004; and the *Armory Show*, Nina Menocal gallery, New York, 2004. — IC

Umberto PEÑA
Born in Havana in 1937

Umberto Peña graduated from the Academy of San Alejandro in 1958. The following year he joined the Cuban Printmakers Association. In 1960 he took courses on the materials used in mural painting at the Graduate Polytechnical Institute and on Byzantine mosaics at the La Ciudadela School of Applied Arts, both located in Mexico. In 1960 he created a wood engraving mural entitled *Las dictaduras en América* [Dictatorships in the Americas] and had his first solo exhibition at

the Centro de Arte Mexicano Contemporáneo. In 1963 he became artistic director of Casa de las Américas in Havana, devoting himself to designing their publications. He participated in the Gathering of Young Artists at the second Biennial in Paris in 1961, organized by UNESCO. From that year until 1967 he worked as a designer for the Cuban delegation to UNESCO. In 1964 he won a special prize with his copperplate engraving *Buey XXV* [Ox 25] at the Exhibition of Havana, organized by Casa de las Américas. In 1967 he won one of the first five awards for foreign artists at the fifth Young Painting Biennial, Paris. About 1976 he began work on *Trapices* [a neologism from *trapo* (rag) and *tapiz* (tapestry)], monumental examples of experimenting with textiles, which would be exhibited four years later at the Capitolio Nacional. He created the stage designs and costumes for the play *Morir del Cuento* [Dying from the Story], written and directed by Abelardo Estorino and performed by the group Teatro Estudio in 1983. In 1986 he was a member of the jury for the third National Book Art Competition and served on the selection committee for the Billboard Art competition. He currently resides in Spain. — LR

Marta María PÉREZ
Born in Havana in 1959

Marta Maria Pérez graduated from ISA in Havana in 1984 and has established herself as one of the most important Cuban contemporary photographers, taking up themes related to Afro-Cuban religion in a highly sophisticated manner. Her work has been exhibited in countless solo and group exhibitions. Her solo shows in Spain include *Marta Maria Perez Bravo* at the Llucià Homs in Barcelona and at the L'Algepsar gallery in Castellón, both in 2004. Among the group exhibitions are *Latin American Photography II: Selections from the Lehigh University Art Gallery Collection*, Bethlehem, Pennsylvania, 2006; *Intimate Reflections*, Kunsthalle, Attersee, 2005; *The Other Side of the Soul*, Kornhausforum, Bern, 2005; *Mapas abiertos: Fotografía Latinoamericana 1991–2002* [Open Maps: Latin American Photography 1991–2002], Centro de la Imagen, Mexico City, and Palau de la Virreina, Barcelona, 2004; *The Song of the Earth*, Fridericianum, Kassel, 2000; *Cuba: Maps of Desire*, Kunsthalle, Vienna, 1999; *Mirror Images: Women, Surrealism and Self-representation*, List Visual

Art Center, MIT, Cambridge, Massachusetts, 1998; and *Space "Projects,"* Museo del Barrio, New York, 1998. She represented Cuba in the fifth Istanbul Biennial in 1997. In 1996 she won the Fototeca de Cuba's first prize in photography for *Nudi '96* and the "artistic discovery" award at ARCO Contemporary Art Fair in Madrid in 1997. She currently resides in Monterrey, Mexico. — IC

Antonio PÉREZ GÓNZALEZ (Ñiko)
Born in Havana in 1941

Ñiko, whose real name is Antonio Pérez Gónzalez, worked in advertising before the Revolution. In 1960 he worked at the Consolidado advertising agency in Havana. Later he worked as a typographer in the technical propaganda department of the Integrated Revolutionary Organization (ORI). Between 1968 and 1970 he worked in the promotional department of COR. In 1970 he took a course on graphic design given by Polish experts in the field. He also studied aesthetics, art history and the psychology of perception. In the mid-1970s he joined the marketing department of ICAIC, where he remained for fifteen years. His first solo exhibition, *Grito a grito* [From Cry to Cry], was held in the Galiano y Concordia art gallery in Havana in 1973. Countless other solo and group exhibitions throughout his long career have followed. His work has won many prizes in salons, festivals and competitions. In 1983 he was decorated with the National Order of Culture and the Raúl Gómez García medal. He has resided in Xalapa, Mexico, since 1988; a retrospective of his work, *1968–1988: Carteles cubanos de Ñiko* [1968–1988: Ñiko's Cuban Posters] was held that same year at the Ramón Alva de la Canal gallery in Xalapa, Mexico. He has also been active in teaching and is the author of various catalogue articles. Although it was not printed at the time, his poster *Hasta la victoria siempre* [Always Towards Victory] was the first poster in the new Cuban poster movement to use Che Guevara as a subject. — EV

Faustino PÉREZ ORGANERO
Born in Banes in 1942

Faustino Pérez Organero studied journalism at the University of Havana. In 1960 he began self-taught work designing the presentation of television programs. About 1965 he moved

to the Intercomunicaciones advertising agency and later to COR, where he remained for thirty years. He was also an important contributor to OSPAAAL. For many years he was head of the design department of the publisher Política. In 1995 he began working as a designer in the Imágenes advertising agency of the corporation CIMEX. His work has been exhibited in various group exhibitions and has won many prizes. He has served on the juries of several graphic propaganda competitions and salons. In 1983 he received the Raúl Gómez García medal and the National Order of Culture from Cuba's Council of State. Since 2003 he has been working freelance. — EV

Manuel PIÑA
Born in Havana in 1958

Manuel Piña obtained a degree in mechanical engineering from the Vladimir Polytechnic Institute in the Soviet Union in 1983. His highly conceptual photography is a clear example of the new paths Cuban photography has taken since its historical photojournalism. Some of the solo exhibitions of his work include: *Deconstructing Utopias*, Marvelli gallery, New York, 2004; *Displacement and Encounter: Projects and Utopias*, Canadian Museum of Contemporary Photography, Ottawa, 2002; and *Manuel Piña*, Nina Menocal gallery, Mexico City, 2002. His work has been shown in group exhibitions such as *Certain Encounters: Daros-Latinamerica Collection*, Morris and Helen Belkin Art Gallery, Vancouver, 2006; *Open Maps: Latin American Photography 1991–2002*, Amos Anderson Art Museum, Helsinki, 2005; *"We Come in Peace." Histories of the Americas*, Musée d'art contemporain de Montréal, 2004; *Stretch*, The Power Plant, Toronto, 2003; and *Cuba on the Verge: An Island in Transition*, International Center of Photography, New York, 2003. He is presently an assistant professor in new media at the University of British Columbia in Vancouver. — IC

Marcelo POGOLOTTI
Havana, 1902 – Havana, 1988

Marcelo Pogolotti's mother was from the United States and his father was Italian; he spent his childhood between Cuba and Europe, mostly in Italy. He began studies in engineering in 1919 at the Rensselaer

Polytechnic Institute in Troy, New York, but dropped out in order to devote himself entirely to art, enrolling in the Art Students League in New York. Following a brief journey to Europe he returned to Cuba and took up various activities, without abandoning painting. At the time he was striving to "rediscover Cuba" in paintings that incorporated elements of Impressionism and Fauvism. In 1927 he contributed to the magazine *Revista de Avance* and participated in the *Exhibition of New Art*. Keen to learn new techniques, he returned to Europe in 1928 and settled in Paris. Initially attracted to Surrealism, after meeting the painter Fillia he joined the Futurists and was a signatory to one of Marinetti's manifestos. His work was exhibited in Turin, Savona, Cuneo and elsewhere. In 1932 he was part of a group of Futurist painters whose work was exhibited at the Laxer-Normand gallery in Paris. During this period he began to distance himself from the machine aesthetics of Futurism and to experiment with abstraction. He also created the series of drawings *Nuestro tiempo* [Our Times] (1930–31), which served as the basis of his new approach to painting and gave rise to major works in Cuban painting with a social theme. In 1934–35 he exhibited with the Association of Revolutionary Writers and Artists (AEAR) in Paris, alongside Fernand Léger, Edouard Pignon, Jacques Lipchitz, Frans Masereel, Jean Lurçat, Amédée Ozenfant, Robert Delaunay, André Lhote and others. He contributed to the magazine *Commune*. In 1938 the Carrefour gallery mounted a solo exhibition of his work, with a written introduction by Jean Cassou. That same year he lost his vision entirely. Back in Cuba, his work was shown in important solo and group exhibitions and he began writing what would become a major body of essays and novels. — RC

Fidelio PONCE DE LEÓN (Alfredo Puentes Pons)
Camagüey, 1895 – Havana, 1949

After erratic attempts to study at the Academy of San Alejandro, beginning in 1916, Alfredo Puentes Pons set off on a solitary path, in every sense of the word. He was self-taught, never travelling abroad but assimilating the heritage of classical painting and modern sources through books. He decided to create an artistic name—Fidelio Ponce de León y Henner—and disappeared from Havana.

Little is known about his novelistic life in small cities and towns in the interior of the country, apart from his alcoholism, illness, poverty, marginality and utter devotion to art. He returned to Havana about 1930 and became known through his participation in regular get-togethers of artists such as René Portocarrero, Mariano Rodríguez, Jorge Arche and Arístides Fernández. His first solo exhibition at the Havana Lyceum in 1934 was a revelation. Standing apart from all nationalist discourses, painting classical themes using a fantastic palette of whites, greys and ochres, he was a singular and impossible-to-categorize figure in Cuban modernism and one of its most passionate defenders. His work was included in major group exhibitions that helped consolidate modernist painting in Cuba. — RC

Eduardo PONJUÁN
Born in Pinar del Río in 1956

Eduardo Ponjuán graduated from ENA in 1978 and ISA in 1983. His artistic career began in the 1980s, working in drawing and painting. He spent a considerable amount of time working with René Francisco Rodríguez in a solid artistic duo of great importance to Cuban art of the past few decades.

His first solo exhibition, *Paisajes* [Landscapes], was held in 1983. Working with René Francisco, the project *El artista melodramático* [The Melodramatic Artist] in 1989 was one of the most talked-about exhibitions of the day. Some of the later exhibitions of these two artists include *Arte y confort* [Art and Comfort], Mexico City, 1993; *Corriente alterna* [Alternate Current], Havana, 1995; *Call Malevich* at the Kunsthalle Düsseldorf and Kunsthalle Lingen, Germany, 1996; and *Utopian Territories: New Art from Cuba*, Vancouver, 1997.

In 2003 the Museo Nacional de Bellas Artes organized a solo exhibition in Havana entitled *Lo tengo en la punta de la lengua* [It's on the Tip of My Tongue]. More recently, his solo show *Amores con la china de una taza de porcelana* [Love with the Chinese Woman on a Porcelain Cup] was shown in the ninth Havana Biennial. He has taught painting for many years at ISA in Havana. — CM

René PORTOCARRERO
Havana, 1912 – Havana, 1985

René Portocarrero studied briefly at the Villate Academy and the Academy of San Alejandro between 1924 and 1926, when he continued his training on his own. His first solo exhibition was held at the Havana Lyceum in 1934. In 1937 he was an adviser to Free Studio for Painters and Sculptors in Havana and contributed to the magazine *Verbum*, which was his first contact with the group of artists and intellectuals taking shape around the poet José Lezama Lima. He provided numerous illustrations and a few articles for two later magazines edited by Lezama, *Espuela de Plata* (1939–41) and *Orígenes* (1944–56). In 1943 he created the important series *Interiores del Cerro* [El Cerro Interiors], *Festines* [Feasts] and *Figuras para una mitología imaginaria* [Figures for an Imaginary Mythology], in which the most important features of his style were defined. He painted rural landscapes and created a major series of pastels in which he began to develop the theme of popular celebrations. Beginning about 1950 he worked in ceramics in the Santiago de las Vegas Experimental Studio. In 1951 he received the National Painting Award for his oil painting *Homenaje a Trinidad* [Tribute to Trinidad], a forerunner to his "Havana landscapes." He published *Máscaras* [Masks], a collection of twelve drawings based on the carnival in Cienfuegos, and painted his important series *Color de Cuba* [The Colour of Cuba], made up of little devils, made-up characters, carnival revellers and Havana landscapes. In 1964 he was awarded the Sambra International Award for the best collection of work at the São Paulo Biennial; two years later his *Retratos de Flora* [Portraits of Flora] were exhibited in the thirty-third Venice Biennale. In 1970 and 1971 he painted a large series of works entitled *Carnavales*. Some of his later series include *Figuras sedentes* [Seated Figures], 1975–76; *Transfiguración y fuga* [Transfiguration and Fugue], 1982; and *Madres eternas* [Eternal Mothers], 1982. Throughout his life he created numerous murals in various media. — RC

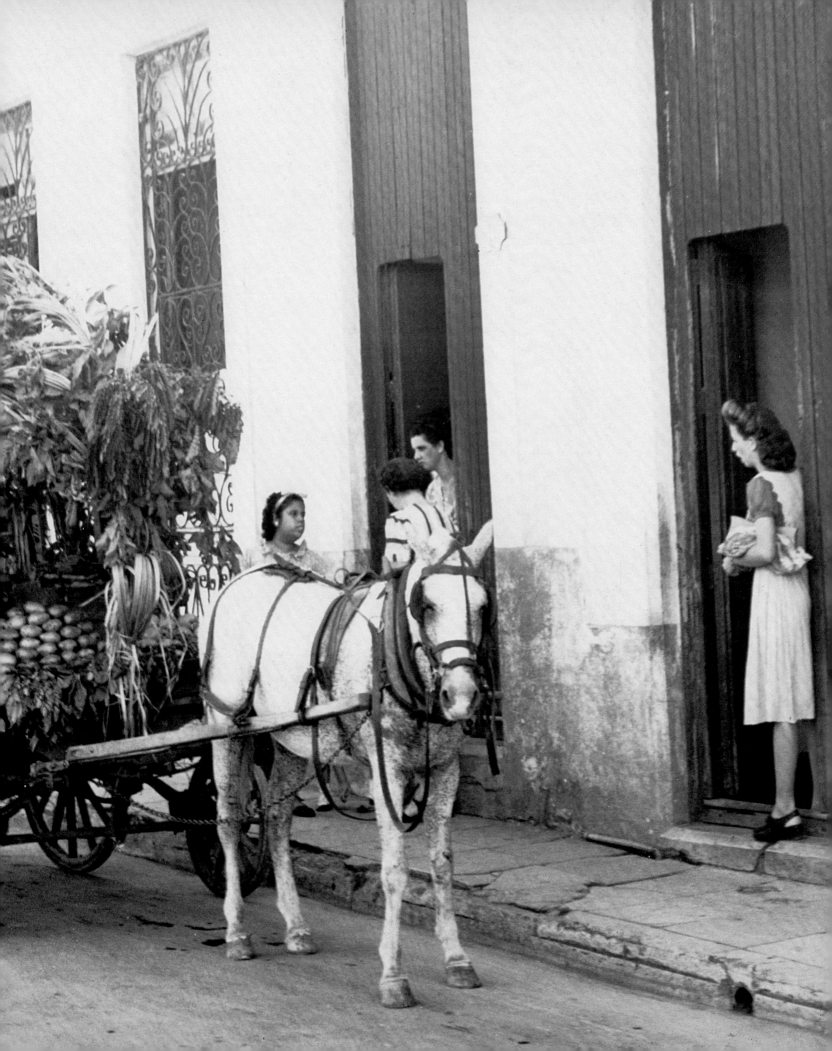

R

Domingo RAMOS
Güines, 1897 – Havana, 1956

Domingo Ramos was a painter who graduated from the Academy of San Alejandro in 1907. Upon completion of his studies he travelled to Europe, studying at the San Fernando School in Madrid and later, in 1919, exhibiting his work in Barcelona along with a group of young Cuban artists temporarily residing there. When he returned to Cuba, about 1920, he began to paint the most varied views of the Cuban countryside at different times of the day. He rendered the country's open spaces magnificent with his excellent technique and unmatched use of colour in large and even gigantic formats, the latter little seen in Cuba. Because of his valuable and extensive output of landscape paintings he became known, for much of the first half of the twentieth century, as the painter of the Cuban countryside. — EC

Sandra RAMOS
Born in Havana in 1969

Sandra Ramos graduated from ISA in 1993, working initially in printmaking. Over time, her work has come to include virtually all visual media. Her first solo exhibition, *Manera de matar las soledades* [How to Fight Solitude], was held in Havana in 1993. Some other important exhibitions of her work include *Cruzar las aguas* [Crossing the Waters], Ludwig Foundation of Cuba, 1995; *Inmersiones y enterramientos* [Immersions and Burials], Galería Habana, 1999; *Illusions*, Promo-arte Latin American Art gallery, Tokyo, 2002; *Sea of Sorrows*, Fraser gallery, Washington D.C., 2004; *Prints of Sandra Ramos*, Maison Rodolphe-Duguay, Nicolet, Quebec, 2006; and her most recent and most extensive exhibition, *Criatura de isla* [Island Creature], La Barbera, Espacio de Arte Contemporáneo, Villajoyosa, Spain, 2006. Her work has been included in more than a hundred group exhibitions around the world and can be found in prestigious collections such as those of Casa de las Américas and the Museo Nacional de Bellas Artes in Cuba; the Museum of Fine Arts in Boston; the Museum of Fine Art in Fort Lauderdale; the Museum of Modern Art in New York; the Fuchu Art Museum in Tokyo; the National Gallery of Canada in Ottawa; and the Ludwig Forum in Germany. — CM

Teodoro RAMOS BLANCO
Havana, 1902 – Havana, 1972

Teodoro Ramos Blanco studied at the Academy of San Alejandro. He won first prize in the Mariana Grajales National Monument Competition in Havana in 1928. The following year, he received the gold medal at the Exposición Iberoamericano in Seville. His first solo exhibition was held in 1930 at the Casa de España in Rome; later that same year his work was shown at the Círculo de Bellas Artes in Havana. Throughout the 1930s he worked intensively, frequently exhibiting his work in 1933 and 1934 at the Club Atenas, the Círculo de Bellas Artes and the Havana Lyceum. He won an award at the second National Salon of Painting and Sculpture in 1938 and in 1940 won first prize in the Antonio Guiteras National Mausoleum Competition in Havana. He taught at the School of Visual Arts, part of San Alejandro, until 1944. In 1946 he won an award at the third National Salon of Painting and Sculpture, part of the Salón de los Pasos Perdidos at the Capitolio Nacional. In 1954 he won an award in the second Spanish-American Art Biennial in the Museo Nacional de Bellas Artes in Havana. In addition to his abundant body of paintings, Ramos Blanco created a significant number of environmental sculptures that testify to his artistic versatility. — RC

Eladio RIVADULLA
Born in Havana in 1923

Eladio Rivadulla studied drawing, painting, printmaking and sculpture at the Academy of San Alejandro between 1937 and 1943. At the same time he studied typography and visual communications with a German professor from the Bauhaus. In 1943 he began to produce silkscreen film posters, from conception to printing, something that had never been done before in Cuba. He contributed to many periodicals, including *Bohemia*, *Carteles*, *El Mundo* and *UNESCO* bulletin. On his own initiative, on the morning of January 1, 1959, he designed and printed the first poster of the Cuban Revolution: *Fidel Castro. 26 de Julio* [Fidel Castro: 26th of July]. From that date until 1967 he designed propaganda posters and billboards for the ministries of Public Works and Construction. During this period he also worked with ICAIC in setting up their own silkscreen studio. Another important aspect of his work, from 1967 to 1992, was

his book illustrations and designs for publishers such as *Pueblo y Educación*, *Orbe*, *Letras Cubanas*, *Gente Nueva* and *Arte y Literatura*. His work has been included in numerous solo and group exhibitions and is held in collections around the world. He has won countless prizes and distinctions. In 1998 he received the National Design Award from ICL, the first time this award was granted. — EV

Fernando RODRÍGUEZ
Born in Matanzas in 1970

Fernando Rodríguez graduated from ISA in 1994. He is a charismatic sculptor who began working in the early 1990s in Havana and who has also worked in drawing and most recently in video. His first solo exhibition, *Arte-sano* [a play on words: *artesano* means artisan, while *arte sano* means healthy art], was held in 1992. His most important solo shows include *Soñando* [Dreaming] (with Tania Bruguera) at the Gasworks gallery in London, 1995; *De una experiencia colectiva* [From a Collective Experience], Galería Habana, 1999; *Comfortable*, LiebmanMagnan gallery, New York, 2000; and *Puramente formal* [Purely Formal], Galería Habana, 2002.

Some of the many group exhibitions in which he has participated include *Las metáforas del templo* [Metaphors of the Temple], Centro de Desarrollo de las Artes Visuales, Havana, 1993; *Arte e individuo en la periferia de la Postmodernidad* [Art and the Individual in the Periphery of Postmodernity], fifth Havana Biennial, 1994; *New Art from Cuba*, Whitechapel Art Gallery, London, 1994; *Adentro/Afuera: New Work from Cuba*, Walter Phillips Gallery, Banff Centre, Alberta, 1996; *Trabajando p'al inglé* [Workin' for the Englishman], Barbican Centre, London, 1999; *Contemporary Cuban Art and Recent Acquisitions*, Bronx Museum of the Arts, New York, 2001; *Museo tomado* [Captured Museum], Museo Nacional de Bellas Artes, Havana, 2006; and *Habana Factory*, A Chocolataría, Santiago de Compostela, Galicia, 2006. — CM

Mariano RODRÍGUEZ
Havana, 1912 – Havana, 1990

Mariano Rodríguez travelled to Mexico in 1936 to study painting in fresco with the painter Manuel Rodríguez Lozano and Diego Rivera's assistants. He returned to Cuba in 1937 and worked as an assistant to muralists and as a part-time instructor at the Free Studio for Painters and Sculptors in Havana. A year later, his oil painting *Unidad* [Unity] won a prize in the second National Salon of Painting and Sculpture. His first solo exhibition was held at the Havana Lyceum in 1939, the year in which he also painted the mural *Educación sexual* [Sex Education] in the Santa Clara teachers college. He was a co-founder of the artistic and literary magazine *Espuela de Plata* (1939–41). In 1941 he illustrated José Lezama Lima's book *Enemigo rumor* and in 1943 painted two murals with a religious theme for the church in Bauta. The following year he exhibited his work for a second time at the Lyceum and was part of the exhibition *Modern Cuban Painters* at the Museum of Modern Art in New York. That same year marked the beginning of his contributions to the magazine *Orígenes*; he created the cover for its first issue. He travelled to the United States in the years 1944, 1945 and 1946, where he met the painters whose work he had previously admired through reproductions. He began decorating ceramics in 1950 in the Santiago de La Vegas Studio. Two years later he created the mural *El dolor humano* [Human Suffering] in Havana's Retiro Odontológico building. In 1960 he was named cultural attaché for the Cuban embassy in India, where he created a large number of oil paintings and drawings. Upon his return to Cuba he was founder and chair of the visual arts section of UNEAC and in 1962 he was appointed head of the visual arts department of Casa de las Américas, an organization he presided over from 1980 to 1982. After that date he devoted himself entirely to painting. The largest exhibition of his work ever was held at the Museo Nacional de Bellas Artes in 1975. — RC

Leopoldo ROMAÑACH
Sierra Morena, 1862 – Havana, 1951

Leopoldo Romañach spent part of his childhood and adolescence on the Catalan coast in Spain, whence his great love of the sea. Upon his return to Cuba he worked in the family business and studied painting in Santa Clara, where he won a grant to study at the Academy of San Alejandro. He later took classes in the Free Painting School in Rome in 1890. After living briefly in New York he settled in Cuba for good, although he travelled frequently to Europe. He taught at San Alejandro and, after fifty years of service, was given an honorary doctorate and named professor emeritus of colouring. His extensive body of work embraced many different artistic currents: turn-of-the-century Italian tenebrism, realism and Symbolism. — EC

Rigoberto ROMERO
Pinar del Río, 1940 – Havana, 1991

Rigoberto Romero was a photographer and airplane mechanic. He studied aviation in the Soviet Union in 1961 and obtained a Bachelor's degree in art history from the University of Havana in 1975. He worked in the air force from 1961 to 1970. A pupil of Raúl Martínez, with whom he studied photography and drawing, he was a photographer with ICL from 1970 to 1985. He contributed to cultural publications in France, Germany, Czechoslovakia, Mexico, the United States, Nicaragua and Cuba. He is seen as one of the best young photographers of the 1970s. Along with Raúl Corrales, Mario García Joya and Gory, he won an award at the Contemporary Latin American and Caribbean Photography Competition at Casa de las Américas in 1981. He is the author of books such as *El patio de mi casa no es particular* (1977), *Hermanos* (1980) and *Trinidad* (West Germany, 1988). His photographs have appeared in anthologies such as *Cuba: cien años de fotografía* (1998) and his work has been seen in numerous exhibitions in countries including Germany, Argentina, France, Czechoslovakia, Mexico, the United States and Cuba. — RDV

S

Lázaro SAAVEDRA
Born in Havana in 1964

Lázaro Saavedra graduated from ISA in Havana in 1988, the year of his first solo exhibition, *Pintar lo que pienso, pensar lo que pinto* [Painting what I Think, Thinking what I Paint], at Galería Habana. He was a member of the Grupo Puré, whose projects involved vernacular roots with social connotations.

Some of the solo exhibitions of Saavedra's work include *A Retrospective Look*, alongside the work of Rubén Torres Llorca, in Havana, 1989, which won the award for best-curated show in Cuba that year; *El desafío de mi arte* [The Challenge of My Art], Havana, 1991; *Historia para historiadores* [History for Historians], Cienfuegos, 1995; *Levántate Chago, no jodas Lázaro* [Get up, Chago, Stop Screwing Around, Lázaro], Espacio Aglutinador, Havana, 1996; *Fellowship Recipients*, Ludwig Forum für Internationale Kunst, Aachen, 1996; *Body, Soul and Thought*, Gallerie S, Aachen, 1996; *Mental Massage*, Media Center, Rice University Media Center, Houston, 1997; and *Mi dossier, el descaro y la representación* [My File, The Cheek and Representation], Centro de Desarrollo de las Artes Visuales, Havana, 1998. In 2002 the Museo Nacional de Bellas Artes in Havana organized the exhibition *El único animal que ríe* [The Only Animal that Laughs], a kind of compendium of his productive career.

Saavedra's work has been shown in numerous collective exhibitions since the late 1980s, including *La tradición del humor* [The Humour Tradition] at the third Havana Biennial, 1989; *Cuba OK*, Kunsthalle Düsseldorf, 1990; and *Trabajando pa´l inglé* [Workin' for the Englishman], Barbican Centre, London, 1999. — CM

Osvaldo SALAS
Havana, 1914 – Havana, 1992

Osvaldo Salas was a photographer. His family moved to New York in 1926, where he worked as a mechanic and a welder from 1929 to 1949. He was a member of the Inwood Camera Club in New York. In 1950 he opened a photographic studio across the street from Madison Square Garden in New York. He created portraits of Marilyn Monroe, Elizabeth Taylor, Sarita Montiel, Imperio Argentina, Joe DiMaggio, Rocky Marciano, Ted Williams, Roy Campanella and Sugar Ray Robinson, among other personalities. He worked for the magazine *Life*. In 1959 he returned to Cuba and worked at the newspaper *Revolución*. He covered Fidel Castro's trips to Venezuela and the United States and the most important events in Cuba. He was a founding member of the newspaper *Granma*. In 1983, the International Press Organization of the Soviet bloc bestowed on him the title International Master of Press Photography.

His work has been exhibited in Europe, Asia and Latin America and has received numerous national and international awards. In 1981 he was awarded the National Culture Distinction award; in 1982 the Cuban delegation to UNESCO gave an award to the work *Después de los 60* [After the Sixties]; and in 1985 he received the Crystal Sunflower award from the magazine *Opina*, the first and only time it has been given to a photographer. He was also awarded a Cultural Diploma by the Republic of Angola. His photographs have illustrated various books, including *Che Guevara and the Cuban Revolution*, 1987; *Alicia, maravilla de la danza*, 1988; *The Human Right to Dignity and Changing the History of Africa*, published by Ocean Press in 1989; *Fidel, Barbudos* (alongside the work of Korda and Corrales), 1996; and *Cuba, la fotografía de los años 60* (alongside the work of Korda, Corrales, Mario García Joya and Ernesto Fernández), 1988. They have also been included in major anthologies such as *Cuba: 100 años de fotografía*, published by Mestizo in Spain in 1998. — RDV

Tomás SÁNCHEZ
Born in Aguada de Pasajeros in 1948

Tomás Sánchez began studying at the Academy of San Alejandro in 1964, when he also began practising yoga. In 1966 he transferred to ENA, where he graduated in 1971 and taught until 1976. He sketched stage designs and puppets for puppet theatre. He won first prize in the drawing category in the National Salon for Young Artists in 1971 and second prize in lithography in the National Print Salon in 1973. His first solo exhibition was held in 1974 and his work has been shown in important international print exhibitions. He was awarded first prize in painting and printmaking at the third National Salon of Visual Art Instructors and Teachers in 1975. In 1980 he received first prize in painting at the Leopoldo Romañach National Landscape Competition and a prize at the nineteenth Joan Miró International Drawing Competition in Barcelona. A solo exhibition of his drawings was held in 1983 at the Fundació Joan Miró in Barcelona, later travelling to Moscow, Prague, Cyprus, Athens and Vienna. In 1984 he won the Amelia Peláez National Painting Award at the first Havana Biennial. Other awards include a special mention at the second Havana Biennial in 1986; a medal at the fifth Inter-American Biennial of Graphic Arts in Cali, Colombia, and an

honourable mention at the first International Painting Biennial in Cuenca, Ecuador, in 1987. A retrospective exhibition of his work was held at the Museo Nacional de Bellas Artes in Havana in 1985. He was the recipient of a National Culture Distinction award in 1988. His work was exhibited in the third Havana Biennial and in the Arvil gallery in Mexico City in 1989. He participated in the travelling exhibition of Latin American art entitled *Un Marco por la Tierra* [A Frame on the Ground] in 1992. He emigrated to the United States in 1993. His work was shown in the Museum of Art in Fort Lauderdale in 1994, at the Marlborough gallery in New York in 1999 and at the Foire internationale d'art contemporain (FIAC) [International Contemporary Art Fair] in 2001 in Paris and Madrid. He resides in Costa Rica. — HM

Helena SERRANO
Havana, 1933 – Miami, 1994

Helena Serrano was a painter, draftsman, printmaker and graphic designer. She graduated from the Academy of San Alejandro in 1956. Her first solo exhibition was held two years later at the Museo Nacional de Bellas Artes in Havana. In the 1960s she worked first as a graphic designer in the Audiovisual Media Studio of the Ministry of Education and later in the promotional department of CDR. Her work was included in some thirty group exhibitions and received numerous honours. In the late 1970s she worked as head designer at the National School of Design in Havana. — EV

Loló SOLDEVILLA
Pinar del Río, 1901 – Havana, 1971

Dolores ("Loló") Soldevilla was a painter, sculptor, draftsman and printmaker. She began painting in 1948 and the following year moved to Paris, where she studied at the Grande Chaumière. She returned to Cuba for a short time in 1950, when her first solo exhibition was held at the Havana Lyceum. Upon her return to France in 1951, where she remained for two years, she joined the studio of abstract painters Jean Dewasne and Edgar Pillet. At the same time she took a course on engraving technique given by the professors Stanley William Hayter and Gustavo Cochet. She returned to Cuba for good about 1956 and, with Pedro de Oraá, opened the Color-

Luz gallery. She joined the Diez Pintores Concretos group in the late 1950s. She also wrote fiction and, with considerable acumen, art criticism. — EV

Alfredo SOSABRAVO
Born in Sagua la Grande in 1930

Alfredo Sosabravo studied at the annex of the Academy of San Alejandro between 1955 and 1957. Along with Acosta León, he learned woodcut engraving, which was an important part of his work until 1965. The solo exhibition *Metamorfosis*, which brought together some of his thematic series, was held at Galería Habana in 1964. In 1965 he created his first lithographs at the Experimental Graphics Studio in Havana and began working in ceramics. A major exhibition of his oil paintings and ceramics was held at Galería Habana in 1967. He participated in the second International Biennial of Ceramics in Vallauris, France, and the International Competition of Contemporary Ceramic Art in Faenza, Italy, where he received an honourable mention and a gold medal respectively. In 1978 he began his ceramic mural *Carro de la Revolución* [Vehicle of the Revolution] on the mezzanine of the Habana Libre hotel, his largest sculpture to that date and the precursor to a series of ceramic works on an environmental scale on which he has worked since the 1980s. Also in 1978, his *Autopsia del robot* [Autopsy of a Robot] anticipated his sculptural torsos and the great series *Anatomicum*. Two years later he exhibited a group of ceramics in the eleventh Venice Biennale. Seven of his works have been part of the collection of the Museo Nacional de la Cerámica in the Castillo de la Real Fuerza in Havana since 1990. In 1982, he resumed painting, returning to his former work in collage. He has received the most important honours bestowed by Cuba's Ministry of Culture and Council of State. In 1997 he won the National Visual Arts award and the following year a retrospective of his work was held to mark the occasion and the beginning of his collaboration with the Ars Murano studio in Venice. — LR

Leandro SOTO
Born in Cienfuegos in 1956

Leandro Soto graduated from ENA in 1976. He is a multidisciplinary artist who works in stage design, painting, video, installation and practically all forms of artistic expression. In Cuba he is associated with performance art, an art form he introduced to the country and baptized "visual action." His work was exhibited in *Volumen uno* and promoted the exhibitions of the important group behind the show in the early 1980s.

His first solo show, *La historia del hombre contada por sus casas y sus cosas*, [The History of Man Told Through His Houses and Belongings], was held in the Cienfuegos art gallery in 1977. In 1984, the important exhibition *Retablo familiar* [Family Altarpiece] was held in Havana. The Museo Nacional de Bellas Artes devoted its space for young artists to his exhibition *Lienzos sagrados* [Sacred Canvas] in 1991.

Leandro Soto moved to Mexico in the late 1980s, where he worked with local communities. He moved to the United States in the 1990s and began teaching at the university level, giving courses on stage design and performance. In 2003, his visual art exhibition *Oggun: Recreating the Bridge among Worlds* was mounted at Arizona State University. — CM

T

José TOIRAC
Born in Guantánamo in 1966

José Toirac came on the scene in the late 1980s and graduated from ISA in 1990. He has more than twenty solo exhibitions to his credit—most of them collectively organized— and his work can be found in the collections of institutions such as the Museo Nacional de Bellas Artes in Havana, the Museum of Modern Art in New York, the Ludwig Forum in Aachen, Germany, the Centro Atlántico de Arte Moderno in Las Palmas, Canary Islands and the Montreal Museum of Fine Arts.

Some of his most notable solo exhibitions include *Masa: Retratos* [Mass: Portraits], Havana, 1995; *Mediaciones II* [Mediations II], Galería Habana, 2002; *Sacrifice*, Gallery 106, Austin, Texas, 2003; and *Think Different*, Art in General, New York, 2002. In 2007 the Museo Nacional de Bellas Artes in Havana mounted his project *Orbis: Tribute to Walker Evans*, alongside the work of Meira Marrero.

José Toirac's work has been included in group exhibitions such as *The American Effect*, Whitney Museum of American Art, New York, 2003; *New to the Modern: Recent Acquisitions from the Department of Drawings*, Museum of Modern Art, New York, 2001; and *Cuba Siglo XX: Modernidad y sincretismo* [Twentieth Century Cuba: Modernity and Syncretism], Centro Atlántico de Arte Moderno, Las Palmas, Palma de Mallorca and Barcelona, 1996. — CM

U

Enrique de la UZ
Born in Havana in 1944

Enrique de la Uz abandoned studies in architecture in order to devote himself to photography. He has contributed work to the most important Cuban magazines and served on the jury of various competitions. In 1992 he won first prize in the Havana Salon. His work has been published in anthologies and exhibited in Europe, Asia and throughout the Americas. He is currently chair of the photography section of UNEAC. — RDV

V

Juan Bautista VALDÉS
Cuba (?) – Kingston, Jamaica, 1903

Juan Bautista Valdés was one of the few photographers to have taken José Martí's portrait. He lived in exile in Kingston, Jamaica, where he had a photographic studio at 13 Duke Street. From this studio came the only surviving full-length photograph of Martí, which is viewed as his best image, taken in October 1892. Valdés's home in Jamaica was a meeting place for Cuban émigrés and the headquarters of the Cuban Revolutionary Committee in Jamaica. — RDV

Jaime VALLS
Barcelona, 1883 – Havana, 1955

Jaime Valls studied fine art in his native city of Barcelona. He journeyed to Cuba at the turn of the century and settled there permanently. Soon afterwards he began providing illustrations to periodicals such as *Discusión* and *El Fígaro*. In 1905 he was named artistic director of the weekly illustrated magazine *El Chato Cómico* and in 1908 managing editor of the weekly *Ataja*. At the same time he was supervisor of modelling and drawing in the Cuban public school system. After working in the field of advertising he established his own agency. He was also a pioneer of the poster in Cuba and won prizes in poster competitions. He was a member of the Grupo Minorista since its inception and his studio became a meeting place for artists and intellectuals. He journeyed to Paris in 1927, returning to Cuba in 1928. He contributed to *Revista de Avance* and *Social*. His work as a draftsman and illustrator took as its central themes popular Cuban types and customs drawn from Afro-Cuban milieux. Because of ill health he withdrew from all activity in 1940. — LM

Z

Rafael ZARZA
Born in Havana in 1944

Rafael Zarza graduated from the Academy of San Alejandro in 1963. Since 1965 he has worked at the Experimental Graphics Studio in Havana as a graphic designer for the Ministry of Culture and in the René Portocarrero Silkscreen Studio. In 1968 he won the Portinari prize in the Exhibition of Havana at Casa de las Américas. He participated in the sixth Biennale de Paris, International Young Artists' Show, Musée d'Art Moderne de la Ville de Paris, 1969. He won an honourable mention at the International Poster Competition for Peace, Security and Collaboration, Moscow, 1962; the special prize for the 25th anniversary of the Revolution at the ninth UNEAC Salon in Havana in 1984; and the prize for billboard art in the Billboard Art competition in Havana. Some twenty solo exhibitions of his work have been held in Cuba and abroad. He is a member of UNEAC and UNESCO's International Association of Visual Artists. — HM

LIST OF WORKS

List in alphabetical order of artist's names
and illustration numbers.
All works are part of the exhibition
unless accompanied by a ★

A

Eduardo ABELA
San Antonio de los Baños, 1889 –
Havana, 1965

125 ★
Guajiros
[Peasants]
1938
Oil on canvas
84 x 71.5 cm
Museo Nacional de Bellas Artes,
Havana
Inv. 07.180

129
El triunfo de la rumba
[The Triumph of the Rumba]
About 1928
Oil on canvas
65 x 54 cm
Museo Nacional de Bellas Artes,
Havana
Inv. 07.205

130
El gavilán
[The Sparrow Hawk]
About 1928
Oil on canvas
81 x 65 cm
Museo Nacional de Bellas Artes,
Havana
Inv. 05.147

P. 360
En la gloria
[In Glory]
1932
Pencil and ink on paper
22.3 x 21.4 cm
Museo Nacional de Bellas Artes,
Havana
Inv. 07.384

Edmund ALLEYN
Quebec city, 1931 – Monreal, 2004

p. 21
1-3
*"Cuba vue par le peintre Edmund
Alleyn"*
Macleans magazine
February 1968
33.7 x 26.6 cm
Private collection, Montreal

José ABRAHAM
Havana, 1912 – Houston, Texas,
1997

176
Sloppy Joe's Bar from the outside
1954
Gelatin silver print
20 x 26.5 cm
Joe Abraham Collection, Houston,
Texas

José Manuel ACOSTA BELLO
Matanzas, 1895 – Havana, 1973

118 ★
Cover of the magazine "Social"
Vol. 14, No. 7, July 1929
31 x 25 cm
Biblioteca Nacional José Martí,
Havana

Ángel ACOSTA LEÓN
Havana, 1930 – Havana, 1964

301
Cafetera
[Coffee Maker]
1959
Oil on Masonite
122 x 127 cm
Museo Nacional de Bellas Artes,
Havana
Inv. 73.140

José (Pepe) AGRAZ
Havana, 1909 – Havana, 1982

287
Che and Camilo, Havana
1959
Gelatin silver print
18.2 x 24 cm
Fototeca de Cuba, Havana
Inv. EM-33

288
Fidel and Camilo, Havana
1959
Gelatin silver print
18 x 24 cm
Fototeca de Cuba, Havana
Inv. EM-31

290, 291
From the series "Havana"
January 8, 1959
1959
Gelatin silver prints
18 x 23.9 cm
20.7 x 25.4 cm
Fototeca de Cuba, Havana
Inv. EM-30; EM-28

Alejandro AGUILERA
Born in Holguín in 1964

397
Playitas y el Granma
[Playitas and the Granma]
1988
Wood, polychromed plaster, wire,
gummed fabric, metal
230 x 160 x 70 cm
Museo Nacional de Bellas Artes,
Havana
Inv. 90.3700

**Osvaldo Pedro Pascual
ALBURQUERQUE**
Born in Havana in 1926

195
*Benny Moré (centre). To his left, the
Cuban singer Gloria, with members
of the group Los del Conjunto
performing for a Radio Progreso
broadcast*
1950s
Gelatin silver print
18.7 x 24 cm
Vicki Gold Levi Collection,
New York

Juan Carlos ALOM
Born in Havana in 1964

375
Arbol replantado
[Transplanted Tree]
1994 (artist's print)
Gelatin silver print
40.6 x 50.8 cm
Museum of Art / Fort Lauderdale,
Florida
Gift of C. Richard Hilker
Inv. 99.2.1

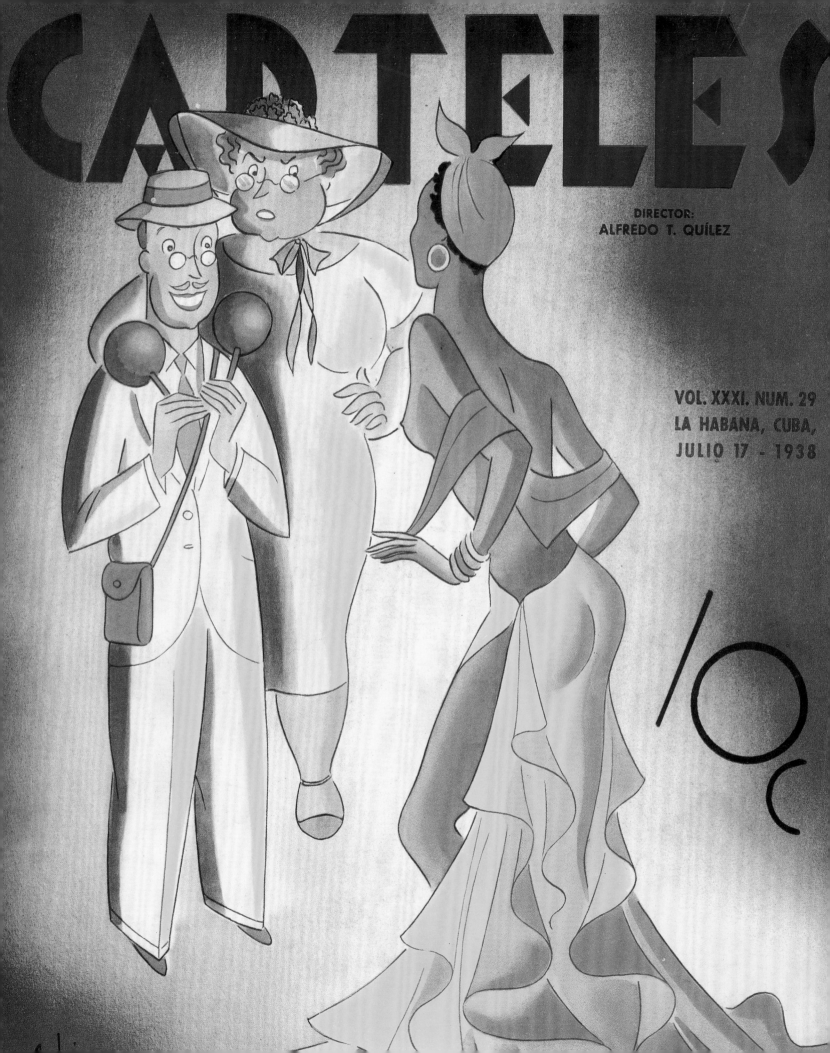

CARTELES

DIRECTOR:
ALFREDO T. QUÍLEZ

VOL. XXXI. NUM. 29
LA HABANA, CUBA,
JULIO 17 - 1938

10c

Eufemia ÁLVAREZ
Born in Havana in 1943

299
Revés en Victoria
[Turning Reversal into Victory]
1970
Poster. Silkscreen
Published by Comisión de
Orientación Revolucionaria (COR)
101.6 x 68.7 cm
Museo Nacional de Bellas Artes,
Havana
Inv. 82.353

Pedro ÁLVAREZ
Havana, 1967 – Tempe, Arizona,
2004

401
*Primera Convención Cubana sobre
el fin de la historia*
[First Cuban Convention on the
Purpose of History]
1993
Acrylic on canvas
102.5 x 141 cm
Museo Nacional de Bellas Artes,
Havana
Inv. 93.1474

American Photo Studios
Active in Havana, 1902–1959

14
*Panorama with the Glorieta de La
Punta*
Early 20th century
Gelatin silver print
20 x 150 cm
Fototeca de la Oficina del
Historiador de la Ciudad, Havana
Courtesy of the Museo Nacional
de Bellas Artes, Havana

Federico AMÉRIGO
Matanzas, 1840 – Valencia, Spain,
1912

55
Paisaje
[Landscape]
n.d.
Oil on canvas
96 x 184.5 cm
Museo Nacional de Bellas Artes,
Havana
Inv. 72.154

José ARBURU MORELL
Havana, 1864 – Paris, 1889

57 ★
*Retrato de la familia González
de Mendoza*
[Portrait of the González de
Mendoza Family]
1886
Oil on canvas
90.5 x 159.5 cm
Museo Nacional de Bellas Artes,
Havana
Inv. 96.424

Jorge ARCHE
Santo Domingo, Cuba, 1905 –
Cádiz, Spain, 1956

136
Trabajadores
[Workers]
1936
Oil on cardboard
63.5 x 52.5 cm
Museo Nacional de Bellas Artes,
Havana
Inv. 68.19

219 ★
Primavera o Descanso
[Springtime, or Repose]
1940
Oil on canvas
127 x 152 cm
Museo Nacional de Bellas Artes,
Havana
Inv. 07.252

220
Bañistas
[Bathers]
1938
Oil on canvas
109 x 133.5 cm
Museo Nacional de Bellas Artes,
Havana
Inv. 68.20

221
Jugadores de dominó
[Domino Players]
1941
Oil on wood
94 x 103 cm
Museo Nacional de Bellas Artes,
Havana
Inv. 74.766

222
Retrato de Mary
[Portrait of Mary]
1938
Oil on canvas
91.5 x 76.5 cm
Museo Nacional de Bellas Artes,
Havana
Inv. 73.40

223 ★
José Martí
1943
Oil on canvas
86 x 68.5 cm
Museo Nacional de Bellas Artes,
Havana
Inv. 07.250

Lorenzo Romero ARCIAGA
Havana, 1905 – (?)

225
La taza de café
[The Cup of Coffee]
About 1940
Oil on panel
97.3 x 123 cm
The Cuban Foundation,
Museum of Arts and Sciences,
Daytona Beach, Florida
Inv. 71.01.010

Luis ARGÜELLES

173
*Alicia Alonso choosing a dancing
outfit*
1950s
Gelatin silver print
13.9 x 16.9 cm
Vicki Gold Levi Collection,
New York

Constantino ARIAS
Havana, 1920 – Havana, 1991

Courtesy of María Josefa González

175
Ernest Hemingway (right), with
Reinaldo-Ramirez-Rosell,
producer in the Travel and
Tourism Department of the
Tourism Institute, Havana
1952
Gelatin silver print
24 x 19.2 cm
Vicki Gold Levi Collection,
New York

199 ★
*Hospital Emergencias : La Habana,
Calle Carlos III*
[Hospital Emergencies: Havana,
Calle Carlos III]
1948 (later print)
Gelatin silver print
44.5 x 35 cm
Fototeca de Cuba, Havana
Inv. EM-51

200
*José, el billetero. Plaza del Vapor,
La Habana*
[José the lottery ticket seller.
Plaza del Vapor, Havana]
1948
Gelatin silver print
23.4 x 29.7 cm
Fototeca de Cuba, Havana
Inv. EM-41

201
*Hagan juego. Casino Parisién,
La Habana*
[Placing Bets. Parisién Casino,
Havana]
1953
Gelatin silver print
18.2 x 24 cm
Fototeca de Cuba, Havana
Inv. EM-47

202
*Huésped en el Hotel Nacional.
La Habana*
[Guest at the Hotel Nacional,
Havana]
About 1950
Gelatin silver print
29.6 x 23.2 cm
Fototeca de Cuba, Havana
Inv. EM-48

203
Sepulturero. Cementerio de Colón,
La Habana
[Gravedigger. Colón Cemetery,
Havana]
1958
Gelatin silver print
28.7 x 23.2 cm
Fototeca de Cuba, Havana
Inv. EM-34

204 ★
Ama de casa. Marianao, La Habana
[Housekeeper. Marianao, Havana]
1952
Gelatin silver print
35.5 x 28 cm
Fototeca de Cuba, Havana
Inv. EM-52

205 ★
El Caballero de París. La Habana
["The Parisian Gentleman."
Havana]
1950
Gelatin silver print
35.5 x 28 cm
Fototeca de Cuba, Havana
Inv. EM-50

206–209
De la serie « Bar Rumba Palace »,
Playa de Marianao, La Habana
[From the series "Rumba Palace
Bar", Marianao Beach, Havana]
206
Prostitutas
[Prostitutes]
207
Sin título
[Untitled]
208
Bailarina
[Dancer]
209
El Chori con orquesta
[El Chori and His Orchestra]
1950
Gelatin silver prints
24 x 30 cm (each)
Fototeca de Cuba, Havana
Inv. EM-43; EM-44; EM-49; EM-45

210
Elecciones políticas, Calle Virtudes,
La Habana
[Voting Day, Calle Virtudes,
Havana]
1950
Gelatin silver print
27.5 x 34.9 cm
Fototeca de Cuba, Havana
Inv. EM-35

211 ★
Entierro de la Constitución. Fragua
Martiana de La Habana
[Burying the Constitution.
Martí Forge, Havana]
1952 (later print)
Gelatin silver print
30 x 40 cm
Fototeca de Cuba, Havana
Inv. EM-39

Santiago ARMADA (Chago)
Santiago de Cuba, 1937 –
Havana, 1995

302 ★
The Gulf Key
1967
India ink on bristol board
57.5 x 72.5 cm
Museo Nacional de Bellas Artes,
Havana
Inv. 93.1224

Not illustrated
Siempre la lengua
Serie "La chanson du condom"
[Always the Tongue
Series "The Condom Song"]
1969
Ink on bristol board
32.2 x 50.1 cm
Museo Nacional de Bellas Artes,
Havana
Inv. 93.1201

Estudio ARMAND
Armando HERNÁNDEZ LÓPEZ
Santa Clara, 1906 – Miami, 1992

p. 151
Olga Chaviano, star and lover of the
mafioso Norman Rothman
1950s
Gelatin silver print
22.7 x 18.1 cm
Vicki Gold Levi Collection,
New York

Belkis AYÓN
Havana, 1967 – Havana, 1999

376, 377
La sentencia no 1
[The Sentence No. 1]
La sentencia no 2
[The Sentence No. 2]
1993
Collographs on fine cardboard, 3/6,
2/6
92 x 67.5 cm
93 x 68 cm
Museo Nacional de Bellas Artes,
Havana
Inv. 93.1277; 93.1278

Juan AYÚS
Born in Havana in 1937
and
Alberto KORDA
Havana, 1928 – Paris, 2001

341
Comandante en Jefe: ¡Ordene!
[Commander-in-Chief: At your
Orders!]
1962
Poster. Offset
Published by the Unión de Jóvenes
Comunistas (UJC)
94.8 x 49.2 cm
Museo Nacional de Bellas Artes,
Havana
Inv. 76.2917

René AZCUY
Born in Havana in 1939

339 ★
Film poster for François Truffaut's
"Stolen Kisses"
1970
Poster. Silkscreen
Published by Instituto Cubano del
Arte e Industria Cinematográficos
(ICAIC)
76.5 x 50.8 cm
Museo Nacional de Bellas Artes,
Havana
Inv. 76.2543

Not illustrated
Testimonio
[Testimony]
1970
Poster. Silkscreen
Published by Instituto Cubano del
Arte e Industria Cinematográficos
(ICAIC)
76.2 x 50.8 cm
Museo Nacional de Bellas Artes,
Havana
Inv. 76.2902

B

Carleton BEALS
Medicine Lodge, Kansas, 1893 –
Killingworth, Connecticut, 1979

Not illustrated
"The Crime of Cuba"
1933
Original edition
31 black and white photographs by
Walker Evans
J.B. Lippincott, Philadelphia, 1933,
441 pages
22.5 x 15 cm
McGill University Librairies, Rare
Books and Special Collections,
Montreal
Inv. F 1787.B32

José BEDIA
Born in Havana in 1959

365 ★
El golpe del tiempo
[The Blow of Time]
1986 (version for MNBA 1991)
Installation: acrylic, Masonite,
wood, earth, stones, vegetable
fibre, fabric
300 x 401 x 69 cm
Museo Nacional de Bellas Artes,
Havana
Inv. 91.1072

367
Afluente
[Affluent]
1980
Acrylic, photographs, wood arrows,
feather on canvas
121 x 200 cm
Museo Nacional de Bellas Artes,
Havana
Inv. 95.784

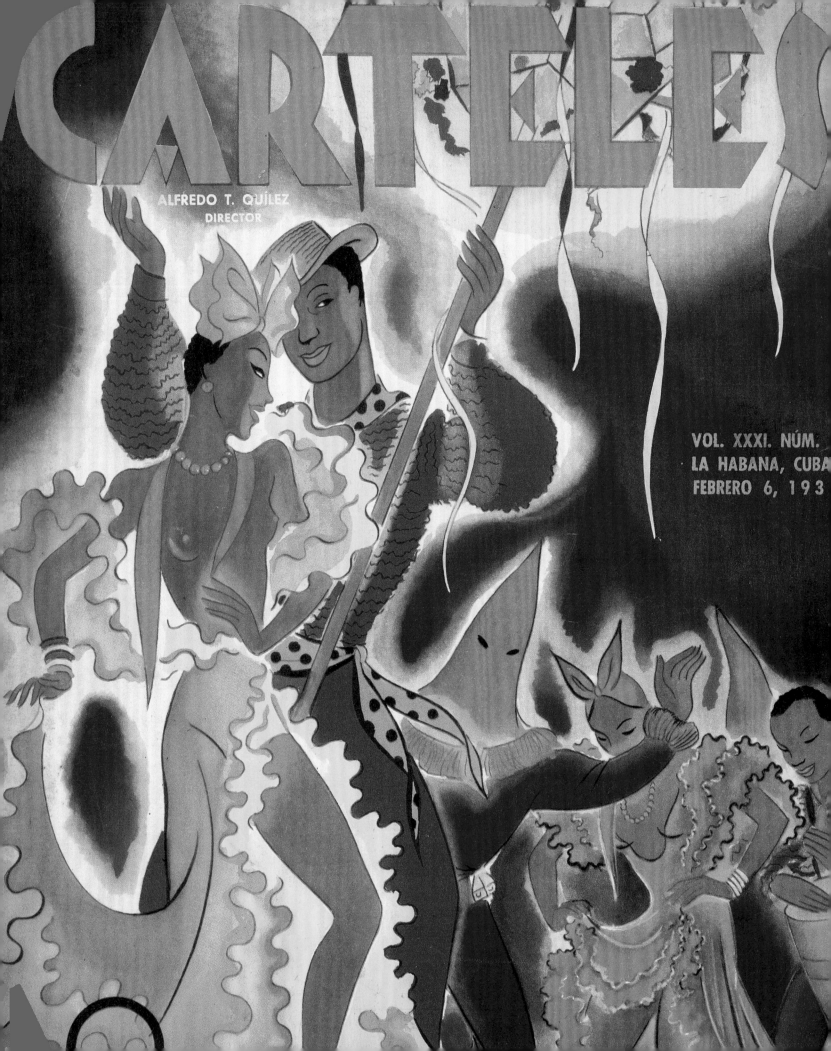

CARTELES

ALFREDO T. QUÍLEZ
DIRECTOR

VOL. XXXI. NÚM.
LA HABANA, CUBA
FEBRERO 6, 193

Félix BELTRÁN
Born in Havana in 1938

344
Otras manos empuñarán las armas
[Other Hands Will Take Up Arms]
1969
Poster. Silkscreen on cardboard
Published by Instituto Cubano del
Amistad con los Pueblos
54.7 x 33.3 cm
The Montreal Museum of Fine Arts
Gift in memory of Vera J. Bala
Inv. 2002.21

354
Clik. Ahorro de electricidad es
ahorro de petróleo
[Click. Saving Electricity Saves Oil]
1968
Poster. Silkscreen on cardboard
Published by Instituto Cubano del
Petróleo, Havana
54.7 x 33.3 cm
The Montreal Museum of Fine Arts
Gift in memory of Vera J. Bala
Inv. 2002.30

Cundo BERMÚDEZ
Born in Havana in 1914

230
El balcón
[The Balcony]
1941
Oil on canvas
73.7 x 58.7 cm
The Museum of Modern Art,
New York
Gift of Edgar Kaufmann, Jr., 1942
Inv. 644.1942

231
Barbería
[Barber Shop]
1942
Oil on canvas
63.8 x 53.7 cm
The Museum of Modern Art,
New York
Inter-American Fund, 1944
Inv. 68.1944

Rafael BLANCO
Havana, 1885 – Havana, 1955

133
La toga viril
[The Virile Toga]
1944
Oil on canvas
56 x 76 cm
Museo Nacional de Bellas Artes,
Havana
Inv. 90.2547

Joaquín BLEZ
Santiago de Cuba, 1886 – Havana,
1974

3
Peasants with General Molinet,
Chaparra Sugar Mill
About 1910
Gelatin silver print
14.7 x 19.5 cm
Fototeca de Cuba, Havana
Inv. EM-22

10
President Mario García Menocal
About 1913
Toned gelatin silver print
35.6 x 28 cm
Fototeca de Cuba, Havana
Inv. EM-14

11
President Alfredo Zayas
About 1921
Toned gelatin silver print
33.6 x 26.4 cm
Fototeca de Cuba, Havana
Inv. EM-13

80
Lidia Dotres
About 1930
Toned gelatin silver print
34.7 x 27.2 cm
Fototeca de Cuba, Havana
Inv. EM-10

81 ★
Untitled. Havana
About 1920
Transparent oil on photographic
paper
33 x 25.3 cm
Fototeca de Cuba,
Collection Joaquín Blez, Havana
Inv. R 86-675

82
Nude
About 1920
Toned gelatin silver print
25.3 x 20.3 cm
Fototeca de Cuba, Havana
Inv. EM-5

84 ★
Nude, Havana
1920 (posthumous print from an
original negative)
Gelatin silver print
35.5 x 27.8 cm
Fototeca de Cuba, Havana

85
Nude
About 1920
Toned gelatin silver print
22.9 x 16.7 cm
Fototeca de Cuba, Havana
Inv. EM-6

86
Odalisque
1926
Toned gelatin silver print
25.9 x 33.2 cm
Fototeca de Cuba, Havana
Inv. EM-15

87
Facundo Bacardí, Jr.
About 1920
Toned gelatin silver print
35.4 x 27.9 cm
Fototeca de Cuba, Havana
Inv. EM-12

88
Blez's photo studio
About 1950
Gelatin silver print
20.2 x 23 cm
Fototeca de Cuba, Havana
Inv. EM-17

89
President Gerardo Machado
About 1925
Toned gelatin silver print
25.8 x 20.3 cm
Fototeca de Cuba, Havana
Inv. EM-11

Not illustrated
Lidia Dotres
About 1930
Toned gelatin silver print
34.2 x 27.5 cm
Fototeca de Cuba, Havana
Inv. EM-8

Not illustrated
Lidia Dotres
About 1930
Toned gelatin silver print
34.3 x 27.3 cm
Fototeca de Cuba, Havana
Inv. EM-9

Juana BORRERO
Havana, 1877 – Key West,
Florida, 1896

40 ★
Pilluelos
[Urchins]
1896
Oil on canvas
76 x 52.5 cm
Museo Nacional de Bellas Artes,
Havana
Inv. 84.69

Ricardo BREY
Born in Havana in 1955

366
La estructura de los mitos
[The Structure of Myths]
1984
Oil, collage on canvas
120 x 202 cm
Museo Nacional de Bellas Artes,
Havana
Inv. 88.286

Tania BRUGUERA
Born in Havana in 1968

408
Autobiografía (Versión Dentro de
Cuba)
[Autobiography (Version in Cuba)]
2003
Installation: 2 Soviet speakers of
the 1970s, security guard, wood
platform, unplugged microphone,
8 subwoofers, 3 unfinished
plasterboard walls, spotlight,
soundtrack
Various dimensions
Running time of soundtrack:
60 min
Collection Daros Latinamerica,
Zurich, Switzerland

Andrés GARCÍA BENÍTEZ, *Cover of the magazine "Carteles,"* February 1938

C

Servando CABRERA MORENO
Havana, 1923 – Havana, 1981

312 ★
Milicias Campesinas
[Peasant Militia]
1961
Oil on canvas
140.5 x 201 cm
Museo Nacional de Bellas Artes,
Havana
Inv. 2423

313
Tiempo Joven
[Youthful Days]
1973
Oil on canvas
76.5 x 153 cm
Museo Nacional de Bellas Artes,
Havana
Inv. R 73.44

314
Puro
[Pure]
1979
Oil on canvas
102 x 82.5 cm
Museo Nacional de Bellas Artes,
Havana
Inv. 92.28

Panchito CANO

171
*Marines having a good time,
Santiago de Cuba*
1945
Gelatin silver print
23.5 x 19.5 cm
Vicki Gold Levi Collection,
New York

Los CARPINTEROS
Active in Havana since 1991

Alexandre ARRECHEA
Born in Las Villas in 1970
and
Marco CASTILLO
Born in Camagüey in 1971
and
Dagoberto RODRIGUEZ
Born in Villa Clara in 1969

402
Horno de Carbón
[Coal Oven]
1998
Watercolour, pencil, coloured
pencil on paper
219.1 x 130.2 cm
The Museum of Modern Art,
New York
Gift of Dean Valentine and Amy
Adelson, New York, 2003
Inv. 439.2002

403
Estuche
[Jewellery Case]
1999
Wood
225.1 x 129.9 x 129.9 cm
Private collection
Courtesy of the Sean Kelly Gallery,
New York

Mario CARREÑO
Havana, 1913 – Santiago, Chile,
1999

143
El ciclón o Tornado
[Cyclone, or Tornado]
1941
Oil on canvas
78.8 x 104.1 cm
The Museum of Modern Art,
New York
Inter-American Fund, 1944
Inv. 657.1942

217 ★
*El nacimiento de las naciones
americanas*
[The Birth of the American
Nations]
1940
Oil on canvas
146 x 199 cm
Museo Nacional de Bellas Artes,
Havana
Inv. 07-335

218
Descubrimiento de las Antillas
[Discovery of the Caribbean]
1940
Oil on canvas
95.5 x 119 cm
Museo Nacional de Bellas Artes,
Havana
Inv. 73.172

226
Los cortadores de caña
[Sugar-cane Cutters]
1943
Duco on wood
164 x 122 cm
Isaac, Carmen Lif and family
collection, Santo Domingo,
Dominican Republic

229
Interior
1943
Oil on canvas
63.5 x 76 cm
Museo Nacional de Bellas Artes,
Havana
Inv. 1048

Luis CASTAÑEDA
Born in Havana in 1943

325
Group photo, Havana
1967
Gelatin silver print
17.4 x 27 cm
Private collection, Paris
Courtesy of Günter Schütz

332
*View from above of artists working
on the Salón de Mayo Mural*
1967
Gelatin silver print
14.7 x 27.2 cm
Private collection, Paris
Courtesy of Günter Schütz

Manuel CASTELLANOS
Born in Sancti Spíritus in 1949

303
La marcha del pueblo combatiente
[A Combatant People on the
March]
1980
Pencil, watercolour on cardboard
29.5 x 69 cm
Museo Nacional de Bellas Artes,
Havana
Inv. 81.512

Esteban CHARTRAND
Limonar, Matanzas, 1840 –
New York, 1883

41 ★
Paisaje Marino
[Seascape]
1877
Oil on canvas
64.5 x 127 cm
Museo Nacional de Bellas Artes,
Havana
Inv. 06.99

51
Vista del central Tinguaro no. 2
[View of the Tinguaro Sugar Mill,
No. 2]
1874
Oil on canvas
43.5 x 74 cm
Museo Nacional de Bellas Artes,
Havana
Inv. 1.121

52
*Vista del central Tinguaro no. 1.
Casa de Calderas*
[View of the Tinguaro Sugar Mill,
No. 1–Boiler House]
1874
Oil on canvas
53.5 x 92 cm
Museo Nacional de Bellas Artes,
Havana
Inv. 1.122

53 ★
Cimarrones
[The Runaways]
1880
Oil on canvas
54 x 91.4 cm
Isaac, Carmen Lif and family
collection, Santo Domingo,
Dominican Republic

Fernando CHAVIANO

213 ★
*De la serie « Afrenta al Apóstol José
Martí »* [Parque Central de
La Habana]
Sin título
[From the series "Insult to the
Statue of José Martí" (Parque
Central, La Habana)]
Untitled
1949
Gelatin silver print
35.2 x 28.2 cm
Archivo de FotoCreart, Ministry of
Culture, Havana

Luc CHESSEX
Born in Lausanne, Switzerland, in 1936

p. 21
4. *Portrait of Bernard Rancillac Wearing a Hat*
1967
Gelatin silver print
17 x 25 cm
Private collection, Paris
Courtesy of Günter Schütz

5. *Edmund Alleyn at work*
1967
Gelatin silver print
19.2 x 23.1 cm
Private collection, Montreal

Estudio COHNER
Samuel Alejandro COHNER
Washington, D.C., 1833 – Havana, 1869

32
Tobacco Sorting
About 1895
Toned gelatin silver print
14.9 x 20.4 cm
Fototeca de Cuba, Havana
Inv. EM-24

Guillermo COLLAZO
Santiago de Cuba, 1850 – Paris, 1896

56 ★
La siesta
[The Siesta]
1886
Oil on canvas
66 x 83.5 cm
Museo Nacional de Bellas Artes, Havana
Gift of Susana de Cárdenas, 1955
Inv. 96.640

Hugo CONSUEGRA
Havana, 1929 – Rego Park, New York, 2003

266 ★
Antropofagía o Frente a Babilonia
[Cannibalism, or Opposite Babylon]
1960
Oil on canvas
130 x 100 cm
Museo Nacional de Bellas Artes, Havana
Inv. 2435

Guillaume CORNEILLE
Born in Liège, Belgium, in 1922

326
Street mural by children
1967
Gelatin silver print
16.5 x 24.8 cm
Private collection, Paris
Courtesy of Günter Schütz

Raúl CORRALES
Ciego de Ávila, 1925 – Havana, 2006

216
Indigentes
[Indigents]
1954
Gelatin silver print
17 x 24 cm
Vicki Gold Levi Collection, New York

275
Milicianos en el Malecón
[Militia on the Malecón]
1960 (modern print)
Gelatin silver print
27.9 x 35.6 cm
Collection of the artist
Courtesy of the Couturier Gallery, Los Angeles

276
La caballería
[Cavalry]
1960 (modern print)
Gelatin silver print, 4/6
30 x 40 cm
Collection of the artist
Courtesy of the Couturier Gallery, Los Angeles

278
Sombreritos, La Habana
[Hats, Havana]
1960 (modern print)
Gelatin silver print
30 x 40 cm
Collection of the artist
Courtesy of the Couturier Gallery, Los Angeles

281
Tumbadora, Santo Domingo, Las Villas
De la serie "La banda del Nuevo ritmo"
[Conga, Santo Domingo, Las Villas From the series "The New Rhythm Band"]
1962 (modern print)
Gelatin silver print
40 x 30 cm
Collection of the artist
Courtesy of the Couturier Gallery, Los Angeles

289
First Havana Declaration, Plaza de la Revolución, Havana, September 2, 1960
1960 (modern print)
Gelatin silver print
30 x 40 cm
Collection of the artist
Courtesy of the Couturier Gallery, Los Angeles

Not illustrated
La pesadilla, Caracas, Venezuela
[The Nightmare, Caracas, Venezuela]
About 1959 (modern print)
Gelatin silver print
40 x 30 cm
Collection of the artist
Courtesy of Couturier Gallery, Los Angeles

Not illustrated
El sueño, Caracas, Venezuela
[The Dream, Caracas, Venezuela]
1959 (modern print)
Gelatin silver print
40 x 30 cm
Collection of the artist
Courtesy of Couturier Gallery, Los Angeles

Cuba Collective, Salón de Mayo

334
"Cuba colectiva" Mural
1967
Oil on canvas
501 x 1083 cm (6 panels)
Museo Nacional de Bellas Artes, Havana
Inv. T.9045.0-5

Cuban participants:
Eduardo Abela (painter), Roberto Álvarez Ríos (painter), Jesús de Armas (caricaturist), Arístide (caricaturist), Ávila (caricaturist), Juan Boza (painter), Jorge Camacho (painter), Agustín Cárdenas (sculptor), Jorge Carruana (humorist) with Oscar Hurtado (writer), Salvador Corratge (painter), Santiago Armada (Chago) (caricaturist), Sandu Darie (painter), Juan David (caricaturist) with Rego, Roberto Estopiñán (sculptor), Pablo Armando Fernández (writer), Fernando Luis (painter), Carlos Franqui (writer) with Gherasim Luca, Fuentes (?), Mario Gallardo (painter), Guerrero (caricaturist), Fayad Jamis (painter and poet), Roberto Fernández Retamar (writer), Wifredo Lam (painter), César Leal (painter), Raúl Martínez (painter), José Masiques (painter), Ruperto Jay Matamoros (painter), Tomás Marais (painter), René de la Nuez (caricaturist), Tomás Oliva (sculptor), Lisandro Otero (writer), Heberto Padilla (writer) with Lou Laurin, Amelia Peláez (painter), Domingo Ravenet (painter), Mariano Rodríguez (painter), René Portocarrero (painter), Loló Soldevilla (painter), Pablo Toscano (painter), Luis Miguel Valdés (art student), Antonio Vidal (painter), anonymous (caricaturist), Haidée Santamaría, a Cuban child, a carpenter, a space reserved for Fidel Castro

International participants:
Eduardo Arroyo, Valerio Adami, Antonio Recalcati, Bernard Rancillac, Anick Siné, Piotr Kowalski, Irene Domínguez, Peter Weiss, Gudmundur Erro, Pierre Golendorf, Gilles Aillaud, José Pierre, L. Delfino, K. Carol, Michel Leiris, Ansgar Elde, Jean Messagier, Gillet, Aedmundo, Alleyn, Hiquily, Ezio Gribando, M. Dulloc, Fuentes, Lourdes Castro, Cesare Peverelli, Félix Labisse, Gunilla Palmstierna-Weiss, Roland Penrose, Gili Gheerbrant, Micheline Catti, Juan Goytisolo, Rene Bertholo, Jacques Monory, Couturier, Paul Rebeyrolle, Edward Lucie Smith, Gerald Gassiot-Talabot, Jean Jacques Leveque, Michel Ragon, Marc de Rosny, Lucien Coutaud, Luigi Carluccio et Denys Chevalier, Lütfi Özkök, Alain Jouffroy, Corneille, George Limbour, Maurice Nadeau, Albert Bitran, Ivon Taillandier y Szeeman

Arturo CUENCA
Born in Holguín in 1955

392
Ciencia e ideología
[Science and Ideology]
1988
Diptych: acrylic on canvas
Overall dimensions: 160 x 120 cm
Museo Nacional de Bellas Artes,
Havana
Inv. 89.1237, 89.1237.1

D

Sandu DARIE
Romania, 1906 – Havana, 1991

268 ★
Dinamismo espacial (triptico vertical)
[Spatial Dynamism (Vertical Triptych)]
Second half of the 1950s
Oil on Masonite
107 x 107 cm
75.5 x 76 cm
107 x 107 cm
Museo Nacional de Bellas Artes,
Havana
Inv. 07.429; 07.430; 07.428

E

EDDO

p. 372
Students rioting over the killing of the student Carlos Martinez. Calle San Lázaro and Belascoaín
1947
Gelatin silver print
20 x 25 cm
Vicki Gold Levi Collection,
New York

Gilles EHRMANN
Metz, Lorraine, 1928 – Paris, 2005

329
Wifredo Lam begins work on the spiral in the Salón de Mayo Mural
1967
Gelatin silver print
30 x 20.1 cm
Private collection, Paris
Courtesy of Günter Schütz

Antonia EIRIZ
Havana, 1929 – Miami, 1995

315
Una tribuna para la paz democrática
[A Tribune for Democratic Peace]
1968
Installation: oil and collage on canvas to be placed in front of folding chairs
Various dimensions
Painting: 220 x 250,5 cm
Museo Nacional de Bellas Artes,
Havana
Inv. 89.1533

Juan Francisco ELSO
Havana, 1956 – Havana, 1988

360 ★
Por América (José Martí)
[For the Americas (José Martí)]
1986
Installation: wood, plaster, earth, pigment, synthetic hair, glass
144.2 x 43.8 x 46.4 cmv
Hirshhorn Museum and Sculpture Garden, Smithsonian Institution,
Washington D.C.
Joseph H. Hirshhorn, Purchase Fund, 1988
Inv. 98.15

José A. ENGUITA

p. 364
The Malecón in the Summer, Havana
1956
Gelatin silver print
18.8 x 24.3 cm
Vicki Gold Levi Collection, New York

Carlos ENRÍQUEZ
Zulueta, 1900 – Havana, 1957

124 ★
El rapto de las mulatas
[The Abduction of the Mulatto Women]
1938
Oil on canvas
162.5 x 114.5 cm
Museo Nacional de Bellas Artes,
Havana
Inv. 07.269

138
Mujer en el balcón
[Woman on the Balcony]
n.d.
Oil on wood
52.5 x 35.5 cm
Museo Nacional de Bellas Artes,
Havana
Inv. 0-310

141
Bueyes
[Oxen]
1935
Oil on canvas
71.5 x 56 cm
Museo Nacional de Bellas Artes,
Havana
Inv. 07.275

142 ★
Campesinos felices
[Happy Peasants]
1938
Oil on canvas
122 x 89.5 cm
Museo Nacional de Bellas Artes,
Havana
Inv. 07.267

144
Virgen del Cobre
[Virgin of El Cobre]
About 1933
Oil on canvas
72.5 x 60 cm
Museo Nacional de Bellas Artes,
Havana
Inv. 07.272

145
Sin título
[Untitled]
1937
Oil on canvas
122 x 89 cm
Museo Nacional de Bellas Artes,
Havana
Inv. 85.19

Tomás ESSON REID
Born in Havana in 1963
and
Carlos RODRIGUEZ CÁRDENAS
Born in Sancti Spiritus in 1962

380 ★
¡Viva Cuba libre!
[Long Live Free Cuba!]
1989
Oil on canvas
200 x 200 cm
Sammlung Ludwig – Ludwig Forum für Internationale Kunst,
Aachen, Germany
Inv. 2651

Carlos Alberto ESTÉVEZ
Born in Havana in 1969

400 ★
La verdadera historia universal
[The True History of the World]
1995
Installation: mixed media (carved and polychromed wood, fabric)
Various dimensions
Museo Nacional de Bellas Artes,
Havana
Inv. T-526

Walker EVANS
Saint Louis, Missouri, 1903 –
New Haven, Connecticut, 1975

78
*Press clipping from the archives of a
Havana newspaper photographed by
Evans*
*Headline: "The Young González
Rubiera Shot Dead as Flight Law
Enforced"*
n.d.
Negative
16.5 x 21.6 cm
The Metropolitan Museum of Art,
Walker Evans Archive, New York,
1994
Inv. 1994.256.131

79
*Photograph by Fernando Lezcano
Miranda (Havana, 1905 – Havana,
1949) from the archives of a Havana
newspaper reproduced as
anonymous in Carleton Beals's "The
Crime of Cuba"*
Two Men Fighting on Street, Havana
n.d.
Negative
20.3 x 25.4 cm
The Metropolitan Museum of Art,
Walker Evans Archive, New York,
1994
Inv. 1994.258.279

90
*Coal dockworker with cigarette,
Havana*
No. 79 from the book "The Crime
of Cuba"
1933
Negative
21.6 x 16.5 cm
The Metropolitan Museum of Art,
Walker Evans Archive, New York,
1994
Inv. 1994.256.660

91
*Coal dockworkers at the port,
Havana*
1933
Negative
16.5 x 21.6 cm
The Metropolitan Museum of Art,
Walker Evans Archive, New York,
1994
Inv. 1994.256.24

92
Havana policemen
1933
Negative
10.8 x 6.4 cm
The Metropolitan Museum of Art,
Walker Evans Archive, New York,
1994
Inv. 1994.251.721

93
*Candy vendor, selling caramels
("piruli"), Havana*
1933
Negative
10.8 x 6.4 cm
The Metropolitan Museum of Art,
Walker Evans Archive, New York,
1994
Inv. 1994.251.684

94
Beggar seated on street, Havana
1933
Negative
10.8 x 6.4 cm
The Metropolitan Museum of Art,
Walker Evans Archive, New York,
1994
Inv. 1994.251.745

95
Woman in a courtyard, Havana
No. 44 from the book "The Crime
of Cuba"
1933
Negative
10.8 x 6.4 cm
The Metropolitan Museum of Art,
Walker Evans Archive, New York,
1994
Inv. 1994.251.714

96
Señorita at a café, Havana
1933
Negative
10.8 x 6.4 cm
The Metropolitan Museum of Art,
Walker Evans Archive, New York,
1994
Inv. 1994.251.704

97
Citizen in downtown Havana
No. 85 from the book "The Crime
of Cuba"
1933
Gelatin silver print
24 x 13.4 cm
The Metropolitan Museum of Art,
Walker Evans Archive, New York
Gift of Lincoln Kirstein, 1952
Inv. 52.562.2

98
Cobbler posing, Havana
1933
Negative
10.8 x 6.4 cm
The Metropolitan Museum of Art,
Walker Evans Archive, New York,
1994
Inv. 1994.251.682

99
Woman standing on street
1933
Negative
10.8 x 6.4 cm
The Metropolitan Museum of Art,
Walker Evans Archive, New York,
1994
Inv. 1994.251.712

100
Village general store
1933
Negative
16.5 x 21.6 cm
The Metropolitan Museum of Art,
Walker Evans Archive, New York,
1994
Inv. 1994.256.658

101
*Cinema showing "Six Hours to Live,"
Havana*
No. 33 from the book "The Crime
of Cuba"
1933
Negative
16.5 x 21..6 cm
The Metropolitan Museum of Art,
Walker Evans Archive, New York,
1994
Inv. 1994.256.67

102
*Mother and children in doorway,
Havana*
1933
Gelatin silver print
9.8 x 16.8 cm
The Metropolitan Museum of Art,
Walker Evans Archive, New York
Gift of Arnold H. Crane, 1971
Inv. 1971.646.9

103
*People in downtown Havana.
Shoeshine newsstand*
No. 82 from the book "The Crime
of Cuba"
1933
Negative
6.4 x 10.8 cm
The Metropolitan Museum of Art,
Walker Evans Archive, New York,
1994
Inv. 1994.251.541

104
*Shanties with church in distance,
outskirts of Havana*
1933
Negative
6.4 x 10.8 cm
The Metropolitan Museum of Art,
Walker Evans Archive, New York,
1994
Inv. 1994.251.797

105
*Shanties in village, outskirts of
Havana*
No. 92 from the book "The Crime
of Cuba"
1933
Negative
6.4 x 10.8 cm
The Metropolitan Museum of Art,
Walker Evans Archive, New York,
1994
Inv. 1994.251.801

106
*Woman behind barred window,
Havana*
No. 40 from the book "The Crime
of Cuba"
1933
Negative
21.6 x 16.5 cm
The Metropolitan Museum of Art,
Walker Evans Archive, New York,
1994
Inv. 1994.256.260

107
Housefront, Havana
1933
Negative
10.8 x 6.4 cm
The Metropolitan Museum of Art,
Walker Evans Archive, New York,
1994
Inv. 1994.251.646

108
Man on crutches, Havana
1933
Gelatin silver print
24.5 x 18.3 cm
The Metropolitan Museum of Art,
Walker Evans Archive, New York
Anonymous gift, 1999
Inv. 1999.246.45

109
*Havana street, newsboys waiting for
the paper*
No. 80 from the book "The Crime
of Cuba"
1933
Negative
10.8 x 6.4 cm
The Metropolitan Museum of Art,
Walker Evans Archive, New York,
1994
Inv. 1994.251.696

110
Girl behind barred window, Havana
1933
Gelatin silver print
14.8 x 22.9 cm
The Metropolitan Museum of Art,
Walker Evans Archive, New York
Gift of Lincoln Kirstein, 1952
Inv. 52.562.3

111
*People waiting for food rations,
Havana*
1933
Negative
6.4 x 10.8 cm
The Metropolitan Museum of Art,
Walker Evans Archive, New York,
1994
Inv. 1994.251.654

112
Photograph in the archives of a
Havana newspaper reproduced as
anonymous in Carleton Beals's
"The Crime of Cuba"
*The corpse of González Rubiera on
the ground with blood-stained face,
Havana*
n.d.
Negative
15.9 x 22.9 cm
The Metropolitan Museum of Art,
Walker Evans Archive, New York,
1994
Inv. 1994.257.97

113
Photograph in the archives of a
Havana newspaper reproduced as
anonymous in Carleton Beals's
"The Crime of Cuba"
*Wall Writing: "Down with the
imperialist war, Communist P[arty]"*
n.d.
Negative
6.4 x 10.8 cm
The Metropolitan Museum of Art,
Walker Evans Archive, New York,
1994
Inv. 1994.251.784

p. 369, 377
*Cinema entrance with movie poster
"Un adiós a las armas"* [A Farewell
to Arms], *Havana* (details)
1933
Gelatin silver print
15.2 x 24 cm
The Metropolitan Museum of Art,
New York
Gift of Arnold H. Crane, 1972
Inv. 1972.742.15

Not illustrated
People in Downtown Havana
1933
Gelatin silver print
15 x 22.8 cm
The Metropolitan Museum of Art,
New York
Gift of Lincoln Kirstein, 1952
Inv. 52.562.7

Not illustrated
Cinema Showing "Six Hours to Live"
1933, printed about 1970
Gelatin silver print
16.2 x 21.2 cm
The Metropolitan Museum of Art,
New York
Gift of Arnold H. Crane, 1971
Inv. 1971.646.12

Not illustrated
Coal Dock Workers, Havana
1933
Gelatin silver print
12.7 x 17.7 cm
The Metropolitan Museum of Art,
New York
Purchase, The Horace W.
Goldsmith Foundation
Gift through Joyce and Robert
Menschel, 1990
Inv. 1990.1143

F

**Antonio Eligio FERNÁNDEZ
(Tonel)**
Born in Havana in 1958

384
Dos Cubas
[Two "Cubas"]
1990
Ink and tempera on cardboard
54.2 x 79 cm
Museo Nacional de Bellas Artes,
Havana
Inv. 91.1156

385
Cuba
[Cuba (Bucket)]
1991
Ink and tempera on cardboard
54.8 x 77.9 cm
Museo Nacional de Bellas Artes,
Havana
Inv. 91.1156

386
"El bloqueo"
[The Blockade]

Installation: 99 concrete blocks,
cement, sand, wire
1989
250 x 850 x 10 cm
Museo Nacional de Bellas Artes,
Havana
Inv. 91.1156

Photo and plan of the installation
"El bloqueo" [The Blockade] ★
1992
Collection of the artist

Arístides FERNÁNDEZ
Güines, 1904 – Havana, 1934

139 ★
El batey
[The Sugar Mill]
About 1933
Oil on canvas
60.5 x 53 cm
Museo Nacional de Bellas Artes,
Havana
Inv. 73.30

Ernesto FERNÁNDEZ NOGUERAS
Born in Havana in 1939

212
*Statue of Martí during construction
at the Plaza Cívica, Havana*
1957 (artist's print)
Gelatin silver print
40 x 50 cm
Collection of the artist
Courtesy of the Fototeca de Cuba,
Havana

Antonio FERNÁNDEZ REBOIRO
Born in Nuevitas, Camagüez, in
1935

337 ★
*Film poster for Masaki Kobayashi's
"Harakiri"*
1964
Silkscreen
76.2 x 50.8 cm
Museo Nacional de Bellas Artes,
Havana
Inv. 76.2470

356 ★
*Film poster for Sergio Giral's
"The Other Francisco"*
1975
Silkscreen
76 x 50 cm
Cinémathèque québécoise,
Montreal
Inv. 1996.0023.AF

Andrés GARCÍA BENÍTEZ, *Cover of the magazine "Carteles,"* May 1937

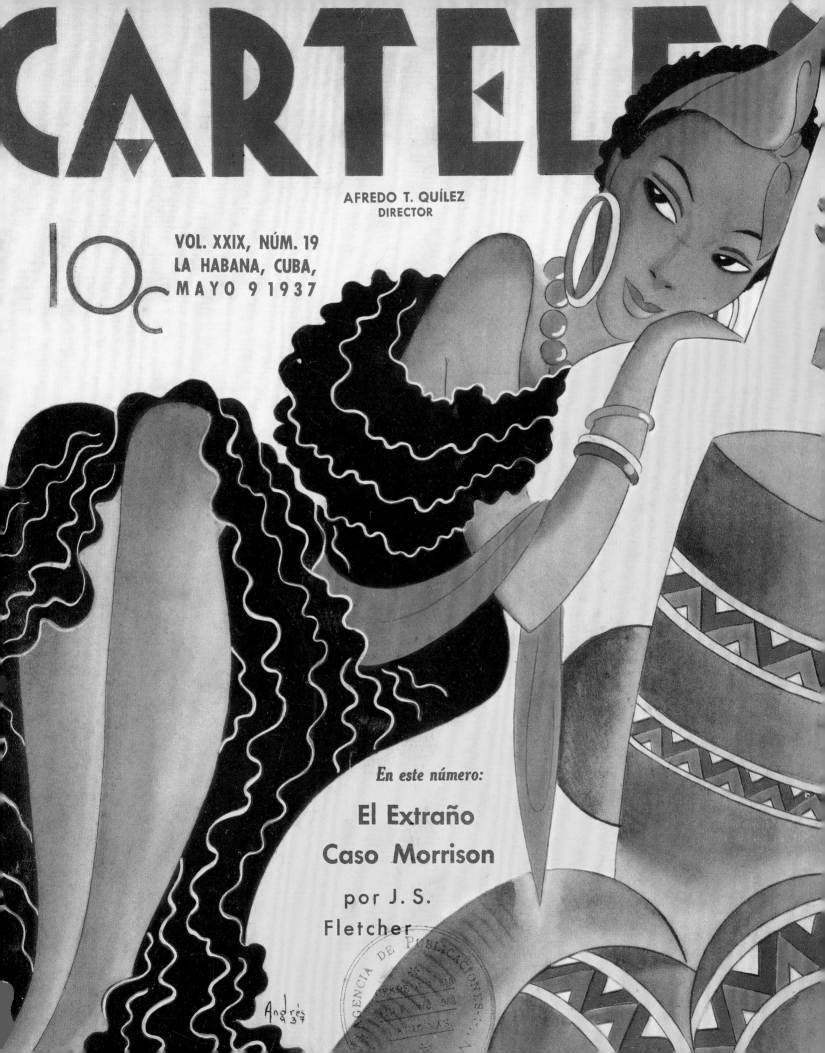

357 ★
*Film poster for Humberto Solás's
"Cecilia"*
1982
Silkscreen
76 x 50 cm
Cinémathèque québécoise,
Montreal
Inv. 1996.0059.AF

José Alberto FIGUEROA
Born in Havana in 1946

298 ★
El Vedado
1991
Gelatin silver print
30.5 x 40.6 cm
Collection of Darrel Couturier,
Los Angeles

387 ★
Rafter
1994
Gelatin silver print
40.6 x 30.5 cm
Collection of Darrel Couturier,
Los Angeles

388 ★
*Spanish Homenaje
De la serie "Proyecto Habana"*
[Tribute
From the series "Havana Project"]
1993
Gelatin silver print,
edition 6/29/02-2
35.6 x 27.9 cm
Collection of Darrel Couturier,
Los Angeles

p. 307
Calle Carlos III, Havana
1988
Gelatin silver print
30.5 x 40.6 cm
Collection of Darrel Couturier,
Los Angeles

Jesús FORJANS
Born in Havana in 1928

349
*Jornada de solidaridad con
Zimbabwe. 17 de marzo*
[Day of Solidarity with Zimbabwe.
March 17]
1969
Poster. Offset
Published by OSPAAAL
53.5 x 33 cm
Museo Nacional de Bellas Artes,
Havana
Inv. 76.2520

José Manuel FORS
Born in Havana in 1956

364
Homenaje a un silvicultor
[Tribute to a Silviculturist]
1984
Manipulated photograph
96.5 x 121.5 cm
Museo Nacional de Bellas Artes,
Havana
Inv. 91.657

Gilberto FRÓMETA
Born in Havana in 1946

304, 305
*Cuando de gobiernos se trate, este
lema siempre tendrá vigencia,
aunque quede sólo uno de nosotros
vivo*
[When it Comes to Governments,
This Slogan Will Always Hold True,
Even if Only One of Us Is Left
Standing]
1975
Diptych: photoengravings on
cardboard
50 x 75.5 cm each
Museo Nacional de Bellas Artes,
Havana
Inv. 75.126

G

L. Adele GALLO
Chile, 1908 – Havana, 1984

333
*The finished Salón de Mayo Mural
on site at the Cuban pavilion*
1967
Colour photograph
20 x 25 cm
Private collection, Paris
Courtesy of Günter Schütz

Carlos GARAICOA
Born in Havana in 1967

410 ★
*De cómo la tierra se quiere parecer
al cielo (II)*
[How the Earth Wants to Be Like
the Sky (II)]
2005
Installation: metal, light
Various dimensions
Courtesy of the Galleria Continua,
San Gimignano/Beijing

411
Ahora juguemos a desaparecer (II)
[Now Let's Play Disappear (II)]
2002
Installation: metal table, candles,
wire, closed-circuit projection
100 x 250 x 350 cm
Courtesy of the Galleria Continua,
San Gimignano / Beijing

Not illustrated
La habitación de mi negatividad II
[The Room of My Negativity II]
2005
3D animation transferred to video
Running time : 43 min. 42 sec.
Museo Nacional de Bellas Artes,
Havana
Inv. 06.33.1

Víctor Manuel GARCÍA
Havana, 1897 – Havana, 1969

126
Dos mujeres y paisaje
[Two Women and Landscape]
n.d.
Oil on canvas
64.5 x 65.5 cm
Museo Nacional de Bellas Artes,
Havana
Inv. 80.700

140
Desahucio
[Eviction]
n.d.
Oil on cardboard
45.5 x 38 cm
Museo Nacional de Bellas Artes,
Havana
Inv. 76.1616

Andrés GARCÍA BENÍTEZ
Holguín, 1916 – Holguín, 1981

Covers of the magazine "Carteles"
Vicki Gold Levi Collection,
New York

119
Illustration: G. Ferrer
Vol. 19, No. 32, August 6, 1933
32.2 x 24.8 cm

120
Illustration: not signed
Vol. 19, No. 34, August 20, 1933
32.2 x 25 cm

122
Illustration: Rodriguez Radillo
Vol. 24, No. 33, August 18, 1935
32 x 25 cm

123
Vol. 28, No. 43, October 25, 1936
31.4 x 24.5 cm

p. 391
Vol. 31, No. 29, July 17, 1938
32.2 x 25 cm

p. 394
Vol. 31, No. 6, February 6, 1938
32.3 x 25 cm

p. 401
Vol. 29, No. 19, May 9, 1937
32.1 x 25.2 cm

p. 406
Vol. 31, No. 28, July 10, 1938
32.2 x 24.9 cm

p. 411
Vol. 34 No. 34, August 20, 1939
32.3 x 25 cm

p. 419
Vol. 33, No. 21, May 21, 1939
32 x 25.1 cm

Mario GARCÍA JOYA
Born in Santa María del Rosario
in 1938

273
Somos Cubanos
[We are Cuban]
1959 (artist's print)
Gelatin silver print
35.7 x 26.4 cm
Fototeca de Cuba, Havana

274
Untitled, Havana
About 1960 (recent print)
Gelatin silver print
35.5 x 27.9 cm
Collection of the artist, Miami

Not illustrated
Comandante en Jefe, La Habana
[Commander-in-Chief, Havana]
1963 (artist's print)
Gelatin silver print
35.5 x 25.9 cm
Fototeca de Cuba, Havana

Armando GARCÍA MENOCAL
Havana, 1863 – Havana, 1942

68 ★
Embarque de Colón por Bobadilla
[Bobadilla Sending Off Columbus]
1893
Oil on canvas
309 x 464 cm
Museo Nacional de Bellas Artes,
Havana
Inv. 07.66

70
Nocturno en la bahía
[Nighttime at the Bay]
About 1930
Oil on canvas
77 x 101 cm
Museo Nacional de Bellas Artes,
Havana
Inv. 95.1189

71
Carga al machete (boceto)
[Oil sketch for *Charge of the
Machetes*]
About 1896
Oil on canvas
40.5 x 61 cm
Museo Nacional de Bellas Artes,
Havana
Inv.1.163

Augusto GARCÍA MENOCAL
Havana, 1899 – Havana, 1974

69
No quiero ir al cielo
[I Don't Want to Go to Heaven]
1930
Oil on canvas
200.5 x 180.5 cm
Museo Nacional de Bellas Artes,
Havana
Inv. 44

Flavio GARCIANDÍA
Born in Caibarién in 1954

321
Todo lo que usted necesita es amor
[All You Need Is Love]
1975
Oil on canvas
150 x 250 cm
Museo Nacional de Bellas Artes,
Havana
Inv. 0-357

373
*Pies de Plomo
De la serie "Refranes"*
[Lead Feet
From the series "Proverbs"]
1985
Acrylic on masonite assemblage
68 x 70 x 9 cm
Museo Nacional de Bellas Artes,
Havana
Inv. 88.283

Antonio GATTORNO
Havana, 1904 – Acushnet,
Massachusetts, 1980

224
La siesta
[The Siesta]
1939–40
Oil on canvas
106 x 137.5 cm
Private collection, Miami

Federico GIBERT GARCÍA
Matanzas, (?) – Havana, 1953

13
*Panorama of the Castillo de
La Punta and the Havana Prison*
1916
Gelatin silver print
20 x 190 cm
Fototeca de la Oficina del
Historiador de la Ciudad, Havana
Courtesy of the Museo Nacional
de Bellas Artes, Havana

José GÓMEZ DE LA CARRERA
Spain, (?) – Havana, 1908

4
Riflemen of the Mambí army
1898
Gelatin silver print
13.3 x 22.8 cm
Biblioteca Nacional José Martí,
Havana

5
*Mambí fighter put in primitive
stocks by his fellow men*
1898
Gelatin silver print
15.3 x 20.5 cm
Fototeca de Cuba, Havana
Inv. EM-25

José GÓMEZ FRESQUET (Frémez)
Havana, 1939 – Havana, 2007

309–311
*From the series "Canción
americana"* [Songs of the Americas]
1969
Silkscreens

309
Sin título
[Untitled]
70 x 52.5 cm
Museo Nacional de Bellas Artes,
Havana,
Inv. R/76.11

310
Sin título
[Untitled]
65.5 x 51 cm
Collection of the artist
Courtesy of the Museo Nacional
de Bellas Artes, Havana

311
Sin título (Niños y metralleta)
[Untitled (Children and Machine
Gun)]
60.9 x 70 cm (recent print)
Collection of the artist
Courtesy of the Museo Nacional
de Bellas Artes, Havana

Not illustrated
*Festival de la cancion popular.
Varadero / Cuba*
[Festival of Popular Song.
Varadero / Cuba]
1967
Poster. Silkscreen
Published by Consejo Nacional de
Cultura (CNC)
60 x 40.7 cm
Museo Nacional de Bellas Artes,
Havana
Inv. T-3937

Alfredo GÓNZALEZ ROSTGAARD
Guantánamo, 1943 – Havana, 2004

335
*Canción protesta. encuentro. agosto
1967. Casa de las Américas, Cuba*
[Protest Song. meeting. august
1967. Casa de las Américas, Cuba]
1967
Poster. Silkscreen
Published by Casa de las Américas
110 x 90 cm
Museo Nacional de Bellas Artes,
Havana
Inv. 82.350

336
*Black Power. Respuesta al
asesinato: violencia revolucionaria*
[Black Power. Retaliation to
Crime: Revolutionary Violence]
1969
Poster. Offset
Published by OSPAAAL
56 x 33 cm
Museo Nacional de Bellas Artes,
Havana
Inv. 76.2890

345
Che radiante
[Radiant Che]
1969
Poster. Offset
Published by OSPAAAL
66 x 39 cm
Museo Nacional de Bellas Artes,
Havana
Inv. 76.2503

355
ICAIC. Décimo Aniversario
[ICAIC. Tenth Anniversary]
1969
Poster. Silkscreen
Published by Instituto Cubano del
Arte e Industria Cinematográficos
(ICAIC)
72.2 x 45.8 cm
Museo Nacional de Bellas Artes,
Havana
Inv. T-3843

GUILLÉN

192
*Dámaso Pérez Prado, popularizer of
the mambo, with his orchestra*
1950s
Gelatin silver print
15.9 x 22.5 cm
Vicki Gold Levi Collection,
New York

H

Moisés HERNÁNDEZ FERNÁNDEZ
Spain, 1877 – Santiago de Cuba,
1939

34
Untitled, Santiago de Cuba
1927
Gelatin silver print
16.3 x 25.4 cm
Diario de Cuba Collection, Fototeca
de Cuba, Havana

K

KARREÑO

Not illustrated
February Fiestas in Havana, 1937
About 1937
Poster. Lithograph
Published by the Cuban Tourist
Commission (Corp. Nacional del
Turismo), Havana
Printed by Compañía Litográfica de
la Habana, Cuba
60.3 x 36.2 cm
The Wolfsonian-Florida
International University, Miami
Beach, Florida
The Mitchell Wolfson Jr. Collection
Inv. TD1990.276.4

Alberto KORDA
Havana, 1928 – Paris, 2001

270
Guerrillero Heroico
[Heroic Guerrilla]
1960 (recent print)
Gelatin silver print
50.8 x 40.6 cm
Collection of Diana Díaz
Courtesy of the Couturier Gallery,
Los Angeles

271 ★
*Contact sheet: Shots of Fidel Castro,
Jean-Paul Sartre, Simone de
Beauvoir and Che Guevara
(including "Heroic Guerilla")*
1960
Gelatin silver print
20.3 x 25.4 cm
Korda Collection, New York

279
*Camilo desfila con la caballería.
La Habana, 26 de julio 1959*
[Camilo Parading with the Cavalry,
Havana, July 26, 1959]
1959 (modern print)
Gelatin silver print
40 x 30 cm
Collection of Diana Díaz
Courtesy of the Couturier Gallery,
Los Angeles

280
*El Quijote de la farola, Plaza de la
Revolución, La Habana, 07/26/59*
[The Lamppost Quixote, Plaza de
la Revolución, Havana, 26/07/59]
1959 (modern print)
Gelatin silver print
35.6 x 27.9 cm
Collection of Diana Díaz
Courtesy of the Couturier Gallery,
Los Angeles

282
Miliciana, La Habana
[Militia Woman, Havana]
About 1962 (modern print)
Gelatin silver print
35.6 x 27.9 cm
Collection of Diana Díaz
Courtesy of the Couturier Gallery,
Los Angeles

285
*Che Presidente del Banco Nacional
de Cuba se entrevista con Jean-Paul
Sartre y Simone de Beauvoir*
[Che, President of the National
Bank of Cuba, speaking with Jean-
Paul Sartre and Simone de
Beauvoir]
1960 (modern print)
Gelatin silver print
27.9 x 35.6 cm
Collection of Diana Díaz
Courtesy of the Couturier Gallery,
Los Angeles

286
Fidel en el Bronx Zoo
[Fidel visiting the Bronx Zoo]
1959 (modern print)
Gelatin silver print
30 x 40 cm
Collection of Diana Díaz
Courtesy of the Couturier Gallery,
Los Angeles

292
David y Goliat
[David and Goliath]
1959 (modern print)
Gelatin silver print
35.6 x 27.9 cm
Collection of Diana Díaz
Courtesy of the Couturier Gallery,
Los Angeles

Estudio KORDA
1953–1968
Alberto KORDA [Díaz Gutiérrez]
Havana, 1928 – Paris, 2001
and
Luis KORDA [Pierce Byers]
Manzanillo, 1912 – Havana, 1985

322
*Construction of the temporary
gallery at the Cuban pavilion for the
1967 Salón de Mayo in Havana*
1967
Gelatin silver print
17.7 x 28 cm
Private collection, Paris
Courtesy of Günter Schütz

324
Wifredo Lam in Pinar del Río
1967
Gelatin silver print
18.4 x 28 cm
Private collection, Paris
Courtesy of Günter Schütz

L

Wifredo LAM
Sagua la Grande, 1902 – Paris, 1982

238 ★
La jungla
[The Jungle]
1943
Gouache on paper mounted on
canvas
239.4 x 229.9 cm
The Museum of Modern Art,
New York
Inter-American Fund, since April,
1945
Inv. 140.1945

239 ★
Huracán
[Hurricane]
About 1946
Oil on jute
218.5 x 198 cm
Museo Nacional de Bellas Artes,
Havana
Inv. 88.271

240
Madre e hijo, II
[Mother and Child, II]
1939
Gouache on paper
104.1 x 73.7 cm
The Museum of Modern Art,
New York
Purchase, 1939
Inv. 652.1939

241
El rey del juguete
[The King of the Cup and Ball
Game or Zoomorphic Figure]
1942
Tempera on kraft paper
106 x 85 cm
Museo Nacional de Bellas Artes
Inv. 74.1137

242
Maternidad en verde
[Mother and Child in Green]
About 1942
Oil on kraft paper
106 x 86.5 cm
Museo Nacional de Bellas Artes,
Havana
Inv. 74.1129

243
Mujer sobre fondo verde
[Woman on Green Background]
About 1942
Oil on kraft paper
106.9 x 84.2 cm
Museo Nacional de Bellas Artes,
Havana
Inv. 92-23

244
Figura con gallo
[Figure with Rooster]
About 1942
Oil on kraft paper
104.5 x 85.5 cm
Museo Nacional de Bellas Artes,
Havana
Inv. 2461

245
Silla
[Chair]
About 1942
Oil on kraft paper
111.6 x 81.5 cm
Museo Nacional de Bellas Artes,
Havana
Inv. 2438

246
El ruido
[The Murmur]
1943
Oil on paper mounted on canvas
105 x 84 cm
Centre Georges Pompidou, Paris,
Musée national d'art moderne/
Centre de création industrielle
Donation to the French
government, 1985
(work on deposit at Musée Cantini,
Marseille)
Inv. AM 1985-97

247 ★
Silla
[Chair]
1943
Oil on canvas
131 x 97.5 cm
Museo Nacional de Bellas Artes,
Havana
Gift of Lilia Esteban and Alejo
Carpentier, 1976
Inv. 07.296

248
Mofumba
1943
Oil on canvas
184.2 x 128.3 cm
Maria Bechily & Scott Hodes
Collection, Chicago

249
La cena
[The Dinner]
About 1944
Oil on paper
81 x 70 cm
Museo Nacional de Bellas Artes,
Havana
Inv. 89.1177

250
Buen Retiro
1944
Oil on paper mounted on canvas
93.5 x 73.5 cm
Collection Jean-Jacques Lebel,
Paris

251
Figura alada o Composition
[Winged Figure, or Composition]
1945
Oil on paper
80 x 97.5 cm
Museo Nacional de Bellas Artes,
Havana
Inv. 79.472

252
Retrato de H. H., VI
[Portrait of H. H., VI]
About 1944
Tempera on kraft paper
106 x 84 cm
Museo Nacional de Bellas Artes,
Havana
Inv. 74.1118

253
Sin título
De la serie "Canaima"
[Untitled
From the series "Canaima"]
1947
Tempera on kraft paper
91.3 x 73.3 cm
Fondo Cubano de Bienes
Culturales
Courtesy of the Museo Nacional
de Bellas Artes, Havana
Inv. 0024

254
Torso de mujer
[Female Torso]
About 1947
Oil on kraft paper
92.6 x 75.5 cm
Museo Nacional de Bellas Artes,
Havana
Inv. 0-44

255
Desnudo sobre fondo negro
[Nude on Black Blackground]
About 1950
Oil and charcoal on canvas
105.5 x 90.5 cm
Museo Nacional de Bellas Artes,
Havana
Inv. 07.287

256
*Figura alada con candil o Personaje
con un quinque*
[Figure with Oil Lamp, or Winged
Figure with Lantern]
1955
Oil and charcoal on canvas
100 x 127.5 cm
Museo Nacional de Bellas Artes,
Havana
Inv. 88.343

257 ★
La Sierra Maestra
[The Sierra Maestra]
1959
Gouache on paper mounted
on canvas
247 x 310 cm
Private collection, Paris

258 ★
El tercer mundo
[The Third World]
1965–66
Oil on canvas
251 x 300 cm
Museo Nacional de Bellas Artes,
Havana
Inv. 07.279

Víctor Patricio de LANDALUZE
Bilbao, Spain, 1830 – Havana, 1889

54
Corte de Caña
[The Cane Harvest]
1874
Oil on canvas
51 x 61 cm
Museo Nacional de Bellas Artes,
Havana
Inv. 95.791

60
En la ausencia
[When Nobody Is Around]
About 1880
Oil on cardboard
30.5 x 24 cm
Museo Nacional de Bellas Artes,
Havana
Inv. 95.794

61
José Francisco
About 1880
Oil on cardboard
30.5 x 24 cm
Museo Nacional de Bellas Artes,
Havana
Inv. 95.795

62 ★
Día de Rey en La Habana
[Day of the Magi, Havana]
n.d.
Oil on canvas
51 x 61 cm
Museo Nacional de Bellas Artes,
Havana
Inv. 95.1441

63 ★
El zapateo
[The Zapateo]
About 1875
Oil on canvas
49 x 56.3 cm
Museo Nacional de Bellas Artes,
Havana
Inv. 95.898

64
Diablito
[Little Devil]
n.d.
Oil on canvas
35.5 x 27 cm
Museo Nacional de Bellas Artes,
Havana
Inv. 95.789

Eduardo LAPLANTE
France, 1818 – Cuba, after 1860

43–50
After Justo Germán Cantero's
"Los Ingenios"
From the series "Los Ingenios"
[Sugar Mills]
1855–57
8 coloured lithographs
Published by Luis Marquier,
Havana, 1857
43. *The Acana Sugar Mill*
27.1 x 37.6 cm
44. *The Santa Teresa Sugar Mill in
Agüica*
27.2 x 37 cm
45. *The Ponina Sugar Mill*
27 x 38.2 cm
46. *The Flor de Cuba Sugar Mill*
27.2 x 39.6 cm
47. *The Buena-Vista Sugar Mill*
27.2 x 36.7 cm

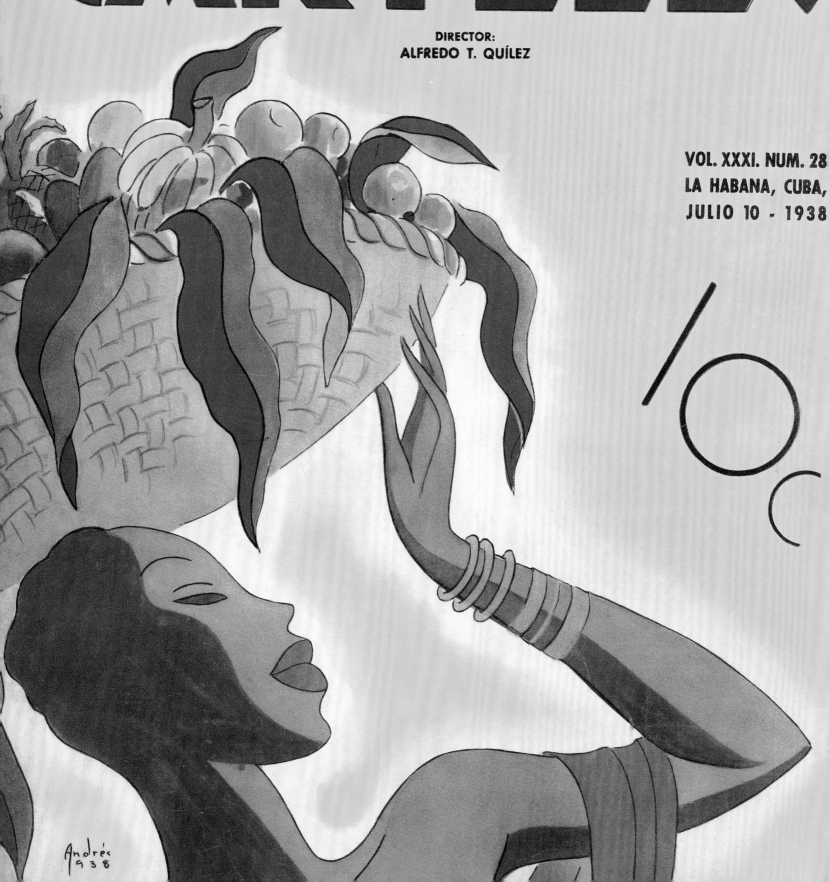

CARTELES

DIRECTOR:
ALFREDO T. QUÍLEZ

VOL. XXXI. NUM. 28
LA HABANA, CUBA,
JULIO 10 - 1938

Andrés
1938

48. *The Narciso Sugar Mill*
27 x 37 cm
49. *The Progreso Sugar Mill*
27.2 x 38.8 cm
50. *The Boiler House at the Asunción Sugar Mill*
27.2 x 39.5 cm
Museo Nacional de Bellas Artes, Havana
Inv. G1764; GEC 335 - B (1973); R.81.194; GEC 338 - B (1973); R.75.365; T48; R.75.353; 67.796

Lou LAURIN LAM
Born in Stockholm, Sweden, in 1934

331
Painters Eduardo Arroyo and Gilles Aillaud standing by the Salón de Mayo Mural
1967
Gelatin silver print
25 x 17.1 cm
Private collection, Paris
Courtesy of Günter Schütz

Alexis LEYVA (Kcho)
Born in Isla de la Juventud in 1970

390
Para olvidar
[In Order to Forget]
1996
Installation: kayak, beer bottles
675 x 356 cm
ASU Art Museum, Tempe, Arizona
Purchased with funds provided by the ASU Art Museum Store, the Friends of the ASUAM and by the Fund at Arizona State University
Inv. ASUAM 1998.410.001

391
A los Ojos de la Historia
[In the Eyes of History]
1992–95
Watercolour, charcoal on paper
152.4 x 125.1 cm
The Museum of Modern Art, New York
Purchased with funds given by Patricia and Morris Orden, 1996
Inv. 82.1996

Fernando LEZCANO MIRANDA
Havana, 1905 – Havana, 1949

p. 380
Street scene at night, Camagüey
1949
Gelatin silver print
18 x 23 cm
Vicki Gold Levi Collection, New York

Julio LOPEZ BERESTEIN
Cuba, 1915 – Havana, 1968

p. 361
Galeria del Prado
From right to left: José Gómez Sicre, Mario Carreño, Cundo Bermúdez, Alfredo Lozano, Amelia Peláez, Mestre, María Luisa Gómez Mena, Roberto Diago, Eugenio Rodriguez, Acevedo, a sculptor, a gallery employee
1944
Sepia-toned silver gelatin print
12.7 x 17.8 cm
Jesús Fernández-Torna Collection
Courtesy Prado Fine Art Collection, Miami

Rogelio LÓPEZ MARÍN (Gory)
Born in Havana in 1953

320
El triángulo de las Bermudas
[The Bermuda Triangle]
1978
Oil on canvas
77 x 155 cm
Teatro Nacional de Cuba, Havana

363 a–i
Es sólo agua en la lágrima de un extraño – [It's Only Water in a Stranger's Tear—]
1986
9 hand-coloured gelatin silver prints
50.5 x 40.5 cm each
Museum of Contemporary Photography, Columbia College, Chicago
Inv. 2002.127.1–9

a. *Como un nadador que se ha perdido debajo de la capa de hielo, busco un lugar para emerger*
[Like a swimmer trapped beneath a layer of ice, I keep searching for a way out]

b. *... pero no hay ningún lugar. Toda la vida nado con la respiración. No sé cómo podéis vosotros hacerlo*
[. . . but there is no place. I've swum for a lifetime holding my breath. I can't imagine how the rest of you do it]

c. *Estamos ciegos. Cegados por el futuro. No vemos nunca lo que está ante nosotros, nunca el próximo segundo. Vemos sólo lo que hemos visto ya. Es decir, nada de la capa de hielo, busco un lugar para emerger*
[We are blind. Blinded by the future. We never see what's coming never the next moment, only what we have already seen. That is, only the layer of ice above us, looking for a way out]

d. *Al fin y al cabo no puedo ser el único que se ha dado cuenta. Tan listo no soy. Sólo se han puesto de acuerdo en no hablar de ello*
[I can't be the only one to have noticed, I'm not that smart. They've merely agreed not to talk about it]

e. *Como caminan todos toda su vida sin conocer el momento siguiente, sin saber si con el próximo paso pisarán aún suelo firme o caerán en la nada*
[We all walk blindly throughout our lives, never knowing what the next moment will bring, or whether with our next step we'll touch solid ground or tumble into the void]

f. *Pensé que era el sueño equivocado o el mundo equivocado al que habia ido a parar. O quizás era yo el equivocado para este mundo, para este sueño*
[I thought I had ended up in the wrong dream or the wrong world. Or maybe I was wrong for this world, or this dream]

g. *... pero si resulta que sólo soy vuestro sueño común, que todos vosotros me habéis soñado desde el principio, que nunca fui otra cosa que el sueño de otros, entonces os ruego mis queridos soñadores, desde el fondo de mi corazón, liberadme. Soñad con otra cosa, no conmigo...*
[. . . but if it turns out that I'm only your shared collective dream, that you all dreamt me from the start, that I was never anything but other people's dreams, then I beg of you dear dreamers, from the bottom of my heart, free me. Dream of something other than me . . .]

h. *No puedo más. No pretendo que os despertéis. Por mi seguid durmiendo mientras queráis y dormid bien pero dejád de soñarme*
[I can't stand it any longer. I don't expect you to wake up. Sleep as long as you like, sleep well, but dream of me no more]

i. *Y explicadme una cosa, damas y caballeros. ¿Que sucede con un sueño cuando despierta el soñador? ¿Nada? ¿No sucede ya nada?*
[Tell me something, ladies and gentlemen: What happens to a dream when its dreamer awakes? Nothing? Is nothing happening any longer?]

Translation adapted by the Montreal Museum of Fine Arts with the artist's authorization.

M

E. MAÑAN

83
Portrait of Tina de Jarquer, Spanish music star with the band Velazco
1923
Toned gelatin silver print
32 x 23.5 cm
Private collection
Courtesy of the Fototeca de Cuba, Havana

Olivio MARTÍNEZ
Born in Santa Clara in 1941

338
Julio 26 '53. XIV aniversario del asalto al Moncada
[July 26/53. 14th Anniversary of the assault on the Moncada barracks]
1967
Poster. Offset
Published by Comisión de Orientación Revolucionaria (COR)
99.3 x 53.3 cm
Museo Nacional de Bellas Artes, Havana
Inv. 82.351

348
Guatemala
1969
Poster. Offset
Published by OSPAAAL
54.5 x 33 cm
Museo Nacional de Bellas Artes, Havana
Inv. T-4037

353
Ten designs for panels from the series "Vallas de la zafra de los 10 millones" [Campaign of the 10-million-ton Cane Harvest]
1969–70 (artist's proof)
Silkscreens, 7/7
a. One Million: 25 x 50 cm
b. Two Down: 25.4 x 49.9 cm
c. Third: 27.1 x 51 cm
d. Four Already: 24.7 x 50.1 cm
e. Half Way There: 25.5 x 51.6 cm
f. Six: 25.5 x 51.6 cm
g. Seventh: 24.3 x 50.2 cm
h. Eight Down: 24.5 x 50.1 cm
i. One to Go: 26 x 50.9 cm
j. Ten: 25.3 x 49.9 cm
The Montreal Museum of Fine Arts
Purchase, in process of acquisition
Inv. 1244.2007.1-10

Raúl MARTÍNEZ
Ciego de Ávila, 1927 – Havana, 1995

316
Todos somos hijos de la patria
[We Are All Children of The Homeland]
1965
Oil on canvas
191 x 200 cm
Museo Nacional de Bellas Artes, Havana
Inv. 0.431

317 ★
Martí y la estrella
[Martí and the Star]
1966
Oil on canvas
184 x 143 cm
Museo Nacional de Bellas Artes, Havana
Inv. 71.276

Not illustrated
Cuba en Grenoble
[Cuba in Grenoble]
1969
Poster. Silkscreen
Published by CNC / OSPAAL
148 x 92 cm
Aberlardo Estorino Collection
Courtesy of Museo Nacional de Bellas Artes, Havana

Estudio MARTÍNEZ OTERO
Manuel MARTÍNEZ OTERO
Valencia, Spain, 1862 – Caibarién, 1906
and
Manuel MARTÍNEZ ILLA
Puerto Padre, 1883 – (?)
and
Arturo Juan MARTÍNEZ ILLA
Puerto Padre, 1886 – Caibarién, 1965

8
Official Raising of the Cuban and Spanish Flags by the President of the Spanish Community and the Mayor of the Town, Havana
1908
Gelatin silver print
18.1 x 22.1 cm
Estudio Martínez Otero Collection, Fototeca de Cuba, Havana
Inv. EM-20

29
Untitled
About 1908
Gelatin silver print
18.7 x 24.3 cm
Estudio Martínez Otero Collection, Fototeca de Cuba, Havana
Inv. EM-21

31
Untitled
About 1910
Toned gelatin silver print
20.3 x 25.3 cm
Estudio Martínez Otero Collection, Fototeca de Cuba, Havana
Inv. EM-18

33
Untitled
About 1920
Gelatin silver print
19.4 x 25 cm
Estudio Martínez Otero Collection, Fototeca de Cuba, Havana
Inv. EM-19

Luis MARTÍNEZ PEDRO
Havana, 1910 – Havana, 1989

267 ★
Aguas territoriales n° 5
[Territorial Waters No. 5]
1962
Oil on canvas
186.5 x 148.5 cm
Museo Nacional de Bellas Artes, Havana
Inv. 07.414

Conrado W. MASSAGUER
Cárdenas, 1889 – Havana, 1965

186
"Visit Cuba: So Near and Yet So Foreign"
About 1950
Postcard
15 x 9 cm
Vicki Gold Levi Collection, New York

Ana MENDIETA
Havana, 1948 – New York, 1985

368 ★
Sin título (Varadero)
[Untitled (Varadero)]
1981
Gelatin silver print
(Lifetime black-and-white photograph)
20.3 x 25.4 cm
Private collection, Aventura, Florida

369
Esculturas Rupestres
[Rupestrian Sculptures]
1981
Gelatin silver print
(Lifetime black-and-white photograph)
20.3 x 25.4 cm
Courtesy of the Estate of Ana Mendieta Collection and Galerie Lelong, New York

370
Sin título (Guanabo)
[Untitled (Guanabo)]
1981
Gelatin silver print
(Lifetime black-and-white photograph)
20.3 x 25.4 cm
Courtesy of the Estate of Ana Mendieta Collection and Galerie Lelong, New York
Inv. GL 6270-A

371
Ochún, Key Biscayne, Florida (still 5)
1981
Colour film transferred to Beta SP
Running time: 8 min, 38 s
Courtesy of the Estate of Ana Mendieta Collection and Galerie Lelong, New York
Inv. GP 1203

372
Guanaroca (Esculturas Rupestres)
[First Woman (Rupestrian Sculptures)]
1981 (estate print 2001)
Box-mounted black-and-white photograph
135.9 x 99.7 cm
Courtesy of the Estate of Ana Mendieta Collection and Galerie Lelong, New York
Inv. GL 3461-C-EC

Manuel MENDIVE
Born in Havana in 1944

319
Che
About 1975
"Plaka" paint on wood
102 x 126 cm
Museo Nacional de Bellas Artes, Havana
Inv. 80.360

After Federico MIALHE
Bordeaux, 1813 – Paris, 1881

59
Album pintoresco de la isla de Cuba
[Picturesque album of the island
of Cuba]
Published by Bernardo May & Cie.,
1853 (?)
McGill University Library, Rare
Books and Special Collections
Division, Montreal
25 x 35 cm each
a. Title page
b. Pl. 4: Havana. View from
Casa-Blanca
c. Pl. 10: Fuente de la India and
Paseo de Isabel II
d. Pl. 12: The Two-wheeled
Carriage
e. Pl. 15: Cockpit
f. Pl. 16: Day of the Magi
g. Pl. 21: The Outskirts of Baracoa
and the Inhabitants' Mode of
Transportation
h. Pl. 23: Living Quarters of the
Sponge Fishermen of Bahía de
Nuevitas
i. Pl. 24: Trinidad
j. Pl. 26: View of a Boiler House

José MIJARES
Havana, 1921 – Miami, 2004

235
Vida en un interior
[Life in an Interior]
1950
Oil on canvas
144 x 120 cm
Museo Nacional de Bellas Artes,
Havana
Inv. 07.189

Emilio MOLINA
1906 – (?)

114 ★
*The "Heraldo de Cuba" after riots
following the fall of Machado,
Havana*
1933
Digital reprint
25.4 x 18.7 cm
Archivo de FotoCreart, Ministry of
Culture, Havana

115 ★
Fall of Machado, August 12, 1933
1933
Digital reprint
16.3 x 25.4 cm
Archivo de FotoCreart, Ministry of
Culture, Havana

James Wilson MORRICE
Montreal, 1865 – Tunis, 1924

p. 17 ★
1. *Café el Pasaje, Havana*
About 1915–19
Oil on canvas
National Gallery of Canada, Ottawa
Gift of G. Blair Laing, Toronto, 1989
Inv. NGC30401.1

p. 17 ★
3. *The Pond, West Indies*
About 1921
Oil on canvas
81.5 x 54.8 cm
The Montreal Museum of Fine Arts
Gift of the Louise and Bernard
Lamarre family
Inv. 1998.29

p. 17
5. *Village Street, West Indies*
About 1915–19
Oil on canvas
60.2 x 82 cm
The Montreal Museum of Fine Arts
Purchase, William Gilman Cheney
Bequest
Inv. 1939.685

Vicente MUÑIZ
Havana, 1916 – Miami, 2007

189
*Archway at the entrance to the
Tropicana cabaret*
1958
Gelatin silver print
22.8 x 18.3 cm
Vicki Gold Levi Collection,
New York

190
*Chorus of Paquito Godines at the
Tropicana cabaret*
1957
Gelatin silver print
18.2 x 22.7 cm
Vicki Gold Levi Collection,
New York

Eduardo MUÑOZ BACHS
Valencia, Spain, 1937 – Havana,
2001

358 ★
*Film poster for Julio García
Espinosa's "The Adventures of Juan
Quin Quin"*
1967
Silkscreen
76 x 50 cm
Cinémathèque québécoise,
Montreal
Inv. 1996.0060.AF

359 ★
*Film poster for Juan Padrón's
"Elpidio Valdés and the Rifle"*
1980
Silkscreen
76 x 50 cm
Cinémathèque québécoise,
Montreal
Inv. 1996.0043.AF

N

Estudio NARCY
Ibrahim Arce
Camagüey, 1908 – Havana, 1968

196
The singer Celia Cruz
1950s
Gelatin silver print
26 x 20 cm
Vicki Gold Levi Collection,
New York

Liborio NOVAL
Born in Havana in 1934

272
Vencimos
[We Won]
1960
Gelatin silver print
22.4 x 32.8 cm
Fototeca de Cuba, Havana

277
*I like mine better [Peasant looking
at hats, Havana]*
1960
Gelatin silver print
22.1 x 32.8 cm
Fototeca de Cuba, Havana

284
Untitled
1961 (reprint)
Gelatin silver print
22.4 x 32.8 cm
Collection of the artist
Courtesy of the Fototeca de Cuba,
Havana

Not illustrated
Image of a Colleague
1964 (artist's print)
22 x 33 cm
Collection of Heidi Hollinger,
Montreal

O

Ernesto OCAÑA ODIO
Santiago de Cuba, 1904 –
Santiago de Cuba, 2002

215
Homeless, Santiago de Cuba
1945
Gelatin silver print
10 x 12.5 cm
Fototeca de Cuba, Havana

Ernesto OROZA
Born in Havana in 1968

409
De Aachen a Zurich
[Aachen to Zurich]
2005
Video transferred to DVD, black
and white
Running time: 3 min, 14 sec.
Song: Enrique Bryon's *La comparsa
de los Congos Lucumí*
Collection of the artist, Aventura,
Florida

P

Ernesto PADRÓN
Born in Cárdenas in 1948

347
Todos con Viet Nam. Del 13 al 19 de marzo
[Together with Vietnam. March 13–19]
1971
Poster. Offset
Published by OSPAAAL
53.5 x 33.4 cm
Museo Nacional de Bellas Artes, Havana
Inv. 76.2767

José PAPIOL
Born in Havana in 1933
Faustino PÉREZ ORGANERO
Born in Banes in 1942
Ernesto PADRÓN
Born in Cárdenas in 1948

Not illustrated
Décimo aniversario del triunfo de la rebelión
[Tenth Anniversary of the Triumph of the Rebellion]
1969
Series of ten posters. Offset
Published by Comisión de Orientación Revolucionaria (COR)
57 x 29 cm each
Museo Nacional de Bellas Artes, Havana
Inv. 84.119 - 84.128

Amelia PELÁEZ
Yaguajay, 1896 – Havana, 1968

232
Jarrón con flores
[Pitcher of Flowers]
About 1945
Oil on canvas
112 x 87 cm
Museo Nacional de Bellas Artes, Havana
Inv. 05.146

233
Peces
[Fish]
1943
Oil on canvas
115.6 x 89.2 cm
The Museum of Modern Art, New York
Inter-American Fund, 1944
Inv. 80.1944

Alberto PEÑA (Peñita)
Havana, 1897 – Havana, 1938

137
Sin trabajo
[Without Work]
1931
Oil on cardboard
59 x 45 cm
Museo Nacional de Bellas Artes, Havana
Inv. 88.241

146
La llamada del ideal o Martí
[The Call of the Ideal, or Martí]
1936
Oil on canvas
95 x 81 cm
Museo Nacional de Bellas Artes, Havana
Inv. 88.240

René PEÑA
Born in Havana in 1957

378, 379
From the series "Man-made Materials"
Keloid 2
80 x 98.5 cm
Lips
80,1 x 129,2 cm
1998–99 (recent prints)
Gelatin silver prints
Collection of the artist
Courtesy of the Museo Nacional de Bellas Artes, Havana

Umberto PEÑA
Born in Havana in 1937

308
Aayyyy, shass, no aguanto más
[Aayyyy, Shass, I Can't Stand it Anymore]
1967
Oil on canvas
170.5 x 170 cm
Museo Nacional de Bellas Artes, Havana
Inv. 89.746

Marta María PÉREZ
Born in Havana in 1959

374
Recuerdo de nuestro bebé
[Memories of Our Baby]
1987–88
8 gelatin silver prints
41.5 x 51.6 x 2.4 cm (each framed print)
Sammlung Ludwig – Ludwig Forum für Internationale Kunst, Aachen, Germany

Antonio PÉREZ GÓNZALEZ (Ñiko)
Born in Havana in 1941

343
Hasta la victoria siempre
[Until the Victory Always]
1968
Poster. Offset
Published by Comisión de Orientación Revolucionaria (COR)
98 x 54.3 cm
Museo Nacional de Bellas Artes, Havana
Inv. 82.352

Faustino PÉREZ ORGANERO
Born in Banes in 1942

350
Jornada de solidaridad con Zimbabwe. 17 de marzo
[Day of Solidarity with Zimbabwe. March 17]
1970
Poster. Offset
Published by OSPAAAL
54.4 x 33 cm
Museo Nacional de Bellas Artes, Havana
Inv. T-3806

351
Jornada de solidaridad con el pueblo de Palestina. Mayo 15
[Day of Solidarity with the People of Palestine. May 15]
1968
Poster. Offset
Published by OSPAAAL
54.4 x 33 cm
Museo Nacional de Bellas Artes, Havana
Inv. T-3805

Manuel PIÑA
Born in Havana in 1958

389
From the series "Aguas baldías"
[Water Wastelands]
Untitled
1992–94
Digital colour print
Museum of Art / Fort Lauderdale, Florida
Gift of Terri and Joe Burch in loving memory of C. Richard Hilker
Courtesy of the Marvelli Gallery, New York
Inv. 2003.6

Marcelo POGOLOTTI
Havana, 1902 – Havana, 1988

127
El capitalismo
[Capitalism]
About 1934–35
Oil on canvas
92.5 x 73 cm
Museo Nacional de Bellas Artes, Havana
Inv. 67.649

128
El matón
[The Thug]
About 1935
Oil on canvas
91.5 x 72 cm
Museo Nacional de Bellas Artes, Havana
Inv. 73.161

Andrés GARCÍA BENÍTEZ, *Cover of the magazine "Carteles,"* August 1939

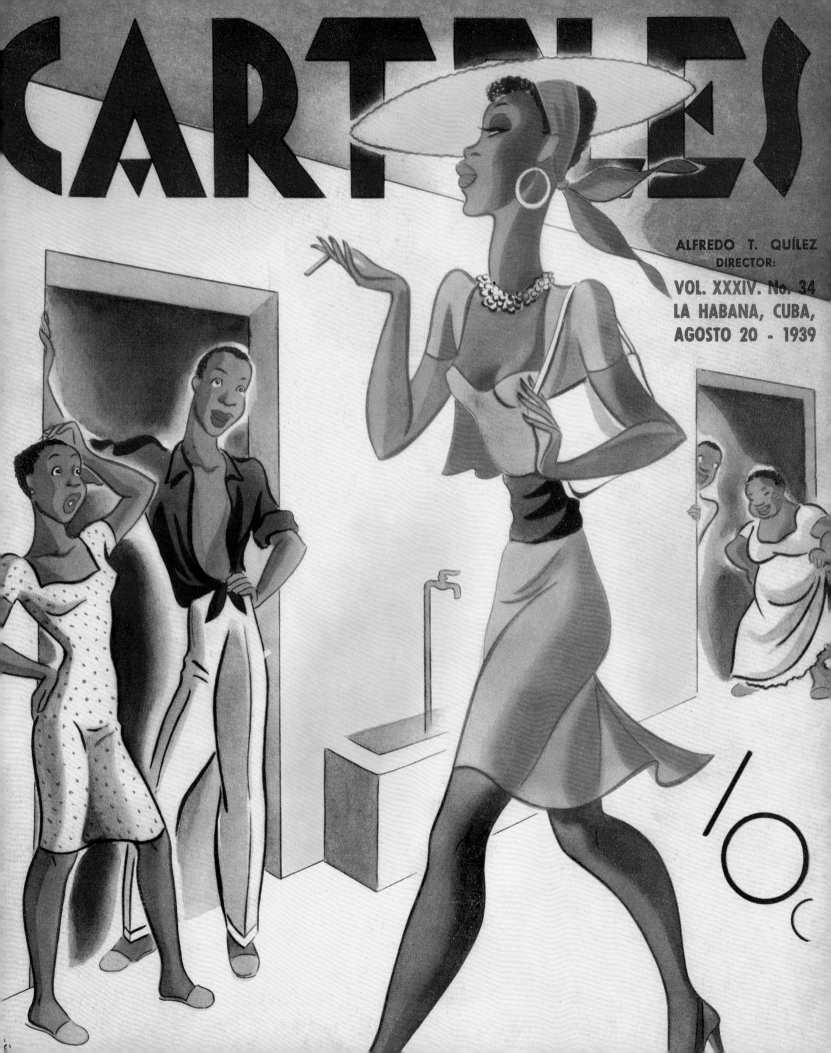

CARTELES

ALFREDO T. QUÍLEZ
DIRECTOR:
VOL. XXXIV. No. 34
LA HABANA, CUBA,
AGOSTO 20 - 1939

147
Barrio industrial
[Industrial District]
About 1938
Oil on canvas
92 x 72 cm
Museo Nacional de Bellas Artes,
Havana
Inv. 2388

148
Marina interior (Marina o Nave marina)
[Ship Interior (Marine, or Ship)]
About 1934
Oil on canvas
73 x 92 cm
Museo Nacional de Bellas Artes,
Havana
Inv. 89.1263

149
Goliat
[Goliath]
n.d.
Pencil, crayon on paper
49 x 33.1 cm
Museo Nacional de Bellas Artes,
Havana
Inv. 89.1276

150
Hitler
1935
Pencil, gouache, crayon on paper
49 x 33.6 cm
Museo Nacional de Bellas Artes,
Havana
Inv. 73.1758

151
Sin título
[Untitled]
1935
Pencil, crayon on paper
48.8 x 33.1 cm
Museo Nacional de Bellas Artes,
Havana
Inv. 89.1329

152–159
From the series "Nuestro Tiempo"
[Our Times]

152
Fordismo (El acaparador)
[Fordism (The Monopoly)]
About 1930–31
Pencil, crayon on paper
29 x 40 cm

153
La caridad (Caridad de mal metal)
[Charity (Charity of Metal Sickness)]
About 1930-31
Pencil, crayon on paper
29 x 39.9 cm

154
Aquí se trabaja para nada (Colonia)
[Work Here Is Done for Nothing (Colony)]
1931
Pencil, crayon on paper
24 x 30.4 cm

155
Hacia El Dorado (Emigración)
[To El Dorado (Emigration)]
1931
Pencil, crayon on paper
25.8 x 35.1 cm

156
¡Queremos trabajo! (La cola o Socorro a los desocupados)
[We Want Work! (The Line, or Aid to the Unemployed)]
1931
Pencil, crayon on paper
26.2 x 35.5 cm

157
Un lago de sangre
[Bloodbath]
1931
Pencil, crayon on bristol board
32.5 x 45.7 cm

158
El amo y sus perros de presa (Sistema nazi)
[The Master and His Bulldogs (Nazi System)]
1931
Pencil, crayon on paper
24.8 x 32 cm

159
Los negocios marchan... (Cuerpo a cuerpo)
[Business is Good . . . (Hand-to-hand)]
1931
Pencil, crayon on paper
28.9 x 40 cm

Museo Nacional de Bellas Artes,
Havana
Inv. 89.1340; 89.1269; 89.1314;
89.1300; 89.1316; 89.1280; 89.1304;
89.1305

160 ★
El cielo y la tierra
[Heaven and Earth]
1934
Oil on canvas
81 x 100.5 cm
Museo Nacional de Bellas Artes,
Havana
Inv. 07.263

161
Sin título
[Untitled]
About 1935
Oil on canvas
73.5 x 93 cm
Museo Nacional de Bellas Artes,
Havana
Inv. 89.1257

162 ★
Paisaje Cubano
[Cuban Landscape]
1933
Oil on canvas
73 x 92 cm
Museo Nacional de Bellas Artes,
Havana
Inv. 07.239

163
Obreros y Campesinos
[Workers and Peasants]
About 1933
Oil on canvas
65.5 x 81.5 cm
Museo Nacional de Bellas Artes,
Havana
Inv. 73.1868

164
Grupo
[Group]
About 1937
Oil on canvas
65 x 81.5 cm
Museo Nacional de Bellas Artes,
Havana
Inv. 89.1258

165
La columna o El rescate
[The Column, or The Recovery]
n.d.
Ink on cardboard
38.9 x 55.4 cm
Museo Nacional de Bellas Artes,
Havana
Inv. 89.1275

166
El intelectual o Joven intelectual
[The Intellectual, or Young Intellectual]
1937
Oil on canvas
89 x 116 cm
Museo Nacional de Bellas Artes,
Havana
Inv. 89.1254

Fidelio PONCE DE LEÓN
Camagüey, 1895 – Havana, 1949

134
Los Rostros de Cristo
[The Faces of Christ]
1936
Oil on canvas
76.2 x 83.8 cm
Private collection, Miami

135 ★
Tuberculosis
1934
Oil on canvas
92 x 122 cm
Museo Nacional de Bellas Artes,
Havana
Gift of Alfredo Antonetti and Vivar,
1966
Inv. 07.245

265 ★
Niños
[Children]
1938
Oil on canvas
94.5 x 122.5 cm
Museo Nacional de Bellas Artes,
Havana
Inv. 07.241

Eduardo PONJUÁN
Born in Pinar del Río in 1956

395
Utopía
[Utopia]
1991
Six-panel installation
Oil on canvas
91 x 64 cm each
Museo Nacional de Bellas Artes,
Havana
Inv. 92.90

396 ★
Morir por la patría es vivir
[To Die for Your Country Is to Live]
1989
Oil and wood on canvas
57.2 x 42 x 2 cm
Museo Nacional de Bellas Artes,
Havana
Inv. 95.1437

René PORTOCARRERO
Havana, 1912 – Havana, 1985

227
Mujer ante la Ventana
[Woman at the Window]
About 1940
Oil on canvas
66.5 x 64 cm
Museo Nacional de Bellas Artes,
Havana
Inv. T-7966

234
Figura mitológica
[Mythological Figure]
1945
Gouache on cardboard
94.6 x 94.6 cm
The Museum of Modern Art,
New York
Inter-American Fund, 1945
Inv. 166.1945

236 ★
Homenaje a Trinidad
[Tribute to Trinidad]
1951
Oil on canvas
87 x 113.5 cm
Museo Nacional de Bellas Artes,
Havana
Inv. 87.259

237
Paisaje de La Habana en rojo
[Landscape of Havana in Red]
1972
Oil on canvas
107 x 153 cm
Museo Nacional de Bellas Artes,
Havana
Inv. 75.63

R

Domingo RAMOS
Güines, 1897 – Havana, 1956

72 ★
Paisaje II
[Landscape II]
1940s
Decorative panel: oil on canvas
164 x 51 cm
Museo Nacional de Bellas Artes,
Havana
Inv. 81.17

73
Paisaje de Matanzas
[Landscape of Matanzas]
1930
Oil on canvas
99.5 x 132.5 cm
Museo Nacional de Bellas Artes,
Havana
Inv. 109

74
Paisaje con río
[Landscape with River]
1942
Oil on canvas
46.5 x 50 cm
Museo Nacional de Bellas Artes,
Havana
Inv. 1.135

75 ★
Paisaje I
[Landscape I]
1940s
Decorative panel: oil on canvas
136 x 56 cm
Museo Nacional de Bellas Artes,
Havana
Inv. 81.18

76
Flamboyán
[The Flamboyant Tree]
1949
Oil on canvas
49 x 39.5 cm
Museo Nacional de Bellas Artes,
Havana
Inv. 795

77
Viñales
[Landscape of Viñales]
1940
Oil on canvas
195 x 300 cm
Museo Nacional de Bellas Artes,
Havana
Inv. 795

Sandra RAMOS
Born in Havana in 1969

381
La balsa
[The Raft]
1995
Chalcograph, 8/10
50 x 86 cm
Museo Nacional de Bellas Artes,
Havana
Inv. 95.1243

382
El bote
[The Boat]
1995
Chalcograph, 8/10
50 x 86 cm
Museo Nacional de Bellas Artes,
Havana
Inv. 95.1242

383
El batiscafo
[The Bathyscaphe]
1995
Chalcograph, 8/10
50 x 86 cm
Museo Nacional de Bellas Artes,
Havana
Inv. 95.1244

Teodoro RAMOS BLANCO
Havana, 1902 – Havana, 1972

131
Vida interior
[Inner Life]
1934
Marble
30 x 17 x 23.5 cm
Museo Nacional de Bellas Artes,
Havana
Inv. 95.1346

132
Anciana negra
[Old Black Woman]
1939
Acana wood
28.3 x 14.6 x 10.8 cm
The Museum of Modern Art,
New York
Inter-American Fund, 1942
Inv. 776.1942

Eladio RIVADULLA
Born in Havana in 1923

340
Fidel Castro, 26 de julio
[Fidel Castro, 26th of July]
1959
Poster. Silkscreen
92.5 x 68.6 cm
Collection of the artist
Courtesy of the Museo Nacional
de Bellas Artes, Havana

352
Emulando venceremos
[Emulating We Will Win]
1960s
Poster. Silkscreen
81 x 54.5 cm
Collection of the artist
Courtesy of the Museo Nacional
de Bellas Artes, Havana

Fernando RODRÍGUEZ /
Born in Matanzas in 1970

398
Mis dioses mi familia
[My Gods My Family]
1993
Set of 6 pieces in carved and
polychromed wood
1. 26 x 22,5 x 6 cm
2. 29,3 x 18,2 x 8,7 cm
3. 23,5 x 19 x 9,7 cm
4. *Che*: 27,5 x 21,7 x 7 cm
5. 35 x 17,5 x 10 cm
6. 28,5 x 20,5 x 7,5 cm
Museo Nacional de Bellas Artes,
Havana
Inv. 93.778-93.778.5

406
Tiempos modernos
[Modern Times]
2006
3D animation transferred to DVD
Running time: 2 min, 14 sec. (loop)
Museo Nacional de Bellas Artes,
Havana
Inv. 06.39.1

Magea RODRÍGUEZ

168
The band Hermanas Benítez
1950s
Gelatin silver print
19.1 x 24.2 cm
Vicki Gold Levi Collection,
New York

Mariano RODRÍGUEZ
Havana, 1912 – Havana, 1990

228
El gallo
[Rooster]
1941
Oil on canvas
74.3 x 63.8 cm
The Museum of Modern Art,
New York
Gift of the Comission for
Intellectual Cooperation, 1942
Inv. 30.1942

Leopoldo ROMAÑACH
Sierra Morena, 1862 – Havana, 1951

65
Marina
[Seascape]
n.d.
Oil on canvas
81 x 116 cm
Museo Nacional de Bellas Artes,
Havana
Inv. 67.242

66
Retrato de muchacha con caña
[Portrait of a Young Girl with
Sugar Cane]
1926
Oil on canvas
170 x 84 cm
Museo Nacional de Bellas Artes,
Havana
Inv. 85.624

67
La niña de las cañas
[Girl of the Sugar Cane]
n.d.
Oil on canvas
71.5 x 56 cm
Museo Nacional de Bellas Artes,
Havana
Inv. 1.151

Rigoberto ROMERO
Pinar del Rio, 1940 – Havana, 1991
and
Leovigildo GONZÁLEZ
Born in Havana in 1943

296, 297
*Sin título. De la serie "Con sudor de
millonario"*
[Untitled. From the series "With
the Sweat of the Workers for the
'Millonario's Sweat'"]
1974
Gelatin silver prints
20 x 24.9 cm
18.3 x 24.2 cm
Fototeca de Cuba, Havana
Inv. EM-4; EM-1

Not illustrated
*Sin título. De la serie "Con sudor de
millonario"*
[Untitled. From the series "With
the Sweat of the Workers for the
'Millonario's Sweat'"]
1974
Gelatin silver print
15.3 x 15.3 cm
Fototeca de Cuba, Havana
Inv. EM-2

S

Lázaro SAAVEDRA
Born in Havana in 1964

393 ★
El arte un arma de lucha
[Art: A Weapon in the Struggle]
1988
Acrylic on cardboard and papier
mâché
70 x 50 cm
Museo Nacional de Bellas Artes,
Havana
Inv. 90.3651

394
Detector de ideología
[Ideology Detector]
1989
Ink, cardboard, plastic, metal,
acetate
20.1 x 20.5 x 10.1 cm
Museo Nacional de Bellas Artes,
Havana
Inv. 92.253

407
El síndrome de la sospecha
[Suspicion Syndrome]
2004
Colour video installation
Running time: 2 min, 57 sec. (loop)
Private collection, Montreal

Osvaldo SALAS
Havana, 1914 – Havana, 1992

283
Tres hermanos
[Three brothers]
1963 (recent print)
Gelatin silver print
27.3 x 38.8 cm
Fototeca de Cuba, Havana

293
Cigarro
[Cigar]
1967 (recent print)
Gelatin silver print
40.2 x 27.3 cm
Fototeca de Cuba, Havana

323
*Wifredo Lam in the 1967 Salón de
Mayo gallery ("Composition," [about
1951–58] on the left and "Mother and
Child, III" [about 1952] on the right)*
1967
Gelatin silver print
20.3 x 25.5 cm
Private collection, Paris
Courtesy of Günter Schütz

330
*Artists painting the Salón de Mayo
Mural*
1967
Gelatin silver print
17.7 x 27.8 cm
Private collection, Paris
Courtesy of Günter Schütz

Tomás SÁNCHEZ
Born in Aguada de Pasajeros in
1948

318
Por la mañana
[In the Morning]
1973
Oil on canvas
80.5 x 101.5 cm
Museo Nacional de Bellas Artes,
Havana
Inv. 90.2690

361
La inundación
[The Flood]
1984
Acrylic on canvas
130 x 150 cm
Museo Nacional de Bellas Artes,
Havana
Inv. 07.725

362 ★
Relación
[Relation]
1986
Acrylic on canvas
200 x 350 cm
Museo Nacional de Bellas Artes,
Havana
Gift of the artist, 1986
Inv. 87.1

Valentín SANZ CARTA
Santa Cruz de Tenerife, Canary
Islands, 1849 – New York, 1898

42 ★
Las malangas
[Malangas]
About 1880
Oil on canvas
171 x 113 cm
Museo Nacional de Bellas Artes,
Havana
Inv. 95.766

Helena SERRANO
Havana, 1933 – Miami, 1994

342
Día del Guerrillero Heroico. 8 de Octobre
[Day of the Heroic Guerrilla. October 8]
1968
Poster. Offset
Published by OSPAAAL
49.5 x 35 cm
Museo Nacional de Bellas Artes, Havana
Inv. T-3783

Loló SOLDEVILLA
Pinar del Rió, 1901 – Havana, 1971

269
Homenaje a Fidel
[Tribute to Fidel]
1957
Sculpted polychrome wood
145 x 152.5 cm
Museo Nacional de Bellas Artes, Havana
Inv. 68.7

Alfredo SOSABRAVO
Born in Sagua la Grande in 1930

306
El hombre del Napalm
[Napalm Man]
1967
Oil, collage on canvas
122 x 91 cm
Museo Nacional de Bellas Artes, Havana
Inv. T-7968

307
Si yo tuviera un martillo
[If I Had a Hammer]
1967
Oil, collage on canvas
124 x 93 cm
Private collection
Courtesy of the Museo Nacional de Bellas Artes, Havana

Leandro SOTO
Born in Cienfuegos in 1956

399
La familia revolucionaria
[The Revolutionary Family]
1984
Manipulated photograph, oil, lamps, wood
202 x 160 x 23 cm
Museo Nacional de Bellas Artes, Havana
Inv. 91.772

T

José TOIRAC
Born in Guantánamo in 1966

404
Autorretrato. Homenaje a Durero
[Self-portrait. Tribute to Dürer]
1995
Oil on canvas
180 x 120 cm
Museo Nacional de Bellas Artes, Havana
Inv. 95.773

José TOIRAC
Born in Guantánamo in 1966
and
Meira MARRERO
Born in Havana in 1969
and
Patricia CLARK
Resides and works in Phoenix, Arizona

405
La Edad de Oro [The Golden Age]
2000
Video installation on three monitors, soundtrack
Running time: 10 min, 57 sec.
The Montreal Museum of Fine Arts
Purchase, The Museum Campaign 1988–1993 Fund
Inv. 2006.75

U

Enrique de la UZ
Born in Havana in 1944

294, 295
From the series "No hay otro modo de hacer la zafra" [There is No Other Way to Harvest the Cane]
Untitled
1970
Gelatin silver prints
30.4 x 20.5 cm each
Collection of the artist
Courtesy of the Fototeca de Cuba, Havana

V

Juan Bautista VALDÉS
Cuba (?) – Kinsgton, Jamaica, 1903)

1
José Martí in Kingston, Jamaica
1892
Gelatin silver print
16 x 12.2 cm
Fototeca de la Oficina del Historiador de la Ciudad
Courtesy of the Museo Nacional de Bellas Artes, Havana

Jaime VALLS
Barcelona, 1883 – Havana, 1955

117
Cover of the magazine "Bohemia"
January 13, 1935
31 x 23 cm
Biblioteca Nacional José Martí, Havana

Z

Rafael ZARZA
Born in Havana in 1944

300
En el campo
[In the Field]
1972
Oil on canvas
159 x 250 cm
Museo Nacional de Bellas Artes, Havana
Inv. T 9083

346
Jornada de solidaridad con el pueblo de Laos. 12 de octobre
[Day of Solidarity with the People of Laos. October 12]
1969
Poster. Offset
Published by OSPAAAL
53.5 x 33 cm
Museo Nacional de Bellas Artes, Havana
Inv. 76.2633

ANONYMOUS
PHOTOGRAPHS

2
Male Victim of the Re-concentration
1897
Gelatin silver print
10.2 x 7.3 cm
Biblioteca Nacional José Martí, Havana

6
The Lowering of the Spanish Flag and Raising of the American Flag at the Castillo de los Tres Reyes del Morro, January 1, 1899
1899
Gelatin silver print
16 x 21 cm
Private collection
Courtesy of the Fototeca de Cuba, Havana

7
The Lowering of the American Flag and Raising of the Cuban Flag at the Castillo de los Tres Reyes del Morro, May 20, 1902
1902
Gelatin silver print
16 x 20.7 cm
Private collection
Courtesy of the Fototeca de Cuba, Havana

9
The "Texas" entering the Bay of Havana
1925
Gelatin silver print
18.8 x 23.8 cm
Vicki Gold Levi Collection, New York

12
*Young woman wearing a Cuban flag
for a school function*
1930s
Gelatin silver print
15.1 x 10 cm
Vicki Gold Levi Collection,
New York

27
*The Pérez Beato-Arango Family,
Calle Industria*
1920s
Gelatin silver print
20.5 x 15.3 cm
Vicki Gold Levi Collection,
New York

28
Untitled, Santiago de Cuba
About 1910
Gelatin silver print
10.6 x 14.6 cm
18.2 x 30.3 x 4 cm (album)
Fototeca de Cuba, personal
collection of Joaquín Blez, Havana
Inv. EM-7

30
*Statue of a Virgin in a Catholic
Procession, Santiago de Cuba*
About 1930
Gelatin silver print
12.7 x 18 cm
Diario de Cuba Collection,
Fototeca de Cuba, Havana
Inv. EM-23

116 ★
*The people kill Machado's assassin,
Gustavo Sánchez, in Santiago de
Cuba*
1933
Digital reprint
16.5 x 25.4 cm
Archivo de FotoCreart, Ministry
of Culture, Havana

167
The Singer Kasandra
1961
Gelatin silver print
25.2 x 20.2 cm
Vicki Gold Levi Collection,
New York

169
Hot tamales street vendor, Havana
1950s
Gelatin silver print
24.1 x 19.1 cm
Vicki Gold Levi Collection,
New York

170
*Still from a Cuban television
advertisement for Firestone tires*
About 1950
Gelatin silver print
18.5 x 23.6 cm
Vicki Gold Levi Collection,
New York

172
*The famous Cuban boxer Kid
Chocolate praying to Santa Bárbara
after serving seven months in prison
for possession of marijuana*
1950s
Gelatin silver print
18.8 x 23.5 cm
Vicki Gold Levi Collection,
New York

174
*Meyer Lansky (right), the famous
American gangster who financed
the construction of the Hotel Riviera
in Havana*
1950s
Gelatin silver print
24 x 19.4 cm
Vicki Gold Levi Collection,
New York

177
Sloppy Joe's Bar
1940s
Gelatin silver print
18.8 x 24.3 cm
Vicki Gold Levi Collection,
New York

178
*Josephine Baker (centre) next to the
pianist Felo Bergaza and other
friends in the dressing room of the
Tropicana cabaret*
About 1950
Gelatin silver print
18.8 x 23.6 cm
Vicki Gold Levi Collection,
New York

179
*Rodney, the country's most famous
choreographer and artistic director
of the Tropicana cabaret, with
Carmen Miranda*
1955
Gelatin silver print
24.1 x 19.1 cm
Vicki Gold Levi Collection,
New York

180
*The actor Robert Taylor and his wife,
the actress Barbara Stanwyck, at
Sloppy Joe's Bar*
1940s
Gelatin silver print
24.3 x 31.5 cm
Vicki Gold Levi Collection,
New York

181
*Marlon Brando playing the conga,
Havana. With him, the Cuban author
Guillermo Cabrera Infante*
1956
Gelatin silver print
24.1 x 19.4 cm
Vicki Gold Levi Collection,
New York

191
*The dancer Esperanza Muñoz,
believed to be the inspiration for
Rita Longa's sculpture and the
Tropicana's logo*
1950
Gelatin silver print
14.6 x 9.2 cm
Vicki Gold Levi Collection,
New York

193
The singer Rita Montaner
1948
Gelatin silver print
17.2 x 10.5 cm
Vicki Gold Levi Collection,
New York

194
Showtime at the Sans Souci cabaret
1950s
Gelatin silver print
19.4 x 24.3 cm
Vicki Gold Levi Collection,
New York

197
*Famous Cuban caricaturist Conrado
W. Massaguer (third from the left) at
a birthday party organized by friends*
1943
Gelatin silver print
11.2 x 16.1 cm
Vicki Gold Levi Collection,
New York

198
*Left to right: the singer in Orquesta
Sensación; a friend; the singer
Pacho Alonso; and Celeste Mendoza
(The Queen of "Guaguancó") at
La Bodeguita del Medio*
About 1950
Gelatin silver print
19 x 24 cm
Vicki Gold Levi Collection,
New York

214
*Anselmo Aliegro and Fulgencio
Batista. Santiago de Cuba*
About 1950
Gelatin silver print
18 x 24 cm
Diario de Cuba Collection,
Fototeca de Cuba, Havana
Inv. EM-53

259
*Left to right: Alfred H. Barr Jr., José
Gómez Sicre, María Luisa Gómez
Mena and Edgar J. Kaufmann Jr.*
1942 (?)
Gelatin silver print
20.3 x 25.4 cm
Torna & Prado Fine Art Collection,
Miami

260–264 ★
*5 Installation views of the exhibition
"Modern Cuban Painters." The
Museum of Modern Art, New York.
March 17, 1944 through May 7, 1944*
Archival photographs
The Museum of Modern Art,
New York
Courtesy of the Photographic
Archives, The Museum of Modern
Art Archives
Inv. (IN255.13); (IN255.15);
(IN255.16); (IN255.17); (IN255.18)

327
*Wifredo Lam and schoolchildren in
front of a memorial to Che*
1967
Gelatin silver print
18 x 23.8 cm
Private collection, Paris
Courtesy of Günter Schütz

p. 17 ★
2. *Café el Pasaje in Havana*
Gelatin silver print
8.9 x 9 cm
The Montreal Museum of Fine Arts
Gift of David R. Morrice
Inv. 1981(1974).Ph.3

p. 385
Wagon
About 1940s
Gelatin silver print
19 x 24.3 cm
New York, Vicki Gold Levi
Collection

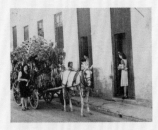

POSTCARDS

15
*Havana: Carnival Float on the
Malecón*
About 1928
Published by C. Jordi, Havana
9 x 14 cm
The Wolfsonian–Florida
International University, Miami
Beach, Florida
The Vicki Gold Levi Collection
Inv. XC2002.11.4.332

16
Havana: Carnival Season
About 1922
Published by Edición Jordi, Havana
9 x 14 cm
The Wolfsonian–Florida
International University, Miami
Beach, Florida
The Vicki Gold Levi Collection
Inv. XC2002.11.4.98

17
*Memorial Wall to the Cuban
Students, Havana, Cuba* (sic)
1907–15
8.6 x 13.6 cm
The Montreal Museum of Fine Arts
Purchase, in process of acquisition

18
*Shooting of Cuban Prisoners at
Castillo de los Tres Reyes del Morro,
Havana, Cuba*
About 1908
Published by H. H. Stratton,
Chattanooga, Tennessee
9 x 14 cm
The Wolfsonian–Florida
International University, Miami
Beach, Florida
The Vicki Gold Levi Collection
Inv. XC2002.11.4.95

19
*Palacio Presidencial, Avenida de las
Misiones, Havana, Cuba*
1940s
8.7 x 13.7 cm
The Montreal Museum of Fine Arts
Purchase, in process of acquisition

20
Marianao Bathing Beach
1937
Published by C. Jordi, Havana
Printed by Curt Teich, United
States
9 x 14 cm
The Wolfsonian–Florida
International University, Miami
Beach, Florida
The Vicki Gold Levi Collection
Inv. XC2002.11.4.114

21
The Prado, Havana, Cuba
1941
8.9 x 14.1 cm
The Montreal Museum of Fine Arts
Purchase, in process of acquisition

22
National Casino at Marianao
1935
8.9 x 14 cm
The Montreal Museum of Fine Arts
in process of acquisition

23
*Havana: Parque Central, Capitolio,
Teatro Nacional*
About 1940s
8.6 x 13.8 cm
The Montreal Museum of Fine Arts
in process of acquisition

24
Havana: Miramar Yacht Club
About 1925
Published by C. Jordi, Havana
9 x 14 cm
The Wolfsonian–Florida
International University, Miami
Beach, Florida
The Vicki Gold Levi Collection
Inv. XC2002.11.4.116

25
*Havana: Parque Central, Hotel
Inglaterra, Teatro Nacional*
About 1925
Published by C. Jordi, Havana
9 x 14 cm
The Wolfsonian–Florida
International University, Miami
Beach, Florida
The Vicki Gold Levi Collection
Inv. XC2002.11.4.100

26
A Bit of Old Havana, Cuba
1925
8.7 x 14 cm
The Montreal Museum of Fine Arts
in process of acquisition

35
*Havana: Source of the Almendares
River. Cuban Landscape*
n.d.
8.4 x 13.7 cm
The Montreal Museum of Fine Arts
in process of acquisition

36
Tobacco Field, Cuba
About 1908
Published by H. H. Stratton,
Chattanooga, Tennessee
14 x 9 cm
The Wolfsonian–Florida
International University, Miami
Beach, Florida
The Vicki Gold Levi Collection
Inv. XC2002.11.4.92

37
Cutting Sugar Cane, Cuba
(19th c. photo)
About 1908
Published by Harris Bros. Co,
Havana
9 x 14 cm
The Wolfsonian–Florida
International University, Miami
Beach, Florida
The Vicki Gold Levi Collection
Inv. XC2002.11.4.93

38
Havana. Cockfight
1914
8.7 x 13.6 cm
The Montreal Museum of Fine Arts
in process of acquisition

39
Wharf Scene, Havana, Cuba
About 1908
Published by H. H. Stratton,
Chattanooga, Tennessee
Printed by American Photo
Company, Havana
14 x 9 cm
The Wolfsonian–Florida
International University, Miami
Beach, Florida
The Vicki Gold Levi Collection
Inv. XC2002.11.4.99

182
*"Smoke Havana Cigars: a sign of
good taste!"*
About 1939
Published by the National
Commission for Propaganda and
Defense of Cuban Tocacco at the
New York World's Fair
Printed by Tichnor Brothers, Inc.,
Boston
9 x 14 cm
The Wolfsonian–Florida
International University, Miami
Beach, Florida
The Vicki Gold Levi Collection
Inv. XC2002.11.4.109

183
*"This is for Ma . . . and this is for
ME!: Greetings from Cuba—Isle of
Bacardi"*
About 1940
Published by Bacardi, Havana
9 x 14 cm
The Wolfsonian–Florida
International University, Miami
Beach, Florida
The Vicki Gold Levi Collection
Inv. XC2002.11.4.120

184
La Florida, Bar Restaurant, The Cradle of the Daiquiri Cocktail
About 1925
Published by La Florida, Havana
Printed by Compañía Litográfica de La Habana, Cuba
9 x 14 cm
The Wolfsonian–Florida International University, Miami Beach, Florida
The Vicki Gold Levi Collection
Inv. XC2002.11.4.78

185
Sloppy Joe's Bar. Havana, Cuba
About 1925
Published by Sloppy Joe's Bar, Havana
Printed by Compañía Litográfica de La Habana, Cuba
9 x 14 cm approx.
The Wolfsonian–Florida International University, Miami Beach, Florida
The Vicki Gold Levi Collection
Inv. XC2002.11.4.81

p. 17 ★
4. Cuba: Paisaje tropical
[Cuba: Tropical Landscape]
Before 1912
Published by C. Jordi, Havana (no. 191)
13.6 x 8.5 cm
Collection Lucie Dorais, Ottawa

p. 17 ★
6. Cuba: Pueblo de Pescadores
[Cuba: Fishing Village]
Before 1912
Published by C. Jordi, Havana (no. 191)
8.6 x 13.8 cm
Collection Lucie Dorais, Ottawa

p. 21
6. Cuban Pavilion, Expo '67, Montreal
1967
8.9 x 14 cm
The Montreal Museum of Fine Arts, in process of acquisition

p. 24
Coconut Trees on Avenida Del Puerto, Havana
Late 1920s
Published by EKC
8.8 x 13.7 cm
The Montreal Museum of Fine Arts, in process of acquisition

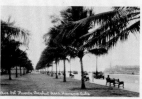

PRINTED DOCUMENTS

58
Cigar box labels and cigar rings
19th century
Selection of colour lithographs
Various dimensions
Museo Nacional de Bellas Artes, Havana
Variable dimensions

121 ★
Cover of the magazine "Bohemia"
1930s
31 x 25 cm
Vicki Gold Levi Collection, New York

187
"Cuba, Ideal Vacation Land"
Guidebook cover
About 1951
19.5 x 13.5 cm (closed)
Vicki Gold Levi Collection, New York

188
"Tropicana: A Paradise under the Stars"
Brochure cover
1955
32.2 x 24.4 x cm (closed)
Vicki Gold Levi Collection, New York

328
Special issue of "Granma" covering the 1967 Salón de Mayo
July 1967
54.6 x 38.1 cm
Collection Günter Schütz, Paris

Not illustrated
"I am The Man : a Cuban Musical"
About 1950
Film poster. Lithograph
Published by Behar, S.A., Cuba
95.3 x 69.9 cm
The Wolfsonian-Florida International University, Miami Beach, Florida
The Vicki Gold Levi Collection
Inv. XC2002.11.4.390

Other photographs and printed documents from a private collection in Paris, obtained with the kind help of Günter Schütz and the Vicky Gold Levi collection in New York are included in the exhibition but not documented in the catalogue.

Andrés GARCÍA BENÍTEZ, *Cover of the magazine "Carteles"*, May 1939

CARTELES

ALFREDO T. QUÍLEZ
DIRECTOR:

VOL. XXXIII. No. 21
LA HABANA, CUBA,
MAYO 21 - 1939

Andrés
1939

SELECT BIBLIOGRAPHY

Books and Monographs

Alonso, Alejandro G. *Amelia Peláez*. Havana: Letras Cubanas, 1988.

———. *Sosabravo. Alea jacta est*. Catalogue raisonné. Havana: 2005.

Amado, Jorge. *Album Fotográfico - Che*. Milan: Ed. A & A, 1990.

Arístides Fernández. Havana: Publicaciones del Ministerio de Educación, Dirección de Cultura, 1950.

Billeter, Erika. *Canto a la realidad. Fotografía Latinoamericana 1860-1993*. Barcelona: Lunwerg Editores, 1993.

Block, Holly, ed. *Art Cuba: The New Generation*. New York: H.N. Abrams, 2001.

de Bozzi, Pénélope and Ernesto Oroza. *Objets réinventés: la création populaire à Cuba*. Paris: Alternatives, 2002.

Camnitzer, Luis. *New Art of Cuba*. Austin: University of Texas Press, 2003.

Carreño, Mario. *Mario Carreño: Cronología del recuerdo*. Santiago (Chile): Editorial Antártica, 1991.

de Castro, Martha. *El Arte en Cuba*. Miami: Ediciones Universal, 1970.

Cien imágenes de la Revolución Cubana: 1953–1996. Havana: Editorial arte y literatura and Oficina de Publicaciones del Consejo de Estado, 2004.

Corrales, Raúl. *Cuba: la imagen y la historia*. Panama City: Ediciones Aurelia, 2006.

———. *Girón: memorias de una victoria*. Rome: Percorsi Immaginari, 2001.

———. *Testimonios de Patria o Muerte*. Havana: Letras Cubanas, 1981.

Costa-Peuser, Diego, ed. *Remembering Cuba through its Art*. Miami: Arte al Día International, American Art Corporation and Padrón Publications.

Cruz Díaz, Ursulina. *Diccionario biográfico de las artes plásticas*. Havana: Pueblo y Educación, 1999.

Cundo Bermúdez. Madrid: Industrias Gráficas Caro, 2000.

Cushing, Lincoln. *¡Revolución!: Cuban Poster Art*. San Francisco: Chronicle Books, 2003.

de Juan, Adelaida, *Caricatura de la República*. Habana: Ediciones Unión, 1999.

———. *Cincuenta artistas plásticos cubanos*. Havana: Unión de Escritores y Artistas de Cuba, 1996.

———. *Del silencio al grito*. Havana: Letras Cubanas, 2002.

———. *Más allá de la pintura*. Havana: Letras Cubanas, 1993.

———. *Pintura Cubana: temas y variaciones*. Havana: Ediciones UNEAC, 1978.

Desnoes, Edmundo. "1952-1962 en la pintura cubana," in *Pintores cubanos*. Havana: Ediciones Revolución, 1962, pp. 39–48.

Espinosa, Magaly and Kevin Power, eds. *El nuevo arte cubano: antología de textos críticos*. Santa Monica, California: Perceval Press, 2006.

Fouchet, Max Pol. *Wifredo Lam*. Barcelona: Ediciones Polígrafa, 1976.

García Osuna, Alfonso J. *The Cuban Filmography: 1897 through 2001*. Jefferson, North Carolina: McFarland, 2003.

Gaudibert, Pierre and Jacques Leenhardt. *Wifredo Lam : œuvres de Cuba*. Paris: Séguier, 1989.

Gold Levi, Vicki and Steven Heller. *Cuba Style: Graphics from the Golden Age of Design*. New York: Princeton Architectural Press, 2002.

Gómez Sicre, José. *Pintura cubana de hoy*. Havana: María Luisa Gómez Mena.

González, Margarita, Tania Parson and José Veigas. *Déjame que te cuente. Antología de la crítica en los 80*. Havana: Artecubano Ediciones, 2002.

Guía de Arte Cubano. Havana: Museo Nacional de Bellas Artes [2003].

Haya, María E., ed. *Cuba: la fotografía de los años 60*. Havana: Fototeca de Cuba, 1988.

Hernandez, Orlando. *La Isla Grande: cien viejas postales de Cuba*. Italy: Oltre l'Orizzonte, 1998.

Jouffroy, Alain, *Lam*. Paris: Georges Fall, 1972.

Kwan, Kevin, Peter Castro and Ramiro Fernandez. *I Was Cuba: Treasures from the Ramiro Fernandez Collection*. San Francisco: Chronicle Books, 2007.

Korda, Alberto. *Diario de una Revolución*. Valencia, Spain: Ediciones Aurelia, 2006.

Laurin-Lam, Lou. ed *Wifredo Lam: Catalogue Raisonné of the Painted Work. Vol. 1, 1923–1960*. Lausanne: Acatos, 1996.

———. *Volume II, 1961-1982*. Lausanne: Acatos, 2002.

Leiris, Michel, *Wifredo Lam*. Milan: Fratelli Fabri, 1970.

Lezama Lima, José. *La visualidad infinita*. Havana: Letras Cubanas, 1994.

Loviny, Christophe, ed. *Cuba by Korda*. Melbourne and New York: Ocean Press, 2006.

Lowinger, Rosa and Ofelia Fox. *Tropicana Nights: The Life and Times of the Legendary Cuban Nightclub*. Orlando, Florida: Harcourt, 2005.

Lucie-Smith, Edward. *Latin American Art of the 20th Century*. London: Thames & Hudson, 1993.

Martínez, Juan A. *Cuban Art and National Identity: The Vanguardia Painters, 1927–1950*. Gainesville: University Press of Florida, 1994.

Merino Acosta, Luz. *La pintura y la ilustración: dos vías del arte moderno en Cuba*. Havana: Ministerio de Educación Superior, 1990.

Mora, Gilles. *Walker Evans: Havana 1933*. New York: Pantheon Books, 1989.

Mosquera, Gerardo. *Art Cuba: The New Generation*. New York: H.N. Abrams, 2001.

———. *Contracandela: ensayos sobre kitsch, identidad, arte abstracto y otros temas calientes*. Caracas: Monte Ávila Editores Latinoamericana and Galería de Arte Nacional, 1995.

———. *Exploraciones en la plástica cubana*. Havana: Letras Cubanas, 1983.

Myerson, Michael ed. *Memories of Underdevelopment: The Revolutionary Films of Cuba*. New York: Grossman Publishers, 1973.

Noceda, José Manuel. *Wifredo Lam en las colecciones cubanas*. Havana: Artecubano Ediciones, 2002.

Núñez Jiménez, Antonio, *Marquillas cigarreras cubanas*. Madrid: Tabapress, 1989.

———. *Wifredo Lam*. Havana: Letras Cubanas, 1982.

Ortiz, Fernando, *Wifredo Lam y su obra vista a través de significados artísticos*. Havana: Publicaciones del Ministerio de Educación, Dirección de Cultura, 1950.

Paranaguá, Paulo Antonio, ed. *Le cinéma cubain*. Paris: Centre Georges Pompidou, 1990.

Pereira, María de Los Angeles. *Escultura y escultores cubanos*. Havana: Artecubano Ediciones, 2005.

Pérez Cisneros, Guy. *Características de la evolución de la pintura en Cuba*. Havana: Dirección General de Cultura, Ministerio de Educación, 1959.

Pino-Santos, Carina. *Fin de Milenio – Nuevos artistas cubanos*. Havana: Letras Cubanas, 2001.

Pogolotti, Graziella. *El Camino de los maestros*. Havana: Letras Cubanas, 1979.

———. *Examen de conciencia*. Havana: Ediciones Unión, 1965.

———. *Experiencia de la crítica*. Havana: Letras Cubanas, 2003.

Pogolotti, Marcelo. *Del barro y las voces*. Havana: Letras Cubanas, 2004.

Pool, Sean M, *Gattorno: A Cuban Painter for the World*. Miami: Arte al Día International and American Art Corporation, 2004.

Riggs, Thomas ed. *St. James Guide to Hispanic Artists. Profiles of Latino and Latin American Artists*. London: St James Press, 2002.

Rigol, Jorge. *Apuntes sobre la pintura y el grabado en Cuba*. Havana: Letras Cubanas, 1982.

———. *Víctor Manuel*. Havana: Letras Cubanas, 1990.

Rosenheim, Jeff L., ed., with the collaboration of Alexis Schwarzenbach. *Unclassified: A Walker Evans Anthology*. Zurich/Berlin/New York: Scalo with the Metropolitan Museum of Art.

Ruiz, Raúl R. *Esteban Chartrand. Nuestro romántico*. Havana: Letras Cubanas, 1987.

Sánchez, Juan. *Fidelio Ponce*. Havana: Letras Cubanas, 1979.

Seoane Gallo, José. *Eduardo Abela cerca del cerco*. Havana: Letras Cubanas, 1986.

Sims, Lowery Stokes. *Wifredo Lam and the International Avant-garde, 1923–1982*. Austin: University of Texas Press, 2002.

Stermer, Dugald, ed. *The Art of Revolution*. New York: McGraw-Hill, 1970.

Sullivan, Edward J., ed. *Latin American Art in the Twentieth Century*. London: Phaidon, 1996.

Tonneau-Ryckelynck, Dominique and Pascal Dron. *Wifredo Lam: œuvre gravé et lithographié: catalogue raisonné*. Gravelines, France: Édition du Musée de Gravelines, 1993.

Torriente, Loló de la. *Estudio de las artes plásticas en Cuba*. Havana, 1954.

Turner, Jane, ed. *Encyclopedia of Latin American and Caribbean Art*. New York: Grove's Dictionaries, 2000.

Valdés, Rayna Maria. *Cuba en la gráfica*. Italy: G. Constantino, 1992.

Vázquez Díaz, Ramón. "Encuentro con Amelia Peláez," in *Amelia Peláez: óleos, temperas y dibujos (1929-1964)*. Salamanca, Spain: Gráficas Varona, 1998.

Veigas, José, ed. *Mariano: tema, discurso y humanidad*. Seville, Spain: Escandón Impresores, 2004.

Veigas, José, et al. *Memoria: Cuban Art of the 20th Century*. Los Angeles: California International Arts Foundation, 2002.

Vich Adell, Mercedes, ed. *Pintores cubanos*. Havana: Gente Nueva, 1974.

Wood, Yolanda. *De la plástica cubana y caribeña*. Havana: Letras Cubanas, 1990.

Exhibition Catalogues

2007

Cuba Avant-garde: Contemporary Cuban Art from the Farber Collection. Gainesville: Samuel P. Harn Museum of Art, University of Florida.

Loló, un mundo imaginario. Havana: Museo Nacional de Bellas Artes.

Los 70: puente para las rupturas. Havana: Museo Nacional de Bellas Artes.

María Magdalena Campos-Pons: Everything is Separated by Water. Indianapolis: Indianapolis Museum of Art.

Wifredo Lam in North America. Milwaukee: The Patrick and Beatrice Haggerty Museum of Art, Marquette University.

2006

Che Guevara: Revolution & Icon. London: Victoria and Albert Museum.

Cuba: Vanguardias 1920–1940. Turin: Palazzo Bricherasio (works from the Museo Nacional de Bellas Artes).

Domingo Ramos: paisajes. Havana: Museo Nacional de Bellas Artes.

Frémez: alto contraste. Havana: Museo Nacional de Bellas Artes.

José Manuel Fors: historias circulares. Havana: Museo Nacional de Bellas Artes.

Novena bienal de la Habana 2006: dinámicas de la cultura. Madrid and Havana: Centro de Arte Contemporáneo Wifredo Lam and Consejo Nacional de las Artes Plásticas.

Wifredo Lam: orichas. Paris: Galerie Thessa Herold.

2005

AfroCuba: Works on Paper, 1963–2003. San Francisco: International Center for the Arts, San Francisco State University.

Arte de Cuba. Centro Cultural Banco do Brasil [works of the Museo Nacional de Bellas Artes, Havana (São Paulo, Rio de Janeiro, Brasilia and other cities)].

Carlos Garaicoa: Capablanca's Real Passion. Los Angeles: The Museum of Contemporary Art.

Carlos Garaicoa: Carta a los censores. Monaco: Fondation Prince Pierre de Monaco.

El arte del tabaco: exposición de marquillas. Havana: Museo Nacional de Bellas Artes.

Gattorno: A Cuban Painter for the World. Miami: Lowe Art Museum, University of Miami.

Jorge Arche centenario. Havana: Museo Nacional de Bellas Artes.

Lam et les poètes. Paris and L'Isle-sur-la-Sorgue: Musée Campredon and Maison René Char.

Raúl Corrales: pasos por la historia: homenaje en su 80 aniversario. Havana: Museo Nacional de Bellas Artes.

Sosabravo de hoy. Havana: Museo Nacional de Bellas Artes.

2004

Ana Mendieta: Earth Body, Sculpture and Performance 1972–1985. Washington, D.C.: Hirshorn Museum and Sculpture Garden, Smithsonian Institution.

Arístides Fernández, entre el olvido y la memoria en el centenario de su nacimiento: pinturas y dibujos. Havana: Museo Nacional de Bellas Artes.

Carlos Garaicoa: la misura di quasi tutte le cose. Siena: Palazzo delle Papesse, Centro Arte Contemporanea.

Carpentier, coleccionista. Havana: Museo Nacional de Bellas Artes.

Inverted Utopias: Avant-Garde Art in Latin America. Houston: Museum of Fine Arts.

Kcho – Núcleos del tiempo. Havana: Galería Villa Manuela.

La sociedad cubana del siglo XIX: reflejos de una época. Exposición de pinturas y grabados. Havana: Museo Nacional de Bellas Artes.

Mirar a los 60: antología cultural de una década. Havana: Museo Nacional de Bellas Artes.

MoMA at El Museo: Latin American and Caribbean Art from the Collection of The Museum of Modern Art. New York: Museo del Barrio.

Wifredo Lam – Los años decisivos, 1939-1947. Quito: Centro Cultural Metropolitano (works from the Museo Nacional de Bellas Artes).

2003

8 Bienal de La Habana: el arte con la vida. Havana: Centro de Arte Contemporáneo Wifredo Lam and Consejo Nacional de las Artes Plásticas.

Archipiélago: Kcho. Havana: Pan American Art Gallery.

Autobiografía: una exposición de Tania Bruguera. Havana: Museo Nacional de Bellas Artes.

Carlos Garaicoa: autoflagel-lació, supervivència, insubordinació, cicle ficcions. Barcelona: Fundació "la Caixa."

Cuba on the Verge: An Island in Transition. New York: International Center for Photography.

Fluid/Fluido Exposición de Los Carpinteros. Havana: Museo Nacional de Bellas Artes.

Inside, Outside: Contemporary Cuban Art. Winston-Salem, North Carolina: Charlotte and Philip Hanes Art Gallery, Wake Forest University.

La habitación de mi negatividad. C. Garaicoa, Havana: La Casona.

Lázaro Saavedra: el único animal que ríe. Havana: Museo Nacional de Bellas Artes.

Mendive. Las aguas, lo cotidiano y el pensamiento. Havana : Museo Nacional de Bellas Artes.

Menocal-Romañach. Salamanca, Spain: Caja Duero (works from the Museo Nacional de Bellas Artes).

Uno, dos, tres . . . once!: exposición homenaje al cincuenta aniversario de la fundación del grupo Los Once. Havana: Museo Nacional de Bellas Artes.

Wifredo Lam – Colección del Museo de Bellas Artes de La Habana. Alicante: Area de Cultura y Educación.

2002

Carlos Garaicoa: Continuity of Somebody's Architecture. Kassel: documenta 11.

Carlos Garaicoa: ni Christ, ni Marx, ni Bakounine: photographies, installations, vidéos. Paris: Maison européenne de la photographie.

El siglo de Pogolotti. Havana: Museo Nacional de Bellas Artes.

Escuela de la Habana, tradición y modernidad. Zapopan, Mexico: Museo de Arte de Zapopan.

Kunst aus Kuba: Sammlung Ludwig/Art from Cuba: The Ludwig Collection. St. Petersburg: State Russian Museum/Ludwig Museum in the Russian Museum.

La razón de la poesía: Diez Pintores concretos cubanos. Havana: Museo Nacional de Bellas Artes.

Toirac: mediaciones, mediations II. Havana: Galería Habana.

Wifredo Lam: mito y convivencia. Centenario. Havana: Museo Nacional de Bellas Artes.

2001

Alfredo González Rostgaard. A Retrospective: Cuban Revolutionary Posters. New York: Center for Cuban Studies.

Imágenes desde el silencio. Colografías y matrices de Belkis Ayón. Havana: Museo Nacional de Bellas Artes.

Kcho. 25 piedras: exposición de litografías. Havana: Taller Experimental de Gráfica.

La Jungla: Kcho. Havana: Museo Nacional de Bellas Artes.

Lam métis. Paris: Musée Dapper.

Museo Nacional de Bellas Artes, La Habana, Cuba: Colección de arte cubano. Havana: Museo Nacional de Bellas Artes.

Shifting Tides: Cuban Photography after the Revolution. Los Angeles: Los Angeles County Museum of Art.

2000

Cuba sí: 50 Years of Cuban Photography. London: Royal National Theatre.

Cuban Art of Three Generations. Little Rock: Arkansas Arts Center.

Graphics from Latin America and the Caribbean: From the Collection of the Inter-American Development Bank, Washington, D.C. York, Pennsylvania: York College of Pennsylvania Art Galleries.

Séptima bienal de La Habana 2000. Havana: Centro de Arte Contemporáneo Wifredo Lam and Consejo Nacional de las Artes Plásticas.

Sosabravo – Premio nacional de artes plásticas. Havana: Galería La Acacia.

1999

Arte cubano: más allá del papel. Madrid: Fundación Caja.

Contemporary Art from Cuba: Irony and Survival on the Utopian Island. New York: Arizona State University Art Museum.

Pintura española y cubana del siglo XIX. Salamanca, Spain: Caja Duero (with the Museo Nacional de Bellas Artes).

1998

Cuba, 100 años de fotografía: antología de la fotografía cubana, 1898-1998, Madrid: Casa de América with Fototeca de Cuba.

Víctor Patricío Landaluze: sus años en Cuba. Bilbao: Museo de Bellas Artes de Bilbao (with the Museo Nacional de Bellas Artes).

1997

Breaking Barriers: Selections from the Museum of Art's Permanent Contemporary Cuban Collection. Fort Lauderdale, Fort Lauderdale Museum of Art.

Che Guevara. Icon, Myth and Message. Los Angeles: Fowler Museum of Cultural History.

Cuba: A History in Art. Daytona Beach, Florida: Museum of Arts and Sciences, 1997.

Kcho: Todo cambia. Los Angeles: Museum of Contemporary Art.

Pintura europea y cubana en las colecciones del Museo Nacional de La Habana. Madrid: Fundación Cultural Mapfrevida.

Tarsila, Frida, Amelia: Tarsila do Amaral, Frida Kahlo, Amelia Peláez. Barcelona: Fundació "la Caixa."

Utopian Territories: New Art from Cuba. Vancouver and Havana: Morris and Helen Belkin Art Gallery, Contemporary Art Gallery, Fundación Ludwig de Cuba.

1996

Ana Mendieta. Santiago de Compostela: Centro Gallego de Arte Contemporánea.

Cuba Siglo XX: Modernismo y Sincretismo. Las Palmas de Gran Canaria: Centro Atlántico de Arte Moderno.

Marta María Pérez. Monterrey: Galería Ramis Barquet.

Siete fotografos cubanos. El voluble rostro de la realidad. Havana: Fundación Ludwig de Cuba.

1995

Antonia Eiriz: Tribute to a Legend. Fort Lauderdale: Fort Lauderdale Museum of Art.

Cuba: la isla posible. Barcelona: Centre de Cultura Contemporània de Barcelona.

Cuba sur les murs. Mons: Centre Culturel de la région de Mons.

Painting, Drawing, and Sculpture from Latin America: Selections from the Collection of the Inter-American Development Bank. Washington, D.C.: Inter-American Development Bank Cultural Center.

1993

Cuban Artists of the 20th Century. Fort Lauderdale: Fort Lauderdale Museum of Art.

1992

Crosscurrents of Modernism: Four Latin American Pioneers: Diego Rivera, Joaquín Torres-García, Wifredo Lam, Matta. Washington, D.C.: Hirshhorn Museum and Sculpture Garden, Smithsonian Institution.

Cuba 1959-1992. Fotografien. Berlin: Neue Gesellschaft für Bildende Kunst.

Fidelio Ponce y su época. Miami: Cuban Museum of Art and Culture.

Wifredo Lam. Madrid: Museo Nacional Centro de Arte Reina Sofía.

Wifredo Lam: A Retrospective of Works on Paper. New York: Americas Society.

Wifredo Lam and His Contemporaries 1938–1952. New York: Studio Museum in Harlem.

Wifredo Lam, Matta. Washington, D.C.: Hirshhorn Museum and Sculpture Garden, Smithsonian Institution.

1991

Amelia Peláez, exposición retrospectiva 1924–1967. Caracas: Fundación Museo de Bellas Artes.

Cuba-USA: First Generation. Washington D.C.: Fondo del Sol Visual Arts Center.

Los hijos de Guillermo Tell: artistas cubanos contemporáneos. Caracas: Consejo Nacional de la Cultura and Museo de Artes Visuales Alejandro Otero.

1990

Kuba o.k.: aktuelle Kunst aus Kuba/Kuba o.k.: arte actual de Cuba. Düsseldorf: Städtische Kunsthalle Düsseldorf.

No Man Is an Island – Young Cuban Art. Pori, Finland: Pori Art Museum.

The Nearest Edge of the World: Art and Cuba Now. Boston: Massachusetts College of Art.

1989

Outside Cuba/Fuera de Cuba: Contemporary Cuban Visual Artists. New Brunswick, New Jersey and Miami: Office of Hispanic Arts, Rutgers University and the Research Institute for Cuban Studies, University of Miami.

1988

Amelia Peláez: A Retrospective 1896–1968. Miami: Cuban Museum of Arts and Culture.

La Vanguardia. Surgimiento del arte moderno en Cuba. Havana: Museo Nacional de Bellas Artes.

Made in Havana: Contemporary Art from Cuba. Sydney: Art Gallery of New South Wales.

Mariano uno y múltiple. Santa Cruz de Tenerife: Centro Cultural de la Cajacanarias.

Salon and Picturesque Photography in Cuba 1860-1920: the Ramiro Fernandez Collection. Daytona Beach: Museum of Arts and Sciences.

Signs of Transition: 80's Art from Cuba. New York: Museum of Contemporary Hispanic Art.

Wifredo Lam. Düsseldorf: Kunstsammlung Nordrhein-Westfalen.

1987

Raúl Corrales y Constantino Arias. Cuba, dos épocas. Mexico: Fondo de Cultura Económica.

1985

Cuba: A View from Inside. 40 Years of Cuban Life in the Work and Words of 20 Photographers. New York: Ledel Gallery.

1984

René Portocarrero. Madrid: Museo Español de Arte Contemporáneo.

1983

Cuban Poster Art: A Retrospective, 1961–1982. New York: Center for Cuban Studies.

1982

Cuban Art, a Retrospective, 1930–1980. New York: Signs Gallery.

1980

Two Centuries of Cuban Art: 1759–1959. Sarasota and Daytona Beach: John and Mable Ringling Museum of Art and Museum of Arts and Sciences.

1977

Cuba: peintres d'aujourd'hui. Paris: Musée d'Art moderne de la Ville de Paris with the Association française d'Action artistique.

Culture et révolution: l'affiche cubaine contemporaine. Paris: Centre Georges Pompidou.

1968

Totems et tabous: Lam, Matta, Penalda dans une installation improvisée par Pierre Faucheux. Paris: Musée d'Art moderne de la Ville de Paris.

1960

Pintura contemporánea en Cuba. Caracas: Museo de Bellas Artes.

1952

7 Cuban Painters: Bermúdez, Carreño, Diago, Martínez-Pedro, Orlando, Peláez, Portocarrero. Washington, D.C.: Pan American Union.

1941

Exposición de arte cubano contemporáneo, Havana: Capitolio Nacional, Comisión Nacional Cubana de Cooperación Intelectual.

Articles and special issues

Alonso, Alejandro Alonso. "Raúl Martínez: el tiempo que vive," *Revolución y Cultura* (Havana), no. 10 (October 1986), pp. 40–51.

Barr, Alfred H. "Modern Cuban Painters," *Museum of Modern Art Bulletin* (New York), vol. 11, no. 5 (April 1944), pp. 5–9.

Barros, Bernardo. "Origen y desarrollo de la pintura en Cuba," in *Anales de la Academia Nacional de Artes y Letras* (Havana), vol. 2 (1924), pp. 60–85.

Brownstone, Gilbert. "Entretien avec Abel Prieto," *Le Journal des arts* (Paris), 19 November 2004, p. 19.

Cepero Amador, Iliana, "Joaquín Blez: El fotógrafo dandy," *Revolucion y Cultura* (Havana), no. 1 (January 2006), pp. 51-57.

Collective, "Cuba Theme Issue," *The Journal of Decorative And Propaganda Arts* (Miami), no. 22, (1996).

Collective, *FC – Fotografía Cubana – Anuario de fotografía cubana* (Havana), no. 0, (2005).

Collective. "La Habana," *Parachute* (Montreal), no. 125 (January–March 2007).

"Colores cubanos en Nueva York," *La Gaceta del Caribe* (Havana), (May 1944), p. 5.

Fernández, Antonio Eligio (Tonel). "Antonia Eiriz en la pintura cubana," *Revolución y Cultura* (Havana), no. 3 (March 1987), pp. 38–45.

———. "Hilo conceptual y 'arte global.'" *La Gaceta de Cuba* (Havana), May–June 2004, pp. 15–19.

———. "Umberto Peña expone," *Revolución y Cultura* (Havana), no. 9 (September 1988), pp. 26–31.

Fuente, Jorge de la. "Comentarios sobre el nuevo arte cubano," *Unión–Revista de Literatura y Arte* (Havana), vol. 2, no. 32 (1989).

de Juan, Adelaida. "Retrato de Arche," *Artecubano* (Havana), no. 1 (2006), pp. 41–44.

López Núñez, Olga. "Sanz Carta y sus paisajes cubanos," *Revolución y Cultura* (Havana), March–April 1993.

Merino Acosta, Luz. "Nueva imagen desde la cotidianeidad," *Artecubano* (Havana), no. 1 (1996), pp. 37–45.

Mosquera, Gerardo. "El nuevo arte de la Revolución," *Unión–Revista de Literatura y Arte* (Havana), no. 13 (1991), pp. 17–20.

———. "Servando Cabrera Moreno: toda la pintura," *Revolución y Cultura* (Havana), no. 59 (July 1977), pp. 44–59.

Oraá, Pedro de. "Una experiencia plástica: los diez pintores concretos," *La Gaceta de Cuba* (Havana), vol. 34, no. 6 (November–December 1996), pp. 50–53.

Pogolotti, Graziella. "Antonia Eiriz: arte entre dos mundos," *Unión–Revista de Literatura y Arte* (Havana), vol. 3, no.1 (1964), pp. 157–58.

———. "La pintura abstracta y la dictadura," *Nuestro Tiempo* (Havana), vol. 5, no. 28 (March–April 1959), p. 13.

———. "Revelación de la máquina en Acosta León," *Casa de las Américas* (Havana), no. 9 (November–December 1961), pp. 129–30.

Sontag, Susan, "The Cuban Poster," *Artforum* (New York), vol. 9 (October 1970), p. 57-63.

del Valle, Rufino and Ramón Cabrales. "Cuba sus inicios fotográficos," *Opus Habana* (Havana), vol. 8, no. 3 (December 2004 – March 2005), pp. 5–15.

Photo credits

Unless otherwise indicated, all works illustrated in this catalogue are by Rodolfo Martínez, independent photographer, Havana.

Introduction

Page 17: from left to right: National Gallery of Canada; The Montreal Museum of Fine Arts; The Montreal Museum of Fine Arts, Brian Merrett; Lucie Dorais, Ottawa, 2007; The Montreal Museum of Fine Arts; Lucie Dorais, Ottawa, 2007
Page 21: left column: The Montreal Museum of Fine Arts, Christine Guest; right column: Private collection, Paris. Courtesy of Günter Schutz; © Edmund Alleyn; The Montreal Museum of Fine Arts, Christine Guest

Joe Abraham Collection, Houston, Texas: ill. 176
Archivo de FotoCreart, Ministry of Culture, Havana: ill. 114, 115, 116, 213
Arizona State University Art Museum, Tempe, Stu Mitnik: ill. 390
Banque d'images, ADAGP / Art Resource, New York: ill. 271
Biblioteca Nacional José Martí, Havana: ill. 2, 4, 118
CNAC / MNAM / Dist. Réunion des Musées Nationaux / Art Resource, New York: ill. 246
Collection of the artist, Aventura, Florida: ill. 409
Collection Cinémathèque québécoise: ill. 356, 357, 358, 359
Courtesy of the Galleria Continua, San Gimignano – Beijing, Ela Bialkowska: ill. 410, 411
Courtesy of the artist: ill. 274
Courtesy of the artist: ill. 311
Courtesy of the artist: ill. 378, 379
Courtesy of the artist: ill. 408
Courtesy of the Couturier Gallery, Los Angeles: ill. 270, 275, 276, 278, 279, 280, 281, 282, 285, 286, 289, 292, 298, 387, 388 ; page 307

Fototeca de Cuba, Havana: ill. 3, 5, 6, 7, 8, 10, 11, 28, 29, 30, 31, 32, 33, 34, 80, 81, 82, 83, 84, 85, 86, 87, 88, 89, 199, 200, 201, 202, 203, 204, 205, 206, 207, 208, 209, 210, 211, 212, 214, 215, 272, 273, 277, 283, 284, 287, 288, 290, 291, 293, 294, 295, 296, 297
Fototeca de la Oficina del Historiador de la Ciudad. Courtesy of the Museo Nacional de Bellas Artes, Havana: ill. 1, 13, 14
Courtesy Sean Kelly Gallery, New York: ill. 403
Pablo L. Garcia Lazo: ill. 134
Vicki Gold Levi Collection, New York: ill. 9, 12, 27, 167, 168, 169, 170, 171, 172, 173, 174, 175, 177, 178, 179, 180, 181, 189, 190, 191, 192, 193, 194, 195, 196, 197, 198, 216; pages 151, 364, 372, 380, 385
Courtesy Ludwig Forum für Internationale Kunst, Aachen, Germany: ill. 374, 380
Courtesy of the Estate of Ana Mendieta Collection and Galerie Lelong, New York: ill. 368, 369, 370, 371, 372
Michel Motron, Paris, 2007: ill. 250
Museum of Art / Fort Lauderdale, Florida, Gerhard Heidersberger: ill. 375, 389
Museum of Arts & Sciences, Daytona Beach, Florida, James Quine: ill. 225
Courtesy Museum of Contemporary Photography, Columbia College, Chicago: ill. 363
The Montreal Museum of Fine Arts: ill. 405, 406, 407 ; page 24
The Montreal Museum of Fine Arts, Jean-François Brière: ill. 328, 344, 354
The Montreal Museum of Fine Arts, Brian Merrett: ill. 38, 119, 120, 121, 122, 123, 187, 188; pages 391, 394, 401, 406, 411
The Montreal Museum of Fine Arts, Christine Guest: ill. 17, 19, 21, 22, 23, 26, 35, 53, 59, 117, 186, 353
© The Museum of Modern Art / Licensed by SCALA / Art Resource, New York: ill. 132, 143, 228, 230, 231, 233, 234, 238, 240, 260, 261, 262, 263, 264, 391, 402
Don Queralto: ill. 224, 226, 241, 259; page 361
Silvia Ros: ill. 15, 16, 18, 20, 24, 25, 36, 37, 39, 182, 183, 184, 185
Private collection, Paris. Courtesy of Günter Schutz: ill. 322, 323, 324, 325, 326, 327, 257, 329, 330, 331, 332, 333
Lee Stalsworth: ill. 360
Michael Tropea Photography, Chicago: ill. 248
© Walker Evans Archive, The Metropolitan Museum of Art, New York: ill. 78, 79, 90, 91, 92, 93, 94, 95, 96, 97, 98, 99, 100, 101, 102, 103, 104, 105, 106, 107, 108, 109, 110, 111, 112, 113; pages 369, 377

Catalogue

Edited by
Nathalie Bondil

Publisher
Francine Lavoie

Coordination
Sébastien Hart

Revision
Clara Gabriel

Translation
Timothy Barnard
Elise Boyer
Jill Corner
Frank Runcie

Copyright
Linda-Anne D'Anjou

Research and documentation
Maryse Ménard
Isbel Alba

Technical support
Jasmine Landry
Micheline M. Poulin
Majella Beauregard

Graphic design
Pilotte communication design
Based on design and layout by Susan Marsh

Pre-press and printing
Transcontinental Litho Acme

Legal deposit: 1st quarter 2008
Bibliothèque et Archives nationales du Québec
National Library of Canada

PRINTED IN CANADA

All rights reserved.
The reproduction of any part of this book without the prior consent of the publisher is an infringement of the Copyright Act, Chapter C-42, R.S.C., 1985.

Cover
See p. 147 (detail)
Worldwide distribution – English version:
See p. 189 (detail)

Back cover
See p. 187, 93, 150, 241

The Montreal Museum of Fine Arts
P.O. Box 3000, Station H
Montreal, Quebec
Canada
H3G 2T9
www.mmfa.qc.ca

Distribution

Cuba. Art and History from 1868 to Today
© The Montreal Museum of Fine Arts 2008
ISBN The Montreal Museum of Fine Arts: 978-2-89192-323-1
www.mmfa.qc.ca

Worldwide distribution:
Prestel Publishing
ISBN Prestel Publishing: 978-3-7913-4019-7
www.prestel.com

Prestel Verlag
Königinstrasse 9
D-80539 Munich
Germany
Tel: 49 89 38 17 090
Fax: 49 89 38 17 0935

Prestel Publishing Ltd.
4 Bloomsbury Place
London WC1A 2QA
United Kingdom
Tel : 44 20 7323 5004
Fax: 44 20 7636 8004

Prestel Publishing
900 Broadway. Suite 603
New York, NY 10003
Tel: 212 995 2720
Fax: 212 995 2733
E-mail: sales@prestel-usa.com

Aussi publié en français sous le titre
Cuba. Art et histoire de 1868 à nos jours
© Musée des beaux-arts de Montréal / Hazan 2008
ISBN Musée des beaux-arts de Montréal: 978-2-89192-322-4
www.mmfa.qc.ca

Worldwide distribution:
Hazan
ISBN Hazan: 978 27541 0282 7
www.hachette.com

To be published in Spanish in 2008 under the title *Cuba. Arte e historia, de 1868 hasta nuestros días*
© The Montreal Museum of Fine Arts 2008 / Lunwerg Editores
ISBN The Montreal Museum of Fine Arts: 978-2-89192-324-8
www.mmfa.qc.ca
ISBN Lunwerg Editores: 978-84-9785-444-3

Worldwide distribution:
Lunwerg Editores
www.lunwerg.com